Exploring the Beloved Country

THE

AMERICAN

LAND AND

LIFE SERIES

EDITED BY WAYNE FRANKLIN

Exploring the

Beloved Country

GEOGRAPHIC

FORAYS INTO

AMERICAN SOCIETY

AND CULTURE

BY WILBUR ZELINSKY

FOREWORD BY D. W. MEINIG

UNIVERSITY OF IOWA PRESS

IOWA CITY

University of Iowa Press,

Iowa City 52242

Copyright © 1994 by the

University of Iowa Press

All rights reserved

Printed in the United States

of America

Design by Richard Hendel

Printed on acid-free paper

01 00 99 98 97 96 95 94

C 5 4 3 2 1

01 00 99 98 97 96 95 94

P 5 4 3 2 1

Library of Congress

Cataloging-in-Publication Data

Zelinsky, Wilbur, 1921–

 Exploring the beloved country: geographic
forays into American society and culture / by
Wilbur Zelinsky; foreword by D. W. Meinig.

 p. cm.—(American land and life
series)

 Includes bibliographical references and
index.

ISBN 0-87745-484-1, ISBN 0-87745-483-3

 1. United States—Geography. 2. United
States—Civilization. 3. Human
geography—United States. 4. Landscape—
United States. 5. Names, Geographical—
United States. I. Title. II. Series.

E161.3.Z45 1994

917.3—dc20 94-24887

 CIP

To a most extraordinary daughter

Contents

Foreword D. W. MEINIG

What a pleasure it is to invite readers to enjoy this rich helping of Zelinskyana gathered from a dozen different sources and served in this convenient and attractive form. It is an invitation to join with a highly creative, energetic, wide-ranging mind in the exploration of that "remarkably interesting and momentous phenomenon we call the United States of America."

Wilbur Zelinsky is one of those rare cases in academic life of a scholar who has followed his own avid curiosity rather than shaping his work to the fashionable topics and modes of his times. Indeed, one of his strongest predilections is to examine things not examined by anyone else. That is not because he ignores the work of others or seeks to call attention to himself. Any perusal of his references will attest to his amazing range of reading across many fields and his readiness to acknowledge what he has learned from others. Rather, his choice of topics arises not only from his love of the American landscape and his keen interest in popular culture but also from a tireless, inventive search for more and better ways of measuring how the American "cultural system and its major components have varied through time and space."

The sheer variety and choice of his topics—only partly displayed in the table of contents of this collection—are quite extraordinary: towns, house types, cuisines, magazines, season of marriage, personal names, cemetery names, and similarly ordinary things. Such a list could be seriously misleading to those who know him not: eclectic, obvious, commonplace, surficial? They would be deeply wrong on all counts. Those who know him well and have followed his work closely know that they are in the company of an unusually intelligent and perceptive mind that sees such mundane, vernacular phenomena not simply as items to be noted, described, and enjoyed on the surface but as "subliminal texts," tantalizing clues to something far greater, important—and elusive. As he notes, these topics are in fact an interrelated set of narrow borings deep into underlying structures in the search for sensitive measures of such cultural characteristics and changes as the quest for community, national identity, cultural diffusion, convergence, modernization, transnationalization. Typically, these exercises are presented with clear

explanations of purpose, method, pitfalls, and conclusions, and always with suggestions for further extension and refinement. They also display a remarkable capacity for detail and analysis; Wilbur Zelinsky was processing staggering amounts of data before there were computers. More important has been his quest for a level of understanding and appreciation beyond the crude mechanistic models that have long dominated so much of American geography and social science.

For all that odd list of seemingly simple subjects, a scientist at work? Yes, and with what zest! I know of no geographer and few others whose work is so obviously permeated with the love of what he is doing. Propelled by that "incendiary curiosity" he so aptly describes, it comes bubbling forth in a language brimming with energy, ideas, and a sense of excitement about the current foray of his compelling pursuit. For first-time readers it may take some getting used to, so unlike the usual academic prose it is, but I am confident that they will soon be ensnared and become eager companions for his next investigation.

Despite all that idiosyncratic prose, a scientist at work? Yes, but an uncommonly modest, sensitive, and morally concerned one. Zelinsky is forthright about his choice of topics and his purpose, but he is never assertive about his ideas or achievements. He is deeply serious about the importance of ideas and the need for continued dedicated research on the great questions of humankind, but he has been shatteringly critical of the practice of science as it has been applied to those questions. To appreciate that one must turn to the one great piece missing from this collection—for it is not directly about America per se—"The Demigod's Dilemma," the most courageous and powerful presidential address ever delivered to the Association of American Geographers. It is a radical, disturbing critique, yet, typical of the man; it is a prophetic cry about the purpose of knowledge and the need for unstinting pursuit thereof; it is the passionate testimony of a deeply humane geographer.

So *Exploring the Beloved Country* takes its place alongside his earlier landmark in geographical interpretation, *The Cultural Geography of the United States*, as an attractive way of joining with a delightful companion in the investigation of many a topic few likely ever thought worth giving serious thought to. Do give it a go; the results can be surprising, fascinating, and important.

About This Book and Its Author

What excuses can I muster for this anthology of previously published articles? The most obvious rationale is also the flimsiest: simple convenience. Anyone rash enough to crave the twenty-one selections gathered and reformatted here would otherwise have to endure quite a bit of trekking through the stacks of a large research library. Moreover, even then there are two or three items that might elude the pursuer.

The real explanation for the genesis of this book, implausible though it may sound, is akin to a ploy so often adopted by European travelers of the past century who had recently returned from a tour of the wild new lands and peoples of North America: "My friends have importuned me to report my experiences in a form they may enjoy at their leisure," or words to that effect. Strangely enough, within a space of a few weeks in 1990, three colleagues whose opinions matter to me quite independently suggested that I put together in book form a selection of my better papers. I thanked them politely, idly mulled the matter over but took no action, letting the notion float down into my subconscious. And there it quietly festered until re-emerging in 1993 as something I truly felt worth doing, for a variety of reasons.

Egotism, I trust, is not one of them, for I am acutely aware of the limitations of my knowledge, skills, and intellect. Instead, a determining objective is to shed a modest beam of light on the nature and dynamics of this remarkably interesting and momentous phenomenon we call the United States of America—more illumination than would be generated by reading the various pieces in isolation. I am immodest enough to believe that juxtaposition has its virtues, that the totality may be greater than the sum of these previously scattered parts. Perhaps both author and reader may come across hidden connections and fresh questions that might otherwise escape notice. In any event, if there is any central argument running through this volume, it is simply that without elucidating the historical geography of this land, without viewing America simultaneously in both time and space, we cannot begin to arrive at a proper understanding of who and what we are and where we are going, or the meaning of the American project in the larger scheme of things.

Another motive behind this project is quite private, and I feel a twinge of embarrassment in mentioning it. The concentrated effort of assembling and editing the materials that follow has obliged me to become better acquainted with myself, to discern some of the deeper workings of my mind. Most of what materialized I need not bore you with. But one of the discoveries—one so obvious now as to be laughable—is that every single item reproduced herein is indeed exploratory in nature, a foray into terra incognita. (At least eight are literally exploratory in the sense of being products, in part, of travel and field observation.)

Each item included here is the result of some internal impulse I do not fully understand, a curiosity so incendiary that it would dominate my waking thoughts for weeks and months on end. The same might be said about a number of other essays not appearing here for lack of space but which are listed at the end of this book. All of these items dealing with American society and culture, I must repeat, were spontaneously begotten, unlike some of my work in other areas which came to pass because of commissions of one sort or another.

The critical reader may question the necessity for this publication given the existence of the earlier *Cultural Geography of the United States* (Zelinsky 1973), a slim volume that has met a friendlier reception than I had any reason to hope for. But, whatever its merits, the previous opus operates along a different dimension. It is a broad conspectus, a skimming across a continental expanse as it distills and rearranges a wide assortment of pre-existing work by scholars and writers of many dispositions, with only some minor original contributions of my own. If the thrust of that effort was intrinsically horizontal, the direction of the twenty-one pieces anthologized here is vertical. These are narrow borings, piercing as deeply as possible toward whatever structure lies concealed from our quotidian gaze. When enough of the undisturbed spaces between these shafts have been punctured (be my guest!), we may begin to grasp the innermost contours of a bewildering American reality. In this context, I should mention a parallel book-length venture of mine that pursued the same strategy of focused penetration: a biography of the cultural symbols of American nationalism (Zelinsky 1988), and one that led to revelations that startled at least its author.

The historical geography of American society and culture has not been my only concern. I have spent much time and effort over the past forty-odd years in analyzing the population geography of the United States and other parts of the world, work not altogether alien to what you find between these covers. I have also perpetrated more than my share of sermons and programmatic statements on questions geographic and social and have dabbled with cartographic and energy issues among others; I have even managed some research in economic geography within a traditional mode. But the themes that most excite me, those to which I cannot resist returning again and again, are of a social and cultural complexion. So here you have them for whatever they may be worth, those of my brainchildren that matter most to me. Whatever their failings, I trust I have not totally disguised the

sheer joy and excitement of these exploratory ventures and that a bit of my plea-
sure might rub off on the reader.

One further point calls for explanation: the term "beloved" in the title is not
an expression of either naïveté or irony. As certain passages in the following essays
and other writings may make clear enough, I am agonizingly aware of the ambi-
guities, contradictions, and dark stains in the American chronicle and of the un-
forgivable sins committed in our name at home and abroad. But I am also mind-
ful of the heart-stopping glories of certain humanized landscapes, the virtues of
our better angels, be they celebrated or obscure, the inextinguishable promise of
the nation (not the state!), that unique compact, however inadequate in execution,
we have made with ourselves and the world.

As in all cases of serious love, for kin, mate, or dearest friends, there is an
unavoidable ambivalence in one's affection for this or any other country. May I
compare my attitude on good days to that of Walt Whitman, Ralph Waldo Em-
erson, or Carl Sandburg, on bleaker days to that of Henry Adams, Herman Mel-
ville, or Samuel Clemens in their later writings, and in between perhaps to Tho-
mas Wolfe? I do, however, enjoy one advantage over all but one of these
gentlemen and the majority of my compatriots: the double vision that is my heri-
tage by virtue of being the offspring of immigrant parents. Even at the worst of
times I do not regret their decision to abandon their homeland.

A word or two about the design of this volume. If, of necessity, all books are
arranged in linear fashion, that should not oblige the reader to follow any particu-
lar sequence in traversing these articles. Be guided by whim. The four-fold classi-
fication I have hit upon—society, the built landscape, language, and transnation-
alism—is rather arbitrary, and there is almost complete disregard for chronology
of composition. Equally sensible alternative arrangements are possible, and, in
fact, most of the articles are affiliated in some manner with most of the others.
The sole exception, the single place where placement reflects logic, has to do with
the final trio of selections. The theme of the transnationalization of culture is one
that has captured my imagination recently, and I suspect it will continue to do so
for some time, in part because the salience of the subject has become so overpow-
ering and because students of the humanities and social sciences have given it so
little systematic attention. (Those unexplored frontiers beckoning again!) Indeed,
the disproportion between the abundant research on the global dimensions of
political and economic phenomena and the meager output on the sociocultural
realm is disconcerting and baffling.

As Edward Said (1993: 58) has stated, "Cultural experience or indeed every
cultural form is radically, quintessentially hybrid, and if it has been the practice
in the West since Immanuel Kant to isolate cultural and aesthetic realms from the
worldly domain, it is now time to rejoin them." If Said has chosen, quite produc-
tively, to explore the interrelationships between culture and imperialism, i.e., the
"core-periphery" geometry of the modern world, by probing the novel and art

and music, I prefer to work the other side of the cultural street: the popular or vernacular phases of modern, or postmodern, existence. In any event, at this juncture in world history, we can no longer pretend to understand America unless we treat in depth the intricate, many-sided commerce in ideas, values, and practices that binds us so tightly into a planetary community.

All the articles have been reprinted with no major changes except the relegation of footnotes to endnotes and the creation of a consolidated bibliography. The minor changes involve only correction of typographical errors, the removal of a couple of factual blunders, and a few verbal infelicities. With difficulty, I have resisted the temptation to update the material and language, but when it seemed sensible to do so, I have attached a brief commentary or afterthought.

Perhaps other writers share a private fantasy of mine. It resembles what I understand is the practice of some stage performers who work solo—singling out a specific member of the audience and aiming the words or music directly at him or her. In my mind's eye, I like to visualize the ideal, knowing reader, some paragon who not only finds palatable whatever I have to say but also is able to anticipate every twist and turn of the argument, to relish each of those nuances of which I am barely aware. Mirabile dictu, such an individual has actually materialized in the person of Wayne Franklin, soulmate and editor of this book and the series that it joins. Am I not blessed?

Society

Selfward Bound?

Take a large human population. After it has been stirred and seasoned well for two centuries, relax traditional social and economic constraints. Give many of its individual members enough leisure time and money so that they can do pretty much what they wish to please themselves. Add several dashes of new social and technological forces; let the mixture simmer for a couple of decades; then ask: what sorts of choices will be made by the millions of participants in such a macro-experiment? What things will how many persons do, and *where* will they do them?

The ingredients for this recipe are, of course, to be found in the United States; and the challenge to the adventurous chef is enormous, exhilarating—and frustrating. Our nation has witnessed the attainment of a degree of affluence and freedom of attitude and action, of a range of individual and social options, on the part of a quite massive fraction of its total adult population that is unprecedented in human history, yet may be predictive of things to come in other highly advanced countries. But this recent acceleration in social history has been so rapid that social scientists are not yet fully aware of the qualitative transformation of their subject matter. Clearly neither our theoretical nor our data-gathering apparatus has been revamped to the point where one can readily validate, or disprove, the hypothesis that motivates this study: *That the increasingly free exercise of individual preferences as to values, pleasures, self-improvement, social and physical habitat, and general life-style in an individualistic, affluent national community may have begun to alter the spatial attributes of society and culture in the United States to a significant extent.*

This notion happens to be imbedded in an even more fundamental proposition, namely, that we are now engaged in a process of deep, perhaps revolutionary, structural change in human society, the causes and consequences of which are still unclear. The geographer has been accustomed to seeking the sources for areal diversity in human activities in three sets of factors, all operating complexly through time and space, and interacting with each other: the laws of economic

3

behavior; the still dimly apprehended laws of socio-cultural behavior; and the opportunities and constraints of an exceedingly complicated physical environment. Perhaps we can no longer afford to ignore a fourth major set of less familiar factors: the differences in personality structure, however generated, among a growing number of human beings in quest of self-fulfillment.

Presume, then, the existence of a growing tendency for individuals to sort themselves out, consciously or otherwise, with increasing independence from the traditional factors of social ancestry, economic coercion, or early upbringing. Presume also the increasing power of each person's temperamental predilections, tastes, and private impulses, of what might be labeled, for lack of a better term, the "personality factor." What are the possible spatial consequences? And how do we search them out?

RESEARCH STRATEGY

No direct precedent for this study is known to exist.[1] This fact compels more than normal care in designing and explaining its *modus operandi*. If an axiomatic belief in an ongoing, fundamental reordering of human sensibilities and social arrangements is accepted, there are at least two large classes of geographic phenomena that might flow from such change. Firstly, it is conceivable that, given the erosion of conventional social ties, heightened personal mobility, ready access to advanced modes of communication for business and pleasure, and thus the effective annihilation of space, at least in its familiar frictional guise, there might arise a superficially random array of individuals. A kind of social entropy might prevail in which persons could locate virtually anywhere and engage in almost any tertiary or quaternary occupation or non-economic pursuit with little reference to the locational constraints of the past (Abler 1973). Such new modes of spatial behavior would be of considerable geographic interest, but, unfortunately, our prevalent methodologies are not designed to detect or analyze them.

Secondly, whether or not such a reordering of locational and activity patterns is gestating (and my personal suspicion is that it is), the newly emergent social-psychological forces may also prompt conventionally mappable shifts in the location of individuals or in their attributes. Thus, new migrational and circulatory currents could be set in motion as flexible, atomistic individuals, largely unshackled from traditional determinants, are attracted to, or repelled by, specific habitats or communities. Or even if such persons remain *in situ*, a strongly altered perception of self, associates, and environs might engender new forms of behavior.

Observational convenience dictates that only the second of these options be pursued. Similarly, technical problems preclude any direct attack on the question of whether or how territorial mobility has been modified by the "personality factor." An early decision was reached to cast the widest observational net feasible in this initial foray into terra incognita, and thus to consider the entire national

territory as the study area. The results could indicate the wisdom of designing further research at other areal levels or in selected localities. The critical operational problem thus becomes: Can we lay hands upon sufficient bodies of quantifiable nationwide data that will inform us, in a significant way, about those attributes or acts of Americans at particular points in space and time which reveal the exercise of personal choice minimally constrained by social inheritance, employment, or other accidents of place, time, and circumstance?

An obvious strategy is to observe or interview a sufficiently large, carefully selected sample of the national population.[2] Quite apart from technical difficulties and the prohibitive expense of such a procedure, the validity of the results might be badly contaminated by deliberate or unconscious response errors, or by self-consciousness over the fact of being observed. Equally obvious and much less costly is a resort to the standard data collections used by geographers and others for individuals, households, and various social and territorial aggregations; but censal and other governmental statistics, maps, and the more familiar documentary sources are of negligible utility in an enterprise of this sort. Such items as vital statistics, occupational, educational, ethnic, linguistic, class, electoral, and a wide range of economic attributes are, wholly or in large part, the products of traditional causative factors. For the individual, the data recorded under such headings tend to reflect the accidents of time and place of birth or the operation of large economic and political forces far beyond his control.

We are left, then, with that broad category of items known as "unobtrusive measures," those devices whereby the actor creates, or allows to be created, some record of attitude or activity quite spontaneously without being asked or openly watched.[3] Such measures would clearly be most useful in a study of this sort, if they do indeed sensitively reveal personality traits and unconstrained individual choice, can be readily interpreted, are accessible for all or a reasonably large, unbiased sample of the national population, and are procurable at little or no cost. Some obvious candidates must be discarded. Choice of college, residential architecture, and change in religious affiliation are decisions that strongly tend to be assortative in terms of personality; but they are usually once-in-a-lifetime items, if that often, restricted to a small portion of the aggregate population, and data collection and evaluation present crushing problems. Much higher hopes can be held out for the ultimate utility of an unobtrusive measure I have elsewhere characterized as the best available approximation to "the ideal cultural metric"—the choice of forenames conferred upon infants by their parents (Zelinsky 1970b). Unfortunately, the collection, sorting, and manipulation of an adequate volume of names make for a costly, difficult venture.

SOURCES OF DATA

The final alternatives are two categories of data that do, in many instances, meet the criteria set forth for this study: consumption of certain personality-

sensitive goods and services;[4] and membership in truly voluntary organizations. Although the geographic analysis of patterns of consumption is one of the more scandalously neglected phases of economic geography for an obscure variety of historical and technical reasons,[5] the potentialities would seem to be major. I suggest that, over and above the many staple items most of us consume or those for which level of effective demand is determined mainly by income, class status, education, size-of-place, and other familiar variables, there is a large group of commodities and services for which appetites are generated to a meaningful degree by qualitative attributes in our personal makeup. Obviously, care must be taken to correct for the economic, social, and traditional cultural factors that help structure market areas. Furthermore, it may be difficult to control for such technical factors as the differential warping of demand through regional advertising or the spatial frictions intrinsic to distributional systems. In some instances, an interesting innovation might be caught in mid-flight, so to speak, as it is being diffused outward from points of origin to its ultimate limits.[6]

There are several categories of commodities that could be useful unobtrusive measures of personality: the offerings of specialized book clubs; fan mail; special-interest magazines; the wide variety of greeting cards (and perhaps slogan-wielding buttons, posters, and bumper stickers, all of which serve as informal Rorschach Tests); specific types of phonograph records and tapes; juke-box plays; various kinds of antiques; wallpaper; diagnostic elements of clothing, ornament, diet, drink, and stimulants (unrelated to ethnic or religious considerations); color[7] (and odor?) preferences in various contexts, e.g., autos, household appliances, men's shirts, lipstick, or hairdye; certain craft and hobby goods; athletic equipment and card, board, and other indoor games; and a wide variety of pets. The problem, of course, is gaining access to adequate quantities of well-distributed, place-specific data.[8]

The potential sources of data include: manufacturers and wholesalers of specified items; mail-order firms; national department store chains; and mailing-list companies. In addition, there are sources of information on consumption patterns that use a mixture of direct questioning with an assortment of unobtrusive approaches: the U.S. Department of Commerce (1963–66); market research organizations; and advertising firms. After some serious probes, I discovered that, at least within the time and means immediately available, the difficulties of exploiting such sources were insuperable—with one happy exception. Nevertheless, I firmly believe that the research possibilities awaiting us in such relatively private, confidential files are vast and staggering. And most intriguing are the materials which might be extracted from the market research industry.[9] The investigator needs only sufficient time, perseverance, and perhaps charm and funding to discover who has what and how to win their confidence and cooperation.

Within the rubric of personality-sensitive goods and services, the great, fortunate exception turned out to be the special-interest magazines.[10] All current American periodicals of any consequence are indexed in a variety of publications.

The most inclusive of these (Garry 1970; Standard Rate and Data Service) were carefully scrutinized. After the exclusion of all magazines concerned with manu-facturing, commerce, union activities, professional matters, and all other liveli-hood-related items, church-related publications, and those catering to particular regions, localities, ethnic and traditional fraternal groups, as well as the mass-circulation magazines aimed at broad, undifferentiated reading publics, the result was a fairly lengthy list of items, which, one might reasonably assume, reflect the personal proclivities of readers whose patronage is very much a matter of indi-vidual discretion. Fortunately, circulation data for many of these periodicals were obtainable at the state or county level for either 1970 or 1971 (the principal data-gathering effort having been made between September 1971 and March 1972) from two standard sources (Audit Bureau of Circulation; Standard Rate and Data Ser-vice). Letters were written to the publishers of the remaining magazines soliciting recent circulation statistics. Many of those that did reply could furnish nothing more detailed than figures on paid circulation by state, although a few forwarded recently completed surveys of readership characteristics. The other respondents either had no locationally organized circulation records, or they were arranged in such a fashion that extracting figures for state, county, or other standard units would have entailed an inordinate amount of office work. Since there were rela-tively few sets of data available at the intrastate level, I decided, with some misgiv-ings, to use the state as the basic areal unit for subsequent analysis.

The quest for data on membership in voluntary organizations was more ardu-ous and perhaps more rewarding qualitatively, if not quantitatively. Many, per-haps most, adult Americans belong to one or more voluntary associations.[11] In the majority of instances, the associations are "voluntary" only by courtesy, since membership is obligatory or perfunctory in varying degree because of conditions of employment, profession, parenthood, or the vagaries of personal history and location. In narrowing the field down to the *purely voluntary* association[12]—that toward which loyalty and interest are spontaneously extended, without social or economic pressure or hope of material advantage—one can exclude trade unions, professional and commercial associations and other business-related groups, criminal organizations, many charitable groups, ethnic and church-related soci-eties, local athletic boosters, adolescent gangs, neighborhood organizations of all sorts, and, with some hesitation, fraternal lodges. In addition, I think it prudent to ignore associations having severe membership qualifications, aside from age or sex,[13] such as veterans and alumni groups, family clubs, those including only de-scendants of specific populations (e.g., the DAR), or those of specific national, racial, or regional provenance, and also those which are too broad-spectrum and fuzzy in structure, e.g., the major political parties, the PTA, YWCA, AAA, Red Cross, Boy Scouts.

What is left, then, are two major categories of truly discretionary, voluntary associations operating throughout the nation and drawing their clientele from a broad, if probably upward-biased, stratum of society: those which are ideological

(or "instrumental") in the very widest sense of the term (subject to the exceptions already noted); and those (the "expressive") devoted to the enhancement of a wide range of pleasures and specific leisure-time interests, unconnected with one's ancestry, nativity, occupation, or family or local obligations. In brief, the two categories are those concerned with "causes" and with amenities. The first set of associations promotes all manner of specific issues—political, social, charitable, intellectual, and aesthetic; the second group, which may overlap the first in specific instances, embraces "amateurs" (in the strictest sense of the term) banded together to reinforce their skills and enjoyment of such activities as sports, crafts, hobbies, non-professional science, the popular and fine arts, and the adulation of celebrities. An element of self-improvement is probably present in most groups in either category. There is some duplication of entities and adherents as between special-interest magazines and the purely voluntary associations, inasmuch as virtually every one of the latter publishes one or more periodicals, copies of which may be made available to non-members.[14] As in the case with magazine circulation data, the analysis of membership patterns in the purely voluntary association is based on the premise that the decision to join (or not join) says something revealing about basic personality structure, however that elusive concept may be defined.

Fortunately, an extraordinarily comprehensive *Directory of Associations* has been assembled in recent years and is being updated periodically.[15] This publication was carefully scanned and a list compiled of all groups appearing to meet the criteria established for this study. A letter was then mailed to the secretary or executive officer of each, explaining the nature and purpose of the research and requesting the most recent statistics on membership by state or smaller areas. Many failed to respond, despite a follow-up inquiry; but a lively, voluminous correspondence developed with the more cooperative organizations. A number of them were able and willing to supply tables, membership rosters, or other materials from which state membership totals could be derived. A few were also able to send detailed analyses of membership characteristics, a variety of pamphlets, and other interesting matter.[16] But, disappointingly, many of the responding organizations do not keep membership records in suitable form or they were prohibited by their by-laws from divulging such information to non-members.

The resultant array of voluntary organizations is smaller than I might wish; and although it may be diverse enough for the immediate purposes of this study, I regret the non-representation of such special interest groups as the astrology buffs, wine-lovers, doll collectors, button fanciers, balletomanes, nudists, or anti-obscenity forces.

This recital of how the data-gathering strategy was formulated and carried out may seem inordinately long or pedantic; but it is necessary in view of the unique character of the data set and the severe constraints imposed on the analyst by the nature of these data. For my purposes, an ideal aggregation of data would have

included material on an even wider variety of special-interest magazines and voluntary organizations, along with a large array of facts on the consumption of other personality-sensitive goods and services. And these data would be coded in terms of small areas, SMSAs, and SEAs at the very least, but preferably by county and Zip Code areas; and, in addition, a large range of personal data would be anonymously available for every individual or household in question, or a generous fraction thereof, in the style of the Bureau of the Census Public Use Sample.[17]

LIMITATIONS OF THE DATA

As matters stand, we are limited for the moment to a consideration of the information concerning the social and cultural geography of the United States imbedded in a matrix showing how many persons belonged to, or purchased, each of 163 items in each of the fifty states and the District of Columbia as of 1970 or 1971. The major limitations of these data must be noted carefully.

One obvious objection can be dismissed immediately. Is all this effort worthwhile, and will we learn anything new in light of the fact that special-interest magazines and purely voluntary organizations have been fixtures on the American scene for several decades? The rejoinder is that the growth in both number and variety has been so great in recent years it is difficult to believe their study will not divulge something unexpected and interesting. This may be a classic instance where quantitative expansion is transmuted into qualitative change. Although we lack reliable historical-statistical analyses of either periodicals or voluntary groups, the general trends are beyond dispute. The mass-appeal periodicals have obviously fallen upon evil days in terms of circulation and revenue, while it is common knowledge that as a group special-interest magazines are flourishing, a situation of much import to the sociologist. Similarly, the increase in numbers, membership, and diversity of voluntary associations, which can be confirmed by a glance through the current *Encyclopedia of Associations* (Fisk 1973) and a comparison with earlier editions, is truly impressive.[18]

It is the technical limitations of the data and their interpretative potential that give me pause. Even assuming that the figures reported by the magazines and associations are complete and accurate, their lists include clients who are undesirable in the context of this study: college and public libraries; corporations; and dealers, unless, of course, such individuals happen also to be collectors or practitioners themselves. Only in a few instances was it feasible to purge the roster of such irrelevancies.

The assumption that circulation or membership figures realistically reflect the innate preference structure of the American population without locational or social bias is not entirely tenable. It is naive to contend that all potential readers or members have complete and perfect knowledge of all reading matter or activities in which they might be interested, or that access is fully open to all. No organiza-

tion is totally devoid of racial, ethnic, class, economic, or religious discrimination; and the pragmatic hurdle of dues or subscription costs may shut out many an ardent devotee. Furthermore, local membership or circulation drives may distort the locational pattern. Not the least of problems is the fact that many organizations started and existed as regional groups long before going national, and that consideration, along with political stresses and strains within an association, may badly contort the contemporary pattern. This general pitfall has been partially circumvented by the substantial redundancy inherent in the data set. Most areas of interest are represented by two or more items, so that in the subsequent analysis individual peculiarities have been dampened out to some degree.

Next there is an obvious bias in selection of people whose preferences are being sampled, with an over-representation of the highly educated, well-to-do, and metropolites, while the poor or poorly educated and the inhabitants of small towns and the countryside are slighted.[19] If the population at risk is considered to be the 145 million adult Americans (15 years and older) as of 1970, the nearly 60 million choices represented by the 163 items in the data set amount to 0.41 choices per adult. Moreover, there must be several million families whose preferences are not registered at all in the following calculations, even though I strove conscientiously to include magazines and organizations catering to the interests of the least privileged elements of the population.[20]

This flaw would be fatal were it not for the fact that, for better or worse, the topic being studied is not the total population of the United States or the attributes of individual members thereof, much as I might wish it were. Instead the nature of the data dictates that the objects of study must be a set of abstractions: preference patterns, or dimensions; or, if it is permissible to extrapolate a term from the psychology of individuals to a much broader arena, "sentiment structures."[21] Such entities have a quasi-independent life above and beyond the individual. Their reality is not vitiated by the fact that a given individual or family (or magazine or association for that matter) may have no connection with any of these structures or that others may participate in several. Furthermore, a concentration on abstractions derived largely from a relatively elite segment of the national population does not run counter to the proto-theory underlying this study.

The most intractable problem is how to interpret results generated from data packaged by states. It is a common analytical practice to treat as equivalent areal entities differing vastly in population, territory, or other respects, as we are doing here. The canny reader can calibrate to the fact that there are almost forty times as many readers and members in New York as in Wyoming. Moreover, he can steer his way around the reefs and shoals of the ecological fallacy, and keep constantly in mind the fact that any statistic imputed to a given state reflects the attributes of only a limited fraction of its population. But one is genuinely baffled in attempting to divine the territory or populations for which interpretations are to be inferred from our statistical manipulations.

In large part, the difficulty stems from the sheer perversity of our state boundaries and also the fact that data on paid circulation for magazines are reported by place of sale or delivery rather than by residence of purchaser. Thus, in terms of intra-state social geography, there is a drastic difference between the relative uniformity of a Vermont or North Dakota on the one hand and, on the other, a Florida, Maryland, or Ohio, whose opposite corners are so incongruously disparate. Similarly, what is one to make of a composite figure for culturally heterogeneous Missouri, Pennsylvania, or Indiana? The nature of the data is such that a single large metropolis could easily swamp the remainder of the state, so that, to an undetermined degree, the values cited for New York, Illinois, Wisconsin, and Minnesota may largely reflect conditions in, respectively, New York City, Chicago, Milwaukee, and Minneapolis–St. Paul.[22] In the case of the District of Columbia, where a substantial portion of the working population commutes daily to or from Maryland and Virginia, all results must be ingested with the grossest possible grain of salt. Similar reservations must be expressed for the other small, highly urbanized states: New Jersey, Delaware, Connecticut, and Rhode Island. The moral is clear: future investigations of personal preferences in the United States must generate data assignable to SMSAs, SEAs, or other relatively realistic areal aggregates.

A final shortcoming, but one which emerges only when diachronic analysis is tried, bedevils virtually all time series. The thing being counted is not invariant. Each of the magazines and associations in question has undergone change, sometimes quite mercurially, in both actual character and in the way it is perceived by actual or potential adherents. I need cite only *Esquire, Cosmopolitan,* or, if we go back to its earlier volumes, *National Geographic,* to prove the point.

At this juncture, I hasten to reassure the patient reader that our data have not been qualified out of existence. Despite major blemishes and shortcomings, much that is new, provocative, and significant emerges from this laboriously constructed body of statistics.

When data on the total adult population and aggregate membership and readership for each state are arranged in order of descending ratio between these two quantities, the outcome is at least mildly surprising. The highest ratios, i.e., the greatest average membership or readership per capita, are found not in the more prosperous, advanced, and urbanized states, such as California or those of the Northeast, but rather in the thinly settled reaches of the Far West.[23] Evidently, magazine reading and the vicarious encounters of an association substitute, to some extent, for face-to-face social contacts among widely dispersed populations. The expectedly low values for the Deep Southern states may reflect just the opposite tendency: a lessened need for social surrogates among a denser, more communal, generally less affluent population. Thus, insofar as one can cautiously apply conclusions to the totality of a state's inhabitants, or any segment thereof, by factor analyzing its personal preference data, as is done below, they can be ac-

cepted with greatest confidence for most western states, least trustingly for the southern states, and in intermediate degree with respect to the central and north-eastern states.

ANALYSIS

The immediate product of the data-gathering process was a 163 × 51 table, with each cell containing the number of members or readers (or, more precisely, average number of copies sold per issue) reported for a given variable for 1970 or 1971 in a given state. To facilitate further computations, values were totalled for each state and the percentile share of each magazine and association in that total was calculated. In essence, then, the data set declares how large a share of an arbitrarily delimited universe of presumably freely expressed personal preferences was accounted for in each state by each of the component interests. Although the cartographic and statistical analysis of each of the 163 national patterns would undoubtedly be entertaining and informative, such heroic drudgery would also create intolerable redundancy.

The quickest, most effective route toward delimiting the spatial and other structures imbedded in the data would seem to be the now familiar factor analytic technique (Rummel 1970). A seven-factor Varimax rotation solution was adopted, and both the Q-mode and R-mode analyses were run. The decision for seven factors was reached after trying all alternatives from three through twenty, and discovering that no more than seven or less than three factors could be interpreted from any of the resulting arrays of factor loadings and scores. Incidentally, the configuration of the factors was reasonably similar from one solution to another. Since none of the factors emerging from this analysis, as set forth in tables 1 and 2 and figures 1 to 10, is intuitively obvious and since nothing closely resembling them has been found in the previous literature dealing with American society in quantitative terms, it seems advisable to describe and discuss each in turn, and then to offer some summary observations.

The difficulties of identifying and interpreting factors extracted from personal preference data solely in terms of internal evidence prompted me to turn to analy-ses of the factorial ecology of the United States based on other sets of data for greater insight. Unfortunately, little effort has actually been expended by earlier investigators to identify and map the underlying structure of the American popu-lation in terms of social, economic, and demographic attributes. There are, of course, numerous analyses of individual items locally or nationally, but the fac-torial ecology of varied sets of data at the national scale has been relatively ne-glected.[24] The two sets of maps that have been produced, those by Cole and King (1968: 295–304) and David Smith (1973: 88–89, 97, 100) employ overlapping data sets that are, however, somewhat different in both topical coverage and dates, and rely upon different mapping methods. Not surprisingly, then, these two sets of maps do not closely resemble each other, except for the predictable, if blurred,

TABLE 1. *Factor Analysis of Variation in Circulation or Memberships in 163 Special-Interest Magazines and Voluntary Associations, 1970–1971 among 51 States as Measured in 51-Dimension State-Space, Factor Scores*

Q-1: The Urban-Migrant Factor

National Geographic	9.719	Saturday Review	0.430
Playboy	6.133	Stag	−0.405
Cosmopolitan	1.159	Real Story	−0.418
Skiing	1.149	Lady's Circle	−0.513
True	1.033	Flower & Garden	−0.554
Glamour	1.003	Outdoor Life	−0.566
Ski	0.977	Field & Stream	−0.765
Esquire	0.666	Sports Afield	−1.054
National Rifle Association	0.657	American Wildlife Federation	−1.602
Argosy	0.632	Secret Romances	−1.717
Psychology Today	0.590	True Story	−2.087
Gourmet	0.589	American Bowling Congress	−2.112
Holiday	0.481		

Q-2: The Middle West Factor

American Bowling Congress	10.004	Yachting	−0.401
Outdoor Life	3.663	Common Cause	−0.436
National Geographic	3.064	Penthouse	−0.451
True	2.815	Mademoiselle	−0.463
Popular Mechanics	2.303	Glamour	−0.704
Sports Afield	1.861	Gourmet	−0.732
Field & Stream	1.694	Cosmopolitan	−0.748
True Story	1.427	National Wildlife Federation	−0.845
Argosy	1.226	Holiday	−0.889
Lady's Circle	0.809	Esquire	−1.022
Western Horseman	0.750	Secret Romances	−1.081
Prevention	0.737	Playboy	−1.089
Workbench	0.479	National Council of Garden Clubs	−1.161
Flower & Garden	0.420		

Q-3: The Southern Factor

True Story	7.580	Ingenue	1.456
Field & Stream	3.925	National Wildlife Federation	1.345
Secret Romances	3.443	Glamour	1.319
Sports Afield	3.090	Popular Mechanics	1.135
National Council of State Garden Clubs	2.399	Holiday	1.007
		Modern Screen	0.999
Playboy	2.191	True	0.997
Outdoor Life	2.083	National Geographic	0.965
Modern Romances	1.593	Hot Rod	0.910
Flower & Garden	1.582	True Confessions	0.890

(*Continued*)

TABLE 1. (*Continued*)

Home & Garden	0.886	Railroad Model Craftsman	−0.431
National Rifle Association	0.744	American Rhododendron Society	−0.433
True Love	0.739	American Philatelic Society	−0.434
Esquire	0.693	American Badminton Association	−0.434
Organic Gardening	0.624	Amateur Chamber Music Players	
True Romances	0.457	Society	−0.434
Izaak Walton League	−0.400	Society for the Preservation & En-	
Saddle & Bridle	−0.402	couragement of Barber Shop	
American Artist	−0.403	Quartet Singing in America	−0.434
American Humane Association	−0.403	National Model Railroad	
Hit Parader	−0.404	Association	−0.437
Bloodhorse	−0.407	Art News	−0.439
Garden Club of America	−0.407	Soaring Society of America	−0.440
American Numismatic Society	−0.408	Dune Buggies	−0.440
Water Skier	−0.409	War Resisters League	−0.442
National Field Archery Association	−0.410	National Mustang Society	−0.443
Chronicle of the Horse	−0.411	Salt Water Sports	−0.448
Thorobred Record	−0.413	Antique Motor Car Clubs	−0.449
Flying Models	−0.414	International Arabian Horse	
Road & Track	−0.414	Federation	−0.445
American Rabbit Breeder's		Camera	−0.460
Association	−0.414	Skin Diver	−0.460
American Iris Society	−0.414	Model Railroader	−0.462
Trains	−0.417	Yachting	−0.465
Popular Dogs	−0.419	League of Women Voters	−0.472
Gourmet	−0.419	Amateur Trapshooting Association	−0.477
International Brotherhood of		Art in America	−0.493
Magicians	−0.423	Trailer Life	−0.501
American Guild of Handbell		Camping Guide	−0.506
Ringers	−0.427	Natural History	−0.524
National Horseshoe Pitchers		Sky & Telescope	−0.539
Association	−0.427	New Republic	−0.541
Metropolitan Opera Guild	−0.428	Psychology Today	−0.556
Registered Catteries	−0.430	Common Cause	−0.641
International Federation of Homing		Western Horseman	−0.663
Pigeon Fanciers	−0.430	Skiing	−1.089
Pure-Bred Dogs	−0.430	Ski	−1.141
Specialty Dog Clubs	−0.431	American Bowling Congress	−3.511
American Orchid Society	−0.431		

TABLE 2. *Factor Analysis of Variation in Circulation or Memberships in Special-Interest Magazines and Voluntary Associations among 51 States as Measured in 163-Dimension Preference Space, Rotated Factor Loadings*

R-1: The Urban Sophistication Factor

Metropolitan Opera Guild	.883	Railroad Model Craftsman	.471
Esquire	.870	International Fed. of Amer. Homing	
Art News	.861	Pigeon Fanciers	.467
Mademoiselle	.836	Playboy	.460
Stereo Review	.831	Super Stock	.453
Saturday Review	.815	Horticulture	.452
Common Cause	.814	Cars	.441
Gourmet	.792	19 Specialty Dog Clubs	.438
Down Beat	.783	Salt Water Sportsmen	.419
Holiday	.773	Pure-Bred Dogs	.410
High Fidelity	.768	Sports Afield	−.408
New Republic	.763	Shooting Times	−.421
Glamour	.758	Modern Screen	−.442
National Review	.730	Guns & Ammo	−.445
Modern Photography	.729	Personal Romances	−.455
Hit Parader	.727	Motion Picture	−.467
Popular Photography	.695	Trap Shooting	−.491
American Philatelic Society	.663	Horseman	−.498
Audio	.661	International Arabian Horse	
Amateur Chamber Music Players		Federation	−.500
Society	.652	National Horseshoe Pitchers	
War Resisters League	.650	Association	−.512
Car & Driver	.641	Western Horsemen	−.522
Popular Dogs	.632	True Confessions	−.555
Antiques	.606	True Romances	−.555
Motor Boating & Sailing	.605	Master Detective	−.567
Trains	.578	True Experiences	−.571
Sports Car	.568	Field & Stream	−.586
Natural History	.543	Saga	−.615
Chronicle of the Horse	.520	Official Detective	−.650
Yachting	.514	Outdoor Life	−.668
Penthouse	.509	True Detective	−.712
Garden Club of America	.501	Argosy	−.728
Model Railroader	.495	True	−.744
Camera	.492	Man's Magazine	−.744

R-2: The Innovative West vs. Traditional South Factor

Camper Coachman	.555	National Geographic	.520
International Arabian Horse		Trailer Life	.513
Federation	.547	Camera	.497
American Bowling Congress	.524	2 Antique Motor Car Clubs	.481

(*Continued*)

TABLE 2. (*Continued*)

Ski	.447	True Romances	−.638
Amateur Trapshooting Association	.439	Intimate Story	−.650
Cosmopolitan	.424	Saddle & Bridle	−.652
Natural History	.420	Shooting Times	−.652
National Mustang Society	.418	American Camellia Society	−.655
Soaring Society of America	.403	American Rose Society	−.688
Cycle World	.398	Flower & Garden	−.698
Skiing	.396	Real Story	−.702
Dune Buggies	.395	Modern Romances	−.734
Psychology Today	.390	Hounds & Hunting	−.764
Coin World	−.394	True Story	−.775
Sports Afield	−.408	Real Confessions	−.780
Personal Romances	−.455	Real Romances	−.788
Field & Stream	−.468	True Love	−.795
True Experiences	−.549	Hunter's Horn	−.803
American Guild of Handbell		Secret Romances	−.819
Ringers	−.596	National Council of Garden Clubs	−.820
Ingenue	−.601	Home & Garden	−.830
National Horsemen	−.604	Modern Loves	−.832
True Confessions	−.637	American Cooner	−.837

R-3: The Migrant Factor

Citizens Band Magazine	.712	Woodall's Trailer Travel	.494
Camping Journal	.687	American Numismatic Society	.469
Trailer Life	.650	Coin World	.443
Dog World	.601	Sports Car	.441
Cycle	.593	Cycle Guide	.405
Pure-Bred Dogs	.569	Movie Mirror	.399
Camper Coachman	.537	Soaring Society of America	.395
Cycle World	.525	National Model Railroad	
Radio Relay League	.516	Association	.392

(No negative loadings greater than −.400 were generated.)

R-4: The Sex and Romance Factor (or Anti-Sex-and-Romance Factor)

National Geographic	.582	Penthouse	−.515
Radio Relay League	.524	Intimate Story	−.518
Pure-Bred Dogs	.451	Downbeat	−.521
League of Women Voters	.404	Cars	−.601
International Federation of Homing		Men	−.616
Pigeon Fanciers	.403	Lady's Circle	−.652
Secret Romances	−.426	Personal Romances	−.666
Hot Rod	−.448	Man's Magazine	−.713
Real Story	−.469	For Men Only	−.717
Super Stock	−.484	Stag	−.748

TABLE 2. (*Continued*)

R-5: The Latitudinal Factor

Popular Hot Rod	.823	Super Stock	.399
Golf	.776	Sportfishing	.396
Popular Cycling	.761	National Audubon Society	−.404
Car Craft	.755	National Rifle Association	−.430
Golf Digest	.747	National Horseshoe Pitchers	
American Orchid Society	.610	Association	−.453
Screen Stars	.604	Outdoor Life	−.466
Modern Movies	.597	Amateur Chamber Music Players	
Photo Screen	.565	Society	−.472
Motor Trend	.564	Creative Crafts	−.535
Hot Rod	.493	Ski	−.620
Skin Diver	.470	Skiing	−.627

R-6: The Aquatic Factor

Rudder	.784	19 Specialty Dog Clubs	.453
Yachting	.717	League of Women Voters	.430
Salt Water Sports	.679	Camera	.425
Boating	.666	Registered Catteries	.405
Sport Fishing	.617	International Arabian Horse	
Motor Boating & Sailing	.615	Association	−.399
Skin Diver	.571	Amateur Trap Shooting Association	−.408
Road & Track	.557	Guns & Ammo	−.411
American Badminton Society	.554	Field & Stream	−.422
Popular Dogs	.551	Sports Afield	−.433
Horticulture	.548	Western Horseman	−.546
Garden Club of America	.542	Prevention	−.571
Antiques	.518	American Iris Society	−.622
Flying Models	.489	Horseman	−.682
Amer. Philatelic Society	.481	Quarter Horses	−.701

R-7: The Midland and Midwest vs. Southwest Factor

Workbench	.841	Ingenue	.420
Better Camping	.805	International Brotherhood of	
Popular Mechanics	.800	Magicians	.406
Society for the Preservation & En-		National Model Railroad	
couragement of Barber Shop		Association	.399
Quartet Singing	.681	Flower & Garden	.399
Camping Guide	.622	Motion Picture	−.390
Motor Trend	.601	True Detective	−.400
Woodall's Trailer Travel	.549	Playboy	−.466
Camping Journal	.506	Saga	−.474
Trains	.499	Cycle World	−.486
Izaak Walton League	.484	Dune Buggies	−.500
Railroad Model Craftsman	.475	Movieland & TV Time	−.520
Sports Afield	.467	Cosmopolitan	−.569
Model Railroader	.459	Amer. Contract Bridge League	−.621

parallelism between Smith's map of the "General Socio-Economic Well-Being Component" and the unnamed Factor I of Cole and King, one which appears to describe much the same general concept.

Given the absence of any firm datum plane of "standard factors" against which to match the factors developed in this study from personal preference data, it seemed prudent to improvise one for the occasion. Statistics for some thirty-seven items were drawn from census sources for 1970 or the preceding decade. The selection includes the following types of attributes: general demographic; place of residence or work; migration; occupation; economic status; and education. It was designed to measure such essential elements in a socioeconomic profile of the American population as all observers could readily agree upon. The only deliberate "cooking" of data was the inclusion of no less than nine measures of migration. This was done after the factor analysis of the personal preference data in an effort to verify, or disprove, the presumption of migrational dimensions. The correlation of standardized data with factor loadings and scores for the ten factors described above (table 3) was performed chiefly to aid in the interpretation of the factors.

The Urban-Migrant Factor

This factor accounts for 34.1 percent of the variance, thus exceeding any other factor in either the Q-mode or R-mode in explanatory power; yet its identification is not immediately obvious. It is tempting to consider Q-1 simply as a measure of general socioeconomic well-being, for there are some positive correlations between state loadings on it and indicators of their economic status, level of occupational structure, and educational attainment (as displayed in table 3). On the other hand, the associations are too weak to be totally plausible; and the anomalously poor showing of such advanced states as New York, Pennsylvania, Ohio, Michigan, or Illinois (including Washington, D.C.) shakes one's faith in such an interpretation (figure 1). Similarly, identifying Q-1 as a measure of urbanization is unsatisfactory. There is plainly some sort of relationship, but we stumble over the mystery of the weak loadings of the states just listed and, conversely, the high ranking of relatively non-urban Alaska, New Hampshire, and Virginia.

The best available interpretation of Q-1 (keeping in mind the eternal caveat that it is abstracted from dirty data in awkward areal parcels) is that it is a dimension associated with populations who have *recently* migrated to rapidly growing metropolitan and high-amenity areas. Note the significant correlations of Q-1 loadings in table 3 with all six variables indicating long-distance migration, but most especially with Item 19: Estimated net [inter-state] migration, 1960–70. With only two exceptions (Utah and New Mexico), all states falling within the upper two quintiles in figure 1 experienced a substantial net influx of migrants during the 1960s, while those in the bottom quintile lost heavily during the same period and were either relatively rural in character or had cities with limited drawing power. The identity of those magazines and associations with strongly positive or

TABLE 3. *Correlation Coefficients: Factor Loadings and Scores for States Extracted from Rotated Matrix of 163 Special-Interest Magazines and Voluntary Associations Correlated with Selected Social, Economic, and Demographic Variables*

	Q-Mode Loadings		
	Q-1: Urban Migrant Factor	Q-2: Middle West Factor	Q-3: Southern Factor
General demographic			
1. Population change, 1960–1970	.620	−.363	−.286
2. Persons 65 years & older as % of total population	−.317		
3. Median age of population			
4. Negroes as % of total population		−.385	
5. Foreign-born as % of total population	.502		−.609
Place of residence or work			
6. Urban population as % of total population	.510		−.665
7. Population in urbanized areas as % of total population	.445		−.510
8. Population in urban places outside urbanized areas as % of total population		.329	
9. Change in urban population, 1960– 1970	.433	−.278	
10. Rural-farm population as % of total population	−.708	.624	
11. % of total employed working out- side county of residence		−.341	
Migration			
12. Migrants, 5 yrs. and older as % of total population	.319		
13. % of native population residing in state of birth	−.497		.491
14. % of native population born in dif- ferent state	.475		−.462
15. % of native population living in same house as in 1965	−.363		.287
16. % of native population living in same county as in 1965 but different house			
17. % of native population living in dif- ferent county but same state as in 1965		.361	

(*Continued*)

TABLE 3. (*Continued*)

	Q-Mode Loadings		
	Q-1: Urban Migrant Factor	Q-2: Middle West Factor	Q-3: Southern Factor
18. % of native population living in different state in 1965	.406		−.292
19. Estimated net migration, 1960–1970	.601	−.362	
20. Persons who have always lived in same house as % of total population	−.412		.422
Occupation			
21. Employees in manufacturing industries as % of total employed		.283	.371
22. Employees in white-collar occupations as % of total employed	.511		−.711
23. Government workers as % of total employed			−.330
24. Professional, technical, & kindred workers as % of total males employed 14 years and older	.352		−.279
25. Workers in recreational and entertainment services as % of persons employed 14 years and older			
Economic Status			
26. % of labor force unemployed			
27. Median family income, 1969	.423		−.777
28. % of families under poverty level, 1969	−.345		.793
29. % of families with income of $15,000 or more, 1969	.475		−.462
30. Mean family income, 1969	.524		−.743
31. Index of income concentration, 1969			.414
32. % of families receiving public assistance income			.454
33. Change in median family income, 1960–1970		−.288	.436
Education			
34. % of persons age 14–17 yrs., attending school		.405	−.754
35. Median school years completed by persons 25 yrs. & older	.354	.278	−.822
36. College students as % of total attending school			−.547
37. Persons 25 yrs. & older who have completed 4 yrs. of college or more as % of total population	.538		−.709

TABLE 3. (*Continued*)

R-Mode Factor Scores

	R-1: Urban Sophistication	R-2: Innovative West vs. Traditional South	R-3: Migrant	R-4: Sex & Romance	R-5: Latitudinal	R-6: Aquatic	R-7: Midland & Midwest vs. Southwest
1.			.496			.388	−.289
2.							.436
3.	.344						.296
4.	.505	−.390		−.438			−.321
5.	.469	.498				.470	
6.	.576	.475			.317		
7.	.679	.302			.359		
8.	−.650				−.300		
9.	−.306		.356				−.369
10.	−.483		−.367			−.466	.365
11.	.734						
12.	−.485	.292	.277				−.369
13.		−.432	−.431				.440
14.		.424	.442				−.403
15.	.290		−.384				.548
16.				−.312	.350		
17.	−.301					−.499	
18.	−.342	.306					−.458
19.			.544			.430	
20.		−.343	−.497				
21.	.280	−.405				.383	.460
22.	.593	.511					−.305
23.				−.307			−.580
24.	.407				−.580		
25.			.312				−.304
26.	−.502		.294		−.296		−.346
27.	.454	.580				.355	
28.	−.271	−.661					−.309
29.	.501	.522				.333	
30.	.430	.574				.379	
31.		−.439				−.310	−.481
32.		−.396					−.487
33.	.283	−.523	−.315	−.386			
34.		.737					.309
35.		.776					
36.	.414	.452					
37.	.388	.591					−.377

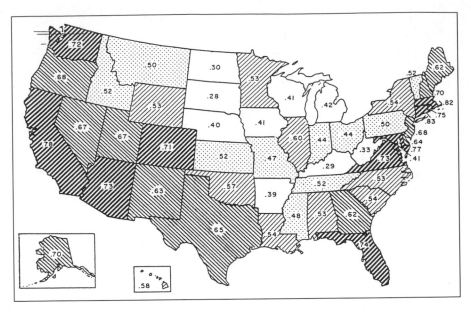

FIGURE 1 Q-1: Urban-Migrant Factor (factor loadings in quintiles).

negative factor scores contributes less to labeling Q-1 than will be the case with most other factors. At most, we can say that high values for *National Geographic*, *Playboy*, *Cosmopolitan*, or *Skiing* are not inconsistent with the image of a mobile, amenity-seeking urbanite, just as the array of items with the lowest scores fits comfortably with the concept of a staid and sober "Middle America."

Following this interpretation, the geographic pattern can be described quite simply. All the southwestern and Pacific Coast states (except Hawaii, which barely edged into the plus column in migrational terms during the 1960s) form a single large region of high loadings on Q-1, and were also possessors of cities attracting large flows of relatively skilled, well-educated, well-to-do migrants.[25] In the Northeast, the northern and southern flanks of Megalopolis—again zones of migrational gain—load strongly on the Urban-Migrant Factor, as does Florida and, more surprisingly, Georgia (where the burgeoning Atlanta metropolitan area may have tipped the balance). The large contiguous zone of medium or low loadings is one of rural exodus or relatively depressed urban-industrial centers.

If my reading of Q-1 is correct, its implications for social-geographic, psychological, and demographic theory may be truly major, for this factor seems to be telling us that *if one wishes to describe or predict the personal preference patterns of the inhabitants of a given state, then the single most important fact to be learned about that area is the extent to which the population consists of long-distance migrants who have arrived in its cities during the recent past.*[26] For the time being, we must regard as moot the question of whether the implied distinctiveness of the

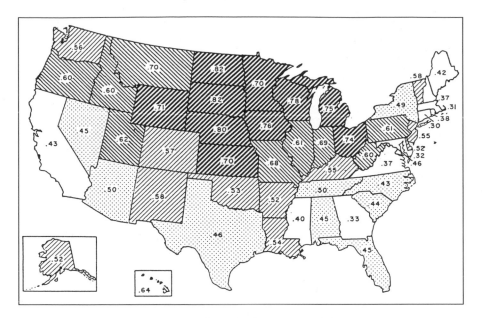

FIGURE 2 Q-2: Middle West Factor (factor loadings in quintiles).

migrant's preference pattern resides in his intrinsic personality structure or derives from the act of moving and the impact of novel surroundings, or from both. A consideration of other factors will oblige us to return shortly to the riddle of whether people select places or whether, contrariwise, the place selects and fosters latent temperaments in our innate being.

The Middle West Factor

The identification of Factor Q-2, one which accounts for no less than 32.6 percent of variance, is crystal clear after only the briefest glance at figure 2; and a Middle Western label is further confirmed by the configuration of factor scores. States with high loadings form a single large block in the north-central portion of the country. In fact, the loading for any given state seems to be a function of its linear distance from some point in central South Dakota, with only Hawaii and Vermont far out of line. The Middle Western designation makes sense not only in terms of the geometric clustering of loadings but in a historical sense as well. Consider the moderately strong values for the Middle Atlantic states of Pennsylvania, New Jersey, and Delaware, whence much of Middle Western culture may have originated, and for Utah, Idaho, and Oregon, whither many a Middle Westerner migrated in the nineteenth century. The factor scores reflect a fondness for domesticity, the more traditional arts and crafts and outdoor activities, and a passion for bowling, but an antipathy toward the exotic, sophisticated, risqué, or left-of-center.

FIGURE 3 Q-3: Southern Factor (factor loadings in quintiles).

The Southern Factor

In spatial terms, this large factor (accounting for 22.2 percent of variance) is analogous to the Middle West Factor in that a compact region of high loadings corresponds tidily with another major culture area—the American South (figure 3). But such an interpretation is fraught with hazard and reservation. An almost equally persuasive case could be made for identifying Q-3 as a poverty dimension, one connoting low levels in all departments of socioeconomic well-being. Thus, it correlates negatively at a significant level with virtually every measure of socioeconomic and educational status presented in table 3; and there is that disconcerting outlier of high loadings for the three relatively depressed states of northern New England. Is Q-3 lodged principally in the South because that region happens still to lag behind the rest of the country in quantifiable social and material attainment, so that this factor basically depicts the "culture of poverty"? Or does it really pertain to a distinctive regional culture which, by chance, is practiced by a relatively poor population? I lean toward the latter judgment. The high loadings for Maine, Vermont, and New Hampshire are cancelled out by low loadings for such relatively impoverished states as New Mexico, South Dakota, Idaho, and Montana. Even more persuasive is the culture pattern implied by the factor scores. The high values for *Playboy*, and especially *Ingenue* and *Glamour*, and the strong aversion to bowling do not reflect income or education but, much more probably, regional tastes.

In summarizing the Q-mode factor analysis of the personal preference data,

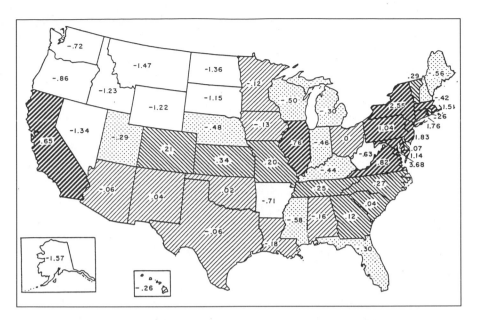

FIGURE 4 R-1: Urban Sophistication Factor (factor scores in quintiles).

we have found that the three interpretable factors account for a reassuring total of 88.9 percent of variance. Thus, the examination of the relative popularity of 163 items in a 51-dimension state-space has shown that we can describe or predict the profile of personal choices among a number of personality-sensitive goods and activities within a given state's population with a rather high degree of confidence, if we know three things about that population: (1) the extent to which it is composed of recent migrants to growing urban areas; (2) the extent to which it is identified with Middle Western culture; and (3) the extent to which it is identified with Southern culture. But even greater insights into the structure of American preference patterns during our dawning post-industrial period can be won by viewing the 1970–71 data set from a different geometric perspective, the R-mode, seeing what factors emerge from a consideration of vectors in a 163-dimension preference space, and, then, combining these observations with the information forthcoming from the Q-mode.

The Urban Sophistication Factor

The strongest of the seven interpretable R-mode factors, R-1, has less explanatory power than any of the three Q-mode factors, accounting, as it does, for only 18.5 percent of variance; but its geographic message is at least as compelling (figure 4). This is an entity clearly and intimately associated with urbanism, but after a fashion far different from that of Q-1, the Urban-Migrant Factor (although no less than eleven states appear in the upper two quintiles of values for both factors).

Factor R-1 can be appropriately labeled the Urban Sophistication Factor, for it is involved with the values and preferences of cosmopolites residing in or near many of the older, demographically less dynamic metropolitan centers of the nation. It can be suggested further that this preference structure diverges sharply from that of Q-1, a distinctively mid-twentieth century, westwardly tilted urban pattern, and harks back to an earlier, basically nineteenth-century wave of metropolitanization with firmer links to the Old World and the past.

I place in evidence the decided easterly bias of the higher factor scores, with an especially notable concentration in all those states, except New Hampshire, falling within the bounds of Megalopolis. The strength displayed by Kansas and Colorado is difficult to explain; but Illinois' and Missouri's high rankings may be accounted for by the early social maturation of Chicago and St. Louis, while San Francisco may, in parallel fashion, have bolstered California's factor score. Quite unanticipated though they were, the relatively high factor scores for the Carolinas and Georgia and the low values for such Middle Western states as Ohio, Michigan, and Wisconsin (and, even more emphatically, Florida, Texas, Hawaii, and Arizona) do make sound sense in the light of the generational hypothesis. The preference patterns of denizens of the well-ripened, stabilized urban centers of the Eastern Seaboard—and a very few large, old colonial outposts in the wilderness beyond—reflect a mental set fixed some decades ago, although now necessarily expressed via largely twentieth-century options. The interpretative evidence in the factor loadings of magazines and organizations on R-1 is even more convincing than the map pattern. They reveal a liking for the fine arts, music, political involvement, high fashion, good food, tourism, the more sophisticated hobbies, including sex, and the tonier types of motoring, but a shrinking away from many a Middle American delight and the plebeian interests represented by those "pulp" magazines specializing in crime, romantic confessions, and the raunchier forms of prurience.

The Innovative West vs. Traditional South Factor

The R-2 factor shares a certain western complexion with Q-1 (figure 5), but has only a weak linkage with either urbanization or migration (table 3). Given a bipolarization of the spatial pattern, with the western states tightly clustered at the positive end of the scale and the Deep Southern states at the other extreme, it is tempting to classify R-2 solely in regional terms. But, after studying the pattern of factor loadings for magazines and associations, I have crept out on a speculative limb—one pointing in a most thought-provoking direction—by pinning the adjectives "innovative" on the West and "traditional" on the South. The latter is easily justified. There is scarcely any reading matter listed as having a relatively large negative loading that would be truly anachronistic at the hearthside of an eighteenth-century British country squire or in the bedrooms of his more literate chambermaids. On the other hand, with two or three exceptions, the items with

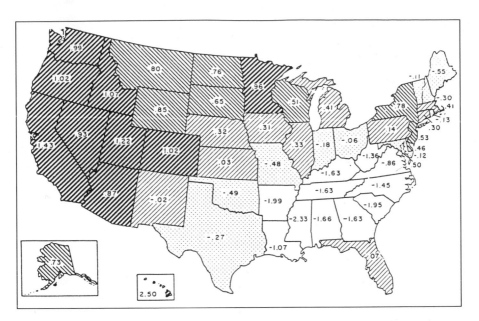

FIGURE 5 R-2: Innovative West vs. Traditional South Factor (factor scores in quintiles).

positive loadings do generally connote the trendier, emergent interests of the late twentieth century: campers and house trailers; motorcycles; gliding; wildlife preservation; dune buggies; collecting ancient autos; parlor psychology; skiing; and the suddenly fashionable Arabian horse. The attributes of the R-2 factor do corroborate the growing belief that the West has become the prime source for social innovations in contemporary America and that the South still harbors more than its share of change-resistant folk. If this notion is correct, then figure 5 may also indicate that the northeastern states, once indisputably the scene of the nation's dominant culture hearth, now retain only a modest fraction of their former inventiveness.

The Migrant Factor

Although it accounts for only 5.1 percent of variance, R-3 (figure 6) is a factor of extraordinary interest, for it is the least ambiguous, and possibly the most theoretically suggestive, of all the factors treated in this essay. As indicated by the correlation coefficients of table 3, it is associated clearly and simply with the attributes of certain interstate migrants.[27] Despite a superficial resemblance between the spatial array of state factor scores and the map pattern for Q-1, the Urban-Migrant Factor (figure 1), there is hardly a shred of urbanism here. Factors R-1 and R-2 have between them rather thoroughly soaked up whatever variance is explainable through an urban tropism. Furthermore, there is a remarkable indifference to economic considerations: the sole correlations of significance in that sector are with states having a high incidence of workers in recreational and entertainment

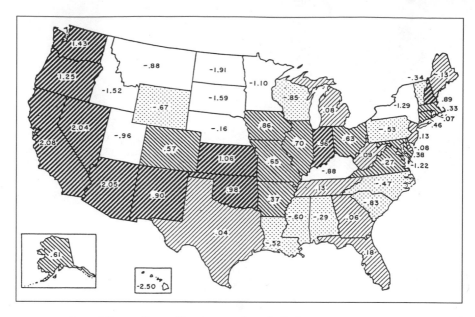

FIGURE 6 R-3: Migrant Factor (factor scores in quintiles).

services and—contrary to all orthodox demographic doctrine!—those states with high unemployment rates (table 3). We seem to be confronted, then, by a pure streak of wanderlust, or the questing after amenity, and by evidence that such an impulse to migrate with scant desire for material gain bespeaks a distinctive pattern of personal preferences in other departments of behavior.[28] Most of the positive factor loadings listed for R-3 can be related to a rootless life-style, although the logic of the connection between the dog fancy or coin-collecting and the itch to move is not at all clear.

The Sex and Romance Factor

This factor is noteworthy as the most clearly psychological, but also the most perplexing geographically, among the entire set (figure 7). The character of the magazines with significant negative loadings leaves no doubt that this preference structure smacks of eroticism in both its male and female aspects. (The implications of sexual overtones in auto racing is a beguiling one.) Factor R-4 could more justly be labeled the Anti-Sex and Romance Factor not only because the periodicals which identify it load negatively, but also because the motley handful of positive items impart very little information.

The two areal clusters of high factor scores in figure 7 call for quite different explanations. An aversion to such publications as *Stag, Personal Romances,* or *For Men Only* may reflect the Mormon upbringing of much of Utah's and Idaho's population and perhaps New Mexico's as well. On the other hand, the relative

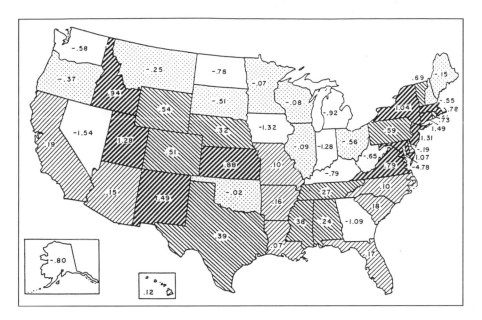

FIGURE 7 R-4: Sex and Romance Factor (factor scores in quintiles).

unpopularity of such items in the Megalopolitan states may stem from their relative sociocultural maturity. *Intimate Story* or *Man's Magazine* may titillate in frontierish Nevada and Alaska or in darkest Iowa and North Dakota, but provoke only yawns in Washington, D.C., or New Jersey, where the latest in porno chic is readily at hand.

The Latitudinal Factor

Both the map patterns and the identity of magazines and associations loading positively and negatively on R-5 point unmistakably toward a north-south polarity (figure 8). The higher factor scores are found in our subtropical regions, with the curious exception of Iowa. (New Mexico's low score may mean that a relatively high altitude can be translated into a northward shift in behavior.) The lowest scores are within close reach of Canada. In fact, one could not ask for finer type-casting for the extreme cases: Hawaii and Florida at the positive end, and Alaska, New Hampshire, and Vermont at the other. The high-loading preference items also match expectations: golf, motorcycles, the auto cult, orchids, skin-diving, and fishing in the low-latitude zone. Only the emphasis on matters cinematic is mildly startling. On the other hand, only skiing could have been anticipated among the strongly negative items. As with the Urban-Migrant Factor, we are led to speculate as to whether this preference structure suggests passive acceptance of environmental opportunity or rather a more active seeking out of compatible habitats by amenity-seeking migrants.

The Changing Map of American Society 29

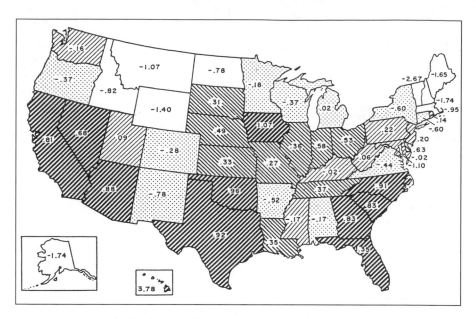

FIGURE 8 R-5: Latitudinal Factor (factor scores in quintiles).

The Aquatic Factor

The salience of the environment is even more apparent in the case of R-6, which, like the Latitudinal Factor, is bipolar in character (figure 9). In fact, the designation maritime vs. continental would be as fitting as aquatic. As is clear from its loadings, this factor implies a taste for the varied recreational activities found only along ocean or lake shore, or, when inverted, for the hunting, fishing, and equestrian activities available to the landlocked sportsman. It is not at all obvious why—assuming, as always, that the data must be taken at face value—such additional interests as badminton, gardening, stamp-collecting, or dog-breeding should vibrate on the same wavelength as a maritime frame of mind. Figure 9 offers fewer anomalies than may appear at first glance. Contact with the sea is rather difficult, and thus not too avidly sought, in the cases of North Carolina, Pennsylvania, and Texas, whereas there are many water-oriented people in the inland, but lacustrine, states of Michigan and Wisconsin. More awkward are the perverse scores for Louisiana, California, and Nevada.

The Midland and Midwest vs. Southwest Factor

The last of the R-mode factors is the only one of this seven-factor set that seems to refer to a conventional culture area (figure 10). The strong cluster of higher factor scores is reminiscent of the map pattern for Q-2, the Middle West Factor, but with two major differences. The center of gravity has been shifted eastward, so that the upper two quintiles of values include those four states (Pennsylvania, New Jersey, Maryland, and Delaware) that roughly comprise the Midland, one of

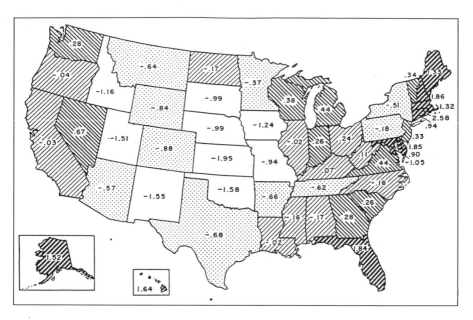

FIGURE 9 R-6: Aquatic Factor (factor scores in quintiles).

the three major colonial culture areas. And this factor tends to be rather more bipolar in structure than Q-2 insofar as a diffuse Southwest, rather than the entire remainder of the nation, stands in opposition to the Midwest and Midland. The factor loadings fit the interpretation. The only surprise, but hardly an illogical one, is the alliance between the Southwest and bridge-playing. I rejoice in the apparent statistical documentation of temperamental bonds between the Midland and the Midwest. Hitherto, the thesis that much of the culture-formation as well as peopling of the Midwest flowed from a Midland hearth has been only speculative. Furthermore, there is a hint of the eighteenth-century flow of settlers from Pennsylvania and Maryland to North Carolina in that state's relatively high factor score, if one cares to erect a case upon such a fragile data base.

In summary, then, an excursion into the R-mode factor analysis of the data set—the landscape of personal choice as glimpsed in the perspective of a 163-dimension preference space, so to speak—has yielded more complex, and perhaps subtler, insights into the preference structures of a large fraction of the American population than is the case with the Q-mode. But the seven interpretable factors have also yielded a far less complete explanation of variance, only 68.1 percent, or scarcely more than two-thirds. Consequently, we can go far toward a complete description or prediction of the within-state composition of preference structures by discovering the degree to which a state is related to just three factors. But if we wish to examine the pattern of between-state variance in the popularity of a given personal preference item, its associations with no less than seven factors, or temperaments, however informative, will still leave a very

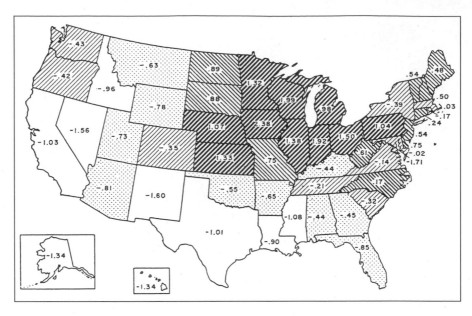

FIGURE 10 R-7: Midland and Midwest vs. Southwest Factor (factor scores in quintiles).

sizeable fraction of the variance unaccounted for. Thus, places would appear easier to characterize than the national patterns of temperaments, at least within the framework of this particular data set for 1970–71.

THE COMPOSITE REGIONS

Before summarizing whatever lessons can be extracted from perusing the factor-analytic results in the aggregate, these results can be milled further to yield a higher level of geographic abstraction: the composite regions implicit in the factor loadings and scores. In the case of the Q-mode analysis, simple visual inspection of figures 1, 2, and 3 establishes the reality of three macro-regions: the West-cum-Outer-Megalopolis; the Middle West; and the South. But the more complex products of the R-mode analysis call for computer processing. Consequently, a cluster analysis was performed on the seven sets of R-factor scores.[29] Figure 11 is a translation of the resultant taxonomic tree or "dendogram" into cartographic terms. The three largest regions, which, incidentally, meet the contiguity constraint (with the excusable exception of Louisiana), are the very same which are identifiable through Q-mode analysis. The West, minus Nevada, Alaska, and Hawaii, appears as an eight-state aggregation, occupying the Pacific Coast region and the Southwest. Note that Texas and Oklahoma are aligned unequivocally with the West rather than the South. The South is also an eight-state cluster, and one predictably bereft of Florida and Virginia, thanks to recent migration streams and the whimsicalities of state boundaries. The genuine surprise

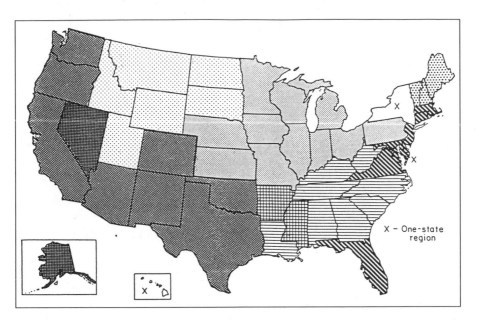

FIGURE 11 Regions as defined by cluster analysis of seven sets of unweighted factor scores from R-mode factor analysis of 163 special-interest magazines and voluntary organizations, 1970–71.

is the standoffishness of Arkansas and Mississippi. After forming a two-state region rather early in the clustering procedure, they reject merger with other areas until quite late in the game, when the only other holdouts are the highly aberrant Washington, D.C., Hawaii, Alaska, and Nevada. Perhaps this intensely deviant corner of the Old South (recall that these two states lurk at the very bottom of the factor scores for R-2 and the very top for Q-3) might be dubbed the "Super-South."

The grandest of the territorial aggregations can be called the "Middle West Extended." It embraces a core of eleven states—ten traditionally identified as Middle Western, plus (on a note of triumph!) Pennsylvania. The juncture with the Dakotas, Montana, Wyoming, Idaho, and Utah further down the dendogram is a sensible event in culture-historical terms. These states are basically colonial to the Middle West in terms of initial settlers and culture. It is also gratifying to find a discontinuous, but unmistakably, Megalopolitan region forming a sturdy bough upon the tree. The discordant exiling of Washington, D.C., can be blamed upon the anomalies of the raw data; but this loss is balanced by the take-over of Virginia, a state where the thoroughly southern inclinations of many rural and small-town indigenes are obliterated, in statewide reckoning, by the temperaments of invaders and urbanites in Fairfax County and the ex-urban outliers of Washington, not to mention Richmond. Quite similar is the recent annexation of Florida to Megalopolis displayed in figure 11. Evidently, the out-migrants from the Megalopolitan

homeland have cancelled out the intensely southern folk of northern Florida. New York State, which one would expect to assign to Megalopolis, stands in dubious solitude, perhaps because of the uniqueness of New York City tastes, or perhaps as the deviant result of combining them with those of a substantial, quite different Upstate population.

The three-state grouping of Vermont, New Hampshire, and Maine may well represent the torso of the traditional New England culture area after the amputation of Massachusetts, Connecticut, and Rhode Island by Megalopolis. The last culture area to be discerned in figure 11 is a single state, Hawaii, which culturally and ethnically cannot be expected to align closely with any of the other states. Finally, there is the coupling of Alaska with Nevada as a two-state twig that rejects convergence with any other until the very stump of the tree. Perhaps they are united in sharing the last sizeable population imbued with a strong frontier mentality and mythology.

SOME GENERAL OBSERVATIONS

Several higher-order generalizations can be gleaned from the factor-analytic data and the eleven maps we have just inspected:

1. The identity of most of the ten factors is not readily inferred from the names of their more characteristic magazines or organizations. Only in the cases of the Aquatic, Latitudinal, and Sex and Romance Factors is there such a superficial correspondence. In the others, the covert message of the factor analysis must be dug out through parsing of map patterns and correlation with socio-economic factors, a process reaching its extreme in the instance of R-3, the Migrant Factor. In this respect, the factorial ecology of personal preference patterns appears to differ significantly from that of other phenomena studied by social scientists to date, ones which wear their nametags on their bosoms, so to speak.

2. Our factor analysis fails to support the cohesiveness of several social groups that might have been expected to show evidence of unity. Thus, for example, the dog or auto enthusiasts do not form single monolithic blocs, but are aligned in two or more temperamental directions. Similarly, the cleavage of the horsey set and flower folk along regional, class, specialty, and other lines.

3. There is a distinctly non-random spatial grouping of loadings and scores for each factor individually and for all the factors considered *in toto*. Thus, the factors, or temperaments, are regionally arrayed, for whatever reason.

4. Two types of regions can be recognized: those corresponding to first-order culture areas; and those that show affinity for specific kinds of personality and habitat.

5. Two classes of culture areas are discernible, even in the light of state-level data: the older, traditional variety, namely, the South, Middle West, and, less distinctly, the Midland, New England, Hawaii, and perhaps the Mormon

area; and the newer, still emergent areas, namely, the West (or Pacific-Southwest Crescent) and Megalopolis.

6. Thus, even when an individual is given the loosest possible rein in spending purely discretionary time and money, the cultural ambience of his surroundings exerts a powerful effect.[30]

7. Despite shortcomings in data and the coarseness of the areal framework used, at least two psychological entities emerge: the preference structure associated with the propensity to migrate, and that identified with prudishness or its obverse. In addition, either personality or happenstance, or both, may be associated with preference patterns attuned to latitude or to distance from the sea.

8. The data suggest that we need to pay more attention to the problem of whether individuals freely choose migrational destinations in keeping with their own basic personality structure or whether the locality somehow triggers latent tendencies in its inhabitants, whatever their reason for being there. In other words, do people select places, or vice versa? Obviously, this is but one version of one of the largest, most enduring problems of social science, that of social change and causality, one we cannot evade and perhaps can never solve.

9. Residence in or near a large city seems to be a major correlate of personal preference patterns, but certainly not in any simple, one-dimensional manner. It is possible to distinguish two broad modes of urbanization: an older, essentially nineteenth-century model best exemplified by, and still thriving in, Megalopolis; and a newer, more foot-loose, essentially post-industrial model most fully fleshed out in the West and Southwest.

10. Thus, our analysis has unpeeled two temporal strata that are complexly superimposed in the minds and behavior of the American population, each distinct and recognizable in terms of general cultural configuration and pattern of urbanization.

11. No obvious relation has yet appeared between any of the regional groupings of factor loadings or scores and of the standard economic or social regions of the United States, such as the Corn Belt, Cotton Belt, or Manufacturing Belt, unless the South or Megalopolis is regarded as such.

The Central Hypothesis Considered

The last of these points is the most tentative, and calls for further discussion. Thus far I have done no more than define and delineate territorial patterns for a series of preference patterns. But such a descriptive exercise does not begin to test the central hypothesis of this essay. Is the presumed increasingly free expression of individual preference truly bringing about some significant alteration in the spatial attributes of American society and culture? Or are the patterns described above no more than the regular by-products of standard economic and social factors, as flavored by elements of regional cultures?

The conceptual difficulties of devising a rigorous test of the validity of our hypothesis are enormous; and, given the nature of available materials and our totally inadequate understanding of the deep changes now going on in the structure of American society, the problems of executing such a test seem insuperable at the moment. If the hypothesis does have merit, then such factors as can be extracted from relatively standard data on the social, economic, demographic, and other characteristics describing the overt structure and behavior of the American population would have interacted with the "personality factor" strongly and to an ever-increasing degree in recent years. Thus each universe of phenomena would bear the firm imprint of the other. In order to demonstrate the extent of any cause-and-effect relationship between the personality factor and the standard set of factors, one would have to have a theory of social change sufficiently powerful to enable us (1) to specify with some precision just how these factors should act upon each other, in which directions, and to what extent, and, thus, (2) to specify how the standard factors would have operated in recent time had the personality factor been absent—in effect, to produce a plausible simulation of the social geography of the United States in 1970 as it might have evolved following the rules of the 1920s or 1930s, and to compare that construct with today's reality. Even if we were favored with unlimited data of ideal quality, the problems of such a hazardous enterprise verge on the superhuman.

Another research strategy, but one yielding only suggestive, rather than definitive, results, would be to demonstrate that preference structures, or temperaments, such as those ferreted out in this study, have been on the rise during the recent past. Such an approach would be especially persuasive if such growth could be charted for items which are conspicuously personality-sensitive.

A Final Overview

What have we learned? Not as much as might have been hoped for; but, in the face of ragged data and in lieu of any fixed theoretical signposts, much more than we had any right to expect. And—to use that old tired formula so often trotted out to wind up an inconclusive scientific report—certainly enough to warrant much more thought and effort in pushing forward.

Over and above the factual harvest reported above, there seem to be two large geographic points to drive home and one disquieting query: the announcement of a previously undescribed realm of man-in-terrestrial-space; the suggestion that a new model of causality may be in order for the human geographer; and concern over the implications of the novel polity of post-industrial humanity.

Our evidence indicates, however clumsily and coarsely, that a hitherto uncharted, multidimensional domain of geographic phenomena can be detected hovering over the surface of the United States: the world of virtually unconstrained personal impulse. Although there are still many things to be learned, especially at different spatial scales, in various time periods, and using additional source materials, perhaps as glimpsed via other perspectives, a new land has been

sighted. Expanding our zone of scientific attentiveness in matters human and geographic beyond the familiar chambers of the economic, demographic, social, and cultural into the deep corridors of personal perception and the appetite for self-creation is one way to enrich our understanding of the former.

The spatial form of the quite real, if impalpable, landscape of individual choice is not totally unrecognizable. Thus, we can decipher the imprint of several macroscopic American culture areas, both old and new. There are also patches of tangency with the grosser features of the physical habitat, and no less so with those billowing contours of social and demographic well-being so often traced across the American map. Indeed it would be strange if this were not so, for this is obviously a world where everything somehow connects with everything else. Yet this new set of phenomena is not just a carbon copy of any earlier set we have known. If we are still watching pretty much the same team of players moving about the same field, the rules are changing before our eyes.

The secret agenda of this essay—to plant a few strategic charges of blasting powder below the mechanistic models of geographic explanation—remains as much a matter of intent as of accomplishment. My data are not lacking in ambiguity. But if they are consistent with more than one interpretation of the nature of reality, I am not dissuaded from tunneling deeper into the axiomatic cellars of current geographic practice. With rare exceptions, we have left unchallenged the assumption that human behavior, solo or en masse, is the outcome of large, impersonal forces external to man or beyond his control. The substitution of a deterministic set of economic (or socio-political or cultural) laws for a deterministic physical habitat has not really altered the basic logic of our model. Neither does the introduction of behavioristic psychology or a mindset bent on reducing the explanation of all physiological and mental events to fundamental biophysical laws represent any genuine advance over cruder determinisms. We somehow remain passive puppets following the signals called out by some exogenous universals—ultimately a parsimonious set of equations. We have believed this because we wished to believe it, because it has been pleasant and profitable in the short run to do so, because we have sought only confirming evidence or have interpreted what we have found in the ways least likely to splinter our model of reality.

Although this analysis is cloaked in conventional form and adopts conventional methods, I have subversively sought, and perhaps found, disconfirming, or suspiciously ambiguous, evidence, not inconsistent with a belief that the world of man is increasingly the product of energies and aspirations, frankly mysterious and improvisatory in character, that are internal to us as individuals or adherents of groups, that our future paths and the limits of human unfolding are in no sense preprogrammed. To be alone and relatively free in a world we must constantly invent, to learn that there is no one out there to tell us what comes next, is almost as frightening as the realization of how little we truly know about ourselves.

Finally, there is a latent question that has been throbbing away quietly, but with growing insistence, since this study was conceived more than three years ago. It

has grown larger and darker as the data take on new colorations in the lights and shadows of our rapidly changing social climate in the United States. (Perhaps I cannot fully measure how large or dark until this paper is re-read some years hence.) Are the newly emergent, often vicarious communities of self-selected individuals superior, or even acceptable, replacements for the confining, womblike certitudes of traditional local societies? Are we trudging along the road to utopia or dystopia? May not individual alienation or the burden of constant choice be too stiff a price to pay for the intoxication of almost limitless mobility and personal experimentation? Putting it baldly: Is what we are winning worth what we are losing? For the time being, we can only observe, analyze, think, and feel to the limits of our blinkered capacity. As with almost all important questions, the final reckoning is centuries away—or, possibly, unattainable forever.

COMMENT

If the ordering of the twenty other essays in this volume fails to honor any chronological or other compelling sequence, there is a certain logic in awarding "Selfward Bound?" pride of place. Perhaps more neatly than any other single effusion of mine, it epitomizes my scholarly concerns, aspirations, and strategies.

Despite much daydreaming about the possibility during and since the research reported in this paper, I have not updated the work, this rather quixotic effort to nail down the moving, swirling target that is American society. The prospect of investing so much energy and a large block of uninterrupted time (at least a year) is simply too daunting, especially when so many other irresistible temptations beckon. Fortunately, someone else has had a try at it, after a fashion.

In his chatty, semipopular *The Clustering of America*, Michael Weiss (1989) has presented the results of a prodigious number-crunching operation, one involving largely proprietary data, access to which is denied the disinterested, but relatively impecunious, scholar. After analyzing great gobs of information at the zip-code level for 1980 or thereabouts on consumer behavior and attributes culled from subscription lists, mail orders, warranty cards, and many media, product, and opinion surveys, as well as the traditional federal data sources, Weiss identified a set of forty archipelagos fully occupying our national territory. Each of these entities is a dispersed group of small areas, or clusters, inhabited by persons of presumably rather similar socioeconomic background, tastes, and behavior. These are interesting and useful findings, although their validity is not beyond challenge, as noted in my review of the book (Zelinsky 1992). But it is regrettable that Weiss did not experiment with a wider range of spatial alternatives, including a test of those macro-regional "structures of feeling" I managed to chart.

What neither Weiss nor I has been able to do is track change over time in whatever spatial entities we have discerned, or rather to do so with any rigor. (Weiss does comment on the comings and goings of some clusters in the 1970−80

period but in a rather offhand manner.) Although I spent much effort trying to detect trends in whatever pre-1970–71 data I procured, the materials were too sparse and weak to yield much enlightenment and are left unmentioned in the article. Now if only a well-funded someone with unlimited geographic curiosity were to exploit the vast hoard of computerized public and private consumer and demographic data for the 1990s and earlier decades and then document the spatial and temporal dynamics of a fluid national community, what a great social science benefactor that someone would be!

Economic Geography 50 (1974): 144–179

NOTES

I am most grateful for the assistance in statistical design and computations rendered by Jui-cheng Huang, Glen D. Kreider, John Longfellow, Stephen L. Morgan, Ryan Rudnicki, and Anthony V. Williams, all of whom are from Pennsylvania State University.

1. Two ultimate ancestors, however, must be acknowledged: Ullman (1954) and Lowenthal (1961). Since Edward Ullman published his truly seminal programmatic statement twenty years ago, North American and European geographers have slowly, but surely, turned their attention toward recreation, tourism, and the amenities in general as consequential items in the spatial ordering of human activities. Thus, for example, we now have book-length treatments of such previously slighted topics as the spatial patterns of summer vacations (Cribier 1969) and the geography of sport (Rooney 1974). Following Lowenthal's richly provocative essay, geographers have begun a virtual stampede in exploring the perceptual and psychological approaches to some of their basic problems (Brookfield 1969; Downs and Stea 1973; Saarinen 1969); and their interests have converged with those of environmental psychologists (Proshansky, Ittelson, and Rivlin 1970). These new interests have also been prominent, along with social geography and the study of communications, in an emerging "geography of the future" (Abler et al. 1975). Some of the themes in this essay are foreshadowed in the author's recent work (Zelinsky 1970a, 1971, 1973, 1975) and in passages by such other geographers as Campbell (1968), Wagner (1972), Vance (1972), and Sopher (1972). But these matters transcend disciplines. The implications of a post-industrial society have been vigorously proclaimed and explored by Daniel Bell and his associates (1968, 1973). Perhaps the most explicit and persuasive prophet of a "spaceless society" has been Melvin Webber, a city planner and general urbanist (1963, 1964, 1968). Although his writings are reflective in character and directed to questions of general social policy without formal analysis of data, they could serve as a prologue to the present paper. Similarly, the sociologist Alvin Toffler has stressed the theme of "the demise of geography" in his semi-popular treatment of "Future Shock" (1970: 83–85); and psychologists have begun to take heed of spatial mobility as a developing factor in American behavior (Jennings 1970). We seem to be in the presence of a new set of ideas simultaneously inventing themselves in a number of minds.

2. There has been, of course, a prodigious amount of work performed by psychologists in defining, describing, and testing the structure of human personality and its multiple components. It is rather startling, however, to learn that what appears to be the first attempt by psychologists to measure the regional aspect of personality phenomena in the United

States was published only a few months ago. In their analysis of the 16 Personality Factor Questionnaire applied to a stratified sample of 3,772 males and 2,672 females in thirty-six states grouped into six regions, Krug and Kulhavy (1973) present findings which, while not directly comparable, are not inconsistent with the results of this study. Their final conclusion is noteworthy: "While many of these findings are generally congruent with commonly prevailing attitudes, they suggest that there is no single trait which appears to be distinctive of a particular region of the country. Instead, a rather complex pattern of differences emerges which makes traditional stereotypic conceptions inadequate and provides substantially richer ground for generating hypotheses as to the origins of these differences. . . . Whatever their origin, however, it is clear that practically significant personality differences do exist across the country in a measurable and quantifiable way" (40, 73).

3. The possibilities are explored in detail by Webb et al. (1966). Two imaginative examples of the technique in non-geographic research are McClelland's (1961) celebrated use of elementary school readers, literary texts, and ceramic motifs in charting the fluctuations of the "achievement factor" in various civilizations and Richardson and Kroeber's (1947) graphing of psychological and cultural change via an analysis of the physical dimensions of women's gowns over a two-century period.

4. I am emboldened by the fact that just such a procedure was recently proposed (but, alas, not executed) by a philosopher (Durbin 1972).

5. A major factor has been the lack of ample supplies of good, ready-made data. But such a lack has been overcome in innumerable studies dealing with the geography of retailing and, most especially, in work on central-place theory. Unfortunately, the preference structures of consumers have been treated as givens in such research, as demand schedules fixed by income, size-of-place, or other supra-individual factors. But, to take the most basic of all modes of consumption, that of food, geographers have been joined in their studied neglect of the whys and wherefores of personal and inter-regional differences in taste in the United States by nearly all anthropologists, sociologists, and nutritionists. The only substantial recent geographic publications on this topic are, in an American context, by Hilliard (1972) and, at the world scale, by Kariel and Kariel (1972: 70–97).

6. This statement may apply to most of the variables used in this study and may describe a virtue rather than a defect. I prefer to view the social map of the United States as an object being perpetually transformed through contagious and hierarchical diffusion of innovations rather than as one governed by equilibrium-seeking processes.

7. For a rudimentary venture in this direction, see Williams, Morland, and Underwood (1970).

8. There may be another major problem inhibiting the potential investigator in sectors where such data are pertinent: the fear of appearing frivolous. Ours is a society, and hence a social science, still suffering from the aftereffects of a puritanical or mid-Victorian ethos. The disreputable topics of leisure, pleasure, or fun in any form still largely languish beyond the academic pale, important though they really are. Thus, to take one example, there has been a crashing silence among "serious" students on the subject of fashion in dress, although the few explorations of that theme (Blumer 1968, 1969; Simmel 1957) demonstrate exciting possibilities.

9. This surface has been scratched, and perceptively punctured, in a remarkable study of regional variations in the tastes of British consumers (Allen 1969). In the United States,

there is an enormous store of publicly available literature in the fields of marketing and advertising in general and on the psychological aspects thereof in particular. Much of the more serious work is reported in three major journals (*Journal of Advertising Research, Journal of Marketing, Journal of Marketing Research*). There are also several voluminous bibliographies covering all aspects of advertising and marketing (Advertising Research Foundation 1960; Magazine Advertising Bureau of Magazine Publishers Association 1969; Rezvan 1951; Wales and Ferber 1963). Particularly thought-provoking are the reams of statistical tables, usually derived from interviews with carefully chosen panels of respondents, covering patterns of expenditure, including reading habits, often in incredible detail (Market Research Corporation of America 1960; National Industrial Conference Board 1967; W. R. Simmons & Associates Research 1971; Daniel Starch & Staff; U.S. Bureau of Labor Statistics 1963–66). With some frequency, data are presented by area, but almost never by units smaller than census regions or divisions. I am tantalized by the likelihood that private files may contain consumer preference materials by states, metropolitan areas, and other reasonably small areas.

10. Their research potential is discussed by Webb et al. (1966: 75–82).

11. The incidence of membership depends, in large part, on the definitions used. Curtis's figure of 50 percent for the adult American population in 1960 (1971: 874) is a reasonable approximation. The literature on the sociology and history of voluntary organizations is voluminous (Blau and Scott 1962; Hausknecht 1962; Schlesinger 1944; Sills 1968), but the topic has hardly been touched by geographers. Among the immediately useful generalizations issuing from sociological analyses are the following: (1) social class and level of education tend to be positively associated with membership; (2) men are more likely to be affiliated than are women; (3) affiliation by age tends to approximate a normal curve; and (4) the married are more likely to be joiners than the non-married. Rather unexpectedly, there seems to be no positive association between incidence of membership and size of place for cities of 100,000 or more.

12. My dichotomous classification of associations into the "purely voluntary" and all others is strictly ad hoc. More elaborate—and, in other contexts, more useful—typologies are available, e.g., Sills's two-dimensional system (the dimensions being institutionalization and professionalization) (1968: 368) or Gordon and Babchuk's three-dimensional scheme, where locus is determined by purpose, accessibility, and social status (1959: 28). My "purely voluntary" cohort embraces portions of the two principal Gordon-Babchuk types, the "instrumental" and the "expressive."

13. The assumption is that both sexes and members of every major age cohort are amply represented in every locality.

14. "Media of communication, e.g., books, newspapers, magazines, etc., are other channels linking individual and community. Since they do not involve direct social interaction, these media are not wholly equivalent in function to associations. However, in terms of such functions as disseminating information and contributing to an understanding of the world, books and magazines can be defined as functional equivalents of associations. Even if what is read does not reach beyond the level of a women's magazine, the person is in a somewhat different situation, for better or worse, with respect to the larger world than the person who reads nothing at all" (Hausknecht 1962: 92).

15. The 1968 edition (Ruffner et al. 1968) and its supplements were the prime sources

used, but a 1973 edition (Fisk 1973) is now available from Gale Publishing Company. This three-volume work is heartily recommended to the casual browser; its educational and entertainment value is surprising.

16. One included an honorary membership in the International Kitefliers Association.

17. Anyone concerned with the problems and rewards involved in assembling Multiple Data Files can usefully consult Marvick and Bayes's (1969) searching discussion of the topic.

18. Another independent line of evidence bolsters the argument that there has been a genuine increase in range of personal options in this nation in recent times and that individuals have availed themselves of these choices. A comparison of the frequency of the various given-names bestowed upon males in selected localities in the eastern United States as of 1968 with the values noted for the same areas in 1790 revealed a marked expansion in the vocabulary of name-words and a corresponding decrease in the incidence of the more common traditional names (Zelinsky 1970b: 753). Unpublished data on names recently given to the newborn in New York City and Chicago, which have just come to my attention, indicate that there may have been a marked acceleration during the past five years in the diversity of names and the weakening of traditional practices. I realize that this contention seems to violate the popular belief that American society is undergoing rapid homogenization in spatial and other dimensions, but the definition and measurement of sociocultural convergence or divergence are much trickier questions than they seem at first (Zelinsky 1970b: 755–58; 1975: 85–88).

19. Less is known about the sociology of reading than is the case for membership in voluntary associations, in part because social scientists, with such rare exceptions as Thorndike (1939) and Palm (1973), have made scant use of data on periodical circulation or libraries. Despite its vintage, the best general treatment of the subject remains Wilson's (1938) study. But there is ample confirmation of the expected correlations between socioeconomic status on the one hand and purchase or actual reading of printed matter on the other in all the various statistical compilations of the market researchers. Thus, for example, a 1959 sample survey disclosed that households with a "heavy exposure" to magazines, i.e., ten or more in the house during a specified brief period, had an average income of $6,125, and the household head had enjoyed 12.0 years of schooling, while for his counterpart, whose premises were unsullied by any magazines, the figures were $3,865 and 7.9 years (Market Research Corporation of America 1960). The many special surveys made on behalf of individual publishers, some of which are publicly available, indicate strong differences among the public for various magazines. Thus, no less than 50.7 percent of *Esquire*'s male readers in 1971 had a college education, but only 25.8 percent of the men indulging in *Hot Rod* (MacFadden-Bartell Corp. 1971a) and all but 2.3 percent of *Cosmopolitan*'s women readers had progressed past elementary school, while 24.5 percent of *True Story*'s audience reported eight years or less of formal education (MacFadden-Bartell Corp. 1971b).

20. Another source of bias, but one which seems to be conveniently ignored almost everywhere in the social science literature, stems from the fact that the American population is differentiated genetically and somatically along regional and other lines—but in ways that are poorly understood. The best general account of these phenomena is quite brief (Coon 1965: 301–308), and the technical literature is scattered and incomplete in coverage (Hunt 1972). Until proof to the contrary is forthcoming, it is reasonable to suspect that there may be some relationship between genetic constitution and personality structure and, moreover, that persons of different inherent endowment or body build will interact

differently with varied climatic and other environmental conditions. Unfortunately, anthropologists, geographers, and others have studiously avoided the anthropometry of Americans, their environmental physiology and psychology at the macro level, and related matters.

21. The term is derived from Catell (1965: 161). The terms "sentiment structure," "preference pattern," "dimension," "factor," and that fine old-fashioned expression "temperament" are used interchangeably in the following discussion. The concept is treated here in much the same light as in the writings of the psychologists Catell (1950, 1965) and Eysenck (1960). Outside the field of psychology, it is the anthropologists who have been most concerned with problems of personality and of national and regional character. A useful summary is provided by Honigman (1967), and, in addition, there have been extensive reviews of current literature (Fischer 1965; LeVine 1963; Pelto 1967; Wallace and Fogelson 1962).

22. The dilemma is compounded when a single state contains two or more large, demographically and culturally contrasting metropolises as happens in California, with its incompatible Los Angeles and San Francisco or Florida with its "urbane Miami" and "folksy St. Petersburg" (Thompson 1965: 198).

23. The high rankings of Washington, D.C., and Delaware reflect the waywardness of our data. Purchases by Virginia and Maryland residents inflate the figures for Washington, D.C., and much the same thing may have happened to Delaware with Pennsylvanians and New Jerseyites commuting to Wilmington.

24. David Smith (1973: 79–103) has provided us with a comprehensive review of the relevant literature.

25. One of the rare attempts to describe the recent migrational flow of just such a population, namely physicians, is to be found in Pierre De Vise's analysis (1973: 69–77) of the locational aspect of the supply and demand for medical services.

26. Vance (1972) has probed deeply into the state of mind associated with Q-1 in his delineation of current trends in the Far West, and D. Elliston Allen (1969) appears to have detected a rather similar phenomenon within Great Britain. "It is only in the London area . . . that the signs are becoming definite and widespread of the emergence of the altogether new type of character: the stock of responses to one's social peers and contemporaries substituted for the firmly implanted code of personal behavior; the keener, more anxious tuning-in to the values and opinions of the groups in which one moves and has one's being; the gyroscope of the previous individualism replaced by a questing social radar. We do not know for sure yet whether this is a final, long-enduring new creation, called into being by the new era of mass abundance, or merely a temporary expedient while society takes new bearings in the fundamentally altered situation in which it finds itself. We can, however, be sure that, having now begun to appear in Britain, it will inexorably spread. But, like everything else, it will not spread to each region at a uniform pace, but only so fast as happens to suit the pre-existing pattern of each one in turn. Scotland and the South-West, almost certainly, will be the last two to succumb" (205).

27. Among the empirical findings of a study of members of voluntary associations in Spokane was the apparent fact that "mobility and community attitude are both significantly associated with membership in voluntary associations" (Freeman, Novak, and Reeder 1957: 533).

28. "If very large urban concentrations do develop throughout the nation, permitting

local residents to find work at home whatever their vocational interests . . . distinctive styles of life in the various urban areas could become the main desiderata of residential choice. That is, a Los Angeles resident graduating with a degree in chemistry could stay at home and work as a chemist, but he would be free, if he chose, to exchange his present decentralized automobile-oriented urban life for the more centralized, mass transit–oriented environment of a San Francisco or New York. Inter-regional migration could become much less involuntary, in response to money income differentials and job opportunities, and much more oriented toward personal tastes and urban amenities—oriented toward 'psychic income' " (Thompson 1965: 199).

29. "The program algorithm is an agglomerative, polythetic, un-weighted pair-group method of cluster analysis. It could also be described as a monotonic hierarchical method based on average within-group pair-wise distance. . . . After distance functions for all pairs of samples have been calculated, the clustering procedure is started. The pair of samples with the smallest distance function is selected and recorded, the factor measurements for the two samples are averaged. All distance function comparisons in the list that involve either of the samples in the selected pair are recomputed using the averaged factor measurements of that pair. Then the next pair in the list is combined and the above procedure is repeated" (from mimeographed notes prepared by James M. Parks and John Longfellow).

30. A comparison with Great Britain is instructive (Allen 1969: 195–200), for there too "the reef-like complexes of drives and reactions founded in the most enduring and immutable layers of the human personality" seem to have survived, if the market research evidence is to be believed, "beneath the pall of homogeneousness imposed by a modern mass-consumption economy."

A Sidelong Glance at
Canadian Nationalism
and Its Symbols

nyone decoding the changing nature of American nationalism and its attendant symbols, as I have been trying to do for the past several years (Zelinsky 1988), cannot help but dream about the ideal research strategy: comparing developments in my native land with those in several other nation-states. Unfortunately, the realities of limited time, funds, and linguistic prowess have precluded the full enactment of any such heroic agenda. But I would like to report on a single tentative foray into the cross-national arena.

If only a single country must be used for comparative purposes, the choice is preordained. Because of the Siamese twinship with its northern neighbor, comparisons are unavoidable, if more than slightly misleading, between the United States and Canada.[1] In point of fact, it is difficult to identify a less compatible pair when it comes to describing and interpreting the development of nationhood and statehood and their associated symbols. Yet to a far greater degree than Canadians, Americans are victims of the "facsimile fallacy" (Wallach 1982), the delusion that Canada is little more than the northward extension of their country—and the most logical of candidates for eventual political, as well as economic and cultural, annexation. And, for a variety of reasons, such self-deception is seductively inviting.

CONTINENTAL COMMONALITIES AND CONTRASTS

It was out of the maternal loins of Great Britain that both nations first greeted the world; and, ever since, their two sociocultural systems have matured almost simultaneously within a common Western European, basically British mold. Furthermore, during the first century and a half of European settlement, the human geographies of the two future states were closely intertwined (Harris 1987; Meinig 1986). Their demographics have evolved along parallel paths, and both countries have received, and continue to accept, roughly similar mixes of immigrant strains—with the momentous exception of the Afro-American slave population.

45

Leaving aside Canada's considerable Francophone component and the even more numerous speakers of Spanish within the United States, the vast majority of both populations share virtually the same spoken and written English. Cognate Christian, Jewish, and other denominations thrive on both sides of the border. Basic patterns of diet and costume are virtually indistinguishable, as is also the case for sport, music, and all the other diversions falling under the heading of popular culture. British common law has supplied the genesis for both legal systems. Canadians and Americans share overlapping physical geographies; the environmental attitudes of both peoples have not differed in any drastic way; and their technological and economic systems are so intimately entangled that amputation is unthinkable.

Yet, despite these and other commonalities that may suggest near-total closure in modes of thinking, feeling, and behaving to the casual observer, the deeper actuality is utterly different. If we examine the ethos of Canada—that central core of social axioms, the unwritten code that governs thought and behavior—we find that it diverges sharply from that of Americans, indeed nearly to the limit possible for two siblings sharing a common ancestry. Nowhere is this more dramatically illustrated than in the evolution of the nationalisms and the associated symbolic lives of the two lands. Furthermore, on any worldwide scale of aberrations from the modal course of nationalistic development, Canada would rank quite high, a far stronger candidate for uniqueness than the United States.

What is suggested thereby is the most major of contrasts in pattern of origin, a continuing failure to merge their innermost identities, and indeed the probability of further drifting apart in terms of those values that matter most. For the student of the American scene, then, the ultimate lessons to be drawn from Canadian experience are less of comparability than of alternatives: the very different America that might have been.[2] More immediately, the unusual historical and political experiment that is Canada serves to cast into stronger relief the salient features of American nationalism. Thus, as much because of, as despite, all the differences in symbolic posture to be noted below, the opportunity to juxtapose the two systems is not to be resisted.[3]

A review of our checklist of nationalistic symbols in Canada reveals how very few are well developed and how many are realized weakly or belatedly, or are altogether lacking. Perhaps the most telling deficiency lies in the realm of heroes. The fact that no single figure commands universal reverence or even respect among Canadians is painfully clear to citizens of the country and anyone else who cares to inquire.[4] None of the long succession of British, French, and Canadian explorers, soldiers, and statesmen have attained apotheosis or have been celebrated beyond the limits of their localities for more than brief periods (Lentner 1970: 16; Wecter 1941: 31, 32). Furthermore, Canadians have no idealized national figure to call their own in the style of Miss Liberty, Uncle Sam, or John Bull.

Nationalism has not been a significant factor in the Canadian place-name cover (or in the choice of given names for children); and the few individuals, such

as Guy Carleton, the Earl of Selkirk, or Baron Dorchester, who left more than a few marks on the map are hardly the sort to swell the ordinary Canadian's breast with jingoistic passion (Orkin 1970: 166–168). After one has disposed of the dubious candidacy of Sir John A. Macdonald (Cook 1971: 201), no one remotely analogous to George Washington can be nominated as a national father figure for Canadians; and any equivalents of Franklin, Jefferson, Jackson, Lincoln, or even Davy Crockett are conspicuous by their absence. Whatever public eidolons have enjoyed any measure of popularity have been borrowed from other countries, principally Great Britain, of course, or are collective entities.

> Canadians showed an attraction for group or collective heroes, since their environment was to be mastered more by organization men—the Hudson's Bay Company trapper, factor, or trader, the Royal Canadian Mounted Policeman; the Saskatchewan graingrowers' associations; or, earlier, the servants of New France—than by individuals. (Winks 1979: 18)

It is ironic indeed that the one eidolon that has won worldwide recognition as the exemplar of Canadianness, the red-coated Mountie, is more the product of Hollywood than of any domestic effort (Berton 1975).

The pattern of Canadian history, the relative strength of regional feeling, or the bent of the national character, with less emphasis on personal prowess and aggressiveness than in the United States, may offer more logical explanations for the collective hero than does the physical habitat. Canada's military chronicles fail to provide the wherewithal for fabricating heroes, at least any who do not pit the passions of one province or faction against another.[5] And the course of political events has been singularly bereft of the stuff of epics.[6]

> . . . parliamentary agreement lacks the drama which attends a revolutionary union. Thus the smartly uniformed figure of victorious George Washington, the "father of his country," astride his battle charger, which has fired the patriotic imagination of every American school child, has no counterpart here. Canada's debt of gratitude to its founders has had to be spread out to encompass the Fathers of Confederation—and it is uphill work making folk heroes of thirty-seven frock-coated politicians who came to a federal agreement seated around a conference table in Charlottetown. (MacRae and Adamson 1983: 220)

National holidays in Canada have never assumed the prominence they have enjoyed in the United States; and it was not until the late nineteenth century that they began to attain whatever popularity they were to have. In a catalog of sixty-four Canadian "high days and holidays," Foster and Grierson (1967) list only nine with any nationalistic tinge, while only three—Victoria Day (May 24, formerly Empire Day), Canada Day (July 1, formerly Dominion Day), and Remembrance Day (formerly Armistice Day)—can claim the attention of the inhabitants of all the provinces. Moreover, certain celebrations, notably St. Jean Baptiste Day (June 24) and Orange Day (July 12) may serve to inflame sectionalism rather than

further any national cause. Significantly, there are no holiday observances honoring Canadian individuals. For a time, Empire Day festivities, in obvious imitation of the American July 4, promised to become *the* central day of the nationalist's calendar, at least within British Canada.[7]

> . . . Empire Day celebrations were widely supported by both students and the general public as long as the majority of English-speaking Canadians could equate Canadian nationalism to British imperialism. As the twentieth century advanced declining support for the concept of imperial unity plus the counter lure of American ideals destroyed the climate in which Empire Day festivities had first blossomed. (Stamp 1973: 32)

The adoption and use of a national flag and related insignia have been of even more questionable value in fostering Canadian unity and pride. The ambiguities of Canada's political and symbolic linkages with the mother country inhibited any early assertion of national identity through flag display, even though the maple leaf had been suggested as early as 1806 (Stanley 1965: 22). The Canadian coat of arms was officially adopted in 1921, nearly a century and a half after the equivalent act in the United States. Until 1965, Canadians made do with provincial flags and the British flag or variants thereof.[8] But the gradual emergence of Canada as a sovereign entity finally stirred its people into the quest for their own distinctive banner. The process was long (1921–1964), tortuous, and often extremely acrimonious (Canada 1966; Matheson 1980; Stanley 1965). Indeed there may have been no other issue during the country's peacetime political history, as discussed in and out of parliament, that raised heat under collars to anything like the same high temperature (Matheson 1980; Schwartz 1967: 106–110). Public opinion was deeply divided over the proper choice,[9] and the conclusion of the official debate in 1964 failed to quench the conflagration.

Although the maple leaf design has been generally accepted, warmly by some, grudgingly by others, "it appears to be too soon, even yet, to be able to discuss the flag dispassionately in most general circles throughout the country" (Swan 1977: 79);[10] and, as Desmond Morton has noted,

> . . . a love affair has never quite developed between the Maple Leaf and the Canadian people. While it's widely recognized abroad, for some at home it's still the Pearson pennant. (Feutl 1984: 11)

In any event, nothing remotely resembling the American flag fetish has appeared in Canada, and the older union jack and red ensign are still widely displayed, as are the provincial flags. In fact, within Quebec the blue-and-white fleur-de-lis banner far outnumbers past and present national items. The red-and-white formula derived from the new flag has, in a sense, become the national colors, but is far less pervasive than its American counterpart.

If the impact of the Canadian flag is the mildest and tardiest echo of the Ameri-

can phenomenon, much the same is true of the national mascot, the beaver. It may have been the earliest distinctively Canadian symbol (Stanley 1965: 21), but this drab, if industrious, beast has ignited nothing like the furious devotion commanded by the American eagle. If there are any Canadian homes, flagpoles, or ships adorned by beavers, I have failed to find them.

Canada followed the American precedent, as did Australia, Brazil, Pakistan, and Turkey some years later, by creating a synthetic national capital on a virgin site. Ottawa's location, like Washington's, is on or near a cultural divide, but the similarities do not extend much farther. If the Constitutional Convention decided upon the District of Columbia expeditiously and with only minor wrangling, the selection of Ottawa in 1859 occurred only after nineteen years of bitter, divisive negotiation (Knight 1977). The final choice, the least obnoxious among the five finalists, pleased no one except the locals. Although the metropolis has grown in many ways, it has acquired nothing like the rich array of nationalistic objects assembled within Washington, nor has it begun to rival that city's symbolic aura.

The literature on Canadian public monuments is even sparser than that for the United States. What can be gleaned from the few publications and limited field observation is that politically oriented monuments claim a relatively minor role in the landscape, with the interesting exception of Quebec, where they are indeed numerous and where related commemorative events have been frequent (Hébert 1980; Roy 1923). The cities of Montréal and Quebec contain at least eighty-five examples, the great majority of which celebrate early provincial military and ecclesiastical notables and some explorers and idealized types. Only two or three deal with British royalty, while World War I is acknowledged by no more than a pair of monuments (Roy 1923). The limited number of examples in Ottawa sharply contrasts with their profusion in Washington (Kalman and Roaf 1983). Nowhere in Canada do we find counterparts of the Liberty Bell, Plymouth Rock, Independence Hall, or the Gettysburg battlefield.

Within the Anglophone community, one finds a memorial or cenotaph at the ceremonial center of almost every town of consequence. It reminds the viewer of the great bloodletting of World War I, clearly the central event of modern Canadian history. Monumental references to earlier or later conflicts on Canadian soil or abroad are remarkably rare; but the erection of the Stone of Remembrance in Winnipeg in 1960, symbolically sited near the locational heart of Canada, fits solidly into the tradition generated by the losses of 1914–1918 (Allen 1983: 12–13). With striking uniformity, these somber works in marble, granite, and limestone speak less of martial exploits and national glory than of duty, redemption, sacrifice, and grief.[11] Although Canada fought on the winning side, I find greater similarity to the twentieth-century war memorials of Germany than to those of the United States. Such melancholy is seldom seen in American public art. The conclusion must be that Canadian monuments have done little either to bolster or register Canadian nationhood or statehood.

The same statement applies to vernacular architecture, that other most visible vehicle for nationalism. Various local styles did evolve within the provinces, reworked from European models, of course. Something resembling a national style emerged only in the latter half of the nineteenth century, but a style with no overt ideological message. "Only a style with the mixed forms, and broadly general associations of High Victorian could function as a national style for a country like Canada" (Gowans 1968: 216). Specifically rejected was the Classic Revival of young America or the later Colonial Revival vogue, for they smack of un-Canadian thoughts (Gowans 1966: 70–71).

"One of the first tasks in developing a national consciousness is the creation of a literature which inspires and reinforces national pride" (Schwartz 1967: 165)—or other works of art to the same end. Canada may have its fair share of the world's competent, even brilliant, writers, artists, composers, cinematographers, and performers, not to mention scholars and scientists; but, putting aside for the moment the "Group of Seven," no single transcendent culture hero has appeared, and in the realms of letters and music, the country and world at large have yet to discover a distinctive Canadian voice (Bailey 1972; Clark 1938: 245, 248; Frye 1971; Vipond 1974: 329–390; Watt 1966). Thus, if, to quote Aldous Huxley (1932: 50), "Nations are to a very large extent invented by their poets and novelists" (Watt 1966: 242), Canada is still waiting to be invented.

Its problem resembles that of nineteenth-century America, whose creative people were forever scrambling to scale the heights of European achievement; but the struggle has been even more dispiriting for the Canadian aspirants, especially those working in the English language, for they must compete with the rich, accumulated heritage of the United States as well as the British Isles, along with the massive, day-to-day barrage of cultural goods from south of the border. And, of course, the division of the country into two major language and cultural communities has helped the situation not at all. In addition, Canadians suffer from a dearth of those quotable, memorable verses, catch phrases, political documents and orations that were so lively an element in the life of the early American republic.

When it comes to the elemental matter of language, the foundation stone of so many nationalisms, the plight of Anglophone Canadians is even more trying than that of Americans, who are at least very aware of the differences between Americanese and the King's English (or of the French-Canadians vis-à-vis Parisian French). They may never realize that such a thing as Canadian English exists.[12] There are difficulties even in the field of journalism in a country whose human geography is so disjointed or archipelagic, for as late as the 1960s no metropolitan newspaper had "been able to attain national stature analagous to that of the London *Times* in Britain, or even of the *New York Times* in the United States" (Watkins 1966: 295). (Since then, the *Toronto Globe and Mail* has reached that eminence.) It was only in the 1960s that a deliberate campaign began among the literati and other circles, officials and otherwise, to win the war for Canada's cul-

tural integrity and for "Canadian content" (Nevitte 1979), and the outcome remains in doubt.

One area that reveals the Canadian dilemma as well as any is that of popular song, for there are scarcely any, aside from the national anthem(s), that extol the glories of the dominion. And the national anthem is to be what: *God Save the Queen, The Maple Leaf Forever,* or *O Canada*? Moreover, there is a distinct shortage of indigenous tunes being sung by Canadians. In the standard collection of songs (McMillan 1949), only 9 out of a total of 119 seem to have originated within the country, and 8 of those are French-Canadian. As far as folk music is concerned, Canada's resources are considerable, but the great majority of items (and the French-Canadians are, once again, disproportionately numerous) originated in Europe, very few having been created within the country. My purely personal impression is that the ratio of indigenous to immigrant folk tunes is much higher in the United States, so that, to the modest degree that folk music serves the cause of nationalism with North America, the Yanks may enjoy the advantage. Within the realm of art music, Canadian composers felt no serious nationalistic impulses until the 1920s, some generations after the phenomenon developed among their European confreres, and the results were not especially significant (Proctor 1980: 5, 19–21, 176–177).

The drive for cultural autonomy and selfhood has been particularly frustrating in the making of motion pictures. The combination of a limited market for the domestic product and the crushing mass of American and European imports has had a near-lethal impact on the Canadian film industry. The result is that, at least before the advent of television, few Canadians had anything like that set of visual images of varied portions of their land that has been so much a part of the mental equipment of twentieth-century Americans (Berton 1975: 230).[13]

The one field of endeavor where Canadians have projected a clear image of themselves, or rather their habitat, is that of landscape painting. In fact, the recognition of the "Group of Seven" in the 1920s, with much critical as well as popular acclaim, was a watershed event in Canadian culture history given the fact of a public anxiously seeking national symbols (Cook 1974: 277; Rees 1978: 63; Reid 1973: 135–152; Vipond 1974: 463–519). But even in this instance, the development may not have been wholly indigenous if Nasgaard's (1984: 158–202) thesis is valid, for both the style and subject matter of these artists may have been inspired in considerable measure by the work of their North European contemporaries. In any event, the contrast with the American experience is enormous, not merely in terms of timing (a lag of a century and a half), but especially in subject matter. The Canadian artists were totally unconcerned with heroic personages or historic events; their eyes were fixed instead on the austere vistas of the Canadian Shield. It is not at all coincidental that most of the symbolic stock of Canadian nationalism, undeveloped though it may be, is so largely drawn from the same vast northern reaches of the land, where so few Canadians live or even visit.

In contrast to their American brethren, Canadian historians have suffered

from the meagerness of the raw materials for the making of proper nationalistic myths with which to regale their readers. In any event, historiography has been only modestly effective in energizing a vibrant national consciousness (Berger 1966; Schwartz 1967: 53; Stamp 1973: 33, Vipond 1974: 59–151). Similarly, the schools may have tried periodically to promote such feelings, but have not been nearly as persistent or successful as the American institutions.[14] Among other difficulties, the political and cultural structures of the country militate against teaching a monolithic curriculum or party line. "The teaching of a national history creates national myths which facilitate nationalism—but there are ten versions of Canadian history taught in the schools" (Watkins 1966: 295). Thus the failure of the Canadian Education Association in 1897 to convince the provinces to adopt a single standard text on Canadian history (Tomkins 1974: 21). Even today this balkanized situation remains unchanged, with each province or region using its own set of textbooks. At the very least, one might have expected a Canadian frontier myth to have flourished, but the history and nature of the phenomenon was not at all identical with the American experience. Consequently, although the image of the homesteader does have some potency, "The frontiersman . . . has never been a figure for special glorification in Canadian literature as he has been in American" (Lipset 1965: 52). The closest counterpart to the American eidolon may be the fur trapper, voyageur, and woodsman rather than the pioneer cultivator.

The Canadians have also failed to come up to standard in those other departments of symbolic behavior which can breed a fervent nationalism. Thus although historical sites, parks, and other such landmarks are by no means lacking, they do not generate anything like the traffic or level of interest observable in the United States; and the pilgrimages to Ottawa—if that is the proper term for such visitations—do not begin to match the hordes converging on Washington, even allowing for differences in population size.

On the athletic scene, the strategy of using sports to produce a spirit of nationhood in Canada has yielded only weak results (Kidd 1982). Ice hockey may be a nationwide infatuation, and we may associate lacrosse and curling with Canadians, but such enthusiasms do not automatically translate into chauvinism, any more than the passion for rugby or their version of football makes the British more British. Mass obsessions do not a nation make.[15] Moreover, hockey, like baseball, basketball, soccer, golf, tennis, and racing in all its forms, is an activity cultivated by many lands. And insofar as Canadians participate in international competitions, the effect, as in the United States, does more to advance statism than genuine nationhood.

Unquestionably, Canada's most triumphant nationalistic gesture was Expo 67. This first and probably last such effort (Vancouver's Expo 86 was in a lesser league) was, arguably, the most brilliant and successful world's fair to have been mounted anywhere to date; but, more to the point, very much like its counterpart in Philadelphia ninety-one years earlier, it brought into being for a few radiant

months an unprecedented national self-knowledge and togetherness, an acknowledgement of the Canadian fact by the world in general (Allwood 1977: 166; Hartje 1973: 32–59). It was another of those watershed events after which life can never be quite the same again.

This review of nationalistic symbols and behavior confirms what a number of observers have noted: the weakness and vagueness of Canadian nationalism. To quote only three:

> There is a legal and geographical entity, but the nation does not exist. For there are no objects that all Canadians share as objects of national feeling. (Hanly 1966: 312)

> In Canada, the provision of either unambigous or unifying symbols has been singularly lacking. (Schwartz 1967: 42)

> Canadian nationalism—if such there be—does not fit any of the classic definitions of nationalism. Common language, religious and ethnic origin must obviously be rejected . . . and common historical tradition . . . raises more questions about a Canadian "nationality" than it answers. There is no great national hero who cut down a maple tree, threw a silver dollar across the St. Lawrence and then proceeded to lead a revolution and govern the victorious nation wisely and judiciously. There are no great Canadian charters of freedom or independence expressing the collective will of the people. But the search goes on. (Brown 1966: 155)

Just why should Canadians be afflicted by this syndrome of a murky self-image, uncertain identity, and pallid national symbols in such an un-American fashion? And, however flaccid or ill-defined it may be, why has the course of Canadian nationalism diverged so sharply from that of the United States? And why so belated a drive toward nation-building? I have alluded to some of the contributing factors already, but an exploration of the more fundamental explanation is in order.

One need not be an uncritical advocate of environmental or cultural determinism to admit that both physical and cultural geography in Canada have something to do with a lack of muscularity in its nationalism. The Canadian ecumene is fragmented to an extent probably unmatched in any other nation-state large or small, except possibly Indonesia. Thus the country is essentially an archipelago, a constellation of inhabited islands separated by immense stretches of virtually peopleless, trackless forest, rock, and water. Under such conditions, the nurturing of a consensual national soul is uphill work. To compound the problem, the vari-

ous islands are inhabited by persons of disparate origin, history, and cultural outlook and practicing varied economies; and, until the coming of a modern highway network and mass telecommunications, mutual acquaintance was sorely limited.[16] To their credit, perhaps, the Canadians have made a virtue of necessity by turning to the wilderness, especially "the true North strong and free," to fabricate most of whatever national symbols have earned general acceptance (Berger 1966; Harris 1966). In any case, circumstances have conspired to plague the Canadian state with centrifugal tendencies from its wavering beginnings to a problematic present (Knight 1982; Merrill 1968). Indeed Ontario may be the only province that has never speculated aloud about the delights of secession. And, however long or well the federated state hangs together, the profound political and cultural chasm between the Québécois and other Francophones on the one hand and English-speaking Canadians on the other is most unlikely to vanish (Brazeau and Cloutier 1977; McKinsey 1976; Williams 1980, 1981). Inventing a single kit of national symbols that would be effective among both communities is a chore that challenges the imagination.

Canada's political history and an exceptionally leisurely adolescence preceding mature statehood, the fact that the Confederation was a pragmatic entity rather than an idealistic one, obviously explain some of the deficiencies in nationalist sentiment.[17] Progressing from a string of dependent colonies to an uneasily unified, more-or-less sovereign entity, Canada has never been able to decide unequivocally whether it is the trans-Atlantic extension of British and French civilizations or a new-born member of the North American community, or "a piece of real estate in limbo between Britain and the United States" (Regenstreif 1974: 65).

It is poised rather hesitantly between the two magnetic poles of Great Britain and the American dynamo; or, to take the least cheerful view, it is a country that has lost whatever opportunity it ever had to be anything but the acquiescent economic and cultural satellite of the United States.[18] Even today, after bringing home the constitution in 1982, the umbilical cord may be frayed but not severed, for the governor-general representing the British monarch still resides in Ottawa and lieutenant-governors in the provincial capitals, and membership in the Commonwealth is still a reality. With such a dual loyalty, without a clear vision of one's allegiance and identity, nationalism and its symbolic props are hard to come by. The problem is certainly exacerbated by the workings of modern technology (Watkins 1966: 293–298). The Canadian economy and society ripened in a period when transnational travel, communication, organizations, and commerce had become powerful forces, tending to flatten place-to-place differences, when the crystallization of one's own indigenous national culture was a much less straightforward process than it had been during the American genesis.

But all such explanations are subordinate to the most fundamental of all: the kinds of people who created Canada, their most deeply cherished cargo of social and political values, and thus the distinctive way in which Canada originated. These founders may have sailed from the same general regions of Europe as did

the makers of America, but, in all likelihood, they were crucially different in character and inclinations (Bailyn 1986).[19]

> Overall, there was no master plan, no vision, as in New England, of Old World regeneration overseas, and next to no interaction among these somewhat adventitious French and British beginnings in the northwestern Atlantic. (Harris 1981: 10)

However decisive such original divergences may have been, and the point is certainly debatable, the traumatic events of 1775–1783 and the years immediately following most emphatically pushed the two groups of English-speaking North Americans far along different paths. The British colonists who were scattered through the Maritimes and Lower and Upper Canada must have felt too insecure amidst the truculent, downtrodden French-Canadians to have had second thoughts about the wisdom of revolting against the Crown, if indeed they even had first thoughts. Faced with the prospect of bodily harm and loss of property, many of the substantial minority of loyalists initially residing within the thirteen rebellious colonies sought refuge within Canada as well as other British havens. Those who arrived in the Maritimes and the emptier fringes of Quebec and the future Ontario were, by instinct or nurture, persons who cherished tradition, order, allegiance to established authority, tolerance of diversity, and looked askance at individualism: in short, counterrevolutionary (Lipset 1963: 23, 38–39; Lentner 1970). And it is altogether plausible that those 19th century emigrants from Great Britain who opted for Canada further intensified this initial value system. Consequently, the achievement of autonomy was slow, tortuous, and undramatic, and sadly deficient in the ingredients of myth.[20]

> Because Canada arrived at freedom through evolution in allegiance and not by revolutionary compact, it had not a mission to perform but a destiny to work out. That destiny has never been manifest, but always exceedingly obscure (Morton 1962: 86). As Morton has said, ". . . the society of allegiance admits of diversity, the society of compact does not, and one of the great blessings of Canadian life is that there is no Canadian way of life, much less two, but a unity under the crown, admitting of a thousand diversities." (Smith 1970: 265)

The end result, then, has been a pluralistic mosaic within a state whose spiritual gyroscope revolves about the principle that individuals must hold the greater good of society in highest esteem, in loyal allegiance to the wisdom of the past. Paradoxically, such "crownism," if we may so label the Canadian version of statism, has permitted greater social variety and lower levels of tension than among the individualistic Americans, who, as Tocqueville tellingly observed, have managed so well to impose conformity upon themselves.

The muted nationalism that flows from such an ethos obviously begets few strident symbols or exuberant behavior, certainly nothing remotely embodying a sense of messianic mission. And, aside from whatever overt, self-conscious ges-

tures issue from the special Canadian identity, there are manifestations in the humanized landscape that geographers have been slow to appreciate. But an increasing number of casual American visitors have been surprised and delighted by the striking differences between their own metropolises and the Canadian cities, and the physical virtues of the latter. Careful statistical analysis ratifies their impressions (Goldberg and Mercer 1985). If they were to examine small towns and countryside as well, geographers would discover some corresponding cross-national differences. The explanation lies not in the workings of the marketplace or in zoning practices, but in the unspoken moral code that governs Canadian life.

The combination of spatial propinquity and ideological antipathy to the revolutionary young United States goes far toward accounting for the early stirrings of Canadian nationalism and its later development (Conway 1974: 77–78; Graham 1969; Johnson 1961; Lipset 1965; Tomkins 1974: 18; Wallace 1920). ". . . Canadian national life can almost be said to take its rise in the negative will to resist absorption in the American republic" (Clark 1938: 243).

> . . . the phenomenon called Canada was founded first and foremost as an essentially defensive reaction—primarily against the United States. The founding values of this country were based on the premise that what the Americans did in the 1770s and what that Republic was ostensibly created for should not happen here. Virtually everything that has taken place in Canada follows from that premise. Instead of liberty, individualism, achievement, and optimism, Canada institutionalized authority, order, ascription, and a certain pessimism. (Regenstreif 1974: 54)

If there was any single historical episode that served as the generating impulse for nascent Canadian nationhood, it was the War of 1812, with its border clashes between the neighboring armies and fleets (Wallace 1920: 141), an unpleasantness most Americans have conveniently forgotten.[21] It is easy to believe not only that Canadians "are the world's oldest and continuing anti-Americans" (Lipset 1963: 246), a fact of which most Americans are maddeningly unaware, but that if the United States had not existed, there never would have been a Canada.

But, whatever its origins, that set of reserved and ambivalent emotions that comprise Canadian nationalism seem to fit the country's requirements.

> There is probably a relationship . . . between the rather quiet, undefined nature of Canadian nationalism and national stability. Clear cultural symbols are rallying points but they also are targets. It is hard to be angry with a beaver. Canada is sustained by nationalism based on cultural belief. In sum, the country has been stable because most Canadians are not deeply angered by Canada as it is. (Harris 1981: 27)

Yet there is also little doubt that many Canadians, uncomfortable as they are with the abnormal nature of their nationalism, are uneasily aware that their country is

something of an unclassifiable misfit among the world community of nation-states. But a blessed sort of misfit. Are there any other countries, aside from Canada, Australia, New Zealand, and Switzerland, that have never acquired any national enemies?

The result, conscious or otherwise, has been a synthetic patchwork of nationalistic strategems designed to foster some awareness of unity and particularity from coast to coast. Most are not to be found in the United States. Significantly, these are the doing of governmental agencies or of corporations which may be virtual instruments of, or close collaborators with, the Federal regime. These devices do not issue from a spontaneous upwelling of mass emotion, as occurred in the early United States. The Ottawa administration played a decisive role in planning and constructing the transcontinental Canadian Pacific Railroad which "was more than a railroad to Canadians. It was the 'National Dream,' a Canadian epic still celebrated in song, poem, and story" (Stahl 1981: 129); and much later it also served as midwife to the symbolically as well as practically urgent TransCanada Highway in the 1950s, not to mention TransCanada Airways (Air Canada) in the 1930s. It is on stamps, currency, and other official documents that Canadians are forever being reminded of land and nature—those indispensable emotional anchors for a highly urbanized population—through images of beaver, caribou, wolf, trees, grainfields, fishing schooners, and the great wild North in general (Harris 1966; Stahl 1981: 97–128). And the one universally revered Canadian symbol, the Mountie, is, of course, a civil servant (Berton 1982: 25–42). In a manner quite at variance with American tradition, the Canadian government has actively intervened in cultural matters with a view toward strengthening national integrity, and usually with a sense of being embattled against the leviathan to the south.

> Defense of the national interest produced not only the tariff and the railway subsidies, but also the Canadian Broadcasting Corporation, the National Board, Air Canada, the National Research Council, and the Canada Council. No new government is without some novel scheme for using the taxpayers' money to ensure that the national consciousness is safe. (Cook 1971: 201)

I suspect that there is more than pure chance behind the fact that Canada produced more than one edition of its excellent national atlas before the United States finally bestirred itself and scraped up a governmental appropriation for its own publication.

From early on, Canadians have felt culturally beleaguered, and certain of the basic elements of the America ethos may have been filtering northward into English-speaking Canada for generations (Smith 1971). Indeed some Canadian localities have known greater empathy with adjacent American regions that with more distant sections of their own land. It was a particularly distressing problem after motion pictures, radio, and television became universally available. The counterattack came with the establishment of the CBC, with its generally superior programming over both English and French networks (Elkin 1975: 238–239;

Schwartz 1967: 38–40). Although the inundation by American radio and television has, if anything, continued to grow over the years, it is likely that the CBC has served a beneficial, nation-building purpose (Peers 1966: 262–263). The efforts of the National Film Board may have also aided the knitting together of the nation, but, splendid though their documentaries may be, the films appear only intermittently on Canadian screens, and even less often abroad (MacCann 1973: 32–42; Tomkins 1974: 22).

Other agencies, at least nominally nongovernmental, have exerted themselves in the service of national bonding. Thus the United Church of Canada (created in 1925 with the fusion of Methodists, Congregationalists, and some Presbyterians) represents a conscious attempt to support nationalism through a unified, nationwide church (Vipond 1974: 152–217). Similarly, various trade unions and voluntary associations, including the patriotic-hereditary variety, have deliberately stressed the national theme (Clark 1938; Vipond 1974: 218). Perhaps the most successful of such groups has been the Orange Order, especially from the 1850s through the 1920s, although membership was largely restricted to white Protestant males of Irish and British stock (Houston and Smyth 1980).

One can also detect signs of a distinctive Canadian personality in the landscape (Holdsworth 1984a, 1984b; Konrad 1983, 1984). Within the vernacular architectural realm, Upper Canadians developed what might best be called British Colonial Classicism (Gowans 1966: 71–72) at an early date in reaction to trends in the United States, but the style never attained national distribution. Architectural styles for both official and domestic structures have tended to be derivative of European and American models and to lag some years behind (MacRae and Adamson 1983). Nevertheless by the end of the 19th century, one can discern a Canadian school of design throughout the country, predominantly High Victorian, Gothic, Second Empire, or a medley thereof in its chains of hotels, railroad stations, bank buildings, courthouses, post offices, city halls, and other official edifices, and all assertively non-American in appearance. One also encounters visual cues to Canadian distinctiveness in the logos and color design of railroad boxcars, grain elevators, and Petro-Canada service stations. This ensemble of nationalistic motifs on the landscape may be less pervasive and cohesive than is the case in the United States, but it offers at least a start toward a composite self-image for Canadians.

This brief review of the Canadian scene has shown that the metamorphoses of the two nation-states, the United States and Canada, have followed totally dissimilar scenarios. But the chronicles of each cast a revealing light on the peculiarities of the other. If the United States has evolved uninterruptedly from nation into state, the Canadians find themselves with a state of sorts, one of rather greater fragility than most other examples among the advanced countries of the world today, but with much less certainty about their nationhood.[22] Indeed it is not unreasonable to claim that "Canadians created a state to make a future nationality

possible" (Brady 1964: 348). Whether, as a state in search of nation, they will ever fully succeed is an open question. But, whatever the outcome, it will bear little resemblance to the American model.

Perhaps we can draw a deeper moral from the Canadian story beyond the obvious one that the two large North American countries are, at heart, utterly different places, as revealed by the outward symbolic trappings of nationalism. This, again, in spite of having so many bonds of kinship and workaday interactions. Only slightly less apparent is the rule that conditions for the belated 20th century fabrication of an intensely self-conscious nation-state are almost impossible to come by, no matter how cleverly one juggles the standard symbolic gimmicks, unless its people already happen to share some central hoard of ideals and a cultural cargo peculiarly their own.

But the ultimate message is more localized, yet comforting perhaps to those of us who fret about the governability of humankind. The Canadian case (perhaps like its Swiss counterpart) may just conceivably confirm the hope that, with a great deal of luck, a large, diverse collection of human beings can coexist in comity and a state of enviable civilization within a single governmental apparatus. And, more to the immediate point, such a desirable, if delicate, state of grace may be attainable without jingoism, without the calculated parading of symbols. How sad that such a muted form of nationalism cannot be packaged for export.

COMMENT

Why include an essay on Canadian nationalism in a collection of items purporting to examine the characteristics of the United States of America? The answer should be clear to all those who read it with care, for the lightly disguised object of inquiry is really Canada's southern neighbor. Surely one of the better ways to grasp the actualities of the USA is to consider the sort of national community it might have become but for the vagaries of demographic and political history—to compare it with such places as Canada, Australia, New Zealand, and even Great Britain. For many years I have been exhorting colleagues and students to indulge in the strategy of comparative transcultural analysis, but this is the only instance in which I have seriously practiced what I preached.

The original intent was to include this essay as a chapter in a book-length treatment of American nationalism and its symbols (Zelinsky 1988), but both editor and author came to realize that, given the design of that volume, a Canadian segment would have been something of an impediment to the flow of the central argument.

North American Culture 4, no. 1 (1988): 2–27

1. In many ways Australia would be a better choice if we are to restrict comparisons to the Anglophone world. Even more productive might be the analogies between the symbolic biography of the United States and that of France, the Soviet Union, or Germany.

2. "Because Canada is different from the United States, because it is a superb testing ground for generalizations about historical development, because it has played so central a role in North American, imperial, and even United States historiographies, it is in the interest of Americans that it survive intact. Canada is essential to Americans, as a source of study, a source of contrasting knowledge about the use of the environment, about the impact of technology, about how people who share a continent may come to conduct their public lives differently from each other. If Canada did not exist, Americans would seek to invent it" (Winks 1979: 37).

3. The most useful and exhaustive bibliographic guide to Canadian nationalism and related ideologies, at least up to 1971, is Lambert (1975). Among book-length explorations of Canadian national character and identity, Stahl (1981) and Berton (1982) are outstanding. Perhaps the best single collection of essays on the question of Canadian nationalism is Russell (1966), while Meinig (1984) offers a classic statement on the dilemmas and strategies confronting the American historical geographer who is obliged to include Canada in covering the American scene.

4. I have bypassed few opportunities to quiz Canadians on this matter. The usual response is a long, embarrassed pause, then the suggestion of some sports celebrity, e.g., Gordie Howe. More recently, however, my respondents have been citing Terry Fox (Scrivener 1981) with obvious signs of relief. Admiration is nationwide, and memorials abound to this truly heroic young man whose one-legged transcontinental run was cut short by a recurrence of the disease he was campaigning against. But it remains to be seen how deep and durable the Terry Fox phenomenon will be, and to what degree specifically nationalistic. The same must be said about Steve Fonyo, another amputee victim of cancer, who in May 1985 completed the Atlantic to Pacific journey for the same purpose of generating funds and publicity for medical research.

5. "You don't get any heroes out of wars you lose; Canada was peopled by losers—losers of the 7 Years War (the French), of the War of Independence (American Loyalists), and then of World War I in which Canada generally was the biggest loser of all (60,000 dead of a population its size!!!)" (Gowans 1982). The War of 1812 may be an exception, but a dubious one.

6. "Canada has none of the dramatic heroes or historical occasions that are commemorated by other peoples. Politicians in Canada . . . are often considered rather colourless individuals. National heroes inherited from earlier periods are marked by their divisive potential" (Schwartz 1967: 44).

7. "Paradoxically, an American-style patriotism was gradually promoted by means of flag-saluting, allegiance-pledging, patriotic songs and poems, and other means. Much of this centered on Empire Day which, more than July 1st, became the Canadian equivalent of July 4th" (Tomkins 1974: 19).

8. "It can be said that up to 1964 Canada had no official national flag, but flew several which were regulated by custom, Parliamentary Act, and orders in council. This situation

probably continued in Canada for as long as it did because it was, and indeed still is, rather more of a composite state than a single, homogeneous nation" (Swan 1977: 79).

9. "In 1963, 45 percent supported some kind of national flag, 25 percent stood for the union jack, 16 percent favored the red ensign and 14 percent held no opinion" (Albinski 1967: 170).

10. "Ironically, as has been suggested, perhaps the very intensity of the controversy gave the maple leaf flag a rich and positive meaning from the moment it was first raised" (Albinski 1967: 188).

11. Seldom do these monuments depict the battlefield or acts of valor. As often as not their intent was pacific rather than bellicose. "War monuments and trophies were being erected across the country. Every city and most towns had at least one 'Lest We Forget' monument; every service club a trophy of war. The new Parliament Buildings had a Peace Tower with a carillon and a Memorial Chamber with books of remembrance. These works—cenotaphs, memorial sculptures, war trophies . . . could possess any meaning the viewer wished to give them: sacrifice, waste, sorrow, pride, even redemption" (Tippett 1984: 103).

12. "On first encounter, the most unusual thing about the language of English-speaking Canadians is that many speakers, when they are not merely being diffident, seem hardly aware of its existence" (Orkin 1970: 3).

13. "For decades, we were like blind men, familiar with only one part of the elephant. . . . You had the movies, [Uncle] Sam, to show off your country. New York, Chicago, Philadelphia, St. Louis, San Francisco were all glamorized by Hollywood. But nobody in Vancouver ever saw Toronto or Halifax on the screens of the twenties, thirties, or forties. Your history and geography, often mythologized and prettified, were made familiar to millions by hundreds of major films. But no Hollywood movie ever showed our prairies. *North West Mounted Police* was shot in California; *Saskatchewan* was made in the Rockies. The majority of Canadians in those years were more familiar with the bayous of Louisiana, the blue grass of Kentucky, the hill country of Tennessee and the Arizona desert than they were with the Bay of Fundy's tidal bore, the red roads of Prince Edward Island or the fiords of British Columbia" (Berton 1982: 105).

14. "While it is true that the schools have many failings, implanting cruder forms of traditional nationalistic ideology is not one of them. It is difficult to escape the conclusion that Canada as a country has taken relatively little interest in the trappings of the nation state in its schools" (Milburn and Herbert 1974: 8).

15. "Hockey is Canada's religion. Weekends are centered around it, election campaigns and religious observances are altered to fit its scheduling, and during the annual Stanley Cup playoffs, the whole country stands still. Whatever the reasons, hockey is the Canadian passion" (Kidd 1982: 261–262). But, as Bruce Kidd further notes, despite its being called the Canadian national sport, hockey is dominated increasingly by U.S. business interests, the best players migrate southward, and only two Canadian cities have, or had, truly first-rate teams. In any case, mass preoccupation with an exportable commodity is a paltry foundation for nationhood—just as it would be for such immensely popular American television series as *Dallas* or *M*A*S*H.*

16. "The fact was that a satisfying national definition could not be found. If some islands could be defined easily enough, the archipelago could not. Definitions that satisfied here,

grated there. Symbols like the Union Jack or the fleur de lis were island rallying points and national battle cries. More neutral symbols turned to nature, and no benign Uncle Sam pervaded the national mythology" (Harris 1981: 25).

17. "Nations with long histories and populations that are roughly homogeneous in cultural terms have relatively little difficulty in identifying the signposts in the past that point to the present and future—though there can, of course, be profound differences about what the signposts say. But for countries with shorter and, worse, more complicated histories and cultural diversity, even the discovery of the major signposts provokes bitter controversy. In the United States, the Revolution is the centrepiece in a unifying national myth. But what even serves that purpose in Canada?" (Cook 1971: 200). "When a people literally do not know when they became independent, their view of the process of governance, of law, and of what is meant by independence is likely to differ from that of those who are certain of the precise moment when they leapt full blown from the head of Zeus" (Winks 1979: 48).

18. George Grant (1965) has articulated this point most forcefully in his mordant, chillingly persuasive *Lament for a Nation.*

19. Much too little is known of social differentials as between those immigrants traveling directly to Canada and those sailing toward the thirteen American colonies during the seventeenth and eighteenth centuries. It is a fertile topic for a brave historian (see Bailyn 1986).

20. W. L. Morton's diagnosis of the Canadian condition is unsurpassed: "Canada is not the creation of a covenant, or a social compact embodied in a Declaration of Independence and written constitution. It is the product of treaty and statute. . . . It is the pragmatic achievement of the little-regarded labours of clerks in the Colonial Office and obscure provincial politicians, still unknown to the world. Beneath their work the moral core of Canadian nationhood is found in the fact that Canada is a monarchy and in the nature of monarchical allegiance. *As America is united at bottom by the covenant, Canada is united at the top by allegiance.* Because Canada is a nation founded on allegiance and not on compact, there is no process in becoming Canadian akin to conversion, there is no pressure for uniformity, there is no Canadian way of life" (Morton 1962: 85; emphasis added).

21. But a second threshold event in the process of nation-building was unconnected with anti-Americanism: the traumatic participation in World War I. "Frank Underhill's belief [is] that 'the Canadian Corps . . . is the greatest national achievement of the Canadian people since the Dominion came into being. . . . The four years' career of her fighting troops in France forms the real testimony to Canada's entrance into nationhood, the visible demonstration that there has grown up on her soil a people not English nor Scottish nor American but Canadian—a Canadian nation'" (Berger 1966: 58–59).

22. Much of this nervousness erupted in the November 1988 parliamentary election in which the nominating issue was the far-reaching U.S.-Canadian trade pact. The virulence of the debate as to whether the agreement would endanger Canada's social and cultural, as well as economic, integrity came as a genuine shock to statesman and layperson alike.

An Approach to the
Religious Geography of
the United States

Almost all human geographers will accept the truism that among the phe-
nomena forming or reflecting the areal differences in cultures with
which they are so intimately concerned, few are as potent and sensi-
tive as religion. In seeking to grasp the identity, conformation, and
implications of such cultural regions as may exist in the United States, we must
inevitably approach the areal patterns of religious characteristics and their inter-
actions with other human activities and cultural traits. The immediate inspiration
for this study is a simple curiosity concerning the nature of these patterns, for it
is abundantly clear from the available evidence that this nation has a startling
profusion of denominations, considerable variation in their relative strength from
place to place, and altogether more than enough complexity through time and
space in the relationships between religion and other factors to challenge the in-
genuity of the geographer. A larger purpose is implicit, however. It is hoped that
this paper may provide not only a first approximation of the nation's religious
regions and an introductory statement of the shape and meaning of areal varia-
tions in American religious characteristics, but that it may also contribute some
material toward our still quite shadowy delineation of the general cultural regions
of Anglo-America and stimulate some thought as to the variety of ways in which
religious data might be used in other kinds of geographic work.

In spite of the clear logic of granting religion a prominent place on the geogra-
pher's agenda, a review of the literature indicates surprisingly little discussion of
the subject, whether for the United States or for other parts of the world. A perusal
of five of the larger and more important general treatises on human geography
discloses the fact that two do not directly confront the topic of religion at all,[1] two
others limit their treatment to a single paragraph,[2] and only one deals with reli-
gion in more than cursory fashion.[3] Similarly, two major surveys of significant
recent research[4] contain no references to work on the geography of religion.
There can be little doubt that a wider search of the literature would yield equally
disappointing results. Only one book-length attempt to deal with the geography

of religion has been published, one that is, by the author's admission, an experimental effort based on inadequate materials.[5] Four shorter—and, again, rather provisional—treatments of the subject merit attention, even though they are intentionally limited in purpose and accomplishment.[6] There are innumerable instances in the geographic literature of passing references to the religious situation in discussions of the human geography of various regions, but only a few serious efforts to delve deeply into the relationships between religious and other geographic phenomena.[7] In the case of the United States, only a single pair of highly tentative discussions, both sociological, can be recommended to the student interested in the contemporary geography of religion on a national scale;[8] the available geographical literature on the more limited aspects of the American religious scene consists of two doctoral dissertations, one on religious institutions in Cincinnati and the other treating the historical geography of Roman Catholicism in the Atlantic Seaboard states.[9]

All this would be a matter of interest largely for the specialist in geographic bibliography or the history of ideas were it not that the factors that have generally inhibited work on the geography of religion also operate to circumscribe sharply the possible compass of this paper. There is, first of all, the simple inadequacy of the available statistics and other fundamental data. As is the case with demographic materials in general, the collection of the basic information is a task beyond the capacities of the individual scholar, who must look to national and international agencies. These agencies have either neglected to assemble any data or have done so in ways that make their interpretation difficult, especially for international comparisons.[10] Secondly, there is the intractability of the material itself. Unlike some other demographic or cultural traits, religion is a many-sided phenomenon; some of its more important aspects are extremely difficult to define or measure, and others, such as personal attitudes on religious matters, are possibly beyond the scope of direct observation. Among the multiple definitions of religion we must include: a mental complex accessible only to the anthropologist, theologian, or psychologist; a highly diversified body of customs, some only quite indirectly related to theological concerns; a formal institution, i.e., church or denomination; and a group of persons sharing some degree of religious identity by virtue of tradition or common observance. This wide range of meanings leads, in turn, to a number of serious methodological problems. Should the geographer confine his interest to formal adherence to the various creeds? Or if he rejects this approach, how does he measure and study the intensity of religious belief and observance in all their endless ramifications? Is religion cause or effect in the cultural landscape, or somehow both? Should the geographer simply note the material manifestations of religion, as in the settlement landscape, economic processes, or political relations, or should he concentrate on the inward, spiritual aspects of what is essentially an incorporeal phenomenon?

Largely because of the difficulty of obtaining adequate data on other phases of religion or of making direct observations on its non-material aspects, most of

those geographers who have pioneered in the study of religion have had to restrict their attention to the effects of religious faith and practice on the cultural scene, especially architecture, urban and village morphology, and other phases of the settlement landscape.[11] In the present instance, lack of adequate background studies or good alternative sources of statistics has meant a study limited almost wholly to the analysis of the membership data reported by the various American religious denominations.[12]

NATURE AND LIMITATIONS OF THE DATA

The great bulk of our statistical data on religion in the United States has been collected and published by the Bureau of the Census. Beginning with the Seventh Census in 1850, information on churches was compiled in connection with each of the decennial enumerations until 1890, although the 1880 material never reached the publications stage. In 1906, the Bureau inaugurated a special Census of Religious Bodies which was continued at ten-year intervals until 1936. It is generally believed that the 1926 Census was the most complete and successful in the series. The 1850, 1860, and 1870 enumerations resulted in the publication of information on the number and seating capacity of church edifices, as well as a variety of facts about finances and the educational, missionary, and other activities of the denominations, but no statistics on membership. The earliest figures on number of members (for each denomination, on a county basis) appeared in the reports of the 1890 Census; and this material was published for all the subsequent Censuses of Religious Bodies.

In every instance, the Census canvass involved the procurement of information from the local congregation, at first by direct interrogation by an enumerator and later by means of mailed inquiries. No effort was ever made to ascertain the church affiliation or preference of individuals by including a religious query in the regular census schedule. A single attempt to do so on a sample basis in 1957 proved to be abortive.[13] The constitutional doctrine of the separation of church and state has come to be interpreted in many quarters as even prohibiting the collection by a government agency of any information concerning churches, much less any facts regarding the religious status of individuals.[14] It was apparently a growing sensitivity on this issue that led to a marked deterioration in the response to the 1936 canvass and the failure to publish the partial results of the 1946 Census of Religious Bodies or even to initiate one in 1956. With the withering away of the decennial Census of Religious Bodies and the failure, despite a concerted campaign, to have a question on religious preference included in the 1960 enumeration schedule, it is highly unlikely that any additional religious statistics will be issued by the Bureau of the Census until 1970, if then.

Critics of the various Census efforts to tally church membership have unanimously appraised them as seriously defective in terms of completeness, reliability, and comparability. These shortcomings stem from the highly variable responses

of the thousands of local church officials involved and the many different criteria of church membership used by the various denominations. An additional factor, for which the Census officials are completely blameless, is the frequency with which religious bodies in the United States splinter, merge, change their names, simply vanish, and otherwise make it difficult to keep track of their identity from one enumeration to another. Since the latest official data, those for 1936, hardly seemed adequate in terms of quality or timeliness for a useful study of contemporary patterns of church membership, it was decided to utilize the results of a major private effort to collect comprehensive statistics on American church membership (National Council of Churches of Christ 1956–58).[15] Our complete reliance on this source makes it essential to understand the methods used to assemble the data and their virtues and limitations before we can proceed with any geographical analysis.

Churches and Church Membership in the United States is a compilation of statistics on number of churches and church members, by county, submitted by the national headquarters of the various participating religious bodies listed in the 1953 *Yearbook of American Churches* for the year 1952 or the nearest practicable date.[16] Out of the 251 religious bodies reported in the *Yearbook*, accounting for 92,546,000 members in 285,277 local churches, 112 bodies, with 74,125,462 members in 182,856 churches, were able and willing to participate. Most of the nonparticipating bodies are relatively small or were unable to supply information because of the lack of centralized records.[17] The largest block of missing members, an estimated 9,392,694 persons, is accounted for by five important, but loosely organized Negro groups—two Baptist and three Methodist bodies—in the Southern states, which include a large majority of all Negro church members in the United States. The subsequent discussion is thus largely, but not entirely, confined to the white church membership of the nation. Another predominantly Southern group, the Churches of Christ, with an estimated 1,500,000 members, was not reported; and since less than 1 percent of the estimated 2,720,739 members of the various Eastern Orthodox, Old Catholic, and Polish National Catholic churches were tabulated, they are omitted from further consideration here. The Church of Christ Scientist, whose 1936 membership was estimated at 268,915 has a regulation that forbids "the numbering of people and reporting of such statistics for publication." In the case of the Church of Jesus Christ of Latter-day Saints, some 230,956 of the 1,077,285 members reported for 1952 could not be assigned to any geographic "stakes" and hence are omitted from the tabulations. Nearly half the Roman Catholic county figures were estimated on the basis of a formula derived from known diocesan totals, and are substantially less reliable than the balance of the county data.

The count of members was reported to the National Council of Churches under the several definitions of the participating bodies; and the variety of these definitions is the major source of the non-comparability of the denominational

groups employed in this study. Here we cannot do better than to quote from the introductory material in *Churches and Church Membership in the United States*:

> For those bodies having several membership categories (e.g., baptized, confirmed, communicant), the most inclusive category was generally reported. . . . The Roman Catholics count all baptized persons, including infants. The Jews regard as members all Jews in communities having congregations. . . . Most Protestant bodies count only the persons who have attained full membership, and previous estimates have indicated that all but a small minority of these are over 13 years of age. However, many Lutheran bodies and the Protestant Episcopal Church now report all baptized persons, and not only those confirmed. It is also known that the Church of Jesus Christ of Latter-day Saints includes in its membership children of about eight years of age.

Comparison or correlation of membership statistics with 1950 Census data is hampered by the fact that the place of membership is established by the location of the church and not by the actual residence of the member. Although there is no way of ascertaining their location or the effects of this situation in a cartographic analysis, there are undoubtedly numerous cases where a significant number of members are reported for counties in which they do not reside.

In addition to the problems created by the omission of a good many religious bodies, the variety of membership criteria used, and the lack of complete correspondence between place of membership and place of residence, we also have the fact that the data are not entirely simultaneous, but range from 1951 to early 1954 with a heavy concentration in 1952 and that a significant, but undetermined degree of undercounting and overcounting occurred in the coverage of some localities and groups in spite of careful checking and editing of the raw data. Nevertheless, a comparison of the material provided by *Churches and Church Membership in the United States* with that in the 1936 Census of Religious Bodies leads to the firm conclusion that the former is superior in terms of both completeness and quality of data. Although the later study lacks the wide range of subject matter covered by the 1936 canvass, the use of centralized sources and other methodological refinements eliminated much of the variability and incompleteness of response. Local analysis is facilitated by the publication of county data for all religious groups, whereas county figures were made available only for the major denominations in the tables published by the 1936 Census of Religious Bodies.

PLAN OF STUDY

Since it is obviously impractical to deal individually with each of the 112 religious bodies for which data are furnished in *Churches and Church Membership in the United States*, it was decided to combine various bodies of common origin or close affinity into a relatively small number of denominational groups.[18] In per-

TABLE 1. *United States, Reported Membership in Religious Bodies*

Religious Body	National Council of Churches Survey—*Churches and Church Membership* (1952)[1]	Membership Reported for 1952 in *Yearbook of American Churches*[2]	Current Population Survey, March 1957[3] *(persons 14 years old and over)*
Roman Catholic	29,688,058	30,253,427	30,669,000
Baptist Bodies	9,795,782	17,470,111	23,525,000
Methodist Bodies	8,892,869	11,664,978	16,676,000
Lutheran Bodies	6,418,269	6,313,892	8,417,000
Jewish Congregations	5,112,024	5,000,000	3,868,000
Presbyterian Bodies	3,532,176	3,535,171	6,656,000
Protestant Episcopal	2,544,320	2,482,887	—
Disciples of Christ	1,836,104	1,815,627	—
Congregational Christian	1,263,472	1,269,466	—
Latter-day Saints (Mormons)	953,588	1,210,336	—
Evangelical & Reformed	750,463	751,003	—
Evangelical United Brethren	722,966	724,055	—
Assemblies of God	459,256	370,118	—
Reformed Bodies	349,164	373,780	—
Adventist Bodies	283,516	290,898	—
Church of the Nazarene	249,033	243,152	—
Churches of God	241,966	305,043	—
Brethren Churches	232,569	256,525	—
Unitarian & Universalist	159,904	158,402	—
Mennonite Bodies	100,925	142,513	—
Friends (Quakers)	96,451	114,119	—
Moravian Bodies	48,843	54,505	—
Eastern Churches	13,169	2,353,783	—
Churches of Christ	—	1,500,000	—
Christian Unity Science Church	—	1,112,123	—
Church of God in Christ	—	328,304	—
Pentecostal Assemblies	41,555	300,070	—
Church of Christ Scientist	—	268,915 (1936)	—
Polish National Catholic Church	—	265,879	—
Salvation Army	—	232,631	—
International General Assembly of Spiritualists	—	157,000	—
Old Catholic Churches	1,471	101,077	—

TABLE 1. (*Continued*)

Religious Body	National Council of Churches Survey—*Churches and Church Membership* (1952) [1]	Membership Reported for 1952 in *Yearbook of American Churches* [2]	Current Population Survey, March 1957 [3] (*persons 14 years old and over*)
Federated Churches	—	88,411	—
International Church of the Foursquare Gospel	66,191	78,471	—
Apostolic Overcoming Church of God	—	75,000	—
Other Bodies	261,358	593,017	25,223,000
Total	74,125,462	92,546,000	115,034,000

[1] Includes only those groups reporting membership by county.
[2] Includes all groups reporting total national membership.
[3] Reports religious affiliation or identification rather than formal membership.

forming this operation, I have followed the system employed in the statistical tabulations of the *Yearbook of American Churches*, which involves a combination of historical and theological factors. Twenty-two groups, comprising 80 religious bodies, were selected for further analysis: those twenty denominational groups having a total reported membership in excess of 100,000 each and two smaller groups—the Friends and the Moravian bodies—of especial historical and geographical interest (the first 22 groups listed in column 1 of table 1).[19] The remaining 32 religious bodies, which have an average membership of less than 12,000 and are of marginal interest at best, have been omitted from further discussion. In spite of their recent merger, the Congregational Christian Churches and the Evangelical and Reformed Church are so distinctive in terms of origin, geographical pattern, history and ethnic affiliation that little would have been gained and a great deal lost, for the purposes of this study, by combining them into a single denominational group. On the other hand, the Unitarian and Universalist bodies would have been combined into a single group because of their pronounced similarities even if their recent union had not taken place.[20] The subsequent discussion will show that it has proved profitable, for purposes of geographical analysis, to arrange the 22 major denominational groups into three broad classes in terms of provenience: those of British colonial origin, groups introduced by immigration from the European continent, and those bodies originating in the United States.[21] The classification is as follows:

British Colonial Groups

Protestant Episcopal Congregational Christian
Presbyterian Bodies Baptist Bodies
Methodist Bodies Friends

Immigrant European Groups

Roman Catholic Reformed Bodies
Jewish Congregations Brethren Churches
Lutheran Bodies Mennonite Bodies
Evangelical and Reformed Moravian Bodies

Native American Groups

Disciples of Christ Church of the Nazarene
Unitarian and Universalist Assemblies of God
 Churches Churches of God
Latter-day Saints Evangelical United Brethren
Adventist Bodies

An explanatory note concerning the maps that are the principal means for analyzing the denominational data may be useful to the reader. It was immediately apparent that the statistics on church membership are of much greater geographic, cultural, and demographic significance than those on the number of churches; and there was no difficulty in deciding that the limitations in the completeness and quality of the data precluded the possibility of any useful series of maps showing the relative strength, i.e., percentage within total population or of total church membership, of the various denominational groups. Consequently, the best cartographic expedient was clearly a set of maps showing the distribution of absolute numbers of reported members of the various denominational groups on the basis of counties and Standard Metropolitan Areas. It is interesting to note that the only two previous efforts to map the religious composition of the American population in any detail adopted quite different techniques. In *The Atlas of the Historical Geography of the United States,* the distribution of churches, i.e., congregations, is shown for the leading denominations in 1775–76, 1860, and 1890, for lack of any alternative data in the case of the first two dates and for the sake of consistency in the case of the last.[22] A statistical atlas published by the U.S. Census Office in 1898 has a series of choropleth maps depicting the proportion of the members of the eight leading denominations to the aggregate population by county and state in 1890 and shows the same ratio for eight lesser denominations by state only.[23] In spite of the great differences in kinds of data and methods of representation, comparisons between the earlier and the present series of maps are most instructive.

For all their shortcomings, the statistics presented in *Churches and Church Membership in the United States* have been accepted at face value in constructing the maps, except in two cases where major gaps in the data would have caused serious distortion in the resultant map patterns. The Roman Catholic member-

ship in several counties, including Webb (Laredo), within the Corpus Christi Diocese, which was grossly under-reported in the National Council of Churches' tables, has been estimated on the basis of information supplied by the diocesan chancery; and the omission of figures on the members of the Protestant Episcopal Church in its Sacramento (Northern California) Diocese has been rectified by reference to the *Episcopal Church Annual.* There are many other obvious lesser discrepancies in the statistics, as for example the reporting of only 502 members of Methodist bodies in Lucas County (Toledo), Ohio, or only 48 Methodists in Wake County (Raleigh), North Carolina; but it was felt that any tampering with the figures without a thorough investigation involving extensive correspondence and field work might well have done more harm than good.

The choice of the symbols used in the maps and their quantitative equivalents involved a considerable amount of experimentation. The extremely uneven distribution of human populations, and specifically the heaping up of great masses of persons within relatively minute urban areas and the thin dispersion of small numbers in many extensive rural areas, poses a problem for the cartographer for which there seems to be no truly satisfactory solution. In the present instance, it was decided to use shaded three-dimensional symbols to represent the larger values and open circles for the lesser ones. For the ten smallest denominational groups, the number of reported members in each county or SMA with a total of 1,000 or more is shown by means of a cube,[24] the volume of which is proportional to the value in question, while the area of the open circle is scaled to values ranging from 1 member through 999. The numerical equivalents of the symbols were doubled for all the larger denominational groups, except the Roman Catholic, so that the smallest cubical symbol represents 2,000 members and the others range proportionally higher. In the case of Roman Catholics, the uniquely large volume of membership necessitated much higher equivalents for the symbols—five times those used for the smaller denominational groups, or two and one half times those used for the others. The final choice of values for the symbols represents an attempt to reconcile three rather contradictory purposes: to render legibly the number and location of members in thinly occupied areas; to avoid excessive congestion and overlapping of symbols in areas of concentrated membership; and to make possible realistic comparisons among the various maps using the same values for their symbols.[25]

HISTORICAL CONSIDERATIONS

It is neither feasible nor necessary here to chronicle the complex histories of all the denominations with which we are concerned. But it is essential to sketch some of the broader historical conditions and trends governing the evolution of America's religious life if we are to appreciate the place of the church in our cultural landscape or make much sense of the contemporary distribution of denominations. During the first two centuries of settlement, the overwhelming ma-

jority of the immigrants who entered the United States were drawn from the United Kingdom. The remainder of the white settlers were largely derived from German-speaking areas, principally the Rhineland, or the Netherlands, with only trifling additions from other sections of the European continent.[26] It is hardly surprising, then, to discover that all the principal British sects had made the trans-Atlantic journey and were liberally represented during the later phases of American colonial history, or that several denominations of German and Dutch origin were firmly established in various corners of British North America. It is almost certain, however, that there was no faithful reproduction of the British religious scene in the New World. Although it is quite easy to exaggerate the influence of religious nonconformity in generating movement to America, it is still undoubtedly true that dissenters from the established churches of Great Britain and certain continental countries accounted for a disproportionately large share of the arrivals. This fact clearly stands out in the following tabulation of congregations existing in the United States in 1775–76 that Paullin was able to identify and locate geographically in his remarkable analysis of colonial documents:[27]

Congregational	668	Moravian	31
Presbyterian	588	Congregational-	
Episcopalian	495	Separatist	24
Baptist	494	Mennonite	16
Friends	310	French Protestant	7
German Reformed	159	Sandemanian	6
Lutheran	150	Jewish	5
Dutch Reformed	120	Rogerene	3
Methodist	65	Others	31
Catholic	56	Total	3,228

Unfortunately, we have no comparable statistics for the contemporary religious composition of the British population to set alongside these figures; but it is unquestionable that the "Established," i.e., Episcopal, Church was much feebler on the western side of the Atlantic than in Great Britain. Indeed, one of the central facts of American religious history is the failure of any genuine established church to appear, in spite of tentative efforts on the part of the British Crown and some of the colonial administrations. As a consequence of this, we can note not only the early appearance of a strong denominational diversity but also a freedom to experiment with new modes of religious experience and organization—or to abstain entirely from formal religious adherence. The Great Awakening that reached American shores after bursting forth in mid-eighteenth-century England may well have planted some of the seeds that were later to blossom into a spectacular profusion of denominations; but there were already signs of great ferment among various German and Dutch Protestant congregations. The unsettling effects of the English Civil War, the great difficulty of effectively controlling American congre-

gations across a distance of 3,000 miles, the sharply disruptive effects of the War of Independence, the establishment of the doctrine of the separation of church and state, and, above all, the completely novel social and economic conditions of a rapidly moving frontier all played their part in giving a new coloration and pattern to imported creeds and in spawning the abundance of native American denominations that have never left off their fissiparous ways since the last quarter of the eighteenth century. The same factors that favored variety in religious affiliation also permitted a high incidence of dissociation from formal religious ties or simple lack of interest in spiritual affairs. We are on exceedingly shaky statistical grounds in estimating the ratio of church members to non-members in the early days of the Republic; but most scholars agree that a low point was reached in that period and that the trend has been rather steadily upward ever since.[28] Whatever their origin, a large multitude of the unchurched abounded in the United States at the end of the 1700s and provided a fertile missionary field during the Second Great Awakening in the opening years of the nineteenth century not only for the traditional denominations but for a variety of new ones as well.

The maps of the 1775–76 distribution of American churches furnished by Paullin distinctly foreshadow later regional concentrations. The Congregationalists were powerful in New England, but were infrequently found elsewhere; the Episcopalians, though occurring over a wide area, were most strongly entrenched in Virginia, Maryland, Connecticut, and New York; the Friends, also widely dispersed, were centered primarily in southeastern Pennsylvania and adjacent sections of New Jersey; the Presbyterians were well represented almost everywhere except southern New England, but were most prominent in the newly settled western fringes of the Atlantic Seaboard states; the Dutch Reformed and the various Teutonic churches were strong and even dominant in various sections of New York, Pennsylvania, and the Maryland and Carolina Piedmont. Only the Baptists, who were well nigh universally, if thinly, distributed, had failed to show the regional gravitation that was to become so well marked in their subsequent history. Methodism was still too young and weak in America to have achieved any real regional pattern, but incipient clusters in Maryland and New Jersey faintly reveal the shape of things to come. The minute Roman Catholic population—only an estimated 32,500 in 1784[29]—was confined to relatively libertarian Maryland, Pennsylvania, Delaware, and New Jersey; the few isolated Jewish congregations bear little relevance to later developments.

After the Atlantic Seaboard had been fully occupied and the principal denominations had begun to sort themselves out regionally, four major processes were to shape the present-day areal patterns of religious allegiance in the United States: (1) the westward thrust of the frontier and the differential fortunes of the colonial British and Teutonic churches in claiming the vast, ecclesiastically virgin territories of the central and western states; (2) the rise, growth, and wide dispersion of a number of native American denominations; (3) the great new flood of immigration beginning in the 1830s with Irish Catholics and both Catholic and

Protestant Germans and followed soon after by adherents of numerous denominations from Scandinavia, Eastern Europe, and Southern Europe; and, finally, (4) the great tides of internal migration that have constantly re-grouped the inhabitants and, hence, the religious map of perhaps the most mobile nation of modern times. These are themes that can be most fruitfully pursued in our subsequent discussion; but it is interesting to note the common element of swift movement. There are persistent, relatively stable features in the spatial disposition of some religious bodies, but more important is the phenomenon of constant and rapid change, the restless shifting of forces, the transmutation and re-shaping of regions, and thus the provisional configuration of current patterns. Although critics of American civilization may, with considerable justice, accuse it of being grossly secular, we may note the paradoxical fact, too little studied by cultural historians, of those of our native churches and some revitalized groups of European vintage which have generated especially great momentum, carrying their missionary message not only to the non-Christian sections of the world but to the British Commonwealth and Europe as well. We have, then, a religiously dynamic and complex United States functioning as a hearth area for elements of non-material culture, i.e., new forms of religious worship and concepts of salvation, in addition to the many advanced forms of material technology, for which the nation has received vastly more publicity.

INCIDENCE OF CHURCH MEMBERSHIP

One of the significant background facts to be borne in mind during the subsequent discussion is the great variation among states and counties in the percentage of population reported as members of religious bodies. Although we are exposed to the vagaries of inconsistent and incomplete statistics, certain broad generalizations can be sustained. The incidence of church membership is highest in those areas, particularly in the Northeast, where settlement is old, dense, and stable and where strongly organized denominations, especially the Roman Catholic, are well represented (table 2). It is lowest in those places with heavy inmigration—and thus a temporary loosening of church associations—such as California, Washington, Oregon, Nevada, or Florida—or those areas which are relatively inaccessible, thinly settled, or characterized by low incomes. The low ranking of the Mountain states—except for strongly Catholic New Mexico and strongly Mormon Utah—is readily explained in these terms. The poor showing of the Southern states in table 2 is, in large part, the result of excluding the great bulk of Negro church members from the reckoning. Church members account for 53.9 percent of the white population of the South, only slightly less than the corresponding statistic—54.6 percent—for the nation as a whole. The state figures do, however, mask an interesting differential between lowland and upland tracts that appears in such states as Virginia, Kentucky, Tennessee, West Virginia, Georgia, Alabama, and Arkansas.[30] The low percentages reported for the poor,

TABLE 2. *Reported Church Membership as Percentage of Total Population*

United States	49.2	Virginia	38.5
New England	62.5	West Virginia	32.8
Maine	41.2	North Carolina	39.9
New Hampshire	53.0	South Carolina	40.0
Vermont	52.7	Georgia	38.3
Massachusetts	67.1	Florida	36.4
Rhode Island	75.7	*East South-Central*	38.6
Connecticut	60.5	Kentucky	44.8
Middle Atlantic	59.3	Tennessee	40.2
New York	60.1	Alabama	34.2
New Jersey	57.6	Mississippi	33.9
Pennsylvania	58.9	*West South-Central*	49.0
East North-Central	49.2	Arkansas	31.3
Ohio	46.4	Louisiana	53.7
Indiana	43.6	Oklahoma	42.4
Illinois	53.6	Texas	53.6
Michigan	42.3	*Mountain*	50.4
Wisconsin	63.8	Montana	46.7
West North-Central	53.6	Idaho	44.1
Minnesota	61.6	Wyoming	43.6
Iowa	53.6	Colorado	41.6
Missouri	48.9	New Mexico	64.9
North Dakota	63.0	Arizona	44.9
South Dakota	58.4	Utah	73.3
Nebraska	53.4	Nevada	37.6
Kansas	46.6	*Pacific*	37.7
South Atlantic	39.5	Washington	30.5
Delaware	44.3	Oregon	27.7
Maryland	47.7	California	40.7
District of Columbia	46.6		

Source: *Churches and Church Membership in the United States,* Series A, No. 3, Table 4.

remote, and often thinly occupied areas of high or rugged terrain doubtless reflect the difficulties for actual or potential congregations; but they also quite probably indicate the relative importance in such areas of autonomous, rather tentatively organized groups, largely oriented toward the fundamentalist theology and largely unreported in our statistics.

URBAN-RURAL DIFFERENTIALS

Another major distributional phenomenon that does not appear in our map series is the difference in the strength of membership in the various denomina-

tional groups as between urban and rural areas. Our statistical source indicates that 60.8 percent of the reported literature members of the nation in 1952 were accounted for by the 168 Standard Metropolitan Areas in which 56.8 percent of the population resided in 1950. It is not at all clear whether church membership in the United States is actually more urbanized than the population in general or whether these figures simply reflect under-enumeration of church members in rural tracts and the absence from our statistics of several important, essentially rural religious bodies. There are, however, emphatic differences in the degree to which the membership of the individual denominational groups is urban or rural (table 3). If we accept our figures at face value, 97.5 percent of the American Jewish population is to be found within metropolitan areas, 2.5 percent in intermediate counties (those containing one or more urban places, but not constituting part of a metropolitan area), and none at all in the purely rural counties.[31] The members of the Roman Catholic and Protestant Episcopal churches are also highly urbanized, with 74.5 and 72.7 percent, respectively, in metropolitan areas and only 2.4 and 2.1 percent in rural counties; and the much smaller membership in the Unitarian-Universalist group shows the same predilection for cities.[32] At the opposite extreme the Disciples of Christ, Churches of God, Brethren, Baptist, and Mennonite bodies look to non-metropolitan counties for more than 60 percent of their membership. Five other groups—Lutheran bodies, Latter-day Saints, Friends, Church of the Nazarene, and Evangelical United Brethren—are essentially rural with metropolitan counties making up only 40 to 50 percent of the membership. The remaining six groups—the Congregational Christian Church, Evangelical and Reformed Church, Presbyterian bodies, Reformed bodies, Assemblies of God, and Adventist bodies—approach the national average in the residential composition of their membership. These national averages should be interpreted with caution since there are such significant local departures from the national pattern, as for example, substantial rural Catholic populations in various parts of the Middle West, strong rural concentrations of Episcopalians in Virginia, or a largely urban Baptist population in California. It should also be noted that despite their considerable absolute magnitude and decidedly urban character, the Catholic and Jewish groups nowhere dominate the population of metropolitan areas as overwhelmingly as do the Protestant groups in most urban areas in the Southeast (table 4).

OTHER GENERAL DISTRIBUTIONAL CHARACTERISTICS

We have already touched on the fact that the number and diversity of denominations in the predominantly Protestant United States is unmatched in any other nation. This diversity is apparent even within a small rural county or urban community where it is not uncommon for a dozen or more denominations to be represented by formal congregations; and in the larger cities the number of distinct religious bodies may run to several score. This rampant "over-churching"

TABLE 3. *Denominational Groups by Percentage of Reported Members in Metropolitan and Non-Metropolitan Areas, ca. 1952*

Denominational Group	Metropolitan Counties	Non-Metropolitan Counties	
		Intermediate Counties	Rural Counties
Jewish Congregations	97.5	2.5	0
Roman Catholic	74.5	23.0	2.4
Reported Members of All Protestant Groups	45.6	45.3	9.0
Unitarian and Universalist Churches	74.4	—25.6—	
Protestant Episcopal	72.8	25.1	2.1
Moravian Bodies	70.3	—29.7—	
Congregational Christian Church	59.9	34.9	5.1
Evangelical and Reformed	59.5	37.0	3.5
Presbyterian Bodies	58.1	37.6	4.3
Reformed Bodies	54.9	—45.1—	
Assemblies of God	54.5	—45.5—	
Adventist Bodies	52.1	—47.9—	
Lutheran Bodies	51.1	40.5	8.4
Latter-day Saints	45.8	44.5	9.8
Friends	44.8	—55.2—	
Church of the Nazarene	43.8	—56.2—	
Evangelical United Brethren	42.0	50.6	7.4
Methodist Bodies	40.1	49.8	10.1
Mennonite Bodies	37.9	—62.1—	
Disciples of Christ	36.0	53.3	10.7
Brethren Churches	35.7	—64.3—	
Baptist Bodies	34.9	52.2	12.9
Churches of God	34.6	—65.4—	
Total Reported Church Members	60.8	33.5	5.8
United States Population, 1950	56.8	36.4	6.8

Source: *Churches and Church Membership in the United States,* Series D, Nos. 3 to 6, Tables 136 to 139 and Series E, No. 1, Table 140.

may, incidentally, be one of the by-products of an unusually productive economy, since it is difficult to see how a less prosperous nation could afford to support such an obvious surplus of religious accommodations.[33] One of the surprising facts about the American religious scene, one that does not necessarily follow from the multiplicity of denominations, is the extent to which most of the major groups tend to be national in distribution. No two of the areal patterns closely

TABLE 4. *Leading Protestant, Roman Catholic, and Jewish Standard Metropolitan Areas, as Ranked in Terms of Total Reported Church Members, ca. 1952*

Protestant		Roman Catholic		Jewish	
1. Winston-Salem, N.C.	98.2	Laredo, Tex. (est.)	93.1	New York–Northeastern N.J.	33.1
2. Gadsden, Ala.	97.6	Fall River–New Bedford, Mass.	80.2	Miami, Fla.	29.2
3. Knoxville, Tenn.	97.3	Dubuque, Iowa	78.7	Los Angeles, Calif.	18.0
4. Greenville, S.C.	97.0	Manchester, N.H.	78.6	Atlantic City, N.J.	16.5
5. Greensboro-High Point, N.C.	96.6	Providence, R.I.	78.5	Philadelphia, Pa.	12.8
6. Raleigh, N.C.	96.5	New Orleans, La.	76.9	Baltimore, Md.	11.8
7. Asheville, N.C.	96.2	Springfield-Holyoke, Mass.	75.4	Chicago, Ill.	11.4
8. Charlotte, N.C.	95.8	Albuquerque, N.M.	73.9	Cleveland, Ohio	10.8
9. Durham, N.C.	95.6	El Paso, Tex.	73.2	Hartford-New Haven-Bristol, Conn.	9.3
10. Columbus, Ga.	95.0	Green Bay, Wis.	72.9	Boston-Lowell-Lawrence, Mass.	8.4

Source: *Churches and Church Membership in the United States,* Series D, Nos. 1 and 2, Tables 133 and 134.

resemble each other, and each of the denominational groups does have one or more regional concentrations; but each of the larger groups tends to reach into every corner of the land, however unevenly. Thirteen of the twenty-two groups studied here (including the Roman Catholic and Jewish) are established in each of the forty-eight states,[34] and the remaining nine are among the smallest in terms of membership. However, even the latter groups are dispersed quite widely, so that we find the most areally limited of all—the Moravians—in no less than fourteen states. There has evidently been unusual mobility of people and of religious ideas, with no successful creed limited to a single minor segment of the national territory. Even the Latter-day Saints, who are so nearly synonymous with Utah and some adjacent areas and dominate their region to a degree unparalleled elsewhere, are present in moderate numbers in many other sections of the country.

This strong tendency toward national occurrence among most of the denominational groups is given quantitative expression in tables 5 and 6. The coefficient of geographic association (g),[35] which has been computed by denominational group and by state, is the total church membership of a state or a denominational group less the percentage who would have to be shifted to other states or other groups in order to have the distribution of the group within the nation or the state conform with the national average. Most states and denominational groups have rather high *g* values. Only Utah, kindred Idaho, and the states of the

TABLE 5. *Coefficient of Geographic Association (g) between Distribution of Members of Denominational Groups and Total Reported Church Membership, by State, ca. 1952*

Denominational Group	g
Roman Catholic	80.8
Presbyterian Bodies	80.1
Protestant Episcopal	78.7
Methodist Bodies	72.7
Church of the Nazarene	64.8
Adventist Bodies	64.0
Unitarian and Universalist Churches	62.9
Assemblies of God	61.6
Lutheran Bodies	61.3
Congregational Christian Church	57.5
Jewish Congregations	57.0
Churches of God	55.8
Disciples of Christ	54.9
Evangelical and Reformed Church	50.4
Friends	49.6
Baptist Bodies	48.7
Evangelical United Brethren Church	46.2
Reformed Bodies	42.2
Brethren Churches	41.3
Mennonite Bodies	40.8
Moravian Bodies	36.3
Latter-day Saints	22.0

$$g = 100 - \frac{\Sigma(m - m_s)}{2}$$

Where $m = \dfrac{\text{total, all church members in state}}{\text{total, all church members in U.S.}}$

$m_s = \dfrac{\text{members of denominational group in state}}{\text{national membership of denominational group}}$

Deep South deviate widely from the national pattern; and among the denominations, the more divergent groups are rather small in membership except for the Baptist bodies, with their powerful concentration within the South, and the strongly localized Latter-day Saints (cf. figs. 5, 12). Four denominational groups rank exceptionally high, and thus most nearly approach a uniform and fully national distribution—the Roman Catholic, Methodist, Presbyterian, and Episcopalian (cf. figs. 3, 6, 8, 9). The primacy of the Roman Catholics is, in good part, due to the fact that by accounting for more than 40 percent of reported church members, this group contributes greatly toward the definition of the norm from

TABLE 6. *Coefficient of Similarity (g) between Incidence of Reported Members, of Denominational Groups in Each State and for the United States, ca. 1952*

State	g	State	g
1. Colorado	87.2	26. Minnesota	66.2
2. Ohio	85.0	27. South Dakota	65.7
3. Illinois	84.6	28. Vermont	65.3
4. Maryland	82.6	29. Wisconsin	65.1
5. Washington	81.3	30. Iowa	63.6
6. District of Columbia	80.7	31. Nevada	63.5
7. Missouri	80.5	32. Massachusetts	60.5
8. Michigan	78.8	33. North Dakota	60.1
9. California	78.8	34. New Hampshire	60.0
10. Pennsylvania	78.5	35. Rhode Island	58.4
11. Montana	76.4	36. Delaware	58.1
12. Wyoming	75.8	37. West Virginia	57.2
13. Arizona	75.0	38. Oklahoma	48.1
14. Texas	74.4	39. Virginia	47.9
15. Oregon	72.4	40. Florida	47.9
16. Indiana	71.0	41. North Carolina	46.0
17. Louisiana	70.8	42. Idaho	43.8
18. New Mexico	70.7	43. South Carolina	43.5
19. New Jersey	70.1	44. Arkansas	42.8
20. Kansas	70.0	45. Tennessee	42.4
21. Nebraska	69.5	46. Alabama	41.7
22. Kentucky	67.9	47. Georgia	40.8
23. Maine	67.3	48. Mississippi	37.9
24. New York	67.2	49. Utah	10.7
25. Connecticut	66.2		

$$g = 100 - \frac{\Sigma(m - m_s)}{2}$$

Where $m = \dfrac{\text{national membership of denominational group}}{\text{total, all church members in U.S.}}$

$m_s = \dfrac{\text{members of denominational group in state}}{\text{total, all church members in state}}$

which deviations are being measured. Another factor is the choice of the areal unit; Catholics would probably score much lower and some Protestant groups much higher if g were calculated for counties or some other areal category below the state level. The wide and rather even dispersion of Episcopalians, despite their strong affinity for urban locations, is striking on the map as well as in table 5; and Presbyterians are even more uniformly distributed, relative to both urban and rural population, than the Episcopalians.

Neither the simple distributional map (fig. 6) nor any known statistical index can, however, do justice to the extraordinary position of Methodism in the United States. Although far outnumbered by both Roman Catholics and Baptists and not quite as evenly distributed as the Presbyterians or Episcopalians, the Methodists more closely approach the status of a "national" denomination in a geographical and statistical sense than any other group. This fact is brought out in figure 25 which shows those counties in which Methodists represent a plurality of reported church membership, those in which they are outnumbered only by Roman Catholics, and those in which they are the second largest Protestant group. Although Methodism is dominant in a smaller area than is claimed by either the Baptists or the Catholics (cf. figs. 5, 3),[36] the total area in which it ranks first, second, or third among the twenty-two denominational groups is much larger and is, indeed, well over 50 percent of the national territory. In fact, the only areas of conspicuous Methodist weakness are southern New England, east-central North Carolina, a portion of eastern Kentucky, and scattered sections of the Rocky Mountain states.

The distribution of each of the groups covered in this study could be readily analyzed and explained if we had adequate statistical data on the six demographic processes governing their growth: births, deaths, in-migration, out-migration, conversion (including church mergers), and apostasy (including the division of religious bodies). Unfortunately, we have very little reliable information on the fertility and mortality of the various denominations or the number of their converts or apostates. We do have an abundance of material concerning the organizational history of American churches; but since nearly all the mergers and divisions took place within the boundaries of our denominational groups, little of this information is relevant to our purpose. We must, then, rely heavily on such information as we have on the migration of church members—most of it quite indirect—along with some general facts about the human geography of the United States and items drawn from general observation in our attempt to explain the larger aspects of the present-day areal patterns of the denominational groups. Many of the minor distributional details can be easily dismissed by pointing out the existence of certain seminaries, denominational schools, hospitals, homes for the aged, publishing firms, or military camps. Such special nuclei of church members are particularly conspicuous on the maps of smaller denominations, such as the Adventists or Friends, but can occasionally be invoked even for the larger groups.[37]

Jewish Patterns

The traditional division of the American population into members of three major faiths, Roman Catholic, Jewish, and Protestant, provides a convenient approach to a discussion of the geography of the leading denominational groups. The least numerous of the three and the one whose areal pattern is easiest to describe and explain, by virtue of its recency and extreme urban character, is the

Jewish group (fig. 4). Adherents of Judaism formed an ifinitesimal fraction of the American population until the 1840s when a sizable contingent of German Jews appeared on the scene, and it was not until the 1880s that substantial Jewish immigration, originating largely in Eastern Europe, gave the United States a large non-Christian minority. Jewish immigration had continued, but at a greatly reduced scale, since the general slackening of movement to the United States in the early 1920s.[38] Most of the Jewish newcomers chose to reside in the major ports of entry and the other leading metropolises of the Northeast, pre-eminently New York City, but also Philadelphia, Boston, Baltimore, Chicago, Detroit, Pittsburgh, and Cleveland. As table 4 and figure 2 indicate, the Jewish group comprises a large proportion of the total church membership reported for these larger cities (no less than 33.1 percent in the New York–Northeastern New Jersey metropolitan area), and so could, incidentally, play a pivotal role in those elections or other policy decisions in which Catholic and Protestant blocs are nearly evenly balanced.

There would seem to be a strong positive correlation between size of metropolis and percentage of Jews among total church membership, so that the great bulk of the American Jewish community is confined to a relatively few places. Still there are small, but significant, Jewish groups in most of the lesser cities of the nation. In the smallest of these, Jewish economic activity is largely restricted to retail sales; but in the medium-sized city Jews are attracted to certain wholesale, petty manufacturing, and professional opportunities, in addition to retailing. In fact, there is an interesting correspondence, outside the primary concentration in the urban Northeast, between the importance of a city as a wholesaling center and the size of its Jewish population. There are, of course, major departures from such a pattern of crude economic determinism. The rather larger than expected size of the Jewish groups in Savannah, Charleston, and Norfolk may, in good part, be attributed to the stability and early start of Sephardic (i.e., Iberian Jewish) settlement in those cities. Jewish migrants have followed national trends in moving to Washington, D.C., Florida, and, in especially large numbers, to the Pacific Coast cities. There has been the predictable outward surge to the suburban counties of the larger metropolitan areas; and the amenities would appear to play a greater role in Jewish internal migration than is observed among gentile groups in view of the unusually strong Jewish representation in the Catskill counties, Atlantic City, the larger Florida communities, and such Western centers as Denver, Tucson, and Phoenix.

Roman Catholic Patterns

The historical geography of American Catholicism has been a great deal more complex. Before the annexation of the Louisiana Territory and the acquisition of a substantial French-speaking Catholic population in southern Louisiana, Catholics had been conspicuous by their general rarity in the American population. The great influx of Irish and German Catholic immigrants that began arriving in the

1830s was predominantly urban in destination, the Irish almost wholly so. But many German and Swiss Catholics elected to settle in rural tracts, particularly in the lower Ohio Valley, the eastern Ozarks, the Texas prairies, and various sections of Michigan, Wisconsin, and Minnesota. Except for the movement to Texas, both the earlier and later Catholic immigration tended to shun the Southern states, as did most other immigrant groups. In the latter decades of the nineteenth century and the first quarter of the twentieth, the Irish and German streams were reinforced by substantial Catholic immigration from Italy, Poland, Lithuania, Hungary, Croatia, Austria, Czechoslovakia, Portugal, and French Canada and lesser contributions from such areas as Great Britain, the Low Countries, and the Philippines. Currently, the trickle of incoming European Catholics is probably exceeded by entrants from Puerto Rico and French Canada and those crossing the Mexican border legally or otherwise to add their numbers to the descendants of the substantial Spanish-American population acquired by annexation in 1845, 1848, and 1853. Most of the more recent European Catholic immigrants settled in cities; but significant numbers also gravitated to the agricultural frontiers of the northern Great Plains or to various small mining settlements.

As has been the case with all immigrant communities, the initial areal patterns of Catholic settlement have been considerably modified by later internal migration. The great majority of the numerous Catholic church members on the Pacific Coast or those in peninsular Florida can be traced to sources in the Eastern and Central states rather than to direct European origins; and it is likely that most of the small, scattered Catholic groups in the Southeast are derived from points in the Northeast. It is also quite plausible, even in the absence of direct evidence, that the Catholic population of many of the larger cities of the Northeast and Middle West has been bolstered by in-migration from rural areas. Nevertheless, even though the details of Catholic distribution may have been greatly modified through the years and the total number of communicants has increased enormously, the basic pattern, established as early as 1860,[39] has remained remarkably stable for the past century.

The relative numbers of Catholics and non-Catholics have been plotted by county in figure 1; and since Jews form only a small portion of the non-Catholic population and are numerically significant in only a few counties, the non-Catholic church membership may be interpreted for general purposes as aggregate Protestant membership. Because of the inclusion of baptized infants as members of the Roman Catholic Church and the generally more restrictive criteria of membership and frequent under-enumeration of members among many Protestant groups, this map significantly overstates the relative size of Catholic membership and understates Protestant strength. Using the results of the March 1957 *Current Population Reports* sample survey as a guide to the actual number of professed Catholics and Protestants in the United States, the probable percentages of Catholics and non-Catholics have been indicated parenthetically in the map legend. In spite of the obvious weakness of the assumption that Protestant church member-

ship is uniformly understated throughout the nation, the parenthetical figures probably approach the truth more closely than those derived directly from the National Council of Churches' data.

A study of figures 1, 2, and 3 discloses the existence of several distinct regions in which Roman Catholics either predominate or form a strong minority of total church membership. Perhaps the most impressive aspect of the geography of American Catholics is the fact that they form the largest group in fourteen of our sixteen largest metropolitan areas (Washington and Minneapolis–St. Paul are the two exceptions), with more members than either the Protestant or Jewish faiths, and that they are predominant in many of the lesser as well as the larger cities of the Northeast. Thus although Roman Catholics constitute only a very large minority of the American population as a whole (40.1 percent of total church membership according to *Churches and Church Membership in the United States*, or 26.7 percent according to *Current Population Reports*), they form a substantially larger, even dominant part of the population of the highly urbanized, industrialized, and economically advanced Northeastern states (69.1 percent of total reported church membership in New England, 50.8 percent in the Middle Atlantic States, and 45.2 percent in the East North Central States[40]) which can, in turn, be considered as the "heartland" of Anglo-America.

The great Catholic concentration in the Northeast can be divided into three major sub-regions. First and most decidedly Catholic, by virtue of the convergence of several strong streams of immigration from Catholic sources, is the New England sub-region. The early, powerful Irish movement was followed by large numbers of French-Canadians, Italians, Poles, and other Eastern Europeans, with Portuguese immigrants appearing in noticeable numbers in some localities. This Catholic population is, of course, primarily urban; but there has been significant penetration of the villages and countryside, and only eastern Maine retains something of its original Protestant exclusiveness. Even greater in terms of absolute numbers is the sub-region taking in the huge coastal metropolises from New York southwest to Baltimore—and now, by recent extension, Washington—and reaching inland to include northeastern Pennsylvania, nearly all of upstate New York, western Pennsylvania, northern Ohio, and southeastern Michigan. Southeastern and central Pennsylvania (exclusive of Philadelphia) is the only large Protestant island interrupting the continuity of this area. Catholicism is relatively weak in Indiana and western Michigan, but a third large subregion commences on the western shores of Lake Michigan to include northern Illinois, much of Wisconsin, and major portions of Minnesota and Iowa. Certain lesser concentrations lying on the outskirts of this primary region date back to the early years of settlement. Thus the remarkably persistent Catholic population of Charles and St. Mary's counties, Maryland, bears witness to the initial character of the colony; the sizeable communities in Marion and Nelson counties, Kentucky, may be related to the fact that Bardstown was the first suffragan see west of the Appalachians;[41] the

clusters of Roman Catholics in Cincinnati and at points further down the Ohio and in east-central Missouri largely originated with pioneer settlement.

Quite distinct in origin is the French Catholic region of southern Louisiana, which extends in considerably attenuated form eastward as far as Mobile Bay. The only other significant Catholic concentration in the South is the predominantly Mexican community in the lower Rio Grande Valley and other sections of southern Texas. This region adjoins and overlaps a portion of central Texas in which Catholics of German extraction are a prominent demographic element. The south Texas area might be considered a fragment of a larger Mexican Catholic region which reaches its greatest development in the upper Rio Grande Valley and other portions of New Mexico, south-central Colorado, and southern Arizona. The major Catholic agglomeration located in the southern two-thirds of California contains only a moderate number of persons of Mexican descent and is principally the result of the recent massive migration from the eastern portions of the United States. Except for a few immigrant communities of farmers and miners in Idaho, Montana, and North Dakota, the relative strength of Catholicism is not impressive in the northwestern quadrant of the nation.

There are two extensive portions of the United States in which Catholics are rarely found: the South, and the Mormon region of Utah and adjacent states. Aside from French Louisiana, those portions of Texas with sizeable Mexican or German communities, the moderately large Catholic population of peninsular Florida, the Catholic areas of Kentucky and Maryland noted above, and some of the larger commercial and manufacturing cities, Catholics are quite scarce in the overwhelmingly Protestant South. The Mormon hegemony over a vast section of the Intermontane section of the West has meant feeble representation for almost all non-Mormon groups, whether Catholic, Protestant, or Jewish. It is also important to note that there are many basically rural tracts in the southern Middle West and, as already stated, in central and southeastern Pennsylvania where Catholics form an inconspicuous minority.

The British Colonial Denominational Groups

Very nearly two-thirds (66.4 percent) of the reported Protestant church membership of the United States is accounted for by six denominational groups, the Protestant Episcopal, Quaker, Congregational, Presbyterian, Methodist, and Baptist, which have in common a British colonial origin but are otherwise quite divergent in their history and geography. A considerable proportion of the pre-Revolutionary immigrants in the United States were Congregationalists and Friends from the British Isles, approximately 31 and 9 percent, respectively, if the Paullin tally of congregations in 1775–76 can be applied to the composition of the immigrant group. But at the present time these two groups, which ranked first and fifth among the church groups of 1775–76, have dropped to seventh and nineteenth place among the Protestant denominational groups. There is evidence to

indicate that the Friends had already spent most of their initial missionary fervor by the end of the seventeenth century, well before the crest of their migrational movement to America and that they attracted few converts in the United States. Indeed, the current small size of the group indicates not only a feeble missionary program but also the strong probability that many persons born into Quaker families have left the faith, possibly because this form of worship may not be particularly congenial to the American ethos, and have joined other churches or are unchurched. There are now only three significant clusters of Quakers outside the original nucleus of settlement in southeastern Pennsylvania: that in the North Carolina Piedmont, the community in central Indiana and neighboring portions of Ohio and Illinois, and the much smaller group scattered through southeastern Iowa (fig. 23). It may be assumed that all three represent colonies derived from southeastern Pennsylvania.

The colonial nucleus of Congregationalism in New England persists as the major center for adherents of this creed; but despite a general unaggressiveness in winning converts similar to that observed among the Friends, the Congregationalists were much more successful in maintaining their numbers and in extending, through migration from New England, the area in which they are a significant population element (fig. 11). The only major exception to the strong westward thrust responsible for widespread Congregational representation in the northern third of the United States is the movement to the North Carolina Piedmont. The relative weakness of Congregationalism west of the Appalachians, as compared to the Methodist, Baptist, or Presbyterian showing, may well be attributed to the "Plan of Union" in effect among the Presbyterians and Congregationalists during much of the critical period of settlement. This rather informal agreement on a division of labor was effective in preventing Presbyterian inroads in New England, but it worked greatly to the disadvantage of Congregationalists in the winning of frontier areas.[42]

The Episcopalians, who were apparently outnumbered by the Congregationalists in colonial times, have been able to overtake them both quantitatively and areally (fig. 9). After a period during and just after the American Revolution when the Episcopal Church underwent serious difficulties because of the suspicion of pro-British leanings, it managed to recover much of its importance and extend its membership over the entire territory of the United States. But even now the major grouping of Episcopalians lies within the only region where they figure importantly in the rural population, the primary area of colonial concentration from Connecticut southward to Virginia. From this original cluster we can trace a significant migrational stream to western New York and the northern Middle West. There has not been much deliberate missionary work (except among the Indians of the northern Great Plains[43]); but the contemporary distribution and composition of the Episcopalian population cannot be accounted for by natural increase and migration alone. It appears that, partly for reasons of prestige and social status, a significant number of persons of middle and upper class position and

urban residence throughout the country have gravitated to the Protestant Episcopal Church. This fact is particularly striking if membership statistics for certain suburban counties, which are distinctly upper-income in character, are compared with other counties within the same metropolitan areas.[44] We have, then, a distributional pattern much of which can be accounted for more readily by referring to current socioeconomic factors than by the historical geography of the denomination.

The Presbyterians, who migrated to the United States in considerable numbers both before and after the American Revolution, have not only augmented their ranks through natural increase but have also succeeded in attracting large numbers of converts, particularly during their westward progress across the continent.[45] Once again, the primary initial cluster lingers on as the major modern concentration: the "staging area" in western Pennsylvania and New York and eastern Ohio from which Presbyterians thrust vigorously westward ,and southward (fig. 8). There is no particular pattern in the distribution of this group outside this area of maximum strength and a secondary concentration in the Carolina Piedmont, which might well be anticipated from a study of early routes of settlement; Presbyterians form a strong minority almost everywhere, and occasionally account for a plurality of church membership—except in New England.

Only a small number of Methodists and Baptists migrated to America during or after the colonial period. The spectacular success of these two leading Protestant denominations is almost wholly a matter of the conversion of the unchurched and members of other denominations by zealous bands of preachers who began fanning out into almost all portions of the nation around 1800. Church historians advance the highly plausible thesis that both the theology and polity of these churches were unusually well adapted to the social conditions of the frontier and other recently settled districts.[46] We have already noted the nearly universal prevalence of Methodists as a prominent religious minority and, frequently, as the largest single group. What remains unexplained is their particularly heavy concentration in a wide band reaching westward from New Jersey, Delaware, and Maryland across the southern Middle West to the foot of the Rocky Mountains (fig. 6). It may be assumed that this east-west belt is simply an extension of the colonial beachhead of Methodism in the Middle Atlantic region; but since the genesis of this early cluster has not yet been accounted for, the problem remains open.

One of the most provocative questions confronting the student of American cultural geography is the close affinity between Baptism and Southern culture during the past several decades (fig. 5). The areal distribution of members of Baptist bodies in the Southern states so closely mimics that of aggregate population that it is disconcerting to encounter the occasional gaps, such as those in the Kentucky Bluegrass or a group of counties in Appalachian Virginia or eastern North Carolina. Nonetheless, this powerful dominance of Baptism within the South is evidently rather recent in origin. If we can trust the earlier census enumerations, Baptist congregations were less numerous than those of Methodist af-

filiation in Southern states as late as 1860; and it was only in 1890 that the current pattern plainly emerges. The great multitude of Baptist members in the South tends to obscure the fact that Baptism is one of the most widely disseminated creeds in the United States. Its adherents form a significant minority and even occasionally a plurality of total church membership in most non-Southern regions. An example of particular interest is the New England concentration dating from the eighteenth century.[47]

The Immigrant European Church Groups

The migrational factor readily accounts for the principal distributional features of those Protestant denominational groups considered here which can be traced to the European continent.[48] Among these groups—predominantly German, Dutch, Swiss, and Scandinavian in derivation—religion has remained strongly identified with ethnic origin. Relatively few converts have been made among Americans born into other churches, certainly far fewer than the number of persons who have drifted away from the traditional faith. A glance at the maps reveals the fact that these denominations tend to be more localized than most of the British colonial or native American churches and that their chief strength lies within the Middle Atlantic and Middle Western states (figs. 7, 13, 14, 16, 20, 22). Conversely, they are weak in New England (which did, however, attract many Catholic immigrants) and most of the South, an area which failed to draw many of the nineteenth- and twentieth-century arrivals from Europe. All of these groups, or their antecedent denominations, appeared in eighteenth-century Pennsylvania and the Dutch Reformed group even earlier in seventeenth-century New York and adjacent sections of New Jersey. As soon as the western territories were opened to settlement, they attracted a strong flow of the church members in question, partly from the older nuclei on the Atlantic Seaboard, but in greater numbers from overseas. Thus we now have sizeable clusters—and even an occasional case of local dominance—of members of the Evangelical and Reformed, Brethren, Reformed, and Mennonite churches within western Pennsylvania, Ohio, Indiana, Illinois, Iowa, southern Michigan, and southern Wisconsin.

The largest such migration was that of members of the various Lutheran bodies who have come to be the leading group over much of the territory west of the Hudson and north of the 40th Parallel (fig. 7). A secondary, but unusually interesting movement, beginning in the eighteenth and apparently continuing well into the nineteenth century, was that of Brethren, Moravians, Lutherans, and members of the groups that were to become the Evangelical and Reformed Church southwestward from Pennsylvania and Piedmont Maryland down the Great Valley and the upper Piedmont route to various localities in western Virginia, eastern Tennessee, and, most significantly, into central North and South Carolina (fig. 13). The only other important entry into the South was that of Lutherans and members of the Evangelical and Reformed Church into portions of

central Texas, probably directly from Europe. More recently, some members of immigrant European church groups have moved into Great Plains localities or to the Pacific Coast, notably the Lutherans who are a major element in the population of the northern Great Plains and the Pacific Northwest.

By studying and comparing the maps of all the groups thus far discussed, two broad statements can be ventured concerning their migrational behavior. Firstly, we can readily detect three stages of migration, though not equally well for each denominational group: (1) the consolidation of one or more clusters of immigrants or locally converted church members in the Atlantic Seaboard during the colonial period; (2) a streaming inland of migrants, some from the older centers near the Atlantic, others from European sources, throughout the century during which the vast trans-Appalachian regions were occupied; and (3) a re-distribution of church members after the close of settlement frontiers that followed much the same patterns as can be observed for the general population—toward the Pacific Coast and the southwestern states, toward peninsular Florida and a few other favored localities on the Gulf of Mexico, and toward the large metropolises in the Northeastern quarter of the nation. Secondly, there is also a rather clear latitudinal zonation in the westward movement of Protestant church members from the Atlantic Seaboard, so that we can define three broad east-west belts—a northern zone in which denominations of Scandinavian, North German, and New England provenience (including the Unitarian) are of particular importance; a central zone in which there is a heavy concentration of groups firmly established in the Middle Atlantic area at an early date; and a large southern zone in which Baptism prevails, apparently through both migration and conversion. These zones are most sharply defined toward their eastern termini; but even though they are blurred in the West, at least the first and third are still discernible on the Pacific Coast. It is interesting to note the persistence of patterns established by early migration. Even extensive out-migration from places initially settled by Catholics or members of the non-British Protestant groups has not erased their denominational distinctiveness. Thus modern religious data may serve as tracers of early movements long after Census publications cease to offer information on the national origin of a given local population.

The Native American Denominational Groups

The religious bodies of American origin represent the culmination of a trend toward a special New World identity that is apparent in most other denominations. The Protestant groups of British origin have all been strongly Americanized, in some cases almost totally transformed, and the process has gone quite far with most of the denominations originating on the European continent, in spite of stubborn rearguard actions. Even among English-speaking Catholics and Jews, who apparently will indefinitely retain Latin and Hebrew (at least among those Jews of Orthodox persuasion) as their liturgical languages, the form and spirit of

religious life depart considerably from Old World practice. In some cases the new American sects patterned themselves closely after traditional models, but in numerous instances both theology and style of devotion are quite original.

We are badly handicapped in accounting for the areal patterns in the membership of most native American denominations by two basic facts: only one (the Evangelical United Brethren) of the eight groups that have been mapped for this study can be associated with an immigrant group and so tied in with known migrational currents; and there is good reason to suspect that the under-reporting of membership is more serious among most of these groups that for American denominations in general. The relatively poor statistical situation can be attributed to the loose, uncentralized structure and frequent shifts in alliance that characterize the congregations affiliated as the Assemblies of God, Churches of God, Disciples of Christ, or Church of the Nazarene and make it impossible for the National Council of Churches to gather data on some other equally important bodies (figs. 15, 19, 10, 18). The regionalization of the Evangelical United Brethren, a body formed in 1946 by the union of two essentially Teutonic groups of eighteenth-century Pennsylvania origin and Methodist affinity, follows the familiar pattern already observed for immigrant groups with an initial base in Pennsylvania.[49] There is the marked clustering in southeastern Pennsylvania and the adjacent segment of Maryland, an important, evidently derivative belt to the westward in the lower Middle West, and a scattering further west in the Great Plains and along the West Coast (fig. 14).

We are on fairly solid ground in interpreting the distribution of two other groups, the Unitarian and Universalist and the Latter-day Saints. The former pair are strongly rooted in New England, the Unitarians as a late eighteenth-century offshoot of Congregationalism and the Universalists as a group whose philosophy can be traced to European sources but who found New England during the early 1800s their most congenial rallying ground. Although the map clearly indicates the persistent dominance of the natal area, Unitarianism and Universalism now reach into all sections of the land (fig. 21). The pattern is, in some ways, quite reminiscent of the Episcopalian, for the Unitarians and Universalists are strongly urban in residence, middle and upper class in social orientation, and rather indifferent toward missionary activity. There is one interesting difference, however. Unitarianism seems to have a particular appeal for well-educated persons of a certain libertarian and philosophical bent; and it is not surprising to find a membership symbol wherever a major university community appears on the map.

The Mormons are unique in theology, geographical implications, and the close attention they have received from the historian.[50] The historical facts are familiar enough so as not to call for recapitulation. For the geographer, the salient points concerning Mormonism are its spectacular achievements, after many early vicissitudes in the Middle West: the penetration of the Great Basin region during the 1840s well in advance of regular settlement, the development of workable methods for utilizing arid lands, the attraction of considerable members of overseas prose-

lytes to the "Land of Zion" during the initial years in Utah, and the subsequent success in missionary work and re-settlement elsewhere in the United States and in other countries. The advantages of an early start and particularly effective ecclesiastical and economic organization are reflected in the unique degree of dominance the Mormons have gained in their stronghold within Utah, southern Idaho, and portions of other Western states (fig. 12). A second substantial Mormon group, presumably containing both converts and migrants from Utah, is found along the Pacific Coast, with special strength in the Central Valley and the Los Angeles Basin. There are also numerous groups of Latter-day Saints in the eastern half of the nation, and particularly the Middle West, who may be explained, in part, by the persistence of early splinter groups or by the missionary efforts of the principal denomination operating out from Salt Lake City. In addition, there is a steady migration of Mormons eastward from Utah and in other directions[51] that has been generated by high fertility[52] and the limitations of the local economy.

The remaining native American denominational groups have several elements in common, aside from a tendency toward local autonomy. The Churches of God, Assemblies of God, Disciples of Christ, and Church of the Nazarene may be described as pentecostal, holiness, or evangelical groups that tend to be decidedly fundamentalist and "enthusiastic" and to lay particular stress on individual salvation through a strong personal relation with the Deity. The Adventist bodies stand somewhat aside by virtue of their rather distinctive theology. The Adventist and Mormon movements originated almost simultaneously in the same aptly styled "Burned-over District" of western New York;[53] and, strikingly enough, both denominations are rather poorly represented today in their original habitat. Adventism is now widely distributed throughout the country in both urban and rural areas; but its strongest concentration, that along the West Coast, is unique among all our denominational groups and one for which there is no ready explanation (fig. 17). The other groups are also widely dispersed, but each with a distinct regional emphasis. The largest and oldest is the Disciples of Christ, who first appeared in Kentucky and western Pennsylvania between 1810 and 1830 and are now most numerous in the lower Middle West and Upper South, with significant outliers in eastern North Carolina, the Pacific Northwest, and central Texas (fig. 10). The Church of the Nazarene finds its principal strength in Ohio and Indiana, the Assemblies of God in the West South-Central states, and the Churches of God in those counties in and near the Southern Appalachians (cf. figs. 15, 18, 19). All four groups have two locational aspects in common: a strongly rural orientation[54] and a negative correlation with regions in which the foreign-born are numerous. On the basis of the map data and cursory observation, these fundamentalist churchgoers might be characterized as lower or lower middle-class native whites residing chiefly on farms and in small towns. The defects of our data may well conceal other significant facts, such as the possibility, suggested by travel in the region, that this group of fundamentalist bodies, along with others not included in this study, may be much more strongly represented in the upland

than in the lowland sections of the South. Any attempt to explain the areal patterns of these denominations must fall back upon the facts of their place of origin, the careers of especially forceful individuals, the almost random events of church history and diplomacy, and, possibly, certain common social and cultural tendencies about which we have no information.

THE RELIGIOUS REGIONS OF THE UNITED STATES

In view of strong variations in denominational strength from place to place in the United States that are clearly evident in spite of serious shortcomings in our data, it is most desirable to hazard some delineation of religious regions. There is little doubt that any number of regional systems could be worked out on a quantitative basis which would satisfy various sets of logical, but arbitrary, statistical assumptions. Such an exercise would not, however, answer the question of whether such regions really exist or are just a figment of the geographic imagination. If we accept the inherently reasonable notion that regions truly exist within the cultural landscape when their residents are aware of their existence and find them significant in some manner, it is not too hard to demonstrate religious regions in many parts of the Old World—in the Near East or Eastern and Central Europe, for example. The case of the United States is much less simple. The Mormon realm is an admirable example of a human geographic region in which religion is the chief genetic factor as well as a reason for the persistent distinctiveness of the area; and, on a lesser scale, a good case can be made out for southeastern Pennsylvania having acquired a unique geographic personality mainly because of its large quota of "peculiar people" and other staunch church members to whom religion has been a dominant force. On a miniature scale, there are scattered about the nation a number of small colonies of pietistic church members—notably those within the Mennonite fold—who have gone to some lengths to shun the worldly ways of their neighbors and have created microregions strikingly different in form and function from the encompassing culture (fig. 22).[55]

The special regional character of New England might also be attributed in part to its quasi-theocratic past and the unique blend of denominations housed within the area. Religion is certainly a significant element in the maintenance of cultural identity within the French- and Spanish-speaking Catholic areas; but, strictly speaking, it is subordinate to the ethnic factor, as can be seen if we consider the contrasts with the strong English-speaking Catholic populations which adjoin or overlap these groups at various points. A much less convincing argument could be advanced for the role of religion in the creation and preservation of the South as a distinct geographic region. There are no peculiarly Southern religious practices or denominational groups; and even though the particular combination of churches found within the region is not even distantly approached elsewhere, few, if any, Southerners are conscious of religion as an item setting them apart from the non-Southern population. Thus, with the possible exceptions of the areas

listed above, most Americans do not regard religious affiliation as a factor making one locality markedly different from another and are, in fact, only dimly aware of areal variations in the relative strength of major denominations.

This indifference is reflected and reinforced by the relatively minor contribution of the religious life to the visible landscape of the nation. Outside the Mormon and certain of the older Spanish-American areas, the church has played a rather inconspicuous part in shaping the form and content of settlement, whether urban or rural. In New England, the church building often does dominate the village green; but elsewhere the anomalous status of religion in American life is painfully clear in the relegation of churches to sites generally outside the urban core. Aside from church buildings, the only tangible evidence of spiritual concern is found in burial grounds, parochial school buildings, and the quite occasional nunnery or monastery—a wholly different situation from that documented in great detail by Deffontaines (1948) for much of the Old World. Furthermore, there are some religious bodies, such as the Friends, which are assiduously invisible; and even the connoisseur of ecclesiastical architecture is often hard pressed to distinguish the churches of one Protestant denomination from those of another.[56]

Most of the seven major regions and five sub-regions shown in a general and tentative way in figure 26 can be justified neither by rigorous statistical logic nor by any obvious manifestations in the works or non-religious ways of men, but only by a certain loose areal association among certain groupings of church members, i.e., some moderate degree of areal homogeneity apparent to the map analyst if not to the majority of inhabitants, and the little we know of the configuration of the general culture areas of the United States.[57] It is not at all clear whether their particular religious composition is a genetic factor in the emergence of these general areas, whether it is one of the by-products of the larger culture, or whether there has been a more complex interplay of forces at work; but, in any event, this areal coincidence between religion and other cultural phenomena does call for further investigation into their mutual relations. It is, then, in the hope of illuminating the larger problems of the cultural regionalization of the nation that the following, quite provisional scheme is offered.

Two other prefatory comments are necessary. Although the huge Catholic population of the Northeast is recognized on the regional map by the use of a special pattern showing its principal concentrations, this population appeared too recently to have been effective in shaping the enduring cultural personalities of the Northeastern states. Consequently, regional boundaries were drawn solely upon the basis of earlier Protestant groupings. Elsewhere, in the Spanish Catholic region and the French Catholic sub-region, Catholicism was a decisive early force and is so acknowledged in locating regional boundaries. It was impossible, without making the map altogether too complex, to recognize the religious uniqueness of many of our larger cities. It is hoped that the reader will realize that such cities as New York, Miami, Detroit, or Pittsburgh do form areally minute sub-regions standing quite apart from the larger regions in which they are situated.

New England, the first of our major religious regions, is one in which Roman Catholicism is widely dominant, but its distinguishing characteristic is the strength of its Congregationalist population and, to a lesser extent, the large contingents of Unitarians, Universalists, and Episcopalians. There are substantial Jewish populations in some of the larger cities and rather more Baptists in the region than are found in most of the remainder of the American Northeast. Conspicuous by their rarity are Methodist and Presbyterians (except in northern New England) and members of the various Teutonic denominations (except for a modest number of Lutherans in southern New England).

A second, much larger region denoted as the Midland reaches westward rather irregularly from the Middle Atlantic shore to the Central Rockies. Methodism is the branch of Protestantism most strongly represented, but religious composition varies greatly from place to place. Many cities and some rural tracts are dominated by Catholics, while the Jewish element is prominent in the larger metropolises. Large numbers of Presbyterians, Baptists, Episcopalians, Disciples of Christ, and various native American and Teutonic groups appear in many localities. A major sub-region, the Pennsylvania German, can be delimited in Pennsylvania and portions of Maryland, West Virginia, and Virginia, within which churches of Teutonic provenience are clearly in the majority or form a large minority and Catholicism is inconspicuous.

The Upper Middle Western Region is one in which Lutheranism frequently shares dominance with Catholicism, but it is still recognizable as the westward extension of New England in the strong showing of Congregationalists and, in some cities, Unitarians. Large minorities of Methodists, Episcopalians, and Presbyterians are in evidence. Locally, Baptists and members of various native American and Teutonic churches may be important.

The large Southern Region is readily identified as one in which Baptists are strongly dominant and Methodists form persistently large minorities. Presbyterians and Episcopalians are also well represented, while such native American churches as the Disciples of Christ, the Church of the Nazarene, or Churches of God show some strength locally. The uniformly British and native Protestant character of most of the Southern Region is interrupted by islands of Catholics—German- and Spanish-speaking in Texas, French-speaking in Louisiana, and Catholics of Northern origin in southern Florida. Each of these sub-regions is clearly set apart from the remainder of the South by important non-religious factors. A sub-region of peculiar interest is that located in the Carolina Piedmont, an area whose cultural distinctiveness has not been fully appreciated in the geographical literature. This sub-region is decidedly a portion of the South; but the significance of Presbyterians, Friends, Congregationalists, and various Teutonic groups suggests a divergence in general demographic, cultural, and historical development from, say, Virginia or South Carolina that even the casual student would have little trouble in detecting. The common boundary between the Southern and Midland regions shown in figure 26 corresponds surprisingly well

with what is known about the northward extent of the more general Southern culture area, except possibly for the exclusion of part of the Kentucky Bluegrass from the South.[58] I believe it is safe to state, from personal observation and discussion, that there is a closer identification in the Southern Region between religious denomination on the one hand and caste and class on the other than is to be found elsewhere in the United States, although something of the same situation seems to prevail in rural and small-town society in a good many parts of the Middle West. This correlation between religious and social status is distinct from, though not unrelated to, the lowland-upland dichotomy already noted in the religious structure of the South.

The Mormon Region is the most easily mapped and described of all seven, for within it only negligible numbers of Catholics, Jews, or other Protestant church members appear. The almost equally distinctive Spanish Catholic Region is centered primarily in New Mexico, Arizona, and southwestern Texas, but extends northward into Colorado and overlaps the Western Region in southern California. Members of various British and native Protestant denominations, particularly the Baptist and Methodist, form sizeable minorities alongside the Catholic plurality.

The last of the regions, the Western, has the least recognizable personality. As the recipient of steady streams of migrants from all other sections of the nation, this region has substantial numbers of members in almost all the denominational groups, but is not the major center for any, with the doubtful exception of the Adventists. Neither do we find any clear patterns of dominance by any single church, if we except the Catholic situation in portions of California; but there is a tendency for the groups that are best developed in the New England and Upper Middle Western regions to be well represented in the Pacific Northwest and for the denominations that are firmly based in the Southeastern states to gravitate to central and southern California.

After analyzing recent church membership data which, for all their shortcomings, constitute the best set of statistics yet to appear on the religious composition of the American population, it is possible to offer several significant, but highly general, observations on the distributional aspects of the major denominational groups:

1. The great multiplicity of denominations in the country as a whole is matched by the heterogeneity of religious composition within smaller areas. The major exceptions are to be found in the Mormon Region and much of the South.

2. As a corollary to (1), we must note that while no two denominational groups have strongly similar distributional patterns and each does have one or more major regional concentrations, most denominational groups do tend, to a striking degree, to be national in distribution.

3. The system of religious regions and sub-regions tentatively postulated in this study contains only two or possibly three cases of regions whose religious

distinctiveness is immediately apparent to the casual observer and is generally apprehended by their inhabitants. The other regions in this set are suggested on the basis of their possible correlation with general culture areas and/or on the basis of the areal association of church membership patterns of various denominational groups as observed on a rather coarse scale.

4. There is a great deal of heterogeneity within the postulated religious regions in terms of the lesser details of the areal patterns of individual denominational groups (but, as indicated in [3], much less variability on the macroregional scale). This heterogeneity has been partially recognized in the establishment of the sub-regions. Although there are many sharp contrasts among small rural tracts, the most important contrasts are those between rural and urban patterns. These rural-urban differentials can, indeed, be said to transcend the limits of all the regions and present a national dichotomy, the understanding of which is basic not only for the study of religion and demography but for most of the phenomena of concern to the human geographer as well.

5. It is possible to offer only partial, rudimentary interpretations of the areal patterns of the individual religious regions and the various denominational groups, mainly in terms of migrational history and, to a much lesser degree, vital trends and the processes of conversion and apostasy.

6. It is apparent from general observations and from such scanty information as has been brought into evidence in this study that there is almost certainly some sort of areal correlation between religious adherence on the one hand and length, stability, source, and type of settlement, rural-urban residence, social class, economic status, and certain cultural and psychological characteristics on the other, both for individual denominational groups and for the religious regions. Unfortunately, we lack the information or the research techniques to state the precise nature and significance of such inter-relationships. Thus it would not be prudent to search further at this time for the answers to the questions that have motivated this study: What kinds of religious regions and how many exist in the United States; how did they happen to originate; and how has religion interacted with other phenomena in imparting regional differences to the land and people of the nation?

The temptation to speculate on the inter-relationships between religious affiliation and political, social, and economic behavior is admittedly almost irresistible; but the data are hopelessly inadequate not only for purposes of explanation but even for satisfactory basic description. In pursuing such research, it would be foolhardy to rely solely on membership data, the only sort we have or are likely to be given for some time, even assuming their completeness, accuracy, and comparability; but it may be profitable to see, in retrospect, why we have leaned as heavily as we have on such a seemingly slender reed. Each of our denominational groups—in fact almost every one of the individual religious bodies—is a haven for persons of widely differing theological, social, and cultural attitudes. There is

usually a characteristic and strongly defined cluster of traits, a mode or stereotype which adequately defines much of the membership; but significant minorities of members may be strewn along the entire range of the theological or social gamut. A brief consideration of the Methodists, whom we have described as perhaps the most nearly national in distribution of all the major denominational groups, would bear out this contention, but any other group would do as well. Even the Roman Catholic Church is much less monolithic in structure and behavior than many persons believe; there are many distinct and semi-autonomous foreign-language groups within the Church, each jealously guarding its particular set of cultural characteristics, and beyond the basic religious life of the English-speaking parish there lies a great array of monastic orders, social and cultural lay groups, and educational institutions catering to a broad variety of tastes. The ascription of a common cultural and historical background to the Jewish population is possible, although an experiment fraught with hazard. In actuality, American Jewry is deeply cloven not only along the lines separating the Orthodox, Conservative, and Reformed sectors but by political, national, and class barriers as well. The heterogeneity of most of the Protestant denominations finds expression in the constant emission of new splinter groups.

What we need, then, are not only tabulations of formal adherence to a given creed but also some adequate measures of intensity of religious belief, frequency or regularity in religious observances, locus on the liberal-fundamentalist spectrum, and statistics that will enable us to relate religious behavior with social, demographic, and economic characteristics. If denominational affiliation is so poor an indicator of the religious or social identity of an individual, and hence, by implication, of a locality, why should geographers concern themselves at all with the topic? Simply because, despite a general looseness in structure and willingness to be as miscellaneous as possible which we find among most American church groups, they do have central tendencies. They are not only convenient receptacles for people of common national origin, spiritual aspiration, or socio-economic attitudes, but they can also at least partially re-mould the personalities and actions of the persons born or adopted into the fold. It is unquestionable that individuals born within Catholic, Jewish, Mormon, Mennonite, or a number of other Protestant groups will inherit an ineradicable set of cultural differences from their families and co-religionists. Those who elect to transfer their allegiance to a faith to which they are not native but toward which they feel a strong affinity may frequently find themselves carried along faster and further than they had originally intended as they comply with the group norms. We may have trouble in detecting contrasts in the appearance, behavior, or material works of American denominations, for this is a nation in which religious feeling tends to run shallow despite the luxuriation of creeds; but the sense of religious difference—as distinct from religious feeling *per se*—is a powerful and often highly emotional element in the minds of Americans that works to bind together or separate groups of people and thus to create areal resemblances or contrasts.[59] Of central importance

to geographers is this fact that religious institutions seek out, accentuate, and preserve differences among men and that differences, not only in the land but in the people who occupy it, whether they be real or imagined, are the meat and drink of geographers. Religious denominations have certainly been among the factors in the creation and perpetuation of some American cultural regions. In the case of the Mormon realm, it has been a phenomenon of overwhelming importance; and in New England and eastern Pennsylvania less decisive, but certainly significant. Elsewhere, as in the South where Baptism was apparently adopted as the creed most compatible with the genius of the region long after its personality had become clearly defined, a given blend of denominations may well have helped to crystallize a region or at least served to prevent its obliteration. From the scanty evidence available, we have reasonable grounds for proposing the hypothesis that religion is a significant element in the population geography of the United States, in the geography of a number of economic, social, and cultural phenomena, and in the genesis and persistence of general cultural regions; but we have too little knowledge of the precise ways in which religion operates in these various directions. Devising ways to collect and interpret information for testing this hypothesis may prove to be one of the most difficult, but also potentially one of the most rewarding tasks awaiting the student of American cultural geography.

An adequate discussion of the more promising methods that might be tested in approaching the geography of religion in the United States would require a rather lengthy statement. In closing the present study, however, a few tentative suggestions, briefly stated, would seem to be in order. If we assume, as we regrettably must, that there is scant likelihood of any marked improvement in the quantity and quality of our religious data in the foreseeable future, the geographic investigator might gain valuable insights into the role of religion in shaping the individuality and variability of our land by pursuing any of these five, not necessarily exclusive, avenues of research: (1) intensive local studies; (2) detailed study of the historical geography of individual denominations; (3) the statistical analysis of areal association on a national or regional scale involving such religious statistics as we have and relevant demographic, economic, and social statistics; (4) the careful search for relevant material in both the methodological and substantive writings of scholars in other fields touching on religion—theology, demography, sociology, social psychology, political science, and history (including the history of ideas, art history, and other topics beyond the more conventional limits of historical scholarship); and (5) comparative studies involving the United States, or substantial sections thereof, and other portions of the world.

The first approach would take any region of convenient size and character and subject its religious characteristics past and present to the most rigorous analysis possible. All aspects of religion of possible relevance to the geographer would be explored in depth both in the field and through the study of documents. The second method would follow much the same course as the first; and in examining a given group rather than a fixed area would scrutinize all phases of its historical

geography, going beyond the national boundaries when necessary. The next approach, though beset by many statistical pitfalls occasioned by the feebleness of much of the basic information, is greatly to be commended to those who are amply supplied with both technique and caution. After the accumulation of a significant store of information through one or more of these methods, the results of research in corollary disciplines and by geographers in other nations could be exploited most fruitfully in framing a new, more nearly satisfactory statement of the geography of religion in the United States.

[Text continues on p. 126.]

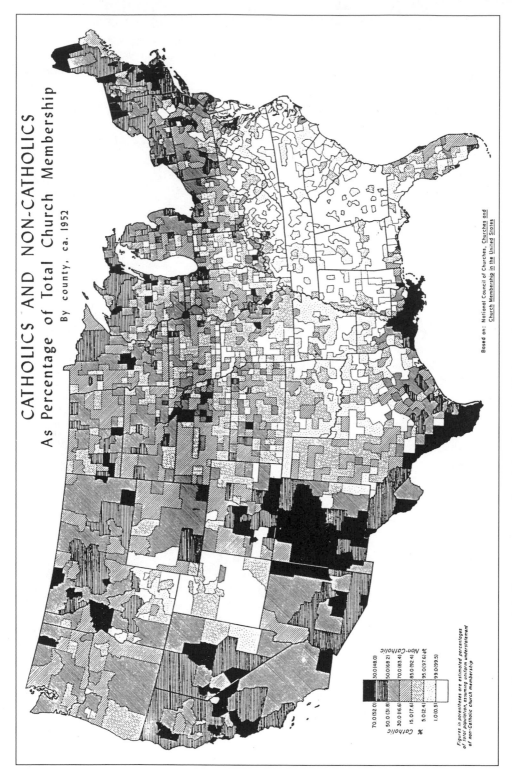

CATHOLICS AND NON-CATHOLICS
As Percentage of Total Church Membership
By county, ca. 1952

Based on: National Council of Churches, Churches and
Church Membership in the United States

Catholic %
70.0(52.0)
50.0(31.8)
30.0(16.6)
15.0(7.6)
5.0(2.4)
1.0(0.5)

Non-Catholic %
30.0(48.0)
50.0(68.2)
70.0(83.4)
85.0(92.4)
95.0(97.6)
99.0(99.5)

Figures in parentheses are estimated percentages
of total population, assuming uniform understatement
of non-Catholic church membership

FIGURE 1 Catholics and non-Catholics as percentage of total church membership by county, ca. 1952.

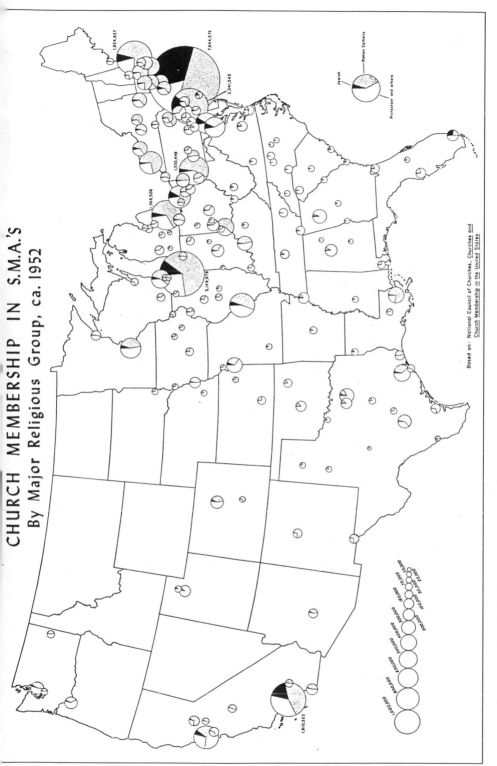

FIGURE 2 Church membership in S.M.A.'s by major religious group, ca. 1952.

FIGURE 3 Reported members of Roman Catholic Church by S.M.A. and county, ca. 1952.

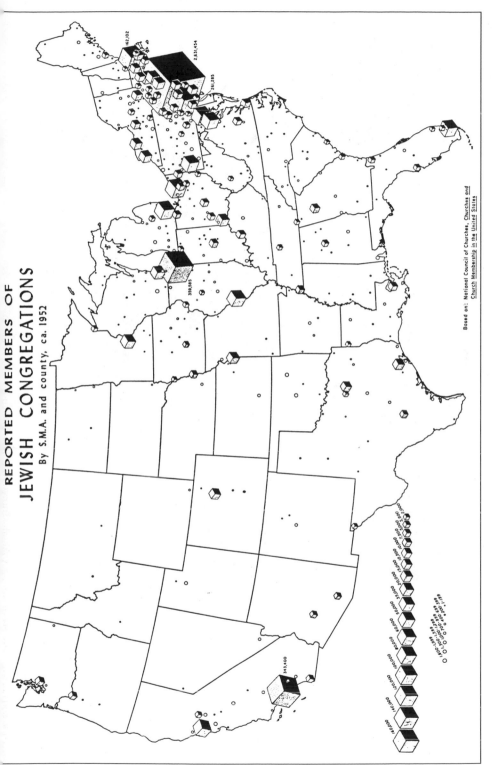

FIGURE 4 Reported members of Jewish congregations by S.M.A. and county, ca. 1952.

REPORTED MEMBERS OF
BAPTIST BODIES
By S.M.A. and county, ca. 1952

LEADING S.M.A'S

Atlanta	146,391
Houston	130,830
Dallas	120,713
St. Louis	109,917
Knoxville	104,450
Birmingham	94,319
Los Angeles	92,156
Washington	86,521
Ft. Worth	81,469
New York-NE New Jersey	74,223
Louisville	71,833
Memphis	68,760
Chattanooga	64,490
Oklahoma City	64,283
Boston-Lowell-Lawrence	62,951
Kansas City	57,854
Greenville	55,448

Based on: National Council of Churches, Churches and
Church Membership in the United States

FIGURE 5. Reported members of Baptist Bodies by S.M.A. and county, ca. 1952

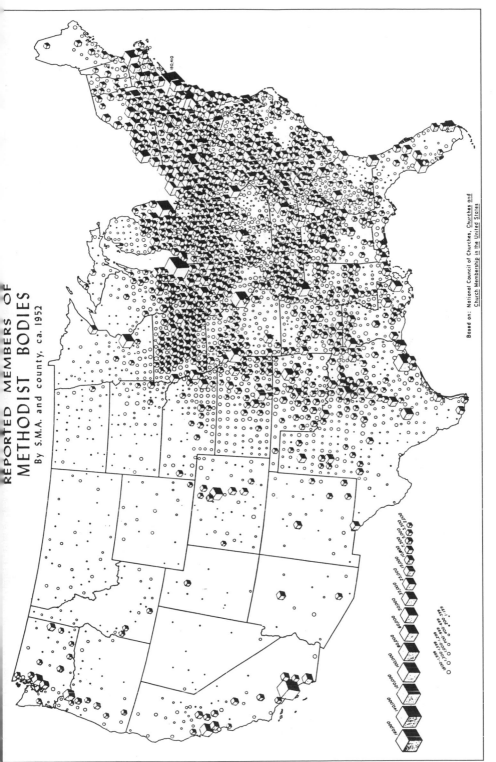

FIGURE 6 Reported members of Methodist Bodies by S.M.A. and county, ca. 1952.

REPORTED MEMBERS OF
LUTHERAN BODIES
By S.M.A. and county, ca. 1952

Based on: National Council of Churches, Churches and
Church Membership in the United States

FIGURE 7 Reported members of Lutheran Bodies by S.M.A. and county, ca. 1952.

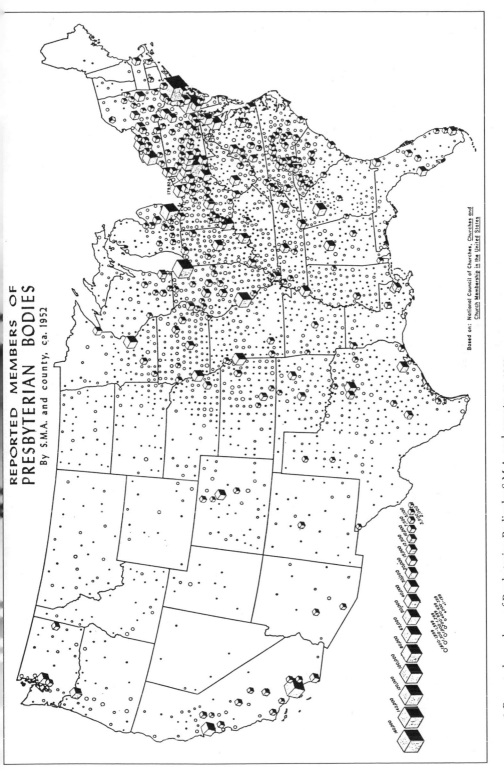

FIGURE 8 Reported members of Presbyterian Bodies by S.M.A. and county, ca. 1952.

FIGURE 9 Reported members of Protestant Episcopal Church by S.M.A. and county, ca. 1952

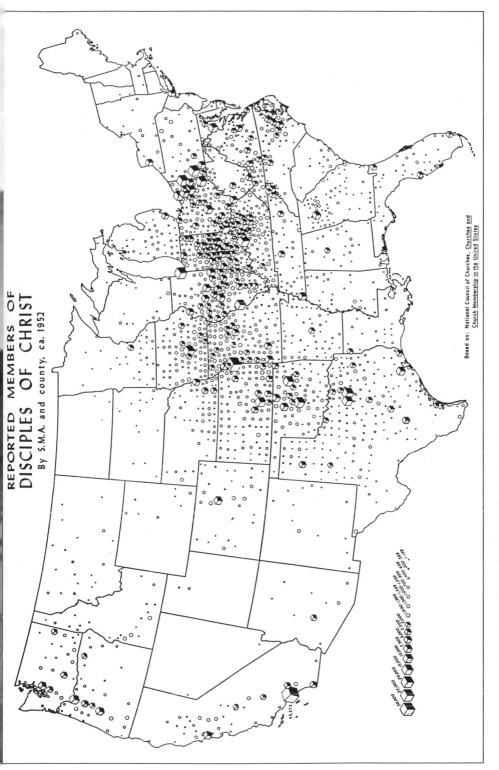

FIGURE 10 Reported members of Disciples of Christ by S.M.A. and county, ca. 1952.

REPORTED MEMBERS OF
CONGREGATIONAL CHRISTIAN CHURCHES
By S.M.A. and county, ca. 1952

102,377

Based on: National Council of Churches, Churches and
Church Membership in the United States

FIGURE 11. Reported members of Congregational Christian Churches by S.M.A. and county, ca. 1952.

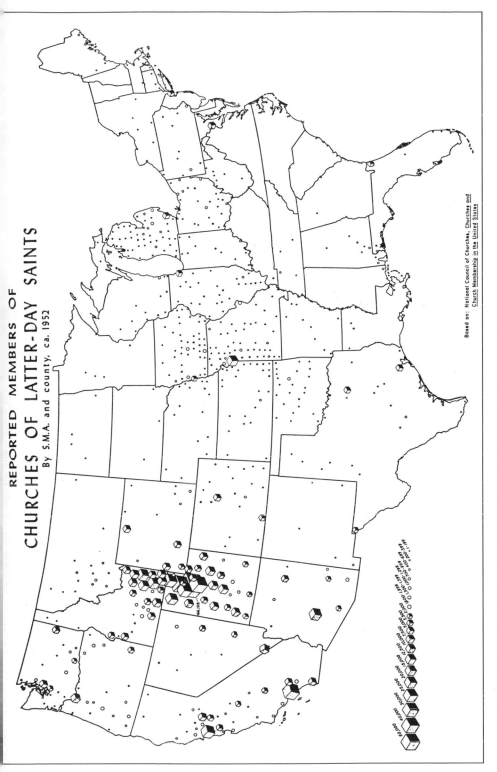

FIGURE 12 Reported members of Churches of Latter-day Saints by S.M.A. and county, ca. 1952.

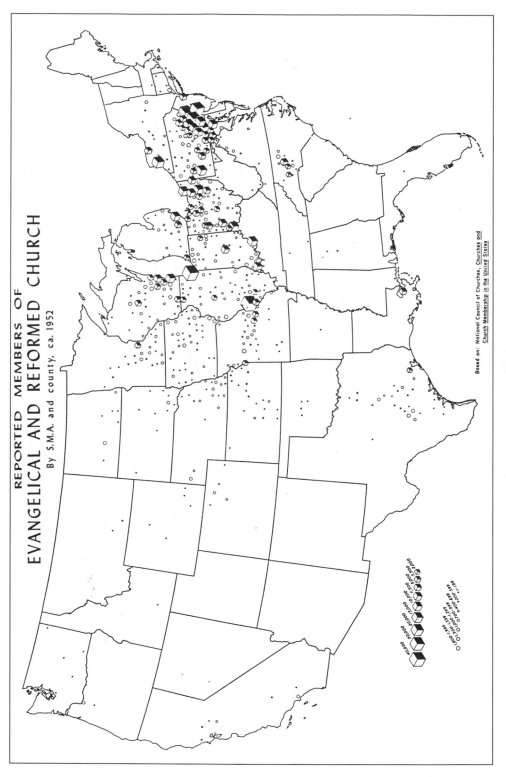

FIGURE 13 Reported members of Evangelical and Reformed Church by S.M.A. and county, ca. 1952.

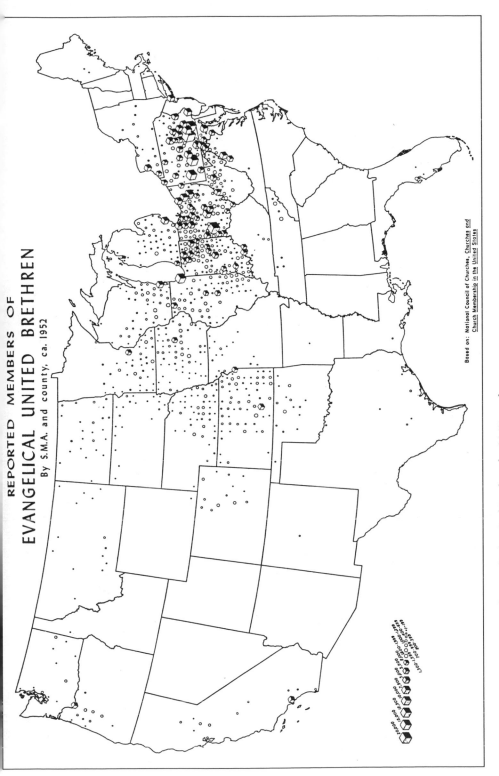

FIGURE 14 Reported members of Evangelical United Brethren by S.M.A. and county, ca. 1952.

FIGURE 15 Reported members of Assemblies of God by S.M.A. and county, ca. 1952.

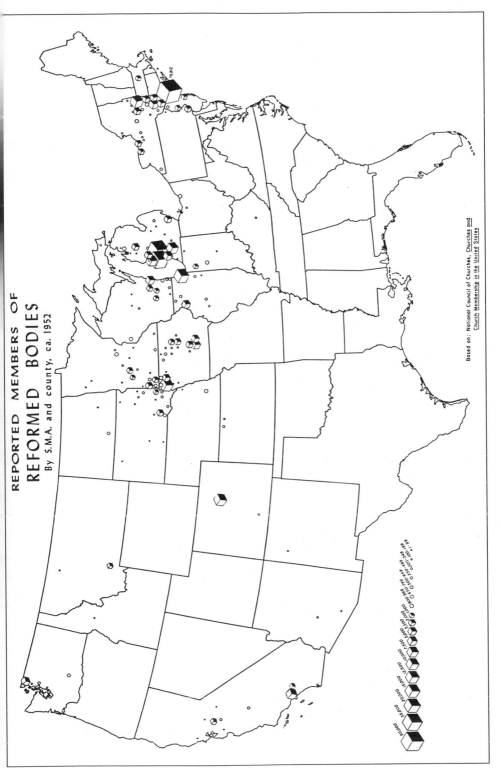

FIGURE 16 Reported members of Reformed Bodies by S.M.A. and county, ca. 1952.

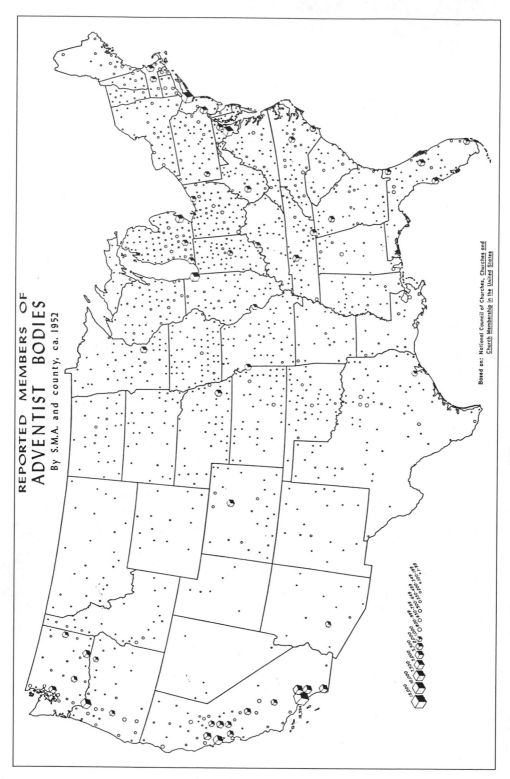

FIGURE 17 Reported members of Adventist Bodies by S.M.A. and county, ca. 1952.

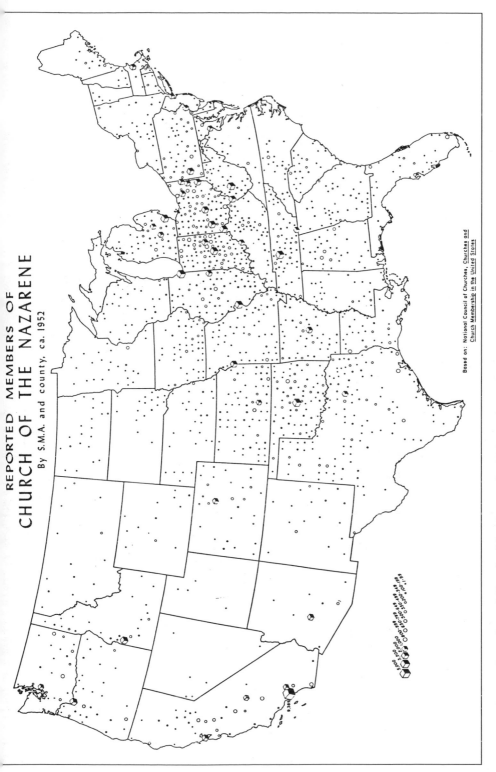

REPORTED MEMBERS OF
CHURCH OF THE NAZARENE
By S.M.A. and county, ca. 1952

Based on: National Council of Churches, Churches and
Church Membership in the United States

FIGURE 18 Reported members of Church of the Nazarene by S.M.A. and county, ca. 1952.

REPORTED MEMBERS OF
CHURCHES OF GOD
By S.M.A. and county, ca. 1952

Based on: National Council of Churches, Churches and
Church Membership in the United States

FIGURE 19. Reported members of Churches of God by S.M.A. and county, ca. 1952

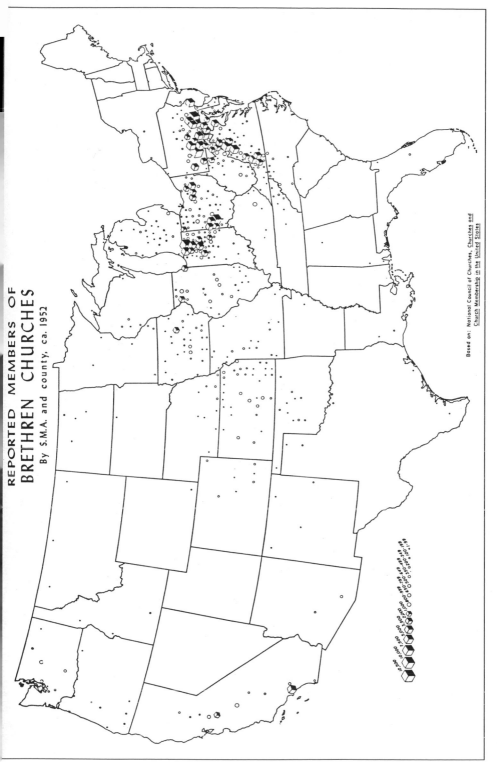

REPORTED MEMBERS OF
BRETHREN CHURCHES
By S.M.A. and county, ca. 1952

Based on: National Council of Churches, *Churches and*
Church Membership in the United States

FIGURE 20 Reported members of Brethren Churches by S.M.A. and county, ca. 1952.

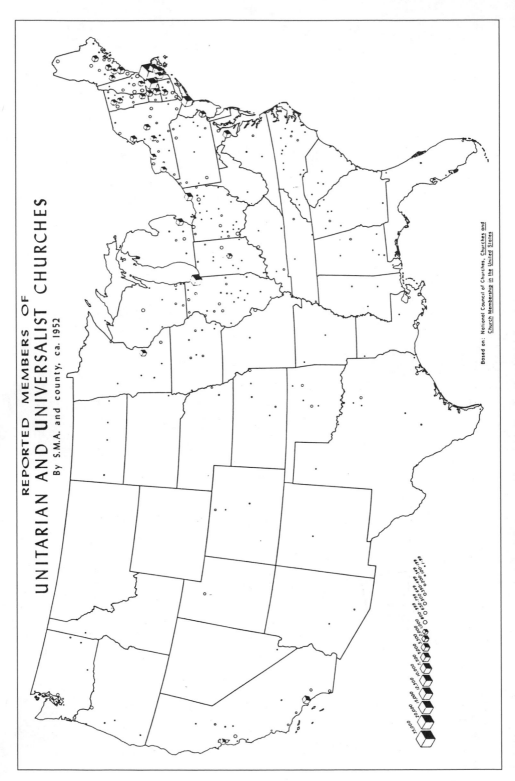

FIGURE 21 Reported members of Unitarian and Universalist Churches by S.M.A. and county, ca. 1952.

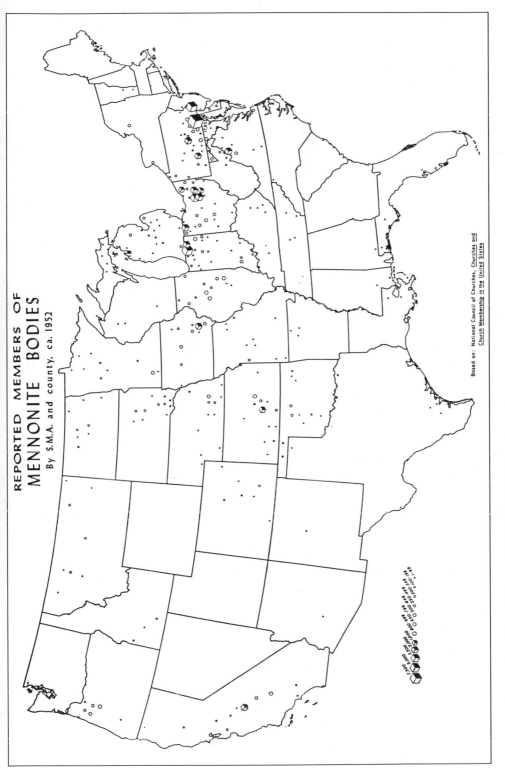

FIGURE 22 Reported members of Mennonite Bodies by S.M.A. and county, ca. 1952.

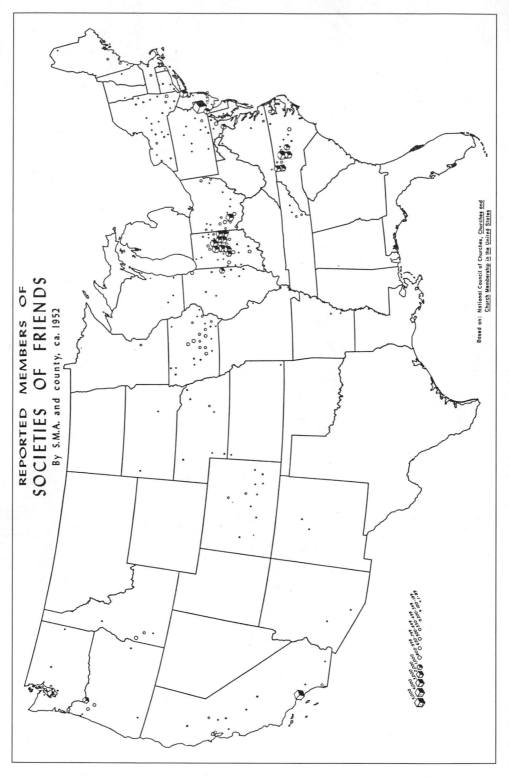

FIGURE 23 Reported members of Societies of Friends by S.M.A. and county, ca. 1952.

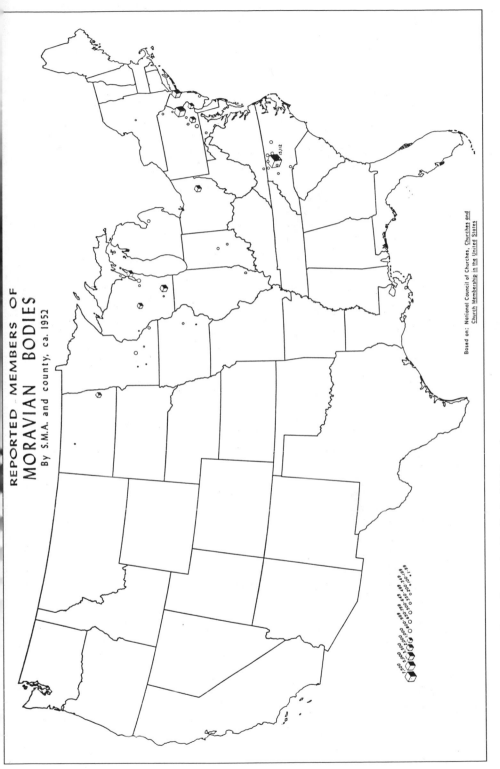

FIGURE 24 Reported members of Moravian Bodies by S.M.A. and county, ca. 1952.

Rank of Reported Membership in Methodist Bodies
Relative to that in Other Denominational Groups

By county, ca. 1952

Leading denominational group

Leading Protestant group, but outnumbered by
Roman Catholic membership

Second largest Protestant group

Lesser rank

FIGURE 25 Rank of reported membership in Methodist Bodies relative to that in other denominational groups by county, ca. 1952.

MAJOR RELIGIOUS REGIONS

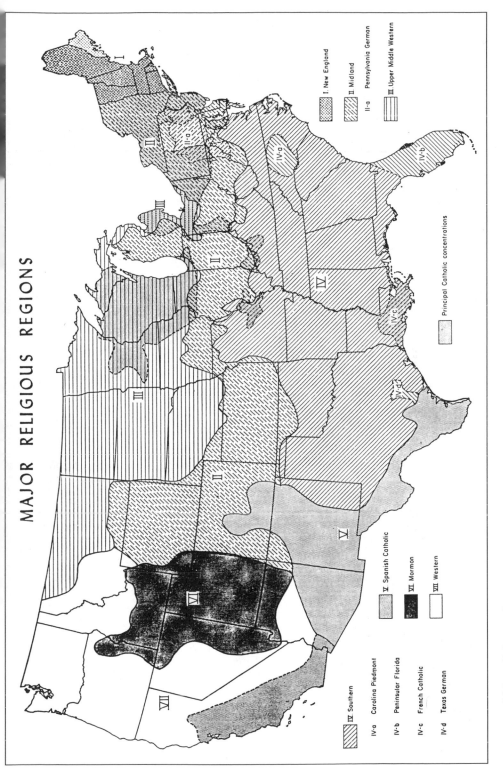

I. New England

II Midland

II-a Pennsylvania German

III Upper Middle Western

IV Southern

IV-a Carolina Piedmont

IV-b Peninsular Florida

IV-c French Catholic

IV-d Texas German

V Spanish Catholic

VI Mormon

VII Western

Principal Catholic concentrations

FIGURE 26 Major religious regions.

What could be more gratifying than the apparent impact of this article? It was only the second publication to examine the spatial patterns of American religion in detail (Gaustad [1962] being the pioneer along a somewhat different path), and it helped spawn a considerable progeny within the geographic fraternity. Indeed a distinct new subdiscipline has materialized. Thus we have today within the Association of American Geographers a specialty group entitled "Geography of Religions and Belief Systems," one that shows every sign of viability and growth. The recent body of geographic work on the religious scene in the United States and abroad is impressive; if I must single out specific items, some of the more interesting samples are Nolan and Nolan (1989) and the output of James Shortridge (1976, 1977, inter alia) and Roger Stump (1984, 1986, inter alia). The outlook is promising.

Annals of the Association of American Geographers 51 (June 1961): 139–193

NOTES

This study was supported by a research grant from Southern Illinois University. I also wish to express my gratitude to John E. Brush, J. Fraser Hart, and Philip W. Porter for the opportunity to examine notes, maps, and seminar papers relevant to the geography of religion in the United States that were produced under their supervision.

1. Vidal de la Blache (1941) and Sorre (1947–52).

2. Hettner (1947: 146–147) and Finch et al. (1957: 534).

3. Almagià (1945–46, 2: 578–581). Figure 24 (pp. 588–589) is one of the better world maps of religious adherence.

4. Taylor (1957) and James and Jones (1954). In a briefer survey, Broek (1959) does enter a plea for the study of religion as a major element in cultural geography, but there is no reference to published studies.

5. Deffontaines (1948). This erudite volume, which leans heavily on anthropological literature, deals almost exclusively with the impact of religion on settlement features and various aspects of human behavior as a one-way process; it is limited in scope, so that it never sorts out the various religions or discusses their geography *per se* or attempts to explore the multi-directional interplay among religion, non-religious phases of culture, history, and the physical environment.

6. Fickeler (1947) presents a valuable critical bibliography of German-language materials relevant to the geography of religion as well as a discussion of some of the methodological problems of the field; Fleure (1951); Fischer (1956, 1957). The last source does exceed the limits implied in its title and, in addition to providing a valuable survey of the distribution of the major faiths, indicates some interesting points of departure for future research on the non-political, as well as political, aspects of the geography of religion.

7. The outstanding examples are Friedrich (1917), Mecking (1929), Lautensach (1942), Credner (1947), Brush (1949), Vaumas (1955), Hahn (1958), Sievers (1958), and Clark (1960). Perhaps the most ambitious of the regional treatments of the geography of religion is Plan-

hol (1959), but it must be considered a brilliant sketch rather than the definitive statement on a huge and complex subject.

8. Smith (1948) and Bogue (1959). Two studies by an American geographer (Kollmorgen 1942, 1943) that have religious overtones are also basically sociological in approach.

9. Hotchkiss (1950) and Hauk (1958).

10. The best recent compilation of statistics for religion on a world scale is United Nations (1956).

11. This is the prevailing theme in Deffontaines (1948) and also, for example, in Credner (1947) and Fickeler (1947). The best recent exposition of this concept is Isaac (1959–60).

12. There is no single comprehensive bibliography of the statistical data and general literature on religion in the United States, but the best general guides are Landis (1959a) and Good (1959). Valuable bibliographical material on immigrant religious communities can be found in Tracy (1956).

13. Only a portion of the material that had been collected and analyzed had appeared (U.S. Bureau of the Census 1958) before the Bureau decided to suspend further publication.

14. For strong arguments against this interpretation, see Smith (1948: 175–176), Good (1959), Bogue (1959), and Duncan (1957).

15. Published in New York (1956–58) in a total of eighty bulletins arranged as follows: Series A, Major Faiths by Regions, Divisions, and States; Series B, Denominational Statistics by Regions, Divisions, and States; Series C, Denominational Statistics by States and Counties; Series D, Denominational Statistics by Standard Metropolitan Areas; and Series E, Analysis of Socio-Economic Characteristics. This survey is briefly described in Zelinsky (1960). It should be noted that for some years the National Council of Churches has also been publishing figures on the total membership of all religious bodies making such data available. The latest such compilation appears in Landis (1959b).

16. National Council of Churches (1953); the purposes, methodology, and problems involved in the survey are described in National Council of Churches (1956–58: Series A, Bulletin No. 1).

17. These 251 religious bodies do not necessarily comprise the totality of religious groups in the United States. It is quite likely that there existed an additional several score of small, ephemeral, local, or poorly organized groups in 1952 that were not reported in National Council of Churches (1953).

18. At this point a bibliographical note on the major descriptive and historical surveys of American denominations may be in order. The *Yearbook of American Churches* contains brief historical and organizational notes on each religious body, in addition to the statistics already mentioned. The best general guide is probably Mead (1956), but it can be usefully supplemented by Mayer (1956). Valuable essays on the leading Protestant denominations are to be found in Ferm (1953). Four of the most useful histories and general analyses of the religious situation in the United States are Latourette (1941), Sperry (1946), Stokes (1950), and Sweet (1950).

19. The following is an alphabetical listing of the denominational groups and their component religious bodies. It should be noted again that many bodies that would have been included within these groups do not appear because of the unavailability of statistical data.

Adventist Bodies: Seventh Day Adventists, Advent Christian Church, Life and Advent Union

Assemblies of God

Baptist Bodies: American Baptist Convention, Southern Baptist Convention, Baptist General Conference of America, Christian Unity Baptist Association, North American Baptist General Conference, Seventh Day Baptist General Conference, United Baptists

Brethren: Church of the Brethren, Brethren Church (Ashland, Ohio), Brethren Church (Progressive), Church of God (New Dunkards), Plymouth Brethren, Brethren in Christ

Churches of God: Church of God (Cleveland, Tenn.), Church of God (Anderson, Ind.), Church of God in Christ

Congregational Christian Churches

Disciples of Christ, International Convention

Evangelical and Reformed Church

Evangelical United Brethren Church

Friends: Religious Society of Friends (Conservative), Religious Society of Friends (General Conference), Five Year Meeting of Friends, Religious Society of Friends (Philadelphia and Vicinity), Central Yearly Meeting of Friends, Oregon Yearly Meeting of Friends Church, Pacific Yearly Meeting of Friends

Jewish Congregations

Latter-day Saints: Church of Jesus Christ of Latter-day Saints, Reorganized Church of Jesus Christ of Latter-day Saints, Church of Jesus Christ (Bickertonites), Church of Jesus Christ (Cutlerites)

Lutheran Bodies: American Lutheran Church, Augustana Evangelical Lutheran Church, Evangelical Lutheran Church, Lutheran Church–Missouri Synod, Evangelical Lutheran Joint Synod of Wisconsin and Other States, United Lutheran Church in America, United Evangelical Lutheran Church, Slovak Evangelical Lutheran Church, Evangelical Lutheran Church in America (Eilsen Synod), Finnish Apostolic Lutheran Church of America, Finnish Evangelical Lutheran Church (Suomi Synod)

Mennonite Bodies: Conference of the Evangelical Mennonite Church, Conservative Mennonite Conference, Hutterian Brethren, Mennonite Brethren Church of North America, Mennonite Church, Old Order Amish Mennonite Church, Old Order (Wisler) Mennonite Church, Reformed Mennonite Church, Stauffer Mennonite Church

Methodist Bodies: Methodist Church, Free Methodist Church of North America, Holiness Methodist Church, Lumber River Annual Conference of the Holiness Methodist Church, Primitive Methodist Church, U.S.A., Reformed Zion Union Apostolic Church, Wesleyan Methodist Church of America

Moravian Bodies: Bohemian and Moravian Brethren, Moravian Church in America

Presbyterian Bodies: Presbyterian Church in the U.S., Presbyterian Church in the U.S.A., United Presbyterian Church of North America, Associated Presbyterian Church of N.A., Cumberland Presbyterian Church

Protestant Episcopal Church

Reformed Bodies: Christian Reformed Church, Reformed Church in America

Roman Catholic Church

Unitarian-Universalist Church: Unitarian Churches, Universalist Church of America

20. During the early stages of this study, serious consideration was given to the possibility of extending the study area northward to include Canada and its excellent census statistics on religious preference. This idea was discarded because of the problems caused by the different dates of the American and Canadian statistics, the completely different methods

used in defining religious affiliation and gathering data, and the lack of identity, in some instances, between denominations separated by the international boundary. The reader may, however, find it worthwhile to examine the maps of the six leading Canadian denominations (Roman Catholic, Anglican, Baptist, United Church of Canada, Presbyterian, and Lutheran) appearing in the *Atlas of Canada* (Canada 1957) alongside those accompanying this study. There is much less to be gained by comparing the religious patterns of the United States and Mexico, since the latter's 1950 census indicates that more than 98 percent of the population adheres to the Catholic faith.

21. A classification based on theological orientation, such as the eleven categories utilized by Mayer (1956), was briefly considered and abandoned.

22. Paullin and Wright (1932: 49–51, Plates 82–88).

23. U.S. Census Office (1898: Plates 34–40). Additional maps and graphs, of less general utility, appear in U.S. Census Office (1874), in which Plate 31 contains a series of graphs showing "Ratio of Church Accommodations to the Total Population over 10 Years of Age" by state and territory for the eleven leading denominations, and U.S. Bureau of the Census (1914), in which Plates 479–492 contain graphs and maps showing the characteristics and distribution, by state, of the major denominations in 1906. Maps of the Roman Catholic population in the Atlantic Seaboard states in 1790, 1820, 1860, 1890, 1920, and 1950 appear in Hauk (1958).

24. The cube offers two major advantages as compared to the rather more popular sphere. Its drafting is much less difficult, and its mensurability, whether casually by eye or precisely by means of a rule, is considerably greater.

25. In some of the more congested maps, particularly the Baptist and Methodist, a number of smaller symbols have been omitted from extremely crowded areas where their inclusion would have seriously impaired legibility without adding much useful information.

26. If we ignore the substantial influx of Negro slaves into the United States, it is only because this movement had little, if any, direct impact upon the religious scene during the earlier periods of American history and because the limitations of our statistical source oblige us to bypass almost completely the topic of Afro-American religious affiliation.

27. Paullin and Wright (1932: 50).

28. Latourette (1941: 177) places church membership at 5.0 percent of total population in 1790 and 6.9 percent in 1800, but without citing any authority. These figures seem unacceptably low, even allowing for a great dropping off in church membership during the Revolutionary period. If we apply the current average of about 387 members per church, a not unreasonable figure for the colonial period, to the admittedly incomplete total of 3,228 churches counted by Paullin and Wright for 1775–76, we obtain 1,249,000 church members or some 48.6 percent of the estimated total population of that time. A progressive rise in church membership during the past hundred years is plausible. Latourette estimates that some 15.5 percent of the American population were church members in 1850. Census data indicate a gradual rise in this index, from 32.7 to 43.6 percent between 1890 and 1936. The latest available figure on total church membership is 109,557,741 for 1958 (1960 edition of *Yearbook of American Churches*), or 63.0 percent of the total population. It is only fair to state that many observers of the current religious scene do not equate this boom in church membership with a genuine revival of religious fervor.

29. Hauk (1958: 34).

30. The bulletins in National Council of Churches (1956–58: Series C) contain maps showing "Reported Church Membership of Major Faiths as Percent of Total Population" by county for each state.

31. In actuality, there are a small number of Jews, almost certainly well below 1 percent of the national total, who reside in rural counties, principally as rural non-farm persons, but are unreported, largely because there is no organized congregation in the vicinity.

32. The high incidence of urban residence indicated for the Moravians is a statistical fluke. Most of the members of this small group happen to dwell in the outer, strictly rural sections of five SMA's.

33. The relatively small number of denominations with significant contingents in the Southern states may, in part, reflect the less advanced condition of the Southern economy; but it is also the result of defects in the data collected by the National Council of Churches and of the general weakness of migratory movement into the region.

34. Two of these more restricted groups, the Disciples of Christ and the Latter-day Saints, are missing in only three and five states, respectively.

35. This index is defined and discussed in McCarty, Hook, and Knos (1956: 30–31).

36. A series of manuscript maps was prepared in the course of this study showing the ranking of the leading denominational groups by county. Only the Methodist map displayed sufficient divergence from the patterns discernible in the maps of absolute membership to merit reproduction.

37. For example, the unexpectedly large Catholic group in Onslow county, N.C., is explained by the presence there of Camp Lejeune.

38. Our immigration and census statistics, which classify arrivals by nation of origin rather than by cultural group or religion, make it difficult to estimate the religious composition of immigrant groups except in the roughest terms.

39. Paullin and Wright (1932: Plate 85).

40. Or 45.1 percent of the population of the Census "Northeast," i.e., New England and the Middle Atlantic States, according to *Current Population Reports.*

41. Latourette (1941: 233).

42. Latourette (1941: 203–214); Sperry (1946: 112–113).

43. For a map of Indian missions in the United States, see Dennis, Beach, and Fahs (1911: Plate 18).

44. Actually there is no solid proof for the notion that persons who have risen on the social ladder have deserted other denominations for the Protestant Episcopal Church. It is simply part of the folklore of American sociology. On the other hand, it is hardly credible that the numerous well-to-do Episcopalians inhabiting the better residential sections of the nation should all be lineal descendants of members of the colonial Church of England or of more recent Anglican immigrants. For a concise survey of what is known of the sociology of religion in the United States, see Bogue (1959).

45. Thereby cancelling, in good part, the rather close identification between Presbyterianism and a Scotch-Irish origin that was valid during an earlier period.

46. For a concise, illuminating statement of church history on the American frontier, see Latourette (1941: 175–223).

47. And the Baptist contingent in neighboring New Brunswick and Nova Scotia (Clark 1960).

48. One of the identifying features of these groups is the fact that they retained the

mother tongue for church services long past the time when it was dropped as the common household language.

49. The Brethren, or German Baptist, bodies might also have been classified as native American since the current polity is so strongly American in character and origin; but their Old World connections are strong enough to confer immigrant status on the group.

50. Perhaps the most objective and penetrating account within the large Mormon literature is the work of a Catholic scholar, Thomas F. O'Dea (1957).

51. Some American Mormons have resettled in Canada. The Albertan communities are discussed in Buchanan (1931).

52. Here, for once, we can speak of differential fertility with some assurance. The vital statistics for Utah's aggregate population may be taken as a valid approximation of the Mormon situation.

53. The remarkable religious ferment in western New York during the early 1800s has been described and analyzed in an admirable historical study (Cross 1950). One of Cross's principal theses, and an idea that will bear further investigation, is that the religious malaise and inventiveness of an area settled largely by New Englanders was basically a series of variations upon the earlier New England religious syndrome.

54. Quite possibly much of this strength in the major metropolitan areas is based on recent migration from the countryside, but this is, of course, pure speculation.

55. Warkentin (1959) treats a Manitoba example.

56. This is not to deny the existence of some interesting denominational, regional, and chronological differences in American church buildings. The stylistic features of Catholic, Christian Scientist, and Jewish structures are easily recognized and widely known, as are the New England colonial, Georgian, and Greek Revival schools of church architecture. There are also other genres, such as the Southern rural black church, which, unfortunately, no scholar has studied as yet.

57. Figure 26 was drawn after studying both the maps showing absolute numbers of church members (figs. 3–24) and the manuscript maps depicting relative ranking of denominational groups. An approach to the delimitation of these areas is attempted in Trewartha (1946), Zelinsky (1951a, 1955), and Kurath (1949).

58. Kurath (1949) and Zelinsky (1951a). The northern limits of the South tend to blur west of the Mississippi, a fact indicated in a study of a rather anomalous area in central and northeastern Missouri (Crisler 1949).

59. There may be little overt difference in the behavior of most Protestant, Jews, and Catholics; but even if he is religiously indifferent, the sense of belonging to an endogamous group is usually strong for a member of any of these three major faiths, and he realizes that he may suffer serious psychological and social disabilities should he marry outside the faith.

The Historical Geography
of Season of Marriage

The analysis of marriage data offers the historical geographer and social historian both exceptional opportunities and exceptional difficulties. In many European communities, documentation of individual betrothals and weddings is available for extended periods, sometimes even for several centuries. In portions of the United States and Canada, local church and civil marriage records may precede by many years the earliest census and other forms of national record-keeping. From such materials we can learn a great deal about many topics, including migration, fertility, literacy, religiosity, changing sociocultural attitudes and behavior, and the economic and social characteristics of the couples—more, I would venture, than we can distill from records of births, baptisms, deaths, or burials. Unfortunately, the detailed data we require for such studies, even for the recent past, are not available in suitable form in centralized collections. That fact, along with the idiosyncracies of local registration systems, creates serious obstacles for anyone seeking to view marital phenomena over broad areas or long stretches of time.

This essay illustrates some of the rewards to be won by wrestling with these difficulties through an examination at a coarse areal scale (i.e., states and provinces) of such data as I have been able to assemble on the temporal patterning, the seasonality, of marriage ceremonies in the United States and Canada from 1844 to 1974. I am concerned primarily with the relative distribution of events among the twelve months of the year and, to a much lesser extent, because of data constraints, with their occurrence within the week.[1] The phenomena so described are, I submit, interesting and significant in themselves; but the results of this investigation—apparently the first explicitly geographic reconnaissance of season of marriage—suggest certain larger questions and possibilities for further research one would do well to pursue.

The incidence of weddings by day, week, or month is relatively easy to quantify and convenient to manipulate statistically. Although we lack all the data that might be desired, nonetheless every state and province in the United States and Canada has compiled month-specific, and sometimes other, information concerning marriages for periods ranging from one decade to more than a century.[2] For most of the 3,326 counties of the two nations, records of license applications and marriage ceremonies are available for public inspection.[3]

But there are problems. As already intimated, no central collection of data exists in either the United States or Canada specifying areas smaller than the state or province; for most years, coverage is incomplete even at this gross scale. The fact that marriage laws vary significantly from place to place with respect to such matters as minimum age, medical examinations, and waiting periods between license application and ceremony undoubtedly has had its impact on geographic patterns. A major consequence is the high frequency in certain places of weddings in which neither partner is a resident of the state.[4] Our variable calendar gives rise to some awkward problems. Thus whether a given month has, say, four or five Saturdays can materially affect the total number of weddings performed during that month. Finally, there are infrequent, but grave, disruptions of the normal annual cycle of events brought about by the outbreak of a major war (the Civil War, World Wars I and II) and even more decidedly by mass demobilization upon its termination.[5] Taken in their entirety, however, these several drawbacks are relatively minor annoyances and do not detract seriously from the analytical appeal of season of marriage.

At the national level, Canada has compiled and published number of marriages by month and province since 1921, while similar material, usually issued some three or more years after the fact, is forthcoming for the United States only since 1949, and then for an incomplete roster of states in most of the annual tables.[6] The primary American documents are the license applications and marriage registrations which are recorded and stored in the courthouses of our 3,066 counties (which hold a vast, untapped wealth of varied demographic data) under the diverse provisions of some fifty states and the District of Columbia.[7] The counties relay summary reports to the appropriate offices of the individual states, which, in turn, submit certain items every year to the U.S. National Center for Health Statistics.

I have managed to fill some gaps in the national compilations by correspondence with, or telephone calls to, all the state and provincial offices of vital statistics who, in every instance, transmitted whatever summary documents were extant and could be mailed. Additional materials were acquired in the Library of Congress collection of state documents and by hand-copying during visits to state offices in New Hampshire, Massachusetts, New Jersey, Delaware, Maryland, the District of Columbia, and, by proxy, in Hawaii through the good offices of Gary

Fuller and the Population Institute, East-West Center. Although I assembled a limited amount of data for selected counties and municipalities in Massachusetts and Pennsylvania, the only practical units of analysis for the entire study area proved to be the state and province.

The earliest complete year for which figures on number of marriages by month are available is 1844 (for Massachusetts); given the lag in reporting data and the problems of collection and analysis, it was not practical to carry this study past 1974. The final, necessarily incomplete data set consists of 2,262 state-years, i.e., the number of marriages (not licenses issued) solemnized in each month of a given year in a given state or province. This is approximately 30 percent of the total that would have been attainable had each jurisdiction kept and published adequate records for the entire study period. Despite the distressing gaps, which are all too visible in figures 1–3, the data set, supplemented by some cautious hops of the imagination, proved adequate for this preliminary investigation.

Unfortunately, a second set of data, one covering incidence of marriages by day of the week, was too fragmentary for serious exploitation. Only two states, New York and Wisconsin, were able to provide detailed information, i.e., number of marriages by specific date, for a significant span of time. *The Vital Statistics of the United States* began tabulating day-of-the-week data no earlier than 1960, and then only for a variable and limited number of states. I found no such material for Canada. Such numbers as I do have suggest that the shifting patterns of spatial differentials in weekly patterns for the United States should be a rewarding topic for the analyst willing to invest a good deal of effort in archival research.[8]

SEASONAL PATTERNS: CLASSIFICATION AND CHRONOLOGY

Virtually all the available annual cycles of marriages by month for states and provinces readily fall into six seasonal types on the basis of the modal or bimodal heaping of events in certain months or clusters of months. Moreover, the changing incidence of these types over time suggests an evolutionary sequence. Table 1 offers representative examples of each type. Doubtlessly, one could devise a more sophisticated typology, but the present one should suffice in an exploratory reconnaissance. In order of historical appearance or disappearance, as shown in table 2, the types are:

Type 1: In which there is a fall maximum, with the months of October, November, and December recording the greatest number of marriages. It was universal throughout the study area before the 1890s but declined from that decade onward and became extinct by the 1960s.

Type 2: In which there is a maximum number of weddings in June but quite often a secondary peaking during the autumn months. It materialized in the 1890s and has appeared frequently in all parts of the United States and Canada, remaining important to this day.[9]

Type 3: In which, once again, June experiences the maximum number of wed-

TABLE 1. *Seasonal Patterns of Marriage: Representative Examples*

Month	Monthly Values as Percent of Annual Total											
	Type 1		Type 2		Type 3		Type 4		Type 5		Type 6	
	Ky.	Mich.	Conn.	Kan.	Mass.	Pa.	N.B.	R.I.	S.C.	Cal.	Nev.	Alb.
	1852	1886	1916	1923	1955	1956	1926	1960	1964	1973	1968	1969
Jan.	6.8	7.2	7.1	6.9	5.8	5.7	4.6	5.4	7.0	5.8	6.2	3.2
Feb.	7.0	6.2	7.6	6.0	7.2	6.1	4.6	6.5	7.6	7.0	6.8	4.6
March	7.8	8.1	4.9	6.2	3.6	4.7	3.8	3.2	7.9	7.5	8.1	5.1
April	6.4	7.0	5.3	7.4	7.1	7.9	7.0	7.4	7.1	7.5	7.8	7.4
May	5.3	7.8	8.2	8.2	10.3	7.9	5.4	10.4	8.2	7.4	8.6	9.5
June	5.9	7.5	13.5	10.6	13.2	16.2	12.4	11.6	11.0	12.6	9.3	11.5
July	5.6	8.1	8.4	8.0	9.0	7.7	9.4	10.0	8.8	8.7	9.0	10.2
Aug.	7.7	7.0	7.2	9.3	7.9	8.4	10.2	8.4	9.9	10.4	10.0	15.1
Sept.	10.2	9.6	10.0	9.6	11.7	11.8	14.8	12.3	8.2	9.7	8.9	7.6
Oct.	11.4	10.4	11.4	8.9	10.6	8.6	11.1	10.3	7.6	6.6	8.0	9.0
Nov.	11.0	10.7	11.0	9.2	8.3	7.9	9.2	9.1	7.6	7.6	9.1	9.1
Dec.	14.8	10.4	5.4	9.7	5.2	7.2	7.5	5.3	9.2	9.7	8.3	7.7

dings, but the next largest number occurs in September. This type first took shape in the 1900s, attained its greatest popularity between 1920 and 1954, then subsequently became quite infrequent.

Type 4: In which September records the greatest number of marriages, while June takes second place. The type appeared in the 1910s, flourished between 1925 and 1939, but is seldom documented afterward.

Type 5: In which a bimodal pattern occurs with June in a leading position and August accounting for the second maximum. It first emerged during the period 1915–1924, then steadily climbed to the dominant position it has held since the 1950s.

Type 6: In which August is first in number of weddings, while a second maximum occurs in June. This pattern originated in the 1940s, and since 1965 it has been subordinate in frequency only to Type 5.

Before examining in detail the special careers of these six types, a few general observations are in order. On the basis of both the detailed state-year data (presented only in distilled form in the accompanying tables and graphs) and the more fragmentary data I have collected through a survey of the literature and my own archival research, it seems safe to conclude that a decisive qualitative change in marriage regimes took place between the demise of Type 1 and the advent of the later types. In the simplest terms, what we have is a shift from a general Fall–Early Winter Pattern to a general Summer Pattern. In the former, marriages

TABLE 2. *North America: Seasonal Patterns of Marriage by State or Province, 1844–1974*

Period	By Number of Years Recorded and Percent of Period Total Type[a]							
	0	*1*	*2*	*3*	*4*	*5*	*6*	*Total*
1844–1889	0	148	2	0	0	0	0	150
		98.7%	1.3%					100.0%
1890–1894	0	19	5	0	0	0	0	24
		79.2	20.8					100.0%
1895–1899	0	14	13	0	0	0	0	27
		51.9	48.1					100.0
1900–1904	0	12	19	1	0	0	0	32
		37.5	59.4	3.1				100.0
1905–1909	0	10	19	4	0	0	0	33
		30.3	57.6	12.1				100.0
1910–1914	1	7	26	3	0	0	1	38
	2.6	18.4	68.4	7.9			2.6	100.0
1915–1919	4	11	19	5	3	3	0	45
	8.9	24.4	42.2	11.1	6.7	6.7		100.0
1920–1924	4	16	26	17	6	4	0	73
	5.5	21.9	35.6	23.3	8.2	5.5		100.0
1925–1929	2	18	15	31	11	9	0	86
	2.3	20.9	17.4	36.0	12.8	10.5		100.0
1930–1934	5	33	14	23	15	12	1	103
	4.9	32.0	13.6	22.3	14.6	11.6	1.0	100.0
1935–1939	3	34	20	26	13	11	0	107
	2.8	31.8	18.7	24.3	12.1	10.3		100.0

most often occurred in a period stretching from October until early January; in the latter, the modal months range from June through September. In neither regime do we find any of the first four months of the year accounting for anything close to the 8.3 percent of the annual total to be expected in a uniform distribution, and only rarely does the value for May exceed that level.

Moreover, the weekly profile of events in places following the Summer Pattern could hardly differ more than it does from that in places observing the Fall–Early Winter Pattern. In the former, the midweek period (Tuesday through Thursday) was the most popular choice for the ceremony, while there was a decided dearth of weddings on Fridays and Saturdays. After the new monthly pattern arrived, the schedule was inverted: the great majority of weddings began to occur on the weekend (Friday through Saturday), but most especially on Saturday, while weekday ceremonies became relative rarities. At the same time, all the evidence points to a strong shift away from the older fashion of staging numerous weddings on church

TABLE 2. (*Continued*)

Period	By Number of Years Recorded and Percent of Period Total Type[a]							
	0	*1*	*2*	*3*	*4*	*5*	*6*	*Total*
1940–1944	5	24	46	18	2	12	6	113
	4.8	23.1	35.6	17.3	1.9	11.5	5.8	100.0
1945–1949	0	24	38	35	3	23	1	124
		19.4	30.6	28.2	2.4	18.5	0.8	100.0
1950–1954	3	27	49	46	17	70	8	220
	1.4	12.3	22.3	20.9	7.7	31.8	3.6	100.0
1955–1959	2	12	39	39	4	126	20	242
	0.8	5.0	16.1	16.1	1.7	52.1	8.3	100.0
1960–1964	9	3	44	34	9	157	35	291
	3.1	1.0	15.1	11.7	3.1	54.0	12.0	100.0
1965–1969	9	1	46	14	4	149	71	294
	3.1	0.3	15.6	4.8	1.4	50.7	24.1	100.0
1970–1974	2	1	27	6	3	179	51	269
	0.7	0.4	10.0	2.2	1.1	66.6	19.0	100.0
Total	49	414	467	302	90	755	194	2,271
	2.2	18.3	20.2	13.4	4.0	33.4	8.6	100.0

[a]0 = Unclassifiable
1 = Fall maximum (Oct., Nov., Dec.)
2 = June (or July) maximum, often with secondary fall maximum
3 = First maximum in June, second in September
4 = First maximum in September, second in June
5 = First maximum in June, second in August
6 = First maximum in August, second in June

and national holidays to the present-day avoidance of all such religious and secular occasions (except February 14).[10]

The nature of the transition from the earlier to the later pattern may be of much more than passing interest. A close inspection of the bulky tabulations of individual state-years (not reproduced here) reveals a surprising abruptness in the event. In almost every instance, there was little advance warning of any impending change; the traditional monthly and weekly cycle continued just as it had for so long. Then, suddenly, usually within five years or less, the new pattern took shape, completely supplanting its predecessor. Does this suggest an equally rapid social and psychological transformation?

The graphic method used in figures 1–3 to display the various seasonal patterns of marriage over time and space calls for some explanation. The time-line for each state and province is segmented into five-year periods for the sake of visual intel-

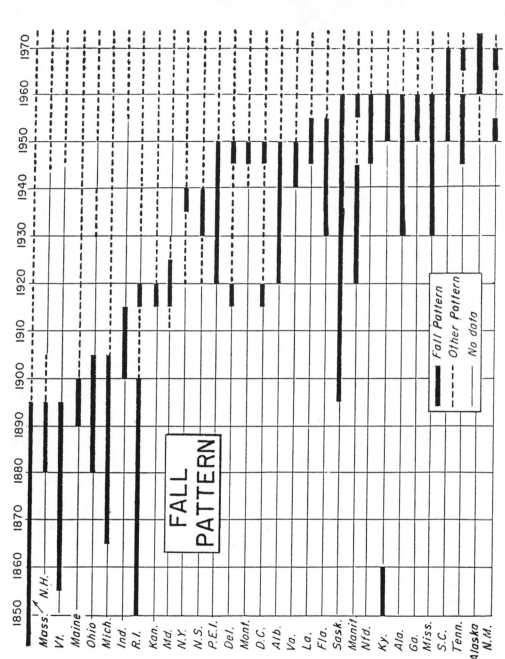

FIGURE 1 Fall—Early Winter Pattern.

ligibility. The appropriate pattern appears whenever data are available or the indicated seasonal pattern has been noted for any single year or group of years within the quinquennium.

All the available evidence for the pre-1890 period (i.e., the 1844—1889 state-years and the more localized early data I have collected) indicates that the Fall–Early Winter Pattern was then universal throughout the United States and Canada (fig. 1). Moreover, it seems to have persisted since the early Colonial era.[11] Most weddings were concentrated within the last three months of the year, and occasionally the peak season extended into early January. Thanksgiving Day, December 24, 25, 26, and 31, and January 1 were especially popular choices, along with Easter and July 4 earlier in the year. On the whole, there was a strong aversion to the summer months. Clearly this was a sensible arrangement for a society imbued with deep religious and patriotic sentiments and one still closely tied, physically or culturally, to the annual cycle of agricultural work.

Within the week, there was a decided avoidance of both Friday (an unlucky day in Christian tradition?) and Saturday. Although Sunday weddings were fairly frequent, an unpublished analysis of all Centre County, Pennsylvania, marriages from 1886 through 1974 reveals the fact that, until 1910, the weekend (i.e., Friday, Saturday, and Sunday) accounted for only 16 to 27 percent of all ceremonies in any given year.[12] The rationale for Tuesday, Wednesday, or Thursday maxima, and a fair sprinkling of Monday events, continues to perplex me, and it is grasping at straws to note that clergymen and church space were largely preempted for other purposes on Sundays, while Saturday was then a full working day for most persons and the principal shopping day for others.

Changes in the location of Type 1 (the Fall–Early Winter Pattern) over time are simple to describe. The supposition that it was the only pattern prevailing before 1890 is supported not only by the data for the earliest states appearing in figure 1 but also by its existence in the earliest years reported for the additional states and provinces entering the graph during the next thirty years, viz., Indiana, Maine, Saskatchewan, Kansas, Delaware, Maryland, Prince Edward Island, Manitoba, and Alberta. After occurrences of the Summer Pattern materialized in the Northeast, Type 1 began to lose territory quite steadily—or at least such seems to be the most likely inference from the fragmented spatial evidence at hand—until, by the 1970s, it had become virtually extinct in North America except for the isolated odd pocket of premodern society (figs. 1 and 2).[13] The regions where the Fall–Early Winter regime lasted longest are noteworthy: the Southeastern states, the Southwest, the Prairie Provinces, and the Maritimes. These are the places that have been the poorest or least developed economically, the most agrarian and least urbanized, precisely the best candidates for latter-day refuges for a premodern or early modern patterning of marriage dates.

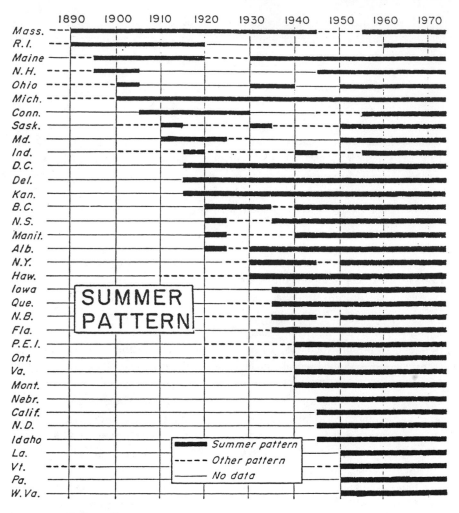

FIGURE 2 Summer Pattern.

THE SUMMER PATTERN

Taken in the aggregate, the spatial and temporal careers of Types 2 through 6, which I have grouped together as the Summer and September Patterns, were almost completely the converse of those experienced by the Fall–Early Winter Pattern (figs. 2 and 3). Simultaneously with, or very shortly after, the shift in monthly values, from fall–early winter to summer maxima, the weekly pattern was also inverted, so that Saturday became strongly dominant, while Friday and Sunday accounted for most of the remaining ceremonies. And, as noted earlier, church holidays, as well as national holidays, fell into disfavor as dates for weddings.

It is obvious enough why the summer months, as well as the weekend, should

be favored for nuptials among those living in the United States and Canada today. This is the period of extended vacations from work and school—at least in recent decades—when it is easiest to assemble friends and relatives, often from distant points, and when weather and travel are most pleasant for that well-nigh universal modern practice, the honeymoon journey.

But just why June should have become the most favored of the summer months, and why it continues to remain so at the national scale, is not at all clear.[14] Although other socioeconomically advanced countries have also transferred most weddings to the June to September period or to the Southern Hemisphere equivalents, only the Netherlands and Sweden seem to share the United States and Canadian obsession with June.[15] However the practice may have begun, it has become deeply entrenched in both fact and the popular mind, with some reinforcement from popular songs and the press. Indeed for most of those in the United States and Canada, June has become synonymous with weddings and "June-bride" virtually a common noun.

The Summer Pattern appeared initially in Rhode Island and Massachusetts in the shape of Type 2 in 1892 and 1893, respectively, and has remained there ever since in one form or another. This is precisely what one would have expected of a sociocultural trait that may be responsive to the level of modernization, for these two states were the first in the nation to become strongly urbanized and industrialized and also, one might assume, to enjoy the various concomitants of advanced status. During the next thirty years, the spread of Type 2 occurrences, insofar as we can piece together the phenomenon from the limited available evidence, either embodies or closely simulates a pattern of contagious diffusion. First, we find its extension into the remainder of New England and, shortly thereafter, into the Middle Western states of record; of course, this widening territorial range also parallels progress in socioeconomic development in the affected areas. But the fact that Florida acquired Type 2 behavior well before its less-advanced neighbors in the Southeast and the way in which the succession of Types 2, 5, and 6 in British Columbia precede their advent in the remainder of Canada suggest that other mechanisms may have been at work, possibly some form of hierarchical diffusion.[16] In any event, the Summer Pattern increased greatly in importance during the early twentieth century, and by the 1940s it was dominant everywhere except in the Southeast and, possibly, the Mountain states (the data for which are meager). As of the following decade, even these final zones of resistance had adopted the new pattern; as indicated in table 2, there were no competitors.

The August Phenomenon

Quite as baffling as the ascendancy of June is the latter-day popularity of August. Relying upon the detailed tabulations not reproduced here, we find that as early as the 1910s, August had become the second most important month in Michigan and the District of Columbia; rather quickly thereafter, Type 5, the bimodal June-August combination, emerged at other widely scattered locations across the continent. Unlike the earlier spatial career of Type 2, there is only a weak approximation here of either contagious or hierarchical diffusion. The single obvious generalization is the reluctance of the Southeastern states to accept the new pattern until quite late in the day. Beginning with the 1940s, we find that August has gained primacy as Type 6, with June providing a secondary maximum; once again, there was no single generative hearth area. The early instances were about as farflung as one could imagine: British Columbia, Iowa, Ohio, the District of Columbia, and Prince Edward Island; the further progress of Type 6 was as spatially erratic as was the case with Type 5, except, once again, for the relative impregnability of the South. No examples at all are to be found in Florida or such strongholds of the Confederacy as Tennessee, the Carolinas, Georgia, Alabama, and Mississippi. Type 6 reached its apogee in the late 1960s, when it accounted for nearly one-quarter of the reported state-years (table 2). Since then, a moderate recession has set in, the significance of which cannot be assessed for another decade or more.[17]

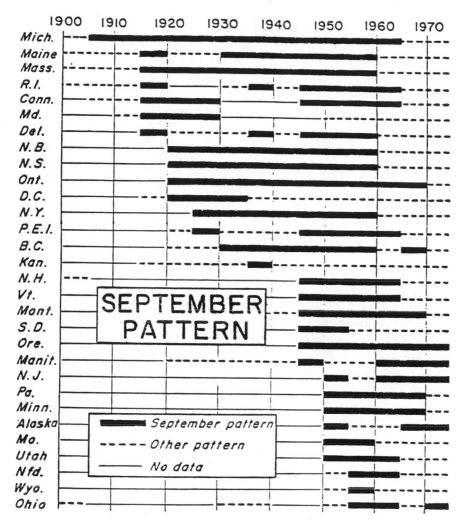

FIGURE 3 September Pattern.

The September Pattern

The earliest examples of the September Pattern materialized as Type 3, i.e., a first maximum in June and a second in September. The first occurrences are reported for Michigan during the period 1905–1914 (fig. 3 presents both Types 3 and 4). However, if pre-1921 data were forthcoming for Eastern Canada, it is quite imaginable that similar developments would be visible there during the same period or even earlier. At any rate, it is clear that by the 1920s Type 3 and its immediate successor, Type 4, in which a regnant September relegates June to second place, were regional phenomena, well entrenched in the Maritimes, Quebec, Ontario, and the northeastern quadrant of the United States. The available data pre-

clude a judgment as to whether a single locality initiated the trend or whether it emerged more or less simultaneously over an extended region.

The September Pattern remained firmly implanted in its natal region throughout its fifty-year vogue, but from 1945 onward and especially during its peak period, presumably the 1950s, instances occurred in the Middle West, the American and Canadian West, and even Alaska, everywhere, in fact, but the innovation-proof Southeast (fig. 3); it does not seem to have penetrated any further south than Missouri. Just as puzzling as its efflorescence was the fading of the September Pattern in the 1960s and its virtual extinction by the 1970s. I use the term "puzzling" after some deliberation because this pattern was unanticipated and remains unexplained. I have no published reference to the importance of September in the marital calendars of the United States and Canada. The national summaries of marriages by month afford no hint of its regional significance, and, as is probably also true in the case of the August phenomenon, it is doubtful whether inhabitants of the areas in question were ever aware of the pattern.

INTERPRETATIONS

What are we to make of the evidence presented thus far? Perhaps the most effective way to answer the question is to examine the possible explanations for the changes in the distribution of the various seasonal types.

The least satisfactory explanation is that the shifting patterns displayed in figures 1, 2, and 3 are simply random, arbitrary sociocultural choices, mere fads perhaps, unrelated to other phenomena. It is ruled out by at least a moderate degree of order or regularity evident in the dynamics of these patterns. Plainly they are the products of other processes, including the alternatives considered in the following paragraphs, which, it is important to note, are not mutually exclusive.

A second approach is to postulate changes in season of marriage as being linked to any of a number of as yet unidentified medium-level social and cultural factors having little or no connection with the more basic processes of social change. Such an explanation may well apply to the September Pattern and, less probably, to the August phenomenon, i.e., the genesis and spread of Types 5 and 6. No judgment is possible on the basis of present knowledge.

The most obvious explanatory strategy is to regard the shifting patterns of Types 2–6 as classic manifestations of the spatial diffusion of innovations. In each of the five cases, a given seasonal pattern first materialized somewhere in the Northeast, until recently the prime region for every kind of invention and innovation within the continent. It then spread outward to most or all of the study area, with varying degrees of spatial continuity or regularity. Thus it is quite possible to suppose that contagious diffusion occurred. That is, individuals may have copied, consciously or otherwise, the behavior of residents of nearby areas. In addition, it is conceivable that some form of hierarchical diffusion took place as members of the middle and lower social strata emulated the seasonal preferences

of members of an elite group, who were less constrained by distance and would have been the earliest adopters of any new social fashions. In my opinion, however, one major proviso must be added to lend plausibility to such an approach: the populations at risk must already have undergone great changes in livelihood and residential structure before they could become receptive to new marriage customs. Possibly the two processes of diffusion and "adjustment" may have been at work jointly.[18] Or one might discard the diffusion approach entirely and regard changes in season of marriage as one of the outward signs of deep structural change in society, the results of which just happen to simulate diffusion.

We must also entertain the possibility that mass communications could have played a critical role in accelerating the progress of the most basic of the changes examined here, that from the Fall–Early Winter Pattern to the Summer Pattern, by propagandizing the fashionableness of June weddings. The readership of newspapers, magazines, and books was large and important throughout our study period; during recent decades, motion pictures, phonograph records, radio, and television have become powerful purveyors of information and attitudes. If these communication media were indeed dominant factors in spreading the June gospel, then we must downgrade other social and cultural items in our attempts at explanation.

As it happens, I have been unable to discover any evidence to support such a contention. A perusal of forty-one nineteenth-century etiquette books originating or distributed within the United States and a sampling of the leading women's magazines of the period turned up only two specific discussions of the timing of weddings, both very brief, one warning against the inappropriateness of Sunday ceremonies and the other extolling the charms of June and October, but noting the unluckiness of Fridays.[19] Most of the many twentieth-century volumes on social usage that were consulted have nothing whatsoever to say about when to schedule a wedding; if the matter is mentioned at all, it takes up only a sentence or two in the most casual, nonprescriptive of tones.[20] The popularity of June and Saturday is one of those facts of life simply to be taken for granted. Although they devote scores of pages to the planning and execution of weddings in paralyzing detail, neither Emily Post nor Amy Vanderbilt, the two most influential arbiters of social correctness in recent times, have any counsel to offer on selecting the wedding date; the same must be said of our contemporary bridal magazines (*Modern Bride* and *Brides*). The necessary conclusion is that, whatever the process involved in introducing the Summer Pattern, it was probably spontaneous and unorganized, not something imposed from above by the makers and shakers of fashion. And, insofar as the mass communication media mentioned the new fashion in wedding dates, it is likely that they documented an existing reality instead of helping to generate it.

One of the more obvious explanations for the basic seasonal shift in the scheduling of marriages that was under way in at least a few states by the last decade of the past century and is now general throughout the United States and Canada

may lie in the recent pervasive commercialization of personal activities. In precisely the same fashion as can be observed for that other great rite of passage, the funeral, the management of weddings shifted from private hands to professional specialists and merchants, becoming enormously more costly in the process.[21] Given the extreme commercialization of the Christmas season and the heavy expenses for the consumer in the weeks preceding and following the holiday, prospective couples and their families could quite logically have turned to the early summer period as the one involving the least financial strain. But such microeconomic considerations are subsumed within a much broader mode of explanation: the sharp reversal in temporal patterns of marriage is but one more of the numerous visible manifestations of that profound, many-sided phenomenon we commonly call "modernization."

In my opinion, the most plausible explanation for the advent of the general Summer Pattern is that it was a delayed response to truly basic changes in the United States and Canadian society and economy, even though the immediate mechanism for its implementation may well have been some form of spatial diffusion or economic constraint. Furthermore, the basic patterns of change suggested by the accompanying graphs do correspond reasonably well to what we know of the spatiotemporal progression of modernization across the territory of the two nations.[22] While it is not yet feasible to furnish conclusive proof of a causal connection between socioeconomic change and the succession of seasonal patterns of marriage, the few publications that do deal with the topic suggest just such a relationship, explicitly or otherwise, and the statistical material that follows points toward the same judgment.[23]

The composition of the labor force is perhaps the most useful indicator of the general socioeconomic structure of United States society for which we can assemble data over any long stretch of time at the state level. In presenting the percent of workers who were nonagricultural and those engaged in nonprimary industries for those sixteen states whose first June maximum in weddings can be dated with some precision, we find that labor force composition in 1880 is a remarkably good predictor of the order in which they later experienced this event (table 3). Even the two exceptions, Delaware and New Mexico, are instructive. Evidently, the nature of the Southern and Southwestern culture systems was such that higher thresholds of nonagrarian (and urban?) activity had to be crossed before the shift to a new seasonal marriage regime could be triggered.[24] A comparison between the occupational figures for the non-Southern states (Maine, Ohio, Michigan, and Indiana) with the Southern (Virginia, Florida, Tennessee, Georgia, South Carolina, Arkansas, and Mississippi) at the time of their initiation into the Summer Pattern further substantiates this interpretation.

The same set of data yields another thought-provoking finding: as time goes on, there is a decline in the relative size of the nonprimary labor force component in the year of the first June maximum. When Rhode Island and Massachusetts reached this point, nonagricultural workers accounted for approximately 92 and

TABLE 3. *Selected States: Date of First June Maximum in Weddings and Structure of the Labor Force, 1870–1957*

State	First June Maximum	Nonagricultural Workers as Percent of All Workers 10 Years Old and Older									Workers in Nonprimary Industries[1] as Percent of All Gainful Workers			
		1870	1880	1890	1900	1910	1920	1930	1940	1950	1880	1900	1940	1950
Rhode Island	1892	84.9	89.5	91.8	93.9	95.5	97.2	97.0	98.3	98.9	88.6	93.4	98.0	98.6
Massachusetts	1893	85.9	89.9	82.3	94.1	95.6	97.0	96.9	97.9	98.5	88.8	93.4	97.4	98.1
New Hampshire	1893	59.2	65.5	72.7	76.7	82.0	86.8	88.5	91.8	94.2	65.2	76.2	91.1	93.9
Maine	1896	57.3	60.2	66.2	69.3	76.0	80.2	83.3	87.5	91.5	58.6	67.3	86.1	89.8
Ohio	1896	48.1	53.9	64.6	69.8	78.2	84.4	88.1	89.8	93.5	53.1	66.6	88.2	92.5
Michigan	1902	48.3	50.2	59.0	61.9	71.1	81.5	87.2	88.9	93.8	48.3	58.5	87.9	93.0
Indiana	1914	34.1	40.9	50.6	57.8	66.9	73.8	80.0	83.1	88.9	40.0	55.1	81.8	87.9
Delaware	1920	54.1	59.2	66.9	70.0	73.5	80.9	82.4	87.0	91.8	58.4	68.9	86.8	91.6
Virginia	1942	36.0	39.0	48.7	49.3	56.1	65.0	69.2	76.9	87.1	37.9	46.5	73.7	84.5
Florida	1943	24.7	29.2	47.6	54.7	63.4	72.1	77.7	83.8	89.0	28.5	47.8	82.0	87.3
Tennessee	1952	23.8	26.6	36.8	38.2	45.7	52.4	60.7	67.9	79.0	26.2	36.3	66.6	78.0
Georgia	1952	21.7	21.7	35.2	35.5	37.9	46.7	57.2	66.9	79.6	21.2	33.6	66.0	79.0
New Mexico	1953–57	27.2	43.6	44.6	47.1	45.6	55.7	58.7	68.6	83.0	37.0	37.7	62.4	79.3
South Carolina	1956	18.2	18.7	23.0	26.6	29.9	37.9	49.9	60.9	74.4	17.9	25.9	61.3	75.0
Arkansas	1956	17.7	14.3	23.3	25.4	30.7	36.6	42.5	50.4	66.0	14.3	24.6	49.3	65.1
Mississippi	1957	14.4	14.0	19.3	20.0	23.6	30.9	34.1	43.8	59.1	13.9	19.6	44.1	59.6

[1] Industries other than agriculture, forestry and fisheries, and mining.

Adapted, in part, from Everett S. Lee, et al., *Population Redistribution and Economic Growth, United States, 1870–1950. I. Methodological Considerations and Reference Tables*, Tables L-4 and L-5 (Philadelphia: American Philosophical Society, 1957).

85 percent of the labor force, respectively, and, by census definition, more than half of their populations had been urban since the 1840s, about a half-century earlier.[25] To take just two later adopters of Type 2, only 68 percent of Ohio's labor force and 80 percent of Virginia's were nonagricultural in the critical years (1896 and 1942), and these states achieved a 50 percent urbanization level as recently as about 1902 and 1953, respectively.

These considerations are pertinent to any theoretical discussion of the processes whereby the sociocultural core of a community enters its truly modern phase. One mode of explanation, which might be characterized as unilinear evolution, is that each community progresses along its own trajectory of socioeconomic development, more or less independently of happenings elsewhere, and that at certain junctures, common to all communities, certain consequences appear, e.g., a new temporal pattern of marriage. In order for this to be true, however, we must ignore the evidence in table 3 suggesting that the relationship between labor force structure (and, presumably, other factors) and season of marriage is not invariant. A more plausible line of reasoning is that the community, be it a state, nation, city, or whatever, is not an independent entity but only one element in a network of interrelated places and changing processes. Thus the aggregation of economic, technological, and other factors required to modernize the sociocultural core of any community varies considerably over time and may be greatly affected by the ever-changing nature of the world-system within which it exists.

This may be the opportune place to step back and see whether the preceding materials can be fitted into a larger historical and theoretical framework. Clearly when large numbers of people rather abruptly and privately reach new kinds of decisions about what may be the most important, emotion-laden rite of their lifetimes, it is reasonable to suspect some important shifts in the general psychic, cultural, and social temper of a community. I believe that the more basic changes in season of marriage observable in the United States and Canada are somehow associated with the transitions from one major period in the social and cultural history of the Western world to the next. For the purpose of this study, three such periods will suffice: a Premodern Period (absent in Euro-America); an Early Modern Period; and a Late, or Advanced, Modern Period.

The transition from a premodern, traditional society to early modern conditions, it is generally agreed, was brought about by fundamental changes in technology and economy. Gradually, but sometimes not so gradually, every aspect of agriculture, mining, manufacturing, transportation, communication, and commerce was altered profoundly with the advent of a highly complex, interactive market economy, as were patterns of politics, settlement, demography, education, medicine and other branches of science, along with much else. Included in this "much else" was some routinization of work schedules in factory and shop, new ways of perceiving and evaluating stages of the human life-cycle, and other dimensions of human time.[26] Yet, remarkably enough, despite the revolutionary

upheavals of life in the workplace and marketplace, most of those portions of the premodern cultural and social heritage that were not incompatible with the imperatives of the new economic order were untouched for many years.[27] Thus religious belief and behavior, language, folklore, the vernacular arts and crafts, and family and kinship relations remained for the most part inviolate. As far as the timing of weddings was concerned, there was as yet little reason to deviate from the practices of an older agrarian way of life—even though many, or most, persons were now residing in towns and cities and the workforce was increasingly nonagricultural. Consequently, one would expect during the Early Modern Period a continuing concentration of marriages in the traditional late autumn–early winter season, the period of greatest leisure and material plenty during the annual cycle of middle-latitude farming folk. Furthermore, one might expect a persistent preference for, or avoidance of, church-ordained holidays or fasts (and the new semi-sacred national holidays) and such days or seasons as were considered lucky or unlucky. As far as timing within the week was concerned, there was little incentive to modify traditional patterns among populations where the six- or seven-day work week was still the norm.

The present-day Advanced Modern Period differs greatly in its social and psychological characteristics from any earlier phase of human existence. With further technological advances and a remarkable expansion of economic products, we have experienced substantial growth in real income and thus a transition from an era when productivity and the escape from material deprivation were the compelling concerns to one in which consumption and leisure now occupy much, perhaps most, of our time and thoughts. Further facilitating this process has been the spread of literacy and education and a rise in personal mobility. It appears likely that the accumulation of economic and technological innovations was finally such that a critical threshold was reached and crossed (rather abruptly, I would speculate), a passage from a time of massive outward change to one of equally momentous inward social and psychological change. This meant the destruction of, or debilitating threats to, traditional attitudes and to ways of thinking and behaving in religion, family and social relations, personal value systems, literature, and the fine arts. Only the odd vestigial trace of the ancient past lingers on. For better or worse, the sociocultural core of the community has been penetrated and finally has succumbed to the new order; in their hearts and minds, men and women have been irreversibly modernized. They can only become more modern, or postmodern, through and through. Along with all the many other changes in human deportment during the Advanced Modern Period, one would expect new ways of dealing with time.[28]

When it comes to scheduling weddings, the shorter workday, the advent of the two- or three-day weekend, and the popularity of extended summer vacations for workers and students all have obvious implications. If modernization fully consummated means a falling away from traditional religious devotion, one would also anticipate a sharp drop in the frequency of weddings on church or patriotic

holidays. And, even if summer weekends would normally be peak periods for nuptials, it might prove difficult to assemble kith, kin, friends, and officiant during such spasms of mass out-migration as the long Memorial Day, Independence Day, or Labor Day weekends, when they would rather be frolicking elsewhere.

CONCLUSIONS

The presentation of a large but incomplete set of data at the state and provincial level on the distribution of seasonal regimes in marriage ceremonies within the United States and Canada and their changes during the period 1844–1974, along with the examination of other related evidence, leads to the following tentative conclusions:

1. Although the choice of the wedding date is an individual or family decision, the aggregate pattern of such decisions seems to reflect the general sociocultural and economic environment of the community at large.

2. The mass media of communication do not appear to have influenced the selection of wedding dates or changes in the pattern thereof.

3. When we map season of marriage, we can discern a certain regionalism in the distribution of the various patterns.

4. When we plot the chronology of significant changes in seasonal regimes, even more evident is a certain regularity in the spatiotemporal distribution of these changes, with innovations beginning somewhere in the Northeast and then moving outward to other parts of the continent.

5. We cannot as yet specify the means whereby changes in the temporal patterning of marriages were transmitted from place to place. Contagious diffusion or hierarchical diffusion, or some combination of the two, may have occurred, or we may be witnessing the process of adjustments to shifts in social structure that have nothing to do with the mechanisms of diffusion, but the evidence for testing any of these suppositions is not yet available.

6. The general pattern of change in season of marriage over space and time— and, most particularly, the transition from the Fall–Early Winter Pattern to the Summer Pattern—seems to parallel the presumed spatiotemporal scenario for the overall socioeconomic development of the continent, but the major shift in season of marriage (to the Summer Pattern) lags after substantial changes in technology and the economy by some years or decades.

7. When this shift did finally materialize, it happened rather abruptly, with little or no suggestion of its imminence in the statistics for the preceding years.

At least three interesting questions have been left unanswered. The significance of the September and August patterns is not at all certain; similarly, the ways in which they originated and spread are unclear. More basic is the problem of whether the most important of the changes detected in this study—that from the Fall–Early Winter Pattern to the Summer Pattern—has the same significance wherever it occurred. If its meaning is indeed constant, is this shift contempora-

neous with other social and attitudinal changes denoting entrance into the Advanced Modern Period?

If the present essay introduces some significant questions, it offers only suggestive rather than conclusive kinds of answers. This is because of its macro (state-level) scale of analysis and the woefully incomplete nature of the data set. Filling in some of the gaps in this set would be extremely difficult and time-consuming and is unlikely to be cost-effective. A more promising approach would be a shift in areal scale. But given the enormous complexity of modernization, not to mention the difficulty of just defining the phenomenon adequately, it would be naive to expect too much of any single dependent variable, such as season of marriage, in our efforts to describe its historical geography or to develop explanations.[29] Nevertheless we may have here a useful device that, in combination with other measures, can suggest new questions and new strategies.

In any event, much more could be learned about the significance of season of marriage through intense analysis of data from a carefully chosen, manageable sample of counties and municipalities. In addition to the store of precise information on day and month of marriage and the attributes of the marriage partners, there are many possible sources of information about the community that might be gathered from local libraries, archives, and informants, as well as from early census schedules and other standard documents that yield data on social and economic topics. Among other strategies, one might infer the extent and date of changes in a community's sociocultural personality through a content analysis of its newspapers over time and by studying its electoral patterns, religious activities, the choice of periodicals and membership in national and regional special-interest groups, and the history of local social, fraternal, recreational, and other organizations. Such an effort might also identify other quantifiable indices that could be combined with season of marriage to plot basic sociocultural change with some exactitude in both time and space. Few research programs could be more enticing for the historical geographer and demographer.

COMMENT

As someone whose batting average with refereed journals leaves little to be desired, it ill behooves me to complain about the publication history of this particular essay. Nevertheless I must admit to some bewilderment. As it happened, I submitted the manuscript to every scholarly journal that might have provided a congenial resting place, only to collect an unbroken series of rejections. Consequently, an in-house mimeographed production and obscure isolation followed. I remain baffled almost to the point of whining. Of all the pieces in this collection, this one inhabits the warmest corner of my heart. A case of love being blind? Or have I broached a new topic too far ahead of its time? Comments from readers would be most welcome.

Working Paper No. 1984-15, Pennsylvania State University's Population Issues Research Center, 1984

NOTES

This study was supported by grants from Pennsylvania State University's Central Fund for Research.

1. Marriage is remarkable for its intense periodicity. Although there are temporal cycles in birth, death, illness, migration, employment, and divorce, in none of these can we detect such great swings in frequency from month to month and among the days of the week as is routinely found in the incidence of weddings. For example, during the period 1749–1795 the month of October accounted on the average for 18.1 percent of the annual total of marriages performed in Sweden and Finland, while only 2.9 percent occurred in August (Swedish Statistical Office 1861: 16).

2. The definitive account is Plateris (1973).

3. The more common questions appearing on license applications concern age, race, place of residence, birthplace, occupation, and identity of parents.

4. Fortunately for the purpose of this study, the overwhelming majority of interstate wedding trips involve adjacent states. Of the 1,791,452 brides in 1974 within the forty-one-state Marriage Registration Area of the United States, 10.0 percent married in a state other than their own. The minimum incidence of nonresident brides was 2.8 percent in Ohio, followed by 4.3 in both Michigan and Pennsylvania; the maximum values were an astonishing 44.9 percent in South Carolina and 45.2 in South Dakota (National Center for Health Statistics 1977, 3: 1-47–1-51). The data on interstate movements in these annual tabulations simply cry out for exploitation by an imaginative geographer.

5. Much less certain is the impact of severe economic depression on the seasonal distribution of weddings (Kirk 1960).

6. Data on marriages by state and month and other characteristics with variable degrees of detail and completeness appear annually in the National Center for Health Statistics' *Vital Statistics of the United States* and from 1949 onward in its *Monthly Vital Statistics Report.*

7. The single most comprehensive collection of such documents, and one accessible to qualified investigators, is that of the Genealogical Society of Utah (Bean 1980). To the best of my knowledge, the only state to have attempted the consolidation of its county marriage records in a central repository is New Hampshire.

8. Explicit treatments of weekly patterns are rare indeed: Duchesne (1975), Sardon (1979). I have also been fortunate enough to obtain special tabulations of marriages by day of the week for four Swedish parishes during the period 1818–1894 from the Demographic Data Base, Umeå-Haparanda, Sweden, thanks to Jan Sundin, Research Leader. All this material supports the contention that weekly patterns, like the seasonal, are somehow related to stage of socioeconomic development; but they also reveal considerable local deviation from the fundamental weekly profile of events. Sardon admits his bafflement with the continuing popularity of Tuesdays through the thick and thin of revolution and restoration and invokes the possibility of undisclosed local factors. There may be more logic than whimsy in the suggestion that, in Brittany of yore, "it was always on a Tuesday that wed-

dings took place" because the ceremony was followed by three days of feasting and a re-cuperative weekend (Hélias 1978: 274).

9. Quebec, which I have assigned to Types 2, 5, and 6 in certain years, is the only state or province with a tradition of July maxima. I can offer no explanation for this singularity. One must be skeptical of the half-serious suggestion furnished by some Quebeckers that July is the only month mild enough for weddings and honeymoons in light of the fact that the province has reported September maxima on a number of occasions.

10. Recent data suggest certain avoidances which may be quite venerable: April 1 (April Fool's Day) and Friday the 13th, except on those occasions when it falls in June.

11. Kelly (1977), Rutman, Wetherell, and Rutman (1980). The same basic seasonal pattern has been documented through analysis of early European records (Bradley 1970; Bourgeois 1946; Ogden 1973; Houdaille 1976; Dupaquier 1977). It is highly probable that, if and when sufficient archival materials are pieced together, we will detect a much greater range in place-to-place variability in weekly and monthly patterns of marriages in early Europe and North America than prevails for modernized communities. Such a conclusion is strongly suggested by Bourgeois (1946), Houdaille (1978), and Edwards (1977).

12. A general discussion appears in Zelinsky (1978).

13. As is certainly the case in the 1970s for the much-studied Amish. "The Lancaster Amish marriages tend to be concentrated around November. . . . Of the daughters, 58 were married in November, eight in December and two in other months. For the mothers the numbers were 42, 16 and four respectively" (Ericksen et al. 1979: 263).

14. The notion that the ending of the school year helped precipitate a rash of June wed-dings has little factual basis. In the 1890s and early years of this century, relatively few young people completed high school, and only a tiny minority even thought of college matricu-lation. The June phenomenon is discussed, but not explained, in Metropolitan Life Insur-ance (1950). "June replaced autumn as early as 1892 in Philadelphia; 1893 in New York City and Massachusetts; 1898 in Pittsburgh and Maine; 1899 in New Hampshire; 1900 in Con-necticut; and 1902 in Rhode Island, Michigan, and Ohio. Similar changes occurred shortly thereafter in Seattle, Wisconsin, Indiana, New Jersey, Kansas, and in many other sections of the country" (Jacobson 1959: 38, fn. 4). The claim that "June has been rightly chosen as a favorite month for weddings" because of optimal temperatures strikes one as naïve in light of the historical evidence (Huntington 1938: 13, fn. 2).

15. The most recent international conspectus on month of marriage is United Nations (1969: 482–497).

16. It is especially regrettable that we lack early data for California. Given the state's precocious development, one may speculate that it acquired the Summer Pattern some time before the Mountain or Plains states.

17. Casual inspection of the post-1974 figures indicates no important shift of seasonal pattern at the national level. For 1982, the monthly distribution, as indicated in preliminary form by various issues of the *Monthly Vital Statistics Reports*, is as follows:

January	5.3%	May	9.6%	September	9.5%
February	5.6%	June	11.6%	October	9.0%
March	6.6%	July	10.0%	November	7.2%
April	7.7%	August	10.1%	December	8.0%

A long-term development that may bear watching is the slow but relatively steady rise in the popularity of May. Are we extending our definition of summer?

18. The idea that outward change in social behavior may be brought about through adjustment to deep-seated shifts in the socioeconomic structure of a community or to the operation of that structure has been advanced by Carlsson's (1966) provocative notion of an adjustment process as an alternative to any form of Hägerstrandian diffusion. It appears to me, however, that one need not regard the two processes as being diametrically opposed; in some cases they could very well function in complementary fashion.

19. Hervey (1852: 1–15), Sherwood (1884: 89–91).

20. For example, Kingsland (1901: 214), White (1901: 270), Roberts (1913: 128–129), Thornborough (1923: 178–179), Hathaway (1928: 103).

21. For a detailed discussion of the secularization and commercialization of death, funerals, and cemeteries in the United States, see Farrell (1980).

22. We lack a detailed account of the historical geography of modernization in North America, but Brown (1976) provides a useful historical introduction.

23. Carter and Sutton (1959) deals briefly with four large sections of the country during the years 1950–1957 using such an explanation, as does Jacobson (1959: 38). The most detailed spatiotemporal discussions of marital seasonality exploit British materials and imply the same mode of explanation (see Beveridge 1936, and, of particular interest, Thomas 1924).

24. Perhaps the most methodical discussion of the role of folklore, sociology, religion, and regionalism in the genesis of seasonal patterns of marriage is Bourgeois (1946), an essay that presents some intriguing maps and graphs. The impact of regional cultures, folklore, religion, economic practices, and other cultural items upon the timing of weddings, over and above the possible role of modernization, is a subject that has not yet received the monographic treatment it merits.

25. Apparently even the largest cities of nineteenth-century United States adhered to the traditional fall maximum long after its economic rationale had vanished (Jacobson 1959: 38).

26. For perceptive discussions of the altered meaning of time in terms of our daily and lifetime regimens, see Mumford (1967: 264–267) and Ariès (1962).

27. This thesis is persuasively set forth in Caldwell (1981).

28. Relevant but not crucial to this discussion is the notion that we habitually perceive different periods of time differently in terms of pleasantness, or its reverse, and their appropriateness for certain activities, as well as other attributes, just as we do with places. Thus, figuratively speaking, each of us wears a mental calendar inside his or her head in a manner analogous to that mysterious entity we call a mental or cognitive map (Gould and White 1974; Downs 1981). No one would seriously argue that Fridays feel like Mondays or that Sundays resemble Wednesdays too closely. Similarly, each month or holiday has its own distinct, if hard to specify, flavor, one that, consciously or otherwise, affects our choice of wedding dates. One can argue that there is, for example, an elusive but real quality that might be termed "Juneness," so that, psychologically, June 1 is more akin to June 30 than it is to May 31. Moreover, these perceptions, these sets of temporal discriminations, vary from community to community and, over time, within the same social group.

29. If season of marriage does prove to have some value as an indicator of the timing of

the attainment of a certain level of modernization, it would claim one special virtue. Unlike any of the other standard measures of modernization, which can be a cause as well as an effect of the phenomenon, not even by the wildest stretch of the imagination can one conceive of any way in which season of marriage might influence modernization's onset or progress.

Landscape

The Pennsylvania Town

We know surprisingly little about the form and appearance of the vast majority of the cities and towns of North America. We know even less about the meaning of these phenomena in the cultural scheme of things. Although each of our major metropolises has generated its own iconography and body of writings—some of them quite masterly[1]—and although a corps of cultural geographers, distinctly rural in their leanings, have told us much about the look of the American countryside,[2] systematic knowledge of the morphology of what lies between, some several thousand smaller cities and towns, remains exceedingly scrappy.[3] But what we strongly suspect, or rather feel, and what is persistently expressed as a vigorous undercurrent in much of our best fiction and social science reportage on the American scene[4] is intimate interaction between "townscape"[5] and the cultural personality of the community, the contention that material fact both reflects and influences cultural behavior.[6]

This is a report of an exploration of a crucially important, but dimly recognized, segment of the American settlement network, those places lying within or adjacent to the Pennsylvania Culture Area (hereafter the PCA to save space and minimize confusion with the Commonwealth of Pennsylvania). It is based on the twin premises that, of all the works of man, the dense, complex, totally artificial creation we call the town or city is probably the most profusely charged with cultural signals and that major clues to regional or national cultural identity can be extracted from groups of agglomerated settlements. The results of the investigation do nothing to undermine these suppositions, but they raise some perplexing questions concerning procedural and epistemological matters and concerning the role of this particular culture area in the historical evolution of the Atlantic community and the postcolonial United States.

This enterprise was ignited by my first exposure to the region, and my curiosity about, and abiding passion for, its landscapes kindled then have never dwindled.[7] During field reconnaissance in southeastern Pennsylvania and Piedmont Maryland in 1949 and 1950, I was struck by the distinctiveness of both rural and urban settlement features;[8] but the opportunity for systematic data gathering came only between 1965 and 1971. These field data have been augmented by more casual impressions within and outside the study area before, during, and after that period.

In the early stages of the project, much time and mileage were consumed in fixing approximate limits for the study area and in deciding just which phenomena were to be noted, and just how. After several decreasingly false starts in Pennsylvania and adjacent states, a standard checklist of traits was adopted, along with techniques for observing and recording them. Thereafter this standardized procedure was followed for all qualified places encountered in a series of zigzag traverses within and around the boundaries of the study area.

In essence, the following features were noted or questions asked in each place: the form and functions of its central square, if any; the presence and frequency of certain house types; the incidence of brick, stone, and stucco as building materials; how many of the brick buildings are painted; how close together adjacent structures happen to be; what percentage of the buildings are set how far back from the street or sidewalk; to what degree residential and other functions are areally intermingled; the occurrence and population of shade trees in the most central section; the presence of brick sidewalks; whether any church buildings occupy central locations; the presence and characteristics of alleys; the street-naming systems and the names of the principal thoroughfares; and a summary impression as to the degree of "Pennsylvanianness" of the place.

As it developed, very little of this information, except street names, could be extracted from documentary sources, such as maps, drawings, aerial photographs, verbal accounts, and census or other governmental statistics, for most of the places in question.[9] Consequently, the only recourse was to field observation. The entire study area was crisscrossed many times along both major and minor highways, following routes laid out in order to sample, in a representative if nonrigorous fashion, all sections of the study area, with special attention to its edges. Along each of these routes, all places meeting certain criteria were methodically observed during daylight hours. Because the "Pennsylvania Town," as subsequently defined in this essay, is time bound as well as space bound, almost all places of recent (approximately post-1860s) origin were ignored. The result was the elimination of virtually all mining and heavy industrial towns and of various recreational and educational centers, and the retention of a group of towns (a total of 234, the locations of which are indicated in figure 1) whose original, and usually current, functions were commercial, transportational, and political, perhaps along with some agricultural processing and other light manufacturing.

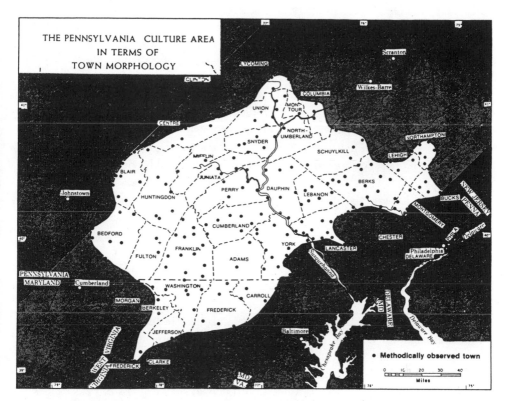

FIGURE 1 The Pennsylvania Culture Area in terms of town morphology.

No upward size limit was necessary, so that such major centers as Harrisburg, York, and Reading were covered; but setting a lower cutoff point proved to be an interesting definitional challenge. It seemed fruitless to include the tiny, almost ubiquitous crossroads hamlet. On the other hand, legal status was hardly an adequate criterion, since many places of interest remained unincorporated as villages, boroughs, or cities. After some dalliance with other measures, one characteristic was deemed the most convenient indicator of at least incipient urbanism. If a public sidewalk existed, whether concrete, brick, stone, or wood, and however decrepit, one which connected two or more structures, the place was included, while sidewalkless settlements were bypassed.

Within each of the places studied, methodical note-taking was limited to whatever section had been formed before about 1870, such dating being largely dependent on architectural style. In many instances such a delineation embraced the entirety of the settlement, in others just the more central business and residential zone. The rationale behind this restriction is that post-1870 construction tends to reflect a series of increasingly standardized national architectural traditions and speaks more of era than of place or any distinctive regional culture.[10] Observations were made on foot and through the windows of a slowly cruising automobile.

Some preliminary trials at coding all structures and other features in a given locality quickly proved futile, given the brevity of a single working lifetime. Even a simple count of things poses problems, as I realized after many tallies of centrally located shade trees. In the course of events I adopted an uncomfortable compromise, one that leaned more toward expedience and the necessity of canvasing selected items over a large territory within a reasonable period rather than toward definitive analyses of all potentially informative aspects of the study area. Thus in some cases the simple presence or absence of a given feature could be noted and street and alley names could be jotted down readily enough where signs were posted; but for most items a subjective cardinal scale was used, adopting such verbal markers as: None, Some, Many, Most, All, and sometimes wordless intermediate grades. In addition to noting the occurrence of things, a composite judgment was passed on each locality: the impressionistic response to the query "How Pennsylvanian is this place?" along a four-point scale, from "totally non-Pennsylvanian" to "totally Pennsylvanian." The scoring was not a matter of adding up individual quantifiable characteristics but rather a conscientious sensing of the entire *gestalt* or visual display, the town "ambience" of a settlement.

I freely concede the likelihood of faulty judgment in individual cases, when something more difficult than copying names or a yes/no answer was called for, and the possibility that scores for particular features might have been influenced by season, time of day, weather, fatigue, and mood. In the aggregate, however, such errors were probably distributed randomly by area or class of place, since the 234 places were approached at so many different times and directions via so many itineraries.

I have dwelt at some length on field methods not to bid for the reader's compassion but to state a fundamental dilemma for cultural geographers. If we wish not to confine ourselves to analyzing single traits or narrowly circumscribed questions or to exhaustive inventorying of a quite restricted territory but aspire instead, as I believe we must, to probing complex bundles of phenomena that extend over large tracts and periods, then there is as yet no way to approach such phenomena in an objective, rigorous fashion within the limits of available time, manpower, and techniques (including even infinitely robust mathematical methods), and there may never be.[11] It is frustrating to have to rely on skimming and sampling and, with the blessings of the gods, on certain intuitive thrusts. Although the fieldwork reported here could be replicated by others, it would be difficult to do so. Sharing or delegating the observational methods I have devised is not a simple chore.

THE PENNSYLVANIA TOWN DESCRIBED

Field investigation strongly confirmed my initial belief that that reasonably contiguous or clustered set of places qualifying as Pennsylvania Towns differs substantially in its key physical attributes from any other regional settlement type in

TABLE 1. *Population Density of Incorporated Urban Places with 1,000 to 249,999 Inhabitants in the Pennsylvania Culture Area, Adjacent States, and Other Selected States, 1960*[a]

Area	1,000–2,499		2,500–4,999		5,000–9,999		10,000–24,999		25,000–49,999		50,000–249,999		All Places	
	No.	Density	No.	Density	No.	Density	No.	Density	No.	Density	No.	Density	No.	Density
Pennsylvania Culture Area	103	1,850	41	3,061	27	3,987	11	4,093	3	6,678	7	7,366	192	4,172
Adjacent areas														
Residual														
Pennsylvania[b]	254	1,477	118	2,050	111	2,691	79	3,742	20	2,426	10	5,601	592	2,832
Delaware	13	2,093	5	2,383	3	4,072	1	1,966	0	0	1	7,680	23	4,061
Maryland[b]	46	1,649	19	2,011	12	3,853	20	4,362	5	5,010	4	5,976	106	3,871
New York	225	991	115	1,777	82	3,000	79	4,172	22	5,622	16	5,700	539	3,277
West Virginia[b]	99	1,878	27	2,761	14	3,331	8	4,674	4	3,018	2	4,953	154	3,001
New Jersey	73	1,034	82	1,230	79	2,119	78	3,501	33	2,982	14	7,584	359	2,974
Ohio	207	1,263	104	1,314	80	1,493	74	2,849	22	4,624	11	5,298	498	2,465
Virginia[b]	69	1,332	25	1,191	18	1,871	17	2,779	3	3,759	6	3,127	138	2,453
Other selected states														
Idaho	33	1,414	16	2,302	6	2,141	8	2,938	3	3,757	0	0	66	2,459
Florida	101	858	77	1,315	47	1,660	30	2,504	12	3,335	8	4,474	275	2,242
Tennessee	81	985	38	1,419	22	2,347	22	2,387	5	1,204	3	4,632	171	2,034
Iowa	132	1,097	42	1,554	32	2,094	11	2,159	7	3,245	6	2,522	230	2,033
New Mexico	22	767	11	904	10	1,824	7	2,020	5	2,199	1	3,457	56	1,973
Total	1,527	1,196	751	1,581	556	2,208	470	3,152	169	3,024	108	4,914	3,581	2,726

Source: Area Measurement Reports (see text note 13).

[a] Density is computed by dividing the sum of the populations reported for a given category of urban places by the sum of their land areas expressed in square miles.

[b] Excluding places falling within the Pennsylvania Culture Area.

TABLE 2. *Incidence of Selected Characteristics Observed in 234 Agglomerated Settlements in or Near the Pennsylvania Culture Area, by Date of Founding and by 1970 Population (Expressed as percentage of places in which feature was noted, or as standardized mean score on cardinal rating scale)*[a]

Date of Founding or 1970 Population and Number of Towns	Is This Place Pennsylvanian? Aggregate Judgment	Mingling of Functions	Contiguity of Buildings	No Setback from Walk	% of Diamonds	% of Alleys	Trees in Walk	% of Row Houses	Duplexes	Brick Bldgs.	Stone Bldgs.	Stucco Bldgs.	% of Brick Walks	Painted Brick Bldgs.
By Date of Founding														
1701–1756 (43)	.82	.87	.40	.62	43.0	72.7	.57	25.6	.24	.64	.14	.19	55.6	.52
1757–1786 (43)	.80	.84	.37	.63	48.8	82.0	.59	16.3	.45	.63	.18	.13	55.8	.52
1788–1804 (41)	.82	.72	.34	.62	35.4	67.7	.70	17.1	.37	.49	.14	.07	55.6	.44
1806–1830 (41)	.79	.94	.22	.61	19.5	73.1	.69	4.9	.48	.42	.10	.07	41.0	.40
1831–1884 (40)	.65	.83	.21	.43	10.0	64.3	.46	20.0	.41	.39	.04	.10	50.0	.25
Undatable (26)	.66	.97	.19	.59	2.5	52.9	.54	3.8	.37	.44	.09	.12	18.2	.39
By 1970 Population (Enumerated or Estimated)														
150–499 (46)	.75	.95	.16	.55	9.8	19.3	.68	8.7	.43	.42	.08	.07	24.4	.42
500–1,027 (47)	.68	.96	.22	.53	28.7	61.1	.58	2.1	.45	.45	.13	.13	33.3	.40
1,032–2,248 (47)	.81	.93	.28	.63	26.6	88.1	.64	23.4	.46	.49	.14	.10	57.8	.45
2,249–6,176 (47)	.81	.81	.29	.53	20.2	93.9	.52	17.0	.46	.55	.11	.13	63.6	.36
6,249–87,643 (47)	.82	.81	.46	.69	45.7	93.7	.70	27.7	.44	.68	.10	.10	61.5	.53
Total	.76	.89	.28	.58	26.3	72.6	.60	15.8	.45	.50	.11	.11	48.2	.43

Sources: Field observations by the author.

[a]Each of the following original scales has been converted to a 0 to 1.0 scale: *Is this place Pennsylvanian?*: 0 to 4 ("Non-Pennsylvanian" to "Totally Pennsylvanian"); *Mingling of functions*: 0 to 4 ("None" to "Complete"); *Contiguity of buildings*: 0 to 8 ("None contiguous" to "All contiguous"); *No setbacks from walk*: 0 to 8 ("All set back" to "None set back"); *Trees in walk*: 0 to 2 ("None" to "Many"); *Duplexes, Brick bldgs., Stone bldgs., Stucco bldgs., and Painted brick bldgs.*: 0 to 4 ("None" to "All").

North America or, for that matter, from any national types. Perhaps the most measurable peculiarity is sheer compactness or tightness. For reasons that seem to have little to do with cost or availability of land, residential and other structures are built close together, and frequently two or more free-standing structures abut each other. This tendency is carried to its logical extreme with the row house, which is more common here than anywhere else on the continent, with the possible exception of a few large contemporaneous cities, such as Baltimore, Washington, or Philadelphia. Unlike the situation in standard apartment dwellings, where the several dwelling units also share a common roof and party walls, each essentially identical unit in the rowhouse complex has its own front entrance and often a rear entrance as well.[12] Both apparent and real density of settlement in the Pennsylvania Town are increased by the frequent practice of eliminating the front yard or lawn for dwellings, or by reducing green space to vestigial proportions. (There may be gardens and other open space to the rear of the structure, or, where feasible, along one side or both sides.) In general, then, we find a strong propensity for the buildings in a thoroughly Pennsylvanian Town not only to huddle together laterally but also to press as closely as possible against the sidewalk and street, with allowance only for a small stoop and, especially in more recent instances, a front porch. Although contiguity of buildings and closeness to the street, and thus overall population density, are to some degree related to size and age of the town, as suggested by tables 1 and 2, spatial propinquity is plain to see in even the tiniest of the villages I have classified as Pennsylvanian. Furthermore, it appears in those attenuated one- or two-street villages that straggle far into the countryside. The rationale is elusive, for neither noise, nor dust, nor fumes are thereby minimized for the householder and, under American conditions, there is slight economic compulsion to hoard ground space. We must fall back on an explanation that explains everything and nothing: cultural tradition.

The fact that all size categories of the Pennsylvania Town are remarkably dense is displayed in table 1. According to the latest official data on land areas (1960) for incorporated places with 1,000 or more inhabitants,[13] those 192 places in Pennsylvania, Maryland, Virginia, and West Virginia that fall within the PCA as delimited in terms of town morphology and for which area figures are given (including a number not covered in my field survey and excluding many that were) have population densities exceeding those of comparable places in adjacent states, in selected nonadjacent states, and, most interestingly, in the residual portion of Pennsylvania.[14] Overall, the Pennsylvania Town is some 50 percent denser than other places cited in table 1; and we have little reason to expect the gap to narrow if allowances are made for interstate differences in municipal incorporation practices or boundary drawing. I hasten to add that the effect of this unusual (by North American standards) density is not congestion or clutter but urbane intimacy and lively visual variety.

If the Pennsylvania Town markedly deviates from national norms along a quantitative scale of building or population density, it differs even more radically

in a qualitative way: the thorough spatial scrambling of many urban functions. Contrary to the pattern in the archetypal American city, perhaps most ideally embodied in the late nineteenth-century Middle Western town, where strict horizontal and vertical spatial (and temporal) segregation reigns, we find nearly total anarchy in the spatial allocation of retail, residential, professional, and governmental activities in all but the largest Pennsylvania Towns. Dwellings, shops, and offices consort cheek by jowl in adjacent buildings or under the same roof, at street level or above; but, with rare exceptions, churches, cemeteries, schools, parks, and playgrounds, if any, and manufacturing and wholesale enterprises are consigned to peripheral locations. I know of no close parallel to this situation elsewhere in the nation, with the possible exception of the traditional, small, relatively diffuse New England village, where house, stable or barn, shop, church, and town offices tend to be jumbled together, but with ample elbow room in between.[15]

The concentration of persons and activity is mitigated in the Pennsylvania Town, and its charm and comfort much augmented, by numerous shade trees planted in the curbing or narrow sidewalks along the streets. Again the practice diverges strikingly from the pattern of other American cities and towns (with, once more, a marginal exception in the smaller New England villages), where shade trees are private property in strictly residential neighborhoods and in whose downtown districts trees and shrubs, along with rain shelters, benches, and public lavatories and other amenities, are almost unheard of and the only shade is furnished by parking meters and signs suspended over sidewalks. We have here another instance of cultural compulsion, for the midsummer midday scene in many a Pennsylvania Town is one of almost twilight gloom under a dense arch of maples or other trees, and the root systems of older trees can wreak havoc with pavements and waterlines. Only in the busiest blocks of the largest cities do the trees vanish because of the crush of pedestrian and vehicular traffic. The most favored species are those that combine hardiness and fast growth with thick canopies of leaves. The lovely sugar maple is found most often, but varieties of sycamore, horse chestnut, linden, catalpa, ash, locust, tulip poplar, beech, and cottonwood are also popular, and the vigorous, exotic ginkgo has been making rapid headway in recent years. Although they figure prominently in street nomenclature and are ubiquitous in the yards of peripheral neighborhoods and the nearby countryside, the elm, walnut, oak, hickory, and the various conifers are seldom seen in central sites, and fruit trees not at all.

Both the rural and urban portions of the PCA stand apart from other regions of the United States in their predilection for the use of brick (almost always red), not only in dwellings, barns,[16] commercial buildings, churches, and other structures but also in sidewalks and, occasionally, for street pavements.[17] Again, neither environmental nor economic conditions can be invoked in explanation, and we must call on a potent historical tradition, probably deriving from eighteenth-century British, Dutch, Flemish, and German sources. Two other building mate-

rials, stone and stucco, are present in at least some sections of the PCA to a degree rarely matched in other American localities; but, in general, they are subsidiary to brick and to the widely prevalent frame and other forms of wood construction. Within the towns, an appreciable percentage of the brick structures are painted periodically, presumably to help protect the surface, a rather uncommon practice outside this study area. Occasionally, white, yellow, or other paints are applied, but in most instances a rather bright brick-red pigment is used, thus reinforcing the general rufosity of the typical Pennsylvania Town.

Most of the research on the older house types of the United States has been directed to rural examples,[18] with no serious attempt to date to evolve a typology of urban structures, old or new, for the Middle Atlantic region. This would be a most useful but highly demanding project. Consequently, I was obliged to rely on general impressions in judging whether regionally distinctive house types or architectural features exist in Pennsylvania Towns, as they certainly do in the countryside. Although I have reached the point of recognizing certain motifs and am increasingly persuaded that some regional house types do indeed exist, I cannot yet specify them precisely.

In any event, one type of residential structure, or rather architectural device, in addition to row housing, seems to be strongly indigenous to this particular area: the duplex house. It is not to be confused with the single-family dwelling with two front entrances, frequently found on Pennsylvania farms, the origins of which are still tantalizingly obscure; and it is much older and more common in the Pennsylvania Town than the examples sporadically built in many American suburbs or near-suburbs elsewhere. In fact, these two-family buildings, with mirror-image halves, spanning several decades of architectural time, dominate some neighborhoods in a number of Pennsylvania Towns; and they comprise one of the better diagnostic elements in this settlement genre.

Obviously only a few aspects of the street plan can be noted by the ground observer. Fortunately, the most important of these, the basic geometry of the original plat and the actual initial street layout of pre-1815 places in Pennsylvania, have been subjected to definitive analysis by Richard Pillsbury.[19] He recognized four principal morphological types: Irregular, Linear, Rectilinear, and Linear-R, the first two designated as "nongeometric" and the latter two as "geometric." On the basis of their location and of reasonably good spatial correlations with other cultural measures, Pillsbury argues that the latter set—that is, geometric urban street patterns—constitutes a useful indicator of the PCA.[20] Although his contention has some merit, given the fact that a considerable percentage of street plans within the territory indicated as "Pennsylvanian" in figure 1 can be classified as Rectilinear and Linear-R, this index is less satisfactory than certain other phenomena, for these morphological types have been exported far westward, and probably southwestward as well, into areas that are at best only dilutely Pennsylvanian.

Two elements of a town's street plan can be studied on the ground and do

provide useful evidence as to possible affiliation with the PCA: the "diamond" and the presence and role of the alley. The diamond, as it is called locally,[21] is an open space consisting of the right-angle intersection of two streets at or near the most functionally central point of a town, along with rectangular corners cut out from the four adjoining blocks.[22] In its fully developed form it is square in shape, but frequently the diamond is elongated, and its length can be several times greater than the width. In extreme cases, a sharp look is necessary, for the notching or setback of the adjoining blocks may be only a meter or two in depth. A common variant is the half-diamond, in which indentations occur at only two of the adjacent corners.[23] More than one diamond can occur in a single town.

Pillsbury intimates that, like their European antecedents,[24] the diamond and other kinds of central squares were intended to accommodate periodic public markets and other community events and that they actually performed this function in early Pennsylvania. Whatever its purposes in the past, the diamond is now perceived "as an extension of the street space, and it is a rare town which does not allow traffic to traverse directly across the square and out the other side, with parking as its only subsidiary use."[25] Although the entire surface of the diamond may be paved, except for tree plantings, in many instances the immediate center is occupied by a flagpole, fountain, or military or other historical monument, with or without a flowerbed and patch of lawn. Although it is clear from the maps produced by Pillsbury and by Edward T. Price that the diamond has been adopted in many communities far beyond the PCA, it is equally clear that it is most abundantly represented in this area, one which appears to be its American hearth.[26] Consequently, frequent occurrence in a given territory may be taken to signify probable membership in the PCA.

Most Pennsylvania Towns have a system of alleys (in the lexical sense of "a thoroughfare through the middle of a square or block giving access to the rear of lots or buildings");[27] and, in fact, nowhere else in North America is the alley so interesting, lively, and important an element in the urban scene as it is here. The alleys frequented by inhabitants of the PCA bear little resemblance to their shabby, often dangerous counterparts in other regions, whose main functions seem to be to provide for commercial deliveries, rubbish disposal, access to garages, questionable juvenile activities, and trysting places for feral mammals. In stark contrast to their degenerate cousins in late nineteenth- and early twentieth-century towns elsewhere, the alleys of the larger, better-developed Pennsylvania Town are well paved, frequently endowed with names and some lighting, and lined with dwellings, shops, restaurants and saloons of all descriptions, offices, and small repair and manufacturing facilities. Though open to vehicular traffic, these narrow passages can be dominated by pedestrians. In many ways they are reminiscent of the mews, closes, and courts of the more fashionable sections of London, Greenwich Village, Philadelphia, and Washington. The strong emphasis on alley activities, it is almost needless to add, is another factor contributing to the exceptional density and intensity of the Pennsylvania Town.

The street names of Pennsylvania Towns proved to be interesting in their own right but of minor value in identifying or bounding the PCA. The reason is much the same as that cited for the diamond: a cultural complex—in this instance the "Philadelphia Complex" of street names—has attained such wide currency elsewhere that its local strength does not help much in demarcating the territory in question. Although an unmistakable clustering of examples is to be found in and near the early PCA, as Pillsbury has shown,[28] two other nomenclatural systems—his Traditional English and the Important Figure complexes—also compete for attention. Nevertheless, it is worth noting that the Philadelphia Complex, with its heavy emphasis on floristic terms,[29] quite aside from a large complement of numbered streets, and many a Broad, Market, and High, further heightens the aboreal theme in the Pennsylvania Town. The question of the extent to which the near-national distribution of this complex came about through the direct influence of Philadelphia and how much by way of a PCA acting as conduit and staging area may be a fruitful one for future investigation.

This, then, in essence, is the Pennsylvania Town: a dense aggregation of spatially mixed functions in regionally distinctive structures, closely spaced and often built of brick, set along a generally rectilinear lattice of arboreal streets and well-kept alleys frequently focused on a diamond-shaped central square (fig. 2). But such a stripped-down definition does not begin to do justice to the vivid reality of the individual towns.[30] In particular, the statistics gathered in this study offer scant clues to one of the most arresting characteristics of the Pennsylvania Town—almost endless variability within and among places. Although they all bear a strong familial resemblance to each other, there is exuberant diversity within the clan. Unlike the peas-in-a-pod situation in so many places in states such as Illinois, Kansas, or Georgia, where the form and substance of the next town is soporifically forecast by the last, here it is the rare building that is the twin of any neighbor, no single block can be mistaken for any other, and no town in its entirety begins to duplicate any near or distant relative. In terms of richness, even idiosyncracy, of architectural invention, as seen in building form and ornamentation of door, window, porch, cornice, eave, chimney, spire, or whatever, the only possible rivals are found in some sections of New England and New York. Another general theme, and one already hinted at, is a strong flavor of Europeanness or, more specifically, the impression that one is experiencing an eighteenth-century town in a North Sea country.

What has been attempted here is the initial description of a single regional settlement type. Two temptations have been avoided. First, I have scrupulously steered clear of the typology for villages and smaller towns so laboriously developed for Western and Central Europe over the past several decades,[31] less out of ignorance than from a conviction that it is inappropriate in a New World setting.[32] Second, after much thought, I have not tried to specify subtypes of the Pennsylvania Town in spatial, temporal, or other dimensions, for I have no persuasive evidence that they really exist.

The Diamond completed, showing the proposed new Fountain, Soldiers Monument.

New Depot.

CHAMBERSBURG, PA.

W.N.Beghtol.

If we define a region as a set of objects within a perceived segment of the space-time continuum whose within-set variability is less than that between it and other sets of similarly defined objects, then the PCA fits that description comfortably.[33] The initial step toward that conclusion involved surveying the outer limits of the presumed region. After a series of trips and careful field inspection of the marginal places, I became satisfied that the bumpily ovoid, or amoebic, boundary depicted in figure 1 encircles a territory within which the great preponderance of pre-1870 agglomerated settlements, or neighborhoods therein, can be called "Pennsylvanian," and that beyond it the diagnostic traits in question are relatively minor or scattered.[34] Like all such regional boundaries, this line is a generalization, a narrowing of what is actually a fuzzy zone of transition or a cultural gradient whose slope varies from the nearly vertical to the slightly tilted.

There is minimal ambiguity in the location of the southeastern segment of the boundary. In fact, the morphological contrasts between the two sides of a razor-sharp line in Bucks, Montgomery, and Chester counties are so great that one is led to speculate about a head-on collision between two quite different cargoes of town-building ideas, one moving northwestward from the colonial purlieus of Philadelphia, and the other southeastward from the central part of the state. As the boundary proceeds southwestward into Piedmont Maryland, it is less dramatically abrupt but still relatively easy to demarcate. The major surprise is a location in Lancaster and York counties much further inland than prior considerations led me to expect.

At the opposite side of the PCA, it was a matter of gauging degree of attenuation, how badly spent the cultural wave originating some distance to the southeast and displaying its principal vector along the strike of the Appalachians southwest into Maryland and Virginia. It is important to stress that this high-water mark, occurring as it does within the last two creases of the Ridge and Valley physiographic province, falls a bit short of the Allegheny Front and a thinly occupied plateau whose landforms, economy, and ethnic makeup contrast strongly with those of the PCA. Apparently, time, remoteness, and the relatively meager economic base of these final narrow valleys and coves served to quench most of

FIGURE 2 A characteristic Pennsylvania Town, Chambersburg, Pennsylvania, in a relatively realistic perspective drawing published in 1877. We are shown the city as it would have appeared looking down a main thoroughfare from an outlying neighborhood toward the central diamond, which is depicted in detail in the corner vignettes. Although there is a church on the diamond and the alleys are poorly developed, Chambersburg was, and is, typical in other respects: regional building types, tight clustering, mingling of functions (visible in the vignettes), the missing front lawns, much use of brick, and general arboreality. Photograph courtesy of the Tavern Restaurant, State College, Pennsylvania.

the Pennsylvanian cultural impulses before the formidable negative factors of the Allegheny Plateau could administer the coup de grâce. More troublesome is the northeastern limit of the PCA, given the complications of topography, the intrusions of latter-day mining and manufacturing enterprises in and near the anthracite region, and a general convergence of cultural currents from several directions. The location shown in figure 1 is an uneasy approximation. Finally, there is the gentle ebbing away of the PCA in the Shenandoah Valley of northern Virginia, where, as is also the case with rural aspects of this cultural complex, the momentum of forces from the hearth area has been dissipated broadly and gradually. There the boundary line can be shifted some distance either way without doing violence to reality.

If we view the PCA from neighboring regions rather than from the inside looking outward, the particularity of its town morphology is especially striking. No one who has wandered among the cities and towns of Ohio, West Virginia, or Virginia (outside the Great Valley) will mistake many of them for a Pennsylvania Town. Similarly, the urban centers, large and small, of New York and Pennsylvania's Northern Tier are cast from an utterly different mold.[35] More enigmatic is the relationship with the more or less contemporaneous settlement landscape of New Jersey. Within an interesting cluster of towns in the southwestern part of that state, we find some intimations of the Pennsylvanian Town type; but the general verdict, as derived from Peter O. Wacker's assiduous analysis,[36] is that the Garden State underwent quite separate and distinct modes of development.

Some independent evidence is at hand whereby the validity of the present approach can be confirmed or challenged: previous attempts by other students to map the PCA or some synonymous concept. This strategy has been developed by Joseph W. Glass,[37] who identified five previous efforts—Pillsbury's, based on urban street patterns; Hans Kurath's Midland speech area; my Pennsylvania German hearth area and religious area; and Henry Glassie's southeastern Pennsylvania—in addition to his own delineation based on characteristics of barns and farmsteads.[38] Glass's regionalization is especially noteworthy because it appears to be the only other one based primarily on field observations. His method was to derive a composite boundary from the five earlier items by means of a centrographic technique and then to superimpose the product on his own and evaluate the closeness of fit visually, with results he found reassuring.

This procedure has been emulated in figure 3, in which the boundary defined in terms of town morphology has been laid over the others. Although some index to degree of similarity could be computed mathematically, a less rigorous evaluation will suffice in light of the fact that the seven different regionalizations were arrived at for different purposes at different scales using different definitions, criteria, and methods. In general, the overlap of areas, or concordance of lines, is quite good. In fact, for more than half their periphery the Glass region and that proposed here are virtually identical. The sector where the discrepancy between the Pennsylvania Town and other measures is most pronounced is toward the

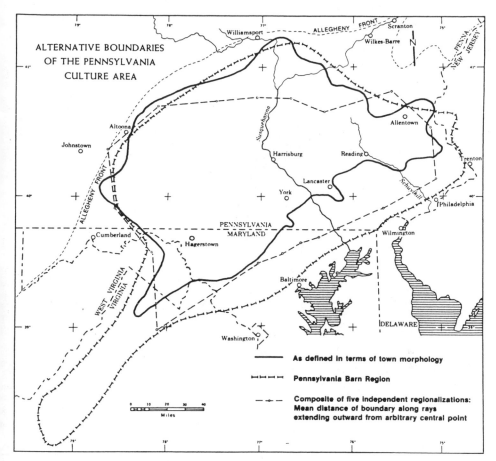

FIGURE 3 Three alternative boundaries for the Pennsylvania Culture Area. Sources: Author's field observations and Glass (1971: 81, 257).

southeast, in the Piedmont sections of Pennsylvania and Maryland. No pat answer is forthcoming as to why a countryside emphatically Pennsylvanian in terms of farm architecture, religion, language, and presumably other traits should lack the regional town type. I can only observe lamely that the various facets of a regional culture are the outcome of varied sets of processes and that it would be quite remarkable to find total spatial correspondence among them or total homogeneity within the region.

VARIETY WITHIN THE REGION

Given the character of the statistics generated in the field for several different attributes, and particularly a heavy reliance on crude cardinal scales, it would be difficult to devise and apply meaningful tests of the amount of variation within

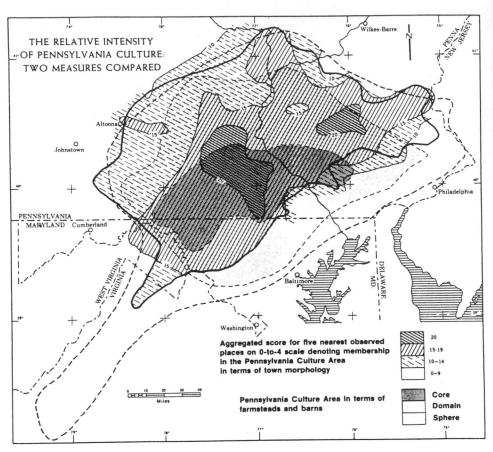

FIGURE 4 The relative intensity of Pennsylvania culture within the Pennsylvania Cultural Area as measured in terms of two sets of criteria: town morphology, and farmsteads and barns. Sources: Author's calculations derived from field observations and Glass (1971: 257).

an area that seems to be different from all others in North America or to see whether subregions can be charted. A series of trials with the various attributes yielded only one with an interesting pattern: a map of responses to the summary question, "Is this place Pennsylvanian?" As an appropriate device for coping with punctiform data, a kind of "moving areal average" was plotted; that is, the sums of scores for the five nearest methodically observed towns as tallied for a dense network of points in and near the study area, which were then converted into a series of isopleths. The resulting statistical surface (fig. 4), one with only mild undulations, tends to form a northeast-southwest cuestaform ridge that crests not far inward from the southeastern limits of the region. The climactic values, or those tracts where all nearby places are rated as thoroughly Pennsylvanian, are found in western Berks County, and a second, larger zone is centered on Cum-

berland County. The surface falls away gradually toward the north and west as the regional boundaries are approached.

The pattern just described conforms well with impressions gained in the field and reasonably well also with Glass's depiction of the core, domain, and inner tracts of the sphere of his PCA as derived from an arithmetic analysis of barn and farmstead traits recorded at regularly spaced points within a rectangular lattice (fig. 4).[39]

The systematic data on Pennsylvania Towns can be partitioned along nonspatial, as well as spatial, dimensions. This has been accomplished in table 2 using two of the most obvious variables that might be associated with town morphology: date of founding (the physical act, not just platting); and number of inhabitants. In both instances, the towns have been grouped into nearly equal quintiles (after eliminating undatable places in the former case), mean values derived for each group, and, where necessary, the score thus produced standardized to a common 0 to 1.0 scale.[40] Admittedly, neither age nor size of town is independent of location. European frontier settlement proceeded in irregular spurts along a strongly northwestward, then southwestward vector over a period of more than a century, as meticulously documented for Pennsylvania by John Florin;[41] and, *ceteris paribus*, older equals larger, so that antiquity and settlement size are correlated with linear distance from the lower Delaware. However, as Howard J. Nelson has demonstrated at the national level,[42] many important places, and lesser ones too, presumably, were established well behind the frontier zone long after it had passed onward; and this, quite demonstrably, occurred in the PCA. The 1970 population figures for the larger places refer only to the city proper; but, even so, they probably overstate the values for the neighborhoods with which we are concerned. It would have been highly desirable to add a third variable, an index of socioeconomic well-being or prosperity; but both the practical and theoretical problems of deriving a single statistic expressing this condition, not just for the present period but, more particularly, for the earlier stages of settlement, are truly formidable. The general impression in the field is that the use of brick, stone, and paint and the general level of architectural resourcefulness increase in direct proportion to a town's financial status—a not very startling observation.

An inspection of table 2 reveals an interesting series of relationships or, in some cases, lack of them. None of the diagnostic characteristics listed gains strength through time. In some the decrease is regular: contiguity of buildings, and the incidence of diamonds and brick construction. More interesting is the abrupt drop-off after about 1830 in values for building setbacks, use of trees, stone construction, painting of brick buildings, and, most of all, scores on the aggregate scale of "Pennsylvanianness." These data suggest considerable stability or standardization in town type from the period of genesis at the beginning of the eighteenth century until the rather abrupt impact of outside, presumably national, influences during the middle decades of the nineteenth century. On the other

hand, the values for mingling of functions and incidence of alleys, row houses, duplexes, stucco, and probably brick walks as well do not vary in linear fashion with date of founding.

Turning to the tabulation in terms of town size, we find the expected positive association with contiguity of buildings and incidence of row houses; but a similar relationship also exists with respect to incidence of diamonds, alleys, brick buildings, and brick walks. The occurrence of trees, duplexes, stone and stucco buildings, and painted brick buildings appears to be unrelated to town size, and, more surprisingly, that is also the case for extent of setback from the walk, except for the largest size category. Most significant of all is a weakly positive association between size and general Pennsylvanianness. One can almost venture to assert that, above a certain low threshold, the adoption of this particular morphology is independent of town size.

ORIGINS

The existence of a distinctive town morphology associated with the PCA, one that displays considerable consistency in the region but does not closely resemble parallel phenomena at the regional scale elsewhere on the continent, immediately raises questions as to origins—and persistence. Definitive answers are not available because of the paucity of both theoretical and empirical work on the evolution of lower-order urban places in the Middle Atlantic region and elsewhere.[43] But some speculation may be useful. Because of a favorable confluence of factors—strategic location, relatively well developed land and water transport, a productive agriculture, a promising, if incipient, set of manufacturing industries, and, most especially, a benign sociocultural and political climate—the processes of town founding and urbanization seem to have advanced more vigorously in eighteenth-century southeastern and central Pennsylvania and adjacent Piedmont Maryland than over any other extended tract in British North America.[44] Thus by the end of the century a dense, interconnected, interactive swarm of urban centers had appeared. Why similar networks failed to materialize by then in the American South or in Canada or were relatively embryonic in New England and New York is another provocative question.

It would seem quite natural for the town builders of the PCA, a varied crew ethnically and otherwise, to adopt the newer notions of architectural and town design that had been blooming vigorously in Great Britain and other northwestern European lands since the late seventeenth century during an unprecedented burst of commercial and industrial growth. What probably happened, however, was not direct imitation of any single model but rather a distillation of influences from several sources and models: a generalized, idealized recombination of the modish elements of current styles from throughout the European source region. What I am postulating is a close parallel to the standardized minting of the colo-

nial Spanish American city from disparate Iberian sources[45] or the creation of the New England village, a pseudo-archaic novelty in the New World crystallized from varied lingering provincial traditions in rural England.[46] Incidentally, much the same sort of development—the reconstitution of basic Ur-European motifs—seems to account for the genesis of vernacular house types and farm buildings in the early United States and Canada.

This process of copying imported contemporary models certainly took place outside the PCA, most crucially, of course, in Philadelphia, but also in Chester and Stroudsburg, Pennsylvania; Wilmington and New Castle, Delaware; Albany; Boston; Baltimore; Annapolis; Trenton; Washington; Georgetown; Alexandria and Fredericksburg, Virginia; Manhattan and Brooklyn in New York; and even as far afield as Cincinnati and St. Louis. But these were all isolated cases. Only in the PCA can we find that critical mass, an implosion of closely spaced communities which was substantial enough to generate its own stubborn, self-perpetuating regional style. In essence, what was elsewhere, even in Europe, largely a transitory phase became here a durable norm: time translated into space, period into region. The result has not been a fossilized townscape. The PCA has had its share of varied urban preservationist activities, but without achieving any Williamsburgs or Sturbridge Villages. These town live congenially and, for the most part, quite unselfconsciously with their pasts, unmolested by tourists, constantly evolving, but along conservative tracks mandated many decades ago. Regardless of what happens in their suburbs and exurbs or along the garish highway strips, these Pennsylvania Towns are in little danger of quickly surrendering their lively individuality.

OTHER UNANSWERED QUESTIONS

Some obvious questions remain on the agenda for future study. First, we cannot account for the curious fact that the PCA is spatially detached from the one place which, by every rule of geographical and historical logic, should have been its parental hearth and functional center: Philadelphia. That there was a vigorous interplay, both economic and cultural in character, between that powerful primate city and its hinterland, near and far, cannot be doubted. In fact, Philadelphia was the first full-fledged Pennsylvania Town, as we have defined it above, to be created on a New World site. We do not yet know its specific role in the molding of the PCA and the interior Pennsylvania Towns, but it must have been substantial. The cultural hiatus between Philadelphia proper and the PCA within Bucks, Montgomery, and Chester counties is puzzling by virtue of a relative dearth of cities and towns of all magnitudes and a distinctively different genre of townscape therein that has yet to be studied systematically. The former feature can be partially explained as a shadow effect, that is, the colonial urban colossus inhibited the rise of small central places in its immediate backyard. A factor contributing to

the non-Pennsylvanian character of the towns lying betwixt Philadelphia and the PCA, albeit in a minor way, may have been a somewhat different ethnic mix in that enigmatic interval.[47]

A second problem is the remarkable lack of notoriety which the Pennsylvania Town shares with the PCA in general.[48] Although those early European visitors who left written accounts of their impressions of the Middle Atlantic region commented copiously on individual cities, they did not seem to find the general townscape of the PCA newsworthy. Evidently, as was the case with the villages of New England, there was enough correspondence with familiar landscapes back home to deflect curiosity.

Rather more mystifying is the scant notice, or complete snubbing, the PCA has received from geographers and other students of the American scene, except, of course, for the Pennsylvania barn and the journalistic overexposure of the Pennsylvania Germans in general and the Mennonites in particular.[49] The failure to appreciate the full regional personality of the PCA stems largely, I suspect, from its "middleness." In many ways it is intermediate between the New England and New York cultural landscapes and those of the South, and thus it is less aberrant from eastern seaboard and national norms. It has also been a major source, or at least channel, for the flow of migrants and ideas into the vast central and western reaches of the nation; and thus much that was to become national and "mainstream" later is found in the PCA, too prosaic and normal to stir up comment.

We still have a great deal to learn about the impact of the PCA on other regions, but there is little doubt that it did play a critical role in the evolution and diffusion of the national culture[50]—Pennsylvania is not idly called the Keystone State. Its influence may be traced far and wide in many branches of technology even though it occupies less than 0.5 percent of the territory of the conterminous United States and even though its approximately 2,220,000 inhabitants accounted for only 1.1 percent of the national population as of 1970. Yet the Pennsylvania Town was not amenable to export. The Philadelphia Complex of street names did successfully emigrate and flourish elsewhere, as did certain street plans, and the diamond and the alley made some slight headway outside their natal zone. But that special and wondrous confection of urban glories that is the Pennsylvania Town is too deeply, delicately rooted in its own era and turf for transplanting elsewhere. Alas.

COMMENT

The heartening news is that, a score of years or so after I began the fieldwork for this article, the look of the Pennsylvania Town remains remarkably stable. This despite the relentless oozing northwestward of Megalopolis, a galactic splatter of exurban dwellings and business enterprises in the countryside, and a substantial influx of Latino and other nontraditional newcomers into such cities as Reading

and Lancaster. Such a condition of salubrious stagnation within cores of larger cities and throughout the entirety of smaller towns reflects both a social conservatism long endemic in the region and an economy that has come to be impervious to both boom and bust.

Geographical Review 67 (1977): 127–147

NOTES

This study was supported by a grant from Pennsylvania State University's Central Fund for Research.

1. For example, Banham (1971), Bunge (1971), Lewis (1976), Mayer and Wade (1969), and Whitehill (1968).

2. The most comprehensive statement to date is Hart (1975), a monograph that also serves as a rich bibliographical resource. Especially relevant to this study is Trewartha's (1946) seminal essay on the settlement morphology of the early Atlantic Seaboard.

3. Although a massive literature on the spatial economy of cities and smaller central places has appeared in recent years, serious attempts to describe and interpret the actual physical form of our urban places have been few and far between. The most notable of these rarities are Reps (1965), Tunnard and Reed (1953), and Warner (1972).

4. When we remember Sinclair Lewis's Gopher Prairie and Zenith, John O'Hara's Gibbsville, the Chicago of Theodore Dreiser, James T. Farrell, Albert Halper, and Saul Bellow, William Faulkner's Jefferson (as well as the rest of his Yoknapatawpha County), Hugh McLennan's Montreal, or the Los Angeles of F. Scott Fitzgerald and Nathanael West, these places—real and imagined—seem somehow more tangible and vivid than anything we can perceive for ourselves, and the cultural overtones and undertones resonate deeply.

5. The potential of this genre is illustrated in Conzen (1960) and Solomon (1966).

6. This notion, along with associated questions, is explored brilliantly in Tuan (1974). In the context of the United States, the most useful statement is Lowenthal (1968). Perhaps the clearest examples of objects that represent the intersection of community personality and physical substance, at least in the form of durable images in popular and scholarly minds, are the New England and Middle Western small towns.

7. The countryside and barns of southeastern Pennsylvania have been adequately celebrated in the popular press, but the "picturesqueness" of the Pennsylvania Town has thus far escaped general notice, I am glad to say. Even the meanest of these places has its visual charms, and the finest examples are superlatively lovely. I have compiled a private list of especially attractive places, but it will be kept highly classified lest I innocently contribute to their touristic delinquency. One Gettysburg is enough. Wolf Von Eckhardt's characterization of Frederick, Maryland, now doomed to bloated prosperity by virtue of a strategic location along the Washington-Hagerstown Interstate Highway corridor, fits at least a score of other places: "a gem of a quaint old town that Americans would travel by the busload to see if it were in Europe" (*Washington Post*, July 2, 1967).

8. Some of these field observations are reported in Zelinsky (1951a).

9. For some of the larger places, useful information is contained in the insurance atlases issued by the Sanborn Company. Another potential source for a greater number of places are the panoramic perspective views of towns and cities that had considerable vogue during

the late nineteenth and early twentieth centuries, as discussed in Hébert (1972). Unfortunately, their reliability is far from total because the earthbound draftsman, who imagined how the place might look from aloft, often invoked artistic license.

10. But in some instances, especially in larger places like Reading, Lancaster, and Harrisburg, or Philadelphia and Baltimore, which have close cultural linkages with the PCA, some of the older architectural traditions have penetrated into younger neighborhoods toward the edge of the city and even beyond into the suburbs. The process of cultural adsorption (a more apt term here than diffusion) seems to be at work in the borough of State College, just beyond the PCA as described in figure 1, a creature of the twentieth century and Pennsylvania State University, which is developing a strong alley complex and considerable boskiness in its CBD, despite the depredations of the Pennsylvania Department of Transportation.

11. Some practical aspects of this general problem are discussed in Glass (1971: 37–45).

12. The origin of the row house in Pennsylvania is treated in Murtagh (1957). The broader context of the phenomenon and its recent resurgence are dealt with in Wurster (1957) and Dingemans (1975).

13. U.S. Bureau of the Census (1964–67).

14. Table 1 raises some interesting questions about West Virginia and Delaware. The unusually great densities in the former are probably accounted for by the close packing of houses in mining towns, for reasons of topography and profit maximization. Why such high values are reported for the relatively small number of Delaware towns is a matter that calls for field investigation.

15. It is, however, a phenomenon highly characteristic of most Mexican villages and cities, and it is also developed to some extent in the American Southwest and Quebec. If the pattern was imported from the respective European source regions, something similar may have happened in the Pennsylvania case.

16. Glass (1971: 115, 123–124).

17. The most recent nationwide data on exterior materials for residential structures in the United States appear to be those reported by the 1940 Census of Housing. With values of brick usage of 42.3, 37.2, and 36.8 percent, respectively, Maryland, Pennsylvania, and Delaware were far ahead of all other states, with the interesting exception of Utah (36.6).

18. As summarized and footnoted in Hart (1975: 153–157), Rickert (1967), and Glassie (1968).

19. Pillsbury (1970). The cartographic and statistical approaches used in this article were severely criticized in Conzen (1971), then further defended by Pillsbury (1971). The results of my investigation tend to support Pillsbury's conclusion, if not necessarily his methods.

20. See, in particular, his map of the distribution of geometric and nongeometric pattern towns in Pennsylvania (Pillsbury 1970: 442).

21. It is designated as the "Philadelphia Square" or "Lancaster Square," the distinction depending on courthouse placement, in Price (1968) and as the "Classical Square" in Pillsbury (1967).

22. As illustrated in Price (1968: 30).

23. Such occurrences were scored as 0.5 in the town surveys.

24. Several occurrences can be found in early modern Europe, a particularly arresting example being Londonderry, Northern Ireland (1611) (Common 1964: 48–49).

25. Pillsbury (1967: 118).

26. According to Pillsbury (1967: 117), "65% of the rectilinear towns founded in Pennsylvania before 1820 . . . employed this form of [classical] square." See also Price (1968).

27. Many towns that are too small to have developed alleys may have had them proposed in the original street plan.

28. Pillsbury (1969).

29. Although the tally is far from complete, because many street signs are missing and because I limited examination to the more central streets, the following tree names were recorded: walnut, 40 times; chestnut, 35; maple, 20; pine, 15; spruce, 13; cherry, 12; locust, 12; poplar, 11; elm, 9; mulberry, 9; vine, 9; willow, 9; cedar, 7; linden, 6; and hazel, 5. In addition, twenty-four other trees and shrubs were recorded fewer than 5 times.

30. For an exemplary account, in visual and other terms, of a particularly interesting town (Bellefonte), see Lewis (1972).

31. For one of the better recent bibliographic entrées to a vast literature, consult the footnotes in Jordan (1974).

32. To which I would like to add the acerbic comments in Hart (1975: 157−160) and the observation that the European (largely Teutonic) typologies are more applicable to agricultural villages than to cities proper. In North America, the genuine agricultural village is rare or nonexistent; what we find instead is a set of agglomerated places, large and small alike, all performing essentially urban functions.

33. Spatial contiguity is a preferred, but not essential, attribute of a region. As it happens, the PCA is admirably compact and contiguous.

34. In effect, what is indicated is the core and domain of the PCA, adopting the terminology proposed in Meinig (1965).

35. De Laubenfels, Thompson, and Brush (1966: 338) describe a pre-1830 Albany that has some of the earmarks of a Pennsylvania Town; but further west my field observations and those of my colleague Peirce F. Lewis indicate that upstate New York towns are quite distinct in appearance from their neighbors to the south.

36. Wacker (1975: 381−394).

37. Glass (1971: 65−82).

38. Pillsbury (1970), Kurath (1949), Zelinsky (1951a: 175; 1961: 193), Glassie (1968: 37).

39. Glass (1971: 257).

40. Obviously some error is introduced into the calculation by including in our statistical universe various marginal and non-Pennsylvanian towns both within and outside the PCA. But any such error is nonsystematic in terms of town size, age, and even location, so it is unlikely that the interpretation of table 2 would be materially affected by their deletion.

41. Florin (1966).

42. Nelson (1974).

43. But some interesting theoretical efforts have been made in this direction, for example, Morrill (1963) and Meinig (1972). Useful empirical accounts of the evolution of the settlement network in various Atlantic Seaboard localities are available in Gottmann (1964), Merrens (1964), Lemon (1972), and Wacker (1975). Lemon states that the county seats, and presumably other towns, in southeastern Pennsylvania "remained open and loosely built-up in form" before 1800 (1972: 140). The chronology of intensive nucleation may be critical to our understanding of some larger issues in the evolution of North American urban

places, but it is tangential to the questions attacked in this paper and especially to the problem of why so many of the towns in the PCA attained such exceptional densities within a particular physical format.

44. The situation is admirably described and interpreted in Lemon (1967).

45. Foster (1960).

46. Powell (1963).

47. Some of this distinctiveness is indicated in Hornberger (1974). Bucks is one of the twenty-two present-day counties analyzed at the minor civil division level.

48. The relative obscurity of Pennsylvania and other Middle Atlantic states in our historiography is dealt with in Shryock (1964).

49. Perhaps the most thorough review of the literature on the region is that scattered through Glass (1971). More recent brief accounts appear in Zelinsky (1973: 125–128) and Gastil (1975: 165–173). It is remarkable that the region has gone totally unremarked upon in recent treatments of the American cultural scene by two of its most perceptive students, Jackson (1972) and Watson (1976).

50. Lewis (1972: 330).

Where the South Begins

Although the cultural individuality of the South has been recognized from colonial times onward, there has never been any serious attempt to determine by scientific means the precise limits of this vast sub-nation. This problem in delimitation merits the time and imagination of social scientists as an aid in filling in a still quite incomplete picture of the cultural landscape of the older portion of our country, for a sound decision as to where the South begins must rest upon a thorough inventory of culture and upon evaluation of a multiplicity of factors. Since the inventory is still highly incomplete and the final evaluation of factors long distant, what is attempted here is a provisional job of boundary-marking based primarily on the one set of data that appear particularly significant and accessible.

American social scientists have had to content themselves with the Census Bureau's definition of a South that terminates along the Ohio River and Mason and Dixon Line although there has been some awareness that the Southern Appalachians and Peninsular Florida cannot properly be termed Southern.[1] For lack of field experience, I cannot challenge the validity of the Ohio River as a cultural frontier, but by almost any criterion the Cis-Appalachian—the eastern—portion of this line requires radical revision. In order to go about redrafting the limits of the South, we must accept some formula whereby the southernness of a locality can be gauged. A set of cultural factors should logically be used since the South is ostensibly a cultural rather than a physical entity, being simply an area occupied by a population that thinks and behaves distinctively.[2] In this distinctive culture there are identifiable patterns of speech, diet, dress, gesture, and miscellaneous custom; and the structure of the economy, the manner of worship, recreation, social intercourse, and political behavior all have meaning for the cultural geographer. The mere listing of all the traits that might help define the South would occupy the full space of this paper, but we are limited in our choice of index items to those with a high degree of pertinence and those which may be readily mapped from field data or statistical publications.[3] Another severe limitation is the fact

that where quantitative data have been published, the unit area—usually the county—is too coarse to furnish the network of values necessary for a realistic boundary line, while the use of manuscript statistics by smaller areas offers grave difficulties.

In this analysis the settlement landscape is offered as a feasible device for delimiting the South.[4] This term denotes the aggregate pattern of all structures and assemblages of structures in which man houses his activities. In the course of field observations of house types, urban morphology, farmsteads, and other settlement characteristics, I have discovered a constellation of traits that are apparently coterminous with the South and function collectively as a regional label. By means of such objective criteria, settlement areas can be explored and their limits marked out with relative rapidity and without excessive travel by anyone trained in their recognition. Such a settlement region cannot be equated exactly to the culture area established by a consideration of the totality of culture, but the manner in which people build and arrange this major portion of the material landscape does reflect quite accurately the general orientation of their culture and obviously bulks large in any attempt at regionalization.

In its dwellings the South is characterized by the presence of a group of architectural styles and regional house types rare or non-existent in other parts of the country. The house geography of the South is vastly complicated by intra-regional variation, class differentials, and temporal changes in style so that no single, concise formula for the recognition of the Southern dwelling can be presented. The following is a list of some of the key elements that dominate the indigenous domestic architecture of the South; the observer can be reasonably certain that he is within the Southern culture area when the bulk of these traits recur with great frequency and, particularly, when they are assembled into one or another of the regional house types that are better defined by photograph than by the written word.

Southern house traits are as follows:

1. The overwhelming dominance of wood as a building material, most often in clapboard but frequently in batten construction. Significant numbers of log structures also occur.
2. A strong preference for one-story construction in both lower and middle class dwellings.
3. A distinctive set of roof plans and profiles. Among the most important are the ⌂ profile of lower class cabins and the elaborate variations on the pyramidal theme for many middle class homes.
4. A liberal use of rear and lateral extensions and, especially, the use of a rear appendage for a kitchen. This trait runs the gamut of all classes.
5. A phenomenal development of porches among all types but most particularly in the case of middle and upper class homes.

6. A general and often deliberate non-use of exterior paint.

7. The universality of brick or stone piers under older middle and lower class homes and the lack of cellars under most modern structures. This is perhaps the best single item for the detection of the Southern culture area although its rationale is somewhat obscure.

8. The widespread use of exterior end chimneys of stone or brick on lower class cabins.

9. The use of two or more front entrances in many cabins and lower middle class dwellings and the presence of a central corridor or concealed breezeway house plan where only one front door appears.

10. The deliberate discouragement of lawns around lower class homes.

Southern towns can be identified with the aid of the following characteristics:

1. The absence of "town houses," i.e., houses designed specifically for urban living, in all but the largest cities.

2. Houses that are set well back from the street and from one another.

3. The complete dominance of brick construction and the lack of shade trees in commercial areas.

4. The rarity of sidewalks and the lowness of such curbs as do exist.

5. The use of sidewalk arcades in front of shops.

6. Marked morphological distinctions among neighborhoods based on class and race.

7. The dominance accorded courthouses in county seats and the presence of at least two regional courthouse square plans.

8. The relatively great dispersion of urban settlement and the presence of large amounts of cultivated gardens and fields even toward the centers of towns.

9. The lack of any regionally distinctive system of street patterns.

The Southern countryside is distinguished by:

1. The abnormal relegation of ordinarily urban functions to the country: the high incidence of the rural school, church, and cemetery, and the crossroads store and post office.

2. The relatively large number of rural non-farm homes.

3. The patternless spatial arrangement of farmsteads and the unlimited proliferation thereon of barns, sheds, and other structures.

4. A virtually complete avoidance of paint on barns and sheds.

5. Small and regionally distinctive barn and shed types.

6. A group of distinctive types of water wells.

7. And, as a product of its economic history, the high rate of house abandonment.

The procedure whereby the preceding list was derived and the manner in which it was utilized are as follows: (1) an extensive reconnaissance through the

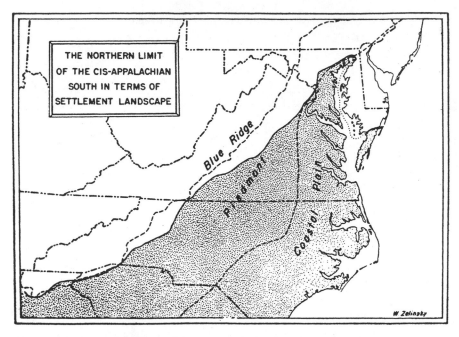

FIGURE 1 The northern limit of the Cis-Appalachian South in terms of settlement landscape.

South and adjacent regions to ascertain their critical traits, (2) an office evaluation of notes and photographs to develop effective formulae for the recognition of settlement regions, and (3) traverses across the border zones in order to locate regional limits as closely as possible in accordance with the resulting formulae. Traits were considered as being significant only collectively as parts of complexes, so that the bulk of the traits listed would have to be present in force before a region could be safely classified as Southern.

The outcome of this procedure was the placing of the northern limit of the Cis-Appalachian South in the position indicated in the map (figure 1). The line trends roughly parallel to the topographic grain of the country, corresponding rather well with the Fall Zone and the front of the Blue Ridge in its northern and southern segments, respectively; but along most of its course it is engaged in an oblique crossing of the Piedmont. In northern Georgia the line enters the mountain region and reaches the crest of the system. The way it bends seaward in west-central North Carolina may be symptomatic of the ambiguous cultural affinities of that area. Physiographic correlations are missing in the isolated segment of the South on the Virginia Eastern Shore.

The sharpness and reliability of the line presented here vary greatly from place to place. On the Eastern Shore an emphatic interstate and cultural boundary match beautifully for unknown reasons; the country to the South is decidedly Deep Southern while the bulk of the Eastern Shore has only pockets and frag-

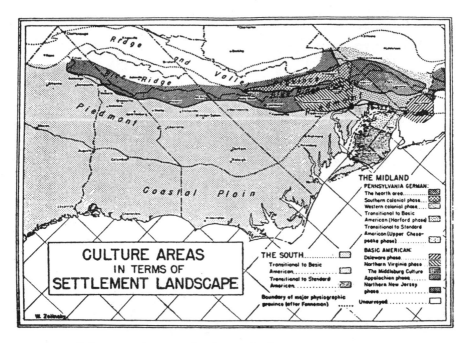

FIGURE 2 Culture areas in terms of settlement landscape.

ments of Southern culture. Between the head of the Chesapeake Bay and the District of Columbia the nature of the line is obscured by sprawling urbanization and the weakness of Southern culture traits on the Maryland Western Shore. The Mason and Dixon Line, be it noted in passing, is significant only along a very short stretch and then only as the absolute northern limit of even isolated Southern traits. From Washington to about the latitude of Lynchburg, Virginia, the transition from one culture to another is sharp. There are places where the line could be literally marked on the ground, so sudden is the transition. Further southward, however, there is an increasingly wide zone of transition, and in some areas of North Carolina the line could be moved some tens of miles either way at the discretion of the observer. In the foothills and fringes of the Blue Ridge in South Carolina and Georgia there is a narrower belt of ambiguity as topographic impediments function as cultural frontiers.

The culture areas against which the boundary of the South abuts are diverse in character (figure 2). The predominantly non-Southern and inland sections of the Eastern Shore resemble the Middle West in their settlement patterns more strongly than does any other region of the Atlantic Seaboard, while the coastal sections fall within what I define as the Basic American pattern. From Cecil County, Maryland, to Washington, D.C., two radically different cultures oppose each other, a transitional phase of Southern type and one of the colonial phases of Pennsylvania German culture. Thence to about the latitude of Charlottesville,

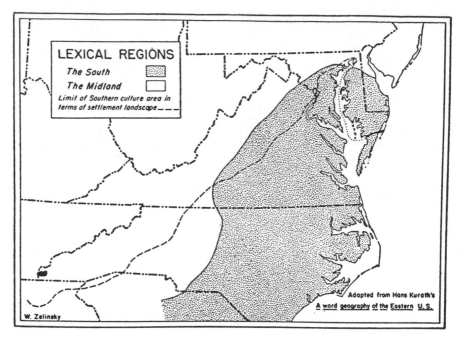

FIGURE 3 Lexical regions.

the South is bounded by a quite distinctive landscape, which I designate as the Northern Virginia phase of Basic American culture. For the remainder of its course the neighboring area contains the Appalachian phase of this same important complex of cultures. With increasing peninsularity southward, this Appalachian settlement culture becomes progressively more dilute and less unlike the Southern type, so that in Georgia the assimilation of lowland traits has rounded off what is elsewhere a much bolder cultural escarpment.

The validity of the line offered here can be partially tested by inspecting other distributional maps of traits commonly agreed to be distinctively Southern. The only such map I am aware of based on actual field work is one derived from the researches of Hans Kurath and his collaborators on the Linguistic Atlas of the United States (figure 3).[5] It shows the limits of the Southern and Midland regions of speech and their various sub-areas, but the fact that it is based on vocabulary and not on any consideration of the all-important factors of grammar and pronunciation leads me to regard it as a tentative formulation and to consider its indifferent correlation with the settlement culture boundary as indecisive.

The concept of the Solid South is firmly entrenched in the public consciousness. The accompanying map (figure 4) attempts to discover what degree of correlation exists between the strength of the Democratic vote and the limits of a South defined in terms of settlement traits. The plotting of data from thirteen presidential elections during the period when the South has been most intensely

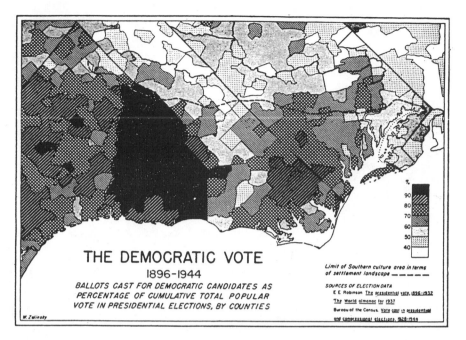

FIGURE 4 The Democratic vote, 1896–1944. Ballots cast for Democratic candidates as percentage of cumulative total popular vote in presidential elections by counties.

solid reveals a disappointingly irregular pattern with weak Democratic and occasional Republican majorities in regions that are obviously Southern and with powerful Democratic strongholds in decidedly non-Southern areas. Evidently the effects of local voting laws, local issues, personalities, and idiosyncracies having no apparent connection with cultural geography make it impossible to use voting characteristics as an index trait in delimiting the South.

Even a cursory review of the problem will develop the probability that the presence of a large number of Negroes has had much effect on the genesis of a culturally distinctive South, and we should expect a map showing the relative strength of Negro population to reveal the outlines of the Southern culture area. The map (figure 5) demonstrates that the correlation is indeed present but is not so pronounced as to offer any formula for demarcating the region. This writer does not doubt that a painstaking study of the historical geography of Negro population distribution in the ante-bellum South will cast a great deal of light on the origin of the South's boundaries, but it is unlikely that the nature of the relationship can be shown readily on a single map. Too many irrelevant variables affect the percentages depicted on this map, and among other factors Negro population has proved to be more mobile than the culture whose character it helped to establish.

One of the least considered traits characterizing Southern culture is the preference shown for the mule as a draft animal in place of the horse. Most of those

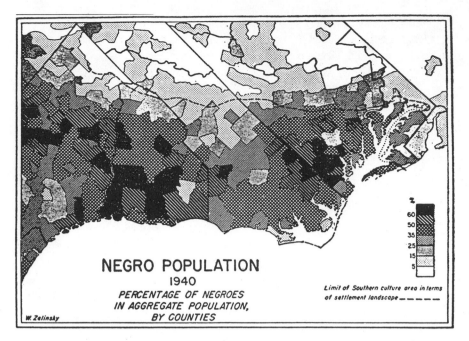

FIGURE 5 Negro population in 1940. Percentage of Negroes in aggregate population by counties.

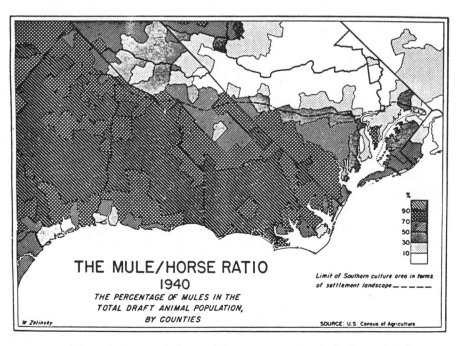

FIGURE 6 The mule/horse ratio in 1940. The percentage of mules in the total draft animal population by counties.

who have commented on the phenomenon have emphasized climatic and ethnic factors as being decisive in the competition between the two animals, but perhaps the use of the mule is at least as much a matter of arbitrary cultural choice as of deliberate reasoning. At any rate, the map (figure 6) shows a surprisingly strong correlation between the mule area and the Southern settlement region, with mule-horse boundary sharpest where the settlement culture boundary is sharpest and with a more gradual transition toward those non-Southern areas most exposed to Southern cultural penetration. The neat fit of most sections of the two lines and the independent nature of the sources of data furnish perhaps the best argument advanced here for the authenticity of the Southern culture area surveyed in terms of settlement traits.

It is much too early to offer any serious claims for the efficacy of the settlement landscape technique in determining the borders of general culture areas in the United States, but the evidence appearing here makes it seem likely that application of the method to the western, northwestern, and Floridian frontiers of the South may turn up much material pertinent to the problem of the South's limits. In any event, the ease and rapidity of application and the intrinsic interest and importance of the data dealt with by this technique should commend its wider use among those concerned with regional studies in the United States.

COMMENT

As the earliest of the items in this assemblage, "Where the South Begins" is also almost certainly the weakest. Something more than mere sentiment led to including this relic from an apprenticeship period. The wide-ranging fieldwork reported here, which was carried out during the summer months of 1949 and 1950, was a practice run for the more intensive travel and observation within Georgia, mostly in 1950 and 1951, that furnished the basis for my doctoral thesis. That document, incidentally, was the first dissertation dealing with the human geography of the state. Aside from whatever value the article may have in showing how a novice tried to teach himself how to grapple with a difficult field problem, I like to believe it has some durable interest for two more important reasons. The question of the spatial bounding of the American South remains alive for a variety of reasons, and I am still pretty well convinced that the boundary I detected—fuzzy in some stretches, sharp in others—was, and still is, a reasonable approximation of the actuality.

Another more poignant reason is the fact that it would be difficult, perhaps impossible, to replicate the study today. In recent years, in travels throughout the South, it is clear that the countryside has undergone a remarkable transformation. This fact came home most forcefully in my latest traverse of Georgia in March 1993 from the Tennessee to the Florida border. With rare exceptions, the traditional farmhouses, barns, fences, wells, and other related items have disappeared

or have been modified beyond recognition. In their place one finds standardized artifacts indistinguishable from what adorns the agrarian and exurban tracts of Kansas, Michigan, or Pennsylvania. Vestiges of the old settlement landscape are visible only in the occasional tenantless buildings, semi-abandoned hamlets, the stranded smaller towns, or the slummier sections of the cities. Should one be happy or sad, or both, over what late-twentieth-century prosperity has meant for the South?

Through pure happenstance, I caught a traditional landscape on the eve of swift and radical change after a century or so of poverty and sluggish evolution. In a sense, then, this paper is akin to a report by an ethnographer on an aboriginal community on the verge of extinction.

Social Forces 30, no. 2 (1951): 172–178

NOTES

1. The most ambitious attempts to date to treat the South as an areal entity are to be found in Odum (1936) and Odum and Moore (1938); but the boundaries suggested in these works fall along state lines. For an example of the methodology of a sociologist who is required to work out a solution to the problem for statistical reasons, though in incidental fashion, see Myrdal (1944, 2:1071–1072). It is significant that the standard texts on the geography of the South (Vance 1935; Parkins 1938) never seriously confront the problem of how to delimit their subject area.

2. This statement does not exclude the possibility that factors in the physical environment may have contributed directly or indirectly to the formation and areal delimitation of Southern culture. It simply reflects the fact that in this case a phenological description is much handier than a genetic one.

3. For example, a highly pertinent phenomenon and one that may prove to be the most sensitive indicator of the extent of the Southern culture area is its dietary complex; but the task of collecting the requisite data in the field demands a large, expensive, and skillful group of interviewers, and, hence, this avenue of research is not likely to be explored very rapidly.

4. The only serious detailed studies on the settlement characteristics of the South that have been published to date are Kniffen (1936) and Scofield (1936). An excellent, but general, introduction to the topic is available in Wertenbaker (1942).

5. Kurath (1949: Fig. 3).

The Log House in Georgia

F ew traits in the older material culture of the United States have captured as prominent a place in its folk mythology as has the log cabin.[1] An even stronger incentive for the study of this frontier phenomenon is the fact that it has much to tell us of our culture history, and even of contemporary human geography, in Anglo-America. For these reasons, and because time is running out for the American log house, special attention was devoted to the recording and interpreting of the log culture complex of Georgia during a general study of the settlement characteristics of that state. The lack of detailed regional studies on log architecture in other parts of the continent seriously reduces our insight into the Georgia data and prevents generalization. Consider this less an apology than an invitation for other students of Americana to join in the collection of material wherever log dwellings or memories of them persist.

CONSTRUCTION OF LOG HOUSES

The log house can be defined by its material, method of construction, and function. The walls are made of round, undressed logs or of logs hewn with ax or adz (but never sawed) to rectangular shape. The logs are laid one above the other and are mortised at the corners of the building by some form of notching that eliminates the need for hardware. These buildings are lacking in affectation, a condition that excludes an increasingly large number of hunting and vacation lodges and also Boy Scout cabins and the like.

The details of log-house architecture and construction have been dealt with so well previously[2] that only a short summary is necessary here. In Georgia the material is generally oak or pine, according to the local silva. The diameter of the logs ranges from about 6 inches to 15 inches, or even 18 inches or more; in general, it decreases in the more recent houses. In a climate where frame, stucco, and even brick structures deteriorate with distressing rapidity, the well-seasoned logs of a

good log house are practically ageless as long as they are under a tight roof and away from the ground.

Although a great number of notching techniques, some rather elaborate, are practiced in Europe, only one is numerically strong in Georgia—saddle notching. A semicylindrical groove is cut across the underside of a log to half or less of its diameter near its end so that it will fit snugly over the log it joins at a right angle. The technique is so strongly dominant that its areal occurrence was not recorded for this study. Dovetail notching—the carving out of angular tenons at the very end of the log—occurs sporadically along with various kinds of square notching, but the distribution of these almost extinct techniques has little meaning in Georgia at present, though this is not to imply that study of them throughout Anglo-America is not strenuously advocated while sufficient evidence remains.

The major technical problem confronting the log-house builder is the finishing of the walls, for even the straightest and roundest logs cannot be superimposed without leaving wide chinks. During the ruder days of the frontier, many log-house dwellers in the Deep South were content with the simple log wall that admitted air freely—tolerable enough for most of the year under a relatively genial climate. Frederick Law Olmsted[3] was only one of several travelers to comment on this kind of house:

> The logs are usually hewn but little; and, of course, as they are laid up, there will be wide interstices between them—which are increased by subsequent shrinking. These, very commonly, are not "chinked," or filled up in any way; nor is the wall lined on the inside. Through the chinks, as you pass along the road, you may often see all that is going on in the house; and, at night, the light of the fire shines brightly out on all sides.

This practice has now vanished: not a single inhabited log house without weatherproofed walls has been noted in present-day Georgia.[4] Most often, the gaps between logs have been chinked with twigs, plus clay, lime, or some other variety of cement, according to the locality. As sawed lumber became more abundant and as log-building skills declined, weatherboarding the outside of the walls, or lining the inside with thin planks, or both, grew increasingly common (figs. 3 and 5). The crudest expedient, nailing short lengths of narrow board (often scrap lumber) over the interstices, is apparently a rather recent innovation (fig. 1).

The plan of the Georgia log house has always been simple. In its most elementary form it is a rectangular pen, the length (generally 15 to 20 feet) governed by the size of available logs (fig. 8). Until recent years the roof ridge has always been parallel to the front of the house, with the gable ends facing sideward. Log houses with frontward-facing gables are a modern idea, nowhere dominant (fig. 4).[5] The one-room log house, which soon proved inadequate even on the frontier, was frequently enlarged, either by the addition of a frame wing or by the attachment of another log pen (fig. 6). The double log pen may be differentiated into two

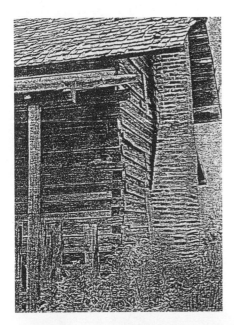

FIGURE 1 (left) Detail of Wheeler County log dwelling. Note square-hewn logs, square corner notching, and chinks covered over with narrow wooden slabs. The brick chimney is found on all surviving log houses in the Coastal Plain.

FIGURE 2 (below) This neat modern house in Rabun County fairly well exemplifies the current log architecture of the Georgia mountains. The round logs have been saddle-notched and are chinked with cement.

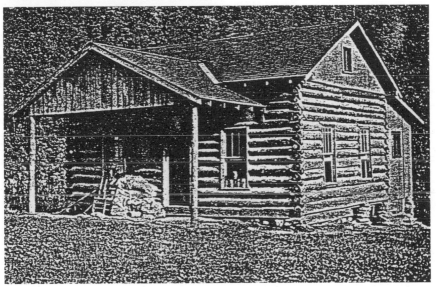

subtypes, one with a corridor extending all the way through the house between the two pens, the other with the two sections adjoining. The former is called the "dog trot" house, after the popular term for the central breezeway or porch; it is indigenous to the South, where the climate can be readily invoked to explain its wide acceptance.[6] Two-story log houses are almost nonexistent in Georgia:[7] ex-

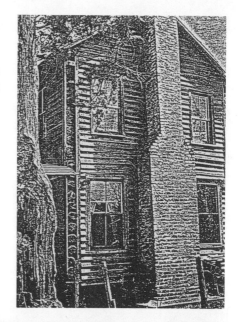

FIGURE 3 (right) Detail of old (probably antebellum) log house in Wayne County, now almost completely clapboarded over. Piers are of log, since the area is lacking in stone. This house is the only two-story log dwelling found in Georgia and one of the very few left in the South.

FIGURE 4 (below) Log house with frontward-facing gable, Walker County. The interior chimneys are a modern innovation.

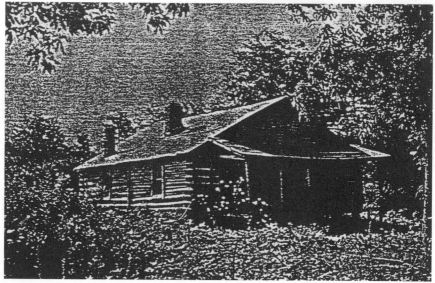

pansion of the log house, as of other types in the South, was virtually never vertical.

Changes in the architecture of the log house have been slow and gradual (a fact, incidentally, that makes the dating of these otherwise recordless structures risky), but within this century another type has emerged. It borrows the floor plan

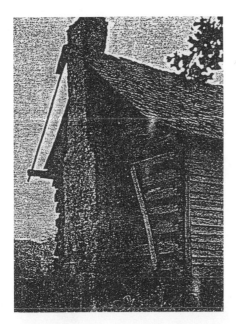

FIGURE 5 (left) Chattoga County house with two types of wall finish, exterior and interior boarding. The shingled roof, stone chimney hooded by roof, and stone piers are all characteristic.

FIGURE 6 (below) Double log pen in Stewart County, with "dog trot" walled in. Note that the large logs used here have been split lengthwise; the flat inner side is boarded over.

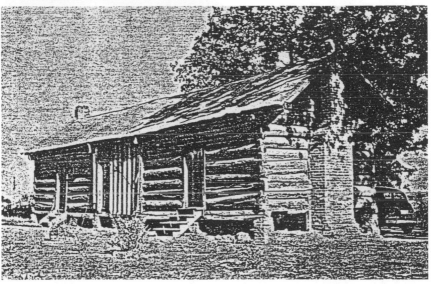

of its predecessors, but in every detail of carpentry, door and window frames, chimney, roof, floors, and foundation—in everything except the wall material—it resembles its modern frame neighbors (fig. 2). And even the finishing of the walls has changed: commercial cement is often used and covered with whitewash or paint; the logs themselves may be given a coat of varnish or dark stain.

FIGURE 7 (right) Detail of house in Polk County in which the logs have been squared off. Dovetail notching has been used, and batten siding covers one wall.

FIGURE 8 (below) An abandoned single log pen in Rabun County in the Georgia Blue Ridge. The square-hewn timbers are characteristic of this area. Note that the building is windowless.

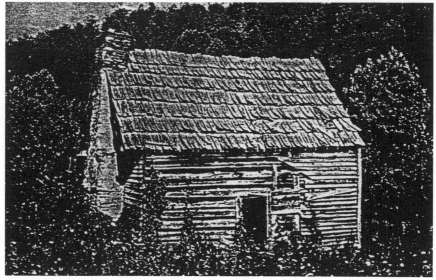

 The log houses of Georgia, like many other dwellings in the state, are erected on piers that keep them a good distance above the ground.[8] In the northern half of the state either rocks or short sections of log may be used, but in the relatively stoneless Coastal Plain the piers are almost exclusively log or brick. The rationale of this practice is obscure, but it is essentially Southern in distribution and may

be accounted for partly as an economy measure and partly as a method for dealing with the ventilation of the house and its protection from moist soil and vermin.

The traditional roof was composed of thin slabs of wood—shingles or "shakes"—laid over a framework of poles. If, as often happened, a porch was added along the front of the house, the roof was continued over it at a somewhat lower pitch. During the earliest years, and particularly in the Coastal Plain, the gable-end chimney was built of mud wattled with twigs.[9] Stone construction came later, and the use of brick for the chimney postdates the frontier era. The stick-and-mud chimney is only a memory in Georgia now, but its past importance is attested by the still common practice of extending the roof past and around the gable-end chimney, in a sort of hood; the reason, of course, is the sheltering of the easily weathered chimney from the elements.[10] Windows were accorded slight consideration in the old log houses. Some were windowless (fig. 8); in others the few apertures were rarely covered, and then usually with a crude board shutter.

NUMBER AND DISTRIBUTION OF LOG HOUSES

The log house was only a single element in the log culture complex that characterized the Southern frontier and has persisted strongly in many sections to this day. It may be safely stated that almost the whole of the gross material culture of the Georgia pioneer was based on the log. He lived in a log house and kept his livestock in log barns (if they were penned at all) and stored his implements and crops in log bins and cribs.[11] If he took the trouble to build a fence around his fields, he split logs lengthwise and arranged them zigzag in a worm fence, again without the benefit of any metal except his ax blade. If he had a well, its superstructure was most likely a pair of logs, one with the bucket fastened to its end pivoted on a vertical log and operating almost effortlessly with the aid of gravity—the now almost extinct sweep well.[12] This frontiersman worshiped in roughly built log churches; he sent his children to equally primitive log schoolhouses. Tidings of an impending Indian raid would send him scurrying to the protection of one of the log forts.[13] When a town was founded, many of the first dwellings and inns were logs, and the chances were that the county courthouse was fashioned from logs; the neighboring log jail frequently outlasted the other urban log structures.

The documentary evidence is emphatic concerning the dominance of log construction in most parts of Georgia from the latter half of the eighteenth century until the eve of the Civil War. But since we have only the casual accounts of travelers, there is no way of determining the relative number of log and non-log dwellings for any particular locality during most of the state's history. The general pattern was probably an almost completely log architecture during the pioneering period, then the steady decline of log building as the well-to-do took to using frame or even brick construction, and finally its reduction to an archaism as the multiplication of sawmills made frame construction feasible even for the poorest

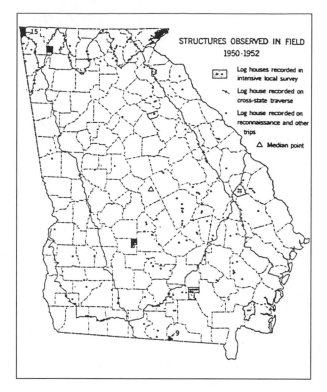

Log houses recorded in
intensive local survey

Log house recorded on
cross-state traverse

Log house recorded on
reconnaissance and other
trips

△ Median point

FIGURE 9 Structures observed in field 1950–1952.

classes. The last phase began in earnest after the Civil War and has continued steadily up to the present. Although the decennial censuses of housing do not include any data on the use of logs, the Bureau of Home Economics of the United States Department of Agriculture fortunately conducted a survey in 1934 of farm housing in sample counties throughout the country that did tally log structures.[14] Sixteen of Georgia's 159 counties were included, and although the inventory was not quite complete, a door-to-door questionnaire was used. Of the 33,139 dwellings recorded, 3.2 percent, or 1,060, were reported as being of log; the percentage ranged from 0.4 in Hancock County to 9.2 in Rabun and Habersham Counties together. By applying the figure of 3.2 percent to the estimated total of rural dwellings in Georgia in 1934, the probable total number of log houses in the state in that year was found to be 15,000.

From 1950 through 1952 a total of 274 log dwellings were recorded during field work in Georgia (fig. 9). Of this total, 154 were discovered on four methodical cross-state traverses during which every rural dwelling was tabulated or nine intensive local surveys, each covering one or more Georgia militia districts (the equivalent of a township). The remainder were noted during the many reconnaissance and incidental trips made during the period. Precautions were taken to

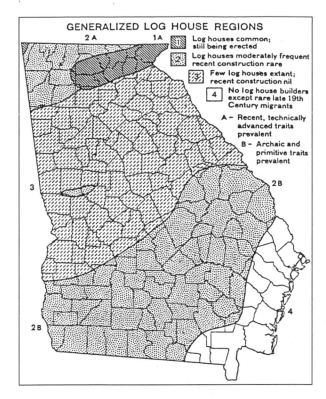

FIGURE 10 Generalized log house regions.

make the sample as random and representative as possible. Since all the counties of Georgia were visited, it is probably safe to apply conclusions to the entire state. The total number of dwellings observed in local surveys and on traverses was 6792, or roughly 1.5 percent of the total number of rural dwellings in Georgia in 1951.[15] Log houses constituted 2.3 percent of the observed structures; but since observation was, in the majority of cases, a simple roadside inspection and did not include questioning the householder, a significant number of clapboarded log houses must have escaped notice. By allowing for this underenumeration and repeating the extrapolation, we find that there were probably 10,000 to 12,000 log houses left in Georgia about 1951. The decrease from the estimated 15,000 of 1934 and a current 36.7 percent incidence of abandonment among observed log dwellings show how rapid the present decline must be. If the trend continues, the virtual extinction of the log house by the end of this century seems probable.

Although the median point of contemporary Georgia log houses falls near the areal center of the state,[16] their distribution is markedly uneven (fig. 10). They occur with greatest frequency in the Blue Ridge, the rough inner edge of the Piedmont, and the small corner of the Cumberland Plateau falling within Georgia,[17] and the next most frequently in parts of the Valley and Ridge country, the inter-

montane basins of extreme north-central Georgia, and a broad belt of territory running northeastward from the Florida line through the central Coastal Plain. They are rare at the present time in most of the Piedmont and Fall Zone,[18] and they do not seem to be indigenous to the lower Coastal Plain and Sea Island areas. Although the areas of intensive field work in 1950–1952 do not coincide with the territory covered by the 1934 sample survey, except accidentally, a similar distribution might be derived from the earlier data, a fact that bolsters the credibility of both sets of evidence. It is to be regretted that the writer's total itinerary could not be given in figure 9, to afford a better idea of the relative frequency of log houses in various parts of the state, but it proved difficult to keep the detailed and elaborate notes during field work that would have permitted this. It should be realized, however, that superior coverage is the reason, for instance, for the several log examples near Athens, an area no richer in log houses than most other parts of the Piedmont.

Of the other elements in the log culture complex, only the rapidly disappearing split-rail or worm fence has been systematically recorded in the field, and its distribution correlates reasonably well with that of log dwellings. The occurrence of log barns and sheds, which are both more numerous and more widespread than log houses, has proved to be much more difficult to chart in the field than that of log houses, and quantitative evidence cannot be offered; they seem to vary in frequency in much the same way as log dwellings and worm fences. The log churches described in the earlier literature appear to be gone, and only a single log schoolhouse has been recorded. Log courthouses, jails, and forts are now one with Nineveh and Tyre.

SIGNIFICANCE OF THE LOG HOUSE
IN THE CULTURAL LANDSCAPE

The distributional facts of log culture in contemporary Georgia have been presented by means of word and map, but there still remains the task of accounting for these facts and interpreting their significance in the total cultural landscape of Georgia. A major question raised is the dichotomy between an apparently logless tidewater Georgia and a much larger inland area where log culture was for a long while supreme. The absence of log dwellings along the Georgia coast during colonial times (except for the few cases noted below) is strongly established by negative documentary evidence; and their extreme rarity and peculiar nature[19] in this area at the present time have been proved by field work and by consultation with local scholars.[20] The bulky early records of the state have been sifted several times by students of various topics, including architecture, without the discovery of a single valid reference to a bona fide log dwelling built by a colonial Georgian of British origin,[21] and it is unlikely that any future researches will alter this statement. This writer has looked into every known post-Revolutionary travel account of Georgia; references abound to log houses in the interior of the state, but there

is not a single mention of them along the coast. Log jails and forts, and probably log palisades, did occur, but the only authenticated log dwellings before the late nineteenth century include two in the now dead town of Frederica on St. Simons Island built by Henry Michel and Henry Myers, who were *German* immigrants,[22] and the early dwellings of the Salzburger settlers at Ebenezer (founded 1734), some 25 miles up the Savannah River from the city of Savannah.[23]

For an understanding of these exceptions, the distribution of the log-house trait in the Old World must be briefly described. The practice reaches across Eurasia in two broad bands: the first extends through the sub-Arctic forests of Sweden, Finland, and central and northern Russia, and, since the seventeenth century, across Siberia to the Pacific, then, later, to Russian America; the second—and the more relevant here—begins in the French Savoy, with a possible minor outlier in northern Spain, and reaches through the mountainous spine of Eurasia at least as far eastward as Iran and possibly Kashmir. Included within it are the rugged areas of southern Germany, Switzerland, Austria, Bohemia, the Carpathians, Transylvania, and perhaps Turkey. Log construction is completely alien to the British Isles, the Low Countries, and the parts of France from which migrants to America were drawn. The log-building technique is apparently of such slight moment in Spain that it was never effectively transferred to Hispanic America;[24] thus, even if there had been much cultural contact between the English in the Carolinas and the Spanish missions in Georgia in the seventeenth century, nothing would have come of it as far as the log house was concerned. A few log houses were known in Spanish Florida,[25] but mutual hostility prevented the English in Georgia from learning of them. There is no evidence that any aborigines in the United States were familiar with log construction (except, possibly, in corncribs), and a spontaneous invention in America, even under the most beneficent environment, is hardly likely. The general answer to the problem of how the log house arrived in the New World and eventually migrated to inland Georgia but not to its coast has been supplied by Shurtleff's brilliant researches and can best be summarized in his own words:[26]

1. Log dwellings were never built by the English or Dutch in their earliest colonial settlements. English and Dutch alike proceeded directly from various temporary types inspired by English or Indian models to framed houses.

2. Log-dwelling technique was brought to the Delaware by the Swedes in 1638 but did not spread beyond that place until the last quarter of the seventeenth century at the very earliest.

Then further:

Delaware Bay was the principal center from which log-wall dwelling construction spread. There the Swedish log-house craft was reinforced in the eighteenth century by immigrants from the forested regions of Germany and Switzerland where log houses were common. The Scotch-Irish who came hard

on the heels of the Germans adopted the log house and helped to spread it along the frontier.

After having learned the craft from the Pennsylvania Germans, English-speaking frontiersmen carried it rapidly westward and southwestward. The log-building trait entered Georgia at the eastern edge of the Piedmont and quickly advanced with the frontier[27] all over the state except the fraction of the Coastal Plain previously occupied by migrants direct from the British Isles. Even though the Oglethorpe colony came some thirty years *after* the introduction of the log house into Pennsylvania and Maryland, its members had had no opportunity to acquire the skills needed for log-house construction. A further consideration, as Shurtleff suggests, is the fact that the presence of an artisan class along the coast made sawed lumber relatively cheap and abundant, whereas the primitive structure and material poverty of pioneer back-country society made the log house a practical expedient.

The problem is complicated by the presence of the several hundred Protestant Salzburgers at Ebenezer and a small colony of Swiss at Purrysburgh, below Ebenezer and across the Savannah in South Carolina.[28] These people had certainly practiced log construction in the Old World and during their first years in America. For reasons that are not at all plain,[29] they not only failed to transmit their architecture to the English but abandoned it for the frame house.[30] The final complication is the fact that log culture had probably arrived in tidewater South Carolina by 1700 (by what route?).[31] Its failure to migrate farther down the coast may be attributed to Georgia's terminal position in British America, the general sluggishness of coastwise traffic, and the late institution of slavery in Georgia (in South Carolina log building found its principal use in slave housing).

The line between the Inland Log Culture Area and the early-settled sections of Georgia where the log complex never took root separates two cultures that differ in many nonmaterial, as well as in material, respects. This line, or rather zone, in the lower Coastal Plain represents the high-water mark of an inland culture spilling out from the interior but dammed by an inhospitable and hard-to-penetrate wilderness of pine and swamp that is densest about 50 miles from the coast. Coastward of this line, certain frame-house traits derived from log culture are lacking or rare; for example, the dog trot, multiple front doors, and "hooded" chimneys. In addition, certain subtle carpentry traits, more easily discerned than described, that are indicative of the temporal or spatial proximity of log houses do not occur in the coastal area. The logless character of the Georgia coastal culture is essentially unmodified by late-nineteenth-century intrusions of a very few log houses from the interior.[32] The log barns and sheds of the coast, also probably of late-nineteenth-century introduction, have held on, possibly because of a cost differential favoring them over frame structures.[33] Worm fences were not unknown in the past, but the date of their entry is uncertain.[34]

Within the Inland Log Culture Area variations in the frequency of log houses

are a matter of the date of settlement and of differential isolation. In Wilkes County, an east-central Piedmont area settled in the last quarter of the eighteenth century, the log houses that were once dominant seem to have vanished,[35] but they are still numerous in Echols County, at the edge of the Okefenokee region and opened to settlement just before the Civil War. The incidence of log houses in a given locality seems to be inversely proportionate to the tempo of traffic in men, goods, and ideas. Good roads are the bane of log houses, and cities the harshest possible environment. (In spite of constant vigilance, not a single log house has been found on a site that could be termed urban.) The mechanism of isolation may be the forbidding topography of the Appalachian chain and its foot-hills or the swamps and dense forests of parts of south Georgia; and there are many subtle forms of economic inertia and isolation that perpetuate the log house in odd corners of the state. It is quite possible that, as a result of the rapid eco-nomic progress of south Georgia in recent years, the log house will quickly lose ground there, as it has already done in the Piedmont, with its relatively dense web of roads and rails and its earlier urbanization and industrialization. Besides being a sensitive gauge of cultural isolation and a clue to culture areas, the log house remains to testify to the paramount fact that the human geography of the South is one of an arrested frontier.

The plotting of various log-house traits in inland Georgia reinforces our specu-lations on the historical geography of the log complex in the state. The single log pen appears to be universally and rather evenly present in the log areas (fig. 11), but the double log pen is concentrated within the southern half of the state. The fact that the double pen is an early form that is no longer being built accentuates the peripheral character of south Georgia culture. The modern log-house types, in contradistinction, are most strongly represented in north Georgia, as is shown by the centrographic analysis used throughout the accompanying series of distri-butional maps.

Although the preparation of round logs is capable of considerable refinement in expert hands, the preparation of square-hewn logs generally indicates a higher degree of skill and produces a superior house.[36] The dominance of a round-log tradition in south Georgia and the popularity of square-log architecture in the north are further clues to the relative cultural complexity of the two areas.

The walls of a log house need special treatment if they are to repel wind and rain. The skilled woodsman carefully selects and shapes his logs and then daubs the spaces in between with some sort of cement. Where a log house has been partly or wholly covered with siding inside or out—a relatively inelegant solu-tion—that fact has been noted and mapped (figs. 14–16). The median points of boarded log houses fall well south of the center of the state; the crudest device—boarding over the chinks with narrow planks—shows the greatest displacement.

Incidental to our purpose but of some intrinsic interest is log-house occupance (figs. 17–19). The high rate of abandonment has already been noted, but even

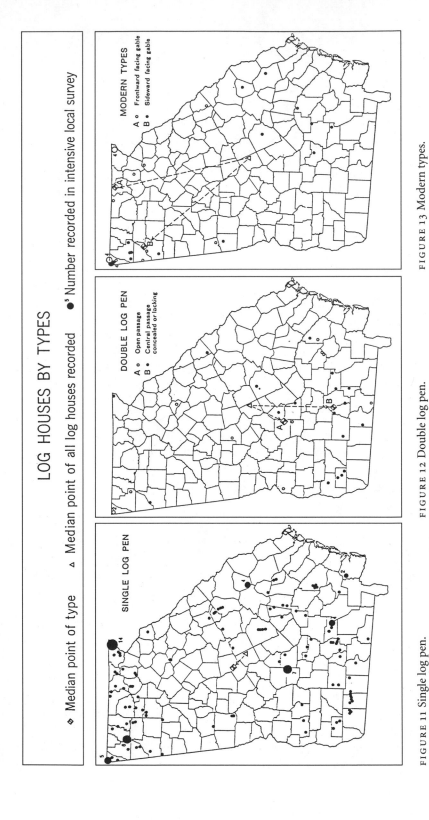

LOG HOUSES BY TYPES

◇ Median point of type ▵ Median point of all log houses recorded ● Number recorded in intensive local survey

SINGLE LOG PEN

DOUBLE LOG PEN

A ○ Open passage
B ● Central passage
concealed or lacking

MODERN TYPES

A ○ Frontward facing gable
B ● Sideward facing gable

FIGURE 11 Single log pen.

FIGURE 12 Double log pen.

FIGURE 13 Modern types.

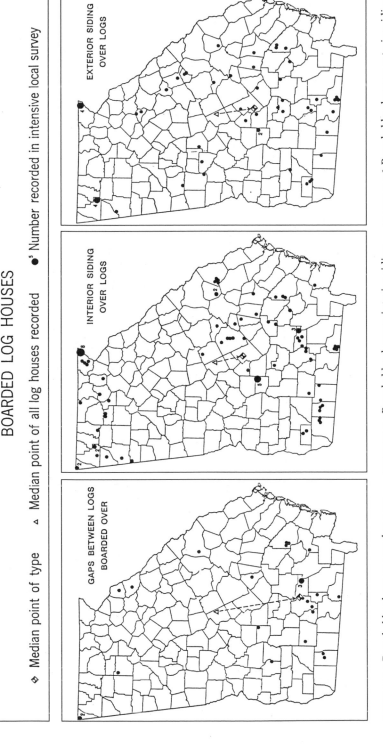

BOARDED LOG HOUSES

◇ Median point of type ▵ Median point of all log houses recorded •⁵ Number recorded in intensive local survey

FIGURE 14 Boarded log houses: gaps between logs boarded over.

FIGURE 15 Boarded log houses: interior siding over logs.

FIGURE 16 Boarded log houses: exterior siding over logs.

LOG HOUSES BY OCCUPANCE

◇ Median point of type △ Median point of all log houses recorded ●⁵ Number recorded in intensive local survey

WHITE OCCUPANCE

FIGURE 17 Log houses by occupance: white occupance.

NEGRO OCCUPANCE

FIGURE 18 Log houses by occupance: Negro occupance.

UNOCCUPIED STRUCTURES

FIGURE 19 Log houses by occupance: unoccupied structures.

more striking is the low frequency of Negro occupance, some 9.2 percent of oc-cupied log houses, though Negroes constitute roughly one-third of the state's ru-ral population. The explanation is historical. Many observers remarked on the abundance of Negro log cabins on ante bellum plantations, but during the havoc of the Civil War and its aftermath the old slave quarters were destroyed, and the freedmen moved to new homesites,[37] where they usually built frame houses in-stead of the obsolescent log cabins. The continuity of log-cabin occupance and construction was maintained largely by white yeoman farmers left comparatively undisturbed by the social upheavals of the nineteenth century, and the log houses now occupied by Negroes have often been acquired from whites by default. Al-though too few aborigines remain in Georgia to affect the contemporary cultural geography of the state, by the early nineteenth century the Indians had borrowed the log-house technique from the whites.[38]

All these distributional facts point to a major conclusion concerning the cul-tural evolution of that preponderant part of Georgia in which the log house has appeared. North Georgia, with its more recent house types, its square-hewn tim-bers, and the dominance of relatively skilled techniques for sealing walls, would seem to lie closer in time and space to the center of dispersion for log-house traits (and presumably others) than south Georgia, with its greater proportion of ar-chaic or degenerate house types, round logs, and cruder treatment of walls.

Other lines of evidence also suggest an early flow of population and ideas from northeast and north to southwest and south. In the case of the log house, Georgia is decidedly colonial to Pennsylvania and certain parts of the Upper South through which the practice of building in logs was introduced by German and Swiss immigrants at the beginning of the eighteenth century and from which it spread outward to vast sections of North America. In the Deep South, as in other frontier regions, logs in the form of houses, churches, barns, sheds, and fences became a mainstay of the economy and profoundly modified the subsequent de-velopment of the region's material culture.[39]

COMMENT

As its documentation indicates, this article was hardly the first to deal with log buildings in North America, even though it may have been the first to treat the topic geographically. Over the past forty years, our knowledge of the origins of this architectural tradition, its historical geography, and the finer details of con-struction has grown mightily. Two exemplary monographs, valuable for both sub-stance and bibliography, are Roberts (1984) and Jordan and Kaups (1989). For what may well be the definitive account of a related set of phenomena, i.e., the origins, attributes, and diffusion of the Pennsylvania Barn (which at least inter-mittently involved the use of log), see Ensminger (1992).

Geographical Review 43 (1953): 173–193

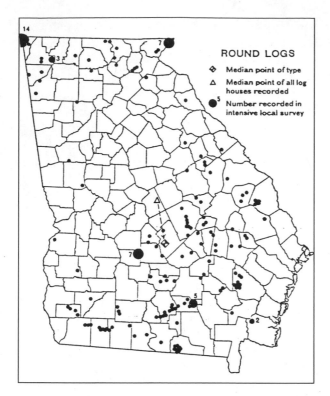

FIGURE 20 Round logs.

NOTES

The fieldwork reported in this paper was made possible by grants from the Viking Fund, Inc. (now the Wenner-Gren Foundation for Anthropological Research, Incorporated), and from the University of Georgia through the office of Dr. George H. Boyd, director of research.

1. Shurtleff (1939), especially pp. 5–6, 214–215. The mythological significance of log cabins is particularly strong in national politics. It figures in the presidential campaigns of 1840 and 1860 and has, since then, been a tradition to be reckoned with by the would-be homespun candidate.

2. Abernethy (1932: 146–148), Johnston and Waterman (1941: 3–8), Olmsted (1856, 2: 9–11), Parsons (1855: 108–111), Wright (1950: 12–34).

3. Olmsted (1856, 2: 10).

4. But Morton Rubin, working recently in Alabama, reports that "at night one can see kerosene lamplight glowing through the cracks [of log houses] into the darkness" (1951: 12).

5. Examples in Arkansas, Oklahoma, and Texas are described in Finley and Scott (1940). Their recency in Georgia is attested by the fact that an informant who left north-

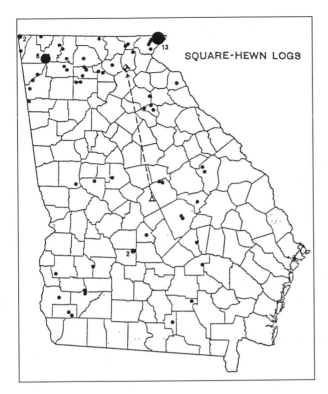

SQUARE-HEWN LOGS

FIGURE 21 Square-hewn logs.

western Georgia some fifty years ago but who still clearly remembers the local architecture does not recall ever having seen one in what is now their chief area of concentration (Kniffen 1951c).

6. One of the earliest descriptions, but still one of the best, of a double log pen is Captain Basil Hall's (1829, 3: 271–272).

7. A single example was found in Wayne County. See figure 3.

8. Olmsted (1856, 2: 9), Rubin (1951: 14).

9. Olmsted (1856, 2: 10, 11), Wright (1950: 32–33), Stoney (1938: 23).

10. Kniffen (1951c) reports "hooded" chimneys on virtually every log house in Louisiana.

11. Hodgson (1823: 137), Hitchcock (1927: 85), Saggus (1951: 13), Wright (1950: 34).

12. A lively description appears in Powell (1943: 57–58).

13. For a general discussion of log forts and blockhouses on the American frontier, see Shurtleff (1939: 9–16, 209–210).

14. U.S. Department of Agriculture (1939).

15. If all the more casually observed structures seen on other trips are included, it is estimated that between 5 and 10 percent of the rural dwellings of Georgia have been noted, but many too hastily to determine their mode of construction. The writer recalls one house

that he must have seen at least thirty times before he finally noticed the log work beneath its weatherboarding.

16. Sviatlovsky and Eells (1937).

17. This is the only remaining area in Georgia where log houses are still being erected as a matter of course (see fig. 2). Even in these well-wooded sections the log house has lost its great competitive advantage over the frame structure. Logs of suitable size and quality for houses are more expensive, now that the virgin timber is exhausted, than their equivalent in planks and siding.

18. Their reappearance in the Pine Mountain district, a distant outlier of the Appalachian system in west-central Georgia, raises the obvious hypothesis of a positive correlation between rugged topography and the rate of log-house occurrence. See also Finley and Scott (1940: 419).

19. The two recorded in Camden County, in the extreme southeast portion of the state, are crude in design. Two structures were noted in McIntosh County that were too aberrant to be classed as log houses by the definition given above, since they were built of thin, rather crooked poles. They did appear to be bastard derivatives of the log house.

20. The writer wishes, in particular, to acknowledge the generous assistance of Margaret Davis Cate of Sea Island, Georgia, whose encyclopedic knowledge of the Georgia coast proved invaluable.

21. In J. P. Corry's painstaking "The Houses of Colonial Georgia" (1930), an extremely useful summary, there are three references to log houses. The first, to the Michel and Myer houses in Frederica, is discussed below; the second is actually a fort not a dwelling; and the third, a log dwelling in Savannah, is obviously a weak experiment at log construction by a builder who had never seen an authentic example of the art.

22. In 1738, Thomas Hawkins of Frederica wrote: "Henry Michel, a Dutch Servant of their Honours and Henry Myers a Dutch freeholder have built them Houses of Squar'd Timber Logs . . ." ("Letter from Mr. Thomas Hawkins . . ." 1913: 16–17).

23. "Die Saltzburger fangen an Häuser von puren dicken Baümen, die aber glatt beschlagen sind, zu bauen, welches in diesem heissen Lande gar *commode* Häuser seen mögen; hiezu aber wird viel Holtz erfordert" (Urlsperger 1744: diary entry for June 30, 1738). It can be readily proved that log work played a major role in the traditional architecture of the Salzburgers. See, for example, Romstorfer (1915: 20, 47, 51).

24. That there were some log houses in Spanish America is, however, well attested: in northeastern Mexico and in New Mexico, according to Kniffen (1952), and among the Tarascans of Michoacán (Stanislawski 1950: 46).

25. John Bartram refers to "half a score" at Rollestown, Florida (1942: 46).

26. Shurtleff (1939: 186, 211–212).

27. Zelinsky (1951b).

28. The best general account of this colony is H. A. M. Smith's (1909).

29. A parallel case is cited by Shurtleff (1939: 170). The frame-building English and log-building Swedes lived side by side in the Delaware Valley for several decades in the seventeenth century without borrowing each other's architecture.

30. "Ich kam bald an . . . niedlichen Häuschen vorüber, alle in dem eigenthümlichen und zierlichen Holzbaustil mit Vordach und Lauben-ein Stil, der übrigens in den Sudstaaten allgemein üblich ist und veillicht abgesehen von der Vorliebe für das Schnitzwerk am Dachfirst auf eine Verwandschaft mit unserem Gebirgbaustil nicht schliessen lässt" (Prin-

ziger 1882: 31). The Reverend John F. Hurst (1892), who visited Ebenezer a few years later, described log houses that are obviously Deep Southern and not Austrian in inspiration, an impression reinforced by the engravings accompanying his article. These log houses had evidently reached Effingham County recently from inland sources. The writer wishes to acknowledge gratefully the assistance received from S. Waltenberger, Dr. Egon Lendl, Dr. Frederike Prodinger, and Dr. F. Breitinger, director of the Salzburger Museum Carolino Augusteum, all of Salzburg, and from Dr. Guido Weigend, Rutgers University, and Clement de Baillou of Athens, Georgia, in unraveling the riddle of Salzburger architecture in Georgia.

31. "Letters from John Stewart to William Dunlop" (1931: 17, 85, 97), Stoney (1938), Davis (1803: 61–62, 63, 75).

32. Interviews with the rural population of the coast produced reports of log structures that were in existence a generation ago and have since been destroyed by man or fire.

33. Kniffen (1952) states that the longevity of log barns is greater than that of log houses.

34. Vocelle (1914: 50) offers a photograph of a jail in Camden County with a worm fence around it, but there is no indication of its date.

35. Minnie Stonestreet, Washington, Georgia, personal communication.

36. The log may also be planed flat on only two sides, it may be hewn to an octagonal shape, or it may be split in two to form puncheons, the flat side facing inward, but these and other variations are minor.

37. Coulter (1947: 50 and drawing facing 214), Frazier (1951: 128), Thompson (1915: 42ff.).

38. Tyrone Power mentions Indian log cabins in the Columbus area (1836, 2: 134).

39. The best general studies of the architectural derivatives of the log house are Kniffen (1936: 184, 190–191) and Scofield (1936: 232–235). On a broader scale, Wertenbaker (1938, 1942) is well worth the attention of the student concerned with the place of the log complex in the development of American culture.

The Greek Revival
House in Georgia

Perhaps no other development in the fine arts in the Deep South has had such far-reaching effects or attracted wider notice than the architectural movement known as the Greek Revival. It is the purpose of this brief study to sketch the characteristics of the Greek Revival building as it appeared in Georgia—a state offering a good cross-section of the Deep Southern culture area—and to explore the significance of this phenomenon as an element in the culture history and geography of the region. The data used here are drawn from the available literature[1] and from field observations made during the period 1950–52 in all sections of the state in the course of a general study of Georgia's settlement characteristics.

Unlike the preceding vogues in American architecture, which were merely automatic responses to European whims, the Greek Revival was primarily an American idea, the first great outpouring of our architectural energies; and nowhere was the product of this sudden self-discovery more inspired or its effects more profound than in the Deep South. Faint foreshadowings of the movement appeared in earlier decades, but it was with the 1830s that the Greek Revival burst into full bloom in Georgia and other Southern states. This was the era when the frontier was moving forward at breakneck speed and the cotton boom was in its first, fine fever. Some of Georgia's newly created wealth was converted into grandiose houses which still mark the course of the tide of slavery and cotton westward across the state.[2] For thirty years, until the very eve of war, the experiment in the architectural new medium went on with unflagging vigor among the members of the upper class.

The momentum of the movement was so great that after the lapse of some twenty years of armed conflict and economic dislocation this architectural genre reappeared, even though in diluted form and in a manner designed to suit the *fin de siècle* taste of late nineteenth-century America. A considerable number of these latter-day attempts in the classic mood still line the streets of Georgia towns, and though all of them have broken sharply with antebellum techniques and many

are frank compromises with Victorian building clichés, some of the old energy of the Greek Revival emerges in most. Indeed, the Greek Revival has never really expired in Georgia; even now there are those who revere tradition and are able and willing to essay new themes in the Greek Revival manner.

In its inner anatomy and sometimes in its outer plan the Greek Revival mansion divulges the humble course of its evolution. Almost every example has a large central hallway that is believed to have its ultimate origin in the breezeway between the two halves of a double log cabin.[3] Some plainer specimens are merely the older two-story frame house with sideward-facing gables and end chimneys to which a classical façade has been appended almost as an afterthought. The symbolic importance of the portico was such that on many a would-be Greek Revival house the pediment is nothing but a false front which is wholly grotesque when viewed from the side. The transitional zone from unadorned frame dwelling to Greek Revival mansion is filled by many an honest compromise between the two types: the portico may be the full two stories high but without properly carved pillars, or the portico may cover half or less of the front. At the opposite extreme, there are temple-like structures that are almost archaeologically precise reconstructions of ancient styles. And well they should be. Some of the better Greek Revival houses involved the services of trained architects—not the local handy man who worked on the older and humbler dwellings—as well as the importing of expensive artisans or specially commissioned work.

All of the more ornate Greek Revival mansions are nearly square in plan; only those that were closely linked with the older folk-architecture were laid off as narrower rectangles. All are set on high basements—and are thus sharply set off from the cellarless homes of the middle and lower classes—and all are, or were, painted white unless brick was used in place of wood. As a rule, the roof is unusually low in pitch and is often invisible to a person standing near the building. The porticoes cover the front and frequently the sides of the structure. These high, broad porticoes in combination with shuttered windows and high-ceilinged rooms fitted this architecture nicely to the hot, humid summers of the region.[4] The treatment of the columns was infinitely varied: some were fluted, others left smooth; square columns were occasionally adopted; some were slimmed down to vestigial ribbons; and all three of the major classical orders were used for the capitals—Doric and Ionic were the most often favored. The design of the pediment was even less inhibited by tradition, with the result that many struck a truly fresh note and were esthetically exciting.

All in all, the Georgia Greek Revival house displays great variety—from pomposity and stolid dignity to graceful improvisation and even whimsicality, from parvenu grossness to delicate romanticism, but in all cases the spirit of the builder, the place, and the era are most effectively conveyed. It is possible to see a certain community of style in each of the cities where the Greek Revival is abundantly represented; but even within single towns the versatility of expression is surprising. It is fortunate that large numbers of these buildings survive, for with them

Georgia architecture reached a climax it was not able to duplicate in the century to follow and one that it may possibly never surpass. But not all antebellum Greek Revival mansions have received the kindly care they deserve. In Greene County

> some . . . have been abandoned entirely, mere heaps of ruins; in others, a tenant family occupies a few rooms on the first floor; in a few cases Negroes have bought the "old place," in yet fewer instances some direct descendant of the original owner lives in the spacious and sturdy building.[5]

The situation is better in the towns, but even there one often encounters boarded-up mansions in decay and others that are used for commercial purposes.

The Greek Revival was not limited to the great two-story mansion in which it registered its boldest achievements. In a few of the towns of Piedmont Georgia, notably in Eatonton and Madison, the classical style was attempted with charming results in the one-story cottage. Its effects can sometimes be seen in middle or even lower class dwellings. The Greek Revival also affected the development of the architecture of public buildings: many county courthouses, federal buildings, city halls, and the like fell under its influence, and although few are as advanced technically as Greek Revival dwellings, all display a genuine grandeur. In Madison, Augusta, Macon, and elsewhere churches were built quite effectively in the Greek Revival style, and the building styles of those college campuses that developed between 1830 and 1860 parallel those of the best homes of the period. There were even some builders of inns who were infected with an enthusiasm for the style. In the post-war resuscitation of the classical medium, its application has occasionally been carried to absurd lengths as, for example, the use of colonnaded fronts on garages.

It might be supposed from the popularity and general excellence of the Greek Revival house in Georgia that there might be some substance to the rather common belief that the antebellum South consisted almost exclusively of a number of large, quasi-feudal baronies, each surmounted by a Big House resplendent with its great white columns. A closer scrutiny of the facts, however, disallows any such conclusion. It is often overlooked that Greek Revival houses were much more abundant in the principal towns of the South than on its plantations. A special search was conducted for antebellum Greek Revival houses, both urban and rural, at all points visited by the author, and the literature has been combed for references to such structures. The inventory of urban examples is reasonably complete, inasmuch as all towns likely to have Greek Revival homes were scanned. The total of these existing structures comes to precisely 200. In the course of almost a thousand miles of systematic but randomized traverses along the dirt roads of rural Georgia, exactly one mansion that could qualify as Greek Revival was encountered. Eighteen additional rural examples were met with along the principal old highways of the state (now entirely paved) where they were especially wont to occur and in the process of exploring those counties (Wilkes, Greene, and Oglethorpe) where such mansions were relatively common. Undoubtedly, a significant

number of rural occurrences were missed, but even if they could be included in the reckoning, the disproportion between urban and rural examples would still be enormous.[6]

Thus the pattern of Greek Revival dwellings in the Georgia of 1860 was one of two dozen or so towns with respectable numbers of such buildings and a thin scattering of mansions in the rural parts of the older plantation belt.[7] "True, many planters lived on a large scale, but they were the exception rather than the rule, and had their residences in the city usually, leaving the management of the plantation to an overseer."[8] The bulk of the impressive mansions in Washington-Wilkes, Athens, Macon, Milledgeville, Columbus, and other towns were occupied by members of the mercantile class and by absentee landlords who had important holdings in adjacent or frequently remote portions of the state.

It is interesting to speculate on the quantitative importance of the Greek Revival mansion in antebellum Georgia but, unfortunately, it is uncertain what percentage of the original number have survived to the present day. It is known that of the roughly 250,000 dwellings standing in Georgia in 1860 only 11,361 or about 4.5 percent were still in existence in 1940, but it is obvious that the survival rate for the Greek Revival mansion must be considerably higher than that for less pretentious homes. If a rough guess may be hazarded, then it might be suggested that the original number may have been somewhere between 500 and 1,000. The use of the higher figure would imply a maximum Greek Revival mansion population of around 5,000 persons, or less than 0.5 percent of the total population of the state in 1860. However unreliable such statistical speculation may be, it is nonetheless certain that for all its glamorous reputation, the pillared mansion was, quantitatively, an insignificant element in the cultural landscape of the Old South.

The locational pattern of antebellum Greek Revival houses in Georgia is of particular interest, for it records some key facts in the state's economy and historical geography during the pre-war decades. It has been stated with considerable truth that

> were we to make a map indicating the white-pillared houses of the antebellum South, we should be duplicating the economic map of the staple crops of the section in 1861. It is axiomatic that where there is wealth, architecture develops new forms rapidly.[9]

Indeed, we find the majority of Georgia's white-pillared houses in those cities of the old plantation belt across the lower Piedmont and the Fall Zone that reached the zenith of their prosperity during the same period in which the Greek Revival was most the rage (fig. 1). The new plantation country of southwestern Georgia was opened too soon before the Civil War to have had an opportunity to develop a pretentious architecture.[10] The same explanation may be valid for the rather wealthy sections of "Cherokee Georgia"—the northwestern corner of the state—where the Greek Revival style never managed to gain much of a foothold. In the relatively slaveless upper Piedmont and in the hill country that was economically

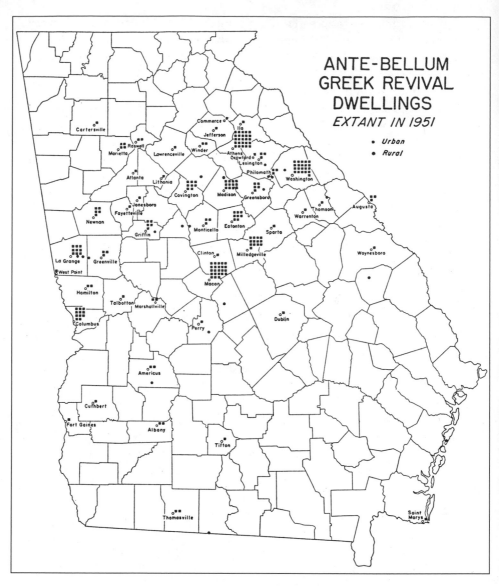

FIGURE 1 Antebellum Greek Revival dwellings extant in 1951.

hostile to the plantation system, the Greek Revival movement failed to materialize at all. The raw backwoods character of interior southeast Georgia before 1860 made it a thoroughly unsuitable habitat for the style.

The coastal areas with their great wealth and large plantations present us with an interesting problem, for there the Greek Revival movement was extremely weak. A single good mansion is to be found at St. Marys, a remarkable one of aberrant design on Sapelo Island, but nothing that is genuinely Greek Revival

in Savannah—the richest and most culturally advanced city in the state—and probably none at all in the countryside. A parallel situation developed in South Carolina where the Greek Revival movement was relatively weak and special in Charleston and other coastal towns but strongly developed in upstate areas.[11] The reason for this anomalous condition would seem to be the fact that in Savannah, Charleston, and other points along the coast, a handsome, highly sophisticated architecture of unique character had been established for many years and almost completely satisfied the architectural aspirations of the mansion-builders of the area. Although the Greek Revival movement made a terrific impact on the cultural near-vacuum of upper Georgia, it caused only a minor ripple in a place like Savannah that could absorb a few of its elements without altering the basic pattern of its building.[12]

The Greek Revival house, it can be concluded, was always minor in terms of the total settlement landscape of Georgia, was mainly an urban phenomenon restricted to a relatively few towns, and was almost unknown in some of the most important sections of the state. Yet its actual importance cannot be fully gauged by numbers of houses and their location, for the influence of the Greek Revival idea on most phases of formal architecture was and is considerable, its quality represents perhaps the highest material achievement of the state, and its traumatic effect on the psychology of Georgians and citizens of the entire nation remains powerful.

COMMENT

This essay is another by-product of my doctoral dissertation. Although there has been a fair amount of work on Greek Revival architecture both before and after the year when this piece appeared, to the best of my knowledge it remains the only attempt to treat the topic geographically. In any case, it would be worth someone's while to revisit all those towns with a significant number of classically inspired buildings to see what fate has befallen the structures after the passage of several decades. Turning to a related question, despite such examples as Athens, Philomath, and Sparta, the urge to adopt classical terms in naming places in Georgia and the remainder of the South was weaker and later there than in the northeastern quadrant of the country.

Journal of the Society of Architectural Historians 13, no. 2 (1954): 9–12

NOTES

The fieldwork reported in this paper was made possible by grants from the Viking Fund, Inc. (now the Wenner-Gren Foundation for Anthropological Research, Inc.), and from the University of Georgia through the office of Dr. George H. Boyd, director of research.

1. The two best discussions of the Greek Revival in the South are Hamlin (1944) and

Major (1926). A briefer treatment is given the subject in Georgia Writers' Project (1940) and Bush-Brown (1937, 1940). Discussions of particular localities are found in Kennedy (1907) (on Savannah), Johnson and Watkins (1935), and Davis (1951). Medora Field Perkerson's exhaustive *White Columns in Georgia* (1952) is a sine qua non as the first detailed guide to Georgia's old mansions.

2. Grecian mansions sometimes appeared in frontier towns almost before the forest was cleared away, as happened in Columbus, Georgia (Arfwedson 1834, 2: 5–6).

3. Bonner (1945: 388), Smith (1941: 27).

4. Bonner (1945: 380), Hamlin (1944: 203).

5. Raper (1936: 93).

6. This disproportion is preserved even if we allow for the fact that upkeep of houses in towns has been much better than in rural areas since the Civil War.

7. The literature on the antebellum architecture of Louisiana and Mississippi (see, especially, Smith 1941) affords the reader a totally different picture: a landscape of few towns but many riverside plantations with Greek Revival dwellings. It is possible that the ease of direct communication between planter and market in the Mississippi Delta eliminated the necessity for many urban centers. Very much the same situation obtained, of course, in colonial Tidewater Virginia.

8. Flanders (1933: 94).

9. Smith (1941: 18).

10. Raper (1936: 95).

11. Johnston and Waterman (1941: 180) report an odd reversal of this pattern in North Carolina, which in many other respects is an atypical section of the Deep South.

12. Kennedy (1907: 221) suggests another factor—that Savannah was used mainly as a winter residence by planter families and that this reduced the likelihood of their building any such summer-oriented structures in the city.

O Say, Can You See?

Nationalism is the reigning passion of modern times. It would be strange indeed if this powerful emotion did not overflow into the visible landscape of a country. It would be equally remarkable if variations in character and over time and space of such tangible expressions of nationalism could not reveal to us something crucial concerning its inner nature and development. For a variety of historical and cultural reasons, an extroverted American republic has been more willing to show its colors in public places than perhaps any other nation in the world.

This essay examines the most nearly ubiquitous nationalistic emblems to be seen in the United States—the national flag (as well as the shield and red-white-and-blue motif that derive from it) and the eagle—to see what their display can tell us about the American nation and its nationalism. Other relevant symbolic objects receive only passing notice.

The term *emblem* is used here in a particular manner to mean something midway between *sign* and *symbol*. The literature on semiotics, which defines and discusses such terms, is quite complex and subject to many alternative interpretations.[1] For present purposes, it is enough to state that a sign is an object that does no more than mechanically identify or indicate other objects in unequivocal fashion. A symbol, on the other hand, resides solely in the imagination. It suggests a variable, often large, often fuzzy cluster of meanings that are sometimes highly emotional in nature. As the quintessentially human construct of the human mind, the symbol has only a tangential relationship to the more external and objective forms of reality. An emblem combines the functions of sign and symbol: it is a label for specific objects, but it can also contain emotive values.

Few observers of the contemporary American scene would question the extraordinary status of the national flag in the individual and collective consciousness of the American people. Citizens confer upon this emblem of statehood a bountiful fund of affection and awe and celebrate it in song, story, and ritual. Indeed, "for many Americans the flag is literally a sacred object." It "is a symbol

so charged with emotion that people cannot look at and judge, even, whether or not the design is aesthetically good or bad." In part, this is because "our nation lacks both a royal family and a single dominant religion. Hence, in searching for an encompassing symbol, the majority have traditionally rallied around the flag. We invented—the first people to do so—an annual Flag Day. Our children pledge allegiance to the flag. . . . Unquestioning loyalty to the flag has been considered a fundamental American principle." And among some segments of the population flag fetishism has gone well beyond the threshold of hysteria.[2]

Although we lack enough data to confirm the notion, I am inclined to accept the statement that "the flag has always occupied a much stronger place in American life and mythology than have flags in other countries" except perhaps for the word *always*.[3] It may not be too extreme to argue that, as the organizing symbol of our nation-state and of the Americanism that may be its civil religion, the flag has preempted the place, visually and otherwise, of the crucifix in older Christian lands.

Thanks to the efforts of various vexillologists, we know all that anyone could reasonably wish to know about legal, heraldic, and most other aspects of the history of the American flag. Moreover, a few scholars have documented the enduring vitality of the flag in our folk arts, especially on items destined for domestic use, including furniture, fabrics, china, crockery, wall decorations, quilts, and virtually every imaginable, and some unimaginable, objects.[4] Anyone who has browsed through American newspapers and magazines of the twentieth and late nineteenth centuries can hardly avoid noticing the extensive exploitation of the flag in mastheads, advertisements, cartoons, and corporate logos, as well as on commercial products and company stationery. The American flag may well have attained the peak of its exposure in the popular arts during the period extending from the 1960s through the Bicentennial, when "Middle Americans" and adherents of the counterculture waged a kind of guerrilla campaign against each other. Both groups brandished the flag, but each followed quite different modes of reverence and taste, so that it appeared in various guises on things and surfaces that might not have been thinkable earlier.

Despite the great prominence of the national flag in American life, scholars have shown no interest in its place within that tableau of outdoor objects we designate as the landscape, except for some commentary concerning its display on school buildings and grounds and a solitary academic sortie that examines flag display in a Philadelphia working-class neighborhood on Flag Day. Nevertheless, even the most casual sort of fieldwork readily reveals how conspicuous and pervasive a role our national flag plays in the present-day American scene. It inevitably adorns every federal, state, county, and municipal facility, and we find flags on or next to, as well as inside, museums, public and private schools, monuments, and many or most office buildings, hospitals, cemeteries, apartment buildings, and churches. On national holidays and other special occasions, parade routes and ceremonial spaces are festooned with countless flags and flaglike bunt-

ing. Surprisingly few factory or warehouse structures lack flags, and often the pole and associated landscaping are large, elaborate, obviously costly affairs. A high percentage of service stations and other highway-related establishments display the flag on poles, exterior walls, or windows. We also encounter it on trucks and automobiles, farm silos, advertising signs and billboards, clothing, and many a manly tattoo and as decals on miscellaneous surfaces. In brief, it is nearly ubiquitous. Perhaps most revealing of underlying attitudes is the large number of private residences equipped with flagpoles or other flag hardware from which the national banner flies, constantly or on selected occasions. As is the case with all the other places noted above, except, possibly, for federal and school buildings, such manifestations of patriotism are quite voluntary, as well as rather expensive. They are not the product of any ukase from on high.[5]

It is important to note that no other types of flags—the nearest competitors being the corporate banners of some franchise operations—approach such ubiquity. Unlike the Canadian situation, where the provincial flag may rival the national device in popularity, one rarely observes the flags of states or our larger cities except on official structures. Indeed most citizens would fail to recognize such localized emblems if they did happen to come across them.

Much less widespread, but still quite numerous, is another symbol related to the flag, but more directly akin to the national seal: the red, white, and blue shield. This familiar design abounds, of course, in markers along the national highway system; but it crops up repeatedly in corporate and association logos and in many kinds of commercial and noncommercial signs. It is but one facet of a more general recent phenomenon that has escaped serious attention, except in connection with the Bicentennial celebrations: the red-white-and-blue motif.[6]

The frequency with which this color combination shows up—almost always in the indicated sequence—in the logos of major and lesser business firms and on every conceivable sort of sign and public decoration—is actually quite astonishing.[7] In some instances, obviously, the choice of hues is calculatedly allusive, but much more often, I suspect, the subconscious mind has been at work. The designer divines, in instinctive fashion, that these are the colors most likely to strike a responsive chord in the general psyche. One might argue that the juxtaposition of red, white, and blue is visually jarring and thus ideal for advertising and related purposes, but other tricolor formulas can be even more effective as attention-getters. Perhaps the most convincing evidence of the nationalistic import of these colors is the relative rarity of the national colors in public spaces in Canada and most other foreign lands, with the exception of Italy, perhaps, and Sweden more definitely.

Is the United States unique among the countries of the world in its obsession with its national flag, and, specifically, in the propensity to display it in public places? In lieu of published data or a methodical worldwide survey, any answer must be provisional. I have the impression that the combination of green, white, and red—the order in which they appear on the Italian flag—has been used with

increasing frequency recently to denote things Italian in signs and advertisements within the United States. But from the scattered information and recollections available to me, my guess is that the only nation that rivals the United States in the frequency and fervor with which the citizenry exhibit the flag of their own free will may be Sweden, where the national colors (blue and yellow) are conspicuously presented on a great variety of objects. Many Swedish homes and vacation cottages are equipped with flagpoles, from which the national flag is flown as frequently as possible. Moreover, the flag appears in many other unofficial locations and on a wide variety of objects. The Swedish flag code is almost as elaborate as the American, and flag display is prescribed for no fewer than sixteen holidays, religious as well as national.[8]

The incidence of national and provincial flags in Canada is significant, but well below the level in its southern neighbor. I recall seeing very few national flags, except in government installations, in Mexico, Central America, Great Britain, and Ireland during my travels there; and I am told that the private display of the national flag in Brazil is exceedingly uncommon. In the course of several thousand kilometers of highway and ship travel through Germany, France, Belgium, Switzerland, and Turkey during the summer of 1983, I took special pains to note flags along the way. In the case of West Germany, I did not observe a single national flag aside from those on naval and merchant ships and government buildings; and very few were visible in the other countries, with the single interesting exception of Switzerland. In that land a fair number of private residences fly the red-and-white national flag, but the frequency of such displays is well below the modest level to be seen in Canada and, presumably, Sweden.[9]

These three interrelated items—the flag, shield, and red-white-and-blue motif—are so omnipresent in such numbers that perceptual saturation may have set in. They recede comfortably into the familiar visual background against which we tend to notice mostly only the out of the ordinary; but if they were absent, we might well be vaguely disturbed. As I can attest from field experience, much concentration is needed to perceive the full extent of their physical presence; but, when one does go through the exercise, the degree to which the American visual scene is punctuated by these symbols is truly mind boggling.

The historical career of the American flag has been radically different both quantitatively and qualitatively from that of other nationalistic items in the American landscape and behavior. During its early career, the national flag was remarkably unimportant to the citizenry at large (and it was many decades before its design and dimensions attained strict standardization).[10] It is possible, although not yet documented, that the flag may have appeared occasionally in domestic crafts at an early date. But, if that was the case, the flag was far less popular than the eagle, Miss Liberty, or the figure of George Washington. What can be established definitely is the fact that, in the early decades of the Republic, the flag materialized seldom, or not at all, in those media logically most congenial to it.

The negative evidence is impressive. In an exhaustive treatment of the Ameri-

can Revolution in drawings and prints that covers the period up through 1789, Donald H. Cresswell does not include a single representation of the flag. Similarly, the largest collection of songs and ballads of the revolutionary period fails to include any reference to the flag even in its earliest versions. In what may well be the most nearly definitive catalogue of American political iconography on textiles we shall ever see—1,501 illustrations in all—the earliest American flag depicted is to be found on an 1815/16 bandanna celebrating the Battle of New Orleans, while the first to appear in a symbolic mode shows up on an 1819 kerchief. An analysis of some 2,500 Fourth of July orations delivered between 1777 and 1876 notes that the flag was seldom mentioned before 1845 and the Mexican War. As of 1794, the "Stars and Stripes had never been carried by our army, nor would it be for another generation to come. We had no navy to display it abroad, and while it floated over some merchant ships and over land fortifications, the vast majority of Americans never came in contact with a fort or with a ship at sea. Since they seldom, if ever, saw the Stars and Stripes, and never, until the Mexican War of 1846–48, fought under it, they did not possess the sentiment of love for the Flag which today is shared by all Americans." [11]

If the ascendancy of the flag began in earnest with the Mexican conflict and perhaps also with the growing popularity of Francis Scott Key's "Star-Spangled Banner," "the start of the Civil War encouraged for the first time on a wide scale the display of the national flag."

[T]he cult of the national flag, as it has endured to this day, was a direct outcome of the Great Rebellion. . . . Edward Everett, in Boston two weeks after the attack on Fort Sumter, spoke of "the flag, always honored, always beloved [but now] worshipped." The word was by no means too strong. And what had been a stern and solemn enthusiasm in wartime became a joyous delirium at war's conclusion. As one writer asserted: "After the fall of Sumter [to federal troops] Cincinnati was fairly iridescent with the red, white and blue." Cincinnati was but typical of all cities, towns, and villages over the length and breadth of the land. [12]

But the climactic era of flag worship was still to come. Indeed, it was only in 1943 that the Flag Code, originated by voluntary associations, was legalized by Congress. Flag Day was first celebrated in 1877, but the movement to popularize the holiday did not really take off until 1890. From the late 1880s onward, and especially during the 1890s, organized zeal on behalf of the flag attained fever pitch. Not too coincidentally, this was also the period when many of our patriotic-hereditary organizations were founded or began to flourish, when fresh varieties of xenophobia began to sprout, and when old-fashioned imperialism attained maximum virulence. In 1888, the influential mass-circulation *Youth's Companion* launched sustained campaigns to install a flag over every schoolhouse in the nation and to adopt the Pledge of Allegiance universally. [13] Almost simultaneously, in 1889, the Grand Army of the Republic proposed that flags be flown by all public

schools in New York, then later proposed the same for other states, and labored mightily against flag desecration and to induce civilians to salute the flag, something citizens had seldom done previously. Indeed we can attribute much of the modern ritual surrounding the flag to the exertions of this first large veterans' organization and its successors. Their efforts bore fruit: "When a G.A.R. committee first mounted a school platform to present its flag to an attentive young audience, the flying of the Stars and Stripes over educational institutions was virtually unknown. By 1895 the commander in chief was able to boast that they floated over 17,988 of the 26,568 public schools within the twenty-one Grand Army departments." [14]

Unfortunately, the available verbal documents say nothing about the flying of flags on private dwellings, business establishments, or public buildings other than schools. Nor do the documents say anything about the changes in this practice over time. But we can extract useful information from two sources: the illustrated county atlases of the late nineteenth century and especially the 1870s, and present-day field observations. A sizable minority of the hundreds of county atlases produced during the last century included not only maps and general accounts of the history and geography of the locality but also—for a consideration, to be sure—marvelously detailed engravings of many of the principal farmsteads, town dwellings, and commercial structures, and, occasionally, the countenances of their proud proprietors were depicted as well. [15] We can be certain that the artists idealized their subjects to some extent, but we can be equally certain that, in this era of exuberant materialism, they overlooked no detail, however trifling, that might brighten the image of their patrons. Thus the drawings of house, shop, or courthouse are photographically precise; among the multitudinous gear depicted, we can see lightning rods, dinner bells, birdhouses, weather vanes, croquet hoops, the very slats of the shutters. As for passing vehicles and pedestrians, we see all the carriage hardware and every flounce on the ladies' skirts. If flags or flagpoles had been visible, the artist would not have omitted them.

I have examined some forty-nine illustrated atlases, with a median publication date of 1875, for counties in Ohio, New York, Pennsylvania, and Michigan, states in which I also carried out field observations. (Illustrated county atlases are rare or nonexistent in Wisconsin and states outside the Midwest and Middle Atlantic regions.) Only 16 of the 3,417 single-family dwellings appearing in these publications were shown flying flags, and another 6 had poles but no flags, making a grand total of 0.6 percent of the buildings enumerated (table 1). [16] Since we are dealing here primarily with upper-class citizens—those most financially capable of expressing patriotic urges in tangible form—this value may overstate the general prevalence of American flags on the residential scene of the 1870s. Flags were much more numerous in the vicinity of nonresidential structures. Of the 246 public edifices (schools, churches, government buildings, and so on) tabulated, 8.9 percent sported flags or flagpoles, while the score is 11.0 percent for the

767 commercial and manufacturing establishments. Architectural eagles were so little in evidence in these early atlases that there was no point in noting them.

During the summers of 1981 and 1982, I systematically observed flags, flag hardware, and eagles on the exteriors and grounds of occupied single-family dwellings in rural tracts and smaller towns on days other than national holidays along automobile traverses through the following areas: central Pennsylvania, southwestern New York, northern Ohio, southeastern Michigan, south-central Wisconsin, southern Ontario, western Connecticut and Massachusetts, western Maryland, eastern West Virginia, western Virginia, and north-central North Carolina. Deliberately omitted were observations of nonresidential buildings and grounds, that is, places in which the incidence of flags is so great as to be uninteresting. Virtually all government facilities fly at least one flag; a conservative estimate for shops and office buildings would be 25 to 30 percent and for factories and warehouses well over 50 percent. I was able to record both flags and eagles only on those trips for which an assistant was available. The large differential between public and private places in incidence of flag display is not surprising. The proprietors or custodians of public places generally have more funds at their disposal; there is more unspoken social pressure to declare national loyalty in locations where people gather; and, given the relatively heavy traffic in public places, there is a greater, if intangible, return on the investment.

Flag display by American homeowners occurs in a variety of ways. The most elaborate is on a large metal flagpole (usually surmounted by an eagle) set in a carefully landscaped plot that may contain decorative objects as well as flowers and low shrubs. But in many places the pole may be much shorter and simply inserted into the grass; and, in the extreme case, the flag may be only the tiny sort schoolchildren brandish while watching parades. Although these poles, or just the flags, usually stand in front of the house, they often appear on lawns off to the side and, occasionally, even in the backyard (thus making a full count from the highway rather difficult). Nearly half the poles observed would seem to be flying the flag night and day throughout most or all of the year; on the others the flag may appear only on holidays and other special occasions. On a significant minority of houses, we find flagpoles attached at an oblique angle to the porch or wall or flags draped on a window or wall or from the porch railing, some of them small, pocket-size affairs.[17]

The incidence of all these forms of flag display among the 11,763 residences observed in 1981–82 was 4.7 percent, several times greater than the value derived for portions of the same areas a century earlier. At 4.2 percent, the popularity of the eagle is almost as great. Although it would be useful to have a denser network of field observations in the states and province already mentioned and in others as well, the data in table 1 seem capable of supporting one major conclusion: a remarkably sharp disparity in the propensity to display flags and—to a lesser, but still significant, degree—eagles as between the Northeast and the South at the

TABLE 1. *Premises of Occupied Single-Family Dwellings Observed for National Flags, Flagpoles, and Eagles*

Area	Premises Observed for Flag Items	Flags on Freestanding Poles		Flags on Buildings		Poles without Flags		Total Flag Items		Premises Observed for Eagles	Eagles on House or Outbuildings	
		(No.)	(%)	(No.)	(%)	(No.)	(%)	(No.)	(%)		(No.)	(%)
Ohio												
1875	1,440	4	0.3	0	0.0	2	0.1	6	0.4
1981	567	24	4.2	8	1.4	38	6.7	70	12.3
New York												
1875	337	3	0.9	0	0.0	0	0.0	3	0.9
1981	731	33	4.5	16	2.2	28	3.8	77	10.5
Connecticut/Massachusetts												
1982	440	22	5.0	13	3.0	8	1.8	43	9.8	440	27	6.1
Wisconsin												
1981	701	33	4.7	0	0.0	33	4.7	66	9.4	701	8	1.1
Pennsylvania												
1875	1,017	5	0.5	0	0.0	4	0.4	9	0.9
1981–82	1,621	44	2.7	18	1.1	33	2.0	95	5.9	834	47	5.6
Maryland/West Virginia												
1982	642	10	1.6	5	0.8	21	3.3	36	5.6	642	49	7.6

Michigan												
1875	623	4	0.6	0	0.0	0	0.0	4	0.6
1981	486	5	0.8	1	0.2	20	4.1	26	5.3
Subtotal (North)												
1875	3,417	16	0.5	0	0.0	6	0.2	22	0.6
1981–82	5,188	171	3.3	61	1.2	181	3.5	413	8.0	2,617	131	5.0
Virginia												
1982	2,942	15	0.5	16	0.5	24	0.8	55	1.9	2,942	114	3.9
North Carolina												
1982	714	0	0.0	2	0.3	1	0.1	3	0.4	714	17	2.4
Subtotal (South)												
1982	3,656	15	0.4	18	0.5	25	0.7	58	1.6	3,656	131	3.6
Ontario												
1981	2,919	48	1.6	2	0.1	34	1.2	84	2.9	0	0	0.0
Total												
1875	3,417	16	0.5	0	0.0	6	0.2	22	0.6
1981–82	11,763	234	2.0	81	0.7	240	2.0	555	4.7	6,273	262	4.2

Note: 1875 is a median date for information gleaned from atlases. The data for 1981 and 1982 are from field observations.

present time (and, inferentially, earlier). Although the flag-and-eagle syndrome may be strongest in portions of Ohio, New York, New England, and Wisconsin, it is far from trivial in all the observed portions of the Northeast, except for some parts of Pennsylvania dominated by pietistic German Americans. But southward from the latitude of Winchester, Virginia, there is an abrupt falling off in the phenomenon; and in the Deep South one can travel many miles before finding even a single private home displaying the national banner—or the Confederate flag, for that matter. The incidence of the American flag is relatively low even on nonresidential properties. This North/South differential would hold even if one were to make allowances for the greater percentage of poorer homes in the South. It is interesting to note that the incidence of the new maple-leaf flag and the older imperial ensign in Ontario, which suffers competition from the provincial flag, is well below the comparable value in the United States Northeast, but also far above the Southern value. Of course, eagles are nowhere to be seen on Canadian buildings.

This observation of a steep latitudinal gradient parallels closely the discovery of an equally sharp disparity between North and South in the incidence of nationalistic place names, a development that long antedates the Civil War and has persisted ever since.[18] What we may be witnessing in the cases both of place names and of tangible nationalistic symbols are but two visible manifestations of a deep, stubbornly durable difference between the cultural and social mind-sets in these two major regions.

Clearly, more data on the history and geography of flag display in the United States and elsewhere, and both indoors and outdoors, would be welcome. The careful field sampling of scores of countries could yield interesting results, as would a comprehensive survey of the American landscape. One could also ferret out relevant material from newspapers, magazines, corporate files, museums, and photographic archives at the cost of much drudgery. In any case, the evidence adduced above, fragmentary though it may be, leads inescapably to one major conclusion: The public display of the American national flag—and derivative items—has increased mightily over the past two centuries and may still be increasing today. This fact suggests some important attributes of the collective emotional life of our citizenry and the changes therein.[19]

This essay covers only a small portion of the material assembled and currently in the process of analysis for a monographic treatment of the shifting symbolic foundations of American nationalism. The historic career of flag display in the life of the country and, inferentially, the changing intensity of flag worship are curiously at odds with the evidence for other nationalistic items. Within the space available here it is hardly possible to set forth the complete documentation or to develop to the full a thesis that is far from simple. It is feasible, however, to outline the basic elements of a likely explanation and thereby reconcile the clashing components of a seemingly impossible paradox.

As we have seen, the national flag appears to have gained steadily in importance

from its relative obscurity, visually and otherwise, in the earliest years of the Republic to its present-day proliferation in the tens, if not hundreds, of millions in both public and domestic sites. It has become a locus, in emotional terms, close to the very center of national existence. But precisely opposite have been the trends for other equally powerful expressions of nationalistic fervor. Thus we find that a populous pantheon of national heroes (largely in the political and military realms) were the objects of intense veneration from the very beginning of national independence throughout the last century. As early as the 1850s, however, there was a perceptible tapering off of this passionate hero worship, and, with the exception perhaps of the Lincoln cult that flourished most vigorously around the turn of the century, the downward trend has persisted into our own times. We live now in a skeptical, antiheroic era, one of ephemeral celebrities rather than durable, authentic heroes. Indeed it is impossible to think of a single twentieth-century figure in America who commands universal devotion, while the mythologized heroes of the past excite us far less than would have been thought possible a few decades ago.

In precisely the same fashion, the observance of national holidays has become perfunctory at best. During the infancy of the Republic, July 4 and Washington's Birthday were great popular festivals, the occasions for wild rejoicing and national glorification. Subsequently, Memorial Day, Lincoln's Birthday, Columbus Day, Flag Day, and Armistice Day came to be holidays of considerable solemnity and patriotic import. Today they pass unnoticed by many Americans. Our national holidays—and the major religious ones as well—have become commercialized, and their deepest meaning for most of us is as an extended weekend. The chronology of nationalistic place naming has followed the same trajectory: the bestowal, during the Republic's first decades, of words from the lexicon of American ideals and the names of national heroes upon thousands of physical and man-made features, then the decline of the practice during the latter half of the past century, and, in recent years, its near extinction.[20]

The American landscape is still thickly populated by nationalistic monuments commemorating eminent personages and major historical events, but the vast majority were erected during the period 1850–1920. Since then, despite the general flowering of public art, overtly nationalistic monuments have been notable for their rarity; and the few recent items have been relatively inconspicuous and usually radically different in form from their forebears. This may not be entirely due to encroaching cynicism, since the nonrepresentational style that has generally dominated all kinds of art, including the public variety, from the mid twentieth century onward does not easily lend itself to the expression of patriotic sentiments, but parallel trends are apparent in school texts and in the fine arts outside of the civic sphere. In the former case, the unabashed jingoism and patriotic exhortations of yesteryear have been replaced by more restrained or equivocal publications and, occasionally, even by mild self-criticism.[21] As far as our more ambitious contemporary painters and sculptors are concerned, few, if any, would

dream of exhibiting the fiercely nationalistic canvases, friezes, and statuary that could have led to artistic fame and fortune in the nineteenth century. The history of American verse, fiction, and music follows much the same pattern.

What are we to make of this contradiction? How can one account for the enormous proliferation of the national flag in a land where other modes of nationalistic celebration have dwindled or fallen by the wayside? I believe there is a rational explanation, but only if one recognizes that, despite obvious legacies and continuities from national beginnings to the present period, the social and political structure of the United States has experienced a truly profound transformation, as has the mind-set of the citizenry.

The present-day United States is a splendid example of the nation-state, a thoroughly modern institution. By definition, such an entity represents an intimate fusion between state and nation. The state, of course, is a military-political apparatus, which, in various forms, has existed for several millennia; the nation, although rather less tangible, can be equally potent—a community of individuals who may or may not have achieved political autonomy but who believe they possess a unique set of historical and cultural traditions (whether genuine or fabricated) or a set of social, religious, or political traits and ideals that set them apart from other nations. The modern state—that is, the would-be perfected nation-state—differs from its antecedents in that it aspires to become the supreme claimant for the loyalty and love of its subjects. It is no longer content to exact obedience and wealth from the indifferent or sullen masses through brute power alone. In the twentieth century, the state can realize its mission most effectively if it monopolizes the deepest feelings of its population, if it is regarded as the ultimate repository of social values. Such an ideal communion between state and citizen comes to pass most readily if the state is able to identify and intertwine itself with a single preexisting nation or, when necessary, with the nation it has been obliged to create.

For most of the world's people today, membership in, and absolute loyalty to, a given nation-state is so commonplace and pervasive that it is difficult to picture any alternative situation. It is only on those rare occasions when we encounter the exceptional condition, that of the "stateless person"—the individual who is unable to find asylum in any country as a temporary or long-term resident, much less as immigrant or citizen—that we are shocked into awareness of "statelessness" and the recognition that the rest of us exist under quite different terms. These terms of existence are now so universal, so much taken for granted, that our vocabulary lacks a word for them. Perhaps *statefulness* will do.[22] In 1776, in America and elsewhere, the term *statelessness* and *statefulness* would have been quite nonsensical.

The process of nation-state formation is least awkward (but perhaps most difficult to observe) when nation and state have originated and ripened almost simultaneously and have hybridized in doing so. We can see likely examples of this in the cases of France, England, Sweden, Russia, Japan, and perhaps Australia.

There have been many more instances of recently formed states inheriting two or more nations and being less than totally successful in forging a homogeneous nation-state: for example, Canada, Lebanon, Iran, Pakistan, India, Belgium, Yugoslavia, and most of the newly independent African states.

In the case of the United States, we witness the birth of a nation taking place before the attainment of political sovereignty. Parallel instances include Eire, Poland, Italy, Bangladesh, Kurdistan, and the Palestinians. Especially instructive is the history of the Israeli nation-state. The preexisting Jewish nation, although territorially fragmented, was intensely conscious of its nationhood and the possession of a particular history and cluster of ideals. Through the mechanism of Zionism, the state, or rather nation-state, of Israel has come into existence, a political entity whose behavior has raised perplexing questions among both citizens and external observers as to whether the conflict between traditional national ideals and the imperatives of statehood can ever be resolved satisfactorily. The case of the American nation-state is parallel, although developments have been less rapid and the contradictions between nationhood and statehood less dramatically joined.

The thesis I wish to propose is that the genesis of a self-aware American nation preceded by a few (probably no more than twenty) years the origin of a sovereign state in 1776, that for the next several decades the concept of nation was more powerful than that of state, and thus, as in some other examples cited above, the two processes—nation-formation and state-formation—were out of phase. The historical evidence is abundant. Indeed, it is something of a miracle that a unified American state appeared at all, survived, and ultimately became omnipotent, given the aversion of early Americans to strong central authority and given their dread of the professional military. In fact, it was only with the events that culminated in 1865 that the solidity of the American nation-state was finally assured, with the state firmly taking the upper hand.

Distinctly different sets of symbolic activities attend nation- and state-formation. For the earlier American nationhood we find a full complement of explicit, semantically rich items that testify to the ideology of pristine Americanism: the heroes and their utterances; the meaningful names; the holidays and other special celebrations; the mottoes and the exuberant oratory; an opulent iconography; the monuments; the music and literature; and much else.

With the advent of a powerful American state by the late nineteenth century, the original symbols and modes of national celebration began to lose their vigor. Whatever symbols lingered did so weakly, either transformed or submerged under the symbolic trappings of statehood.[23] The new symbols have differed from the old as befits the altered policy. Like other successful modern nation-states, the United States acquired its own self-generated momentum and an essentially amoral character. The essential raison d'être for the state is nothing more than its sheer existence; the fact that it survives and functions is the only excuse needed for continuation and growth. The old symbolic underpinnings are called upon

only infrequently and then in greatly modified form. Since the totally evolved nation-state would function within a fundamentally content-free framework stripped of entangling ideas or principles—a status not yet fully achieved by even the most advanced of countries—one would anticipate that its symbolic accoutrements would display the same tendencies. That is just what we can observe today in the United States: content-free nationalistic behavior in flag worship, the sanctification of the presidency, and the engagement in international sport, to take the more obvious examples.

Unlike many other national flags, that of the United States is not quite devoid of a message. The thirteen stripes signify union, as does the field of stars, which has increased in number from the original thirteen to our present fifty. But whatever idealism the concept of union may have conveyed originally, it is likely that now it is simply synonymous with current definitions of statehood. More significant than the numerology of the flag is its more central message, one writ large upon the American landscape. It is an identification tag and the easiest way for present-day Americans to find social meaning, to declare their statefulness, and to identify themselves in a world where other allegiances have lost their power and magic.

I can outline a somewhat similar, but sketchier, case for the eagle, another cherished emblem of American statehood whose popularity seems to have been growing recently. But there is an interesting difference. Unlike the flag, the American bald eagle enjoyed instant popularity upon its adoption as the national totem in 1782, and it has played a prominent role in American iconography and folk art ever since.[24] My speculation is that the eagle, which once embodied certain ideological notions, has gradually shed all meaning except that of being another sign, a flaglike declaration of statefulness.

The general conclusion we can draw from observing the national flag in the American landscape, past and present, is that it seems to provide strong visual evidence of increasing spiritual as well as administrative domination by the central state and, most especially, of the voluntary participation by the general citizenry in our latter-day statehood. Such celebration of statefulness stands in sharp contrast to the fading away or emasculation of the outward signs of an antecedent faith—the axioms and aspirations that had bound together the early, relatively stateless, American nation.

COMMENT

The questions touched upon in this essay, which is a reworked section of a book-length biography of American nationalism (Zelinsky 1988), have lost none of their fascination for me. Overseas journeys during the past several years have strengthened the belief that there is no more persuasive evidence for American exceptionalism than in the countless nationalistic emblems pervading our land-

scape. During a seventy-seven-day trip around the globe in 1988, I was constantly on the lookout for national flags and colors and similar devices. Among the fourteen countries visited, the only display of consequence was in Singapore, but a dubious phenomenon in light of some not-so-subtle official nudging for flag display on the eve of a national election. Subsequent sojourns in Australia, Germany, and Slovenia have further fortified my conviction. Ironically enough, the only possible counterpart to the jingoistic exhibitionism of the USA is, or rather was, the scene in the Soviet Union. During a visit to Russia and three other soon-to-be independent Soviet republics in early 1991, following the demise of the late-lamented Cold War, I witnessed a dismantling process already well under way—and in place-names as well as monuments, posters, and all manner of other stigmata.

Winterthur Portfolio 19, no. 4 (1984): 277–286

NOTES

This essay has benefited substantially from the suggestions and critical comments of Daniel Connors, Alan Gowans, J. B. Jackson, Michael Kammen, Peirce F. Lewis, David Lowenthal, Donald W. Meinig, and Thomas J. Schlereth. The author gratefully acknowledges grants from the John Simon Guggenheim Memorial Foundation and the Earhart Foundation which helped support the research reported in this essay.

1. Perhaps the most thoughtful and useful critical introduction to signs, symbols, and related matters is Firth (1973).

2. "Who Owns the Stars and Stripes?" (1970: 15), Pullen (1971: 184), W. Smith, as quoted in Wolfe (1975: 61). For fetishism, see, for example, Balch (1890), Harris (1971), and Woelfly (1914).

3. "Who Owns the Stars and Stripes?" (1970: 15).

4. Hope (1973: 292–296), Krythe (1968: 1026), Quaife (1942), Quaife, Weig, and Applebaum (1961), Smith (1975), Horwitz (1976: 54–75), Mastai and Mastai (1973).

5. Balch (1890), Davies (1955: 219), Dearing (1952: 472), Cybriwsky (1972: 200–202), Hayes (1926: 120). Federal laws and regulations governing flag display, designed, in part, to prevent commercial abuse and desecration, were not promulgated until well into this century (Collins 1979: 24).

6. John B. Jackson (1982) notes that the usual form of the U.S. shield is "not heraldic in the strict sense." If it were, it would follow the sixteenth-century German or Swiss design. "Why did we deliberately foreswear the feudal or aristocratic shield?" asks Lowenthal (1977: 263). "Who Owns the Stars and Stripes?" (1970: 13).

7. Although it may be an unusually difficult project—especially in view of the fact that color photography has only recently come into general use—a determined researcher should be able to measure the changing incidence of the red-white-and-blue motif, at least in rough fashion. Many landscape and genre paintings await analysis, magazine files with their color advertisements are available, and we could retrieve records of corporate trademarks and other business iconography.

8. Abler (1983).

9. Schiller (1982; Schiller, a Brazilian photojournalist now working out of New York City, mounted an exhibit of her photographs of the flag on the American landscape, October 13 to November 15, 1982, at the Cathedral Church of St. John the Divine.) It is tempting to speculate that one possible reason for general flag pride in Sweden and Switzerland and its visual rarity in other European countries may be that these are the only two nations in the region that have not engaged in warfare since the Napoleonic period. But it is equally likely that coincidence or other factors have been at work.

10. Quaife (1942).

11. Cresswell (1975), Moore (1846), Collins (1979: 68, 71), Martin (1958), Quaife (1942: 99–100).

12. Smith (1975: 91), Mastai and Mastai (1973: 130–133).

13. Horwitz (1976: 73), Myers (1972: 173–183), Davies (1955: 218), Harris (1971).

14. Minott (1962: 25), Davies (1955: 219–222), Dearing (1952: 472).

15. Thrower (1972). Perhaps even more than contemporary photographs, these delightful drawings offer splendid raw material, as yet almost untouched, to the student who wishes to see how life was being lived, or rather how the privileged imagined it ought to be lived, in the late nineteenth century.

16. The forty-nine atlases examined were published in the following years: 1867 (1), 1871 (1), 1873 (2), 1874 (10), 1875 (12), 1876 (14), 1877 (2), 1878 (4), 1879 (1), 1890 (1), 1905 (1).

17. Another observation not readily quantified is that both flags and eagles are entirely absent from houses designed along modernistic or avant-garde (i.e., self-consciously sophisticated) lines. Conversely, of course, they are most likely to adorn the most popular vernacular house types of past and present. There also appears to be rather more spatial clustering of flags and eagles than would occur randomly. Neighbors emulating neighbors? I regard as questionable James Duncan's assertion (1973: 347) concerning an elite residential neighborhood in a Westchester County, New York, community, namely, that "the American eagle and the carriage lamp-posts which light the driveway are probably meant to convey an image of upper-class prosperity rather than any special attachment to the past." Eagles—and flags—are associated with residences along the entire socioeconomic spectrum, provided the houses are built in the folk and popular idioms.

18. Zelinsky (1983).

19. Unfortunately, the American flag industry has not formed a trade association, and no hard data on volume of sales over time are available from any source, but the anecdotal evidence does support the argument advanced in this paper. Journalistic accounts (e.g., Eng 1981) indicate a substantial increase in sales since the 1960s, following a temporary surge caused by the introduction of the fifty-star flag in 1960. According to an official of Annin and Company, the leading flag manufacturing firm, demand increased spectacularly in 1975 with the approach of the Bicentennial, and a high level has been maintained ever since (Connors 1982). Extraordinary events, such as a papal visit or the 1979–81 Iranian hostage crisis, generate extraordinary demand for American (and papal or Iranian) flags. A disproportionate share of the recent growth of Annin's sales has gone to government and corporate customers. A single national survey of some 8,604 households concerning flag ownership and display habits carried out in spring 1959 is of some interest, if only for its uniqueness; but the sampling technique and other aspects of its methodology render the results somewhat dubious (National Family Opinion 1959). Perhaps the most interesting tabulation is one presenting percentage of homes, by major geographic regions, displaying

the flag on nine specified holidays (National Family Opinion 1959: 8). In general, the South scores more poorly than any of the other three regions.

20. Zelinsky (1983).

21. For treatments of early school texts and their role in patriotic indoctrination, see Pierce (1930), Nietz (1961), and Elson (1963). The distinctly different trends in recent American history texts are discussed in FitzGerald (1979).

22. The classic statement of that extreme form of social leprosy known as statelessness, perhaps the earliest, and all the more powerful for being cast in fictional form is Hale (1865). It first appeared in the December 1863 issue of *Atlantic Monthly*. I believe the date is significant. My departmental colleague Peirce F. Lewis coined the term *statefulness*.

23. A rather similar theme—the transition from the traditional and localized to a landscape dominated by centralized economic and political authority and the persistent tension between the two modes of shaping the land—undergirds Stilgoe (1982).

24. For the symbolic role of the eagle, see Herrick (1934), Isaacson (1975), and Horwitz (1976: 51).

The New England Connecting Barn

Observers of the New England rural landscape have been aware for some time that one of its striking features is the physical linking of the farmhouse with one or more barns; yet no attempt has been made to ascertain the cultural or geographical significance of such "continuous architecture." Throughout the remainder of Anglo-America, houses and barns are set apart from each other, probably in conformity with such British example as early settlers may have had, and there is no ready explanation for the New England departure in farmstead pattern. In their approaches to the agricultural scene American geographers, historians, and architects alike have neglected the barn, in spite of its ubiquity, bulk, and manifold promise for the student of regional cultures. Aside from the relatively abundant literature on the Pennsylvania German country and its large, picturesque barns[1] and a few brief geographical articles on other areas,[2] the record remains blank.

We have, then, only the dimmest conception of the origin of any of the non-Teutonic barn types that have become established on this continent; and there is even much work still to be done on the process by which the Pennsylvania barn was transplanted from the Rhineland to the New World. In preparing for the field reconnaissance reported in this paper, the writer searched all available travel and general descriptive accounts, both old and new, dealing with New England for references to barns and related topics, but with the meagerest of results.[3] Apparently, the barns of the region failed to make an impression on either visitors or native observers before the present century, even those who were expressly concerned with agricultural questions.[4] Unfortunately, the sheer bulk of primary sources on New England history prohibited a systematic exploration of this material, but one of the few scholarly contributions on early New England agriculture based on such sources offers this significant observation:

> The New England barn was neither very commodious nor very conveniently arranged considering the great variety of uses to which it was put. It was often

attached to the house, a rather dangerous practice—so much so that one town ordered (1649) that, "there being manni sad ascidantes in the Contree by fire, to the great damming of manny, by joining of barnes and haystackes to dwelling houses, therfor no barne nor haystacke shall be set within six polles of anni dwelling house opon panillte of twentie shillings." [5]

The field evidence presented below by no means excludes so early a date for the connecting barn.

In the modern literature on New England the connecting barn appears fairly frequently in both text and illustration, but with scant discussion of origin or meaning. In particular, certain of the Federal Writers' Project state guides [6] refer to or illustrate it, Samuel Chamberlain [7] in his photographic essays on the region has trained his camera on various barns, and Eric Sloane [8] has pictured connecting barns in both word and sketch; but the most informative single source is probably Congdon's *Old Vermont Houses*. [9]

The traverse route followed during the summer of 1957 in collecting data on the connecting barn (fig. 1) was designed so as to chart the outer limits of the area of frequent occurrence and to provide a cross section through the center. Because of the scarcity of background information, the itinerary was improvised as the field work progressed. In the main, secondary roads were utilized and the larger urban communities avoided. The type of barn, separate or connecting, was noted for each farmstead visible from the road, and in the case of connecting barns the physical details of both house and barn were recorded. A total distance of about 2,600 miles was covered in the six New England states and in New Brunswick and Quebec, and notes were taken on 4,376 farmsteads, of which 897, or 20.5 percent, had connecting barns. Because of the necessarily haphazard pattern of the traverse route, the results afford only a first approximation to a portrayal of the true areal and statistical characteristics of the New England connecting barns and the basis for further, more methodical exploration.

CHARACTERISTICS OF THE CONNECTING BARN

The connecting barn is, by definition, any barn that is physically joined to the farmhouse; there is great variety in its size, shape, and construction, and in the manner of its connection with the house. [10] Basically, almost all the barns of New England are simple rectangular structures with gabled roofs. Their style occasionally reflects some Pennsylvania German or Middle Western influences, but by and large the barns are elementary and functional in design and strongly resemble many of the older, humbler barns found elsewhere in Anglo-America. An overwhelming majority are of frame construction with board siding, but in eastern New England there is an interesting minority of barns—and houses—with shingle siding. The only nonframe connecting barns encountered were one built of brick and one of concrete block; none were made of stone, and, in contrast

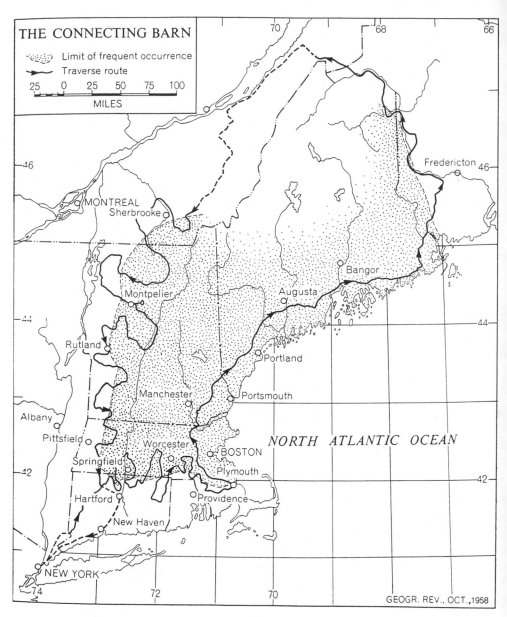

FIGURE 1 Distribution of the connecting barn in New England.

with the South, West, and parts of the Middle West, none were of log. The frequency of painted barns would seem to be rather higher than in most other parts of the country (fig. 2): 610, or about 68 percent of all connecting barns observed, were painted, 400 of them white, 175 red, and the remainder green, tan, or yellow.[11] Another 42 were covered with asbestos or asphalt siding.

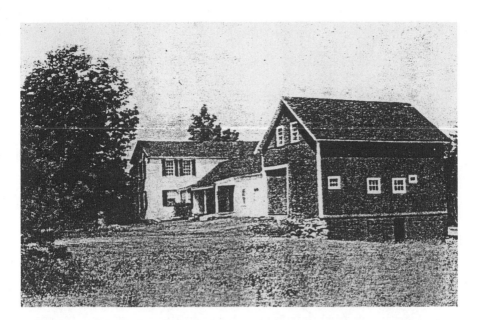

FIGURE 2 The combination of white frame house and connecting red frame barn, as in this example near Pelham, New Hampshire, is quite common.

In size, the connecting barn ranges from a unit scarcely larger than a garage to some rivaling the largest barns of Wisconsin, but the average is smaller than most Middle Western barns. It must be stressed that, from general observation and the meager statistics gathered during this study, there are no significant physical differences between connecting barns and the general-purpose detached barns of New England. Certain specialized barns are almost never joined to the house, among them the widely distributed poultry barn (fig. 3), the tobacco barns of the Connecticut Valley, and the potato barns of the Aroostook Valley. The principal functions of the connecting barn, as of most other American barns, are the storage of farm implements, crops, and feed, the housing of livestock, and, more recently, the garaging of automobiles and the storage of household goods.

The connection between house and barn takes many forms. The most elaborate, and one of the less common, is a corridor or gallery that is roofed but may be open along one side.[12] More frequently, the house and barn are contiguous and share the full extent of one wall, forming a long, straight unit. Even more commonly, the two meet along only part of a wall (fig. 4), *en échelon*. In both cases there is usually a door opening from the house directly into the barn. Many houses and barns simply touch each other at a corner or are connected by a short board fence (fig. 5). Whatever method is used to join house and barn, each preserves its individuality, as is evidenced by the separate roofs (fig. 6); they are *not*, like some dwellings of Central Europe, integrated into a single structure under a common roof.

FIGURE 3 The poultry barn attached to this better-than-average farmhouse near Belfast, Maine, is an almost unique example of the conjunction of a dwelling with a specialized barn.

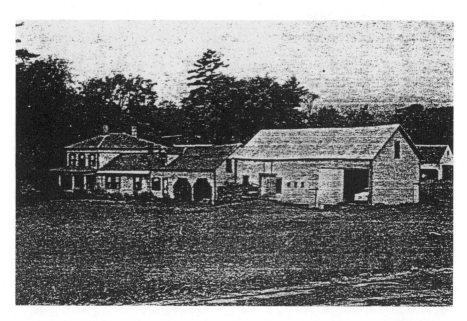

FIGURE 4 A characteristic barn near Lyndon, Vermont. The house would appear to date from about the middle of the last century.

FIGURE 5 This urban dwelling of the Victorian era at Searsport, Maine, has the characteristic barn or shed attached to a rear corner, but only by means of a short board fence.

FIGURE 6 This former farmstead near Concord, Massachusetts, now being used as a country estate, is one of the more elegant examples of the house-barn combination.

FIGURE 7 This example of contiguous farm architecture near New Braintree, Massachusetts, is noteworthy both for the large size of the principal barn and for the total length of the house-barn assemblage.

In New England accretion need not stop at a single barn. Two, or even three or four, barns may extend out from the farmhouse (fig. 7), but they invariably lie at the rear or at one side; no houses were encountered set *between* two barns. The ground plan of the house-barn combination may run parallel to the road or at right angles, or it may assume an L or T shape; but none of these layouts seems to have any functional or geographical significance. Frequently, the farmstead that has a connecting barn may also have barns standing apart, again without any prescribed spatial pattern.

Inasmuch as New Englanders seldom inscribe dates on houses or barns,[13] it is difficult to guess either the absolute or the relative age of contiguous buildings except by studying architectural styles or techniques and the general condition of the structures. It would seem that as a rule the house is older or is contemporary with the first of the connecting barns; if there is more than one barn, the terminal units have often been added at a later date.[14] The relative scarcity of the connecting barn on recent farmsteads, except, possibly, in eastern Maine (fig. 8), leads one to suspect that its popularity may have fallen off sometime in or after the last quarter of the nineteenth century.

One of the interesting things about the connecting barn in New England is the abundance of both full-fledged examples and transitional types, not only in the attenuated *Strassendörfer* but even in fairly large settlements. Farmsteads embed-

FIGURE 8 This farmstead near Searsmont, Maine, is a not too common example of a rather new—or extensively renovated—farmhouse with connecting barn.

ded within expanded villages are a common sight in New England, where town and country have always been peculiarly intermingled. The transitional house-barn complex in a quasi-urban setting generally consists of a substantial house to which is appended a structure that may originally have been either a small barn or just a stable and carriage house but is now almost invariably a garage, storage shed, or workshop (fig. 9). Another intermediate form, most often found around the fringes of the boundary depicted on figure 1, is the wholly rural farmhouse that has a garage, small workshop, or some sort of lean-to attached to it. It might be noted parenthetically that the attached garage, which is a prominent feature of many recently built houses throughout the country, is unrelated in origin to the connecting barn.

DISTRIBUTION OF THE CONNECTING BARN

The field traverse indicates that connecting barns are found with some frequency in northern and eastern New England and the adjacent strips of Quebec and New Brunswick and that only occasionally can one be found beyond the line shown on the map. Toward the south, the boundary runs west from Plymouth to a point northwest of Hartford without ever straying far from the south edge of Massachusetts. It is clear from field reconnaissance and the statements of infor-

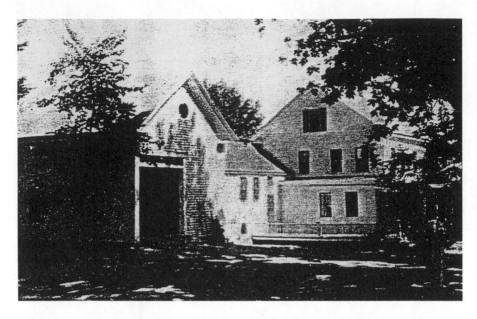

FIGURE 9 This urban dwelling with attached shed, near Sherborn, Massachusetts, is transitional to the fully developed connecting barn.

mants that the connecting barn is unknown southward from this line in Connecticut and Rhode Island, but the situation in southeastern Massachusetts is less clear-cut. The sparseness of agricultural settlement makes it difficult to establish the absence of any farmstead trait, but if connecting barns do occur in the Cape Cod region, they must be rare. After leaving Connecticut, the boundary trends almost due north through western Massachusetts and central Vermont to the Canadian border as it follows rather closely the rugged spine of the Green Mountain range and its southward extension into Massachusetts. In Quebec the line bends gradually eastward as it approaches the unpopulated highlands along the Quebec-Maine border. The segment of the Eastern Townships included within the connecting-barn territory was evidently settled in good part by American frontiersmen early in the nineteenth century,[15] and the area to its north by emigrants from both the United States and the United Kingdom. In any case, the connecting barn is superseded in the north by other Anglo-American barn types rather than by the distinctly different barns found among the French Canadians farther north.[16] A fair number of isolated examples of the connecting barn are to be found elsewhere in the Eastern Townships[17] and in northwestern Vermont. Indeed, the connecting barn appears to have spread over much of New York north of the Mohawk Valley as a minor element in the rural landscape; but even though New England settlement was strong throughout much of the upper Middle West, this barn type seems to have fallen by the wayside west of the Adirondack region. In

southern New York, northern New Jersey, and northeastern Pennsylvania, areas that presumably drew Yankee migrants from southwestern New England only, the connecting barn is wholly unknown.[18]

Because of the virtual absence of agricultural settlement in most of northern and central Maine,[19] no boundary line was drawn through the state, but it is assumed from limited observation that the connecting barn is universal in the settled southern and southeastern parts. It is missing in the upper St. John Valley and the northern part of the Aroostook Valley, regions now strongly French-Canadian in character, but reappears south of Caribou, Maine, and in much of the area between the St. John River and the Maine–New Brunswick border. The New Brunswick segment of the line is sharply defined in the field and separates the connecting-barn territory from an area of detached Anglo-American barn types to the east. However, farther northeast in Maritime Canada it is reported that connecting barns appear in localities occupied by New England emigrants during the eighteenth century, specifically along the south and west coasts of Nova Scotia from Lunenburg to Digby and, particularly, north and east from Digby.

> From Digby east through the Annapolis Valley and around the shores of the Minas Basin and Chignecto where the New Englanders took over completely from the Acadians in the late 50's and early 60's of the 18th Century, the connecting barn is even more common, although by no means universal. One finds it occasionally also inland in Hants County, Colchester County and Cumberland County, and occasionally along the southern shore of Halifax and Guysborough, where I suspect it has New England origins.[20]

Clark also reports that the connecting barn appears in some parts of Prince Edward Island, presumably by cultural diffusion from the mainland, rather than by migration of New Englanders.

Within its primary distribution area in northern and eastern New England, there are pronounced variations in the incidence of the connecting barn. In the marginal parts, roughly the outer 10 to 20 miles, between 5 and 25 percent of all farmsteads have connecting barns. In the areas of Vermont and western Massachusetts traversed for this study, the percentage ranges from 25 to 50. The frequency is greatest in the eastern part of the territory: from 50 to 70 percent in eastern Massachusetts and in New Hampshire and from 50 percent to as high as 85 percent in Maine. With an average of about 65 percent of its observed farmsteads having connecting barns, Maine would seem to contain the strongest concentration at present.

SOME PROBLEMS OF ORIGIN

In attempting to explain the origin and historical geography of the connecting barn, we must rely almost solely on the current distributional pattern and on what

is known of migrational trends during the early years of settlement. As was previously noted, our knowledge of the barns erected in the colonial period by English-speaking settlers is of the haziest sort, and even less is known about their relationships with possible Old World antecedents. Sloane[21] may be correct in asserting that these early barns were "entirely American" and "unlike anything built anywhere else." Although substantial barns were used by large landowners in the British Isles and on the Continent and by the peasantry at large in certain areas of Central Europe, it is likely that few seventeenth-century pioneers in New England with an agricultural background had much of a barn-building tradition. Valuable insight into the barn situation in Pennsylvania comes from the pen of Peter Kalm, a Swedish naturalist endowed with an encyclopedic curiosity who toured the Atlantic seaboard during the years 1748 to 1751 and who had the opportunity to interview survivors of the first generation of Pennsylvania settlement.

> Yet, notwithstanding it was cold . . . all the cattle were obliged to stay day and night in the fields, during the whole winter. For neither the English nor the Swedes had any stables; but the Germans and Dutch had preserved the custom of their country, and generally kept their cattle in barns during the winter. Almost all the old Swedes say, that on their first arrival in this country they made barns for their cattle, as is usual in Sweden; but as the English came and settled among them, and left their cattle in the fields all winter, as is customary in England, they left their former custom, and adopted the English one.[22]

American winters being what they are, even the English settlers eventually saw the wisdom of adopting barns. The most logical hypothesis regarding the connecting barn is that it came into being in or near the original Massachusetts Bay Colony by the middle of the seventeenth century. Its absence in Rhode Island, southeastern Massachusetts, and most of Connecticut could be explained by the fact that these areas were settled before the connecting barn was firmly established in its source region or that they received most of their settlers directly from the British Isles. An examination of the best available maps of the advancing New England frontier and of the migrational routes followed[23] indicates the strong possibility that the connecting-barn territory correlates fairly well with the area settled largely by migrants fanning out from eastern Massachusetts. Beyond the highland crest in Vermont and western Massachusetts that marks the western limit of the connecting barn, the population was apparently drawn chiefly from Connecticut and even, to some extent, from New York. In southeastern Quebec and Maritime Canada the limit of this barn type seems to have coincided with the high-water mark of strong New England settlement. From the beginning of the English Civil Wars until the middle of the nineteenth century, migration from the Old World to New England was negligible, and such interregional movement as occurred was outward from New England to the newer frontiers of North America; hence no alien influences were at work to lessen the popularity of the connecting barn. In more recent years it seems to have lost ground to types preva-

lent in neighboring regions. Its strong persistence in Maine may be attributed to the relative isolation of that state.

Obviously, the connecting barn is a highly practical device in any locality such as New England with severe, snowy winters.[24] The reduced exposure to snow, mud, wind, and cold is certainly a convenience to the farmer and a powerful argument for the connecting barn, only partly canceled by objections to it on hygienic grounds or as a fire hazard. What is puzzling is the fact that similar barns were not in vogue elsewhere, for connecting barns would have meant a gain in both comfort and efficiency for almost any area farther north than, say, Philadelphia.[25] It is paradoxical indeed that the Pennsylvania Germans, some of whom had been accustomed to building house and barn under a single roof in their homeland, should have dropped the practice in America.[26] In particular, there are the most persuasive climatic reasons for connecting barns in the St. Lawrence Valley, where almost none appear; and winter conditions in northern New York and northern Ohio—both of which derived much of their pioneer population from New England—would amply justify their use. If this were a matter of pure climatic determinism, then the optimum region for the connecting barn would logically be northern New York, where winter temperatures tend to range below those in New England and a total seasonal snowfall averaging between 60 and 150 inches well exceeds the 30 to 90 inches recorded for the latter area.

We are forced to accept the suggestion that in the Middle Atlantic States, Connecticut, Rhode Island, and the parts of Canada with no strong influx of New Englanders the early settlers, for reasons that may never be entirely clear, preferred to build their houses and barns at some distance apart. As settlement advanced westward, the emigrants from New England naturally tended to preserve their traditional barn-building ways; but as they became increasingly diluted among settlers from other sources, they began to adopt the material culture of the dominant majority. If this majority had been wholly rational in adapting its farming techniques to the climate of northern North America, the New England connecting barn would have been copied far and wide. As it is, we can add another triumph for conformity to the many instances in culture history where conformity and practicality have conflicted.

COMMENT

I am delighted to report that, after much field and library investigation, Thomas Hubka (1984) has produced a definitive account of the New England connecting barn, one in which he explains its origin and significance in convincing fashion. The argument is too subtle and complex for easy summarization here. Read the full story. But, I might add, there are still some loose ends to be tidied up concerning the spatial distribution of this intriguing barn type.

Geographical Review 48 (1958): 540–553

1. The subject has been covered most recently and with care in Shoemaker (1955), a volume containing valuable bibliographical material. An equally important treatment is Meynen (1939).

2. Durand (1943) and Jackson (1952). Farmstead layout, but not barn morphology, is considered in Trewartha (1948).

3. After a quarter of a century, Wright (1933) remains the best general treatment of the region. However, two more recent volumes are indispensable to the student of New England geography: Kurath (1939) and Thompson and Higbee (1952). Kurath (1939) is notable particularly for its bibliography, the best general one for the region. The following are valuable for special aspects of New England geography or history: Mathews (1909), Brown (1948), Dow (1935), and Scofield (1938). Although little of value turned up in the New England travel literature, the general bibliographic guides to this material may be of interest to students of American historical geography: Cox (1938), Vail (1949), and Handlin et al. (1954).

4. Eric Sloane (1954: 56–57) transcribes without any documentation a "Letter to England, 1780" which states that "these people live near their animals . . . it is difficult to tell where their house ends and their barn begins," and he also quotes an anonymous "English traveler" of 1800 to the same effect. Except for these unverified references, all the literature consulted for this study is mute on the subject of early barn types.

5. Walcott (1936: 233), quoting town records for 1649 in Eaton (1874: 8).

6. Federal Writers' Project (1937a: 65 and following 112), Federal Writers' Project (1937b: following 462), Federal Writers' Project (1938: facing 279).

7. Chamberlain (1944, 1948, 1955).

8. Sloane (1954: 51, 56–57; 1955: 16).

9. Congdon (1946).

10. To the best of my knowledge, there is no vernacular name for this barn type, and the probable absence of any is indicated by the omission of barns in Kurath (1939–43), which offers data on most everyday objects with distinctively regional names or pronunciations of them.

11. We have an early report that many of the barns and stables seen on the road between Boston and Albany were painted red (Rochefoucauld-Liancourt 1799, 1: 396).

12. Congdon (1946: 72–73, Fig. 60) gives an unusually good example.

13. Only two of the connecting barns inspected bore any visible data—1855 and 1883, to be specific—and both were in eastern Maine.

14. Congdon (1946: 79) briefly documents an example of such a gradually elongated series.

15. Hills (1955: 26).

16. Much of this area, both north and south of the international border, is being steadily occupied at present by French-Canadian migrants, but with little visible effect on barn types.

17. Hills (1957).

18. Brush (1957).

19. The unoccupied parts of Maine and other New England states are shown in detail on the two maps accompanying Klimm (1954).

20. Clark (1957).

21. Sloane (1954: 51; 1957).

22. Kalm (1937, 1: 236). It is a matter of the keenest regret that Kalm did not see fit to include New England on his 1750 itinerary (he traveled from Pennsylvania to Quebec via the Hudson–Lake Champlain route), since he was one observer who would almost certainly have furnished us with a detailed account of New England farmsteads. However, Kalm's avoidance of New England was not an isolated instance. The region may have been commercially important throughout the eighteenth century, but it did not begin to attain cultural or scientific eminence until the dawn of the nineteenth century. Most scholarly visitors were attracted instead to such relatively advanced communities as Philadelphia, New York, or Baltimore (Struik I 1948: 4–36).

23. See Mathews (1909), Kurath (1939: Plates 1 and 2), and Dodge (1942: map facing 436).

24. Congdon (1946: 95), Federal Writers' Project (1937a: 65), and Sloane (1954: 57).

25. A possible explanation for the localization of the connecting barn in New England that may merit some investigation is military security. According to this hypothesis, such a structure would afford the beleaguered farmer safe access to his livestock and the various goods stored in barns in a region that experienced more than its share of alarums and excursions during the colonial period.

26. This point is discussed in Shoemaker (1955: 9). Shoemaker was able to locate only three isolated references to house-barn combinations in his detailed study of early records for Pennsylvania.

Where Every Town
Is above Average

Those of us who dote on the exuberant volatility of America's landscapes have learned to expect the unexpected. Such is the welcoming sign in all its current luxuriance. These signs have crept onto the scene so gradually that we have begun to acknowledge them only now that it is impossible to look the other way.

What makes the welcoming sign distinctive is the commodity it purveys: the image of a particular locality. The ostensible purpose is to interest strangers in sampling the wonders of this extraordinary place or, at the least, to wander onward with lingering curiosity.

Although welcoming signs seem to be proliferating, we have little information about them. No trade association is concerned with welcoming signs; no museum preserves them; no hobbyists have begun to pilfer them or form clubs; few photographers or artists care about the signs or the unphotogenic tracts where they tend to breed; and in my diligent quest I have discovered only one sentence about them (by John Stilgoe [1983]) in the scholarly literature. The only people who have made any fuss about the signs are a handful of cartoonists who have exploited them to fine comic effect. What follows (aside from a plea to readers for further enlightenment) is the result of several thousand miles of observation coast to coast in the United States and Canada during 1986 and shreds of information from my roadwise friends.

IN THE FIELD

Signs welcome travelers to the full range of American political jurisdictions. Possibly the godmother of all welcoming signs, the Statue of Liberty, has greeted the nation's visitors in New York harbor since 1886. Regions have signs such as "Welcome to Scenic Western Maryland" and "Welcome to the Harrisburg Area." States sport greetings like "Welcome to New Mexico, Home of 1984 Miss U.S.A. Mai Shanley." Counties get into the act with slogans on the order of "Christmas

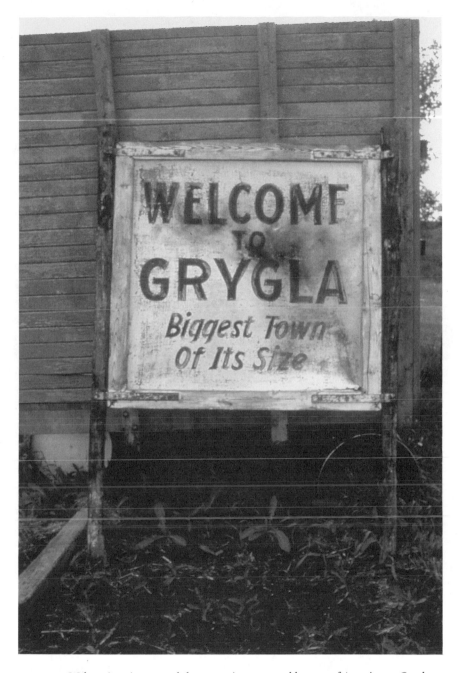

FIGURE 1 Welcoming signs reveal the gregariousness and humor of Americans. Grygla, Minnesota. Photograph by Thomas Harvey, 1980s.

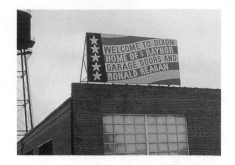

FIGURE 2 Although most welcoming signs greet us at the edge of town, Dixon, Illinois, shouts its unique entitlement to fame from the rooftops. Photograph by John C. Hudson.

Tree Capitol [sic], Indiana County, PA." Even townships erect greeting signs like "Welcome to Union Township. Together We Can Make It Happen." The great majority of welcoming signs, however, beckon us into cities, towns, and villages.

Welcoming signs appear most commonly on the edge of town, at or near the corporate limits. They stand alongside, or in a few cases arch across, the major highways leading into town, and sometimes there are a half-dozen or more. Occasionally, departing visitors see a courteous farewell sign thanking them for their company. Sometimes signs appear near the business or ceremonial center of town or on a municipal water tower. In some cases they show up, with the simplest of messages, at the local airport, but they are rarely in or near railroad depots, or so Stilgoe assures me.

The sponsors include state highway departments, municipal governments, state and local historical societies, business firms, chambers of commerce, civic organizations, citizens' groups, and churches, individually or collectively. In many cases local congregations are reluctant to share display space with secular interests, so they take it solely upon themselves to offer spiritual sustenance as well as greetings to the susceptible visitor.

As far as I can determine, signs are most common along the outskirts of medium-sized communities—those with populations from 2,000 to 250,000. Smaller places may lack both the means and motivation. Larger metropolises seldom avail themselves of such bush-league promotion; their virtues and vices have already received publicity, and identifying the outer edges of, say, metropolitan New York, Atlanta, or Boston is no mean task.

I suspect that welcoming signs are emphatically American. According to my recollections of Western Europe and Latin America, and my conversations with students and colleagues, identification signs at boundaries of political jurisdictions outside North America are simply identification signs. The signs generally contain no information aside from a name and political status. In Canada welcoming signs are popular in Anglophone communities, though far less so than in the United States—another instance, no doubt, of northward seepage of sociocultural contraband. Let me note another American characteristic that may be

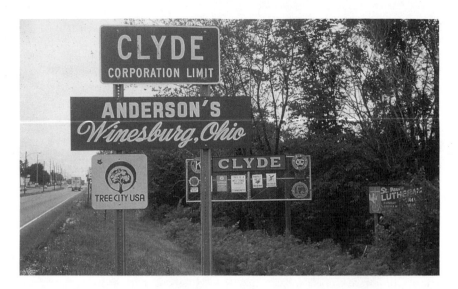

FIGURE 3 A classic cluster of signs stands at the edge of a midwestern town. What is unusual is that the place brazenly confesses that it is the model for Sherwood Anderson's fictional, rather pathological *Winesburg, Ohio*. Photograph by Wilbur Zelinsky, 1986.

unrivaled elsewhere: the penchant for nicknaming our communities and composing mottoes for them.

I am confident that the popularity of welcoming signs varies regionally within North America, but the only generalization that seems defensible at the moment is that they are most numerous west of the Appalachians and in areas settled after the Revolution. Thus in states such as Ohio, Indiana, and Oklahoma, one-quarter to one-half of the medium-sized towns sport welcoming signs. In older portions of Maryland and Pennsylvania, on the other hand, these signs are rare. Only a single, marginal example has come to my attention among scores of despondent towns in the Pennsylvania Anthracite, and welcoming signs are quite infrequent along New England highways. Perhaps there is no felt need for any if you are already convinced of your place in the cosmos, like the British, who have not yet shaken the habits of regarding England, or Greenwich, as the alpha point of our terrestrial globe.

The specimens vary greatly in material, form, and size. Wood, metal, brick, glass, plastic, stone, and ceramic are popular materials, and two or more colors are the rule. The information is predominantly verbal and numerical, but artwork, including maps, landscapes, and drawings, frequently adorns the surface. The signs run the gamut from sloppy, amateurish daubings to slick, expensive, professional jobs. The largest signs rival the standard billboard, and the smallest are no bigger than a breadbox, but whatever their size, they clamor for attention amidst a riot of commercial and official signs. Because of negligent weed control,

FIGURE 4 Monroeville's welcome is modest as well as difficult to read from the congested limited-access highway. Photograph by Wilbur Zelinsky, 1986.

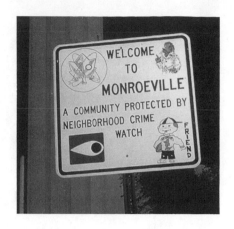

some welcoming signs are difficult to spot or read. Another problem is the small or crowded lettering on some signs that makes their contents difficult for even the alert motorist driving well under the speed limit to absorb.

Siblings of welcoming signs are billboards miles away touting the glories of Place X ("Pittsburgh: Most Livable City in the U.S.") as well as license plates and bumper stickers ("North Carolina. First in Flight," "Wander Indiana," and "New Milford, Ct. A Great Past & A Greater Future"). Two other contemporary phenomena bear family resemblances to the welcoming sign. One is the picture postcard that proclaims the attractions and delights of a locality. This form of merchandise has been popular since the turn of the century and has attained worldwide currency. Less widespread, but more arresting, are colossal sculptures and outrageous effigies standing in certain vainglorious communities. For some reason, these giants are particularly abundant in North Central states. Here roadside spectacles such as Paul Bunyan and his Brobdingnagian ménage, improbable fish, fowl, cattle, and a variety of folk heroes, both historical and mythical, signal entry into realms of local wonders.

Another boundary artifact related to welcoming signs is the welcome center along interstate highways. The earliest of these structures, I am told on good authority, was created in 1935 at New Buffalo, Michigan, just past the Indiana line. Locally oriented welcome centers offering visitors an assortment of information and services have also begun appearing recently in many metropolises.

THE MESSAGE

All these details would be pointless except that the information on the signs, verbal and pictorial, overt and subliminal, tells us so much about the social history and geography of our country. The signs also betray our hidden misgivings about the identities, or lack of identities, of our communities. Thus, in addition to their

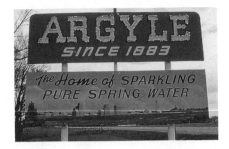

FIGURE 5 What would Sinclair Lewis have said about a Minnesota farming center that has nothing more glamorous to brag about than its water supply? Photograph by Thomas Harvey, 1981.

considerable amusement value, these signs have messages that merit close analysis.

The amount of information on signs varies greatly from terse accounts—name, population, founding date, elevation—to mini-essays. (Significantly, declining population size is never mentioned.) When the authors venture into additional topics, the message is invariably upbeat or self-congratulatory, with never a hint of negative attributes. The two possible exceptions I can cite are actually ambiguous: "Clyde . . . Anderson's *Winesburg, Ohio*" and "McConnellsburg—200 Years of Quiet Progression" [Pennsylvania].

The latter inscription represents a fairly common approach: the self-deprecating light touch, the attempt at whimsy and humor, the inverted puffery so fashionable in recent television commercials. It would be difficult otherwise to categorize signs such as "Grygla, Biggest Town of Its Size" [Minnesota], "Ozona, Biggest Little Town in the World" [Texas], or "Is Cologne Still in Germany? No! Welcome to Cologne" [Minnesota]. One also hopes that "Founded 1872. Welcome to Elgin, Home of Friendly People, Hot Sausage & Fine Brick" [Texas] was done tongue-in-cheek. Playful hyperbole is certainly at work in a sign that characterizes Silver Peak, Nevada, arguably one of the bleakest spots in North America, as "A Virtual Paradise." Occasionally the humor degenerates into the ham-handed, as in "Howard, Colorado. The Home of 150 Nice People and a Few Old Sore Heads." This formula is widely repeated with slight variations. There are also cases, I fear, when the humor is inadvertent, as in "Welcome to Stratford, Home of the Stratford Festival and the Ontario Pork Congress."

The basic thrust of the voluble signs is the exceptional character of the place that is eager to fraternize with you. In some instances, the choice of a theme is preordained, as in communities where notables were born, reared, or spent a portion of their career, for example, "Johnson City, Home Town of Lyndon B. Johnson" [Texas], "Welcome to Mercersburg, Pa., Boyhood Home of James Buchanan," or "Milan, Birthplace of Thomas A. Edison" [Ohio]. One striking case is Ferriday, Louisiana, 1980 population 4,472, that can brag about being the birthplace of evangelist Jimmy Swaggart, pop singers Jerry Lee Lewis and Mickey Gilley, journalist Howard K. Smith, and a noted horticulturalist. Other commu-

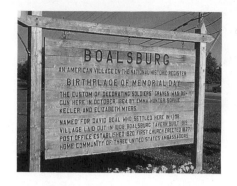

FIGURE 6 Boasting about historic events is common on welcoming signs. Boalsburg, Pennsylvania's, claim to Memorial Day, however, is disputed by other towns. Photograph by Wilbur Zelinsky, 1986.

nities have to dig deeper before coming up with celebrities, for example, "Clyde, Home of Pvt. Roger Young Whose Heroic Deeds Inspired World War II Ballad" [Ohio], "New Lexington, near Birthplace of Januarius MacGahan, 'Liberator of Bulgaria'" [Ohio], "Welcome to Dover, Home of World's Master Carver Ernest Mooney Warther" [Ohio], or "Seiling, Oklahoma, Home of Gary England," an Oklahoma television personality.

By far the largest category of celebrities glorified on welcoming signs is locally bred athletes, such as "East Brady, Pa., Home of Jim Kelly, USFL," "Woodville, Home of Jon Geisler, All Big Ten, Drafted by Miami Dolphins" [Ohio], "Welcome. Yale, Okla. Home of Tami Noble, 1980 National All-Around Cowgirl, 1982 College World Champion Rookie, 1985 National Reserve All-Around Cowgirl," "Home of World's Record Cyclist, Lon Haldeman, U.S. Crossing—Round Trip 24 Days, Two Hours and 34 Mins.," or "Home of Charmayne James, World Champion Barrel Racer, 1984–1985" [Oklahoma].

Gloating over feats of local high school or college teams is even more prevalent. These four, long-winded examples are only a random sampling from a veritable galaxy of such signs: "Home of Hudson Tigers, National Football Champions, 72 Consecutive Victories" [Michigan], "Welcome to Warwick . . . Home of N.Y. State Champions Girls Basketball Class B 1981–82, Boys Cross-Country Class B 1982–83, Warwick Major League Boys District 19 N.Y.S. Champions 1985" [New York], "Home of the Bellevue Redmen. State Champions: Boys Basketball Team 1944–45, Boys Track—Milt Bruckner 880 Run 1949, Wrestling—Don Didion 185 Lbs. 1970–71, Girls Track 3200 Meter Relay 1984, Boys Cross-Country Team 1984, Boys Baseball Team 1985"[Ohio] and perhaps most revealingly, the recently erected "Welcome to Wingate [1980 population 437], State Basketball Champs, 1913, 1914, National Champs 1920 and 3 Hall of Fame Members" [Indiana]. American communities rarely pass up a chance to note the presence of colleges, but the emphasis is usually on their athletic teams, as in "Welcome to Stillwater—Home of the Cowboys" [Oklahoma] and "Adrian City Limits. Home of the Adrian College Bulldogs, Siena Heights College Saints" [Michigan].

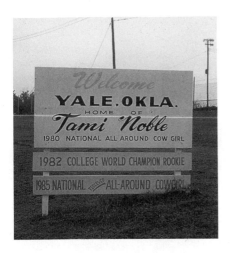

FIGURE 7 Sports heroes confer fame on the whole town. Yale, Oklahoma, basks in the reflected glory of its local overachiever—at least on the welcoming sign. Photograph by Wilbur Zelinsky, 1986.

Many communities are excited about their annual fairs, festivals, or special events, some wondrously inventive, and they are delighted to let the world know about them, e.g., "Victorville . . . Home of the San Bernardino County Fair" [California], "Crowley, La. International Rice Festival," "Welcome to Bucyrus . . . Bratwurst Festival August 14, 15, 16" [Ohio], "Johnny Appleseed Days July 25–26" [Apple Creek, Ohio]. "Welcome to Okeene, Ok., Home of the World's Oldest Rattlesnake Hunt," and "Boissevan, Home of the Canadian Turtle Derby" [Manitoba].

Also competing for the traveler's attention are recreational resources ("Welcome Manford City Limits, Striped Bass Capitol [sic] on Lake Keystone") as well as climatic, scenic, and natural features, as in "Welcome to Historical Sierra Blanca, World's Best Climate" [Texas], "Grants Pass, 'It's the Climate'" [Oregon], "Argyle. Since 1883. The Home of Sparkling Pure Spring Water" [Minnesota], and "Welcome to Fredonia in the Heart of Nature's Best" [Arizona].

Less glamorous, perhaps, but still worthy of horn blowing, are the local economic resources, for example, "Welcome to Nanaimo, the Bathtub Capital of the World" [British Columbia], "Franklin County, Home of Quality Fruit" [Pennsylvania], "Brooten, the Heart of Bonanza Valley, Welcomes You to Irrigation Country" [Minnesota], "You are entering Enola, East Pennsboro Township. Enola yards—one of the largest freight classification yards in the world. A PROGRESSIVE COMMUNITY" [Pennsylvania], or "Welcome to Chelsea . . . City Living 'Country Style.' Oil. Coal. Farming. Livestock" [Oklahoma].

If a place is adequately ancient and picturesque, it can always advertise its quaintness and historicity, as in "Poland, Site of Town One, Range One in the Western Reserve" [Ohio], "Hudson. Visit Our Historic Downtown" [Michigan], and "Welcome to Lafayette, Settled 1750" [New Jersey]. Sometimes the straining for historic respectability is enough to elevate an eyebrow or two, as illustrated on

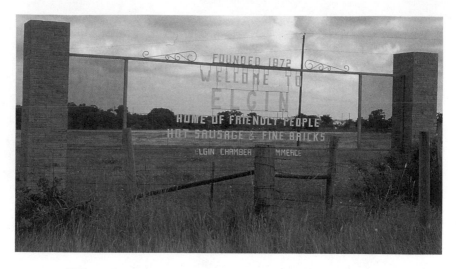

FIGURE 8 This awe-inspiring combination of goodies could only be found in Texas. The unusual structure stands out among welcoming signs. Photograph by Wilbur Zelinsky, 1986.

the elaborate sign in the center of Connersville, Indiana. It bears a lengthy roll call of "Historic 'Firsts' on This Site," beginning with "1669. Early 'Indian Trail' Connecting [prenatal] Cincinnati to Northern Trading Posts" and attaining a brilliant finale with "1977. Wendy's 'Old Fashioned Hamburgers' Restaurant."

Then there are legends that defy classification except as wild categorillas, that wonderful term coined by the late, great John K. Wright, and most briefly defined as the claim to eminence or primacy in some trivial department of human endeavor. Some of the more stimulating examples include "Welcome to Paris, Tennessee, the 'World's Biggest Fish Fry,'" "Welcome to Patterson, State Cleanest City Winner 1980 & 1983" [Louisiana], "The Rayne Chamber of Commerce & Agriculture and the City of Rayne Welcome You to the Frog Capital of the World" [Louisiana], and "Welcome to Dilworth, Largest Railroad Village in Western Minnesota."

Finally, consider the plight of American communities, probably the majority, with nothing worth ballyhooing. What to do? Actually there are several strategies. They can opt for membership in a generic class, such as Tree City, Welcome Wagon Community, or Bicentennial Community, and proudly proclaim it on their welcoming signs. In much the same vein are oblique assertions of tranquillity and ordinariness by communities promising physical security, as in "Welcome to Monroeville, a Community Protected by Neighborhood Crime Watch" [Pennsylvania].

Another tried-and-true alternative is open to localities that are sedate, commonplace, and lacking outstanding native sons and daughters. They can claim

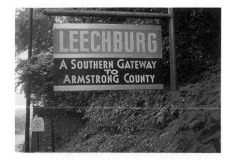

FIGURE 9 Every town can claim some distinction in location, although Leechburg, Pennsylvania, seems to be clutching desperately after fame. Photograph by Wilbur Zelinsky, 1986.

locational uniqueness, and they can do so with a clear conscience, because, as any geographer worth her salt realizes, every point on the earth is uniquely situated and every place squats in the middle of something or other. Thus we encounter a plethora of signs enunciating such memorable sentiments as "Leechburg, a Southern Gateway to Armstrong County" [Pennsylvania], "Welcome to Cambridge, Hub of East Central Shopping Area" [Minnesota], "Welcome to Mc-Alevy's Fort, Heart of Stone Valley" [Pennsylvania], "Welcome to Drain, Pacific Gateway" [Oregon], along with other places identifying themselves as "centers" or "capitals" of whatever. Occasionally a place rises refreshingly above such routine uniqueness, like Key West, Florida, with its end-of-the-world situation and a sign that modestly announces "End of the Rainbow and End of the Route US 1, Key West, Florida, Unlimited Opportunities, Tropical Vacationland." Or a community can invoke centrality in a metaphorical sense, as in "Welcome to Springville, the Heart of Rural America. Farms, Homes, Industry" [New York]. (The "last chance" roadside signs bear a certain affinity to this category.)

The final ploy of the desperate sign maker is to invoke a vapidly uplifting platitude or some form of wishful thinking, generally future-oriented. "A Good Place to Live and Work" is the most hackneyed and widespread of these standbys, but we also have gems such as "Thumbs Up Bellevue" [Ohio], "The Norwalk Jaycees Welcome You. We Believe in Norwalk" [Ohio], "Welcome to West Unity, A Community That Cares" [Ohio], "Happiness Is the City of Hudson" [Michigan], "Welcome to Newton, Building for the Future with Vision" [New Jersey], and the enigmatic "Welcome to Mansfield, A Reason for All Seasons" [Ohio].

What is missing in these signs is as noteworthy as what is there. The genuinely derogatory is totally missing, as well as any serious political utterance. Two possible exceptions are Jersey City's claim, still in limbo, to jurisdiction over Liberty Island, and Vernon, New Jersey's, outrage over a proposed radioactive dump site expressed on the sign: "Welcome to Vernon, United & Dedicated to Environmental Preservation." The only sign I have found with any appeal to intellectuals is, I blush to confess, outside my native land. It reads "Ciad Mile Failte. A Hundred Thousand Welcomes to Pugwash, Home of the Thinkers." Another item oddly missing in the United States is any reference to sister cities.

FIGURE 10 If the pursuit of happiness ends in Hudson, Michigan, what keeps 240,000,000 other Americans mired in misery somewhere else? Photograph by Wilbur Zelinsky, 1986.

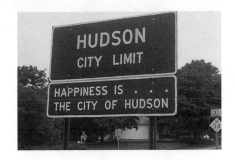

RECONSTRUCTING HISTORY

The welcoming sign resulted from the enormous growth in automobility during the twentieth century, because along with more automobiles came a rise in tourism and roadside messages. However, the present-day ratio of welcoming signs to other highway signs may be different now than it was in the past. One certitude is that welcoming signs are a manifestation of the boosterism endemic in America since the earliest days of the Republic.

Unfortunately, no scholar has undertaken a thorough historical examination of American boosterism, but in my opinion it has changed substantially over time. Community self-promotions today are not simple reenactments of the efforts of yesteryear, the era of innocent crassness. Beating the drums for one's hometown during an earlier period of uninhibited territorial, demographic, and economic growth was not the same as image-mongering nowadays, when the economy has stopped expanding, when we are only a generation or two from population stability or decline (if we ignore immigration), and when we are learning to play zero-sum games in inter-area competition.

After reading scores of welcoming signs I am also struck by how eloquently they express a seemingly permanent trait of our national character: our remarkable extroversion and gregariousness. I am reminded of a wildly friendly puppy yelping with joy, madly wagging its tail, and trying to jump up and launder my face. But noting such almost compulsive amiability does not help us determine when these signs began to appear or how their numbers have changed.

My working hypothesis is that, although isolated examples may have materialized before World War I, welcoming signs are overwhelmingly a post-1945 development. I also believe that they are growing in numbers and in stylistic complexity. Scanty though it may be, the published and private documentation supports my argument about the age of the signs. The earliest dated photograph I have encountered depicts an especially consequential object, the world-famous Hollywood (originally Hollywoodland) sign erected in 1923. Not only has this sign become an icon of American popular culture, but it is probably the inspiration

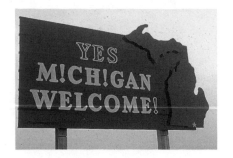

FIGURE 11 American gregariousness unleashed! Brass bands and red carpets may not await visitors traveling north along U.S. 127, but this comes reasonably close. Photograph by Wilbur Zelinsky, 1986.

for many a latter-day welcoming sign. Strictly speaking, however, it is not a welcoming sign. It belongs instead to the company of western hillside letters studied by James J. Parsons. The earliest example appeared at Berkeley, California, in 1905. Since then, the practice of plastering the name or initials of a college or town in huge letters on a prominent hillside or cliff has diffused widely throughout the western half of the country, but only rarely has it penetrated the physically less receptive Midwest or East. Both the chronology and diffusion of hillside letters may offer clues to the welcoming-sign story.

Scanning the literature on the history of roadside America, I have found no mention of the welcoming sign (except the brief Stilgoe aside) and a very meager photographic record. George Stewart's remarkable book *U.S. 40* (1953) documents only a single example, "Welcome to Utah," and it looks recent. In 1986 the Smithsonian's National Museum of American History organized an excellent exhibition titled "At Home on the Road: Autocamping, Motels, and the Rediscovery of America." Although the show covered the past eighty years, only two images of welcoming signs were included: "Welcome to Arizona, the Grand Canyon State" and "Welcome to New Mexico, Land of Enchantment," dated 1940 and 1947.

Personal memories—mine and those of others—tend to confirm that the efflorescence of the welcoming sign is rather recent. Although Alan Gowans recalls being photographed as a child in the late 1920s or early 1930s standing beneath a sign reading "Bienvenue au Province de Quebec," others suggest most signs are more recent. Thomas Harvey writes, "I have seen thousands of photographs of Minnesota towns and do not remember a single welcoming sign beyond simple identification. The mass of those photos are pre-1940." I have been peering intently at roadside objects in North America for forty years, but to the best of my recollection I have only recently come across enough welcoming signs to prompt serious thought.

The physical evidence also suggests that the popularity of the signs is recent. The dates on signs are almost all from the 1970s and 1980s. And although it is easy to find derelict commercial signs bleached and rusting along our older highways, welcoming signs are not among them. Some have begun to show

FIGURE 12 Not many towns would dispute Ash Fork, Arizona's, bid for notoriety or be able to display it on—what else?—a slab of flagstone. Photograph by Peirce Lewis, 1986.

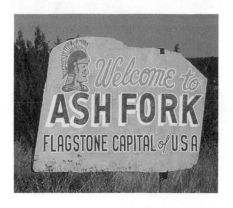

symptoms of weathering, but their general condition and design connotes a recent vintage.

Still another argument, and the most interesting, can be made for the claim that welcoming signs are recent. This takes us into deeper waters, because I contend that welcoming signs are related to a larger later day syndrome—a general craze for flaunting all manner of verbal and nonverbal messages. An American would have to be oblivious not to notice the raging epidemic of T-shirts bearing an incredible array of statements, many unique to the wearer. Closely akin to the T-shirts is the peculiar collusion between businesspeople and consumers known as "designer clothes." Millions of us saunter about in jeans, shirts, shoes, or whatever emblazoned with trade names and emblems. This would have been unheard of a generation ago. Similarly, there has been an extraordinary rise in message buttons on jackets, shirts, sweaters, and headgear, and the buttons convey every conceivable (and many an inconceivable) form of utterance and artistic expression. Not too many years ago buttons were something you wore only during election campaigns. And who can deny that witty and pugnacious bumper stickers, not to mention vanity plates, have been spreading like wildfire in the 1970s and 1980s? Within the past several months the rear windows of automobiles have sprouted little placards containing witticisms such as "Attack Cat on Board." In addition, license plates issued by virtually every state now contain a slogan or attention-getting visual device. This is another practice that was rare during earlier decades.

Although quantitative proof may be hard to come by, my impression is that graffiti on walls, bridges, and public vehicles have increased recently, and outdoor mural art, whether or not officially sanctioned, is on the upswing. I am also tempted to mention the Citizens Band radio fad of the 1970s, although CBs now appear to be in remission. It is not too farfetched to associate all this with the growing propensity over the past hundred years for householders and businesspeople to display the national flag and the eagle, a trend I have documented else-

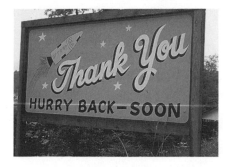

FIGURE 13 Polite towns like Apollo, Pennsylvania, not only greet strangers but also bid them farewell. The town's only connection with the Apollo space program is the name. Photograph by Wilbur Zelinsky, 1986.

where. My thesis is that, for whatever reason, individual Americans and local communities, eager to express themselves, have recently increased their use of publicly displayed objects, including the welcoming sign.

I suspect that this exhibitionism may be an effort to fill the symbolic void that has developed in our public art. From roughly 1855 to 1920, American communities could affirm their identity and their connection with the greater nation and the world of ideas by creating nationalistic statuary, but since then they seem to have lost the will or knack to do so. The welcoming sign may be a feeble stop-gap, inward-looking rather than outward-looking, but perhaps better than nothing.

WISTFUL MANIFESTO

Why have welcoming signs been created? What audiences do they reach? And what is the real meaning of their texts and subtexts?

In a business sense, the sole excuse for the signs is to persuade: to induce the wayfarer to pause for some hours or days, to sightsee, shop, worship, and perhaps give serious thought to starting a business in this exceptional locality. Other functions, such as to identify, inform, celebrate, entertain, or fraternize, are subsidiary. Although it would be difficult to test, it seems unlikely that a welcoming sign would induce anyone to revise an itinerary, reconsider her life plan, or change her business strategy. Community organizations have more effective instruments of persuasion at their disposal.

So I must infer that other motives drive the people who generate signs. (I put aside the thorny question of whether or not the sign promoters are representative of the entire community.) These individuals, and perhaps the entire local citizenry, are probably unaware of the true rationale, the subliminal subtext that is deeply internal and unspoken. Not far below the surface we see evidence of competitiveness in American life among communities as well as businesses and individuals. Each place strives to document its uniqueness (in an interdependent world!), to boost itself above the commonplace and average, to humble the competition. The most popular way of doing so, by boasting of the athletic hero and

the winning team, expresses something about our values that many of us find disturbing. How therapeutic it would be to find a welcoming sign confessing that the local football stalwarts had lost 72 consecutive games!

If we plunge into the recesses of the communal psyche, I suspect we may discover that welcoming signs are expressions of anxiety too subterranean to be openly discussed. As many commentators have noted, Americans, many of them rootless migrants, have always been in quest of their identities, hoping to find a stable, meaningful locus in a world of bewildering change and uncertainty. I believe this search has acquired a new character in recent decades and has broadened in scale from the individual to the local community. The reason is the increase in the forces of homogenization operating in government, commerce, travel, communication, and mass culture at the national and even international scale. Such apparent flattening of place-to-place differences can bring about an identity crisis for towns and even states, an affliction we might call placelessness. What can the community do when the juggernaut of uniformity seems to be pulverizing all resistance? How can it escape the curse of blandness and geographical anonymity? How can it maintain community morale, that sense of worthiness and particularity that makes our collective existence worth living?

Such disquietudes were probably rare before the 1950s, before social and territorial barriers were eroded by electronic communication. In a simpler age only the small, elite book-reading or play-going public was harrowed by savage indictments of social conformity, such as Sinclair Lewis's *Main Street* or *Babbitt*, Sherwood Anderson's *Winesburg, Ohio*, or Elmer Rice's *The Adding Machine*. But now we are deluged daily by seductive TV images of San Francisco, Manhattan, Honolulu, Las Vegas, Miami, and the southern California supercity, not to mention exotic locales overseas. When we glance out our windows how can we choke back pangs of geographical envy? When we dare to examine ourselves, how can we avoid wondering who we really are and what sets us apart?

Every action generates a reaction, every social change, a counterchange. Consequently, we should not be startled by the recent upsurge in exhibitionism, personal and town-wide. And it is logical to find new local and regional magazines flourishing, a rash of local festivals and celebrations of every description, and all those recent museums glorifying the locality past and present. Another symptom of our current malaise is an obsession with rating of places. In addition to such defensive localism, I could also invoke the parallel phenomena of historical nostalgia and preservation as well as the environmental movement, but thereby hang two other essays.

The welcoming sign is an element, however modest, of a larger social phenomena. It is a device, however fragile, that ministers to the psychic well-being of the community: visual pabulum. Its real audience is not the transient motorist or potential guest but the local population itself. It is a form of reassurance, a hopeful declaration that we are truly precious, somehow unique, and that the world will

ignore us at its peril. And until a better placebo comes along, the welcoming sign, that wistful manifesto, may have to do.

COMMENT

There have been some interesting developments since this piece was composed. As expected, the number of American welcoming signs has kept on increasing. Almost as predictable has been the outward diffusion of the practice and its recent adoption overseas on a rather impressive scale. A noteworthy localized wrinkle is the inclusion of annual precipitation on signs erected by Australian communities perched close to the dry margin of the ecumene. A belated addition to the American scene is the occasional sign noting the locality's sister-city affiliations—a European innovation for a change.

Landscape 30, no. 1 (1988): 1–10

On the Superabundance of
Signs in Our Landscape

One of the best ways to study the American landscape is to go abroad. If we keep eyes open and curiosity alive while venturing into alien lands, we not only discern exotic elements, we also realize that certain commonplace things we take for granted are rare or unknown elsewhere. Familiarity breeds sensory insensibility, be it visual, auditory, olfactory, or any other kind. In any event, it had taken me several excursions beyond American shores before it finally occurred to me that the kinds of signage that are ubiquitous in our own public environment are conspicuously absent in other lands.

For the purposes of this essay a simple definition of *sign* will do: fixed material objects presenting explicit verbal and/or graphic messages to the general public. It will quickly become clear that my discussion has little to do with signs in the rather abstruse sense used by students of semiotics. I must also bypass a succulent category that falls within my definitional net: monuments that celebrate persons, events, and other historically memorable items. The topic merits a book-length treatment, moreover the methodical field observations necessary for such a monograph (or even an intelligent capsule account) have not been published yet. And, since my casual sightings in twenty-odd nations suggest that historical monuments are everywhere, I do not offer them as evidence for my argument.

There is a dearth of scholarly or journalistic publications dealing with signs in the American landscape. Aside from items on murals and graffiti (about which more later), most writings have been jeremiads denouncing the visual clutter of roadside signs, not without some justification. But no one has treated the larger meaning of signs in the grand cultural scheme of things.

In what follows I implicitly contrast two landscapes, that of the United States with that of Western Europe and, to the best of my knowledge, the remainder of the non-American world, even if only the former receives much explicit attention. My basic thesis is simple. We find a profusion of nonessential signs in this country but a scarcity of them in the foreign scene. *Essential* signs, those that identify things or dispense socially important information, also abound in America. They

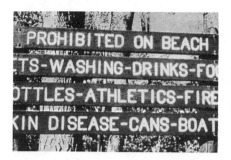

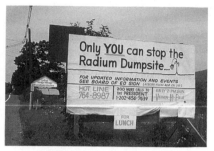

include: street and highway signs and signals, names on mailboxes, identifications of public facilities and commercial establishments, license plates and other identifying marks on vehicles, public notices, indications of political jurisdiction boundaries, and similar items.

Nonessential signs, which have proliferated so lustily in America, serve to persuade, to celebrate, to proclaim oneself, to entertain, or to socialize. They lack urgent social value. Though they can be diverting, we could survive very well without them. They fall into two large subdivisions: commercial signs that try to induce us to purchase some commodity or service, and expressive signs that set forth the views, emotions, or agenda of particular individuals or groups, including the self-congratulatory attributes of specific localities.

Political signs are the major exception to the scantiness of nonessential signs outside the United States. Campaign posters, billboards, and other such ephemera, including buttons and bumper stickers, bloom periodically in rich profusion in the months before local, state, and national elections in the United States, then fade away in the weeks following. In more muted fashion, the same thing happens overseas. But most American political iconography is strikingly devoid of serious content. Usually we see nothing more than the candidate's name, with or without a photograph, the office to which he or she aspires, and, less often than one might expect, the stark label "Republican" or "Democrat." Occasionally the sign contains a stock phrase about the peerless qualities of the contender, but almost never mentions substantive issues, basic principles, or ideology. I have gone out of my

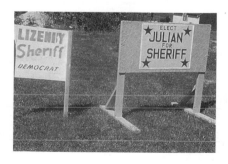

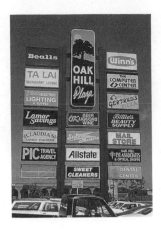
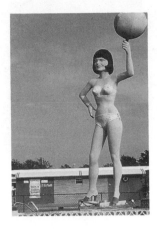

way to photograph American political signs with serious messages, but most of the handful I have managed to capture (aside from bumper stickers) address only local issues.

In contrast, most European and Latin American signs, often surreptitious graffiti, are issue-oriented and are not always excessively polite. I have encountered political seminars on Portuguese walls, violent harangues on Australian utility poles, and voluble sloganeering on hoardings in Soviet cities, both for and against the incumbent regime. Can it be that genuine political discourse is livelier and more central to the collective existence of other lands?

In recent decades public concern over visual blight in the United States has been growing among the rank-and-file as well as professional landscape writers. Much of this outcry is directed against billboards and other commercial displays. Commercial signs that announce particular enterprises are of the essential variety, of course, and have long been part of the human scene. For many centuries European shops and inns have mounted signs, commonly nonverbal, to identify themselves, but such devices have been relatively small, discreet, and confined to the premises. In some societies, that is as far as these signs have been permitted to wander. During a one-week sojourn in Germany in 1990, I scoured hundreds of kilometers of roadside looking for commercial advertisements, but found none.

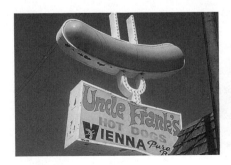

Such objects apparently show up only in airports (and are restrained even there). Subsequently I learned that the only way to ascertain that a German house is for sale is to scan newspaper ads. For-sale signs never appear on the property. Where such reticence is legally mandated, in this realm of human affairs at least, laws and regulations simply ratify the general consensus.

Some American jurisdictions emulate the relative signlessness of the better-mannered sections of Europe by enacting ordinances that strictly control the number, size, and placement of on- and off-premise signs. The State of Vermont is the prime example, but such municipalities as Carmel, California, and my very own State College, Pennsylvania, have joined the movement. And all non-official signage has been banned from the rights-of-way of the Interstate Highway System and many parkways.

Nevertheless, our public urban spaces are thickly infested with commercial and other nonessential signs to a degree unimaginable in other lands. The countryside also has its share of these advertisements. Even our atmosphere is not off-limits to skywriters. No doubt Las Vegas can claim the world championship in the dubious competition for size, brashness, and sheer grotesquerie in commercial signage. Indeed some of its casino structures are, in effect, huge advertising signs. Only in America?

If the number and character of commercial signs in the United States differ from those of other countries only in degree, religious and nationalistic signs are qualitatively different in America from what we observe elsewhere. If you believe

 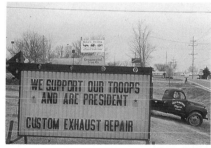

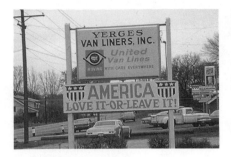
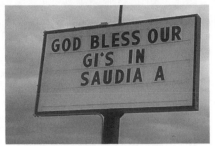

as I do that nationalism is the prevailing creed in our contemporary world, linking the two genres makes a lot of sense. It is true that throughout the Old World and Latin America (except perhaps where state-socialist regimes have tried to proscribe them), there abound crucifixes, countless shrines, sacred tombs, and effigies of divinities and saints. Such religious signs are found in American churches and throughout the Hispanic Southwest but are notably infrequent in the rest of the American landscape. Instead, we find something utterly astonishing and, I believe, uniquely American: billboards and other signs exhorting the readers to walk in the paths of righteousness and become faithful believers. One is tempted to believe that the Almighty has retained the services of some supernatural advertising agency to hawk salvation to His stray American lambs. At the very least, such signs reveal a certain spiritual anxiety. And they are reinforced, of course, by a plenitude of often strident radio and television proselytizing wildly in excess of anything encountered elsewhere.

I have expatiated elsewhere, and in some detail, on the prominence of nationalistic motifs in the American landscape. Here a bald statement should suffice, namely, that such visible tokens of the national faith are both abundant and important in the United States. Even this brief statement is superfluous for anyone who lived through the explosion of yellow ribbons (and flags) in early 1991. In any case, in contrast to the staggering profusion of American flags, our national totem (the bald eagle), and the national colors within our borders, one can crisscross Europe and almost never catch sight of national flags or kindred objects except atop official buildings and installations or on naval and merchant ships.

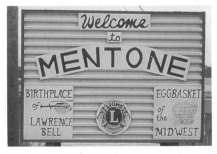

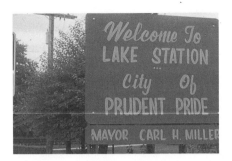

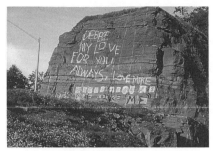

In a 1988 *Landscape* article I described that quintessentially American development, the welcoming sign. It is obviously just a single component within a much larger phenomenon: boosterism. Strangely, no scholar has yet undertaken a comprehensive attack on this rewarding topic; but all observers, American or otherwise, must agree that boosterism flourishes in the United States with an exuberance it displays nowhere else. If the welcoming sign *has* begun to catch on overseas, at least one American boosterish landscape artifact has resisted export: the hillside letters that originated in Berkeley, California, several decades ago and are still confined to the drier, hillier western sections of the country.

In contemporary American life the historic preservation movement recognizes, celebrates, resuscitates, or transforms many fragments of obsolete or stagnant landscapes. With this upsurge of nostalgia we automatically acquire a whole new array of signs. Once again, we part company with Europe, where historic preservation is alive and well but distinctly different in tone. Much less numerous and more subdued there are the historical plaques and other visible cues to commemoration. As various scholars have noted, Europeans' relationship to their crowded, densely layered past and its inescapable landscape evidence differs markedly from that of most Americans, for whom the past has verily been a foreign country.

In the personal realm, Americans exercise an extraordinary freedom of expression when it comes to outdoor displays. I place in evidence some more or less conventional signs that project personal eccentricity, whimsy, and other inclinations of individuals who are willing to share thought and emotion with the whole

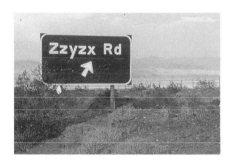

wide world. Such exhibitionism is unmatched in other lands. And am I too ardently boosting our exceptionalism in contending that Americans are more likely to perpetrate outrageous visual jokes via public signs than are residents of more sedate republics and kingdoms?

Akin to such personal manifestos are collective visual statements by neighborhoods or local communities, in the form of outdoor murals. This lively vernacular art first burst into full bloom in Mexico a few decades ago but recently has gained considerable popularity throughout the United States both within and beyond the Hispanic-American community. With the arrival of spraygun technology, the genre has broadened into hit-and-run graffiti—something not totally unknown in Europe—with results that are sometimes aesthetically exciting but just as often deplorable.

Leaving aside the media of poster, board, and wall, many American homeowners crowd their lawns, porches, windows, and mailboxes with all manner of signlike things to express themselves. And there must be something peculiarly North American (for here we must include the Canadians) in the folk tradition of snow sculpture, which abounds when weather permits.

Other seasonal holiday signage reaches heights in the United States far beyond anything that foreign competitors can scale. The greatest extravagances, communal or individual, are those for a Christmas season stretching from early December well into January, but within the past few years, Americans have also begun to indulge in other calendric orgies of exterior decoration. Most noteworthy are the Halloween paraphernalia exhibited on and next to private dwellings. The Eas-

ter season has also begun to set off an epidemic of Easter egg trees and plastic bunnies in yards and on housefronts throughout the land. More muted, but still meaningful, are the colorful paper cutouts on house and school windows celebrating Thanksgiving and St. Valentine's Day. Independence Day, Memorial Day, and other such solemn occasions generate little signage beyond the obligatory flags.

We generate signs not only on house and grounds but on our personal vehicles as well. I have diligently searched abroad for bumper stickers—one of the great American avenues of expression—but to no avail. It may be difficult to believe, but only we Americans and the occasional Canadian plaster the windows of our autos with the decals of colleges we claim to have attended. The United States is also the homeland of the T-shirt, often with incredible messages, a fashion statement we are generously permitting the rest of the world to adopt. The T-shirt may have descended from another indigenous item: the lettered bowling shirt. And Americans outclass other societies when it comes to baring our souls by means of neckties. We also invented snappy epigrams squirted onto birthday, graduation, and anniversary cakes. The message-bearing button is a nineteenth-century American phenomenon that originated amidst political campaign apparatus but has since grown to include every imaginable mode of commentary.

The ultimate in self-expression, in more ways than one, is found in thousands of American cemeteries, in tombstone inscriptions and other burial markers. I have read of truly curious epitaphs in British graveyards without encountering any personally, and I have discovered some poignant statements in other Old

World cemeteries. Nevertheless I am prepared to argue that the incidence of personalized posthumous letters to the world is much greater in this corner of the world than anywhere else. (My all-time favorite is the diehard Penn State fanatic who had images of Beaver Stadium and the Nittany Lion carved into his gravestone.)

A more sober and responsible writer would launch into some final reflections at this point and refrain from introducing further photographic testimony. However, my puckish impulses have gotten the better of me, and thus I offer a few signs that fit into none of the above categories but that are inadvertently laughable or perplexing. They certainly enrich the life of this landscape voyeur.

If we agree that the American landscape excels in its quantity and variety of signs, that this country has generated an inordinate number of new types of signs, and that these objects are interesting in and of themselves, we must still field the inevitable question: So what? Can we learn anything worthwhile from this array? I am convinced we can, for this is a world in which everything is connected to everything else, and signs do not hang in a cultural or geographic void.

The lessons to be drawn from the superabundance of signs in the American landscape emerge at two different levels. The more accessible is the geographic/

economic. The sheer spaciousness of our land, the generous ratio of acreage per inhabitant, makes it easy to bedeck the scene with all manner of superfluous objects, especially when the folks in question are quite affluent relative to much of the rest of the world. Such a combination of preconditions is really exceptional, matched perhaps only in Australia, New Zealand, and Canada. It is impossible to imagine anything like the riotous proliferation of American signs in the prosperous Netherlands, a country where every square meter of ground is jealously husbanded. What we don't find to nearly the same degree, even in such land-rich countries as Canada or Australia, is the economic, political, and moral supremacy of the businessman. In a nation whose business is so largely business, there are few serious constraints on the production and display of the countless commercial signs that are so emphatic a component in our landscape.

But not all the signs I have mentioned can be blamed on the profit motive. A fuller understanding of the role of signs in American life obliges us to consider that controversial concept, the national character. If we examine the attributes of national communities in the aggregate and the modal behavior of their individual members, we do indeed detect sets of shared distinctive peculiarities. I can only begin to suggest the ways that our national character is reflected in the universe of visible, tangible signs liberally punctuating the landscape.

We have few rivals when it comes to gregariousness or extroversion, singly or en masse, an attribute so faithfully documented in our public signage. I believe we can read a moral related to our collective personality, one that is found at a deeper level than the geographic/economic one, and is legible in the artifacts with which we surround ourselves. Whether we are first, second, or nth generation Americans, we remain strangers in this strange and wonderful land, restless, eager strangers yearning to establish, or re-establish, connections and community. That is the subtext to be deciphered in all those welcoming signs, the flaunting of flags and eagles, those outrageous T-shirts, the mounting of historical plaques, and much else. We aspire subconsciously to the rootedness of our Old World cousins. They know just who and where they are, and have little reason to advertise such knowledge on billboards, shirts, caps, buttons, autos, or lawn decorations. In essence, then, we are wearing our heart, an anxious, questing heart, upon that huge sleeve we call the landscape.

I have done little more than tug at this sleeve. If this essay has any valid message, it is—to persist with half of a madly mixed metaphor—that any of us who are would-be cardiologists still have an immense amount left to learn about what makes the American landscape tick—and what the landscape can tell us about the rest of the body politic.

Landscape 31, no. 3 (1992): 30–38

Gathering Places for America's Dead

Few students of the human sciences would dispute the claim that rites of passage—and especially the three most universal, i.e., those arising from birth, marriage, and death—and the phenomena associated with them present us with matchless opportunities for getting at the essence of cultural systems. (In the American and European worlds we might also consider religious confirmations, school graduations, and formal work retirements as additional candidates for those occasions when we risk excavating inner truths.) In confronting such crucial, jolting episodes, emotions run deep, and we can seldom avoid peeling back, at least partially, the core, the most central layers, of our community's value system—traditions and axioms rarely examined during routine stretches of our days and years.

Among such revelatory sets of experiences, there is one of special consequence for the geographer by virtue of its direct, observable impact upon the landscape: that complex of practices having to do with the disposal of the dead (even though geographers may have little or nothing to say about the funeral ceremonies that precede or accompany interment or cremation). In addition to any immediate visual appeal or mappability, the habitations of the departed invite inquiry into all manner of social and geographic questions. Indeed deciding how to bestow our earthly remains is a response to one of the central challenges in defining what it means to be human.

Of necessity, archaeologists have always relied heavily on funerary data in probing the distant human past; but in recent decades students in other social sciences and the humanities have converged on more or less contemporary cemeteries and those of the past few centuries and the objects displayed therein in order to gather and interpret evidence on a broad array of scholarly questions. The fields of inquiry include social history and psychology, art history, folklore, demography, sociology, ethnicity, landscape design, and land use economics. The literature is now so large and diverse that a proper review would far exceed the space avail-

able here, but the interested reader will find an excellent recent bibliographic guide in Meyer (1989: 329–39).

THE HALTING
NECROGEOGRAPHIC AGENDA

Despite a manifesto by Kniffen (1967) many years ago, geographers have contributed less to this thriving area of study than one might expect. Moreover, their contributions have been confined largely to particular landscape items, the evolution of gravestone morphology, and land use matters, almost invariably with reference to specific localities or at best subnational regions. With only a few interesting exceptions, they have been reluctant to address broad national patterns or the deeper intellectual issues implicit in death-related phenomena.

A major reason for the hesitance of American (and other) geographers in dealing with cemeteries and burial practices is a difficult data situation. In contrast to the opportunities open to students of many demographic, social, economic, political, and climatological questions, who can consult copious sets of quantified place- and time-specific information covering the entire country or even the world, the geographer intent upon learning about cemeteries and their attributes must resort to direct inspection in the field, burrowing in local archives, and interviewing knowledgeable persons. Rewarding and indeed often enjoyable though such efforts can be, they are quite costly in terms of time and travel expenses. Consequently, it is scarcely feasible for an individual investigator to tackle more than a single state, as Jordan (1982) has done in Texas or Nakagawa (1987) working solo in Louisiana. A research design that would enable us to undertake a national survey, using some sort of sampling procedure that would ensure results one could safely extrapolate to the whole universe of American cemeteries, may lie beyond our technical as well as financial reach at the present time.

There is one data source of significant, but decidedly limited, value that necrogeographers have not yet seriously exploited: the set of large-scale topographic quadrangles published by the U.S. Geological Survey (USGS). After more than a hundred years of striving, the agency now provides virtually complete, periodically updated coverage of the coterminous United States, mostly at the scale of 1:24,000. Inferior alternative sources, namely air photos or other types of remotely sensed images, are hardly worth mentioning inasmuch as they yield much less usable information than do the maps.

All the cemetery-related items appearing on the USGS sheets are of geographic interest, at least potentially. The list includes cemetery size; shape; compass orientation; topographic attributes; location vis-à-vis churches, roads, agglomerated settlements, and other features; and for many, but far from all, the cemetery's name. Unfortunately, as discussed in detail below, even the best and latest of the quadrangles fail to record the entire inventory of burial grounds within their

boundaries. Whether such oversights reflect the presumably smaller size of most of the missing cases, their relative or total invisibility on the photographs that are now the principal raw material for the maps, or the diligence of ground crews in their checking procedures, it is impossible to say.

In any case, even for those cemeteries that do catch the mapmaker's attention, we have no clues at all for many of the items most urgently needed for a comprehensive study, namely founding date, and thus age; whether active, inactive, or abandoned; number of plots and burials; ethnic, racial, and religious affiliation (unless implied in the name); internal layout; degree of social, class, or other forms of spatial segregation; landscaping, fencing, and quality of maintenance; and proprietorship, i.e., whether governmental (municipal, township, county, or federal), a commercial operation, one owned and managed by a neighborhood group, or simply a private family affair. Of course, it goes without saying that documenting tomb and gravestone styles and the language and artwork inscribed on all the memorializing objects is something far beyond any cartographer's charge.

Limiting ourselves to those topics that are map-readable, there are formidable difficulties in performing any but localized analyses. To take a rather rudimentary chore, the calculation of the acreage occupied by cemeteries and then tabulating and mapping the resulting values by appropriate areal units for all of the United States could conceivably require the entire working lifetime of a single analyst if the task were undertaken by hand. Although such a project may be technically feasible using advanced optical scanning devices and the as yet unwritten software, the cost would be prohibitive unless the work were part of a comprehensive national land use survey adopting the finest possible areal mesh.

What, then, is possible and reasonable if we are curious about the geography of American cemeteries beyond the state or intrastate level, i.e., in terms of the entire country or an extensive portion thereof? I wish to propose a modest start, perhaps the most elemental of tasks, but one leading toward the ultimate goal of a detailed, multidimensional understanding of these gathering places for the American dead in some historic, geographic, and cultural depth: plotting the number and relative incidence of these quite special parcels of land across the national space. In so doing, I believe one can demonstrate the sensitivity of necrogeography to a variety of broader social and historical themes, as suggested earlier.

USING GNIS MATERIALS

Thanks to the USGS's ongoing Geographic Names Information System (GNIS) project, it is now possible to make serious progress toward the goal of mapping the entire array of American cemeteries. Begun in 1968, the project consists of two phases, the first of which had been completed by 1984. Phase I "includes most named features on all of the maps in the USGS topographic map series except

roads and highways" (Payne 1984: 2), a listing of a grand total of approximately two million geographic names. The partially completed Phase II, which is being executed state by state by means of subcontracts awarded to various local agencies, provides additional coverage from scrutinizing other maps and historical and other documentary sources. The roster that will eventually materialize will presumably include the entire American place-name cover except designations for triangulation stations and roads and highways. The potential value of this computerized data set for geographers, linguists, historians, and many other scholars is formidable.

Through the kindness of Roger Payne of the USGS's Branch of Geographic Names, I obtained a special printout of all cemetery names listed in the GNIS files as of July 1992, a total of some 99,625 items. Each entry includes the following information: name, geographic coordinates, state, county, and name of the quadrangle on which the cemetery appears. Before presenting the tabular and cartographic analysis of this material, it is necessary to take note of some troubling questions involving definitions and what might be called the epistemology of cemeteries.

EPISTEMOLOGY OF CEMETERIES

Precisely what is a cemetery or a burial ground? Although the great majority of the sites in question qualify without difficulty, we are left with quite a few problematic cases. How is one to classify the increasingly popular columbaria (or indeed private dwellings) where the ashes of the deceased are kept in small receptacles? How do we deal with burials inside church structures, the isolated tombs of notables (e.g., President and Mrs. Grant's in Manhattan or George Washington's at Mount Vernon), family plots next to residences, cemeteries for pets or racehorses, or those archaeological sites containing burials? There is also the question of whether to regard two or more contiguous burial grounds, possibly distinct in terms of ethnic or religious identity, as single or multiple entities.

Much more pertinent to the present inquiry is the fact that a great many cemeteries are nameless as far as published maps are concerned, and indeed may not be recognized at all even by long-time local residents. As any attentive user of USGS quadrangles is well aware, there are many burial grounds depicted therein without names, indicated only as a parcel of land, often containing a cross, enclosed by a light dashed line, with or without the notation "cem." Such features exist toward the upper end of a continuum of "perceptibility" or "recognizability." Beginning with the top-most category, the gradations are as follows: the mapped *and* named; mapped but unnamed; not mapped but known locally by name; unmapped and lacking a name even among nearby residents but presumably, like the preceding types, still actively used and visited; abandoned sites no longer recognized by the locals; and archaeological burial sites with few or no traces at the surface. The recent accidental unearthing of an antebellum black

cemetery in Manhattan is a well-publicized example of a not uncommon occurrence (Macdonald 1992). To this typology one might add some older, previously mapped items that are no longer identifiable.

Clearly only the first two classes of cemeteries are accessible to a study of national scope. Locating the remaining sites would call for intensive local field and archival study. In one such effort, Gerbers (1979: 18) investigated three valleys in Centre County, Pennsylvania, and located eighty cemeteries in the field, nineteen more than the named and unnamed sites shown on USGS quadrangles. In addition, using documentary sources, he identified fourteen others that were not physically locatable. It is most unlikely, then, that we can ever achieve anything approaching a complete canvass of all cemeteries, past and present, within the United States.

Despite incomplete coverage, it seems safe to assume that the cemeteries recorded on USGS maps and, in part, in the GNIS files account for the great majority of burials that have occurred in American soil over the course of Euro-African occupation. But the question then arises as to whether the GNIS roster offers a reliable sampling of the totality of mapped cemeteries, that is to say, whether the ratio between named and unnamed items remains reasonably constant from place to place. The only way to answer such a question with any certainty would be to scan all the thousands of USGS quadrangles in order to tally the two kinds of cemeteries, a chore beyond the capabilities of a single investigator. What I have done instead is to examine with care several hundred randomly chosen 1:24,000 sheets in three states: Indiana, Tennessee, and Vermont. The results are as consistent as one could hope for, inasmuch as named cemeteries accounted for 61.1, 63.1, and 64.1 percent, respectively, of all mapped cemeteries for the sampled sheets and states. I proceed, then, on the assumption—one that I trust is not too heroic—that the GNIS cemeteries represent a fixed percentage of all the mapped entities within the study area. In quantitative terms, this means that one must inflate the values appearing on the accompanying table and map by 60 percent or thereabouts to find the approximate true value for present-day mapped cemeteries.

AMERICAN EXCEPTIONALISM?

Before discussing the regional patterning of the incidence of cemeteries, it is worth noting that the sheer abundance of these sites, numbering as they do in the hundreds of thousands, may well be another instance of American exceptionalism. Paying special attention to cemeteries in my foreign travels, I have failed to find anything resembling the multiplicity of such places so common within my homeland. Almost invariably overseas, except for the larger metropolises, there is only one cemetery per village, town, or city, and rarely, if ever, any burial sites in the open countryside. Australia is a useful test case since its human geography parallels that of the United States probably more closely than that of any other

country. Excepting the populous state capitals, the formula could not be simpler: one agglomerated settlement above a certain threshold = one cemetery. Furthermore, all cemeteries are in or next to an urban place of some kind.

The international disparities apply at the metropolitan as well as the non-metropolitan level. The number of named and unnamed cemeteries indicated on the 1:50,000 topographic maps for the Greater Toronto area is just 14, while, to take two American metropolises of roughly comparable size, Cuyahoga County (Cleveland), Ohio, has 68 named cemeteries according to GNIS and Allegheny County (Pittsburgh), Pennsylvania, had 140, not counting, of course, numerous unnamed sites. Consulting large-scale metropolitan atlases, one will detect 27 named and unnamed cemeteries for Bruxelles, 90 for Greater London, 143 for Greater Paris, but a grand total of 738 named cemeteries listed for the New York Consolidated Metropolitan Statistical Area by GNIS, plus many more unnamed entities I have not tried to count.

SPATIAL PATTERNS: A FIRST APPROACH

The tallying of named cemeteries at the state scale reveals a pronounced unevenness in their spatial incidence as measured in terms of number of occurrences per 100 square miles (table 1). Leaving aside the rather anomalous case of the District of Columbia, values range from Tennessee's maximum of 29.6 to 0.1 or less for Arizona, Wyoming, Nevada, and Alaska. But equally striking is the decided contrast between the two halves of the country, the eastern and western. Without exception, all those states lying wholly or partially west of the 100th meridian have values significantly below the national figure of 3.3. It is rather startling to learn that California, the most populous of our states, containing some 12 percent of the nation's inhabitants, can claim only 0.55 percent of its named cemeteries.

Given the exploratory nature of this study, it would seem practical to set the western United States aside for the time being as a region with fewer immediate rewards for the necrogeographer than the older, more densely settled East. In doing so, however, one can speculate in passing that the basic explanation for the relative paucity of cemeteries in the West, apart from generally lower population densities, may be the rather late date of settlement for most localities with all that such recency implies in the way of stages of social evolution.

When the number of named cemeteries per 100 square miles is mapped at the county level for the eastern United States (fig. 1), the results are more than interesting; they are, to a great extent, unexpected and perplexing. What was expected and confirmed is a relatively high concentration in most of the larger metropolitan areas, notably New York, Boston, Philadelphia, Baltimore, Washington, and St. Louis, with values exceeding 20/100 mi.2 or—less emphatically but still at levels well above their hinterlands—Detroit, Cleveland, Chicago, Milwaukee, Kansas City, and Albany. There was also minimal surprise in finding considerable irregu-

TABLE 1. *Named Cemeteries by State, 1992*

State	Number	Cemeteries per 100 mi.²	State	Number	Cemeteries per 100 mi.²
District of Columbia*	37	58.7	South Carolina	1,103	3.6
Tennessee*	12,202	29.6	Michigan	2,029	3.1
Massachusetts	1,151	14.7	Maryland	310	3.1
Connecticut	661	13.5	Oklahoma	2,018	2.9
Mississippi*	6,177	13.0	Delaware*	53	2.7
Alabama*	5,622	11.0	Kansas*	2,247	2.7
Ohio	4,412	10.7	Minnesota	2,062	2.5
West Virginia	2,462	10.2	Texas	5,736	2.1
Kentucky	3,824	9.6	Florida*	1,040	1.9
Indiana*	3,336	9.2	Nebraska	1,364	1.7
Missouri*	5,202	7.5	North Dakota*	952	1.3
Arkansas	3,776	7.2	South Dakota*	1,004	1.3
Illinois	3,919	7.0	Oregon	968	1.0
Virginia	2,787	7.0	Washington	427	0.6
New York	2,985	6.3	Colorado	484	0.4
New Jersey*	439	5.8	Hawaii	31	0.4
Rhode Island	57	5.4	Utah*	384	0.4
Pennsylvania*	2,385	5.3	California	542	0.3
Vermont	464	5.0	Idaho	269	0.3
North Carolina	2,438	4.9	New Mexico	424	0.3
Louisiana	2,140	4.8	Montana	320	0.2
Georgia	2,695	4.6	Arizona*	185	0.1
Iowa	2,605	4.6	Wyoming	174	0.1
New Hampshire	409	4.5	Nevada*	70	0.1
Wisconsin	2,099	3.8	Alaska	16	—
Maine	1,128	3.6			
			Total	99,625	3.3**

*State covered in Phase II of GNIS.

**Does not include Alaska.

larity overall in spatial patterns. Such a patchiness in territorial array is especially conspicuous in such states as Kentucky and Mississippi. Another predictable feature of the map is a general gradual downward slope in values with increasing distance westward, particularly beyond the Mississippi River.

Easily the most striking phenomenon in figure 1, one that was scarcely anticipated and overwhelms all the other details within the map, is the wide ridge of elevated values reaching from the upper Ohio Valley southwestward through portions of West Virginia, Virginia, and Kentucky to northern Alabama and Missis-

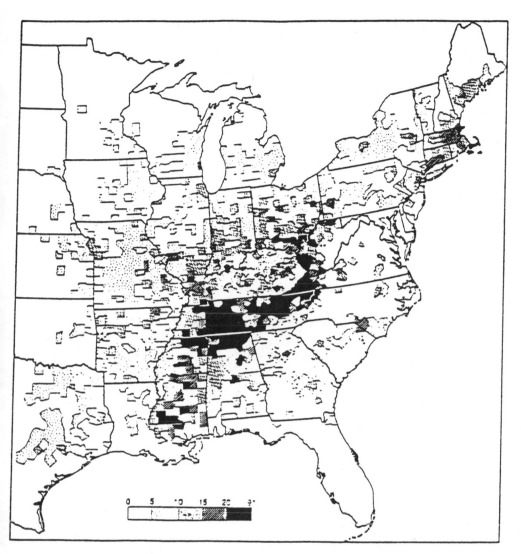

FIGURE 1 Number of named cemeteries per 100 square miles.

sippi and, even if in rather broken fashion, all the way into Louisiana's eastern parishes. By far the strongest expression of the proclivity to create cemeteries occurs in Tennessee. It is there that, among many other high-value counties, we find Rutherford, the national champion, with 571 named cemeteries, an almost unbelievable 91/100 mi.[2] Except for the somewhat intermittent extension the full length of Mississippi and into Louisiana and the failure to penetrate beyond the Mississippi River, this area of exceptionally high values corresponds, albeit quite loosely, to an Upper Southern Culture Area as postulated by Jordan and Rowntree (1990:

230). In any case, we have here a challenge to our interpretive and explanatory powers that is impossible to evade.

Less visually obtrusive, but no less mystifying, is an equally large region of low values that embraces nearly all the territory of the South Atlantic states. A few other subsidiary features demand attention, most prominently the zone of higher values in megalopolitan southern New England, outliers of higher-than-expected values in Maine, Cape Cod, and a discontinuous strip in the upper Atlantic Coastal Plain running through the Carolinas into central Georgia, and, finally, the relative dearth of cemeteries in Louisiana's Acadiana.

EXPLAINING THE PATTERNS

In trying to explain the highs and lows in figure 1 and the more anomalous departures from the grosser regional and national distributional patterns, we can invoke several variables or explanatory factors. The most obvious of these are simple population size and density. Below a certain threshold of a given number of local residents, it is not practical to found and maintain a cemetery; if this population is thinly spread over an extended tract, a "cadaver shed," so to speak, there would automatically be a paucity of such sites per unit area. Conversely, zones of high population density, and most particularly metropolitan areas, will acquire numerous cemeteries as a matter of course. This demographic factor neatly accounts for below-normal values in northern Maine, the Catskills and Adirondacks, New Jersey's Pine Barrens, northern Michigan and Wisconsin, and a number of counties in the Ozarks as well as so much of the American West.

Following the same reasoning, it might be expected that some positive correlation should exist between the longevity of Euro-African occupation of a locality, or, more specifically, the diachronic total of deaths over that period of occupation and the number of cemeteries. To date no one has attempted to calculate, or estimate, the number of deaths occurring in the United States from the pioneer era up to the present by county although it is technically feasible to do so. In any event, leaving aside its obvious relevance for much of the West, such a historical factor could go far toward explaining Florida's low score (1.9/100 mi.²) since so much of that state experienced serious settlement only during the past several decades.

It is also reasonable to assume that ethnic, racial, and religious diversity is conducive to the proliferation of cemeteries. Such social heterogeneity could help account for the relatively high values for the urban areas of the Northeast and Midwest, and could be the explanation behind aberrantly strong showings for North Carolina's Robeson County and vicinity with its tri-racial situation or polyglot Lackawanna County in Pennsylvania's Anthracite region.

It is self-evident that physiography and other physical factors play some sort of role in determining the quantity of cemeteries per unit area, but the relationship

is hardly a straightforward one. Where altitude is excessively high and/or the surface too rugged or where climate and soils are also discouraging, the settlement (and thus the cemetery) fabric is thin or even nonexistent, as in much of the Great Smoky Mountains and the Allegheny Plateau of northern Pennsylvania, as well as the Adirondacks and Catskills and other such near wildernesses. Areas characterized by poor drainage offer few usable sites for cemeteries, and the same is true in places where strip-mining has played havoc with the surface as has happened on a massive scale in much of western Kentucky and southern Illinois and Indiana. On the other hand, there are extensive tracts of relatively rough terrain that are rather well populated and where the difficulties of overland travel and transport could have led to an abundance of cemeteries serving small pockets of territory, as may be the case in southern Ohio and portions of West Virginia, as well as much of the rest of the Upper South.

It seems logical that the cost of land may also enter the equation. Obviously enough, within the metropolitan areas the price of inner city real estate has propelled most cemeteries into suburban tracts, but economics may also operate in nonmetropolitan places. The dearness of highly productive farm land in the Cash Grain Region may be responsible to a measurable degree for the relative scarcity of cemeteries in central Illinois and nearby sections of Indiana. Legal considerations may also affect numbers and location. In lieu of detailed study, one can speculate that variations in relevant state laws and regulations and local zoning ordinances may have had some impact upon the geography of cemeteries.

What is more readily apparent is the salience of regional culture, and most pointedly in the case of southern Louisiana, or Acadiana, where the ethnic and religious scene is so distinctly alien to the remainder of the Deep South. As fully documented by Nakagawa (1987), the cemetery landscape in an essentially WASP northern Louisiana and its eastern parishes is a world apart from an Acadiana of essentially Mediterranean provenience.

Figure 1 suggests the pervasiveness of another variable that may overarch all the preceding factors at both the micro and macro scales: degree of modernization, or level of socioeconomic development. The map could be likened to a palimpsest or a multi-layered fabric, something embodying the residues of successive episodes of societal evolution. Like so much else in recent human history, funerary practices in America and elsewhere have progressed by stages from premodern to contemporary modes (Mitford 1963; Stannard 1977; Sloane 1991). In Colonial and early Republican days, the management of dying, death, mourning, and burial was a family-cum-church, or cooperative neighborhood, affair in which little or no money changed hands, labor was mostly voluntary, and interment was almost always nearby in a relatively small local, family, or denominational burial ground.

Since then, by fits and starts, but irreversibly, death and grief have become commodified by hospitals, insurance firms, florists, greeting card publishers, fu-

neral directors, and professionally managed cemeteries containing some of the country's most expensive real estate. In keeping with the basic thrusts of modernity, cemeteries have become fewer in number but larger and more methodically managed, hence more efficient and cost-effective. But, rather paradoxically, the customer may now have more locational choice than in the past, and the array of options may include posthumous migration by rail or air to a locality of earlier residence at a considerable remove from the place of death.

In any event, the modernization of funerary practice would seem to be visible in the blankness of Florida as depicted in figure 1. It is not just the lateness of peopling in the peninsular section of what is now a state teeming with human beings. What is crucial here, as in California or much of the Southwest, is the fact that the peopling took place during a period when the forces of modernity were in full command, when a limited array, an oligopoly, of impressively large, well-manicured, entrepreneurial cemeteries could handle all the potential traffic quite handily.

At the intrastate level we can witness the developmental factor at work in Illinois, Indiana, and Ohio. All the constituent counties may coexist simultaneously in calendar time, but the central and northern sections of the states inhabit a more advanced stage of developmental time—the urban-industrial and incipiently postmodern—while their southern segments, or in Ohio's case the southeastern, lag behind in a more antiquated mode. All in all, the south-to-north gradient in the incidence of cemeteries accords rather well with such a chronology.

At this point it would be pleasant to report that, in light of the set of genetic factors adduced above, the map has been decoded, that only the most minor of local anomalies await explication. But that is far from the actuality. Left unsolved are two of the largest, most challenging features of figure 1: the northeast-southwest band of exceptionally high values roughly paralleling the Ohio and lower Mississippi at some distance; and, inversely duplicating it, a wide strip of exceptionally low values in the South Atlantic Coastal Plain and Piedmont extending into the Blue Ridge and beyond. The latter has a reasonably dense population, and much of it, especially in the Carolina Piedmont, is now urbanized, but there is no corresponding proliferation of cemeteries. Even more unsettling is the fact that, in terms of Euro-African settlement, this is the most venerable section of Anglo-America, the most likely to have generated and preserved large numbers of both small and large burial grounds. Moreover, land is relatively cheap and much of the territory has thus far failed to progress much beyond the premodern stage.

IS THE MAP TELLING THE TRUTH?

How real are these apparent anomalies? Isn't it conceivable that the gap between what seem to be excessive highs and lows on the map are, in fact, artifactual,

the result of the ways in which information was gathered? It is plausible that not every USGS field crew assigned to a specific area was as thorough in gathering toponymic data as other groups working elsewhere. However, over the years such discrepancies would tend to wash away at least in terms of the macroscopic patterns that are so perplexing in figure 1. In any case, it is most difficult to imagine any mechanism whereby data collectors in Tennessee, for example, could have proved to be an order of magnitude more productive than their colleagues in South Carolina or Maryland.

Another opportunity for distorting reality could have materialized in Phase II of the GNIS project. We would expect deflated values for those states that have not yet undergone this stage in name gathering, as, for instance, Kentucky. When and if its Phase II is completed at all adequately, it is likely that much of the sharp disconformity with adjacent portions of Ohio, West Virginia, Virginia, and Tennessee will simply vanish. Furthermore, "one most important factor . . . could be the thoroughness of the individual contractors. Although cemetery is a feature class that should be completely researched, the ability to ferret out appropriate materials varies widely" (Payne 1992). Evidently the contractor for Tennessee, Alabama, Mississippi, and Ohio was especially conscientious in collecting all relevant items.

But when we examine the *intrastate* incidence of named cemeteries, the case for an artifactual explanation crumbles. Note especially the emphatic west-to-east declivity along that long line running from West Virginia's northern boundary into northeastern Alabama, something that would resemble a veritable cliff, in places perhaps a vertical one, if the data were to be rendered as a three-dimensional statistical surface. It is well-nigh unimaginable that such a strong linear discontinuity, spanning as it does several states and so sharply dividing subsections thereof, could arise from the vagaries of data gathering. The only other possible explanation that comes to mind is that there may be a strong place-to-place differential in the proclivity to preserve older burial grounds and their names, a notion that strains credulity.

Further substantiating the actuality of the zone of maximum values occupying the central portion of figure 1 is the latitudinal slope leading up to it in Illinois, Indiana, and Ohio and in an Alabama counterpart running in the reverse direction. This is the general pattern one could expect if we are indeed confronting a cultural phenomenon that, under usual American conditions, would tend to melt gradually into alternative modes of behavior in neighboring tracts.

A MYSTERY LEFT UNSOLVED

If we are left with no alternative but to accept the two large regional anomalies—one unusually high, the other unexpectedly low—as genuine sociocultural phenomena, there is still much about the situation that is unexplained and baf-

fling. It is essential to recall that the map does not document number of burials but rather the number of decisions per unit area to create a distinct and separate place for the interment of groups of the departed. Inspection of the topographic maps for those districts with exceptional numbers of cemeteries reveals that a considerable majority are minute in size, overwhelmingly rural in location, and bear family names in a disproportionately large percentage of cases (Zelinsky 1990). Moreover, their siting suggests that, at the present time, a great number of them are relatively inaccessible and probably receive few or no recent burials, or are abandoned. But such observations do not begin to account for their profusion, past or present.

As already noted, there is a loose spatial relationship between the zone of high values and the Upper Southern Culture Area, but it is a quite imperfect match. Any spatial correlation halts abruptly at the Mississippi River although the culture area in question continues into portions of Arkansas, Missouri, Oklahoma, and Texas. Moreover, the spillover of high values into Mississippi, Alabama, and Louisiana, spatially sporadic though it may be, extends far beyond the margins of the Upper South. Compounding the problem is the fact that the incidence of cemeteries is well below national norms in the major source regions for the Upper Southern cultural complex, namely the Midland and the Great Valley, as well as other possible points of entry for settlers and ideas. Obviously the spatial diffusion model fails to solve the mystery, and we have an undeciphered message on our hands.

What remains? Is it possible, as Terry Jordan (1992) has tentatively suggested, that the unusual proliferation of small cemeteries is a practice somehow associated with partial Indian ancestry or early contracts with Native American groups? Are those major aberrations in figure 1 somehow linked to areal differentiation in religious beliefs and practices, or to some other as yet unidentified social or cultural attribute? Is the tendency to initiate many more or many fewer cemeteries than the modal value for Americans just one facet of a larger cultural complex that remains undiscovered? One can only speculate pending further study.

What is credible is that a practice that would seem, a priori, to be so automatic, so geographically unpromising—the decision as to whether or where to create a spatially discrete burial ground, choosing between a pattern of many small cemeteries closely spaced and an array of larger sites at wider intervals—has proved to be just the opposite. As one element, though perhaps the most elemental in a complex of practices linked to the most mind-shattering of rites of passage, the numerosity or dearth of cemeteries might well be just the most accessible of a cluster of related practices. Citing analogs from other realms of research, this particular place-name cover *may* have rendered partially visible a hitherto totally hidden complex of thinking and behaving, just as certain types of remote sensing have revealed unsuspected geologic structures or, in the case of South America's previously undetected pre-Columbian ridged fields, an elaborate agrarian system

and all that is implied thereby socially and politically. Careful field study of other funerary traits, preferably at the national or regional scale, could provide some answers and, even more probably, additional questions.

COMMENT

Henry Glassie (1993) has offered an intriguing hypothesis that could help explain the curious geographical conundrum set forth in this article: that the great abundance of small burial grounds beyond that northeast/southwest line stretching along the Appalachian system may be related to the special intensity of the Great Revival along the early-nineteenth-century settlement frontier. Working out the historical geography of that major religious phenomenon is no simple chore but would certainly be quite rewarding, and not just for whatever light it might shed on the mystery at hand.

Professional Geographer 46, no. 1 (1994): 29–38

Language

Classical Town Names
in the United States

The Classic Revival—in essence the notion (sometimes articulate, more often subliminal) that the United States is the latter-day embodiment of the virtues and ideals of ancient Greece and Rome—has been one of several pervasive elements in American mythology that have helped make our cultural history and geography distinctively American. The important legacy of the Classical World has been bestowed on all the countries comprising the Greater European community in a variety of ways, principally as a direct hereditary residue or as sets of traits dispatched outward through the normal diffusional processes, most notably in law, religion, science, education, the fine arts, language, and literature. In addition, there has been the deliberate resurrection and pursuit of things classical that began in the Renaissance and has not fully subsided even now.

It is a working hypothesis of this paper that nowhere else within the broad spatial and temporal range of this prolonged, far-flung revival, with the possible exception of Revolutionary France, was there such an intense, self-revelatory florescence of this movement as occurred during the early decades of our national existence. Although American culture shares with others a good many Neoclassical elements—for example, architectural styles, city planning, personal names, scholarly vocabulary, military terminology, ceremonial language (as in official mottoes, inscriptions on public buildings, and academic diplomas), the iconography of currency and seals, and divers aspects of politics, education, journalism, oratory, and literature—Americans have cultivated these with special earnestness and vigor. This is most obviously the case with the one item that has been accorded appreciable attention, the architecture of homes, churches, colleges, cemeteries, commercial structures, and public buildings.[1] Then there is the profusion of classical forenames for both males and females that, at least in the masculine department, far exceeds anything found in contemporary Europe or elsewhere. Thus we have had the widespread use of Homer, Claud(ius), Virgil, Lucius, Marcus, Julius, Augustus, Horace, Ulysses, Cassius, Alexander, and Hector, among

many others. I also suspect that something deep-seated in the American character comes to the surface in our insistence on the use of classical terms for many naval vessels and for the majority of our rocket missile systems and spacecraft, which, besides whatever military, economic, scientific, or entertainment value they may have, are quite blatantly proclaimed to be national status symbols.[2]

But perhaps the most persuasive evidence pleading the American's image of himself as the reincarnated Athenian or Roman is the number, range, and persistence of classical place-names. Indeed, no other territory colonized by Europeans has anything in its toponymy even faintly resembling the United States situation, with the marginal exception of a few score Brazilian names of classical coloration[3] and a curious small cluster of classical (and Biblical) names in Colombia's Cauca Valley.[4] Neoclassical place-names are conspicuous by their near absence in Australia,[5] New Zealand, South Africa,[6] temperate South America, Siberia, and Canada, even in those Canadian areas cheek by jowl with the American zones of climactic "classicity."[7] Although a lively curiosity concerning this American eccentricity is apparent,[8] students of place-names have so far failed to produce any satisfactory study of the phenomenon, just as scholars cultivating the larger domain of American Studies have neglected to treat the classical theme in national thought and behavior in depth or in cognizance of its many dimensions.[9]

In view of all this, there is ample motive to plot and interpret the spatial and temporal patterning of this peculiarly American practice of memorializing the ancient world of Greece and Rome in the place-names of the United States and to search out its possible relevance to the structure of our history and human geography.[10] Happily, as is often the case with such forays into *terra quasi-incognita*, the serendipity factor comes into play. Four major findings or themes have been developed, three of which were unanticipated, and all of which seem more important than the simple curiosity value of a strange American foible.

1. As already noted, the frequent, deliberate adoption of classical names for places in an area lacking a direct historical link with the world of Mediterranean antiquity is an idiosyncrasy peculiar to citizens of the United States and almost certainly derives from a central trait of the national character. Although full exploration of this concept lies beyond the bounds of this paper, the way in which toponymic classicity correlates spatially with certain other areal patterns strongly supports the plausibility of this statement.

2. The historical geography of classical town names reinforces the notion of the primacy of "New England Extended,"[11] in the cultural, social, and economic evolution of the nation, despite the paucity of classical terms in nuclear New England. It also strengthens the suspicion that this region may have been the source of most of the characteristics that make the United States peculiarly American. A practice originating and flourishing along the growing edge of the culture area that was clearly the intellectual pacemaker of the young Republic spread vigorously outward to the farther reaches of the expanding region. Eventually, like many another idea and innovation of similar nativity, only a few of which have

been studied, it diffused throughout the country and became continental in scope.

3. The chronicling of the spatial career of classical place-naming suggests the operation of not one, but three, different mechanisms whereby this innovation diffused outward, in order of increasing velocity: the process of short-distance contagious diffusion among juxtaposed communities and persons (that is, the Hägerstrandian diffusion model [12] that has captured so much scholarly attention in recent years); the carrying of the idea over considerable distances as part of the mental baggage of pioneer settlers from the "culture hearth" or from zones strongly affected by it; and the nearly instantaneous, but scattered, adoption of the new idea over a wide range of territory through the use of rapid channels of communication among the social elite.

4. The existence of a "hollow frontier" [13] in the space-time behavior of this specific idea is clearly documented, and creates the presumption that similar hollow frontiers may have developed for other cultural innovations of sufficient spatial and temporal range.

A CLASSICAL PLACE-NAME DEFINED

The peculiarities of the subject matter and the data demand close attention to several technical problems. Precisely which classes of named features are to be studied? What is or is not a "classical place-name" in a modern North American context? How does one find complete and reliable information on the incidence of such names in the full range of time and space under observation?

It was decided at the outset to restrict the inquiry to names of political and settlement entities within the coterminous United States, more specifically to counties, minor civil divisions of every description, all agglomerations of dwellings from the smallest hamlet to the major metropolis, and post offices (excluding substations). [14] Stated in somewhat more austere terms, our universe of discourse is that set of decisions concerning names of governmental and settlement units (loosely designated as "towns" in the title) made by the administrators or residents therein—though not without occasional broad hints from the Post Office Department in Washington. Thereby excluded, for reasons of scarcity of data, of the nonlocal nature of the naming process, or of the meager incidence of classical names, are all natural features, streets, highways, railways, city neighborhoods and subdivisions, uninhabited railroad stations, schools, mills, mines, plantations, and other miscellaneous cultural items. It is regrettable that no agency or scholar has ever collected the names of the hundreds or thousands of phantom paper towns—places platted and usually registered and advertised, but never built—for they too would have been grist for our mill. The heavy reliance placed on post-office names is in large part a matter of convenience, since the lists are complete, reliable, and accessible; but it is also based on the high degree of coincidence, during much of recent American history, between clustered settlements of all sizes

and the existence of post offices. Although many of the more ephemeral post offices were, in fact, identified with open-country neighborhoods rather than with genuine hamlets or villages, and often had no fixed location,[15] there is no way of winnowing these from the rest.

It was decided to regard as "classical" (1) all those names that are directly derived from the world of ancient Greece and Rome, that is, the place-names, names of historical or mythological personages, and other elements in the classical vocabulary, and (2) those names that are historically derived from the first group, such as New Philadelphia, Indiana; New Cincinnati, Kansas; or Syracuse, Ohio. A good many early American settlements, of nonclassical as well as classical nomenclature, generated chains or clusters of such derivatives through the migration of their natives and by the general spread of their fame and the adoption of their names into the standard stockpile of attractive, dignified titles for places.[16] Eventually, the process of naturalization and dilution of original meaning went quite far—for example, with such names as Homer, Troy, Virgil, or Arcadia—but the line of descent is unmistakable.

It is immediately clear to anyone who pursues the question that such neoclassical names are a subspecies of a populous tribe of names to which the designation "exotica" might fittingly be given, and which have flourished more abundantly in the United States than elsewhere. In most places and eras, place-names spring spontaneously from local history and from past or present geography and personages, or are transplanted localisms imported by migrants as part of their personal histories. Such "normal" place-names, of course, predominate in the United States in all their aboriginal, British, Dutch, French, and Spanish multiplicity, but in addition there is that profusion of names plucked from distant corners of the globe without direct historical association (for example, Angola, Pekin, Valparaiso, Odessa, or Cairo); from travel accounts, published history, and imaginative literature (including the Greek and Roman classics; the Hebrew, Christian, and Mormon Bibles; Norse mythology; and modern fiction and verse); and those that are simply coined on the spot. One can plead the extenuating circumstance that never before in human history have there been so many places to label so quickly and that the many improbable names are the offspring of desperation.[17] But I prefer to believe that these exotica document the extroverted buoyancy and expansiveness of spirit that many observers identify as American. In any event, it is a matter of no little interest that the same district in west-central New York in which the neoclassical place-name idea first took coherent form is probably the earliest major testing ground for other classes of exotica as well.[18]

EXCLUSIONS AND IDENTITIES

In practice, it proved difficult to apply the given definition for classical place-names without further qualifications and without firm knowledge of the history of the names and the intentions of the namers, information that more often than

not is missing. It is also clear, even where the naming process is fully documented, that the namers were not always fully aware of their own motives, that subconscious or inarticulate feelings were at work. Certain classes of words of ultimately classical origin were automatically excluded: scientific, technical, or other terms now considered to be standard English (for example, zenith, delta [in the landform sense], zephyr, lithium, campus, zodiac); botanical names of classical coinage now in common use; names derived from European place-names whose Latin or Greek origin is commonly recognized only by scholars (for example, Vienna, Chester, or Lancaster); names alluding to contemporary or relatively recent individuals (for example, Alexandria, Augusta, Eugene, or Ulysses), even when the name would otherwise be eligible; most recent Latinate forms (for example, Atlanta, Carolina, or Columbia); and modern Romance and Greek names, whether conferred by early French and Spanish settlers or more recent groups (for example, Acadia, Cartagena, Marseilles, Ypsilanti, or Naples). Another important group of exclusions consists of local filiations in which derivative settlements have been named after the nearby mother town, as happened, for example, in Orange County, Vermont, where in addition to the original Corinth we have Corinth Center, Corinth Corners, East Corinth, West Corinth, and South Corinth. In such cases, only the oldest occurrence is accepted, since there is a minimum of decision-making involved in the later ones. In those instances where a settlement has been given the same name as the township or county in which it is situated (as in Ionia County, Michigan, which also has the city and township of Ionia), each local duplication is assigned an arbitrary value of 0.5 for statistical purposes, since some freedom of choice is apparent. Many agonizing decisions had to be reached on an individual basis, such as the many names that are both Biblical (or Egyptian or Mesopotamian) and classical in character and might derive from either source. Thus, even with the available data on etymology and settlement history, a good many arbitrary judgments were made. I am confident, however, that no systematic bias in selection was in operation and that, though another investigator would arrive at a somewhat different roster of names, the resulting spatial-temporal array and the analysis thereof would not yield significantly different results.

The identity of the names recorded, as set forth, in part, in table 1, is of only incidental importance to our purpose but is certainly of major interest to the general student of American toponymy. Ignoring minor variants in spelling, a total of 424 individual names was noted, including those ending in the three suffixes -polis (or -ople),[19] -adelphia, and -sylvania. Names that refer to historic personages, mythological beings, major cities, and historic sites are in the majority; but in addition there are various numerals, letters of the alphabet, common phrases (Quid Nunc, Sub Rosa, Vox Populi, Rara Avis), common nouns, and a few verbs. Not all the namers' choices were arbitrary or the result of historic happenstance. A significant minority reflect local conditions or aspirations. Thus Agricola, Ceres, Bovina, and Pomona proudly proclaim an agrarian bias, and Dendron, Lignum, Quercus, and Salix may tell us something of the biota, as Ak-

TABLE 1. *Occurrences of Individual Classical Place-Names and Suffixes**

Name	No. of Occur- rences	First Occurrence State	Date	Name	No. of Occur- rences	First Occurrence State	Date
Troy	97	N.Y.	1789	Hector	19	N.Y.	1802
Eureka	83.5	Calif.	1850	Orion	18.5	Mich.	1837
-polis, -ople	68.5	Md.	1702	-adelphia	18.5	Pa.	1682
Annapolis	9.5	Md.	1702	Mars	18	Maine	1790
Minneapolis	7	Minn.	1852	Urbana	18	Ohio	1805
Etna	57	Maine	1820	Alta, Alto, Altus	17.5	Ark.	1879
Antioch	56	Ga.	1837	Sardis	17.5	Ga.	1837
Athens	54.5	Pa.	1786	Solon	17.5	N.Y.	1798
Rome	54.5	N.Y.	1796	Attica	17	N.Y.	1811
Albion	51	Maine	1804	Cincinnati,			
Arcadia	50	N.Y.	1825	Cincinnatus	17	Ohio	1790
Palmyra	49	N.Y.	1789	Euclid	17	Ohio	1810
Sparta	48.5	S.C.	1785	Plato	16.5	N.Y.	1837
Seneca	45.5	N.Y.	1800	Virgil	16.5	N.Y.	1804
Phoenix	39.5	S.C.	1837	Atlas	15.5	Ill.	1837
Alpha	39	Ohio	1851	Scipio	15.5	N.Y.	1794
Homer	37.5	N.Y.	1794	Syracuse	14	N.Y.	1825
Caledonia	36.5	Vt.	1792	Cicero	13.5	N.Y.	1807
Carthage	36.5	N.C.	1803	Vesta	13.5	N.Y.	1823
Macedonia	35	N.C.	1823	Nero	13	Tenn.	1851
Utica	33	N.Y.	1798	Sylvania	12.5	Pa.	1828
Corinth	31	Vt.	1811	Alba, Albia	12	Pa.	1851
Milo	30	N.Y.	1818	Ceresco, Cresco	12	Wis.	1850
Omega	29	Ohio	1842	Marathon	12	N.Y.	1827
Smyrna	27.5	N.Y.	1808	Xenia	12	Ohio	1810
Argo	25.5	Mo.	1837	Fabius	11.5	N.Y.	1798
Adrian	25	Mich.	1828	Utopia	11.5	Ohio	1847
Olympia, Olympus	24.5	Ky.	1811	Berea	11	Ohio, Ky.	1859
Akron	23.5	Ohio	1828	Ceres	11	Pa.	1810
Clio	23	S.C.	1828	Crete	11	Ill.	1846
Venus	22	Va.	1883	Hibernia	11	Iowa	1837
Delphi, Delphos	21.5	N.Y.	1819	Neptune	10.5	Ohio	1842
Altamont	21	Tenn.	1846	Scio	10.5	N.Y.	1828
Cambria	21	Pa.	1800	Aeolia, Eolia	10	Ga.	1837
Cato	20.5	N.Y.	1802	Corydon	10	Ind.	1811
Ionia	20.5	N.Y.	1828	Juno	10	Ky.	1851
Ovid	20.5	N.Y.	1800	Jupiter	10	Ark.	1842
Pomona	20.5	Tenn.	1859	Ithaca	9.5	N.Y.	1811
Minerva	19.5	N.Y.	1817	Ulysses	9.5	N.Y.	1799

TABLE 1. (*Continued*)

Name	No. of Occur-rences	First Occurrence		Name	No. of Occur-rences	First Occurrence	
		State	Date			State	Date
Argenta,				Dido	6.5	Ala.	1859
Argentum	9	Ark.	1879	Elyria	6.5	Ohio	1817
Helvetia	9	Calif.	1839	Hesperia,			
Rhodes	9	Tex.	1883	Hesperus	6.5	Mich.	1883
Tully	9	N.Y.	1803	Pactolus	6.5	N.C.	1828
-sylvania	9	Va.	1720	Romulus	6.5	N.Y.	1794
Elysian, Elysium	8.5	Mo.	1819	Hercules	6	Tenn.	1890
Rubicon	8.5	Wis.	1846	Ilion, Ilium	6	N.Y.	1846
Agricola	8	Kans.	1876	Lithia	6	Va.	1883
Ajax	8	Va.	1803	Petra, Petros	6	Ark.	1859
Delta	8	Mich.	1843	Stix, Styx	6	Ohio	1837
Marcellus	8	N.Y.	1794	Vulcan	6	W. Va.	1840
Pella	8	Ill., Ind.	1870	Galatea, Galatia	5.5	Tex.	1859
Americus	7.5	Ga.	1832	Galen	5.5	N.Y.	1812
Argus	7.5	Ala.	1837	Hannibal	5.5	N.Y.	1820
Aurelia, Aurelius	7.5	N.Y.	1789	Media	5.5	Pa.	1850
Bucyrus	7.5	Ohio	1828	Athena, Athenia	5	Pa.	1830
Castor	7.5	Mo.	1859	Brutus	5	N.Y.	1828
Laconia	7.5	Ind.	1828	Cadmus	5	Kans.	1877
Castalia	7	Ohio	1836	Caesar	5	Ohio	1810
Manlius	7	N.Y.	1794	Ephesus	5	Ga.	1883
Mentor	7	Ohio	1820	Nextor	5	Ill.	1851
Mount Ida	7	Wis.	1870	Pandora	5	Tenn.	1851
Bono	6.5	D.C.	1819	Parnassus	5	S.C.	1842
Bovina	6.5	N.Y.	1820	Patmos	5	Ohio	1859
Corona	6.5	Miss.	1859	Theta	5	Tenn.	1883

*Names occurring five times or more. Local duplications have each been assigned a value of 0.5.

ron and Altus advertise the elevation of the site. More than one college town bravely christened itself Athens. Not unexpectedly, Washington has its Pluvius, and there are Neptunes in coastal New Jersey and Florida. But the largest group of referential names deals with mineral or metallurgical activity: Argentum, Aurum, Cuprum, Eureka, Ferrum, Lithopolis, Petroliopolis, and Vulcan, among others. In a few instances, we find such predictable pairings of names as Alpha and Omega or Romulus and Remus. It hardly needs to be said that, just as in the case of the American Greek Revival dwelling, which is a caricature (however lovely a one) of the original temple model and bears not the slightest resemblance to the

TABLE 2. *Adoption of Classical Place-Names by Political and Settlement Units, by State and Period**

	Before 1820	1820– 1860	1860– 1890	After 1890	Total
New York	82	51.5	13.5	3	150
Vermont	5.5	1.5	0	0	7
New Hampshire	2	.5	.5	1	4
Massachusetts	1	0	1	0	2
Delaware	1	0	0	0	1
District of Columbia	1	0	0	0	1
Ohio	36	92	22	8.5	158.5
Illinois	1	77	38	15	131
Iowa	0	77	49.5	4	130.5
Michigan	0	63.5	28.5	10	102
Indiana	4	57	20	7	88
Wisconsin	0	50	17	15	82
Pennsylvania	9.5	44.5	29.5	14.5	98
Tennessee	3	26	24	11	64
Mississippi	0	19	17.5	15	51.5
Maine	11.5	14	0	0	25.5
Kansas	0	15	92.5	7.5	115
Missouri	4	45	48	27	124
Nebraska	0	1.5	47	6	54.5
North Carolina	2	13.5	42	27.5	85
South Dakota	0	0	39.5	8.5	48
Alabama	1	18	33.5	25	77.5
Minnesota	0	18.5	33	13	64.5
Kentucky	3	18	32.5	29	82.5
Georgia	2	23	30.5	30.5	86
West Virginia	0	7.5	25	24.5	57
Colorado	0	0	18	11	29
Louisiana	0	9	13.5	11	33.5
Nevada	0	0	8	6.5	14.5
Maryland	3	4.5	6	4	17.5
Rhode Island	0	0	3	0	3
Connecticut	0	0	1	0	1
Oklahoma	0	0	5	55.5	60.5
Texas	0	14	32.5	47.5	94
Virginia	3	13.5	25.5	44	86
Arkansas	0	16.5	32.5	36	85
Florida	0	3	26	32	61
Washington	0	2	8	32	42

TABLE 2. (*Continued*)

	Before 1820	1820– 1860	1860– 1890	After 1890	Total
North Dakota	0	0	16	27.5	43.5
South Carolina	1.5	13.5	16	27	58
California	0	11.6	18.5	21.5	51.5
Oregon	0	6	14	19.5	39.5
Montana	0	0	5.5	17.5	23
Utah	0	0	6	10	16
New Mexico	0	0	2.5	8	10.5
Idaho	0	0	6.5	7.5	14
Wyoming	0	0	2	6.5	8.5
Arizona	0	0	3	5	8
New Jersey	2	2.5	4	4.5	13
Total	179	829.5	957.5	736.5	2,702.5

* States are arrayed by period of maximum number of occurrences. This table lists only names that can be dated. Table 4 includes certain undated names as well; hence the totals of the two tables do not agree.

homes of the Hellenes, so too with these neoclassical names. They do not realistically replicate the place-name cover of the world of Pericles or Augustus Caesar; but if they tell us little about the Mediterranean realm two millennia ago, they do bear witness to the peculiar values and visions of their American patrons.

FINDING, DATING, AND COUNTING NAMES

Students of American toponymy are unfortunate in having no truly comprehensive, accurate catalogue of the place-names of physical and cultural features for either past or present. So far as contemporary settlements are concerned, the closest approach to complete coverage is that in the carefully edited *Rand McNally Commercial Atlas and Marketing Guide,*[20] the 1965 edition of which lists approximately 114,000 places, including many that fall outside the definition of inhabited settlements given above. For the historical period, two sources of data on agglomerated settlements were invaluable, though not nearly as comprehensive as might be desired: the publications of the decennial Census of Population; and the post-office lists published (with various titles) for the United States Post Office Department on an irregular basis from 1800 to 1873 and quarterly or more frequently from 1874 to the present.[21] All relevant Census tables from 1790 to 1960 were scanned, and the complete listings of minor civil divisions from 1870 on were carefully noted.[22] Nineteen post-office lists, from 1803 through 1950, were scrutinized and the classical names extracted from them. In addition, a modest library

of gazetteers, place-name dictionaries, and the like, of widely varying quality and reliability, exists for individual states and a few counties;[23] all available examples were scanned for information on names and their origins. For each occurrence of a classical name, the location by state and county, the date of the naming or the earliest noted citation, and any relevant historical data were recorded. Unfortunately, the cartographic record is such that the precise intracounty location of many places, or even the earlier location of some county boundaries, cannot be determined, hence the placement of symbols on the accompanying maps is somewhat generalized. Similarly, many dates for name adoptions can only be approximated from the available materials, and some may have been postdated from one year to as many as six years. But these defects are random, and do not significantly affect the analysis of temporal or regional differences.

In all, 2405 classical names were recorded for agglomerated settlements or post offices and 690 for counties and minor civil divisions, for a total of 3,095. Since 449 of these are local duplications, the weighted total comes to 2,870.5. Through indirect evidence, it seems almost certain that at least 70 percent—and possibly more than 80 percent—of all eligible items have been found[24] and that the missing items were either ephemeral or were used for very small places; their omission does not materially skew the subsequent analysis. No precise statement can be offered as to the proportion of classical names to total names, since there is no wholly comprehensive and reliable count of the total number of agglomerated settlements at any given moment in American history. More frustrating still, it is not possible currently even to estimate the total name population (that is, those that existed at the end of a given period, plus those that expired during that same period) either for the entirety of American history or for any specific epoch in any area.[25]

In any event, the 1,510 classical names now extant are equivalent to 2 percent of the combined count of post offices (35,238), counties (3,067), and minor civil divisions (37,867)[26] in 1960; but if the several thousand smaller settlements lacking post offices were to be included, the value would fall below 2 percent. In 1910, when the national total of post offices was near its all-time peak and many still extant places had not yet lost these facilities, some 1,010 agglomerated settlements bore classical names, the equivalent of 1.7 percent of the total number of post offices (59,344). It seems likely, then, that for the past hundred years the incidence of classical names among political and settlement units has ranged between 1.5 and 2.0 percent, a small, but hardly negligible, value.

PECULIARITIES OF TOPONYMY AS AN INNOVATION PROCESS

In contrast with the innovations that have been the subject of most diffusional analyses, we are dealing here with a process of obscure psychological character, and with items the precise taxonomy of which may give honest scholars scope for ·endless argument. These items, moreover, are derived from a distant archaic

world, whose margins in time, space, and cultural affiliation are hard to chart, and information concerning them is either incomplete or imprecise. To complicate things still further, place-name preference does not involve clear-cut decisions among alternatives of differential functional value, as is usually the case in considering innovations in the fields of technology or social organization, as with the celebrated better mouse-trap. Beyond their primary function of unequivocally identifying places (for which any arbitrary arrangement of symbols will do), place-names have only two minor uses: they advertise a place, plying the not so ancient art of image-mongering; and they feed certain vague subterranean appetites, as do personal names, costumes, cosmetics, or jewelry. In the face of such low-key functional competition, names tend to persist indefinitely once they are imprinted on places. It is difficult or even impossible to change them, and revisions are exceptional, though fairly numerous in the aggregate. In essence, then, we are dealing with the naming process during the periods of pioneer settlement and subsequent expansion of the settlement network, and, consequently, within a rather limited time range for the propagation of innovation waves.

COMPOSITE SPATIAL ARRAY OF CLASSICAL NAMES

After this necessarily lengthy exposition of the criteria and methods used in data collection, it is heartening to report that highly interesting and provocative results emerge when these data are plotted in the aggregate, and by decade and county. Taking first the distribution of all known occurrences of classical town names (fig. 1), it is plain that there is only the weakest sort of association with the distribution of total population or with number of settlements[27]—merely the familiar contrast between a solidly populated East and a thinly settled West. After brief study, however, a "Classical Belt," occupying parts of the Northeastern and North Central states and extending west-southwest from central New York to central Kansas, becomes visible, though the dot map technique is not ideal for its depiction.[28] Most conspicuous is the thick swarm of classical names in west-central New York, notably in Cayuga, Cortland, Onondaga, Oswego, Seneca, and Wayne Counties. This is probably the only section of the country where there is much public awareness of a classical tradition. Elsewhere within the Classical Belt several other definite, if less concentrated, groups of names stand out, as in the upper Ohio Valley, southern Michigan, south-central Iowa, and the western Ozarks. Farther afield, still others appear: in central Maine, in the northern Sierras, and in various tracts in Virginia, the Carolinas, and Alabama. Equally striking are several near-hiatuses on the map (ignoring certain areas almost devoid of settlement): most of New England; the coastal plain from Maryland to Georgia; east-central Illinois and northwestern Indiana; southern Louisiana and Mississippi; and the far Southwest in general. The first two may be attributed to early occupation and preemption of naming decisions during the preclassical period, the third has no obvious explanation, and the last two may result from cultural

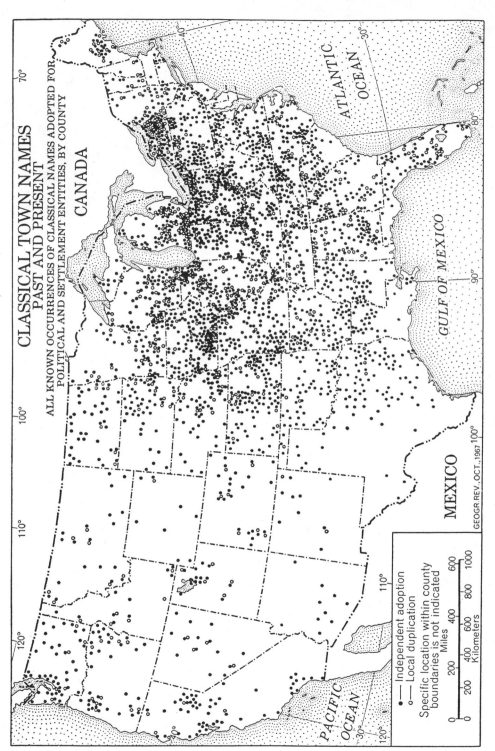

FIGURE 1 Classical town names past and present. All known occurrences of classical names adopted for political and settlement entities by county.

barriers among early settlers of French and Spanish-Mexican origin, together with a distance-decay effect.

Although no rigorous tests have been applied, simple inspection of figure 1 leads to a strong assumption that the distribution pattern is not a random one. Rather it resembles, in its irregular scattering of open blotches, an advanced stage of a bacterial culture in a uniform nutrient medium in which the various daughter colonies have spread outward some distance and have begun to lose coherence. It calls emphatically to mind the Hägerstrandian model of the propagation of innovations by contagious diffusion.[29]

ORIGINS AND ENTRENCHMENT IN THE NORTHEAST

The geography of classical town names becomes much more comprehensible when the data are disaggregated on a temporal basis. When the names extant in 1965 are plotted (fig. 2), the pattern closely resembles that in the first map, though less than half the dots are present. The most striking difference is the thinning out of symbols in the Southeast and a much sharper delineation of the Classical Belt in the shape of a somewhat bent isosceles triangle with its apex slightly east of Syracuse, New York, and the corners set in south-central Kansas and northeastern North Dakota. The geometry of this fan-shaped belt further bolsters the notion of a gradually widening, westward sweep of the idea from an initial New York focus.

A more complete story can be read by examining the time-series of maps that portray the adoption of classical town names by county and decade (figs. 3–14).[30] Five distinct periods can be detected. The first, longest, and least important comprises the entire Colonial era, during which the classical element in toponymy was nearly absent, and classicism in other phases of American life was still at a rudimentary level. Indeed, the only surviving names of importance are Annapolis and Philadelphia. The history of the phenomenon really begins in the immediate post-Revolutionary period. During the late 1780s, and especially the 1790s, there was an abrupt crystallization of the classical idea in the young Republic's newer settlements and the notion of a New Athens or a New Rome was becoming a lively one, supplementing the long immanent doctrine of a New Zion. The concurrent French Revolution, linking as it did the image of the classical world with republican principles, probably gave the new fad added impetus. Scattered occurrences of classical place-names over the length and breadth of the land attest to a widely receptive mood. But it is in west-central New York, particularly in the Military Tract and adjacent areas, that we find a truly formidable cluster.[31] This area may, in fact, be fairly characterized as the culture hearth for classical place-naming.[32] There is more than mere chance in its early focality. West-central New York also appears to be the zone of maximum intensity for the early development of Greek Revival architecture and for the penetration of this style into vernacular domestic building. It was the staging area in which certain classically oriented house-types were standardized before being launched on their westward journeys. And the

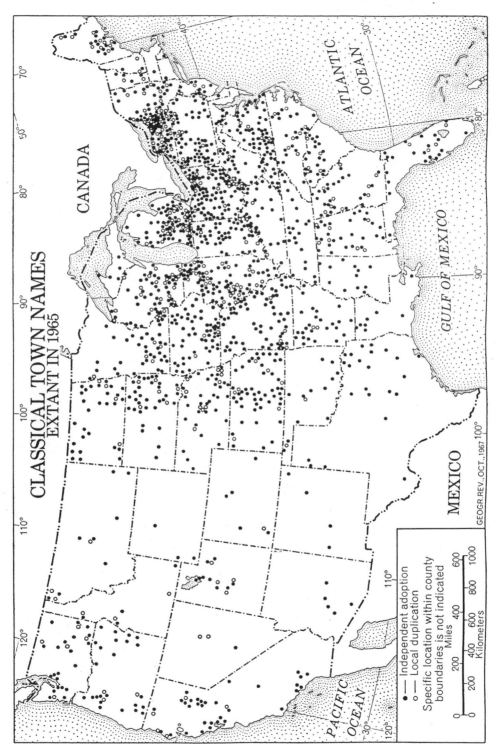

FIGURE 2 Classical town names extant in 1965.

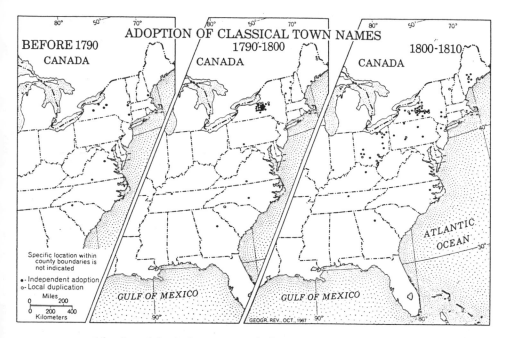

FIGURE 3 Adoption of classical town names before 1790, 1790–1800, 1800–1810.

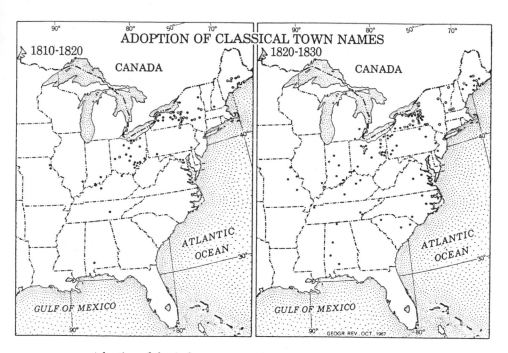

FIGURE 4 Adoption of classical town names 1810–1820, 1820–1830.

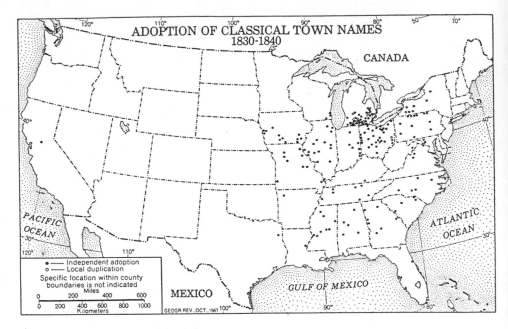

FIGURE 5 Adoption of classical town names 1830–1840.

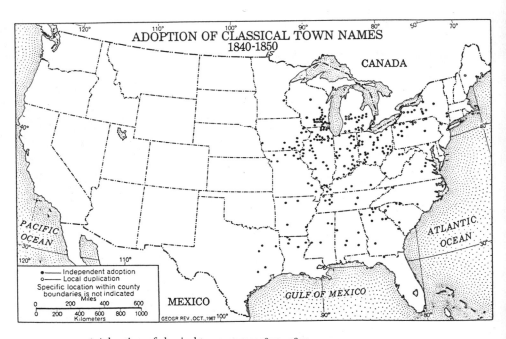

FIGURE 6 Adoption of classical town names 1840–1850.

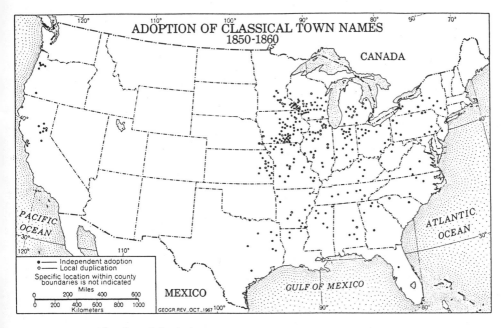

FIGURE 7 Adoption of classical town names 1850–1860.

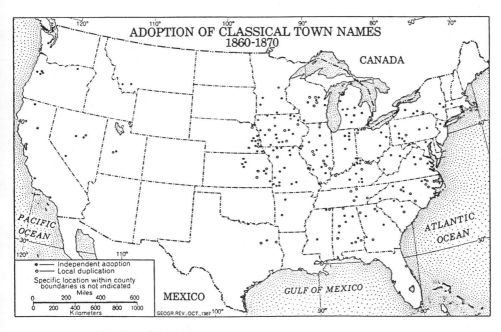

FIGURE 8 Adoption of classical town names 1860–1870.

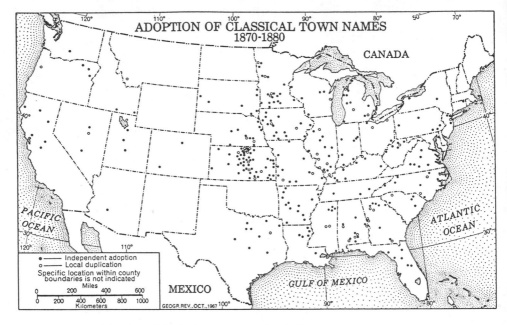

FIGURE 9 Adoption of classical town names 1870–1880.

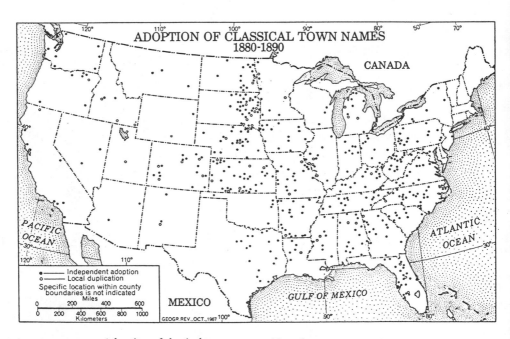

FIGURE 10 Adoption of classical town names 1880–1890.

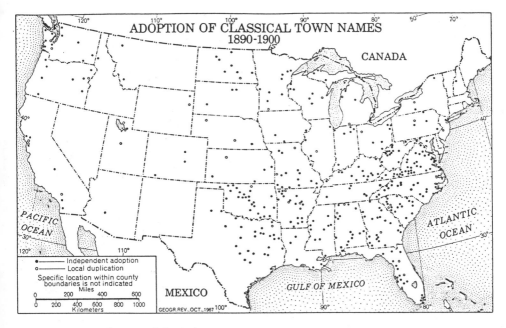

FIGURE 11 Adoption of classical town names 1890–1900.

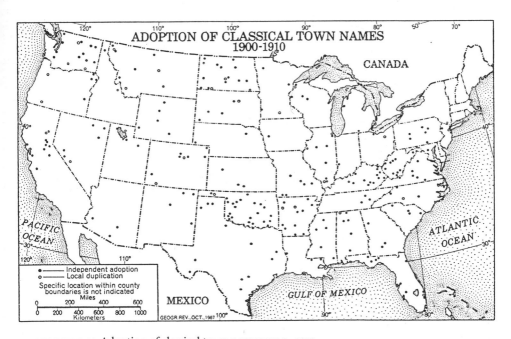

FIGURE 12 Adoption of classical town names 1900–1910.

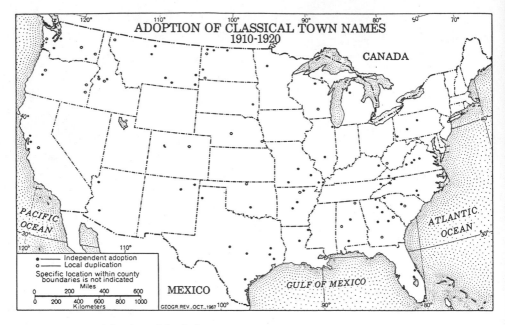

FIGURE 13 Adoption of classical town names 1910–1920.

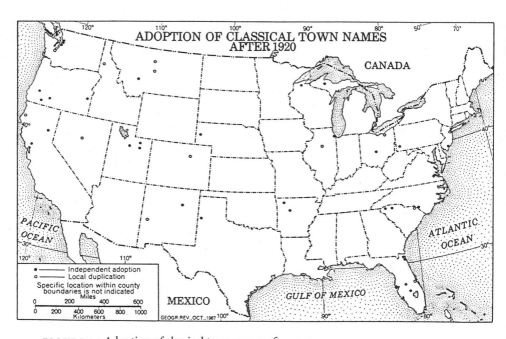

FIGURE 14 Adoption of classical town names after 1920.

suspicion is strong that when the cultural geography of this area receives the attention it deserves, it will be found to have spawned a number of other significant American innovations.

NATIONWIDE DIFFUSION: PATTERNS AND PROCESSES

This period of the birth and consolidation of classical names in New York gives way about 1810 to a third phase, lasting until the Civil War (Figs. 4–7), during which the practice spread outward over a large part of the eastern United States.[33] It is reasonable to speculate that diffusion may have taken place by means of all three processes mentioned earlier. The idea was obviously borne westward into successive zones of pioneer settlement in Ohio, Indiana, Illinois, Michigan, and Wisconsin, and then across the Mississippi to Iowa and Missouri by migrants from New York (and perhaps also by New Englanders of similar proclivities). The small, but by no means trifling, scatter of classical names in the South, some hundreds of miles from their nearest neighbors and in areas well outside the normal range of New York and New England out-migration, opens up the possibility that a more or less spontaneous broadcasting of the idea may have developed, through visits, books, periodicals, and correspondence circulating among decision-makers, though the possibility of the odd migrant is not ruled out. Particularly noteworthy is the thin but definite arc of classical names reaching from central North Carolina to central Mississippi (fig. 5) that would appear to correlate spatially with a principal belt of plantation agriculture.

Another process, the outward movement of the idea qua idea among neighboring communities, as distinct from the movement of people, seems on the evidence of the maps a plausible notion, though again a difficult one to test given the nature of the phenomenon and the data. Accepting its existence for the sake of argument, the persistence of a quite noticeable "innovation front," thick with fresh adoptions of classical place-names, that first appears in Michigan in the 1830s and finally dissipates in the central Great Plains around 1890, can be explained largely as the combined product of two waves nearly coincident in date and velocity—the westward-wending settler and the idea radiating generally outward from its natal New York. Statistical evidence of the existence of a nondemographic innovation wave is cited below. One rather elegant batch of evidence convincingly demonstrates that either contagious diffusion or a rapid communication network among the elite, or both, were in operation: this was the appearance, from 1790 to 1840, of a moderate number of classical names in northern New England, then still a frontier zone that shared the general *Zeitgeist* of western New York, but certainly received few, if any, migrants from that source.[34]

Before 1860, the most noteworthy regional hiatus in classical nomenclature, aside from some large tracts of nonoccurrence in the South, was in the older settled zone nearest the originating center; classical items were rare or nonexistent

in eastern New York, southern New England, New Jersey, Delaware, and most of Pennsylvania. The discontinuity along the Canadian border has already been noted. The weakness of classical naming in those parts of the Northeast that had been fully settled by 1790 is puzzling in view of the exuberant development of Greek Revival architecture throughout New England and eastern New York. However, house-building and renovation is a never-ending process, whereas opportunities for inventive place-namers were few in the former Colonial ecumene during the early nineteenth century.

It is significant that the cultural divide along the Allegheny Front that separates New York and the northern tier of Pennsylvania counties (New England Extended) from the Pennsylvania culture area to the south[35] in terms of dialects, architecture, town morphology, and probably other traits[36] is also the line (rather less distinct, but still recognizable) separating a zone of high frequency for classical names from one of low incidence during much of the nineteenth century. Also, there appears to be some areal association between classical place-names and Greek Revival house types in southern Michigan and certain other parts of the Midwest[37] still awaiting field investigation.

During the later stages of the third phase (circa 1810–1860), the incidence of new names displayed an even stronger westward vector, and a decided decline is noticeable in such older areas as New York and Ohio. This trend anticipates the dominant pattern of the fourth phase, from the 1860s to about 1920, one of a "hollow frontier." An abundance of classical names begins to crop up in most of the Western and Southeastern states, while progressively fewer are recorded in the Northeast. Thus, in essence, what had initially been a trait strongly coincident with a specific "culture sphere," to use Meinig's phrase,[38] was escaping its regional confines and becoming a truly nationwide phenomenon. Another New Englandism (taking a liberal view of the bounds of the region) had been absorbed into the national culture.[39] Analysis of median points of adoptions of classical town names by decade bears out this contention. From 1790 to 1860, the median point moves generally westward along a track not far from that followed by most New England and New York migrants; but thereafter the point hovers within a zone more or less central to the totality of new settlements.

INNOVATION WAVE ALONG A HOLLOW FRONTIER

For the nation as a whole, maximum incidence of new classical names occurred during the 1880s and 1890s when the creation of new post offices reached its peak. This proliferation of post offices, and, inferentially, of new settlements, is clearly associated with the general advance of the settlement frontier throughout the West and in certain mining districts in the East; but in the Southeast, where no visible frontier zone had existed since the 1850s, we must postulate a partial filling in of the holes in an open, inchoate lattice of central places. The

process represented the gradual urbanization, or at least nucleation, of a still pre-dominantly rural settlement pattern.

While all this was going on, I suspect that the namers were decreasingly aware of the pristine import of their choices, the names thus becoming less purely and distinctly classical; but this is a subjective view not easily tested. In any event, the trend was emphatically one of a "wave" or "swell" of classical naming that moved progressively outward[40] from the older Northeastern zone in which such activity dwindled and nearly disappeared. The near absence of new classical names in the core region cannot be explained by a shortage of opportunities. Hundreds of new settlements were named in the Northeast during the late nineteenth century and the early twentieth. In fact, the maximum decades for increment in the number of post offices for New York and Ohio were 1870–1880 and 1880–1890, respec-tively. What appears to have happened is either or both of two phenomena: (1) the kinds of settlement that have come into being in the Northeast within the past hundred years—in large part industrial towns, metropolitan suburbs, and resort and recreational centers—were relatively unreceptive to classical designation as compared with earlier types; or (2), a notion not unrelated to the first, the idea of classical names had become passé, outwearing its mystique in the relatively older parts of the nation, even while it was still flourishing and spreading vigorously in the younger, less developed regions.

There may be other explanatory factors not yet apparent, but it is reasonable to propose that we may have in the historical geography of classical names in the United States a clear-cut example of the hollow frontier. It is hypothesized that culture traits and complexes experience a "life cycle" and enact their spatial-temporal evolution in accordance with a certain internal logic. This results, dur-ing the later stages of the cycle, in a sharp contrast between the nuclear zone in which the trait has become dormant, gone out of style, or even disappeared, and the peripheral zone in which the innovation is advancing, thriving, and even giv-ing off fresh mutations.

Against this point of view it might be argued in the case of classical place-names that, given the obviously close correlation between classical-name adop-tion and the naming of all places that occurred during the period of active frontier advance (except for the aberrant Civil War and Reconstruction decade), the spread of classical names has been simply a function of total settlement advance and the thickening of the settlement fabric. That such a correlation exists is un-deniable, but there is persuasive, though not ironclad, evidence that the two phe-nomena are independent in causation and process, even if fortuitously somewhat coincident in pattern. After 1890 the correlation between new classical names and net change in number of post offices breaks down almost completely: the settle-ment frontier has come to a standstill, but the classical-name innovation wave rolls on for another two or three decades. This phenomenon becomes even clearer if the maximum decades for new classical names and for net change in number

of post offices are examined for each state. In several Northeastern states, the crest of classical naming precedes the peak of post-office increments by one or more decades. This bloc of states is flanked to the west and south by a broad ring of states in which the two peaks coincide. Finally, in the West and Southeast, the decade of maximum number of new classical place-names follows by some interval the maximum decade for post offices. If both processes can be visualized as waves, then the classical-name phenomenon began to diffuse earlier (in post-1790 territory), crested at a lower level, advanced more slowly, and terminated later than did total town-name formation.

REGIONAL VARIATION IN THE DISAPPEARANCE OF NAMES

As we examine the fifth and final phase of the spatial evolution of classical place-names, it becomes plain that the broad peripheral zone of strong activity from 1870 to 1920 was of relatively transient importance, and that it did not give rise to a further intensification or elaboration of the phenomenon, as has occurred along some hollow frontiers. Since 1920 there has been a sharp deceleration, and now a virtual cessation, of classical place-naming. In major part, of course, this is one aspect of contraction or stasis in the number of settlements during the present century. Thus, for example, the current number of post offices now is less than half those listed in the peak year of 1901. Even if the question of whether the total number of agglomerated settlements has changed significantly in recent decades is conceded to be moot, there has certainly been little scope for the imagination of place-namers outside the suburban belts of our cities, an environment evidently hostile to classicism.[41]

Along with the decline in officially listed settlement names, the ranks of contemporary classical settlement names have also thinned considerably. The trend has been such as to restore a semblance of the mid-nineteenth century spatial array, so that figure 2, showing 1965 occurrences, more closely simulates figure 15, which records the 1870 situation, than it does figure 16, the map for 1910. But even in 1910, during the heyday of the popularity of classical names in the western and southern peripheral zones, the incidence remained highest in the Northeastern core area, though less obviously so (fig. 16 and table 3). The survival rate for classical names in the Northeastern and North Central states may have been significantly higher all during their history (table 4), as it has certainly been since 1910. The obvious explanation is that places receiving classical names during the initial stages of settlement had a greater chance of surviving and maturing into durable towns and cities than did those created during the final phases of settlement. The prospects for small, late settlements poorly situated and/or lacking in historical momentum would be much dimmer than those for the earlier settlements that had preempted strategic niches in a developing system of central places. In any event, differential erosion has etched out in bolder relief the relative importance

of classical names in the northeastern quarter of this nation and has lessened their significance almost everywhere else (fig. 2). One might finally claim that the current incidence of classical place-names provides a reasonably good image of regional variation in intensity of past classical sentiment.

Thus the linguistic relics of ancient Greece and Rome survive in our place-name mantle, however unevenly, as witnesses of a major episode in that prolonged, uniquely American, crisis of identity and quest for an elusive perfection.

Geographical Review 57 (1967): 463–495

NOTES

The financial support for this study extended by Pennsylvania State University's Central Fund for Research is gratefully acknowledged.

1. Hamlin (1944) is a comprehensive survey of high merit, but its attention is confined almost exclusively to "specimen" buildings, and little notice is given to the Greek Revival element in American vernacular construction.

2. Other practices that may be peculiarly American are the application of classical terms to political parties and to legislative bodies and edifices, and the use of Greek letters to designate fraternal and honorary organizations on campuses (this last term itself a uniquely American borrowing from the classical vocabulary). See Jones (1964: 228–229).

3. According to the most comprehensive listings of Brazilian place-names current available (Brasil 1960; U.S. Board of Geographic Names 1963), some 113 political and settlement units bear classical names, using the definition developed for this study. The majority of them are in those sections of the states of Minas Gerais, São Paulo, Paraná, and Goiás occupied during the latter half of the nineteenth century and this century. The phenomenon has not yet been studied in Brazil, but according to Carlos Delgado de Carvalho of the Universidade do Brasil, Rio de Janeiro (1966), a definite propensity existed on the part of the republican regime to revive the Hellenistic vocabulary of antiquity in coining new place-names, quite apart from any direct inheritance of classical terms by way of the Roman lineage of the Portuguese language or of Catholicism. On the other hand, Brazil has failed to develop anything resembling Greek Revival architecture.

4. There is no satisfactory explanation of the names Angelópolis, Antioquia, Cartago, Corinto, Filadelfia, and Heliconia, according to James J. Parsons (1966). Parsons (1949: 8–9) also notes the equally puzzling Belén, Betania, Betulia, Jericó, Libano, and Palestina of scriptural provenance in the same region.

5. The only Australian place-name meeting the criteria set forth here is Eureka Stockade, Ballarat, Victoria, possibly an onomastic transplant carried by miners from California. The history and migrations of the term Eureka merit monographic treatment. The word appears to have been first used as a place-name in Humboldt County, California, shortly before 1850 and then to have spread eastward and overseas with spectacular rapidity.

6. The only South African classical town name I have encountered is Bechuanaland's early-nineteenth-century Phillippolis, for which I am indebted to David L. Niddrie (1965). For South Africa, as for other "Neo-European" countries, the place-name indexes of the standard atlases were searched, but with scant result.

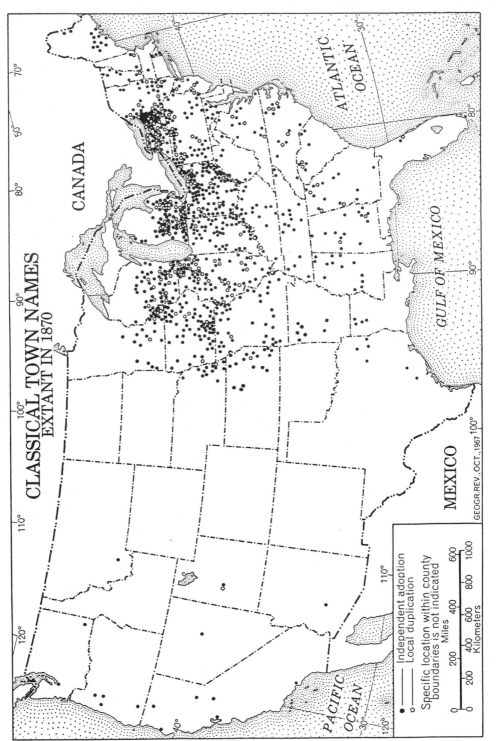

FIGURE 15 Classical town names extant in 1870.

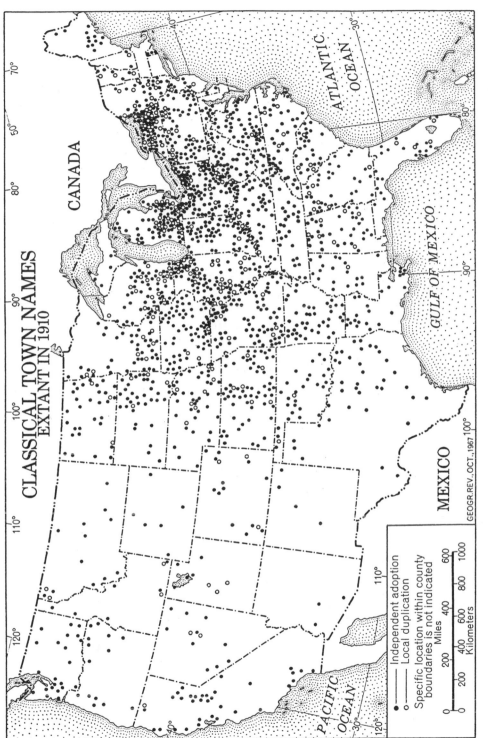

FIGURE 16 Classical town names extant in 1910.

TABLE 3. *Post Offices and Agglomerated Settlements with Classical Names, 1910*

State	No. of Post Offices	Settlements with Classical Names		State	No. of Post Offices	Settlements with Classical Names	
		Number	% of P.O.'s			Number	% of P.O.'s
Nevada	222	7	3.2	Nebraska	1,030	15	1.5
Ohio	1,970	59	3.0	Colorado	855	13	1.5
Michigan	1,480	41	2.8	Oregon	885	13	1.5
Illinois	1,870	51	2.7	North Carolina	1,935	28	1.5
Kansas	1,268	34	2.7	Pennsylvania	3,675	51	1.4
Indiana	1,295	34	2.6	Minnesota	1,355	19	1.4
Iowa	1,395	35	2.5	Virginia	2,673	38	1.4
Rhode Island	125	3	2.4	Utah	348	5	1.4
South Carolina	795	18	2.3	Kentucky	2,890	39	1.3
New York	2,720	60	2.2	West Virginia	2,060	26	1.3
Missouri	2,215	46	2.1	Montana	755	10	1.3
Arkansas	1,810	38	2.1	Maine	970	12	1.2
Oklahoma	1,320	27	2.0	Idaho	577	7	1.2
Wisconsin	1,240	23	1.9	Alabama	1,435	16	1.1
Tennessee	1,318	25	1.9	Arizona	286	3	1.0
Washington	1,018	18	1.8	Texas	2,682	27	1.0
Louisiana	1,255	21	1.7	Maryland	825	8	1.0
California	1,698	28	1.6	Delaware	117	1	1.0
South Dakota	755	12	1.6	New Jersey	777	7	0.9
North Dakota	860	14	1.6	New Hampshire	462	3	0.7
Mississippi	1,335	22	1.6	New Mexico	601	4	0.7
Wyoming	385	6	1.6	Vermont	440	2	0.5
Georgia	1,445	23	1.6	Massachusetts	727	1	0.1
Florida	1,070	17	1.6	Connecticut	378	0	0
				Total	59,602	1,010	1.7

7. Only 28 past and current classical names for political and settlement entities in Canada were encountered after a thorough search of the standard work on the subject (Armstrong 1930), the detailed 1961 census tabulations, the *Gazetteer of Canada: Ontario* (1962), and materials from the files of the Toponymy Division of the Geographical Branch kindly supplied its chief, J. Keith Fraser. If the Canadian incidence of such names were to approximate that in the United States, some 300 such names would exist. The clustering of classical names in such border states as New York, Ohio, and Michigan makes the international contrast all the more striking. That there was some slight seepage of American classicity

across the frontier is established by the location of all Canadian classical names (except for the early Annapolis, Nova Scotia) in the provinces of Ontario, Saskatchewan, and Alberta, where contagious diffusion and migration from the United States would have been maximal. Coincident with this abrupt place-name discontinuity is that in the domestic architecture of the two nations. The failure of the Greek Revival house to cross the boundary and other striking distinctions in house types are noted by Gowans (1958: 79–85, 103–110; 1964). In both instances, we must adduce the strength of antirepublican feelings in loyalist Canada as barring ingress to such ideologically tainted names and building styles.

8. George R. Stewart writes concerning the "Classical Belt" that "this group of names is probably of more interest to more people (to judge from my correspondence) than any other in the country" (1958: 466).

9. It is possible to list here only the most significant items that discuss the role of Neoclassical elements in American life: "Our Classical Belt" (1907), Mumford (1924: 53–71), Sage (1929), Wilkins (1957), Stewart (1958: 181–188), Jones (1964: 227–272), and Fitch (1966: 60–98).

10. Quite apart from the scientific booty to be won in such a quest, I must shamelessly confess to a hedonistic motive. Like Stephen Vincent Benét, "I have fallen in love with American names," and it has been the pleasantest sort of drudgery to wallow in the delights on onomatomania with each taking of the long roll call of American names. They are catnip to the geographic imagination.

11. This convenient term, for which I am indebted to my colleague Peirce F. Lewis, is somewhat elastic territorially, the extent of New England Extended depending on the date and specific cultural features under scrutiny. In addition to the six New England states, it embraces New York (with the possible exception of the zones of early Dutch and British settlement in the Hudson Valley and on Long Island) and the northern segments of Pennsylvania and New Jersey. In less distinct, but still meaningful, fashion, it takes in much of the Upper Middle West and parts of the Maritime Provinces.

12. For concise descriptions of the theory and operation of this model, see Hägerstrand (1952, 1965).

13. This term, first applied to advancing zones of land settlement, also describes a variety of spatial behavior on the part of culture traits, a concept that seems implicit in much of the literature of anthropology and historical geography but one that, to the best of my knowledge, has never been explicitly enunciated. The phenomenon (which seems to work best for religious ideas or institutions and aesthetic styles, vide Buddhism or last year's Parisian coiffure in Central America) may indeed be more universal than has yet been recognized.

14. State names have been excluded because they are few in number and the designated areas gross in size. As it happens, only one, Pennsylvania, fully qualifies for inclusion here, but several others (Vermont, Rhode Island, the Carolinas, Virginia, and the District of Columbia) are at least marginal cases.

15. On this question and other difficulties in coping with post-office names, see Shirk (1965: xi–xiv).

16. As an example of what can be accomplished in such geo-genealogy, see Stewart (1958: Plate between 256 and 257), a map depicting the approximate locations and dates of some thirty-two Winchesters in twenty-five states—most of them towns, but some natural

TABLE 4. *Classical Town Names,*[a] *Past and Present, and Their Survival Rate, by State*

	Total Occurrences Recorded, Including Names No Longer in Use[b]				Names Currently in Use				
	"Independent" Occurrences	Local Duplications[c]	Total	Weighted Total[d]	"Independent" Occurrences	Local Duplications[c]	Total	Weighted Total[d]	Current Names as % of Total Recorded[e]
New Hampshire	4	2	6	5	3	2	5	4	80
Maine	18	15	33	25.5	14	10	24	19	75
New York	133	47	180	156.5	87	48	135	111	71
Michigan	89	37	126	107.5	66	20	86	76	70
North Dakota	40	7	47	43.5	28	4	32	30	69
South Dakota	45	8	53	49	31	6	37	34	69
Virginia	94	2	96	95	61	4	65	63	66
Vermont	6	4	10	8	4	2	6	5	63
Wisconsin	75	20	95	85	44	19	63	53.5	63
California	53	5	58	55.5	32	5	37	34.5	62
Illinois	113	39	152	132.5	68	25	93	80.5	61
Pennsylvania	103	16	119	111	63	9	72	67.5	61
Nebraska	56	13	69	62.5	33	10	43	38	60
Oregon	38	10	48	43	24	3	27	25.5	60
Minnesota	61	13	74	67.5	36	8	44	40	59
Utah	16	5	21	18.5	9	4	13	11	59
Ohio	160	21	181	170.5	90	16	106	98	57
New Jersey	16	2	18	17	8	3	11	9.5	56
Indiana	90	6	96	93	48	5	53	50.5	54
Washington	41	10	51	46	22	6	28	25	54
Missouri	122	9	131	126.5	62	4	66	64	51
Arizona	10	0	10	10	5	0	5	5	50
Idaho	11	6	17	14	5	3	8	6.5	46

	1	2	3	4	5	6	7	8	9
Kansas	107	22	129	118	48	7	55	51.5	44
Montana	20	7	27	23.5	8	3	11	9.5	40
West Virginia	62	4	66	64	23	1	24	23.5	37
Alabama	71	18	89	80	26	7	33	29.5	37
Iowa	146	10	156	151	53	3	56	54.5	36
New Mexico	11	1	12	11.5	4	0	4	4	35
South Carolina	57	8	65	61	18	5	23	20.5	34
Maryland	17	1	18	17.5	6	0	6	6	34
Florida	62	10	72	67	20	4	24	22	33
Georgia	85	12	97	91	25	9	34	29.5	32
Tennessee	66	9	75	70.5	22	0	22	22	31
North Carolina	82	12	94	88	23	8	31	27	31
Arkansas	83	8	91	87	25	2	27	26	30
Kentucky	89	7	96	92.5	25	3	28	26.5	29
Wyoming	10	2	12	11	3	0	3	3	27
Louisiana	31	0	31	31	8	0	8	8	26
Texas	92	4	96	94	23	0	23	23	24
Mississippi	51	5	56	53.5	12	0	12	12	22
Oklahoma	61	3	64	62.5	12	2	14	13	21
Nevada	13	4	17	15	2	2	4	3	20
Colorado	26	9	35	30.5	5	1	6	5.5	18
Connecticut	2	0	2	2	1	0	1	1	
Massachusetts	2	0	2	2	1	0	1	1	
Delaware	1	0	1	1	1	0	1	1	
District of Columbia	1	0	1	1	0	0	0	0	
Rhode Island	3	0	3	3	1	0	1	1	
Total	2,645	453	3,099	2,871.5	1,238	273	1,512	1,374.5	47.9

[a] Including names of counties, minor civil divisions, agglomerated settlements, and other post offices.

[b] Including names whose date or period of origin is unknown.

[c] As between counties or minor civil divisions and agglomerated settlements or post offices located therein.

[d] Assigning a value of 0.5 to each local duplication.

[e] Weighted total of names currently in use (column 8) divided by weighted total of all occurrences (column 4).

features—embracing a total of four generations, beginning with the original British city. The drawing is based on an unpublished study by Fritz L. Kramer and on supplementary data.

17. Countering this argument is the fact that the strain on the onomastic resources of Canadians must have been equally great, but the choices were almost consistently aboriginal, British, and French in origin and, with the exception of Newfoundland, sedate.

18. One of the interesting by-products of this investigation has been the realization that there are distinct regional compages of classes of specific geographic names as well as of generic terms. (On the significance of the latter, see Zelinsky [1955] and Burrill [1956].) Any random handful of town names in Kentucky will look or feel different from one taken in New Hampshire, and there is an equally sharp distinction between the flavors of names in Florida and those in Minnesota, for example.

19. I cannot refrain from passing along such cacophonic miscegenations as Jacksonopolis, Pinopolis, Copperopolis, Layopolis, and just plain Opolis.

20. The entries in this publication (1965) contain no historical or etymological information. The most comprehensive list that does is still Gannett (1947), in which some 8,000 names are briefly discussed.

21. For a complete citation of the earlier lists, which, oddly, were issued by commercial publishers up to 1874, see *Checklist of United States Public Documents 1789–1909, Vol. 1, Lists of Congressional and Departmental Publications,* 3rd ed. (Washington, D.C.: 1947), pp. 848–852. From 1874 to 1954 the relevant publication was entitled *United States Official Postal Guide;* since 1954 county lists of post offices have appeared in a variety of series.

22. Before the 1870 enumeration, the listing of minor civil divisions in census publications can best be described as whimsical. At that time Francis A. Walker, superintendent of the Census, arranged the compilation of complete contemporary lists and, so far as possible, of retrospective tables going back to 1850. For an eloquent account of the difficulties encountered, see U.S. Census Office (1872: xlvi–xlvii). For the names and dates of counties, I have relied heavily on Kane (1960). Wherever possible, the principle of the intercensal decade, beginning on April 1 instead of on January 1, was used in placing names in temporal categories. Thus, for example, a name known to have been adopted in February 1880 would be assigned to the 1870–1880 decade rather than to the 1880–1890 decade.

23. Limitations of space make it impossible to cite here all items in the literature that were used in collecting classical town names.

24. The uniquely comprehensive list of post offices in Baughman (1961) provided a check on the thoroughness of other sources. Some sixty-nine of the ninety-nine Kansas post offices bearing classical names listed in Baughman (70 percent) were also detected in other publications. But the vital statistics of Kansas post offices are not necessarily representative of the national situation. There is reason to suspect that the turnover of post offices in Kansas, and in several other states in the West and South, was much greater, their longevity less, and hence their detection more difficult than in most of the Northeastern states. I am confident, for example, that I have tracked down 100 percent of Maine's classical town names. On balance, it seems reasonable to suggest that some 80 percent of the quarry has been captured. Among the badly needed items in the further exploration of American historical geography are detailed analyses of the evolution and mutations in the settlement network (not just for the period of pioneer settlement, but through all the critical periods

in settlement history) for representative districts in various parts of the nation. At the moment, the picture is reasonably clear only for New England; we do not have, for instance, the dimmest notion of the morphology, functions, and dynamics of the settlement fabric of Alabama for any date or period.

25. As a wild guess I would hazard a total count of between 150,000 and 200,000 for all the political and settlement entities that have ever existed within the coterminous United States.

26. This figure should be reduced by an as yet uncounted number of minor civil divisions, possibly as many as 6,000, that bear nonverbal designations (that is, letters, numbers, or coordinates in the land survey system). If this were done, then the incidence of classical names in the universe of named "towns" would approximate 2.2 percent. During the period 1940–1960, all MCDs in Arizona and Texas lacked proper names. In Alabama, Louisiana, Mississippi, Tennessee, and Wyoming the majority of MCDs were nameless, and unnamed units accounted for between 10 and 50 percent of the territory in California, Kentucky, Maine, Minnesota, Montana, Nevada, North Dakota, and South Dakota. In the remaining states nameless MCDs were either entirely missing or of minor importance.

27. No satisfactory map showing the distribution and density of all agglomerated settlements in the United States has been published. This statement is based on an examination of three maps by Glenn T. Trewartha showing the distribution of hamlets (defined as having 0 to 150 inhabitants) around 1938 (1943: 76–78) and of manuscript maps showing settlements of all sizes prepared by this writer twenty years ago from data in the *Rand McNally Commercial Atlas and Marketing Guide* (1965) for the period 1938–1940.

28. This belt is obvious in the advanced stage of development shown in figure 15. More refined cartographic methods for representing the areal density of such relatively small numbers of punctiform events should perhaps have been attempted. Suffice it to say that there are sharp contrasts in the gross density of ever-existing classical town names (for example, between Ohio, with an average of 272 square miles per occurrence, and Mississippi, with 882 square miles).

29. Hägerstrand (1952).

30. After much hesitation, it was decided not to add to these maps the widely used successive isochronic frontier lines for the period 1790–1890 first worked out for the reports of the 1890 Census of Population and collected into a single drawing by Marschner (1959: 29). These lines, which essentially separate zones with an average of two or more persons per square mile from those with fewer, seriously understate the extent of effectively occupied territory. Thus, many of my symbols would have been set incongruously in land purported to be beyond the frontier. The isochrones need to be reworked, based on the more realistic concept of earliest effective settlement.

31. There have been many brief, offhand references to the strange pattern and imputed pomposity of names in the Military Tract and its environs from the 1790s to the present. In fact, these classical names have been the perennial butt of some ponderous journalistic humor. Serious scholarly inquiries have been few and have been strongly preoccupied with identifying the person(s) behind the name decisions. Among the more useful studies are Paltsits (1911), Marr (1926), Flick (1937), and Stewart (1958: 181–186).

32. It must be stressed that this culture hearth was responsible for the *idea* of classical place-naming rather than for specific names. True, a number of these names did make their

American debut in this locality, but some of the early usages, such as Aurelius, Pompey, Sempronius, or Lysander, died aborning in New York, while some quite important ones were first adopted much further west or south (table 1).

33. Quite fortuitously, the acceptability of Greek names may have been enhanced by the War for Greek Independence (1821–1827), a conflict that enlisted much American sympathy (see, for example, Miller [1938: 42–43]).

34. As of 1870, according to census statistics, only some 1,400 of Maine's residents had been born in New York State (the majority, no doubt, in its eastern portion). This figure equaled 0.25 percent of the state's population, or 5.3 percent of those born outside its borders—a group hardly large enough to exert any appreciable impact on Maine's cultural geography.

35. The out-migration of specific Pennsylvania names and the suffix *-adelphia* is discussed in Russ (1948).

36. This divide is currently being investigated by Peirce F. Lewis, with special attention to its architectural manifestations. His findings to date strongly reinforce the ideas concerning routes of migrants and of ideas embedded in this essay. New England Extended and its southern boundary are mapped in Kniffen (1965: 560, 571) and Kurath (1949: Fig. 3). No discussion has yet been published describing the striking differences in the morphology of agglomerated settlements as between New England Extended and the Pennsylvania Culture Area, but they are obvious to the observant traveler.

37. The classical syndrome as a major ingredient in early Middle Western life is discussed in Agard (1957).

38. Meinig (1965: 213–217).

39. There is a remarkable family resemblance between Kniffen's time-series of maps showing the spread of the agricultural fair (1951a), also of New England–New York origin, and my figures 3–14, and also, allowing for the major environmental constraints that helped shape the latter, between the spatial progression of classical place-names and Kniffen's isochronic map of the covered bridge (1951b: 119).

40. The same general kind of movement is suggested for a related cultural trait, though for an earlier period, in a map showing the antebellum Greek Revival dwellings of Georgia still extant in 1951 (Zelinsky 1954: 11).

41. The only classically named suburbs I have recorded are Olympia Fields, Illinois (Chicago), and Minerva Park, Ohio (Columbus), and I am not prepared to vouch for the authenticity of the latter. The point is established in the single serious study of commercial real-estate nomenclature that has been produced to date (Minton 1959 and 1961). Although Minton confined his researches to territory within commuting range of New York City, there is no reason to deny general validity to his results. Several hundred specific names and generic terms are cited and analyzed, but the only one that may be a bona fide classical specimen is Olympia Heights (1912), possibly a topical reference to the Olympic Games of that date. Minton is explicit on the matter: "Certain types of American place names do not evidence themselves in the development names examined, except as development names may repeat—possibly as specific terms—established names of any origin whatever. Among these types are names based on incidents, Biblical names, classical names, and . . . names whose purpose was to get political advantage by flattery" (1961: 10).

Cultural Variation in
Personal Name Patterns in
the Eastern United States

COMMENT

Fair warning: This is not appropriate hammock reading for you, dear reader—or for its author. Indeed this formidably quantified piece is probably the most demanding of any in this collection. But it may also be the most original and rewarding.

Over the past twenty-odd years there has been a steady accumulation of worthy studies on the patterns and implications of personal naming from a variety of perspectives. However, to my chagrin, no one as yet has taken up the challenge of further experiments with the combined spatial and temporal approach first promulgated in what follows. Eventually?

One of the fundamental problems in the study of American human geography is the discovery and application of efficient, sensitive measures of the extent to which the cultural system and its major components have varied through space and time. Valuable work has been done on specific cultural traits or complexes or on particular culture areas.[1] But apparently no one has suggested the possibility of rigorously scaling spatial and temporal differences, taking into account the totality of American culture, through the use of an appropriate surrogate measure.

Why should the student search for an "ideal cultural metric"? Why not simply collect the desired data on all the salient characteristics of American culture and weave the results into some composite index? The observer of the American scene obviously does not labor under the constraints faced by the analyst of extinct groups who is limited to measuring what is archaeologically retrievable, e.g., stone or ceramic objects, or forms and motifs in enduring works of art, or the knotty problems of the anthropologists who seek to gauge date or amount of divergence between distantly linked cultures through a study of the content of folk tales or by means of glottochronology. Moreover, he is dealing only with a single system, territorially extensive and structurally complex though it may be.

The answer resides in the peculiar nature of cultural systems in general and their multi-dimensional existence. They cannot be defined or measured by simply stacking up information on material manifestations or the countable acts of their members. The best definition of which I am aware is that arrived at by Kroeber and Kluckhohn:[2]

> Culture consists of patterns, explicit and implicit, of and for behavior acquired and transmitted by symbols, constituting the distinctive achievement of human groups, including their embodiment in artifacts; the essential core of culture consists of traditional (i.e., historically derived and selected) ideas and especially their attached values; culture systems may, on the one hand, be considered as products of action, on the other as conditioning elements of further action.

In essence, then, the core of a culture is quite inward in character, a set of ideas, axioms, attitudes, and values, some conscious, others quite deeply hidden; and is seldom accessible to casual scrutiny. One might add that there is a total "style" or flavor to each culture, an ethnicity, of which the participants are keenly, often fervently aware, but which they are incapable of defining with precision. Ideally, one might interview selected groups of individuals in depth in order to define the vital center of a culture, but the organization and financing of an adequate study would pose staggering difficulties; and recent psychological work within anthropology has been beset with controversy and serious procedural questions.[3] And there would still be the unresolved question of recovering information about past generations.

An obvious alternative is to assemble data on artifacts of all sorts, past and present, from the broadest lineaments of settlement down to subtleties of literary and aesthetic expression, on the operation of social, demographic, economic, and political systems, and on the behavioral patterns of individuals, and, then, assigning each variety of information a suitably weighted value, to build a composite index reflecting the inner substance of the culture. This formidable enterprise has been suggested, and is certainly worth attempting ultimately. In the meantime, it may be useful to search for some single index that is quite responsive to the identity of the invisible heart of a culture.

Six specifications can be set forth for such an ideal cultural metric:

1. The characteristic in question must yield significant amounts of information about the essential nature of the culture. This most vital criterion is, unfortunately, also the hardest to test.
2. The characteristic should be ubiquitous throughout both the territorial and temporal range of the culture, that is to say, there must be no awkward spatial or time gaps in its occurrence. Ideally, there should also be a one-to-one correspondence between it and every ultimate culture-bearing unit, i.e., the individual or family.

3. Information concerning past conditions should be retrievable. The evidence should be both durable and resistant to change.
4. The counting or measurement of the item should pose no major technical problems.
5. The characteristic in question must not be contaminated by noncultural factors. Thus it should not be materially affected by changes in the relevant technology, by spatio-temporal variation in the physical habitat or economic system, or by minor historical accidents.
6. Last, but not least, the needed information should be obtainable without excessive effort.

All these specifications can be compressed into six words: sensitivity; ubiquity; durability; simplicity; purity; and accessibility.

PREVIOUS APPROACHES

If we review those aspects of American culture that have already been studied geographically or historically, or whose study has been proposed, each one fails to satisfy at least two of these conditions. Thus in examining those two facets of culture which may be most ideal in terms of sensitivity—religion and language—there is no question as to ubiquity; but in every other respect there may be insuperable obstacles. Sufficiently detailed data concerning American speech are difficult and costly to generate for the present period, and perhaps impossible to recover from deceased generations.[4] Both early and current statistics on American religion are highly questionable, when they are available at all. Proper measurement and interpretation are vexatious problems for both categories of data. Religious practice appears to be particularly resistant to counting, classification, and exegesis.[5] One significant phase of language, the place-name cover, is closely linked with economic factors, settlement technology, and the peculiarities of landforms and biota.[6] And both language and religion are intimately associated with social class, a fact which may or may not be desirable, depending on one's strategy. Similarly, a great deal has been learned about American culture, and much more could be, by means of the settlement landscape in terms of such elements as houses, barns, fences, bridges, church buildings, cemeteries, farmsteads, field, road, and street patterns, town centers, or the general morphology of settlements.[7] But the perishability of evidence or its wholesale revision by later artisans, the impact of topography, soil, and climate, some truly revolutionary advances in technology, the extreme drudgery and rare skills called for in field collection of data, morphological complexity, a rather lumpy spatial and temporal distribution, and many interpretive perplexities all conjoin to render the settlement landscape something less than ideal as an efficient key to the central nature of American culture.

For a variety of reasons, we cannot seriously consider certain other phases of culture, including demographic characteristics, political, especially electoral, behavior, agricultural and other economic practices about which we already have a fair store of information, or such potential areas for geographical investigation as dietary pattern, costume, folklore, recreational patterns, social customs and attitudes, physical gesture and posture, children's games, or the folk arts.[8] Note that all the items mentioned thus far fail to pass the "purity test," in that they interact vigorously with various noncultural elements. Except for our immediate purpose, this is an appealing and valuable attribute that commends their study to the geographer. Thus a thoroughgoing study in American dietary geography might afford not only imperfect, but useful, insights into the essence of the total cultural system, but it could also lead to major revelations concerning human ecology, medical and social geography, the operation of the economic and communication systems, ethnic and racial assimilation, and the processes whereby innovations diffuse.

CULTURAL IMPLICATIONS OF FORENAMES

I wish to argue that, within the English-speaking world, choice of personal names comes closer to fulfilling the stated criteria for an ideal cultural measure than any other known item, and propose to test the hypothesis through the analysis and interpretation of data for selected areas and periods. This inquiry must be limited to patterns of usage among forenames, or given-names, rather than surnames, but not without acknowledging that the latter offer a rich potential harvest for scholars concerned with ethnic geography or the details of migration history.[9]

Everything that follows is based upon a premise that cannot yet be fully proved, but which is supported by the reported results, namely that the pattern of decisions, by parents, as accepted or later modified and changed by children, as to which forenames are to be used is a sensitive indicator of the essential character of American culture. From this, it follows that the study of appropriate places and periods should yield insight into spatial-temporal variations in this cultural pattern. There is great scope for individual whim, family considerations, and any number of trivial factors in each individual name decision, but such random noise is cancelled out in the overall pattern. One can argue along similar lines for voting decisions, or choice of clothing, food, favorite tune, house, or spouse: almost unlimited scope for personal idiosyncracy in the isolated case, but unmistakable general structures emerging when the data are treated en masse. The contention, then, is that, in the aggregate, the naming of children, especially under the very loose rules prevailing in the English-speaking world, is peculiarly responsive to the Zeitgeist and genius loci.[10]

The technology or process of naming is exceedingly simple and essentially unaltered, except for the increasing prevalence of middle-names, since the sixteenth

century or earlier in English and derivative cultures.[11] Names may be selected from a large, expanding pool of standard name-words; or a completely new, and presumably pronounceable, combination of phonemes or letters may be invented and conferred upon the child. Only three restrictions are generally, but not altogether consistently, observed: grotesque and obscene names should be avoided; two or more living siblings should not bear the same name; and, excepting a rather substantial stock of hermaphroditic items, names are either masculine or feminine and should be assigned accordingly.[12] The pattern of selection seems almost totally unrelated to the physical habitat; it has nothing to do with spatial patterning of the economy (although there is a linkage with social class, one left unexplored in this inquiry); technology is relevant only insofar as advances in communication may accelerate knowledge and diffusion of newer naming patterns and stabilize spelling; and newsworthy events produce only minor or temporary fads for naming of infants after national or cultural heroes (*Washington, Booker, McKinley, Dewey, Roosevelt, Franklin, Douglas*) or show business and other celebrities.

Definition and Functions

The study of personal names is still in its early infancy. Most of what is not casual or amateurish in a rather abundant literature is concerned with matters etymological, grammatical, or philosophical.[13] There has been very little work on the social, psychological, regional, or cultural dimensions of personal names.[14] Even such an apparently elementary task as the exact definition of proper names in general, a matter which subsumes the explication of personal names, is still on the scholarly agenda, and it has been a persistent technical problem for the philosopher.[15] In the realm of cultural anthropology, there has never been any attempt to explore fully the function and significance of personal names or to consider the curious fact that conferring names on people (and pets) is one of an extremely limited number of cultural practices (along with the incest tabu, formalized expressions of shame and modesty, or the use of fire) that appears to be followed among virtually all human groups.

Names as we know them are either unnecessary for purposes of identification, or do the job rather poorly. Thus within family groups, such designations as Sis, Dad, Mom, Babe, Dear, Stupid, and other forms of endearment are quite adequate to indicate who is being referred to; and within the larger society, omitting small primitive groups, it is the odd individual, like the present author, who seemingly has a name wholly unique unto himself. There are literally thousands of Robert Johnsons, Fred Smiths, and Frank Thomases in the United States; and in countries with limited stocks of surnames, such as Sweden, or with none at all, such as Iceland, the situation approaches the ludicrous, so that persons must be identified by spatial or social address as well as by name. For purposes of absolute, positive identification, a numerical system would serve much more effectively

than names, either one employing arbitrary, but unique, numbers, such as Social Security, driver's license, telephone, or military serial number, or one based upon personal characteristics, such as fingerprints, serological traits, voice print, or cranial, dental, or other bodily measurements.

Let us proceed on the speculation that a personal name is a kind of statement rather than an identity tag and the related idea that it is also a special variety of common noun rather than a unique personal possession. Surnames define clusters of individuals associated by means of descent, marriage, adoption, enslavement, or occasional free election, and who are assumed to have some vaguely defined qualities in common, at least locally. In the case of the given-name, a greater degree of freedom is exercised, of course; but choice is never fully free or random. And the nature of this choice is pregnant with meaning because each name charges a special field of images, significations, and emotional reverberations for the giver, bearer, and community at large. Rarely are these connotations equivalent to the nominal meaning of the word. The lexical definitions of such nouns and adjectives as *Frank, Dawn, Ray, Earl, Jewel, Robin, Pearl, Victor, Iris, Mark, Ernest, Dean,* or *Hope* probably do not yield much insight into their special cachet as personal names; nor does the historical or mythical derivation of such items as *Luther, Calvin, Augusta, Horace, Alexander, Esther, Eve,* or *Matthew* say much about their present owners or their parents.[16] I do not believe it is too fanciful to claim that each forename is a one-word poem in an undeciphered language. If the key were discovered whereby the entire vocabulary could be unlocked, then perhaps we could command that central essence of a culture, which is being stalked here via a rather roundabout path. In treading upon such ill-defined terrain, one can do no better than to quote from Claude Lévi-Strauss, the one scholar who appears to have thought deeply about the nature of personal names, and considers:[17]

> this impossibility of defining proper names otherwise than as a means of allotting positions in a system admitting of several dimensions.
>
> One therefore never names: one classes someone else if the name is given to him in virtue of his characteristics and one classes oneself if, in the belief that one need not follow a rule, one names someone else "freely," that is, in virtue of characteristics of one's own. And most commonly one does both at once.
>
> They [names drawn from a compulsory and limited list] class the parents who selected their children's names in a milieu, in a period, and in a style; and they class their bearers in various ways: in the first place because a John is a member of the class of Johns, and secondly, because every Christian name has a conscious or unconscious cultural connotation which parades the image others form of its bearer, and may have a subtle influence in shaping his personality in a positive or negative way.

Although it is not immediately relevant to our purpose, remarkably little is actually known about the psychological effects of particular names upon their owners. The general public might assume from the occasional journalistic squib on the topic that interested scholars have pursued definitive investigations; but, alas, the only published items are flimsy, irrelevant, or inconclusive.[18]

The Applicability of Forenames

If American forenames may fulfill the sensitivity criterion, then they are readily shown to pass the other tests with flying colors. At the aggregate scale, personal names are almost entirely untouched by noncultural considerations. Their ubiquity is self-evident; and, aside from the exceptional individual exercising his legal right to petition for a change, there is only one occurrence per person. All current or recent American names have been recorded not just once but in a great many registers and a major portion of early American names from initial colonization onward (Negro slaves excepted) seem to have been preserved. The documentary record on paper, film, or tape (but much less durably on gravestones) is essentially eternal, barring fire, mildew, and other physical hazards, proof against vagaries of fashion and change. Admittedly, there are physical, legal, and financial constraints on accessibility to some useful records. It would be more than heroic, for example, to examine birth, death, marriage, property, tax, and voting registration records in more than 3,000 county courthouses; various insurance corporations and other private businesses may be reluctant to open their files to outside scholars; and certain major federal name registers are hidden from unauthorized eyes for prolonged, perhaps indefinite, periods. Nevertheless, a vast amount of information lies in wait for the student with very little expenditure of funds or physical exertion. The major requirements are time and an enthusiasm for names.

RESEARCH DESIGN

Testing the hypothesis concerning the utility of forenames in measuring spatio-temporal variability in American culture called for three preliminary choices: (1) the specific aspect of naming practice to be analyzed; (2) suitable time periods; and (3) sample study areas.

Among the items that might be investigated are: incidence of specific names; nicknaming; presence or absence of middle-names; whether or not the first-name is suppressed in favor of the middle-name; the substitution of initials for the complete forename(s); and the prevalence of double-naming.[19] The final item can be defined as the habitual combination in speech and writing of a pair of given-names, such as *Billy Joe, Mary Alice, Jimmy Lee, Donna Jean*, or *John Henry*. Although any of these phenomena might be rewarding, it seemed likely that analyzing the frequency of the more important forenames would provide the greatest immediate payoff.

In the early stages of this study, it became apparent that female names would have to be discarded because a far smaller proportion of female than male names are listed in the available records. Less defensible perhaps was the decision to include only presumably British (i.e., English, Welsh, Scotch, or Scotch-Irish) surnames. The assumption is that the culture areas of early America were decisively British in origin, and that it would be interesting and useful to observe their variation through time and space while minimizing the impact of exogenous ethnic and other influences. Obviously, acculturation with non-British groups is important, and in subsequent research other ethnic communities should be considered. The exclusion of the non-British is probably far from total. If any Negroes appear on a name register, they almost always bear British surnames and will thus be included. (Virtually none appear in the 1790 material used for this study, but a large, indeterminate number are present in the 1968 data.) Some surnames, such as *Miller, Anderson, Lee, Horner,* or *Johnson,* are common in Great Britain and at least one other European or Asian nation. Furthermore, persons of non-British stock have often either anglicized their surnames or simply adopted a British surname totally unrelated to the original family name.

Out of tabulating and computational necessity, it was necessary to abbreviate most severely the roster of specific names to be recorded. After a survey of various sources, a list of 179 names (ignoring minor variants in spelling) was drawn up, those considered to be the most heavily used in the entire English-speaking world from the mid-eighteenth century to the present; and a portmanteau "all-other-names" category was designated as No. 180, one that includes all the less common standard names as well as many unique (sometimes wild and wonderful) forenames.

The present study is without precedent, so that methodology was improvised blindly at first and still gropingly in midstream.[20] Where possible, work was repeated and initial procedural flaws corrected; but after a certain point the investigator finds himself "locked in" with methods he knows are less than ideal. Further work can refine one's approach; but I have no reason to suspect that a reprocessing of the data used herein would yield significantly different results.

The complete list of rules followed in tabulating names is a long one, but only a few are of general interest:

1. Only presumably male forenames were tabulated.
2. Persons with presumably non-British surnames were totally excluded.
3. If only initials or a title, e.g., Captain or Rev., were given in place of one or more forenames, the name was not counted.
4. When both first-name and middle-name or double-names were reported, only the first of the names was counted.
5. When the first-name was represented only by an initial but the middle-name spelled out, the middle-name was tabulated.

The bulk of some name lists is such that sampling is necessary. All admissible names were tabulated for places with small populations, while the percentage sampled diminished with increasing population. In every case the number used is great enough so that sampling error is insignificant. After the percentage to be used had been decided, every n^{th} page or column was tabulated.

Because of the amount of labor required to add a usable third date, it was decided to limit this exploratory study to two widely separated time periods: 1790, and the immediate past, in effect, 1966–1968. This strategy was designed to bring out as much of the broad pattern of temporal change in naming practice as is consistent with reasonable effort in data collection and the preservation of a fairly large study area. One could delve further back into the Colonial period, but only at the expense of much trouble in name procurement and a constriction of the area of European settlement. Likewise, it would be possible to secure names of infants born and named in the 1960s, but only at considerable cost.

Most importantly, there is readily available a published roster of all free heads of households as enumerated in the Population Census of 1790, except for the states of New Jersey, Delaware, Maryland, Virginia, Georgia, and the trans-Appalachian territories, the schedules for which were destroyed during the British occupation of the White House in 1814.[21] The importance of eighteenth-century Virginia was such that the editors of the volumes in question substituted the next best source available, names on tax lists for the various counties as recorded during the 1780s. Needless to say, this Virginia material is less complete and more strongly class-biased than are the census data.[22]

For the present period, the simplest expedient was the most recent available residential telephone directories for the selected areas. Although these directories suffer from obvious shortcomings, as, for example, the fact that telephone availability in the counties studied ranges from a minimum of 47.1 to a maximum of 90.6 percent, they do serve the needs of this pilot study quite adequately. The alternative official Federal sources (e.g., 1960 Census schedules, Social Security, Internal Revenue, or Veterans Administration records) offer severe problems in access and in retrieval of data in proper form. State and local records call for herculean efforts in data collection, while the largest commercially available name list, one that provides coverage for some 78 percent of American households, is no more exhaustive than the average of the directories consulted for this study.

In selecting areas to be sampled, two principles were observed: the smallest number of noncontiguous places consistent with reasonable representation of the regional diversity of the 1790 *ecumene*; and a limitation to places with territorial integrity as between 1790 and 1968.[23] Sixteen counties or quasi-counties were selected. Five of these—Boston City (which straddles county lines), Newport Co., R.I., New York Co., Philadelphia Co., and Charleston Co.—were pre-selected in the sense that the demographic, commercial, and cultural importance of these cities, their roles as centers of innovation, was such that it would have been unwise

STUDY AREA: SIXTEEN
SAMPLE COUNTIES
1790 BOUNDARIES

1 - Boston, Mass.
2 - Caswell Co., N.C.
3 - Charleston Co., S.C.
4 - Columbia Co., N.Y.
5 - Dauphin Co., Penna.
6 - Greenville Co., S.C.
7 - Hanover Co., Va.
8 - New Hanover Co., N.C.
9 - Newport Co., R.I.
10 - New York Co., N.Y.
11 - Philadelphia Co., Penna.
12 - Rockingham Co., N.H.
13 - Shenandoah Co., Va.
14 - Washington Co., Penna.
15 - Windham Co., Conn.
16 - Windsor Co., Vt.

FIGURE 1 Study area: sixteen sample counties, 1790 boundaries.

to disregard them. The remaining eleven provide a balance between inland and coastal locations, rural and urban, old and new, and the three major culture areas—New England, the Midland, and the South—that are believed to have existed in eighteenth-century America (fig. 1). In every instance, the 1968 boundaries of the county, or of the recombination of the two or more counties derived from the 1790 unit, appear not to have changed over the 178-year interval. Their 1790 population accounted for 9.5 percent of the national total, while in 1960 they contained only 3.6 percent of the persons living in the conterminous United States. For reasons of convenience, the earlier data are characterized as dating from 1790, although the actual range is 1782 to 1790; and the later material is identified as 1968, despite a spread in actual date from 1966 to 1968.[24] Similarly, the derivative counties are not named in writing of a county which underwent division after 1790. Thus the designation is Shenandoah-1790, when what is really meant is data from 1785 for the territory now occupied by Shenandoah, Page, and Warren counties, Virginia.

MEASURING DIFFERENCES IN FORENAME PATTERNS

The remainder of this paper is concerned with analyzing variance in the incidence of some 179 male forenames among the 93,740 observations taken for some sixteen counties in the Eastern United States at two dates, 1790 and 1968. The listing for each of the two dates of the relative incidence among the sixteen counties of every name that occurred once or more (in a manuscript table not reproduced here) yields three conclusions:

1. There has been considerable overall change in the relative popularity of most individual names, the disappearance of several old names, and the emergence of many new ones;[25]
2. Yet at the same time there has been definite continuity in basic pattern, with many of the more frequent names showing up strongly in both periods; and
3. There has been an impressive diversification in choice of names in 1968 as against 1790, a pattern of many names occurring regularly with at least moderate frequency in the later year, whereas much heavier use was made of a smaller stock of names in earlier times. Thus in 1790, the ten leading names accounted for 50.56 percent of all choices, while the corresponding value for 1968 was only 34.50 percent; similarly, the percentage of items falling into the other-names category rose from 13.64 in 1790 to 18.29 in 1968.

There are severe technical problems in finding the optimal method for describing and comparing forename patterns as between different times and places. How is one to measure and correlate entities with 179 definite dimensions and a final, very troublesome, ambiguous 180th dimension, which, of course, represents the tailing off of hundreds of minor dimensions? Indeed, the multi-dimensionality of personal name usage in the English-speaking world is simultaneously the reason

for its great power in cultural analysis and the greatest drawback in actual manipulation. A sensitive one- or two-dimensional cultural characteristic would be quite easy to handle and would serve to demarcate presumptive gradients in the culture through space-time, but would really offer few clues as to the structure of the thing it helps to indicate.

In the present analysis, only two statistical approaches were attempted, the first, the "coefficient of similarity," possibly the simplest measure available, the other, numerical taxonomy, one of the more recent, complex, and experimental of methods.[26] The generally accordant results strengthen the belief that additional modes of measurement would have led to similar conclusions.

The "coefficient of similarity" states the proportion of a particular statistical distribution, e.g., incidence of various forenames in County A, that would have to be changed so as to create total identity of pattern with another statistical distribution, e.g., the corresponding set of frequencies in County B. Total similarity is expressed as zero, while total dissimilarity equals 1.0. In the present instance the many "other names" lumped together as Item 180 create difficulties for which there are no satisfactory solutions, inasmuch as the structure of the other-name category in one place certainly differs from that in all others. Three solutions are suggested (table 1). In the first, the other names are wholly disregarded; in the second, the incidence of each of the 179 names is measured as a percentage of all names observed, including other names, but the incidence of Item 180 is not considered, while the third method is the same as the second except that the incidence of Item 180 is included. On intuitive grounds, Method 2 appears to be the most meaningful, and is the one generally used in discussing the coefficient of similarity.

The technique of numerical taxonomy makes it possible to indicate distance in a 180-dimensional taxonomic space between any pair of counties or combinations of counties. In addition to furnishing a quite sensitive index to the differences between complexly dimensioned objects, numerical taxonomy also provides a grouping procedure whereby relatively homogeneous clusters, or, to use geographic parlance, regions, can be derived.

If differences between places in terms of forename configurations can be expressed with some precision, there is as yet no indication as to how sensitive an index this particular item may be with respect to the total culture. Some light will be shed on this point by discussing the regionalization of names. But, first, it is more convenient to tackle the question: to what degree are American places becoming more or less alike with the passage of time?

CULTURAL CONVERGENCE OR DIVERGENCE
WITHIN THE UNITED STATES?

Most scholars and laymen seem to believe that regional differences have been diminishing within the United States, as the population undergoes progressive

homogenization. As has happened with many another obvious notions, there have been surprisingly few efforts to test this proposition rigorously; and most of these, in turn, have been confined to economic and demographic characteristics.[27] Despite many pitfalls in data manipulation and interpretation, nearly all such analyses tend to indicate a significant amount of convergence among regions, at least since the late nineteenth or early twentieth century, although it may have occurred at different rates in individual regions. Only a single study, by Glenn and Simmons, has directly confronted the cultural phase of the question by analyzing regional differentials in responses to forty-four national opinion polls on various queries relating to matters of religion, morals, ethics, basic political attitudes, racial and ethnic problems, and the like over the past three decades.[28] The results have been tabulated by age of respondents, the basic premise being that opinions of the elderly reflect the cultural background of their early formative years, while answers given by younger persons would, of course, be shaped by a more recent cultural milieu. This assumption is extremely difficult to prove or reject; but, if it is accepted, then the Glenn-Simmons results raise some reasonable doubts concerning the convergence hypothesis, since in certain respects the youth of various pairings of regions appear to think less alike than do the older generation.[29]

How does the convergence hypothesis stand up when tested against data on forename patterns? The analysis of both coefficient of similarity and taxonomic distance yields summary values for each of the sixteen counties at each date, firstly by taking the sum of the coefficient or distance between it and the remaining fifteen counties, and, secondly, by measuring the coefficient of similarity or the taxonomic distance between the county and the aggregate pattern for all sixteen counties, one in which each place is weighted equally (table 1). Then, finally, the 1968 value is divided by the 1790 figure. A ratio exceeding unity would indicate divergence, while anything less points toward convergence. When the relevant values are totaled for all sixteen counties and divided into each other, an overall ratio is produced for the entire sample population of counties, one again in which each county is assigned equal weight.

The ratio of sums of coefficient of similarity as against all other contemporaneous places for the two dates gives closely parallel results when each of the three methods is used. Thirteen counties consistently score below unity, thus suggesting convergence, while three counties, all in the South, register ratios greater than 1.000 at least two out of three times. The totaled ratio is either 0.884, 0.816, or 0.827, according to which method is used. The totaled ratio of individual county against the aggregate pattern indicates even sharper convergence, a ratio of 0.803; but a fourth county, Newport, now joins the ranks of those with apparent divergence.

Similar manipulations with taxonomic distances yield an even stronger presumption of convergence, with the two totaled ratios coming to 0.564 and 0.574. In this case, the individual ratios for all sixteen counties score well below unity; but the profile of values runs definitely parallel with, if well below, those derived

TABLE 1. *Some Measures of Changes of Degree of Similarity in Personal-Name Patterns, 1790–1968, for Males with Presumably British Surnames in Selected Counties, Eastern United States*

	A. Taxonomic Distance						B. Coefficient of Similarity[1]						
	1. Taxonomic Distance to Aggregate Pattern			2. Sum of Taxonomic Distances to All Other Contemporaneous Places			1. Specified County as Against Aggregate Pattern (Method 2)			2. Ratio of Sums of Coefficients of Similarity as Against All Other Contemporaneous Places for Two Dates			
			1968 value			1968 value			1968 value	Σ1968 values/Σ1790 values			
	1790	1968	1790 value	1790	1968	1790 value	1790	1968	1790 value	Method 1[2]	Method 2[3]	Method 3[4]	
Boston, Mass.	5.32	3.85	0.724	140.82	83.72	0.595	14.13	13.57	0.960	0.938	0.852	0.856	
Caswell, N.C.	6.65	6.35	0.955	134.68	110.32	0.819	16.42	23.23	1.415	1.316	1.212	1.359	
Charleston, S.C.	7.29	3.42	0.469	144.56	79.70	0.551	18.54	13.14	0.709	0.886	0.783	0.790	
Columbia, N.Y.	6.12	3.10	0.507	149.05	77.43	0.519	15.42	11.26	0.730	0.769	0.731	0.729	
Dauphin, Pa.	10.59	3.20	0.302	184.91	77.88	0.421	28.68	12.63	0.440	0.665	0.614	0.624	
Greenville, S.C.	7.05	5.46	0.774	143.62	99.35	0.692	17.99	21.32	1.185	1.100	1.019	1.032	
Hanover, Va.	9.44	3.63	0.385	166.10	82.21	0.495	22.98	14.71	0.640	0.813	0.759	0.814	
New Hanover, N.C.	4.31	3.71	0.861	120.34	83.39	0.693	11.47	13.97	1.218	1.072	0.992	1.019	

Newport, R.I.	5.53	4.80	0.868	142.40	98.17	0.689	14.42	16.34	1.133	0.984	0.968	0.949
New York, N.Y.	6.62	3.44	0.520	137.16	82.36	0.600	16.74	12.44	0.743	0.959	0.859	0.854
Philadelphia, Pa.	6.26	3.14	0.502	132.91	85.55	0.644	15.51	10.18	0.656	0.942	0.868	0.848
Rockingham, N.H.	6.33	3.77	0.596	152.83	79.88	0.523	16.64	13.61	0.818	0.791	0.734	0.762
Shenandoah, Va.	7.93	3.71	0.468	156.91	80.08	0.510	23.44	15.37	0.656	0.795	0.725	0.762
Washington, Pa.	6.15	3.49	0.567	138.10	82.60	0.598	14.65	14.15	0.966	0.923	0.859	0.839
Windham, Conn.	9.69	3.25	0.335	188.23	76.26	0.405	24.50	12.41	0.507	0.609	0.597	0.581
Windsor, Vt.	9.06	6.17	0.681	180.56	107.00	0.593	23.54	18.69	0.794	0.785	0.748	0.715
Total	114.34	64.49	0.564	2,413.18	1,385.90	0.574	295.07	237.02	0.803	0.884	0.816	0.827

[1]Coefficient of similarity $= \dfrac{\sum(n_a - n_b)}{2}$, where $n_a =$ specified name as % of all names observed in Area A,

$n_b =$ same name as % of all names observed in Area B.

Total similarity $= 0$; total dissimilarity $= 1,000$.

[2]In Method 1, percentages are calculated in terms of $\dfrac{n_1}{\sum n_1 \ldots n_{179}} \cdot \dfrac{n_2}{\sum n_1 \ldots n_{179}} \cdots \dfrac{n_{179}}{\sum n_1 \ldots n_{179}}$ i.e. n_{180}, "all other names" is totally excluded.

[3]In Method 2, percentages are computed as follows: $\dfrac{n_1}{\sum n_1 \ldots n_{180}} \cdots \dfrac{n_{179}}{\sum n_1 \ldots n_{180}}$

[4]In Method 3, percentages are computed as follows: $\dfrac{n_1}{\sum n_1 \ldots n_{180}} \cdots \dfrac{n_{180}}{\sum n_1 \ldots n_{180}}$

Source: Calculated by author.

from the coefficient of similarity. Thus the Southern counties, Caswell, Greenville, and New Hanover, again display relatively high ratios, as does Newport, a county not lacking in Southern connections in terms of economic and social history. When separate taxonomic trees are prepared for 1790 and 1968, using the results of a grouping procedure based on numerical taxonomy, the relatively high level at which counties brachiate and the relatively narrow vertical range within which most of the horizontal members appear in 1968 both strongly support the suggestion of greater homogeneity at the later date (figure 2).[30]

Considerable caution is urged in interpreting table 1, quite apart from earlier caveats concerning weaknesses and possible biases in the data. The only safe inference is that for all or most readings, depending on which method is employed, the degree of similarity registers lower in 1968 than in 1790. This does not necessarily prove that convergence is going on now, or that it has progressed uninterruptedly from 1790 to the present. That may be the easiest, most plausible interpretation; but it is also possible that inter-county differences have been either significantly greater or less at some intervening point than they are now. Obviously, additional evidence for one or more dates during the 1790–1968 interval must be analyzed before one can speak with any assurance about convergent or divergent trends at the national scale.[31] The Southern counties call for special attention, particularly since an unpublished study by Conrad Strack dealing with variation in denominational membership by state from 1650 through 1950 strongly suggests that the South has deviated increasingly from the national pattern in terms of religious characteristics, at least since about 1850.[32] Further work on personal names, religious preferences, voting patterns, public opinion polls, and other suitable cultural or quasi-cultural indices is clearly indicated for final answers on the issue of cultural, as distinguished from economic and demographic, convergence in the United States.

The wider implications of the interplay of contradictory processes, which further research may bring to light, are most intriguing in terms of regional theory. The size (and diversity) of the stock of standard given-names has grown over the past two centuries from a few hundred to probably well over 3,000 for both sexes. This may reflect nothing more than the full maturation of the strong American drive toward personal individualism; but it also raises the question of whether horizontal diversity, i.e., between regions, may not have been largely replaced by vertical diversity, as between locally superimposed subcultures—economic, social, ethnic, occupational, and special-interest groups of all sorts. Future work could test what is still almost pure speculation: a transition from a Colonial and early Republican period in which one can discern relatively homogeneous and distinct territorial cells—entities comparable in their tendency toward internal uniformity—toward an extremely complex national society operating more and more as a single vast territorial unit in cultural as well as economic and demographic terms, but one richly stratified, with scores of horizontal layers of variable local thickness and permeability.

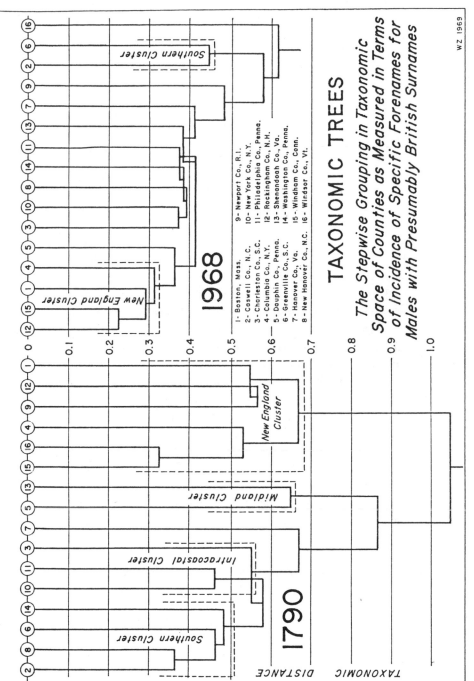

FIGURE 2 Taxonomic trees: the stepwise grouping in taxonomic space of counties as measured in terms of incidence of specific forenames for males with presumably British surnames.

There are many ways in which phenomena observed at different locations can be assigned to spatial categories, or regionalized. In the present instance, where we aspire to the most rigorously objective classification possible, the best method at hand would appear to be that furnished by numerical taxonomy. Since the data refer to noncontiguous places, we are spared any worry over the contiguity constraint.

The procedure is relatively simple, once the concept of taxonomic distance has been grasped. Through the use of a computer program, taxonomic distances among all pairings of counties among the group of sixteen for each date are scanned at each of a series of increasingly higher threshold values (or lower values, in terms of the graphic representation given in the "taxonomic tree," fig. 2) until a level is found at which the distance between a particular pair is exceeded. This couple is then joined and subsequently treated as a single unit in terms of combined forename characteristics. The grouping procedure is continued until other stems have been connected; then larger and larger aggregations are formed until all counties join together within one grand macro-region. Thus Windham-1790 and Windsor-1790 are the first to join (i.e., the most similar) in the 1790 tree; rather later Columbia-1790 is added; and this tripartite region is subsequently linked with another trio that has come together independently—Newport-1790, Rockingham-1790, and Boston-1790—to comprise a Greater New England cluster. Transects may be run across the tree at any appropriate level to specify the regions obtained at that degree of closeness or remoteness in taxonomic space.

Quite definite and "sensible" culture areas can be detected in the 1790 tree (fig. 2). The six most northeasterly counties are limbs of a New England trunk that stands apart from the others and joins them only after a very great taxonomic distance has been traversed. This is precisely what one would have anticipated. (The New England affiliation of Columbia-1790 is no surprise since the population and culture of this Hudson Valley county were strongly shaped by migrations from neighboring Massachusetts and Connecticut.) In a similarly predictable fashion, Caswell-1790, New Hanover-1790, Greenville-1790, and Washington-1790 conjoin to form a distinct Southern cluster. (The southwestern corner of Pennsylvania had been settled largely by pioneers from the older parts of Virginia.) The peculiar behavior of Hanover-1790 should be ignored because of the feebleness and unreliability of the raw data. The least distinctly defined of the three early culture areas is the one variously known as the "Midland" or the "Pennsylvania Culture Area."[33] Only two counties, Dauphin-1790 and Shenandoah-1790, would appear to represent it; and their junction occurs well down the tree. Shenandoah County was then populated largely by recent arrivals from Piedmont and Appalachian Pennsylvania and Maryland and relatively few persons of genuine Virginian provenance.[34] The rather anomalous position of New York-1790, Philadelphia-1790, and Charleston-1790, which stand off separately for a long while, but finally

coalesce with the Southern cluster, would seem to hint a weak, but genuine, "Intracoastal Cluster," a string of coastal metropolises linked together by their common commercial and maritime interests and one with a stronger affinity with the South than with the other two culture areas.

The picture is altogether different in 1968. The various counties cluster much sooner in their progress down the taxonomic tree, thus suggesting greater overall resemblance in patterns of given-names. But, in addition, there is a notable tendency for several counties to collapse simultaneously into a patternless jumble around the 0.4 level, making it much more difficult to pick out regional groupings. Indeed, there are only two coherent clusters: a four-county New England set, the first grouping to materialize on the tree (the idiosyncratic behavior of Windsor-1968 is completely unaccountable); and a two-county "Deep Southern" cluster. The remaining ten counties are of indeterminate allegiance. But this statement applies only to the aggregate structure of the forename pattern. Is it possible to discern less obtrusive regional or other structures by disaggregating the total pattern? But before making the attempt, it may be noted that the foregoing regional analysis is altogether consistent with our limited knowledge of the past and present geometry of the grosser culture areas of the Eastern United States. Thus nothing has yet appeared to dampen enthusiasm for pattern of choice in forenames as a nearly ideal cultural measure.

THE FACTOR ANALYSIS OF VARIANCE IN FORENAME PATTERNS

Factor analysis furnishes a powerful tool for identifying multiple and complex patterns of variance among phenomena in spatial and other dimensions, including certain subtle structures that might otherwise escape detection.[35] Its application to our material provides insights and generates further research problems that could not have been sensed simply by inspecting the raw data or manipulating any of the indices discussed above.

The basic data, i.e., particular names as percentages of all names observed in the given county at the given date(s), can be viewed from two modes or angles, so to speak. One can characterize each county by name profile or locus, i.e., its co-ordinates in an n-dimensioned "name-space," in which each specified name is a single axis, and then proceed to find a series of significant vectors or factors along which counties so defined will tend to cluster.[36] Or, conversely, one can locate each name with reference to its frequency within each county, i.e., in a 16- or 32-dimension "place-space" (depending upon whether one or both dates are utilized), where individual counties act as the axes. The latter strategy has been pursued in the case of the analyses for 1790 and 1968 separately, and, then, both dates combined, with the resultant factors identified by means of Roman numerals (tables 2 to 4). A parallel series of operations were performed in name-space, with the factors being given alphabetic designations (tables 5 to 7).

The Varimax rotated matrix of factor loadings is given for all factors deemed

TABLE 2. *Factor Analysis of Variation in Frequency of Principal Given-Names Recorded for Males with Presumably British Surnames in Sixteen Selected Counties, Eastern United States, 1790, as Measured in 16-Dimension Place-Space*

Rotated Matrix of Factor Loadings

Factor I-1790 Midland vs. New England		Factor II-1790 New England Factor		Factor III-1790 South vs. North		Factor IV-1790 Intracoastal Factor	
Dauphin	0.843	Windham	0.885	Greenville	0.724	Newport	0.210
Shenandoah	0.796	Windsor	0.859	Hanover	0.694	Boston City	0.174
New York	0.701	Rockingham	0.791	Caswell	0.690	Rockingham	0.135
Philadelphia	0.671	Columbia	0.715	New Hanover	0.650	Charleston	0.089
Charleston	0.593	Boston City	0.706	Charleston	0.641	Philadelphia	0.079
Columbia	0.546	Newport	0.678	Washington	0.629	Shenandoah	0.071
New Hanover	0.546	Washington	0.518	Newport	0.564	Hanover	0.062
Washington	0.539	New Hanover	0.516	Philadelphia	0.547	Caswell	0.022
Caswell	0.530	Greenville	0.484	New York	0.541	Dauphin	0.017
Hanover	0.521	Caswell	0.483	Boston City	0.492	New Hanover	0.007
Greenville	0.471	Philadelphia	0.483	Columbia	0.410	Washington	0.000
Boston City	0.459	Hanover	0.459	Rockingham	0.408	New York	−0.018
Rockingham	0.405	New York	0.449	Shenandoah	0.396	Windsor	−0.023
Newport	0.402	Charleston	0.443	Dauphin	0.384	Greenville	−0.030
Windsor	0.354	Shenandoah	0.430	Windsor	0.341	Windham	−0.039
Windham	0.311	Dauphin	0.359	Windham	0.321	Columbia	−0.064
Percent of Total Variance Explained 31.60%		36.08%		29.50%		0.77%	

Source: Calculated by author.

significant (tables 2, 3, 4, 7).[37] In tables 2 to 4, loadings for all counties are given, whereas in table 7 only the first twenty and last twenty names are cited, since the intermediate ones are far less interesting, and greatly lengthen the table without adding much useful information.[38] In addition, factor scores are given for each county in tables 5 to 7, since both factor loadings and factor scores were needed to discover the probable identity of those factors.[39]

It would be repetitious and exhausting to parse each factor individually, although the diligent reader will find that the nuances of each will repay close study. What is proposed instead is a discussion of summary trends, principles, or questions emerging from a survey of all twenty-five identifiable factors. One general observation is in order: there is an emphatic tendency toward bipolarity. For at least nineteen factors, both ends of the scales of loadings or factor scores, the

TABLE 3. *Factor Analysis of Variation in Frequency of Principal Given-Names Recorded for Males with Presumably British Surnames in Sixteen Selected Counties, Eastern United States, 1968, as Measured in 16-Dimension Place-Space*

Rotated Matrix of Factor Loadings					
Factor I-1968		Factor II-1968		Factor III-1968	
		South vs.			
New England Factor		New England		Intracoastal Factor	
Windham	0.915	Caswell	0.896	New York	0.608
Rockingham	0.829	Greenville	0.823	Charleston	0.556
Boston City	0.793	Hanover	0.693	Philadelphia	0.543
Windsor	0.783	New Hanover	0.663	Newport	0.525
Columbia	0.736	Charleston	0.614	New Hanover	0.500
Dauphin	0.677	Shenandoah	0.591	Washington	0.495
Newport	0.650	Washington	0.566	Dauphin	0.440
Washington	0.574	Philadelphia	0.557	Windham	0.389
Shenandoah	0.573	New York	0.529	Columbia	0.386
New York	0.569	Newport	0.490	Hanover	0.383
Philadelphia	0.549	Dauphin	0.481	Shenandoah	0.379
Hanover	0.514	Columbia	0.452	Boston City	0.352
Charleston	0.501	Windham	0.423	Greenville	0.340
New Hanover	0.462	Rockingham	0.406	Rockingham	0.338
Caswell	0.357	Boston City	0.402	Caswell	0.198
Greenville	0.350	Windsor	0.306	Windsor	0.182
Percent of Total					
Variance Explained 40.31%		33.19%		18.46%	

Source: Calculated by author.

lowest as well as the highest, can be identified in regional, ethnic, or demographic terms. The columns of ranked values may be visualized as a continuum stretching from one pole in cultural or demographic space past a zone of indifference in space and/or time to a quite different pole. Furthermore, there are also definite hints of bipolarity in the remaining six factors that might well have been noted in their names.

In the case of every factor, with one possible interesting exception, the pattern of factor loadings and factor scores reconfirmed, and usually extended, preexisting knowledge concerning the cultural and population geography of the Eastern United States. This observation lends further support to the contention that personal names may approximate the ideal cultural metric.

The most persistent pattern of regional differentiation is that between the New

TABLE 4. *Factor Analysis of Variation in Frequency of Principal Given-Names Recorded for Males with Presumably British Surnames in Sixteen Selected Counties, Eastern United States, 1790 and 1968, as Measured in 32-Dimension Place-Space*

Rotated Matrix of Factor Loadings					
Factor I-1970-1968		Factor II-1790-1968		Factor III-1790-1968	
Modern New England Factor-Northern Factor		Colonial New England Factor		Diachronic South vs. New England Factor	
Boston-1968	0.938	Windsor-1790	−0.948	Greenville-1968	0.622
Rockingham-1968	0.934	Windham-1790	−0.935	Caswell-1968	0.604
Windham-1968	0.919	Columbia-1790	−0.932	New Hanover-1968	0.447
Windsor-1968	0.914	Rockingham-1790	−0.924	Hanover-1968	0.413
Columbia-1968	0.900	Boston-1790	−0.923	Charleston-1968	0.387
Dauphin-1968	0.884	Newport-1790	−0.888	Shenandoah-1968	0.354
Shenandoah-1968	0.853	New Hanover-1790	−0.833	Greenville-1790	0.315
Newport-1968	0.838	Philadelphia-1790	−0.828	Washington-1968	0.308
Washington-1968	0.832	New York-1790	−0.811	Washington-1790	0.300
Philadelphia-1968	0.800	Caswell-1790	−0.807	Philadelphia-1968	0.279
Charleston-1968	0.784	Shenandoah-1790	−0.804	Caswell-1790	0.278
Hanover-1968	0.783	Washington-1790	−0.803	New Hanover-1790	0.264
New Hanover-1968	0.776	Charleston-1790	−0.802	New York-1968	0.253
New York-1968	0.767	Hanover-1790	−0.798	Charleston-1790	0.226
Greenville-1968	0.687	Greenville-1790	−0.794	New York-1790	0.196
Caswell-1968	0.619	Dauphin-1790	−0.744	Hanover-1790	0.188
Washington-1790	0.464	New York-1968	−0.521	Newport-1968	0.186
Hanover-1790	0.464	Philadelphia-1968	−0.468	Dauphin-1968	0.186
Caswell-1790	0.462	Newport-1968	−0.462	Philadelphia-1790	0.181
Greenville-1790	0.450	Charleston-1968	−0.418	Dauphin-1790	0.168
Charleston-1790	0.434	Washington-1968	−0.411	Newport-1790	0.118
New Hanover-1790	0.430	Hanover-1968	−0.389	Shenandoah-1790	0.117
Philadelphia-1790	0.427	New Hanover-1968	−0.378	Columbia-1968	0.117
New York-1790	0.413	Dauphin-1968	−0.367	Boston City-1790	0.112
Newport-1790	0.390	Columbia-1968	−0.352	Rockingham-1790	0.098
Dauphin-1790	0.378	Caswell-1968	−0.346	Columbia-1790	0.090
Shenandoah-1790	0.343	Windham-1968	−0.344	Windham-1968	0.064
Boston City-1790	0.318	Rockingham-1968	−0.312	Boston City-1968	0.051
Rockingham-1790	0.305	Greenville-1968	−0.296	Windham-1790	0.045
Columbia-1790	0.278	Shenandoah-1968	−0.277	Windsor-1790	0.044
Windham-1790	0.209	Boston-1968	−0.268	Rockingham-1968	0.025
Windsor-1790	0.207	Windsor-1968	−0.200	Windsor-1968	−0.114
Percent of Total Variance Explained	41.90%		43.10%		7.24%

Source: Calculated by author.

TABLE 5. *Factor Analysis of Variation in Frequency of Principal Given-Names Recorded for Males with Presumably British Surnames in Sixteen Selected Counties, Eastern United States, 1790, as Measured in 79-Dimension Name-Space*

Factor Scores

Factor A-1790 New England Puritan vs. Standard English		Factor B-1790 New England General vs. Non-English (Scotch-Irish & German)		Factor C-1790 "Charleston British" vs. New England General		Factor D-1790 New England General vs. Scotch-Irish		Factor E-1790 South vs. New England	
Windham	7.42	Windham	12.02	Charleston	11.78	Windham	1.22	Greenville	6.25
Windsor	5.88	Rockingham	11.68	Philadelphia	5.51	Windsor	1.07	Hanover	2.99
Columbia	−4.98	Windsor	11.39	Caswell	4.64	Boston	0.00	Caswell	1.21
Rockingham	−5.19	Boston	10.40	New York	4.60	Rockingham	−0.07	New Hanover	0.47
Boston	−15.34	Newport	8.86	Hanover	4.16	Newport	−0.27	New York	−0.42
Newport	−16.87	Greenville	5.24	Dauphin	3.93	Columbia	−3.32	Charleston	−0.81
New Hanover	−28.79	Hanover	4.14	Washington	3.93	Hanover	−4.83	Washington	−0.81
Shenandoah	−29.26	Caswell	3.49	New Hanover	3.93	Greenville	−6.02	Columbia	−2.01
Washington	−32.71	New Hanover	2.50	Greenville	2.51	Shenandoah	−7.36	Dauphin	−2.83
Greenville	−32.99	Columbia	1.54	Shenandoah	1.69	New Hanover	−7.59	Philadelphia	−3.06
New York	−33.68	Washington	−0.02	Newport	0.48	Charleston	−8.01	Shenandoah	−3.06
Philadelphia	−34.95	Charleston	−3.26	Boston	0.22	Caswell	−8.36	Windsor	−3.35
Caswell	−36.34	Philadelphia	−9.06	Columbia	−0.82	Philadelphia	−10.11	Windham	−4.43
Dauphin	−37.33	New York	−11.10	Windsor	−2.03	Washington	−12.67	Newport	−4.99
Charleston	−38.29	Shenandoah	−22.45	Windham	−2.39	New York	−13.22	Boston	−7.16
Hanover	−40.17	Dauphin	−27.96	Rockingham	−2.55	Dauphin	−14.01	Rockingham	−7.75

Source: Calculated by author.

TABLE 6. *Factor Analysis of Variation in Frequency of Principal Given-Names Recorded for Males with Presumably British Surnames in Sixteen Selected Counties, Eastern United States, 1968, as Measured in 103-Dimension Name-Space*

Factor A-1968 New England vs. South		Factor B-1968 Southern Rural vs. Northern Urban		Factor C-1968 Traditional American vs. Modern New England		Factor D-1968 Northern-Coastal-Foreign-born vs. Native-Inland-Southern		Factor E-1968 Southern-Negro vs. Northern-White	
				Factor Scores					
Rockingham	18.42	Caswell	1.34	Philadelphia	11.64	Newport	25.32	Caswell	−1.54
Windsor	18.36	Greenville	1.00	Washington	11.40	Philadelphia	19.94	Greenville	−7.52
Columbia	18.09	Hanover	0.33	Charleston	9.83	Boston	16.98	Hanover	−8.41
Windham	17.87	Shenandoah	−0.32	New Hanover	9.49	Windham	16.79	New Hanover	−12.97
Boston	17.15	New Hanover	−2.36	Dauphin	8.63	Rockingham	16.31	Philadelphia	−13.94
Dauphin	15.69	Washington	−2.65	New York	8.59	New York	16.09	Shenandoah	−14.04
Washington	13.42	Dauphin	−3.27	Hanover	7.74	Columbia	15.22	Charleston	−14.49
Newport	12.89	Windsor	−3.64	Shenandoah	7.48	Washington	14.79	New York	−14.94
Philadelphia	11.38	Newport	−4.20	Newport	7.35	Dauphin	14.61	Boston	−17.45
Shenandoah	9.72	Charleston	−4.22	Greenville	6.80	Hanover	13.52	Windsor	−17.78
New York	8.79	Columbia	−4.25	Caswell	4.82	Charleston	13.17	Windham	−18.37
Hanover	7.47	Rockingham	−4.62	Columbia	4.45	New Hanover	11.62	Columbia	−18.48
Charleston	4.77	Windham	−5.42	Windham	1.37	Windsor	11.35	Washington	−18.49
New Hanover	2.89	Philadelphia	−5.95	Rockingham	−0.65	Shenandoah	7.63	Rockingham	−19.39
Caswell	2.08	Boston	−6.29	Boston	−1.01	Caswell	5.74	Dauphin	−19.67
Greenville	0.80	New York	−10.61	Windsor	−4.13	Greenville	5.68	Newport	−20.67

Source: Calculated by author.

England cluster of counties and the Southern; it stands out sharply in both 1790 and 1968, and diachronically as well (Factor III-1790-1968). A New England entity appears strongly in no less than sixteen factors, while a Southern ingredient is expressed in nine; and they surface together—in bipolar fashion, of course—in four different factors. There is also a rather less sharply focused North-South dichotomy, for we find a Northern component (i.e., non-Southern) specified in some five factors and a yoking of North and South in bipolar harness in four instances. Thus, insofar as can be inferred from this sampling of personal name data, the supreme fact in the spatial configuration of culture in the Eastern United States over the past two centuries has been a decided north-south gradient.

Although both New England and the South have been durable cultural entities, they have performed their roles in sharply contrasting fashion. The velocity of change in personal nomenclature (and in other realms of culture as well, one is tempted to assert) appears quite sluggish in the South, so that there is recognizable continuity through the persistence of specific names. This is most strikingly illustrated in Factor III-1790-1968, the only diachronic factor with an interdigitation of loadings from the two time periods; but the relative Southern inertia is also confirmed by the way in which loadings for Southern counties for both 1790 and 1968 huddle toward the center of the scale for Factors I-1790-1968, II-1790-1968, and B-1790-1968. In New England, by way of complete contrast, the region may have endured, but there has been a complete overhaul in the *dramatis personae*, so that there is virtually no resemblance between the Colonial and the modern name patterns. The rate of onomastic turnover appears to have been unusually rapid (another symptom of the pace of general cultural evolution?), so much so that the region has performed a veritable somersault, and the differences between old and new patterns are among the greatest observed in this study. No less than 41.90 percent of the total variance in place-space for the 1790-1968 data is accounted for by Factor I-1790-1968, one which might very well have been labeled the "Modern New England vs. Colonial New England Factor," with New England counties arrayed at both ends of the column.

The inner complexity of each region is also worth noting. Thus in 1790, a "New England Puritan" pattern (Factor A-1790) can be distinguished from a "New England General" (Factor B-1790), in which traditional British nomenclature figures strongly along with some Puritan peculiarities.[40]

The frequency with which New England loadings range toward the top of the scale encourages speculation that the region may be the most representative—or innovative—for the nation as a whole. It will be interesting to learn in future years whether specific names that load high on Factors A-1968 and A-1790-1968 become more widely diffused throughout the land. Similar questions can be asked of the metropolitan North in general and of the names loading high on Factors B-1968 and D-1968.

If personal name data strongly endorse the validity of the New England and Southern regional concepts, there is only modest support for the existence of the

TABLE 7. *Factor Analysis of Variation in Frequency of Principal Given-Names Recorded for Males with Presumably British Surnames in Sixteen Selected Counties, Eastern United States, 1790 and 1968, as Measured in 104-Dimension Name-Space*

A. Rotated Matrix of Factor Loadings

	Factor A-1790-1968		Factor B-1790-1968		Factor C-1790-1968		Factor D-1790-1968		Factor E-1790-1968	
	Modern New England vs. Colonial America		Old New England vs. Modern North		Traditional British vs. Modern South		Modern British-American vs. Colonial Non-English (Scotch-Irish, German & Dutch)		Modern-Inland vs. Colonial-Coastal	
1.	Harold	0.874	Amos	0.907	William	0.585	Charles	0.353	Floyd	0.547
2.	Albert	0.873	Asa	0.906	John	0.485	Edward	0.343	Elmer	0.518
3.	Norman	0.873	Timothy	0.884	David	0.479	Paul	0.338	Lee	0.483
4.	Lawrence	0.863	Elijah	0.852	Joseph	0.466	Jesse	0.318	Lloyd	0.424
5.	Donald	0.849	Josiah	0.851	Francis	0.458	Clarence	0.281	Clarence	0.371
6.	Stanley	0.847	Ebenezer	0.850	Matthew	0.446	Leroy	0.280	Harry	0.325
7.	Arthur	0.845	Abel	0.843	Thomas	0.446	Jack	0.265	Clyde	0.314
8.	Kenneth	0.837	Israel	0.837	Isaac	0.403	Fred	0.265	Wilbur	0.301
9.	Herbert	0.829	Simon	0.814	Jeremiah	0.396	Ernest	0.265	Leroy	0.295
10.	Raymond	0.821	Ephraim	0.801	Benjamin	0.392	Richard	0.264	Harvey	0.289
11.	Howard	0.820	Stephen	0.791	Solomon	0.388	Eugene	0.262	Wayne	0.286
12.	Clifford	0.813	Jonathan	0.789	Richard	0.365	Gerald	0.258	Earl	0.282
13.	Ralph	0.812	Nathan	0.785	Anthony	0.364	Earl	0.249	Jesse	0.266
14.	Roger	0.809	Aaron	0.773	Alexander	0.362	Harry	0.245	Raymond	0.253
15.	Chester	0.798	Nathaniel	0.693	Samuel	0.355	Marion	0.244	Stanley	0.253
16.	Russell	0.794	Joshua	0.620	Joshua	0.342	Russell	0.243	Paul	0.234
17.	Frank	0.780	Daniel	0.592	Nicholas	0.317	Howard	0.242	Kenneth	0.220
18.	Ronald	0.777	Benjamin	0.582	Moses	0.316	Frank	0.238	Howard	0.217
19.	Harry	0.775	Moses	0.558	Elisha	0.287	Carl	0.236	Leonard	0.204

# / Item	Samuel (0.762)		Frederick (0.550)		Alfred (0.276)		Ray (0.234)		Alfred (0.202)
20. Alfred									
85. Christopher	Fred	−0.412	Wayne	−0.282	Francis	−0.353	Roger	−0.162	−0.134
86. Nathaniel	Eugene	−0.419	Louis	−0.282	Moses	−0.389	Daniel	−0.168	−0.138
87. Elisha	Donald	−0.453	Gerald	−0.284	Jeremiah	−0.390	Alfred	−0.204	−0.143
88. Nicholas	Earl	−0.476	Floyd	−0.285	Hugh	−0.402	Samuel	−0.308	−0.144
89. Daniel	Walter	−0.487	Lee	−0.291	Anthony	−0.415	Nathaniel	−0.358	−0.150
90. Joseph	Harry	−0.496	Earl	−0.291	Frederick	−0.446	Joshua	−0.370	−0.157
91. Jesse	Howard	−0.534	Marion	−0.298	John	−0.495	Christopher	−0.382	−0.159
92. Alexander	Ronald	−0.542	Ernest	−0.301	Daniel	−0.502	Richard	−0.389	−0.168
93. Moses	Gerald	−0.553	Fred	−0.304	George	−0.512	Andrew	−0.595	−0.172
94. Joshua	Arthur	−0.559	Wilbur	−0.307	Abraham	−0.517	Stephen	−0.637	−0.177
95. Matthew	Frank	−0.561	Harvey	−0.312	Nicholas	−0.551	Herbert	−0.678	−0.191
96. Benjamin	Clarence	−0.564	Eugene	−0.316	Andrew	−0.627	Lewis	−0.690	−0.192
97. Samuel	Lewis	−0.603	Ray	−0.327	Christopher	−0.645	Benjamin	−0.705	−0.212
98. Solomon	Francis	−0.604	Jerry	−0.349	Henry	−0.722	Frederick	−0.774	−0.218
99. James	Richard	−0.650	Clyde	−0.416	Philip	−0.724	Alexander	−0.805	−0.242
100. Jeremiah	Hugh	−0.654	Willie	−0.492	Peter	−0.772	Thomas	−0.838	−0.286
101. Isaac	James	−0.670	Jack	−0.526	Jacob	−0.819	Joseph	−0.855	−0.319
102. William	Charles	−0.701	Joe	−0.529	Michael	−0.828	Edward	−0.871	−0.365
103. John	Robert	−0.729	Bob	−0.567	Adam	−0.910	Anthony	−0.921	−0.449
104. Thomas	George	−0.790	Jim	−0.624	Christian	−0.924	Francis	−0.933	−0.575
Percent of Total Variance Explained	31.90%		18.06%		12.68%		10.96%		3.91%

(Continued)

TABLE 7. (*Continued*)

B. Factor Scores

Factor A-1790-1968		Factor B-1790-1968		Factor C-1790-1968		Factor D-1790-1968		Factor E-1790-1968	
Modern New England vs. Colonial America		Old New England vs. Modern North		Traditional British vs. Modern South		Modern British-American vs. Colonial Non-English (Scotch-Irish, German & Dutch)		Modern-Inland vs. Colonial-Coastal	
Windsor-1968	23.87	Windham-1790	22.06	Hanover-1790	29.96	Shenandoah-1968	6.28	Shenandoah-1968	3.60
Rockingham-1968	20.50	Windsor-1790	21.53	Philadelphia-1790	29.22	Greenville-1968	5.56	Washington-1968	2.39
Boston-1968	20.35	Rockingham-1790	15.72	Boston-1790	28.95	Dauphin-1968	5.55	Greenville-1968	2.24
Windham-1968	19.03	Columbia-1790	12.97	New York-1790	28.11	Washington-1968	5.28	Dauphin-1968	2.03
Columbia-1968	18.31	Boston-1790	10.78	Caswell-1790	28.00	Hanover-1968	4.79	Caswell-1968	1.38
Dauphin-1968	15.87	Newport-1790	5.31	Charleston-1790	28.00	Columbia-1968	4.75	Columbia-1968	1.02
Shenandoah-1968	14.39	New Hanover-1790	-2.64	Washington-1790	27.86	Charleston-1968	4.56	Windsor-1968	0.95
Washington-1968	12.07	Greenville-1790	-5.24	New Hanover-1790	27.23	Rockingham-1968	4.55	Charleston-1968	0.60
Newport-1968	7.63	Shenandoah-1790	-5.68	Greenville-1790	27.02	Windsor-1968	4.35	New Hanover-1968	0.39
Greenville-1968	7.39	Washington-1790	-6.32	Rockingham-1790	26.86	Windham-1968	4.30	Hanover-1968	0.18
Charleston-1968	7.22	New York-1790	-7.17	Dauphin-1790	26.60	New Hanover-1968	4.08	Windham-1968	-0.17
Hanover-1968	6.93	Philadelphia-1790	-7.56	Shenandoah-1790	26.59	Boston-1968	4.03	Rockingham-1968	-0.57
New Hanover-1968	6.67	Caswell-1790	-7.59	Newport-1790	25.63	Newport-1968	3.67	New York-1968	-1.02
Philadelphia-1968	5.69	Hanover-1790	-7.77	Columbia-1790	23.94	Philadelphia-1968	3.65	Boston-1968	-1.16
Caswell-1968	5.06	Charleston-1790	-10.41	Windsor-1790	21.90	Caswell-1968	3.06	Philadelphia-1968	-1.53

New York-1968	4.34	Dauphin-1790	−12.26	Windham-1790	21.22	New York-1968	−0.09	Newport-1968	−3.71
Windham-1790	−30.05	Caswell-1968	−13.22	Newport-1968	9.71	Windham-1790	−4.60	Greenville-1790	−7.22
Windsor-1790	−31.23	New York-1968	−15.58	Philadelphia-1968	6.58	Windsor-1790	−5.10	Windsor-1790	−7.35
Newport-1790	−33.19	Greenville-1968	−16.44	New York-1968	6.08	Newport-1790	−6.51	Windham-1790	−7.62
Columbia-1790	−33.36	Hanover-1968	−16.79	Windham-1968	4.32	Greenville-1790	−7.14	Columbia-1790	−7.92
Shenandoah-1790	−35.31	Charleston-1968	−16.91	Rockingham-1968	4.14	Rockingham-1790	−7.21	Shenandoah-1790	−8.57
Dauphin-1790	−35.46	New Hanover-1968	−17.24	Columbia-1968	3.78	Boston-1790	−7.85	Dauphin-1790	−8.88
Rockingham-1790	−36.73	Philadelphia-1968	−17.44	Dauphin-1968	3.76	Hanover-1790	−7.92	Hanover-1790	−8.99
New York-1790	−36.81	Windsor-1968	−17.75	Washington-1968	3.53	Caswell-1790	−8.73	Caswell-1790	−9.18
Charleston-1790	−37.31	Shenandoah-1968	−17.85	Boston-1968	3.26	New Hanover-1790	−9.69	Washington-1790	−9.24
New Hanover-1790	−37.34	Boston-1968	−18.44	Windsor-1968	1.68	Columbia-1790	−12.21	New Hanover-1790	−9.35
Hanover-1790	−37.52	Windham-1968	−19.26	Hanover-1968	1.50	Washington-1790	−12.86	Newport-1790	−9.72
Philadelphia-1790	−37.74	Rockingham-1968	−19.59	Charleston-1968	1.37	Charleston-1790	−13.70	New York-1790	−9.80
Caswell-1790	−38.31	Newport-1968	−19.99	New Hanover-1968	0.21	Philadelphia-1790	−19.53	Rockingham-1790	−10.07
Washington-1790	−38.83	Dauphin-1968	−20.24	Shenandoah-1968	−0.78	New York-1790	−20.13	Philadelphia-1790	−10.70
Greenville-1790	−39.19	Columbia-1968	−20.46	Caswell-1968	−4.60	Shenandoah-1790	−29.24	Charleston-1790	−10.81
Boston-1790	−39.69	Washington-1968	−20.53	Greenville-1968	−5.53	Dauphin-1790	−33.42	Boston-1790	−11.37

Source: Calculated by author.

third major culture area indicated in previous studies—the Midland. Indeed it can be identified as a distinct entity, functioning as one terminus of a bipolar coupling, only in Factor I-1790. In all other instances, the Midland counties—Dauphin, Philadelphia, New York, and, depending on date, Shenandoah or Washington—are scattered among a larger regional category, the "North" (or Non-South) or "Non-New England," i.e., Midland and South; or else these counties occupy central stations along the declivity between New England and the South.

The only totally unexpected regional patterning was discovered in Factor C-1790, which is dubbed " 'Charleston British' vs. New England General." A quite high factor score sets Charleston off from all other counties, while the six Greater New England counties settle to the bottom of that particular scale. Perhaps a peculiarity in Charleston's name pattern might be attributed to demographic and commercial connections with the British West Indies, a hypothesis which the relatively strong factor scores for Philadelphia and New York would tend to bolster.

There is unmistakable evidence of growing interregional connectivity in several factors. An "Intracoastal Factor" appears at both dates (IV-1790 and III-1968); and even though IV-1790 is extremely feeble in terms of explanatory power, accounting for only 0.77 percent of total variance, it does hint, however sketchily and embryonically, of an emergent network of transactions among those five coastal metropolises whose counties register the highest loadings, Newport, Boston, Portsmouth, Charleston, and Philadelphia.[41] The analogous factor in 1968 has gained vastly in strength, accounting for no less than 18.46 percent of total variance, with three of the preceding cities in leading positions, and New York and Wilmington replacing Boston and Portsmouth. The implication is that ideas and migrants have been exchanged among members of an intracoastal shipping system as well as commodities.

A recent northward flow of Southern migrants, and thus Southern name patterns as well, is suggested by the ranking of counties in terms of loadings on Factor III-1790-1968, the "Diachronic Southern vs. New England Factor." The relatively high loadings for Philadelphia-1968, New York-1968, Newport-1968, and Dauphin-1968, all well above the 1790 values for the same places, probably reflect a population movement from the South, one for which there is no evidence in the 1790 material.

As one would expect, certain factors reflect the effect of various non-British ethnic groups, despite efforts to exclude them. The ethnic coloration of these factors may result from disguised non-Britishers in the sample population or the incorrect classification of some surnames; or it also may be the product of local acculturation, with German, Dutch, and other continental groups transmitting their forenames to Anglo-American neighbors, along with a reciprocal transfer. But in every case the ethnic element is relatively muted, a single terminus in a bipolar factor, or just one strand within one of the bipolar entities. Thus,

for example, D-1968, the "Northern-Coastal-Foreignborn vs. Native-Inland-Southern Factor," or E-1968, "Southern Negro vs. Northern White."

Since the Scotch-Irish were deliberately included, along with the English and Welsh, in the sampled population, it is hardly startling to find a Scotch-Irish dimension, appearing either more or less solo as in D-1790 or in combination with German or Dutch populations in B-1790 and D-1790-1968. In all three instances, the factor loadings for names and factor scores for counties indicate a clustering of names popular among that group in places of known high incidence of settlers from Ulster. Factors B-1790 and D-1790-1968 also point to the presence of Teutonic names and persons just where one would anticipate them. These particular non-English patterns in American nomenclature would seem to have vanished utterly by 1968. The study design allows no inferences to be drawn about the acculturation of Teutonic or other continental groups; but there may have been complete cultural absorption of the Scotch-Irish, at least in the sample counties. Just the opposite situation obtains for the Negro component. It is totally absent in the 1790 picture because of the nature of the data, but seems to show up strongly in recent years as Factor E-1968, where we find the factor scoring of counties in reasonably close accord with relative size of Southern Negro population. Finally, a rather fuzzy separation of counties seems feasible in 1968 on the basis of relative number of the foreignborn (Factor D-1968), but as a dimension subsidiary to others.

Initially, there was some expectation that contrasts in rural and urban name patterns would materialize, and also some between coastal and interior localities, and, for 1790 at least, between frontier communities and those already well-established. Although no sign of the last of these can be discerned, the first two dichotomies are visible, but very dimly indeed. There is no evidence of any rural-urban differential in 1790 naming practice, in a period when, of course, urbanization was barely past the primordial stage. The case for such a contrast is limited to Factor B-1968, in which the rural-urban gradient seems less prominent than the North-South polarity. The implications of the D-1968 readings, with a group of Northern-Coastal-Foreignborn counties arrayed against the Native-Inland-Southern, are intriguing to say the least, and cry out for an extension of the analysis into a wider sampling of populations over a broader area. Even more mind-stretching are the hints of larger forces operating in space-time that may be implicit in Factor E-1790-1968, with modern inland counties in polar opposition to colonial coastal places. Are we witnessing the tugging of a continental American force against the umbilical connection with English practice, the splitting away of two national cultures? Or are we examining random noise in a nonsense factor?

Finally, factor analysis lends further confirmation to the claim of strong continuities in basic naming patterns not only in the South but in the Eastern United States in general. Thus there is much similarity between the two sets of names

with high scores for Factors I-1790-1968 and II-1790-1968 (in lists not reproduced here); and most of the names registering the twenty highest loadings on Factor C-1968, "The Traditional All-American vs. Modern New England" were also in heavy use in 1790.

SUMMING UP AND LOOKING AHEAD

This experiment in using forename preferences as a means for identifying constellations of cultural traits among English-speaking folk—culture areas or significant components thereof—in space and time has generated encouraging results. The basic premise that choice of forename offers an index that is sensitive to the nuances of a culture but also ubiquitous, accessible, imperishable, readily manipulated, and free of contamination by noncultural forces has certainly not been fully established; but nothing has been found to contradict the assertion. A really satisfactory answer awaits the cracking of the code of given-names, the difficult task of ascertaining the inner cultural and psychological implications of various names, and then collating those with the personality structure of the total culture.

In retrospect, it appears that forename patterns meet all the technical requirements of an ideal cultural metric quite well, so well indeed that there is the mixed blessing of overly abundant data and classification into hundreds of categories—the problems of selection and compression. It has been proved possible to state the personal name attributes of various places with some precision, to measure with equal precision differences in forename structure over time and space, and to specify how they cluster into regions at various levels of generalization by exploiting the powerful new method of numerical taxonomy. Forename analysis also permits an approach to one of the most profound questions in cultural geography, the extent to which different places are becoming more or less alike in a cultural sense. The results reported in this inquiry generally lean toward the convergence hypothesis, in terms of data for two widely separated dates, 1790 and 1968, but the findings are still ambiguous. Factor analysis confirmed and extended inferences derived from other approaches, and also permitted the dissection of several closely interwoven strands of significance in personal name patterns and the raising of additional questions beyond our immediate reach. It hints strongly of several sets of forces intersecting simultaneously in the same area and the fact that a single name bears a mixed cargo of meanings, regional, religious, ethnic, temporal, and social or residential.

The geographic study of given-name preferences can be pushed profitably in any of several directions. This study reports the characteristics of a thin sampling of places over a large territory. It would be most useful to increase the number of places analyzed—and the range of dates. Such an analysis might tell us whether an older cellular pattern of localized traditional communities has given way to a complex multi-layered sandwich spanning the continent, with vertical diversity

replacing horizontal variety. For any individual place, a careful probe through time, with data from a good many closely spaced dates, would offer valuable insights into the dynamics of onomastic evolution and possible fluctuations in the velocity of change.

In the present study, the subject population was deliberately stripped of as many confusing variables as possible; but in future efforts it would be worthwhile to introduce a series of carefully controlled variables so as to ferret out their significance. Thus it would be useful to compare female with male name patterns, to cross-tabulate name against age, to examine ethnic and racial variables, to have a look at relationships among social class, education, political behavior, and naming practice or those between migrational characteristics and names. And, finally, geographers interested in exploring the processes of cultural diffusion through physical and other forms of space may find that records of personal names offer the richest sort of lode.

Annals of the Association of American Geographers 60 (1970): 743–769

NOTES

I am greatly indebted to Mark S. Monmonier, University of Rhode Island, and Conrad W. Strack and Anthony Williams, Pennsylvania State University, for technical aid and comfort.

1. Some of the more important writings on specific cultural complexes and methods of study are cited at appropriate points in the text, but attention should be directed to publications that approach the culture of particular sections of the United States holistically, methodically, and expertly. Most notable is a series by Meinig (1957–58, 1965, 1968, 1969). Then, chronologically, Webb (1931), Vance (1935), Zimmerman and Du Wors (1952), Landgraf (1954), Arensberg (1955), and Bjorklund (1964).

2. Kroeber and Kluckhohn (1952: 181).

3. For a comprehensive critical review, see Pelto (1967), especially pp. 151–155. The most substantial recent monograph is Honigman (1967).

4. The most useful statements concerning the cultural geography of American speech are Kurath (1949) and McDavid (1958).

5. An excellent general overview of the subject, with many specific references to the United States, is Sopher (1967). American religious data and interpretations thereof are offered in Zelinsky (1961) and Gaustad (1962).

6. An incomparable general introduction to American place-names is Stewart (1958). Specifically geographic analyses of major aspects of toponymy are presented in Zelinsky (1955, 1967) and Burrill (1956). A comprehensive guide is Sealock and Seely (1948), with periodic supplements by the same compilers appearing in *Names*.

7. A considerable body of literature on American houses is of interest to geographers, although mostly non-geographic and varied in origin, purpose, and quality. Possibly the two best bibliographic guides, at least for the Eastern United States, are Rickert (1967) and Glassie (1969). The methodical study of American barns has scarcely begun, but some useful notes and bibliographic citations are scattered throughout Glassie. A good semipopular

introduction to the subject is Sloane (1966). The study of barns as a strategy in analysing the agricultural economy is illustrated in Hart and Mather (1961). The rich possibilities for the study of cultural history and geography through farm outbuildings are shown, in the case of French Canada, in Séguin (1963). American fences have yet to receive the serious geographic analysis they deserve. Virtually the entire corpus of significant literature is cited in a single footnote in Glassie (1969: 226). The geography of graveyards is another undeveloped theme, but one, I suspect, with great potential. A single brief statement (Kniffen 1967) is at once a manifesto and summary of all the recent literature worthy of note. The seminal essay on farmsteads (Trewartha 1948) has yet to be superseded—or followed up. A number of publications have begun to probe the historical and cultural implications of survey, road, and street patterns, notably Trewartha (1946), Pattison (1957), Marschner (1959), Thrower (1957), Reps (1965), and Pillsbury (1968). The subject of town centers has begun to be explored, with promising results in Pillsbury (1967) and Price (1968). Taking the settlement landscape as an aggregate, most folk elements are considered in Glassie (1969). The aggregate pattern is also treated in Trewartha (1946) and Zelinsky (1951a, 1953).

8. Population traits are accorded much attention in mapping early Texas cultural regions in Jordan (1967). The few probes into political behavior are intriguing, as, for example, Jordan (1967), Turner (1950:308), Crisler (1949), and Hart (1967:93–99, Maps 6–8). A fine general account of this nation's folklore, with a generous amount of space devoted to regional folk cultures, is Dorson (1959).

9. There is some confusion in the personal name literature as to what term to apply to items placed before the family name. For obvious reasons, I do not believe that either *Christian name* or *baptismal name* is properly descriptive; and *first-name* is inadequate for our purposes, since middle names are also considered. Thus the terms *forename* and *given name* are used interchangeably throughout to designate both first-names and middle names. Surname analysis is utilized in Meigs (1941) and Lemon (1966). Classification of surnames in the 1790 population census schedules by the Committee of Linguistic Stocks of the American Council of Learned Societies in 1931 produced much of the raw material for a map of "National Origin and Religion 1790" (*American Heritage Pictorial Atlas* 1966: 87). A study of nineteenth-century ethnic geography and migrations in Pennsylvania is being carried on currently by Mark Hornberger, doctoral candidate at Pennsylvania State University.

10. The best general treatments of naming practices in the United States are Krapp (1925, 1: 200–218) and Mencken (1948).

11. For an informal, but highly useful, history of given-name usage in Great Britain, consult Weekly (1940).

12. Church-inspired limitations or pressures among Roman Catholics, Jews, and some Protestant denominations as to which names should be used, and for whom, are increasingly flouted or circumvented in a variety of ways.

13. An excellent guide to the literature is furnished by Smith (1952) and in the annual supplements appearing in *Names*.

14. The most substantial discussions of American personal names containing a regional focus are Stewart (1948), Jacobus (1923), and Pyles (1947). Substantial general treatments of the cultural implications of personal names are to be found in Miller (1927) and Feldman (1959).

15. Pulgram (1954), Searle (1958), Strauss (1959), Thompson (1959), and Zink (1963).

16. Certain clusters of names are popularly recognized as having certain qualities in common. Thus, for example, there is a group of "sissy" names, such as *Percy, Clarence,* or *Algernon*; posh names, such as *Cedric, Reginald, Cyril,* or *Cecil*; rustic yokel names, such as *Elmer, Rube, Lem, Zeke,* or *Abner.* A larger group of Old Testament names, now obsolete for the most part, was categorized as peculiarly Puritan by contemporaries in both England and America (Stewart 1948: fn. 15; Jacobus 1923: fn. 15; and Bardsley 1880). But note again that the literal meaning or etymology of the name cannot explain its particular aura of meaning and overtone. *Ebenezer,* as discussed in Stewart (1948:134–135), is surely one of the most obscure, insignificant proper names in the Bible, but somehow it summoned up for eighteenth-century Congregationalist parents the proper New Englandly resonances with its craggy, austere tonality.

17. Lévi-Strauss (1966: 181, 185, 187).

18. The best general review is Brender (1963). Among other treatments of the subject are Walton (1946), Houston and Summer (1948), Savage and Wells (1948), Murphy (1957), and McDavid and Harari (1966).

19. The most definitive treatments of middle-name usages in the United States are Krapp (1925, 1: 212–218), Minton (1958), and Hartman (1958). Hartman (1958: 294) suggests that forms such as "J. J. Johnson" are most common in the South and small towns. There are strong indications that the patterns of choice differ greatly as between first names and middle names, according to data tabulated from birth announcements in the *Manchester Evening News* since 1963 (Paget 1969).

20. The only publication dealing with the methodology of personal name study of which I am aware is Ellegård (1958). It is particularly useful in its suggestions for measures of onomastic diversity.

21. U.S. Census Office (1907–08). All surviving Census enumeration schedules from 1790 through 1890 are available for inspection, either directly at the National Archives or by means of microfilm. Unfortunately, nearly all of the 1890 material was destroyed by fire. Because of the Disclosure Rule, information concerning individuals is not obtainable from the schedules collected in 1900 or more recently.

22. In retrospect, the inclusion of the 1782 Hanover County data was an error in judgment. The sample is small enough so that random noise may be troublesome, and it is certainly not representative of the total British stock. In short, the tabular data on early Hanover County and its location in figure 2 should not be taken too seriously.

23. The assumption of boundary stability for the indicated counties is more of a pious hope than an unshakable certitude. There is no reliable information in any summary cartographic or verbal form on the precise location of early county boundaries in the United States—a rather bewildering lacuna in our geographic documentation. For the 1790 boundaries, I have relied upon the only available map, one that is most welcome despite its small scale (Friis 1940: Fig. 3). In any event, it is doubtful whether any discrepancies between the 1790 and 1968 boundaries would have introduced systematic biases into the data.

24. In addition, there is considerable temporal spread in the conferral of the names reported for 1782–1790 and 1966–1968, in the former from about 1700 to 1775, and in the latter from the 1870s to the 1950s.

25. Explicit discussion of temporal shifts in name frequencies are in Allen et al. (1941) and Finch, Kilgren, and Pratt (1944). I am grateful to Dr. G. R. Stewart for the opportunity to examine manuscript tabulations and graphs of given-name frequencies among alumni

of Harvard and Princeton universities during the seventeenth and eighteenth centuries. In addition to some pronounced changes in pattern over time, there were also sharp differences among contemporaneous sets of alumni from the two institutions.

26. For a comprehensive discussion, see Sokal and Sneath (1963).

27. Among the more explicit treatments of this notion in the economic and demographic realms are Eldridge and Thomas (1964) and Labovitz (1965). The theme of divergence and, in very recent times, convergence of cultural patterns on the planetary scale runs strongly throughout Spencer and Thomas (1969), perhaps the first full-scale consideration of the question. The basic theses presented by Labovitz and by Spencer and Thomas are similar, though at completely different spatial and temporal scales, namely that after an initial condition during which interregional differences are minor and random, localized technological and cultural advancement and its partial diffusion to, and interaction with, outlying areas lead to a period of maximum differentiation over space; then with the increasingly effective spread and integration of "space-adjusting techniques," such territorial gradients tend to lessen and fade out. This hypothesis of the waxing and waning through history of socioeconomic and cultural distances among regions might well be kept in mind in interpreting the statistical results of this study: the straight-line interpolation of trends between 1790 and 1968 may not be the most realistic of approaches.

28. Glenn and Simmons (1967).

29. Further discussion, confirmation, and qualification of this point are offered in Glenn and Alston (1967) and Glenn (1967).

30. Of the two methods—the coefficient of similarity and numerical taxonomy—the latter would appear to be more sensitive to structural pattern within complex statistical distributions and, hence, probably yields rather better information as to degree of convergence or divergence in total pattern. To take an extreme case, imagine two counties, or the same county at two different dates, in which the relative incidence of, or ratio among, men's names is exactly the same for all specific items, except that in one case *John* accounts for 90 percent of all occurrences, while in the other only 10 percent of the boys are christened *John*. This would produce a coefficient of similarity of 0.800, but the taxonomic distance would be much lower in magnitude and would correctly suggest a continuing similarity in basic pattern.

31. A truly rigorous and perceptive measurement of degrees of difference among dynamic phenomena over space and time is much more complicated than is suggested in this exploratory venture, where a simplistic view is necessary. We have looked at discrete slices of time, applied measuring devices to each, and then naively hung the results side by side. The manner in which cultural change actually progresses through space-time calls for a more sophisticated approach in later work. Thus, given A, a center for cultural innovation, and Places B, C, D as recipients of cultural influences, the investigator may find that B, C, D are indeed convergent with A, but with the A of an earlier epoch, while the present-day A has escalated to another phase. Glenn and Alston (1967: 399, fn. 32) are explicit on this matter in treating rural-urban differences:

> The innovations generated in the cities may be diffused to the hinterland, but there is a time lag between change in cities and corresponding change in rural areas. The mass media and rapid transportation in advanced industrial societies may lessen the lag but do not eliminate it.

Glenn has reinforced the point in personal correspondence (1969):

> I do not foresee an eventual state of static and stable "liberal consensus" across the country. Rather, I foresee that by the time a consensus, or near consensus, is reached on one issue or in one value area, the more highly urbanized regions will be changing in some other respect and the less highly urbanized regions will be lagging behind again. . . . When and if all the regions [of the United States] become highly urbanized, the differential rates of change may be small, perhaps negligible, but I suspect there will always be some lag of the interior regions behind the coastal regions.

32. Strack (1969).

33. These three regions are recognized in several discussions of the cultural geography of the Atlantic Seaboard, including Trewartha (1946), Kurath (1949), Meinig (1957–58), Glassie (1969), and Kniffen (1965). Each of the areas has been treated in considerable depth by Wertenbaker (1938, 1942, 1947).

34. This crisscrossing of "umbilical cords" between culture hearths and frontier communities is shown graphically in Glassie (1969: Fig. 8).

35. The technique is described in Rummel (1967) and King (1969: 184–193).

36. For 1790, only those 79 names that occurred with some frequency were used. In the 1968 and 1790–1968 computations, only the most important 103 and 104 names, respectively, were entered because of limited computer capacity.

37. The term "loading" can be defined most simply in verbal terms as the degree of geometric relationship between a variable and a factor (the cosine of the angle between axis and vector), ranging from 0, when no relationship exists, to ±1.0, when complete identity or its opposite prevails. The absolute value of the variable—here percentile frequency of a name—is not reflected by the loading, only the amount of typicality, the degree of identification between variable and factor. Thus, such extremely common names as *John, William,* or *Robert* may show up quite unobtrusively, if at all, in the accompanying tables.

38. The loadings on the variables in tables 5 and 6 have been eliminated from the published tables to conserve space.

39. In mathematical terms, this term can be expressed as

$$S_{ik} = \sum_{j=1}^{n} L_{ij} \cdot d_{jk}$$

where n is number of variables, L is the loading, d is the datum (name as percent of all names), i is the factor, j is the variable (name or place), and k is place or name. In verbal terms, the factor score is the importance of a term (either a place or a name) in the cluster constituting a factor.

40. Jacobus (1923).

41. The existence of this factor would seem to support the thesis in Merritt (1966) that a budding national consciousness in the mid-eighteenth century is best explained by increasingly effective intercolonial communications in the form of trade, travel, a postal system, newspapers, and rudimentary political associations.

Some Problems
in the Distribution
of Generic Terms in
the Place-Names
of the Northeastern
United States

For many years American toponymy has been the domain of students of language who have been concerned almost exclusively with specific names.[1] There is much in the best of such research to interest geographers, but the even more promising topic of generic terms—the common nouns—used to denote geographic features in the United States has been strangely neglected by geographers and linguistic specialists alike.[2] As major items in any cultural landscape, these terms deserve close scrutiny for their own sake; but of even greater importance are the complex, uncharted inter-relationships among place-names and other phases of culture and the possibility that their study may illuminate significant aspects of American cultural history and geography.[3]

It is the purpose of this exploratory essay to survey the distribution of a selected group of generic terms over an important section of the United States, to speculate about their significance, and to note some of the problems to be encountered in their further study. The fact that several hundreds of thousands of place-names exist in the United States has made it necessary to limit this reconnaissance to a single major region immediately productive of challenging facts and problems—specifically the Northeastern United States—and to a single readily accessible source of data—the large-scale topographic sheets of the Geological Survey and the Corps of Engineers. It is recognized that such an approach represents a crude compromise between two earlier types of studies, both conducted in considerable depth: the analysis of a single term over its entire range in time and space[4] and the intensive inventory of all specific and generic terms within a restricted territory.[5] Obviously, the ultimate synthesis of American place-name study will require a great many more monographs of both types. The utility of the present paper lies in its providing a rough scaffolding that may somehow indicate the shape of the final edifice, or at least afford the builders an overview of their task.

The area encompassed by this study (shown in fig. 1) is that contiguous and more or less compact territory in the Northeastern United States for which topographic sheets of a scale of 1:62,500 or larger were available in 1953. Fortunately, this region happens to include the sites of the earliest permanent European colonization in the United States (except that in Florida and the Southwest) and also constitutes an area that furnished settlers to most of the rest of the nation. In addition to being a culture hearth, the Northeastern United States is also characterized by a degree of cultural diversity well above the average for the country, and is rivalled in this respect perhaps only by Louisiana.

Specific terms were eliminated as a topic of study and also such generic terms as are applied casually in vernacular speech to features of the landscape without being incorporated into particular names, e.g., such usages as *rise, dip,* or *neighborhood.*[6] In other words, only those generic terms appearing on topographic maps as a portion of a geographic name have been studied. Their number has been further reduced by the omission of terms describing the internal features of towns, for lack of adequate coverage, and of that large group applied to coastal features. Because of the enormous number of places named on highly detailed coastal charts and the peculiar cartographic problems involved in depicting their essentially linear distributions, it was deemed best to bypass these terms at present, but not without voicing the hope that they will soon receive the attention they merit. Two final limitations have been the elimination of most terms that occur with great rarity or as minority elements in restricted tracts and, on the other hand, those that are universal in the sense that they occur abundantly wherever their use is appropriate. No doubt many intrinsically important terms are left out by such a policy; but this decision was dictated by a concentration of interest in the major regional variations in the place-name cover.

It is readily demonstrated that the topographic sheets used for this study are in many respects gravely deficient as sources of place-names. The relative completeness and accuracy of the names on a given sheet will vary with its scale, date, and the particular area involved. Furthermore, since the collection of place-names was of incidental interest to government agencies concerned primarily with such matters as relief, hydrology, and material culture, the quality of the toponymic content may differ greatly from one surveyor or map editor to another. In more exacting studies these topographic sheets must be supplemented by a wide variety of other maps, local literature and archival materials, and intensive field work, not only to fill in the details of the contemporary place-name pattern but also to trace the all-important changes that have occurred in the past. Notwithstanding these reservations, the maps accompanying this text afford a meaningful, if crude, approximation of the more or less contemporary distribution of some of the more regionally significant generic terms within the study area.

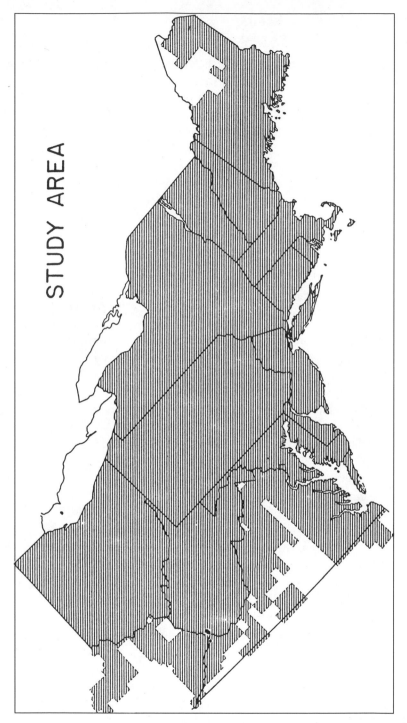

STUDY AREA

FIGURE 1 Study area.

Any observant map-reader who compares large-scale maps of the United States with those of Western Europe will be struck by the relative paucity of place-names on the former—even making generous allowance for omissions by mapmakers.[7] This difference, which is difficult to define quantitatively, may be attributed to the recency of settlement and the simpler history of America, the lower average population densities (and, hence, the coarser grain of the cultural landscape), and, in many areas, the less complex character of physical features.

Among the various classes of physical features in the Northeastern United States, streams appear to be the most often named.[8] Since a generic term is invariably appended when these names are formally recorded on maps,[9] a large mass of stream terms await the attention of place-name geographers. Although a total of perhaps no more than a score of terms are in use for the many thousands of streams in the study area, some of them rather rare and special, it is important to note the existence of some significant sub-classes within this restricted group of words.

First, different terms may denote distinctions in the size of streams. Thus in the Deep South the terms *river*, *creek*, and *branch* (or *fork*) form a hierarchy expressing decreasing magnitude.[10] In Maryland the series is augmented by *run* as an intermediate category between *creek* and *branch*.[11] Farther northward, such series as *river-creek-run* or *river-brook* are prevalent, with the term *river* always unrivalled as a label for the largest streams.[12]

A major distinction must also be made between terms applied exclusively to tributaries and those that may be used for either tributaries or master streams. There are many cases where a tributary acquires a name wholly independently of the main stream (in which event the size hierarchy of terms comes into play); but such terms as *branch*, *fork*, or *prong* are frequently used to denote tributaries, often in conjunction with some directional adjective, such as "right" or "left," "north" or "south," or "upper" or "lower."[13] The matter is complicated, however, by the fact that in some regions *branch* and *fork*, through a process whose history is most obscure, have acquired the status of full generic terms, as in "Grassy Fork" rather than "West Fork" of So-and-So Creek. As will be seen, these variant usages depart sufficiently in areal distribution from the parent forms so that they may be accepted as distinct terms.

The choice of a generic term for a stream may also be affected by its velocity or some other physical characteristic. Thus, in his study of Maryland stream names, Kuethe discovered that *run* was applied to streams of high velocity (in the mountains and Piedmont), while *branch* was most frequently adopted for those of moderate current, and *creek* was used for the most sluggish (in the Coastal Plain).[14] In southeastern Virginia and in other parts of the South not covered by this survey streams which flow slowly through swampy areas may receive the appellation *swamp*. In the glaciated country of New England and northern New York

the terms *deadwater* and *flowage* are sometimes employed for streams that have been partially obstructed so that they have swollen nearly to the dimension of lakes. Elsewhere within this same region the terms *inlet* and *outlet* are used aptly enough for streams entering or leaving glacial lakes. Where streams pass by "a spot to which animals resort to lick the salt or salt earth found there,"[15] the word *lick* is often used as part of a compound specific name, e.g., "Elk Lick Branch," and sometimes, but less frequently, as a pure generic term, e.g., "Elk Lick." In those parts of Tidewater Virginia and the Eastern Shore where ditches have been dug intermittently to drain low ground, it is sometimes impossible to distinguish artificial from natural channels, and the term *ditch* may occasionally be used for the latter.[16]

Since large streams are almost invariably designated as *rivers* in the Northeastern United States, our attention here is limited to the distribution of terms for medium- and small-sized streams. Of these, probably the most important is *creek* (fig. 2),[17] for it occurs in considerable numbers almost everywhere west and south of the Adirondacks and Hudson River in association with medium-sized streams.[18] Like many other important generic place-terms, *creek* is an Americanism in the sense that the British word has acquired an entirely novel connotation on this side of the Atlantic. There are hundreds of instances along the American coast of *creek* being used in its original sense of salt-water estuary or embayment, but its application to fresh-water inland streams is a North American innovation. Students of the American language have not yet fully accounted for this shift in meaning, but the *NED*'s surmise is the most probable and widely accepted explanation:

> Probably the name was originally given by the explorers of a river to the various inlets and arms observed to run out of it, and of which only the mouths were seen in passing; when at a later period these "creeks" were explored, they were often found to be tributaries of great length, and "creek" thus received an application entirely unknown in Great Britain.

Such a hypothesis is strengthened by the near absence of the term in interior New England (as noted in *LANE*). The gradual merging of brackish estuaries with inland streams that occurs within the broader coastal plains to the south is a rarity along the rugged New England coast, and so too the opportunity for extending the term inland. Not much significance need be read into the variations in the frequency of *creek* outside New England, for most of these are caused by shortcomings in map sources or by variable numbers of nameable streams. The decreased importance of the term in the central portion of the study area is largely the effect of strong competition from *run*, which is used for medium-sized as well as small streams.

The distribution of the important stream term *brook* (fig. 3)[19] is in most respects the converse of that of *creek*, for it is well represented in New England, New York, New Jersey, and northern Pennsylvania but is relatively uncommon else-

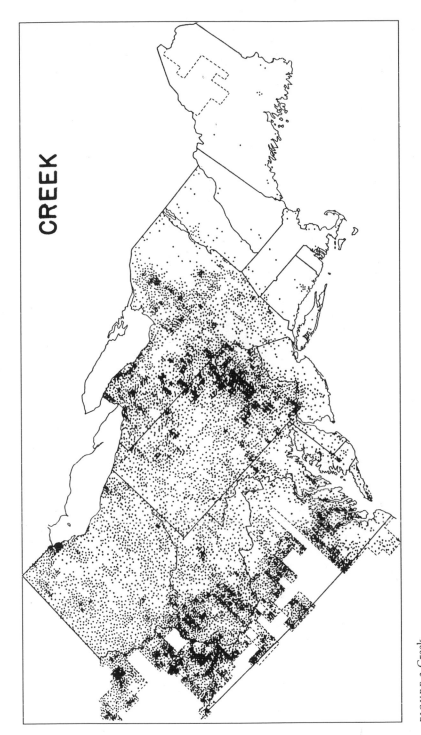

CREEK

FIGURE 2 Creek.

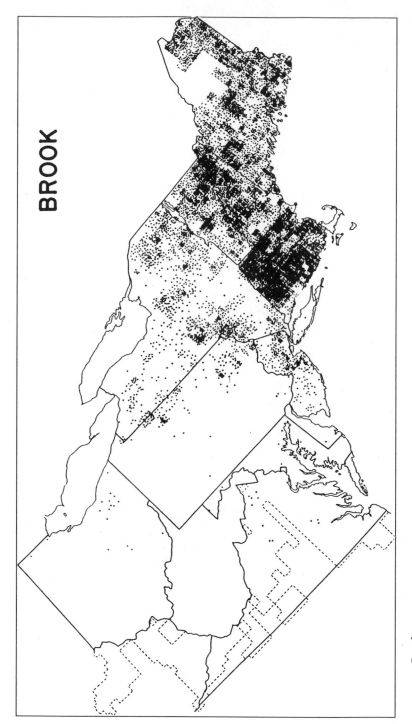

FIGURE 3 Brook.

where.[20] Within the area of its principal concentration, *brook* is used in the common English sense of a small stream or rivulet—in southern New England almost to the exclusion of other terms.[21] The distributional pattern is closely coincident with that of the New England culture area and with its westward expansion during the late eighteenth and early nineteenth centuries. Since the original sense of *brook* is "a torrent, a strong flowing stream" (*NED*), the term was much less applicable in the coastal territories south of New York Harbor and, although in occasional use there, had a slimmer chance of being adopted and spread inland than in hilly New England.

Southwestward of the region dominated by *brook*, the great majority of small streams are termed *runs* (fig. 4).[22] The substitution of this usage for the equally appropriate *brook* throughout most of the central portion of the study area is difficult to explain. In Great Britain, the term is confined to northern England and portions of Scotland, specifically Yorkshire, north Lincolnshire, Norfolk, and Lanark, where it is regarded as dialectal.[23] Further research into the British history of *run* is necessary before its American distributional pattern can be accounted for; but two hypotheses suggest themselves: (1) *Run* may have been a waning but still widespread term in Great Britain at the time of its introduction into America where, for unknown reasons, it failed to gain much of a foothold except within its present range,[24] or (2) the term was taken to Pennsylvania and Maryland by the Scotch-Irish immigrants who were familiar with it in their homeland and thence carried westward by the advancing frontiersmen.[25] At any rate, it is tempting to correlate the area dominated by *run* with the Midland speech demarcated by Kurath in his *Word Geography of the Eastern United States* and to seek a common origin for both. It is especially interesting to note the unusually sharp boundary dividing *run* from its equivalent term *branch* in Virginia and West Virginia.

The use of *branch* in the English sense of a tributary and in conjunction with a directional specific is so widespread within the study area that its occurrence was not plotted. The second major usage of *branch*, as a full-fledged generic term, is an Americanism with a curiously spotty distribution (fig. 5).[26] Although there is a decided preponderance of *branches* in the nomenclature of small streams in most of the southern part of the study area[27]—and particularly in the Appalachians—there are sizeable clusters of occurrences in southern New Jersey, parts of Vermont and New Hampshire, and that north-central Pennsylvania region which will presently be seen to be anomalous in other respects. Within its more southerly range, the important concentration in Maryland and the Eastern Shore is striking.

It is noteworthy that even in the zone of greatest frequency, *branch* (in its full generic sense) does not dominate nearly so much as *brook* or *run* do in their respective areas, for it faces severe competition from both *fork* and *creek*. A fragmented distributional pattern and the complex series of physical connotations may well indicate a complicated history. It is obvious that *branch* in its full generic

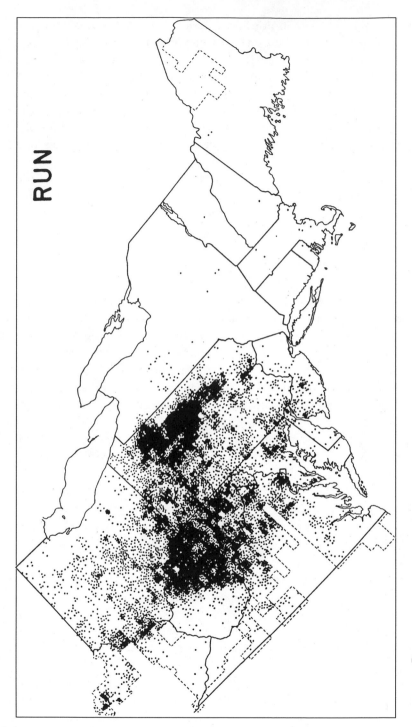

FIGURE 4 Run.

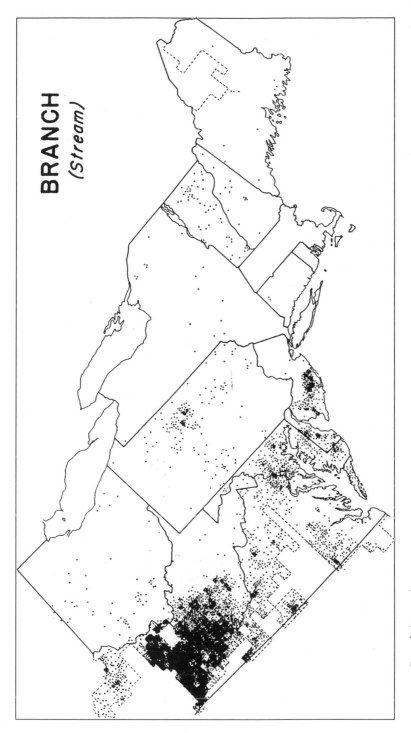

BRANCH
(Stream)

FIGURE 5 Branch (stream).

sense stems directly from the original tributary term, but the locus and method of the transition are uncertain, as is the question of whether a single or multiple origin can be ascribed to it. Neither are there sufficient data on hand to settle the major problem of the dominance of *branch* in the Southeastern United States.

In spite of lower frequency and greater restriction of range, the term *fork* presents an interesting parallel to *branch* (fig. 6). Again a word with a purely tributary sense in Great Britain has retained its original usage rather generally but has been transformed locally into a full generic term. In this case, however, the Americanism is apparently wholly absent from the northeastern half of the study area—except for the aberrant north-central Pennsylvania tract—and is almost completely an inland, montane phenomenon. The absence of *fork* in the oldest colonial regions suggests the possibility of a relatively late origin along an inland frontier.[28]

The closely similar term *prong* is much less current than either *branch* or *fork*. In its basic sense of a tributary, only twenty-six occurrences are noted on maps of the study area—all within its southern half.[29] Thirteen cases of the use of *prong* in the full generic sense of stream have been recorded—eight in Delaware and five in Virginia. The lateness of the earliest *DAE* and McJimsey citations (1725 and 1770, respectively) would make this appear to be another relatively recent term.

In Maine and northern New Hampshire the term *stream* is applied to many and sometimes a majority of medium-sized watercourses; but its use is greatly restricted in other parts of New England and in New York, New Jersey, Pennsylvania, and Virginia, and it is unknown elsewhere in the study area (fig. 7). This distributional pattern is not only unexplained but scarcely noticed in American place-name literature.[30] There is nothing unusual in the physical context of *stream* to help solve the question;[31] but recency of the first recorded occurrence in Virginia (McJimsey 1940) may be an important clue, for the northern New England tract in which *stream* achieves its greatest prominence is one of recent settlement.

In contrast to *stream*, the limitation of the term *kill* to the Hudson Valley, Catskills, and upper Delaware Valley (fig. 8) can be accounted for quite readily. This Dutch equivalent of *brook* or *run* is almost exactly coterminous with the region of significant, or even transient, Dutch settlement. It is interesting to note occurrences as far afield as the Mohawk Valley, Delaware, and Berks County, Pennsylvania. The relative scarcity of *kills* along the lower Hudson Valley and on Long Island is not so easily explained, although detailed historical investigation might show that Dutch toponymy was more thoroughly supplanted by English terms here than in less accessible areas.

The term *lick* has already been cited as one used not only in its strict original sense but also quite often within the specific name of a stream (fig. 9) so as to take on some generic attributes. Until a study has been made of the geography of salt licks and their place in the frontier economy, it will be difficult to determine how closely *lick* as an element in stream nomenclature coincides with the physical and economic entity. What does appear certain from the map is that *lick* is a South-

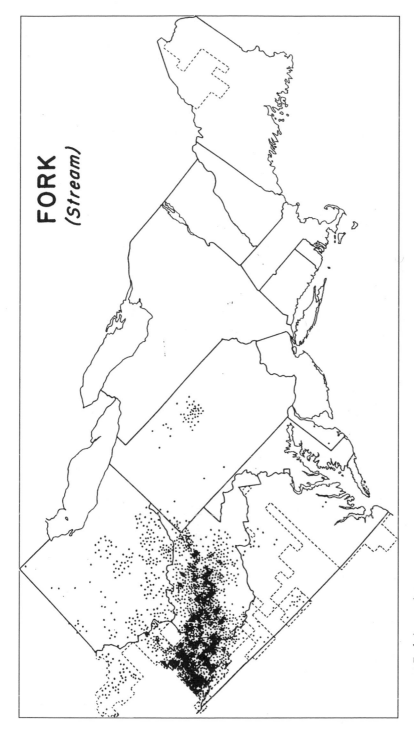

FIGURE 6 Fork (stream).

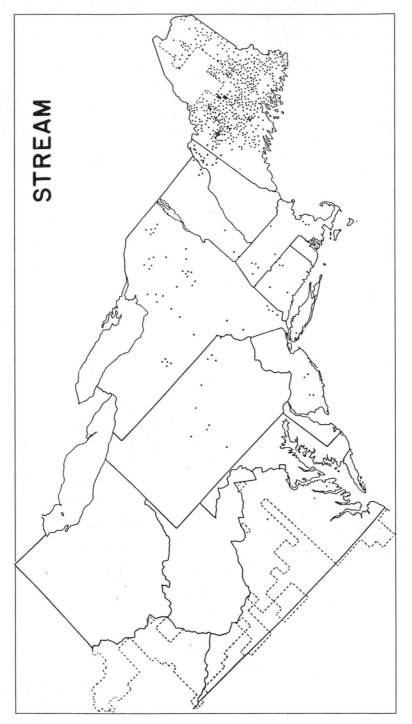

FIGURE 7 Stream.

KILL

FIGURE 8 Kill.

LICK
*(in specific name
of stream)*

FIGURE 9 Lick (in specific name of stream).

ernism, probably of late origin along the frontier.[32] The use of *lick* as a full generic term for stream occurs in scattered localities in West Virginia and in the adjoining portions of Virginia, Kentucky, Ohio, and western Maryland—as well as in north-central Pennsylvania.

Among the remaining minor terms used for drainage features, one of the more interesting is *ditch*. The ambiguity of its connotations on the Eastern Shore has been mentioned previously, but the same phenomenon occurs in poorly drained sections of northern and northwestern Ohio (and other Middle Western areas). A parallel term—*drain*—is found infrequently within the study area but abounds in the formerly swampy tracts of southeastern Michigan.

LAKE TERMS

The percentage of lakes endowed with names within the Northeastern United States is almost as high as that of streams, even though only two generic terms—*lake* and *pond*—are in common use.[33] *Lake*, a widely current English term, is applied in the British Isles to larger bodies of water, but in America to specimens of almost any size. The term may precede or follow the specific in a name but is most often found in a terminal position.[34] *Pond* is, in a sense, an Americanism, for its common meaning in England is "a small body of still water of artificial formation" (*NED*) and only locally is it equivalent to a small lake. In studying the highly divergent patterns of *pond* and *lake* in figures 10a and 10b, it must be remembered that lakes are an important phenomenon only in the glaciated northern section of the study area. Within this region, *pond* predominates greatly throughout all New England, except northeastern Maine, and in eastern New York. Although *lake* is generally reserved in New England for larger bodies of water, there is an extremely wide overlap in usage, many a *pond* being larger than a *lake*. The manner in which this special, local English term came to dominate in New England (and the more lacustrine portions of the Chesapeake Bay region) at an early date[35] remains a mystery. *Lake* is used most frequently in northeastern Maine, the western Adirondacks, northeastern Pennsylvania, and northern New Jersey—the outer rim of the lake zone of the Northeastern United States.[36]

UPLAND FEATURES

The extent to which hills, mountains, and other eminences have been named in various regions of Anglo-America presents interesting irregularities. The majority of eligible places in New England possess names, as do most of those throughout the Folded Appalachians; but in that hilliest of areas, the Appalachian (i.e., Allegheny and Cumberland) Plateau, only a small minority of highland tracts are dignified with names.[37] Among the array of generic terms used for upland features, several are so widespread as to lack regional significance. The most notable example is the ubiquitous *mountain*; but *top* (along with its derivative

POND

FIGURE 10a Pond.

-LAKE

FIGURE 10b -lake.

roundtop), *peak, mound,* and *rock* are also important. The widely prevalent *ridge* offers the interesting problem of a single term covering a multiplicity of features, from an insignificant line of sand dunes or a river levee to a huge mountain rampart.

The term *hill* is favored throughout the United States for protuberances of less than mountain size; but in New England—and particularly the southern half of the region—*hill* is employed for a wide variety of landforms of great range in magnitude, far outstripping all competitive terms (fig. 11a). In the Southern Appalachians *hill* yields precedence to *knob* (fig. 11b), an Americanism that appears to be of late origin.[38] The term *mount,* used in Great Britain for "a more or less conical hill of moderate height rising from a plain" (*NED*), occurs widely throughout the United States, with an especially large concentration in New England and eastern New York. *Mount* is perhaps unique in that the word is obsolete in the vernacular except for its survival in place-names (*DAE*). The influence of biblical nomenclature on the popularity of the term in New England would bear investigation.

Perhaps the most curious term used as a synonym for *hill* within the study area is *cobble,* which is defined by the *DAE* as "a round hill . . . name applied to a hill or other moderate elevation whose sides have a covering of loose or cobble stones." The generic term is evidently unknown in the British Isles, and a German or Austrian derivation is suggested by the *DAE* and Whitney.[39] The fact that the thirty or forty occurrences discovered in this survey are limited to eastern New York and western New England might suggest diffusion from a Dutch source in the Hudson Valley.[40]

Unlike some mountainous regions of Europe, there is a distinct scarcity of names for the component sections of individual hills and mountains in the United States. In the northern half of the study area a "shelf-like projection on the side of a rock or mountain" (*NED*), or sometimes the whole eminence, may be termed a *ledge* (fig. 12), a thoroughly English usage, while in the Southern Appalachians the Americanism *spur* is applied to the rib-like flanks of some mountains.[41] Passes across ridges and mountains are only occasionally bestowed with names, and then in those areas where they are of particular importance in the local routing of communications. The term *pass* occurs in all appropriate sections of the study area, but less often than might be expected.[42] Within New England the Americanism *notch* is greatly favored,[43] especially in the White Mountains, but the term also appears in New York and Pennsylvania (fig. 13). A rather late origin is indicated for *notch*[44] in contrast to the antiquity of almost all other New England terms. Within the Appalachians southward from central Pennsylvania—and to a lesser extent in the Poconos, Catskills, and northern Vermont—passes are denoted as *gaps* (fig. 14). This term does occur infrequently in Great Britain but did not achieve widespread popularity in the United States before the mid-eighteenth century.[45]

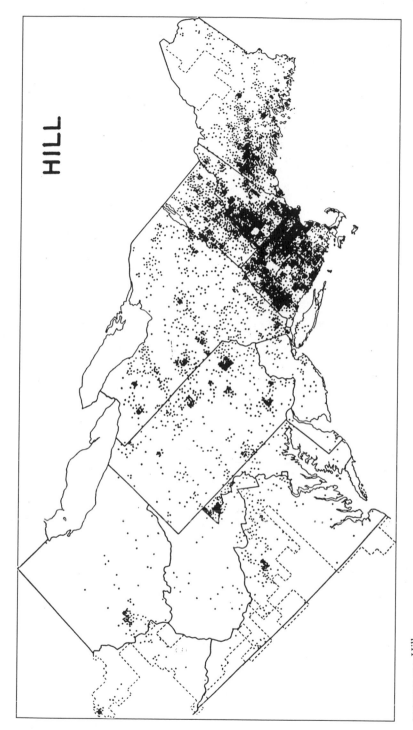

HILL

FIGURE 11a Hill.

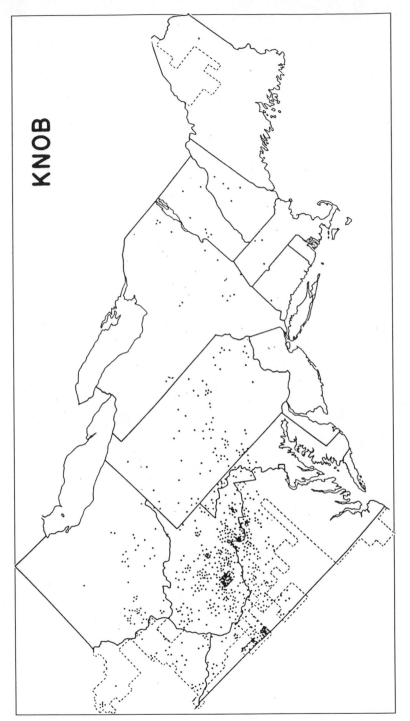

KNOB

FIGURE 11b Knob.

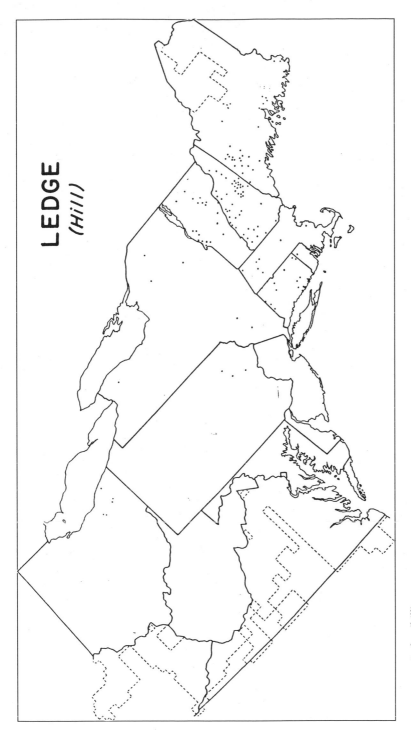

FIGURE 12 Ledge (hill).

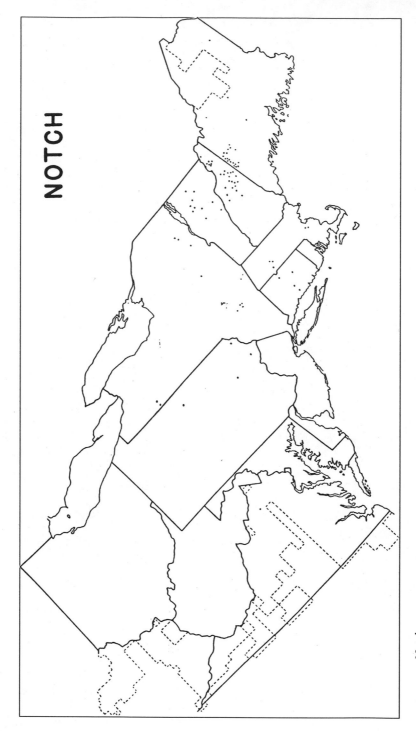

NOTCH

FIGURE 13 Notch.

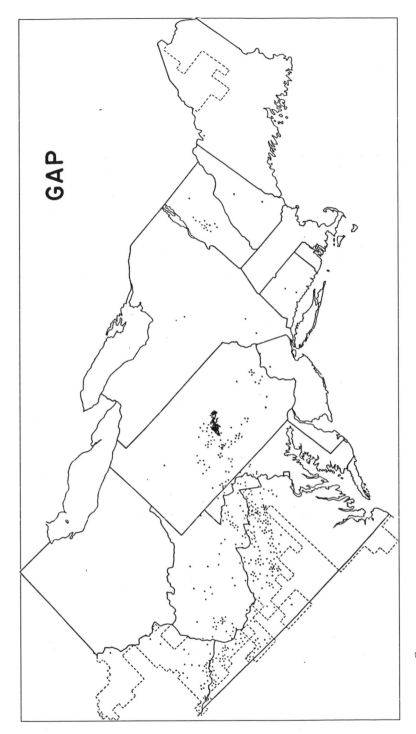

GAP

FIGURE 14 Gap.

Lowland tracts, basins, valleys, and the like have gone nameless in a great majority of the places where they lack strong physical individuality. Since it is difficult to decide which lowland areas merit proper names—outside such obvious candidates as the Appalachian valleys—it is likewise difficult to determine which generic terms are regionalized and which relatively universalized in distribution. An additional complication is created by the widespread habit of regarding stream names as adequate labels for lowland areas, which often are not otherwise designated.[46] Thus it is uncertain whether the three most popular terms—*valley, hollow,* and *bottom*—display any genuine regional concentration. All are abundant in the rougher areas south and west of New England and poorly represented in the latter region. Clearly, a more refined definition of these terms and their relationship to river and pass terms is called for.

Other lesser terms do, however, cluster within more limited ranges. Thus *gorge, gulf,*[47] *glen,*[48] and *gully*[49] are restricted to the northern section of the study area, especially western New York;[50] and *clove,* from the Dutch *klove* or *kloof,* is used for "a rocky cleft or fissure; a gap, ravine" (*NED*) in and near the Catskills. Within the Southern Appalachians the term *cove* is current for a rather uncommon landform, "a recess with precipitous sides in the steep flank of a mountain."[51] A curious distributional puzzle is posed by the term *draft,* which has been adopted for mountain ravines (and also watercourses) in two widely separated tracts: north-central Pennsylvania and an area in the Folded Appalachians along the Virginia–West Virginia boundary between parallels 37° 30′ and 38° 30′—and almost never elsewhere.[52]

VEGETATIONAL FEATURES

One of the more striking peculiarities of American toponymy is the near-absence of generic terms for vegetational features.[53] Such terms in the Northeastern United States as do have any floristic connotations refer primarily to drainage characteristics. Thus the term *swamp* indicates, in general, "a tract of rich soil having a growth of trees or other vegetation, but too moist for cultivation" (*NED*). Although the term has gained almost universal acceptance throughout North America, its greatest concentration appears along and near the Atlantic Seaboard. The etymology and areal source of the word are both obscure. Although it may possibly have been in local use in England around 1600 (*NED*), no documentary proof for this claim has been forthcoming, and the oldest citations yet discovered are in the early colonial records of Virginia.[54]

The widely used English term *meadow* was transferred to the American colonies at an early date but with some change in emphasis, for its American sense is defined as "a low level tract of uncultivated grass land, especially along a river or

in marshy regions near the sea" (*NED*), and the *LANE* states that the "exact meaning varies considerably with the character of the country." At any rate, *meadow*—usually denoting a grassy, often poorly drained tract devoid of trees—failed to penetrate far into the interior of the study area, and today it is found mainly along the Atlantic Seaboard northward of Cape May, New Jersey.

The term *marsh*, like *swamp*, is widely prevalent in the United States, but almost always as a designation for an unforested, water-logged tract, either fresh or salt. Within the study area its primary concentration is in the Chesapeake Bay region. Once again within the Hudson Valley a Dutch term *vly* (or *vlie*) is applied to swamps and marshes. Notable by its absence in the study area is *slough*, a term of wide currency in the Middle West. In southeastern Virginia and thence southwestward along the coastal plain, the Algonquin term *pocosin*[55] is applied to poorly drained interfluves. Within New England and portions of New Jersey and New York fresh or brackish tracts "grown with tufts of grass (hummocks), cranberries, or blueberries, or without any growth" (*LANE*) and too small to be called *swamps* or *marshes* are designated as *bogs*, a usage not too far from the English.

It is interesting to note a few instances of the use of the venerable English term *fen* in Maine and Rhode Island. A rather more perplexing problem is posed by the use of the term *heath* within northeastern Maine (but evidently not in neighboring New Brunswick). The *NED* attributes no particular floral significance to the term, which in Great Britain apparently denotes a flat, rather bleak upland tract with or without heather or some other shrubby growth. In New England *heath* seems to be applied solely to level interfluves covered by cranberries, blueberries, or heather (*LANE*), but field work is needed to establish the precise physical connotations of the word. There is no explanation at hand for its presence in Maine and absence in other American regions.

AGGLOMERATED SETTLEMENTS

If considerable uncertainty surrounds the historical geography of many generic terms describing the relatively immutable physical features of the Northeastern United States, then there is even greater scope for confusion in the study of most terms applied to the cultural landscape. The difficulties are particularly impressive in the study of the class of objects with the most diversified nomenclature—agglomerated settlements: there are great variations in the areal density of towns (fig. 15); the names of individual places often have undergone one or more changes; and, in many cases, the generic element in the name is implicit rather than stated, as in, say, "Brewster," instead of "Brewster Village" or "Brewster City." Thus a fairly exacting study of the distributional significance of various settlement terms would require the drafting of a time series of maps showing the number and location of all instances of a given usage as against the total number of settlements containing explicit generic terms in their names; and some account

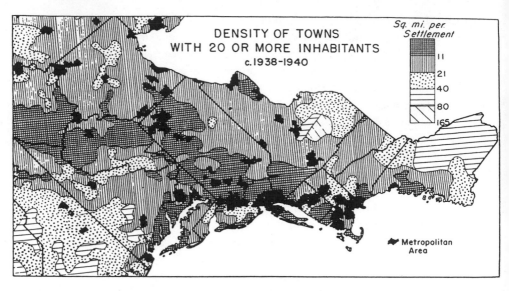

FIGURE 15 Density of towns with twenty or more inhabitants ca. 1938–1940.

would have to be taken of settlement size and morphology—altogether a task of heroic dimensions. Because of this fact, the following statements are merely reasonable guesses.

Certain terms for agglomerated settlements can be safely characterized as universal, *viz.*, *junction, crossing, landing,* and *forge* or *furnace,* as they occur in a large percentage of suitable situations. The suffix -*ton* probably falls into the same category, since there is scarcely a corner of the study area lacking this usage.[56] Another suffix, -*boro* or -*borough,* is much less common but seems to be as widely distributed. The status of -*ville,* perhaps the most popular term for a settlement in the Northeastern United States, is more doubtful (fig. 16). There is a high degree of correlation between the pattern for -*ville* and that for the totality of agglomerated settlements (fig. 15), but the unusually heavy concentration in southeastern Pennsylvania invites further investigation. Another ostensibly universal term is *green,* for some twenty-five occurrences have been recorded in widely scattered portions of the study area.[57]

A clearly regionalized pattern appears in the distribution of *corner* or *corners* in the names of villages (fig. 17), for numerous clusters occur throughout New England, New York, Ohio, northern Pennsylvania, New Jersey, and the Chesapeake Bay region, while almost no examples are found in Kentucky, West Virginia, or southern Pennsylvania. Particularly notable is the strong concentration in south-central Maine. Nothing is known of the history or cultural significance of *corner* except that it is an Americanism entirely unknown in England.[58]

A less complex pattern prevails for another Americanism, *center,* which is distributed widely, though not in vast numbers, throughout the entire northern half of the study area (fig. 18).[59] Although the fact may not help explain the distribu-

-VILLE

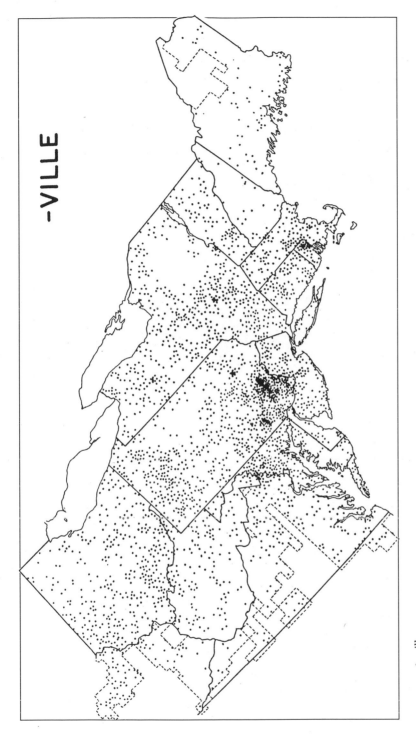

FIGURE 16 -ville.

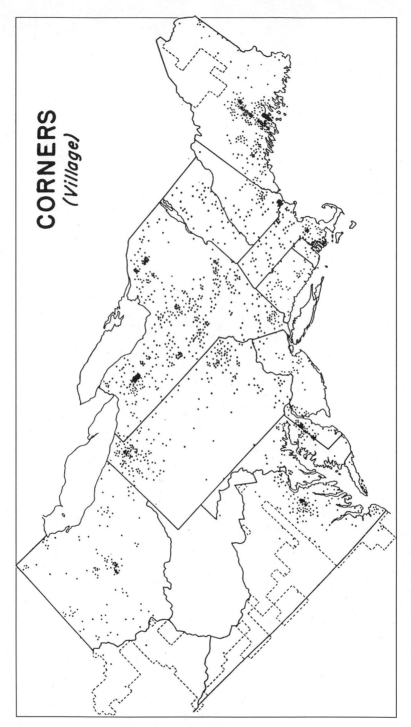

FIGURE 17 Corners (village).

FIGURE 18 Center (village).

tion, it is interesting to note that *center* frequently occurs as the designation for one of a cluster of toponymically related villages. Thus, to quote a fictional example, a "Colchester Center" may lie within a mile or two of "Colchester" which, in turn, is flanked by "North Colchester" and "South Colchester."

Other town terms with essentially New England concentrations are *village* (fig. 19) and *common,* the latter of which is found only in Vermont, Massachusetts, and Rhode Island. In portions of western New York and northern Vermont and Maine the term *settlement* is used for some relatively diffuse groupings of houses, a usage apparently related to frontier conditions.

Two of the most important terms for settlements, -*burg* [60] (fig. 20) and -*town* (fig. 21), occur in nearly all sections of the study area, but for reasons that are not at all clear their major concentrations lie within the central portion. Possibly the essentially urban significance of these terms is more apposite in this region of well-developed urban culture than elsewhere. The term *city* shows an even stronger clustering within the central area (fig. 22). This Americanism [61] is used not only for genuine cities but also as "a grandiose or anticipatory designation for a mere hamlet or village" (*DAE*). In southeastern Pennsylvania, the adjacent part of New Jersey, and southeastern New England there appear a number of villages with the designation *square* in obvious reference to the town square around which the settlement is arranged.

Few generic terms for towns are centered in the southern portion of the study area since settlement is generally sparse and a larger than average proportion of places lack generic elements in their names. The term *crossroads* is one of the few, for even though scattered as far north as Maine and New York, most occurrences are in Tidewater Virginia and Delaware. Within the same Tidewater Virginia region, the term *forks* is attached to many small villages and hamlets situated at road intersections. Because of the wide intervals between genuine towns, the numerous rural stores of the South often take on certain urban functions; and if a small settlement should arise near one, it frequently receives the appellation *store* or *shop* (fig. 23).

HIGHWAYS

Since such phenomena as bridges, wharves, farms, mills, dams, and other areally conspicuous works of man have received universal terms when they have been named by mapmakers, the only important class of artifacts remaining to be discussed is rural highways.[62] Although most of these are designated at the present time only by means of letters and numbers, a variety of generic terms for roads have survived from earlier days or have been recently revived. The most areally restricted is *tote road*, a term for "a rough temporary road for conveying goods to or from a settlement, camp, etc." (*NED*) that occurs only in northern Maine [63] and is documented only as far back as 1862 (*DAE*). The terms *turnpike* [64] and its derivative *pike* [65] obviously refer to the improved toll roads constructed since the

VILLAGE

FIGURE 19 Village.

-BURG

FIGURE 20 -burg.

-TOWN

FIGURE 21 -town.

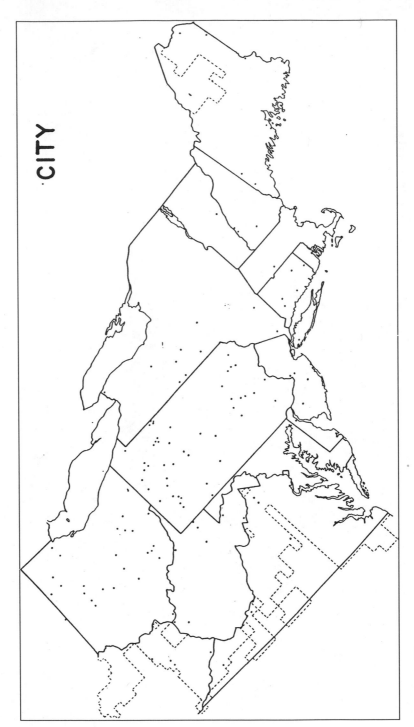

CITY

FIGURE 22 City.

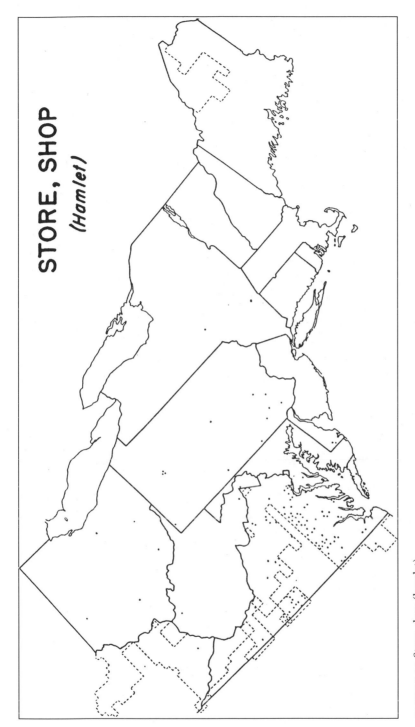

STORE, SHOP
(Hamlet)

FIGURE 23 Store, shop (hamlet).

latter part of the eighteenth century. The contemporary distribution of the terms is markedly uneven: *turnpike* occurs in every state within the study area, but notable concentrations are found only in southeastern New England, the immediate hinterland of Baltimore, and in west-central Ohio; *pike* remains important only in the territory adjoining the Massachusetts–Rhode Island boundary, the Blue Grass region of Kentucky, and western Ohio.

Another group of road terms is current only within the older portions of the Northeastern United States, particularly New England. *Street*, the most important of these, is found in considerable profusion in the rural tracts of Massachusetts and Connecticut and in western New York, an altogether remarkable phenomenon in view of the fact that this relic of the Roman occupation of Britain has long been obsolete in the vernacular of that country.[66] *Avenue*, which has much the same distribution pattern, except for an extension into New Jersey and Maryland, has never been recorded in the sense of a rural road by lexicographers in either Great Britain or the United States. The use of *lane* for rather short public roads extends along the Atlantic Seaboard from New Hampshire to the Potomac and recurs, after a wide gap, in the Blue Grass country of Kentucky (fig. 24). The only definition recorded for England is "a narrow way between hedges or banks" (*NED*); but in this country the *LANE* describes it as a private road and the *DAE* as a Southernism meaning "a road which has a fence on each side." The list of such terms is rounded out by *way*, which occurs infrequently in southeastern New England.

CONCLUSIONS

It is evident from the foregoing series of maps and descriptions that no two of the terms studied have identical or even nearly identical patterns of distribution. This is true not only because of the areal nonequivalence of the various phenomena named, but also because of rapid and often complex linguistic shifts in many terms in a region where migration has been vigorous and settlement so recent that cultural areas have had scant opportunity to crystallize. Nevertheless, it is equally evident that the majority of terms discussed can be sorted into a few rough regional and temporal categories. First, it appears that the Atlantic Seaboard, and especially its New England sector, contains many Anglicisms and archaic terms and that it more closely resembles the home country toponymically than do the interior regions. In areas settled some time after about 1760 (fig. 25) there is an important group of Americanisms and terms with a strong frontier flavor. If one excludes the Dutch terms, which occupy a small but distinctive region, these regionalized groupings may be tabulated as follows.[67]

Old Colonial (Entire Seaboard)

Corner	Marsh (?)	Mill pond
Lane	Meadow	Pond

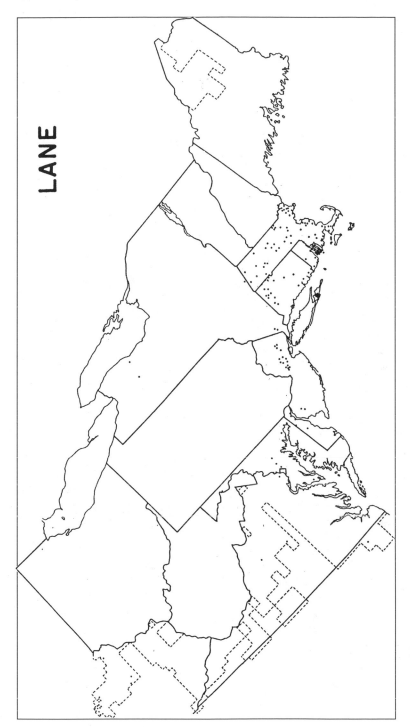

LANE

FIGURE 24 Lane.

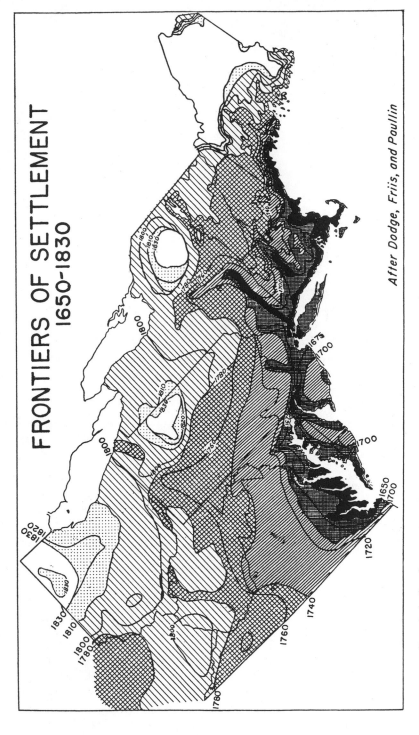

FIGURE 25 Frontiers of settlement 1650–1830.

Avenue	Common	Hill	Street
Bog	Corner	Ledge	Village
Brook	Creek (near	Mount	Way
Center	absence of)		
	Heath	Pond	

Midland

-burg	Square
City	-town
Run	

South

Branch (in non-	Pocoson
tributary sense)	
Crossroads	Swamp (for stream)
Forks (for hamlet)	

Northern Frontier

Center	Flowage	Gully	Notch	Settlement
Cobble	Glen	Inlet	Outlet	Stream
Corner	Gorge	Mount	Pond	Tote road

Southern Frontier[68]

Branch (in non-tributary	Fork (in both tributary and	
sense)	non-tributary senses)	Knob
Cove	Gap	Lick
Draft		Spur

It is tempting to press further and endeavor to establish definite boundaries for culture areas on the basis of place-term distributions; but such an experiment must be deferred because of the inadequacies of the map data and the means for tracing the chronological shifts in the importance and areal extent of the terms.

A variety of research problems are suggested by the provisional data presented here. Most urgent is the need for a series of careful studies of the toponymy of a selected group of communities that will include generic terms, specific names, and vernacular topographic language and will treat these subjects in their full geographic and historical context. In addition, much is to be gained by investigating the historical geography of important individual generic terms over their full North American range. Although abundant documentary materials exist for the study of generic terms in Great Britain, their analysis has been neglected in favor of an exhaustive survey of all individual specific names of the country.[69] If this deficiency were to be remedied, the study of American toponymy could be greatly

advanced. Corollary to such studies, there should be research on the source, rout-
ing, and destination of the settlers of the United States, with particular attention
to the culture and the social psychology of those who were the most active
namers.

Among other unanswered problems is the interaction of differing European
cultures in the United States. Why have no minority cultures except the Dutch
survived in the generic terms of the study area, and specifically why the failure of
German, Swedish, and aboriginal terms?[70] Furthermore, why have these non-
English cultures survived in specific names? And what is the relationship between
specific and generic nomenclature not only as regards cultural survival but also in
a more general sense? A host of interesting linguistic problems with geographic
overtones are offered by generic terms—particularly the process of change in the
meaning of old terms and the invention of new ones in the transfer of settlers
overseas to a relatively similar physical environment and the further changes with
the penetration of the interior. The paramount problem, however, and one that
may never be fully answered, is the nature of the inter-relationships among to-
ponymy, other cultural phenomena, and the physical environment. It is to be
hoped that some way can be found to approach this problem so as to delimit
accurately the past and present culture areas of the nation and to document the
whole marvelously intricate process of cultural evolution.

COMMENT

The recent creation of the computerized Geographic Names Information Sys-
tem by the U.S. Geological Survey makes it feasible now to map with relative ease
all manner of documented generic terms and specific place-names anywhere and
everywhere within the United States. And this is exactly what Jon Campbell (1991)
has done in a fine, truly definitive treatment of generic terms for streams at the
national scale. But I do not regret a single minute spent poring over those great
mounds of topographic quadrangles almost forty years ago: hedonistic drudgery
at its most delectable pitch!

Annals of the Association of American Geographers 45 (1955): 319–349

NOTES

The research reported in this essay was supported, in part, by a grant from the Associa-
tion of American Geographers. Special thanks are also extended to Meredith F. Burrill, U.S.
Department of the Interior, and Hallock F. Raup, Kent State University, from whose critical
attention this work has benefited substantially.

1. All except the most recent materials on the subject are listed in Sealock and Seely
(1948). Much of the more important work is summarized in Stewart (1945) and Mencken
(1947, 1948).

2. Some pioneering essays were written by geographers early in this century, but they failed to stimulate further investigation. The most important of these are Wilson (1900) and Whitbeck (1911).

3. Interesting work along these lines, based chiefly on specific elements in place-names, is reported in Meyer (1945) and Raup and Pounds (1953).

4. West (1954).

5. The most outstanding example is Cassidy (1947), a study based not only on written and cartographic sources but also on painstaking fieldwork. Among the more important studies based largely, if not entirely, on documentary materials are McJimsey (1940), Kenny (1945), and McMullen (1953).

6. The interesting but vexing problem of the relationships between vernacular "topographic" language (using the work in its extended sense) and the generic terms employed in place-names has apparently been left wholly unexplored. A large body of valuable material on vernacular usage is now available in the work of the group headed by Hans Kurath (1939–43 [hereinafter referred to as *LANE*], 1949). The correlation of such material with generic usages in place-names will provide a major research problem in the years to come.

7. Wright (1929: 141).

8. A valuable discussion of the psychology of naming or not naming particular features is found in Stewart (1943).

9. Although sometimes omitted or suppressed in local vernacular usage (McMillan 1949).

10. Much overlap in usage may exist, but in the aggregate the size distinctions implicit in these terms are unmistakable.

11. Kuethe (1935).

12. Because of this universal usage, the term *river* has not been mapped in this study. A problem of some interest is the regional variation in the size of streams to which a given term (*river* among them) may be assigned.

13. But seldom, if ever, are ordinal numbers employed, as in the Far West (Stewart 1939).

14. Kuethe (1935: 258–259).

15. Murray (1883–1928), hereinafter referred to as *NED*.

16. McJimsey (1940).

17. In this map, as in subsequent ones, each dot corresponds to a single occurrence of the usage.

18. Not only within the study area but throughout most of Anglo-America.

19. Kurath (1949: Fig. 93).

20. Although occurrences as far south as Florida can be found (McMullen 1953).

21. The unusually heavy concentration of *brooks* in southern New England in figure 3 is probably as much the result of superior map coverage for that area as of any pronounced areal differential.

22. Kurath (1949: Figs. 18, 93).

23. Murray (1883–1928) and Wright (1898–1905).

24. In this connection the few New England occurrences and those in the Mohawk Valley may be of considerable significance (Hale 1929).

25. The fact that Kurath (1949) notes isolated occurrences of *run* in those portions of eastern North Carolina settled by Scottish immigrants would seem to support such a hypothesis.

26. Also see Kurath (1949: Fig. 93).

27. And throughout the remainder of the Southeastern United States (*Webster's New International Dictionary of the English Language* 1925 [hereinafter referred to as *Webster*]; Schele de Vere 1872).

28. A hypothesis bolstered by the rather late date for the earliest occurrences yet recorded, *viz.*, 1697, in Craigie and Hulbert (1938–44) [hereinafter referred to as *DAE*] and 1721 in McJimsey (1940).

29. Thus supporting *NED*'s contention that *prong* is a Southernism.

30. Hale (1929: 165) mentions the occurrence of *stream* in the Adirondacks without comment.

31. *Webster* equates the term with *brook*.

32. A recent origin is suggested by the dates of the earliest citations: 1747 in McJimsey (1940), 1747 in Mathews (1951), and 1750 in *DAE*.

33. *Tarn, pool, mere, loch*, and *zee* occur, but with great rarity.

34. McMillan (1949: 247).

35. *DAE* records the use of *pond* in 1622; Tyler (1929) in 1644.

36. Figure 10b records only those cases where *lake* is used in a terminal position, but the areal pattern for antecedent cases is much the same. The term *mill pond*, used apparently in the original English sense, is scattered throughout the older portion of the study area, with the largest number of occurrences in the Chesapeake Bay region.

37. Possibly because of the generally uniform size and appearance of hills.

38. *NED* cites *knob* thus; the earliest uses recorded by McJimsey (1940) and *DAE* are 1777 and 1796, respectively. "There is an occasional 'knob' in the Eastern United States, both in the White Mountains and in the Catskills; but the topographical use of this word is decidedly a Southwestern [i.e., South-Central United States] peculiarity" (Whitney 1888: 106–107).

39. Whitney (1888: 109–111).

40. Within the same general area there are numerous cases where *cobble* is used as a quasi-generic term in the specific portion of a place-name.

41. A late origin is likely since the earliest examples in McJimsey (1940) and *DAE* both date from 1737.

42. The only locality in which it seems to outnumber alternative terms is the Adirondacks, according to Hale (1929: 164).

43. Whitney (1888: 135).

44. The earliest citation in *DAE* is 1718, in McJimsey (1940), 1832.

45. McJimsey's (1940) earliest citation is dated 1741, that of *DAE*, 1750.

46. Indeed it is sometimes impossible to judge whether a given term refers to the valley or the stream, e.g., *draft*, for which *DAE* cites both meanings.

47. "Deep and wide, between mountains" (*LANE*).

48. "Small and thickly wooded" (*LANE*); originally a Gaelic term (*NED*).

49. Usually used for valleys containing intermittent streams (*LANE*), possibly an Americanism.

50. Whitney (1888: 157–158).

51. *NED*. The same source also attributes the sense of "gap" or "pass" to *cove* in the United States but is probably incorrect in doing so. The term appears to have originated in the English Lake District (*DAE*; Whitney 1888: 163).

52. Although the term, alternatively spelled *draught*, is not so noted by *NED*, the fact that the earliest citation dates from 1801 suggests the likelihood that it is an Americanism.

53. Wright (1929: 143–144). The only important exception is provided by national and state forests. There are, however, innumerable allusions to plant life in the specific elements of American place-names.

54. *NED*. According to Robert Krapp, as quoted by Gibson (1935), the term was not used in Great Britain because all "swampy" tracts had long since been reclaimed and put under cultivation.

55. Among the several spellings, the chief variants are *poquosin* and *pocoson*.

56. In plotting -*ton* on manuscript maps, a careful distinction was made between towns whose names were formed by the addition of the suffix and those where -*ton* was part of a borrowed name. By this definition "Ironton," for example, would qualify, but "Hamilton" would not.

57. The origin and morphological connotations of the term are obscure inasmuch as none of the dictionaries define *green* in the sense of a settlement, but it is possibly derived from "village green."

58. The earliest citation in *DAE* dates from 1841, but the term was certainly in use long before then.

59. Once again *DAE*'s earliest citation—1791—seems unreasonably recent.

60. The term is unusual etymologically in that it may derive from German, Dutch, and French sources as well as English. It is also interesting to note that it is closely akin to -*boro*.

61. The earliest citation dates from 1747 in New Jersey (*DAE*).

62. Under the rubric of non-material culture some atypical terms for political units, e.g., *town* (for *township*), *borough*, and *hundred*, and for tracts of real estate, e.g., *grant*, *patent*, or *gore*, might logically be discussed, but their distributional traits and the factors controlling them are so special that they merit independent treatment.

63. Except for a single example in the anomalous north-central Pennsylvania region.

64. First recorded in England in 1748 (*NED*) and in the United States in 1785 (*DAE*).

65. Described by *NED* as dialectal, colloquial, and an Americanism; first known adoption in the United States in 1836 (*DAE*).

66. *NED*. This dictionary's definition of *street* as "a paved road, a highway" would seem to apply. Hale's (1929) contention that the term is used as an equivalent for hamlet in certain parts of New York and Connecticut could not be confirmed by a study of the maps of those states.

67. Some terms are recorded as being characteristic of two regions. The term "Midland," used for the central portion of the study area, is borrowed from Kurath (1949).

68. North-central Pennsylvania may be regarded as an outlier of this region.

69. The closest approach to a discussion of British generic terms is found in English Place-Name Society (1924).

70. There are, of course, isolated exceptions, such as *pocoson*, a single case of -*berg* (for mountain in the Pennsylvania German country), and a few *lacs* and *rivières* near the Canadian border. In other parts of the nation Spanish and French terms may locally assume great importance. See Raup (1957) and Hale (1932).

North America's Vernacular Regions

How seriously should the serious geographer take the vernacular, or popular, regions of his country? This breed of areal entities is quite distinct from the more familiar creatures we customarily study. A vernacular region is neither something created by governmental, corporate, or journalistic fiat, nor the scientist's artifact, however sophisticated or otherwise, contrived to serve some specific scholarly or pedagogic purpose.[1] On the contrary, "the vernacular region is the product of the spatial perception of average people," the shared, spontaneous image of territorial reality, local or not so local, hovering in the minds of the untutored.[2]

Until recently, the answer to my initial query, at least in North America, has been: "Not very." While popular regions are granted more than a modicum of respect by scholars in those anciently, persistently settled portions of the Old World where folk culture is a potent social and psychological force frequently reflected in the ways boundaries are drawn and areas administered, we have known and cared about them much less in a younger, more volatile North America. More than likely some students tempted to explore the topic have been deflected by potential allegations of frivolity or cultural slumming. In any event, why bother with phenomena so closely coupled with those relatively old, "folksy" aspects of North American culture surely scheduled for demolition within a society widely described as increasingly standardized, rootless, and even spaceless?[3]

We begin to see reasons for a reversal of this attitude. Quite apart from the sheer thrill of geographic puzzle-solving—and the amusement of the scholarly dilettante—in learning "what is out there," the realization is dawning upon us that popular regions are here to stay, that they are nontrivial in a social-psychological sense, and allied with other potentially momentous developments.

For reasons we are far from fully grasping, a grass-roots form of regionalism has been asserting itself throughout much of the world during recent years (a "regional backlash"?), and may well persist for some decades to come.[4] Fre-

quently, but not invariably, and with or without political prompting, there are connections with a resurrected or synthetic ethnicity. To take only the most boisterous examples, recall recent events in Canada, Great Britain, France, Yugoslavia, Belgium, or Spain. Within the United States, there are unavoidable regional correlates in the Chicano, Puerto Rican, Cajun, Hawaiian, Cuban, and Native American movements, even if they are muted in the case of the Afro-Americans and various ethnic revivals among 3rd or nth generation immigrant stock of European and Asian derivation. As I have argued elsewhere, new, perhaps qualitatively distinctive regions, large and small, and actually or potentially self-aware, have been sprouting of late within this country, chiefly through the spatial sorting out of special-interest, voluntary migrants in quest of compatible physical and social habitats.[5]

We can also find much food for thought in the recent proliferation of regional (and ethnic) periodicals catering to mass markets, the many new regional museums and festivals, and the steady growth of academic, governmental, and popular concern with folklore, a study that is indelibly regional to the core. Linked to all of the foregoing is the burgeoning nostalgia industry (I choose the term with care) in both the commercial and scholarly realms and a vigorous preservationist movement deeply imbued with a sense of place. Furthermore, I suspect that when we have fully decoded whatever it is that has been occurring in North American religion of late, we may find that it too is a component within this interlocking neo-ethnic-regional-nostalgia-preservationist (and environmentalist?) syndrome. Finally, can we ignore the possibility that the recent popularity of perceptual and psychological studies in academic geography may be responding, however obliquely, to these broader currents of change in the popular mind? My contention, then, is that identifying and understanding our vernacular regions is a justifiable, even necessary, pursuit if we wish to apprehend the major social and geographical realities of late twentieth-century America, in addition to whatever intrinsic technical appeal we find in such activity. The question remains, however, as to how best to corner our quarry. Of the two largest hurdles to be surmounted—specifying the particular levels of operational interest within the hierarchy of vernacular regions, and devising the means to collect meaningful, reliable information—the former is much the less troublesome.

In this exploratory study, I have chosen to look at the largest subnational vernacular regions. (I believe we can safely assume that the two national territories, the United States and Canada, lead a dual existence as both political and popular entities with reasonably unequivocal boundaries.) Nested within such higher-order regions are at least three lower strata of areas, with the most atomistic being the little urban neighborhood or, possibly, even the block and the rural valley, cove, or other intimate tract, whether named or not. These smaller items, most of which remain to be mapped and studied, are best examined at the local scale rather than from the continental perspective adopted here.

The difficulties of data procurement can be illustrated by considering the handful of published approaches to America's popular regions. The ideal modus operandi is prolonged immersion in the areas in question and supplementing personal observation and interviews with whatever documents are pertinent. This is the procedure successfully followed by Gary Dunbar in delimiting the popular regions of Virginia and by Robert Crisler in his studies of the Little Dixie region of central Missouri.[6] Rather analogous is the work of E. Joan Wilson Miller in defining the Ozark Culture Region by means of traditional folk materials, although it is not altogether clear to what degree that area is perceived as such by its inhabitants.[7]

Unfortunately, this superior method of firsthand survey cannot be applied to more than one or two states or a few cities during the working lifetime of a single student.[8] The obvious alternative is simply to quiz a sample of the population concerning their awareness of their own or other vernacular regions, using a mail or telephone questionnaire when direct physical access is inconvenient. This technique was adopted in Joseph Brownell's pioneering effort to map the extent of the Middle West by eliciting the opinions of postmasters via a postcard survey.[9] In similar postal fashion, regional consciousness within the various sections of West Virginia has been measured and mapped by Charles Lieble.[10] Much the same sort of exercise has also been performed for Southern Indiana, this time by means of questionnaires administered in college classrooms.[11] Terry Jordan has supplemented a truly encyclopedic acquaintance with his native state in the same manner by extracting responses from students in thirty colleges and universities throughout the Lone Star State to produce a most interesting series of Texas regionalizations as they seem to materialize in the collective popular mind.[12] Clearly the most spatially ambitious of the attempts to recognize vernacular regions through methodical, long-distance interrogation is to be found in Ruth Hale's doctoral dissertation.[13] Postcards posing the question "What name is commonly used to refer to the region(s) of your state in which your county is located?" were dispatched to great numbers of agricultural agents, newspaper editors, and postmasters. Replies were received from no less than 6,800 individuals representing virtually all 3,066 counties in the United States. Exploiting these data, she was able to distinguish some 288 regional entities, many of them quite minute and nearly all below the territorial level aimed for in the present study.

Welcome though the results of such questionnaire-based studies may be, they are, nonetheless, methodologically flawed. In every instance cited above, the persons being questioned were members of an occupational or educational élite, and large segments of the public went unrepresented. Of course, it is feasible, though expensive, to draw an acceptable stratified sample of the general population and to generate a high percentage of responses. Such a procedure (as yet untried) still leaves unsolved an even thornier, probably insuperable, difficulty: the virtual im-

possibility of devising a bias-free questionnaire. And even given the correct wording of questions and proper selection of informants, the very fact of structured confrontation between inquisitor and respondent would almost certainly contribute a significant error to the results of any such social inquiry.

Perhaps the neatest solution to the problems of economizing time and effort and evading the technical boobytraps of questionnaires is to exploit unobtrusive measures of cultural and territorial identity. In a trail-blazing effort of this type, the sociologist John Shelton Reed has recently mapped both the limits and identity of two vernacular regional concepts—the South and Dixie—by calculating the ratio between the incidence of these terms and the term *National* as they appear in telephone directories for selected cities.[14] Inspired by his example, I have shamelessly plagiarized Professor Reed's methodology in the present study, one in which he has barely escaped becoming a coinvestigator.

RESEARCH METHODOLOGY

My procedure is simple in principle, but rather complicated in practice: to ascertain the relative frequency of certain terms appearing in the names of enterprises listed in recent directories for the major cities of the United States and Canada, and to suggest the territorial extent and psychological intensity of the larger, subnational vernacular regions on the basis of these frequencies.

The universe of places studied consists of the central cities of the Standard Metropolitan Statistical Areas of the United States as of 1975 and the Canadian cities of comparable size, i.e., 50,000 or more, 276 localities in all, for which recent (almost entirely 1972 to 1977) telephone directories—or, in four cases (Fitchburg-Leominster, Modesto, Peoria, and Saginaw) only Polk city directories—were accessible.[15] Four nonmetropolitan places were included so that no state or province would go unrepresented, namely: Anchorage, Alaska; Burlington, Vermont; Charlottetown, Prince Edward Island; and Cheyenne, Wyoming.[16] I consulted the directories in various college and municipal libraries, hotels, airports, private homes, and other targets of opportunity, but, above all, in the magnificent Library of Congress collection.

The enterprises whose names were tallied comprise all manner of organized, nongovernmental activity, whether for profit or otherwise, and include retail, wholesale, service, and manufacturing firms, associations, schools, churches, hospitals, places of entertainment, apartment buildings, cemeteries, parks, and a miscellany of other places and activities that happen to be listed in a city directory.

Perhaps the most crucial, and certainly the most difficult, phase of the project was compiling an acceptable checklist of terms. My selection of words with strong locational and cultural content or overtones was based upon: (1) a determination that they occurred often enough in enough different places to merit inclusion, and (2) the judgment that they conveyed interesting information about the conceptual worlds of North Americans at the relatively macroscopic scale of this in-

vestigation (table 1). Although my prime objective was to identify and delimit the grosser vernacular regions—and thus the listing of the more obvious regional and territorial-locational terms—I could not resist the opportunity to include a number of items that are not specifically geographical but which might convey clues to other dimensions of the cultural personality of the two nations and their constituent regions.

I began with the most comprehensive checklist possible of potentially useful terms after browsing through directories for some of our larger cities, consulting the standard compendium of American nicknames, and generally straining my imagination.[17] The result was a roster of well over 400 terms. A series of test trials followed, using directories for widely separated places, a process which eliminated most nominees, but also yielded a few items previously overlooked. After several repetitions of this winnowing action, a point of no return was reached, and a final residuum of 73 terms and their close variants, beyond which additional refinement of the list would have cost too much in time and effort.[18] Nevertheless the experience subsequently gained in tallying terms in the 276 directories did indicate needed improvements in the list if this research is ever to be replicated or updated. I cannot help registering my mild astonishment that such terms as *Appalachian, Caribbean, Creole, Desert, Freedom, Great Lakes, Independence, Liberty, Lone Star, Mayflower, Minute Man, Paradise, Patriot, People's, Plains, Prairie, Progressive, Puritan, Rebel,* and *Yankee* fell by the wayside or recalling my poignant farewells to the likes of *Aloha, Bonanza, Camelot, Eldorado, Eureka, Flamingo, Gopher, Mustang, Quaker, Swanee, Thunderbird, Tivoli, Xanadu,* and other exotica.

In scanning the likely alphabetical loci in a directory and recording the number of occurrences of the given terms, a set of exclusionary rules was observed, all in the interest of ascertaining how many truly local naming decisions—with non-local significance!—were in evidence. They are as follows:

1. The names of governmental agencies were not considered since the affixing of a national, regional, state, or other jurisdictional name is a political decision, not a cultural choice freely arrived at.
2. Personal surnames, such as Atlas, Crown, Holiday, Royal, Sun, or West, were not considered.
3. Duplicated names were counted only once.
4. Branch or local offices of firms or organizations with multiple locations were not counted, only the central office when it could be identified as such. This rule eliminated virtually all citations of transportation and insurance companies, union locals, chain stores, regional and national franchises of all varieties, and greatly reduced the number of times telephone companies, banks, and many national associations were counted.
5. Names that refer to local streets, neighborhoods, or landmarks or to state or local political jurisdictions were omitted. Thus no note was taken of establishments named after a Western Avenue, Northern Boulevard, Eagle Moun-

TABLE 1. *Terms Counted and Analyzed in the Study of Cultural Significance of Names of Metropolitan Enterprises*

Acadia(n)[a]	Mid-America(n)[a]
American[b]	Mid-Atlantic, Middle Atlantic[a]
Apache	Midland
Apollo	Midway
Argo, Argonaut, Argosy	Middle West, Midwest(ern)[a]
Atlantic[a]	Mission
Atlas	Modern(e)
Aztec(a)	Monarch
Canada, Canadian[c]	National, Nationwide[b,c]
Centennial	New England[a]
Central	North American
Century	Northeast(ern)
City(wide)	Northern[a]
Classic	Northland[a]
Coast(al)	North Star
Colonial, Colony	Northwest(ern)[a]
Columbia[b]	Olympia(ic) (U.S.)
Community	Pacific[a]
Continental	Phoenix
Country(side)	Pilgrim
Crown	Pioneer
Delta	Regal, Royal(e)
Dixie[a]	Regency, Regent
Dominion[c]	Southeast(ern)[a]
Downtown(er)	Southern, Southland[a]
Eagle	Southwest(ern)[a]
Eastern[a]	Star
Empire, Imperial	Sun(beam) (light) (shine)
Federal[b]	Sunset
Frontier	Town & Country
Global, Globe	United States, U.S.[b]
Gulf[a]	Universal
Holiday	Victoria
International	Viking
Maple Leaf	Village
Mayfair	Western[a]
Metro(politan)	

[a] Regional term.
[b] National term within U.S.
[c] National term within Canada.

tain, or the like, or the cities of Atlantic City, Columbia, Midland, Phoenix, or Victoria.[19]

Before proceeding to describe and discuss our findings, it may be wise to review the validity of both the premises and the data upon which the analysis depends. As the reader must have surmised several paragraphs ago, the crucial axiom upon which this inquiry rests is that the frequency with which people attach certain names to their enterprises—and the degree to which such names survive—is a relatively sensitive measure of group perceptions of the locus within sociocultural space, and probably along other social and cultural dimensions as well, of the places in question. In other words, the namers, consciously or otherwise, select names with which their clientele can empathize and which should help assure the success of the enterprise in so far as they reflect the inner feelings or aspirations of the local population. There is no direct method to test the validity of this notion, but it is inherently reasonable, and, as we shall see, our empirical results do coincide snugly with the results of other independent investigations in those cases where comparisons are possible.

North American telephone directories constitute a superb source for the names we seek since they list virtually all organized, legal enterprises within a given service territory. But there are several technical difficulties in their use. First, unless the entire directory is searched, we miss those terms that fail to appear at the beginning of a name. Thus, for example, the Canadian Association of Poodle Fanciers would be tallied, but not the Poodle Fanciers of Canada. How much, if any, bias is thereby introduced is unclear; probably very little. Second, the fact that some of the directories encompass most or all of a metropolitan area, while others are limited to a central city, undoubtedly has resulted in uneven coverage from place to place. I can only hope that the bias thus produced is not systematic in character. Third, the set of directories used for this study are not all of the same vintage; but I believe that any temporal bias is minor and, in any case, is randomly distributed over space.[20] Lastly, most of the entries for the metropolises of Québec are in the French language, so that relatively few English-language or bilingual terms were collected for those places, and they may be less diagnostic of regional or cultural identity than one would like.

The selected terms themselves also pose a few problems. Some are ambiguous or polysemous in nature, e.g., *Classic, Community, Delta,* or *Dominion,* and perhaps all carry multiple levels of meaning, so that the interpretation of their popularity must be cautious. Some terms, originally localized in distribution, have transcended their hearth areas, becoming nationalized, so to speak. Thus one may encounter a Dixie Diner, a New England Seafood Restaurant, or a Western Tack Shop just about anywhere in the land. But this fact should be more of a challenge than an annoyance to the student of North American culture. The most serious of the probable flaws in research design, however, has already been mentioned: a

rather arbitrary inclusion of some terms and rejection of other, perhaps equally worthy, candidates. Undoubtedly the most serious source of error in this study is the fallibility of the investigator; there is no telling how many legitimate occurrences of terms have been missed or overcounted or how often the exclusionary rules have been improperly applied. Having confessed these various frailties, what can we learn from the data, shortcomings and all?

THE VERNACULAR REGIONS MAPPED

In a series of seven maps, I have attempted to delimit some fourteen vernacular regions or locational concepts as they are implied by the names of metropolitan enterprises (figs. 1–7). The territories in question are defined as those in which a given term, or a cluster of closely related terms, outnumbers all other regional or locational terms in all, or nearly all, the included metropolitan areas. In addition to the zone in which the specified entity is dominant, in most instances I have also designated a secondary peripheral zone in which it ranks second or third in frequency within the constellation of regional terms. Obviously, I have indulged in a polite cartographic fiction by extrapolating into a two-dimensional space the generalizations drawn from essentially punctiform data. We cannot safely infer from the mind-set of the metropolitan denizens what the regional notions or affiliations of their rural and small-town neighbors might be; we can only speculate.

The South is probably the most populous and sturdiest of our vernacular regions (fig. 1). Metropolises are shown as popularly perceived to be within the South when the combined count of the terms *Southern, Southeast(ern),* and *Dixie,* along with closely related, alphabetically proximal items such as *Southland, Southerner, Southernaire, Dixieland,* and the like account for a plurality of the place's regional terms. It is safe to assume, I believe, that this cluster of terms is convergent in cultural meaning. It is important to note that *Southern* and its terminological ilk are only incidentally locational or latitudinal. The metropolises of the southwestern quadrant of the United States are no further from the equator than the South, essentially a sociocultural rather than a geodetic entity. In fact, Southern terms are totally absent in Honolulu, the southernmost of our metropolises!

The foregoing observation also applies to the terms *Western, Eastern,* and, with much less force, to *Northern* (except in Canada, where, in sharp contrast, *Northern* is saturated with sociocultural connotations, and *Southern* is little more than a direction). We also find that the terms *Northeastern, Northwestern,* and *Southwestern,* as well as *Southeastern,* can carry strong cultural-historical overtones.

The general shape of the South is reassuringly familiar, and the location of its northern and most of its western edge recalls boundaries staked out in earlier studies (fig. 1).[21] There are two rather unexpected details, however. All of Florida,

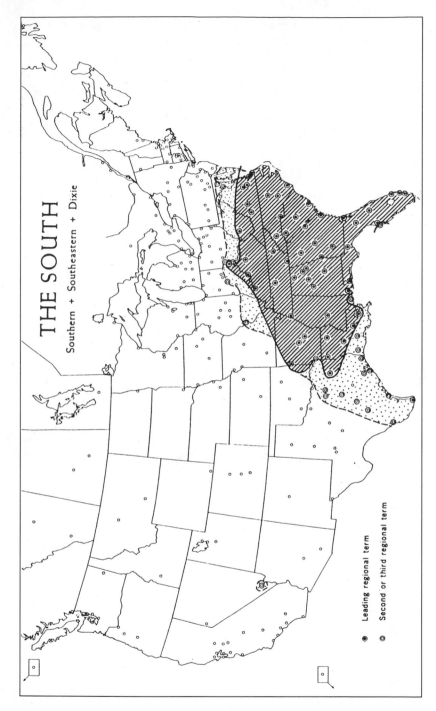

FIGURE 1 The South.

except St. Petersburg, belongs to the South, albeit rather less staunchly than the states to its north; and southern Louisiana and southeastern Texas are only marginally Southern.

We find even less novelty in the bounding of the vernacular Middle West (fig. 2). When the various terms connoting Middle Westernness—*Middle West(ern); MidWest(ern); Mid-American*—are combined, the area of dominance closely simulates earlier regionalizations.[22] It is rather startling, however, to discover that the secondary zone penetrates deeply into Canada's Prairie Provinces and into Colorado and Utah and as far south as Memphis and Fort Smith. The suggestion that Lubbock, Midland, and Odessa, Texas, comprise a diluted outlier of the Middle West would be erroneous. The prevalence of the term *Midwest* in west-central Texas appears to reflect a peculiarly Texan, i.e., state-level, rather than national, framework of spatial orientation.[23]

Of the remaining dozen regions, only three have been depicted on earlier maps: New England, Acadia, and the Middle Atlantic region. The placement of both the primary and secondary zones of New England conforms precisely to a prior regionalization based on other evidence (fig. 3).[24] The location of the Southwest in the same drawing fulfills one's expectations, including as it does large portions of Texas, Oklahoma, New Mexico, and Arizona, with a broad secondary fringe stretching into adjacent states. Once again, note that the most literally southwestern of our metropolises, those in southern California and Hawaii, are far removed from the Southwest's heartland.

I have ventured to assign specific territory to the North American East and West, at least as they may be pinned down by the popular mind (fig. 4). The East (for which there are no prior hints in the literature, as far as I am aware) emerges as a surprisingly small, tight cluster of metropolises, mostly within the southwestern half of Megalopolis, but extending northwest to include Hamilton, Ontario. A large irregular secondary zone reaches all the way from Newfoundland to Alabama. Locationally, the West behaves as one would anticipate. This is the most extensive of our popular regions, embracing as it does a good third of the North American ecumene in its primary phase; and when the peripheral zone is added, it includes more than half of our study area. Perhaps the most striking discovery is the deep eastward invasion—as far as London, Ontario, and Cincinnati—of frequent occurrences of the term *Western* (fig. 4).

Two concepts that are, in a strict sense, perhaps more locational than regional overlap or parallel the East and West—the Atlantic and Pacific regions (fig. 5). For reasons that are far from clear, *Atlantic* usages outnumber other regional terms in only five metropolises in the far northeast of the study area. Spatially detached from the primary zone are two tracts where *Atlantic* is subordinate but significant: virtually the entirety of the Atlantic Coastal Plain from southern New England to Florida; and a curious exclave along the shores of Lake Ontario. The range of *Pacific* occurrences is predictably restricted to the five states and the Canadian province bordering the ocean. Let me suggest that the two isolated patches

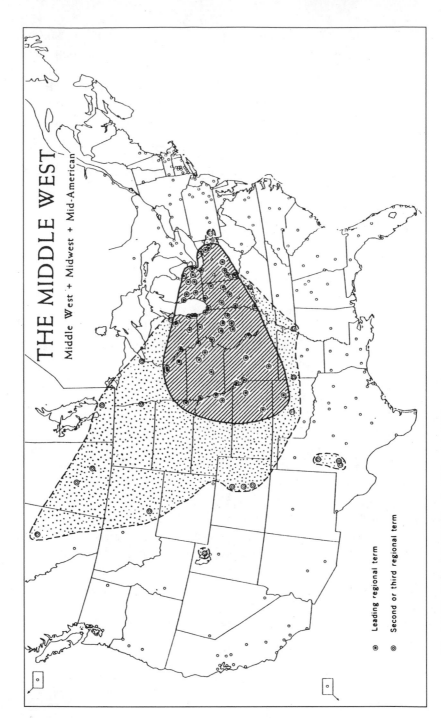

THE MIDDLE WEST

Middle West + Midwest + Mid-American

○ Leading regional term

◉ Second or third regional term

FIGURE 2 The Middle West: *Middle West + Midwest + Mid-American.*

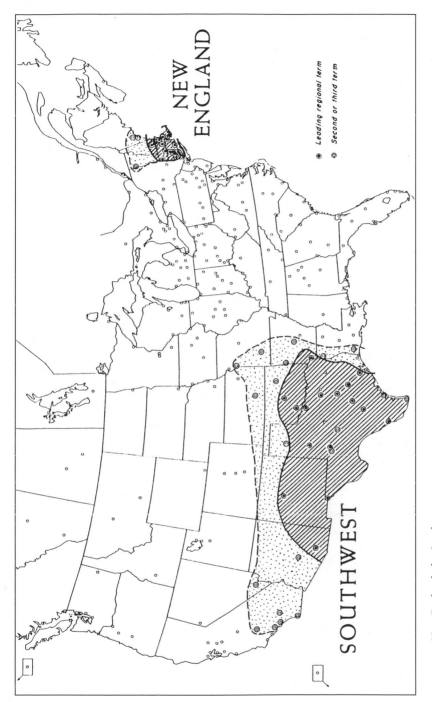

FIGURE 3 New England; the Southwest.

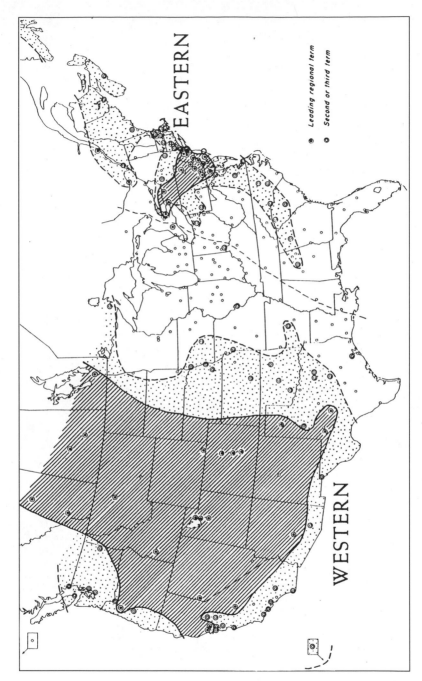

FIGURE 4 The East; the West.

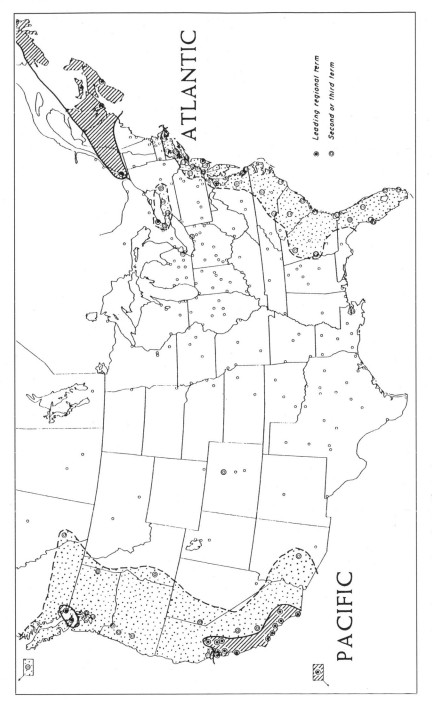

FIGURE 5 The Atlantic Region; the Pacific Region.

of primacy—central and southern California; and Vancouver and Victoria, B.C.—may be synonymous with "The Coast" as it is known in colloquial parlance.

Two of the next three items have never previously seen the cartographic light of day (fig. 6). The regionalization of *Gulf* makes eminently good sense geographically as well as psychologically; but there is reason to wonder about the wedging of the primary North American North into so few places within Ontario, plus the Upper Great Lakes country of the United States—and Anchorage. Latitudinally, many other places qualify as well as, or better than, Green Bay or Saginaw.

By far the weakest and loneliest of our vernacular regions is the Middle Atlantic (fig. 6). The present data add further proof to the contention that, consequential though the Midland region may have been historically and culturally, the regional self-awareness, or articulateness, of its inhabitants has remained quite subdued. Harrisburg, the only metropolis willing to admit a Middle Atlantic allegiance, does indeed lie close to the core of the Midland Culture Area, but at least four other metropolises covered in this study also fall within its boundaries despite the muteness of our onomastic evidence.[25]

Our final three regions offer strong contrasts in territorial extent (fig. 7). Although the core section of the Northwest is limited to portions of Washington, Oregon, and Idaho, its secondary zone embraces an enormous tract from Anchorage to the shores of Lake Michigan. Evidently, the idea of the Northwest, originating in the days of the Old Northwest, has remained alive and strongly competitive with other regional concepts within a broader territory than can be claimed by any of the other three compass diagonals. Thus the popular conception of the Northeast dominates the nomenclature of enterprises in only a half dozen places in the New England and Middle Atlantic states, and is a secondary or tertiary motif in the northeastern sector of Megalopolis. Given the limited range of Acadia as a culture area, the small expanse devoted to *Acadian* is scarcely surprising (fig. 7).[26]

One further regional, or rather a-regional, category imparts an interesting message for which no explanation is at hand (fig. 8). If we arbitrarily define as lacking in regional identity those metropolises in which no single regional term or cluster of closely related terms occurs five or more times, then we can discern a large contiguous tract of regional anonymity extending from central New England across large portions of New York, Pennsylvania, and Ontario into the eastern Middle West. (Only three other places so qualify: Québec; Abilene; and Sherman-Denison.) This no-man's-land is merely the trough of a wider zone in which regional sentiments smolder weakly. Why this apathy toward any regional attachments in this particular area? I can advance no plausible hypothesis for the phenomenon, one which does not disappear even after controlling for size of place. My initial guess, admittedly a desperate one, is that these may be places which happen, for some obscure reason, to be so secure in their social-geographic identity, so self-contained or else so permeated with a sense of "middleness" with

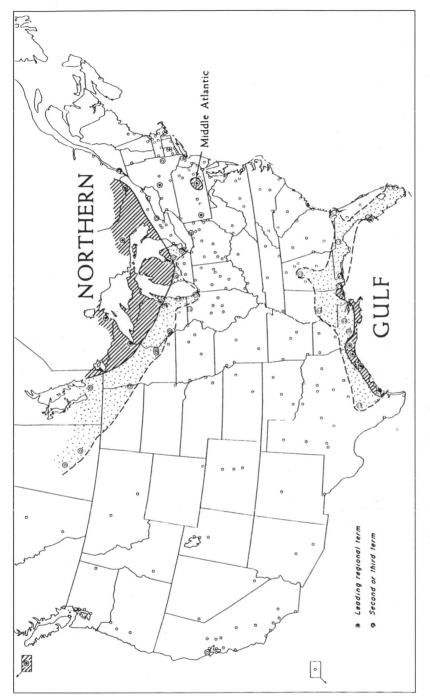

NORTHERN

Middle Atlantic

GULF

◉ Leading regional term
◉ Second or third term

FIGURE 6 The North; the Middle Atlantic Region; the Gulf Region.

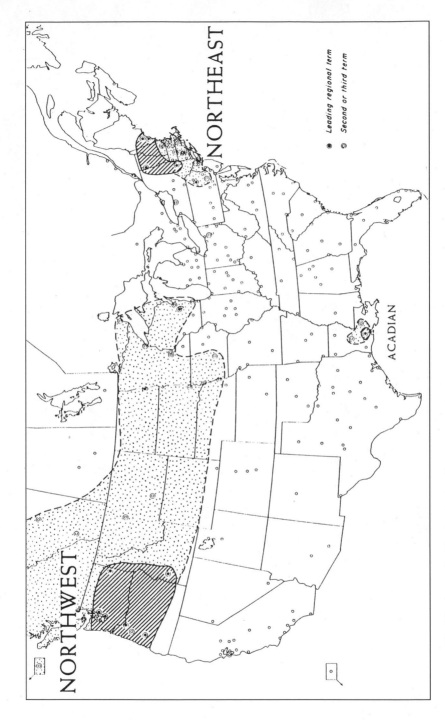

NORTHWEST

NORTHEAST

ACADIAN

• Leading regional term

◎ Second or third term

FIGURE 7 The Northeast; the Northwest; Acadia.

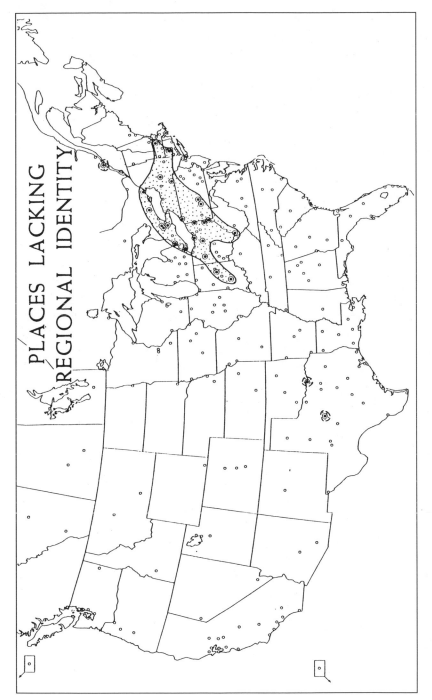

PLACES LACKING
REGIONAL IDENTITY

FIGURE 8 Places lacking regional identity.

respect to other parts of their nations, that they find it pointless to attach regional labels to their activities. Arguing by analogy, why is it that the British, alone among all the nations of the world, do not bother to announce their identity on postage stamps?

All the foregoing maps have been generalized into a single drawing, a summary statement of the vernacular regions of North America (fig. 9). It is necessary to point out that two tracts have been accorded dual memberships, one to both the West and Northwest, the other to the West and Southwest. The data for the six metropolises in question do not admit of any less inelegant solution.

The vernacular region and the culture area are closely related concepts. Both share some common genetic factors, and, by definition, the existence of both is recognized by their inhabitants, even though self-awareness sometimes barely creeps past the threshold of consciousness. Thus the finding that the South, Middle West, and New England as vernacular regions correspond so closely to their delimitation as culture areas by the academic scholar is not unanticipated. Similarly, we have discovered that Acadia and the Midland (or Middle Atlantic area) materialize as cultural entities as well as popular regions, even though less robustly in the latter role. Moreover, it is likely that if the Western, Southwestern, and Northwestern culture areas are ever mapped realistically, their boundaries will not depart too drastically from those set forth here. On the other hand, six of our vernacular regions—the Atlantic, Gulf, North, Northeast, Pacific, and, probably, East—are locational rather than cultural in character, and are unlikely to be duplicated as manifestations of any purely cultural phenomenon. Thus, if required to identify themselves with a culture area, the citizens of Biloxi, Mississippi, for example, would probably respond, "The South," but, if simply asked, "*Where* do you live?" the answer might well be "The Gulf Coast" or some similar locution.

FURTHER INTERPRETATIONS OF THE REGIONAL DATA

In an effort to extract further insights concerning the structuring of popular regions in the North American mind, the data concerning regional terms were subjected to additional arithmetic and cartographic manipulation. The results of comparing the total occurrences of all terms denoting Northernness in each metropolis with those suggesting Southernness fail to startle (fig. 10). The North Extended and the South Extended, each occupying roughly half the study area, and separated by three zones of indifference within which references to either North or South are so few as to be trivial, adjoin each other at or near a median parallel of latitude. The one noteworthy feature on this map is that peninsular tentacle of the Greater South pushing northward all the way across Ohio to Lake Erie scooping up Columbus and Toledo en route. This corridor may well be associated with a heavily traveled commercial and migrational route connecting the Upper South with Toledo and southeastern Michigan.

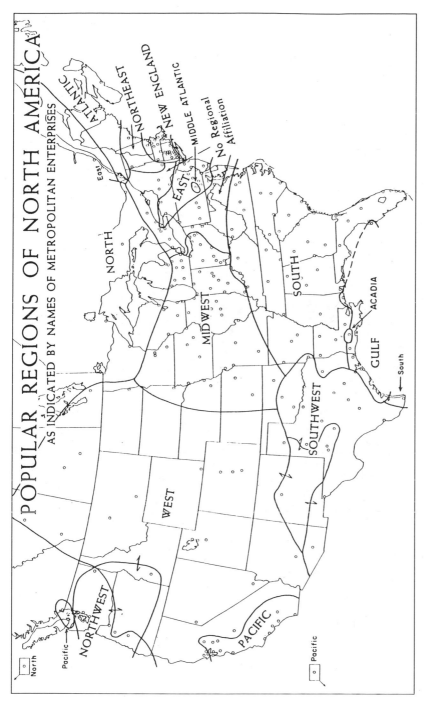

FIGURE 9 The popular regions of North America as indicated by names of metropolitan enterprises.

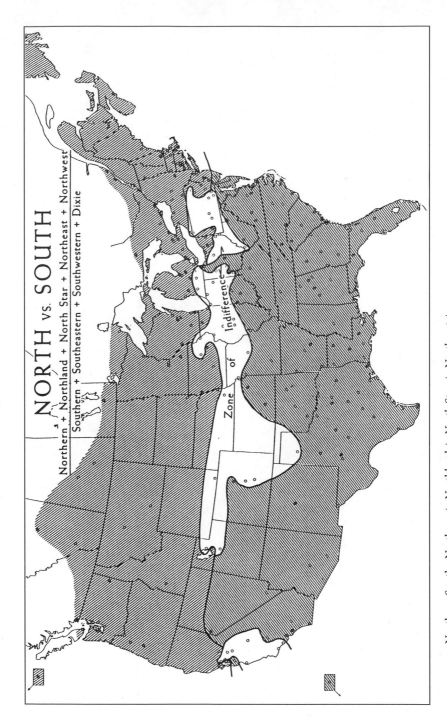

FIGURE 10 North vs. South: *Northern + Northland + North Star + Northeast +
Northwest/Southern + Southeastern + Southwestern + Dixie.*

When this exercise was repeated with terms indicating Westernness and East-ernness, our previous suspicions were amply confirmed (fig. 11). The territory claimed by the Greater West is several times larger than that falling within the Greater East. Moreover, if we were to include *Middle West* and associated terms within the Western set, as one is tempted to do, then that NE–SW-sloping line bounding the two areas would probably be rotated clockwise an appreciable in-terval, while the single blister of indifference in the eastern Middle West might vanish totally. We have here further evidence, if any is still needed, of the extraor-dinary grip of the idea of the West on the North American popular mind. One might also recall that if there is one single term that serves, in both journalistic and popular usage, to label the entire Greater European cultural community, of which North America is, of course, a part, that term is simply, "The West."

Finally, I have attempted to chart variations in the intensity of expressed re-gional feeling (fig. 12). For each metropolis the total number of occurrences of all twenty-five regional terms was summed; the same was done for the remaining forty-eight presumed cultural terms lacking in direct regional significance, in-cluding national and international items; and the regional terms were calculated as a percentage of the total. Although one might challenge the appropriateness of this operation, given the rather arbitrary selection of terms, especially the nonre-gional variety, I am persuaded that the isolines give us at least a rough first ap-proximation of a genuine psychological surface. As previously suggested, regional sentiment is feeblest in a large part of the northeastern United States and adjacent portions of Canada; but low to moderate values extend all the way across the central latitudes of the United States (fig. 8). In expectable contrast, the currents of regional feeling run strongest within the Deep South, where we have the largest grouping of cities with high readings. The only comparable values occur in the Maritimes and neighboring Maine and in the Northwest Extended, tracts contain-ing far fewer metropolises. Perhaps we can draw some inferences from the fact that those corners of the nation are relatively isolated physically and socially and are also most keenly self-conscious about their regional identity.

CONCLUSION

This exploration of the significance of the frequency of selected terms in the names of North American metropolitan enterprises has yielded encouraging re-sults. It has enabled us to identify a plausible set of fourteen relatively large, sub-national vernacular, or popular, regions which mesh reasonably well with a re-lated set of regions—the culture areas of our continent. We have also arrived at a tentative mapping of the geographical variation in the strength of regional feeling. In addition, our data suggest the probability that other valuable clues to the ge-ography of North American society and culture can be distilled from the practices we follow in naming organized activities. But perhaps more than anything else this essay has demonstrated how provisional is our knowledge, and how great our

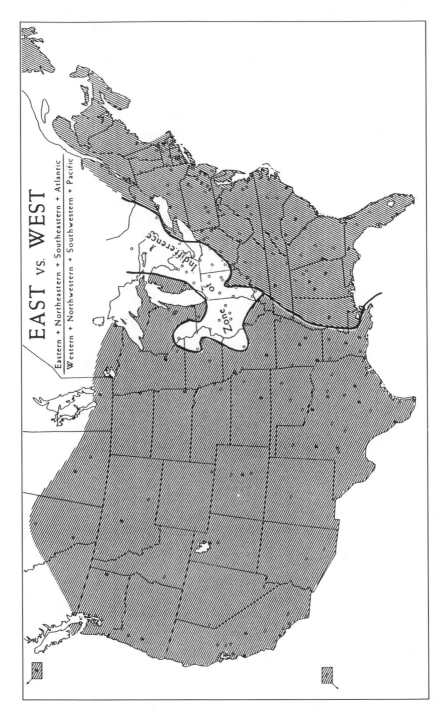

FIGURE 11 East vs. West: *Eastern + Northeastern + Southeastern + Atlantic/Western + Northwestern + Southwestern + Pacific.*

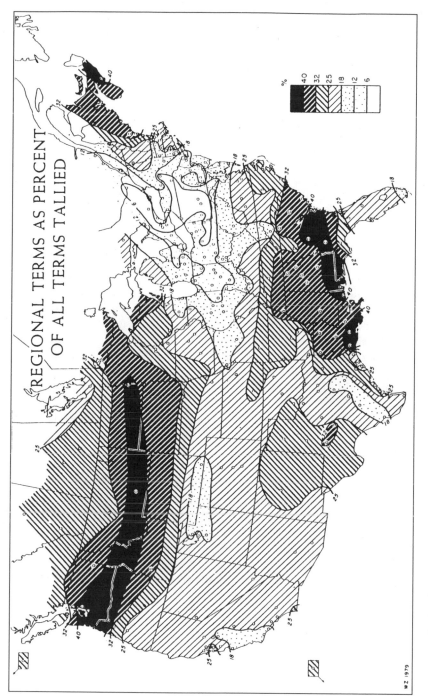

REGIONAL TERMS AS PERCENT OF ALL TERMS TALLIED

FIGURE 12 Regional terms as a percentage of all terms tallied.

ignorance, concerning a topic almost certain to grow in theoretical and practical importance: the nature and meaning of the vernacular regions of late twentieth-century North America.

Annals of the Association of American Geographers 70 (1980): 1–16

NOTES

1. This three-fold classification of geographic regions in terms of origin is suggested by Schwartzberg (1967).

2. The entire definition merits repetition: "Perceptual or vernacular regions are those perceived to exist by their inhabitants and other members of the population at large. They exist as part of popular or folk culture. Rather than being the intellectual creation of the professional geographer, the vernacular region is the product of the spatial perception of average people. Rather than being based on carefully chosen, quantifiable criteria, such regions are composites of the mental maps of the population" (Jordan 1978: 293). The origins of most vernacular regions are obscure or unexplored. It is entirely possible that some are the brainchildren of scholars or other talented individuals that have somehow infiltrated the masses, entering not just the popular culture, but becoming part of folk culture, i.e., materials handed down by oral tradition. We find many instances of this in the realm of folk tales and folk music, e.g., the work of Hans Christian Andersen, Sholom Aleichem, Franz Schubert, Stephen Foster, or W. C. Handy. The same phenomenon seems to have happened with the Corn Belt and the geographically amorphous Bible Belt a generation or two ago and has just afflicted us with those two deplorable terms, the Sun Belt and the Snow Belt.

3. As suggested, for example, in two widely quoted publications (Webber 1964; Toffler 1970: 91–94).

4. Perhaps the most useful introduction to recent trends in ethnicity and associated questions concerning social and territorial identity is Isaacs (1975).

5. Zelinsky (1975).

6. Dunbar (1961), Crisler (1948, 1949).

7. Miller (1968).

8. I cannot leave this style of apprehending regions by way of personal osmosis without noting that a number of geographers, sociologists, and folklorists do approximate the charting and characterization of popular regions, as an incidental by-product or otherwise, in regional investigations based upon a combination of sensitive fieldwork and a thorough digestion of all manner of literature. Among many possible examples, see Meinig (1957, 1969). Similarly, multidimensional exploration of the Pacific Northwest is available in Gastil (1973). At the micro scale, there is the classic study of a Chicago neighborhood by Gerald Suttles (1968).

9. Brownell (1960).

10. Lieble (1974).

11. Good (1976). A similar, but statistically more sophisticated, method was used to produce a map of the larger, popularly perceived regions of the nation in Cox and Zannaras (1973: 171).

12. Jordan (1978).

13. Hale (1971).

14. Reed (1976).

15. For many of our larger metropolitan areas, the practice has been to publish two or more telephone directories, usually one for the central city (and perhaps including the inner suburbs) and one or more for suburban and other outlying areas. In such cases the invariable procedure was to limit my attention to the central city directory or to the directories for the two central cities in SMSAs such as Minneapolis-St. Paul, San Francisco-Oakland, or Tampa-St. Petersburg, because the central city listings are much richer in names of enterprises and the effort to cull duplicated names, a common occurrence, would have been prohibitively time-consuming. I did not consult directories for smaller cities and rural areas because of the enormous effort involved and the relatively meager crop of names to be harvested. Enterprises are relatively infrequent, on a per capita basis, outside the metropolitan areas, and those that do exist are subjected to weak "onomastic pressure," the necessity to adopt a locally unique name. Such pressure is obviously stronger in larger communities and leads to greater inventiveness and range of choices, as well as some remarkable coinages that can make metropolitan name-watching such a joy, as, for example, in the names of restaurants and drinking places.

16. A directory was unavailable for only a single candidate city, Winston-Salem, N.C. The increment of information from a 277th place did not seem great enough to justify an additional journey or waiting for the arrival of a mail order. Mea culpa.

17. Shankle (1955).

18. This final group is patently and deliberately a mixed bag containing terms classifiable into some nine categories: (1) the largest and most important consisting of items referring to regions, physical features, or to compass directions with a variable load of regional meaning; (2) national terms—*American, Canada, Columbia, Dominion, Federal, National, United States*; (3) international terms—*Continental, Global, International, North American, Universal*; (4) temporal and historical terms—*Centennial, Century, Colonial, Frontier, Mission, Pilgrim, Pioneer*; (5) residential terms and those referring to location with respect to the city—*Central, City, Country, Downtown, Metropolitan, Midway, Town & Country, Village*; (6) references to the Classical World— *Apollo, Argo, Atlas, Classic, Olympia, Phoenix*; (7) environmental terms—*Coastal, Star, Sun, Sunset*; (8) two national totems—*Eagle, Maple Leaf*; and (9) miscellaneous abstractions—*Aztec, Crown, Empire, Holiday, Mayfair, Regal, Regency, Victoria, Viking.* This may be as appropriate a point as any to note, with regret, the nonexistence of any useful typologies for the names of enterprises. When and if they are produced, they are likely to resemble the set suggested for place-names in Stewart (1970: xxviii–xxxii).

19. This rule was extremely difficult to apply to occurrences of *Columbia* and *Olympia* in the Pacific Northwest, *Dominion* in Virginia, *Empire* in New York, and similar cases where a term bears both a local and a more general import. I simply used my best judgment. Also quite troublesome were the numerous *Deltas* referring to a deltaic district other than that in the lower Mississippi Valley or to some other implication of the word *Delta.*

20. Unfortunately, it would be extremely difficult, perhaps impossible, to retroject this study to a much earlier date because of the spottiness of archival collections of telephone directories; but an updating twenty or thirty years hence might reveal some useful facts about the nature and pace of sociocultural evolution on this continent.

21. Zelinsky (1973: 118–119), Gastil (1975: 174), Reed (1976).

22. Brownell (1960), Zelinsky (1973: 118–119).
23. Jordan (1977).
24. Zelinsky (1973: 118–119).
25. Glass (1971), Zelinsky (1977).
26. Waddell (1979: viii).

Unearthly Delights

Geosophy . . . is the study of geographical knowledge from any or all points of view. . . . It extends far beyond the core area of scientific geographical knowledge or of geographical knowledge as otherwise systematized by geographers. . . . It covers the geographical ideas, both true and false, of all manner of people—not only geographers, but farmers and fishermen, business executives and poets, novelists and painters, Bedouins and Hottentots—and for this reason it necessarily has to do in large degree with subjective conceptions. —John K. Wright[1]

Americans do not enjoy thinking about death. This dismal truism can be documented by any number of examples, mostly tactics of avoidance. Thus, although funerals and cemeteries represent a robust economic enterprise, hard statistics are difficult to come by, as Jessica Mitford discovered.[2] Cemeteries obviously account for an appreciable fraction of the land surface of the United States, but even the most tentative of percentage figures are unobtainable. Although we can only speculate about the gross number of cemeteries, the total probably falls somewhere between 10,000 and 100,000, depending, in part, on how one defines the term.

This collective national amnesia with respect to a distasteful subject is perhaps best illustrated by the astonishing fact that in virtually none of our planned towns, cities, or suburbs is land set aside for the departed. As William H. Whyte has noted, in discussing our latter-day quasi-utopian urban schemes, "in no new town plan I have seen is there space allotted to a cemetery."[3] Similarly, in few of the many maps and drawings of nineteenth-century American cities that I have recently examined is the cemetery an integral part of the initial plan.[4] When the cemetery did come into being in a plan or in actuality, it was obviously an afterthought.

Even though death is not a favorite topic for the data-gathering organizations of a future-oriented society with scant regard for its past, the dearth of scholarly

interest is nonetheless striking. Economists, sociologists, and geographers have all pointedly shunned the theme of mortality,[5] although it is a commonplace that funerary practices offer some of the most profound insights into the social and psychological structure of cultural groups, past and present. There has been some interesting, but hardly exhaustive, work by art historians and archaeologists on American gravestones,[6] and some landscape architects have considered the design of the more elaborate American cemeteries.[7] But among geographers only Darden, Deane, Francaviglia, Jackson, Kniffen, Knight, Pattison, and Price have written on the cemetery as an element in the cultural landscape, and then only in cursory or introductory essays.[8] Even in the economics of land use, where one might logically expect a sharp focus of geographical interest, attention has been minimal.[9]

MATERIALS AND METHODS

I wish to suggest two productive research strategies for the student of American necrogeography concerned with a fuller understanding of the cultural landscape or with changing geosophical notions. The first is the analysis on a local, regional, and national basis of the spatial patterns of our cemeteries, including size, shape, number, site, situation, and internal design.[10] The second—and the one to be pursued here—exploits the information implicit in the names chosen for our cemeteries. My thesis is that these names are quite literally a legend for a map that has never been drawn—that of the American concept of the afterworld—and that this geosophical design has undergone revision over the past century or more in a manner traceable through toponymic evidence.

Even though most Americans to all appearances have contemplated death and the afterlife only reluctantly, intermittently, usually privately, and—at least until quite recently—hazily, their envisaged abodes for the deceased do have real form and measurable attributes, just as is the case for other mental objects. Moreover, these attributes can be charted by considering cemetery names. Just as future archaeologists could reconstruct the objective American scene with some realism if our place names alone were to survive, so we can piece together, however provisionally, the configuration of the ever-changing eternal resting place of our dead from its nomenclature. And, of course, such an exercise might tell us quite a bit about ourselves and our living world.

The central contention of this essay—that cemetery names meaningfully, if blurredly, convey our collective image of an afterworld—is far from being robust. Methodical analysis is patently impossible until we know a great deal more about two neglected topics: the American cemetery in its major social and geographical contexts, and the social psychology of place-naming in the United States. Thus I offer the assumption as a statement of faith and intuition, one that happens to yield interesting results, rather than as a hypothesis subject to rigorous testing at this time.

In working with this theme, I am beset by two troublesome dualities. The nature of the object being named is ambiguous. The cemetery may be classified either as a this-worldly park, a place of solace and comfort intended primarily for the bereaved, or as a metaphor or working model of the afterlife, a sort of vestibule into the land of the departed and a point of attachment between the here and the there, or as both simultaneously. (Obviously, it may also be an expression of reverence toward the body as the vessel or temple of the soul, from which it is temporarily separated.) Toponymic evidence can be cited to support either interpretation. If I have chosen the second alternative in this essay, it is without any intention of slighting the scholarly potential of treating cemeteries and their names as parts of the living landscape.[11]

Another possible dualistic theme is whether a significant distinction exists between the way namers of cemeteries regard these places (and the afterworld which in my thesis the cemetery epitomizes) and the way their clientele regards them. The American situation contrasts sharply with most Old World experience, for in America a small number of persons were obliged to confer names quickly and self-consciously on all manner of things and places.[12] The problem (echoing the Wrightian phraseology quoted in my epigraph) is whether the unsystematized geographical ideas of persons who were, at least for the moment, "business executives and poets," spontaneously and faithfully reflected the geosophy of the population at large. Or did they foist their own biased notions upon the common herd? A reliable answer awaits more factual evidence than is at hand. In the meantime, I venture my hunch that there was genuine convergence, a give-and-take of attitudes. Thus the careful contrivance of names and the artfully planned physical layout of cemeteries must have colored popular concepts about burial places and the shadowy configuration of an afterworld. But at the same time the name-smiths must have striven diligently to divine the impulses of the popular mind and to chart the channels along which such impulses might be led, just as has been happening with the naming of new automobiles and residential subdivisions. Quite possibly the leaders are leading and being led at the same time.

In the most thoughtful effort to date to categorize American place-names, George R. Stewart has proposed ten classes: descriptive names, association names, possessive names, incident names, commemorative names, commendatory names, coined names, transfer and shift names, folk-etymology names, and mistake names.[13] To this list I suggest adding an eleventh category—projective names, a group abundantly represented among the designations applied to suburbs, subdivisions, cemeteries, and towns platted and promoted by land speculators.[14] Such names are not derived from the history of the locality or the namers, and even if they do happen to describe some aspects of the place in question, such a congruence is accidental as often as not.

The distinctiveness of the projective place-name lies in the fact that it describes either a physical entity which does not yet exist (but may later materialize) or else some fanciful, mentally contrived landscape that can be realized only in the imagi-

nation. It is generally intended to elicit a specific emotional response. The critical attribute is image-mongering, whether inspired by greed or by disinterested idealism.

Not all American cemetery names ought to be characterized as projective. More than half of those listed in the sources used in this study are possessive or locational. Possessive names refer to a municipality or other jurisdiction, church group, and fraternal organization (usually I.O.O.F. or Masons), to an ethnic group (Colored Cemetery, Serbian National Cemetery, German Lutheran Cemetery, for example), or to a founding family or commercial proprietor. The locational cemetery name is simply taken directly from a hill, stream, lake, neighborhood, or landmark feature at or near the burial place. Although there are many borderline cases, such possessive and locational names have been conscientiously excluded, when considering specific names, so that in this essay we are left for most purposes with a group of projective and commemorative names.

Source materials constitute a major problem for the collector of cemetery names. Only two systematic attempts at comprehensive coverage are available; they are for the years 1957 and 1967,[15] and both are restricted to extant cemeteries with business offices, thus excluding countless family plots, other casually managed rural burial grounds, and abandoned graveyards, most of which are unnamed. A more complete inventory could be compiled by scrutinizing the several thousand large-scale topographic quandrangles published by the United States Geological Survey, but such an exercise would require an inordinate amount of (pleasant!) drudgery and would still be incomplete until that far-off day when the final quadrangle has been issued.

The American Cemetery Association's 1967 directory has approximately ten thousand names as against eight thousand in the 1957 list. Because of the obvious qualitative as well as quantitative superiority of the later compilation, I have devoted most of my attention to it. For earlier cemetery names, the most useful source has proved to be the county and city atlases issued in profusion, with lavish pictorial and verbal as well as cartographic material, especially between the years 1865 and 1895.[16] From the magnificent collection of the Division of Maps, Library of Congress, I have been able to identify 703 projective and commemorative names from the late Colonial period through 1910.[17] I made no attempt to collect and tabulate material on the internal nomenclature of cemeteries—that is, the designations of lanes, driveways, specific sections, or other features—since only a small percentage of burial places are so elaborately named.

SOME GENERAL OBSERVATIONS

It will not be possible in this essay to pursue the ultimate geographical implications of the source materials that were consulted. Nonetheless, table 1 provides a statistical footing for what is to follow. The spatial distribution of registered cemeteries as of 1967 was more uneven than that of the living population. An

TABLE 1. *Number of Inhabitants and Cemeteries by State, 1967*

State	Population in 1,000s	Cemeteries[1]	Population: Cemetery Ratio	State	Population in 1,000s	Cemeteries[1]	Population: Cemetery Ratio
Utah	1,022	132	7,742	Missouri	4,587	205	22,376
New Hampshire	691	88	7,852	Indiana	5,012	220	22,782
Iowa	2,772	340	8,153	Wyoming	319	13	24,538
Vermont	420	43	9,767	Kentucky	3,201	122	26,238
Pennsylvania	11,672	1,030	11,332	Florida	6,035	218	27,683
Connecticut	2,913	248	11,766	Arkansas	1,972	71	27,775
Massachusetts	5,434	414	13,126	Michigan	8,608	303	28,409
Idaho	701	52	13,481	New Mexico	1,002	34	29,471
Ohio	10,448	763	13,693	North Carolina	5,059	165	30,661
Montana	699	49	14,265	Texas	10,857	336	32,312
Illinois	10,887	760	14,325	Virginia	4,541	140	32,436
Maine	982	64	15,344	South Carolina	2,638	78	33,821
Oregon	1,981	124	15,976	Washington	3,208	93	34,495
South Dakota	668	41	16,292	Tennessee	3,936	112	35,143
Rhode Island	901	53	17,000	Maryland	3,680	104	35,385
Wisconsin	4,194	246	17,049	Georgia	4,490	120	37,417
New York	18,023	1,024	17,601	Oklahoma	2,516	67	37,552
Colorado	2,012	110	18,291	Alaska	271	7	38,714
California	18,990	1,014	18,738	Arizona	1,637	42	38,976
North Dakota	632	33	19,152	Alabama	3,533	86	41,081
New Jersey	6,981	362	19,285	Mississippi	2,344	57	41,123
Delaware	524	27	19,407	District of Columbia	808	19	42,526
West Virginia	1,807	91	19,857	Louisiana	3,663	75	48,840
Minnesota	3,625	176	20,597	Nevada	438	8	54,750
Nebraska	1,443	66	21,864	Total	197,863	10,147	19,499
Kansas	2,281	102	22,363				

[1]Cemeteries registered in American Cemetery Association, *International Cemetery Directory* (Columbus, Ohio, 1967).

attempt to derive an equation to explain the territorial array of cemeteries at the state level could be quite rewarding. It would have to take into account not only size, density, concentration, and arrangement of population but also longevity of settlement, religious composition, ethnicity, regional culture, terrain, and a variety of economic considerations.

The identity and incidence of three elements of cemetery names are singled out for analysis here: generic terms, the more common specific names, and the referents imbedded in the specific names—that is, the things and qualities in-

voked by the words and affixes used to denote particular cemeteries. But it may be useful to begin by considering the general character of projective cemetery names, which as a group diverge markedly from every other class of American place-names. Several attributes are readily detected. Not too surprisingly, such names are dignified and solemn but not somber. Whimsy, braggadocio, and horseplay—conspicuous elements in many categories of American place-names—are virtually unknown. Indeed, the only two examples of playfulness to come to light are Mount Ever-Rest and Foreverglades Mausoleum, the latter located near Palm Beach, Florida. The term "death" is never used; nor is there any reference to pain, mourning, grief, or other unpleasant sensation. Shadowland and Silent City are the most lugubrious examples I can find, and the word "burial," as part of the generic "burial park" and "burial garden," is the only allusion to interment. So far does euphemism prevail that—as with undertakers' establishments—the uninitiated would have trouble divining the real function of many a burial place, especially the more recent, given no clue but its name. Although the naming process is rarely documented,[18] the namers have obviously pondered carefully the emotional impact and image-building potential of their word choice. In so doing, they severely restricted their environmental frame of reference and forswore many terms frequently applied to other works of man or to natural features.

The result is a euphonious, rather stylized evocation of an idealized habitat for the deceased and the mourners who visit them—and, from a commercial point of view, one likely to melt the sales resistance of the potential purchaser. In essence many of the more elegant projective names are brief prose-poems (mini-*haiku*?), as a few examples should suffice to demonstrate: Green Bower Wildwood Cemetery, Skylawn Memorial Gardens, Green Sanctuary, Lawn Heaven Burial Estates, Ocean View—the Cemetery Beautiful, Chapel of the Chimes, Hills of Eternity, Pleasant Walk Cemetery, Wanderer's Rest, Serenity Gardens, Valhalla Chapel of Memories.

GENERIC TERMS

The prevalence of the term "cemetery" has been so strong among burial grounds bearing explicitly generic terms—96.6 percent before 1914, and 82.4 percent as of 1967—that it might appear at first that little could be learned about the American concept of the afterworld from the choice of such terms (see table 2).[19] As often happens, however, it is the minority that speaks most clearly. The number of generic terms has expanded considerably.[20] Thus the posthumous landscape is more explicitly depicted, and we begin to see it as a grassy, retrospective parkland. Until a half-century ago, only blunt, drab terms such as *cemetery, burial ground, potters field,* and *graveyard* were in use, with Memorial Cemetery appearing only around the turn of the century, and then in California. Today at least thirty-one generic terms are current, and new terms may still be emerging.[21] The

TABLE 2. *Generic Terms in Names of American Cemeteries*[1]

	Pre-1914[2]		1957[3]		1967[4]	
	No.	%	No.	%	No.	%
Cemetery	679	96.6	6,789	84.7	8,323	82.4
Memorial (Memory) Park	2		671	8.4	857	8.5
Memory (Memorial) Gardens	—		239	2.9	486	4.8
Memorial Cemetery	5	0.7	64	0.8	75	0.7
Memorial Park Cemetery	—		53	0.7	57	0.6
Mausoleum	—		34	0.4	55	0.5
Burial Park (Cemetery)	—		5	0.1	39	0.4
Burial (Burying) Ground	13	1.8	34	0.4	34	0.3
Gardens of Memory	—		23	0.3	33	0.3
Crematorium	—		14	0.2	26	0.3
Gardens	—		12	0.2	25	0.2
Chapel (Memorial) (Lawn)	—		6	0.1	14	0.1
(Cemetery)	—		9	0.1	12	0.1
Cemetery Park	—		5	0.1	11	0.1
Park	—		11	0.1	11	0.1
Memorial Estates	—		4		9	
Abbey	—		3		4	
Lawn	—		6		4	
Memorial Chapel	—		3		4	
(Memorial) Shrine	—		2		4	
Burial Gardens	—		1		3	
Churchyard	—		6		3	
Memorial Garden Cemetery	—		5		3	
Sanctuary	—		—		2	
Burial Estates	—		3		1	
Abbey Mausoleum	—		1		1	
Columbarium	—		3		1	
Field	—		—		1	
Plot	—		—		1	
Potters Field	3		1		1	
Graveyard	1		1		—	
Total	703		7,998		10,100	

[1] Excluding those lacking explicit generic terms.
[2] Compiled by author from county and city atlases.
[3] American Cemetery Association, *International Cemetery Directory*, 1957.
[4] American Cemetery Association, *International Cemetery Directory*, 1967.

recent coinages continue to have a euphemistic flavor. Thus Memorial Estates or Gardens of Memory hardly reeks of mortality or suggests the croak of the raven. There is increasing emphasis on memories—pleasurable, one presumes—and on the park-like and edenic nature of the modern burial place. Both trends are merged in the two items that have enjoyed a dramatic increase in popularity in recent years: Memorial (or Memory) Park and Memory (or Memorial) Gardens.[22] There is also a sharp swing toward the use of compound terms such as Memorial Lawn or Lawn Cemetery and a heavy reliance on certain specific and quasi-generic terms that are being rapidly transformed into full-fledged generics—as, for example, *lawn, park, abbey, chapel,* and *rest-haven.* All in all, the terminology of late twentieth-century American cemeteries seems to be in a state of rapid flux; in a few more years this changing vocabulary may provide less equivocal clues to evolving American landscape tastes.

SPECIFIC NAMES

All the specific projective and commemorative names that were recorded ten times or more in 1967 are listed in table 3. As with the stock of generic terms, so too with specific names: a broadening of vocabulary is discernible. The seventy-five items noted in table 3 accounted for 42.4 percent of all those recorded for the nineteenth-century group but only slightly more than one-third of the names of registered cemeteries in 1967. The increased incidence of saints' names may be explained in part by the growth of Roman Catholic and Eastern Orthodox populations; yet many of these names are associated also with Protestant cemeteries. Certain nonhagiographic biblical and theological terms such as Calvary, Holy Cross, Sacred Heart, Mount Olivet, Holy Sepulchre, Trinity, Zion, Mount Sinai, Resurrection, and Mount Lebanon transcend denominational lines, and some secular names, such as Mount Hope and Graceland, likewise have a distinct bouquet of the spiritual. Oddly enough, the most frequent of the pagan allusions is Valhalla. Only one secular personage, Abraham Lincoln, appears in table 3—but in the view of many historians, our sixteenth president underwent the process of canonization almost immediately after his assassination.[23]

Three further aspects of table 3 call for comment before we can take an inventory of the environmental references in the secular specific names. First, there have been some remarkably abrupt changes in naming practice over the past century. Several of the most frequently encountered names among modern cemeteries were unknown in the nineteenth century, among them Sunset, Highland, Hillcrest, Roselawn, Resthaven, Oaklawn, Restlawn, and West Lawn. Moreover, many now-familiar items are encountered only once or twice during the earlier period: Forest Lawn, Mountain View, Grandview, Graceland, Lakeside. In the light of the subsequent discussion, the content of such names will be seen to have more than casual significance.

Second, it appears probable that processes of imitation and diffusion are in-

TABLE 3. *Cemetery Names Most Frequently Used in the United States*

	Number of Occurrences			Number of Occurrences	
	Pre-1914[1]	1967[2]		Pre-1914[1]	1967[2]
St. Mary	15	236	Graceland	2	31
(Mount) Calvary	16	189	Maple Grove	7	31
St. Joseph	11	155	Riverview	4	29
Evergreen	17	136	St. James	1	26
Greenwood	13	109	Holy Sepulchre	2	25
St. John	10	107	Mount Carmel	1	25
Sunset	—	107	Mount Pleasant	9	24
Woodlawn	8	99	St. Francis	—	24
Fairview	7	96	Fairmount	1	23
Riverside	11	93	Lakeside	1	23
St. Patrick	6	81	Woodland	11	22
Oak Hill	7	77	Lincoln	1	21
Highland	—	69	West Lawn	—	20
(Mount) Hope	11	69	Arlington	—	18
Oakwood	9	67	Maple Hill	2	18
Hillcrest	—	65	St. Ann	—	18
St. Peter	1	63	Cedar Hill	2	17
Union	11	61	Oakdale	—	17
Greenlawn	4	56	Chapel Hill	—	16
Holy Cross	1	51	Edgewood	—	15
Mountain View	2	51	Trinity	1	15
Oakland	4	50	Maplewood	—	15
Rose Hill	4	49	Prospect Hill	4	15
Forest Lawn	2	48	Hollywood	2	14
Sacred Heart	1	48	(Mount) Zion	2	14
Oak Grove	10	47	East Lawn	—	13
Elmwood	7	46	Mount Sinai	—	13
Hillside	7	45	Oak Ridge	2	13
Lakeview	8	42	Resurrection	—	13
Roselawn	—	42	Cedar Grove	4	12
Mount Olivet	6	40	Cedar Lawn	2	12
Resthaven	6	40	Green Hills	1	12
St. Michael	1	40	Mount Olive	1	12
Grandview	2	38	Walnut Grove	2	12
Forest Hill(s)	5	36	Mount Lebanon	—	11
Oaklawn	—	34	Valhalla	1	11
Pine Grove	6	34	Lakewood	2	10
Restlawn	—	32	Total	297	3,431

[1]Collected by author from county and city atlases.

[2]American Cemetery Association, *International Cemetery Directory*, 1967.

volved in the naming patterns of modern American cemeteries. The names in table 3 were not reinvented each time they were used but must have been copied from earlier examples. Thus most of the Greenwoods, Forest Lawns, and Arlingtons were inspired by the pioneering enterprises for which they are obviously namesakes. (Why there are so few Mount Auburns is an interesting question. Could it be that the word Auburn simply fails to strike a responsive chord?) Presumably, the initial nineteenth-century naming patterns came from the urban Northeast. During the twentieth century, California and perhaps parts of the South may have become the generators of new ideas.

Third, there appear to be no class or social implications in the names used for American cemeteries, aside from those pertaining to racial, religious, or ethnic affiliation. There may be areal segregation, with the socially and economically superior being interred under more splendid monuments or in mausoleums within larger tracts in more attractive neighborhoods,[24] but the name of the cemetery does not disclose this fact.

PHYSICAL NATURE OF THE AFTERWORLD

Most of the substantive evidence about the physical nature of the American view of the afterworld is given in table 4, a crude content analysis of the specific portions of American cemetery names. The various references are arranged in four classes: floristic, terrain and hydrology, seasonal and meteorological, and other attributes. The most striking general fact emerging from the table is that in visualizing the American afterworld the namers of our public burial places have laid such emphasis on plant life and terrain. Of the 5,742 items tabulated, 4,498, or some 78 percent, are concerned with vegetation and matters of topography and hydrology. The catalogue of omitted topics, including fauna, sound, work, and anything urban, will be noted later.

In the popular imagination—to which, one must assume, these names are peculiarly responsive—paradise is a sedately voluptuous locale whose plant cover and surface configuration are ideally beautiful. The particular items of flora and contour that contribute to such a perfected loveliness merit close scrutiny. This can be done either by field inspection or by the study of names, but more fully perhaps via the latter route. The cemetery may or may not materially deliver the promises implicit in its name. While the oaks, roses, chapel, or view of mountain or brook may be there, often such realization is thwarted by physical or economic circumstance. Thus many a cemetery with crest, view, or -mont in its title is actually quite level—or at least to detect an eminence calls for unusual visual virtuosity—and many a prospect or vista is purely metaphorical. But these are honest, socially acceptable verbal gestures.

The modern American notion of the afterworld is woodland or grassland, or some park-like combination thereof. The nineteenth-century cemetery was emphatically bosky, with the terms *woods, grove, evergreen, forest,* and *sylvan* ac-

TABLE 4. *Landscape References and Other Attributes of Terms Used in American Cemetery Names by Number of Occurrences*

I. Vegetational
a. General Plant Cover

	Pre-1914	1967		Pre-1914	1967
Wood(s)	64	499	Garden(s)	1	11
	37.9%	30.3%	Wildwood	—	10
Lawn	20	491	-hurst	—	9
	11.8	29.8	Meadow	—	9
Grove	50	224	Prairie	—	7
	29.6	13.6	Croft	—	4
Evergreen	17	154	Sylvan	1	4
	10.0	9.4	Desert	—	3
Forest	15	132	Flower	—	2
	8.9	8.0	Glade	—	2
Park	2	56	Green	—	2
	1.2	3.4	Bower	—	1
Floral	—	26	Orchard	—	1
		1.6	Total	170	1,647

b. Specific Plants

	Pre-1914	1967		Pre-1914	1967
Oak	35	348	Olive	2	19
Burr oak	—	4	Magnolia	—	16
Knotty oak	—	1	Fern	2	13
Live oak	—	3	Willow	1	12
Shrub oak	—	1	Chestnut	2	11
All oak	35	357	Locust	1	11
	34.1%	34.5%	Cypress	2	9
Rose	6	140	Acacia	—	7
	5.8	13.4	Beech	1	7
Maple	10	96	Ash	—	6
	9.7	9.2	Hazel	—	4
Pine	10	83	Ivy	—	4
	9.7	8.0	Linden	1	4
Elm	8	68	Palm	—	4
	7.8	6.5	Cherry	—	3
Cedar	8	60	Clover	—	3
	7.8	5.8	Fir	—	3
Laurel	5	36	Myrtle	—	3
	4.9	3.5	Woodbine	—	3
Walnut	5	24	Aspen	1	2
	4.9	2.3	Birch	—	2
Holly	3	19	Cottonwood	—	2

(*Continued*)

TABLE 4. (*Continued*)

b. Specific Plants (*Continued*)

	Pre-1914	1967		Pre-1914	1967
Orange	—	2			
Vine	—	2	Dogwood	—	1
Acorn	—	1	Grapevine	—	1
Alder	1	1	Hawthorn	—	1
Arbor Vitae	—	1	Juniper	—	1
Arbutus	—	1	Palmetto	—	1
Azalea	—	1	Pecan	—	1
Berry	—	1	Redwood	—	1
Boxwood	—	1	Sycamore	1	1
Bush	—	1	Violet	—	1
Cane	—	1	Total	105	1,053

II. Terrain and Hydrology

	Pre-1914	1967		Pre-1914	1967
Hill(s)	53	458	Edge	—	15
	34.4%	25.3%	Mound	3	14
View	25	380	Vale	1	11
	16.2	21.0	Bay	1	10
River	15	129	Knoll	—	10
	9.7	7.1	Cliff	—	6
Crest	—	113	Ocean	—	6
		6.2	Bluff	1	5
Lake	10	87	Sea	—	5
	6.5	4.8	Vista	—	5
Glen	6	76	Mere	—	4
	3.9	4.2	Rock	1	4
Dale	9	71	Summit	—	4
	5.8	3.9	Hilltop	—	3
-mont	4	70	Fountain	—	3
	2.6	3.9	Rolling	2	3
Highland	—	69	Terrace	—	3
		3.8	Overlook	—	2
Ridge	3	64	Slope	—	2
	1.9	3.5	Cove	—	1
Mountain	5	57	Dell	1	1
	3.2	3.1	Den	1	—
Valley	2	37	Falls	—	1
	1.3	2.0	Holm	—	1
Brook	5	29	Pond	1	—
	3.2	1.6	Shore	—	1
Crown	1	19	Spring	1	—
	0.6	1.0	Total	154	1,810

TABLE 4. (*Continued*)

III. Atmosphere, Season, Time of Day

	Pre-1914	1967		Pre-1914	1967
Sunset	—	116	Angelus	—	1
Spring	6	36	Clear	—	1
Sunny	—	19	Northern Lights	—	1
Sky	—	7	Rainbow	—	1
Morning	—	6	Shadow	—	1
Shady	—	6	Total	6	199
Sunrise	—	4			

IV. Other Attributes

a. Color			b. Compass Direction		
Green	24	228	West	6	60
Silver	1	25	East	1	41
Golden	—	3	North	5	19
White	—	3	South	3	15
Violet	—	2	Total	15	135
Blue	—	1			
Ebony	—	1			
Emerald	—	1			
Total	25	244			

c. Miscellaneous Attributes

Fair	8	144	Harmony	1	7
Rest	2	110	Harbor	—	4
Hope	11	78	Paradise	—	4
Haven	1	71	Faith	—	2
Pleasant	10	55	Repose	—	2
Grace	1	38	Serenity	—	2
Grand	2	38	Silent	—	2
Home	5	27	Celestial	—	1
Peace	2	23	Concord	1	1
Bel, belle	—	13	Elysian	—	1
Resurrection	—	13	Modern	—	1
Memory	—	11	Providence	—	1
Eden	—	10	Total	46	667
Eternal, eternity	—	8			

counting for 86 percent of the references to general plant cover. Although the sylvan element is still quite powerful within the current scene, many new cemetery names suggest a much more open landscape. The terms *meadow, prairie, gardens, floral,* and *park* have been coming into vogue. But most impressive has been the widespread adoption of the term *lawn* (never grass or grassy, although a few clovers do appear).

Throughout their history, Americans have been undecided about whether a wooded (and fenced) landscape is preferable to an open grassy (unfenced) sward for residential and other pleasurable purposes.[25] Current cemetery design, responsive to changing tides of fashion, has swung strongly toward the open option, but the swing is hardly irreversible. Indeed, the compromise solution of a park—the interspersion of trees and shrubbery with open lawn and flower bed and the creation of a humanized middle landscape—persists in imaginative literature[26] as well as in toponymy and actual landscape design.

The identity of the plants that are singled out, or ignored, in cemetery names tells us much but also raises more questions than can be answered. In essence, the problem is the degree to which the frequency of plant names in cemetery names matches that of the floristic world of the namers as they experienced it. There are three types of deficiency in our store of facts. First, we know too little about the absolute or relative frequency of various plants in the places inhabited or frequented by the namers of cemeteries, early or recent. The difficulty is compounded by the fact that major alterations of plant cover have occurred almost everywhere in the nation over the past two centuries. Second, we know even less about the flora as perceived: of which plants, wild or domesticated, did the names take particular notice, and to what extent were they able to distinguish one species or genus from another? And, last, what are the psychological connotations of the perceived items, more especially, what are the overtones, good, bad, or indifferent, of the names of such plants?

The term *oak* predominates now as in the past, outnumbering its nearest rival, the maple, by almost four to one, and accounting for more than a third of all plant references. This may simply reflect the high incidence of the genus *Quercus* in much of the countryside. But the oak also symbolizes strength and endurance, and hence immortality; and the word *oak* carries no double meanings. The maple also has no negative attributes, except a much more limited territorial distribution, and it has the distinction of being spectacularly prominent in the symbolically significant autumnal season. Among the other large, areally extensive deciduous species, only the walnut and chestnut are well represented in table 4, perhaps even over-represented in the case of the chestnut. The rarity or non-incidence of birch, beech, poplar, basswood, gum, locust, or tulip may be explained by restricted range, alien origin, untoward verbal or physical connotation, or some combination thereof. The stately elm is reasonably popular, as might be expected in view of its wide range and lack of derogatory verbal overtones. It is difficult to account for the total absence of the geographically widespread hickory,

a tree with many of the same connotations as the oak. Perhaps its relative rarity within urban areas is part of the explanation. The single occurrence of the noble sycamore might be explained by the pun unfortunately implicit in the name. One would also have anticipated greater use of the term *willow*, since it has been so conspicuous in the iconography of American gravestones and in funerary literature. But this may be a case of avoiding any suggestion of mortality in matters nomenclatural.

A different negative effect may operate for the most popular of evergreen items—the pine—since the verb "to pine" projects an undesirable mood. Consequently, though the genus *Pinus* is as far-flung and as visible as the oak, it is less favored toponymically. The cedar and holly are amply represented within the evergreen category, the cedar possibly because of scriptural allusions. I was surprised to discover so few cypresses, firs, and junipers, and nary a spruce, larch, or hemlock. Such floristic imbalance may simply bespeak botanical unsophistication on the part of the many Americans to whom all conifers or evergreens are some sort of pine tree. In addition, the toxic reputation of the hemlock may have further weakened its chances. The absence of the yew is noteworthy also, for, although the word has an ambiguous sound (ewe? you?) and the plant some pagan connotations, it is one of the principal ornamental shrubs in our cemeteries and has been of special significance in British churchyards.[27]

Trees are much more prominent in the landscape of the American afterworld than are smaller plants, with the major exception of the rose and the minor exception of the fern. The number of allusions to ivy, clover, woodbine, azalea, boxwood, violet, and similar items (the laurel can be classed as either tree or shrub) ranges from one to four. Among arboreal names, fruit trees receive rather short shrift, with only the olive, orange, and (perhaps) the cherry being noted.

Thus the composite plant cover indicated by cemetery names may be either a natural or a humanized one. In either case it resembles only vaguely most actual landscapes outside the cemetery gates, and even within those grounds the match between name and actuality is far from perfect.[28]

A comparison of the frequency of reference to particular plants in the two periods shown in table 4 reflects a basic stability in pattern. The enduring popularity of the top seven trees—the oak, maple, pine, elm, cedar, laurel, and walnut—is impressive; but there has also been a dramatic rise in the popularity of the rose, a shrub that thrives best in open, sunny sites. If the list of floristic items has greatly lengthened in recent years, this is a consequence of the increased number of cemeteries and, in part, of relatively greater population growth in localities with such exotic flora as the magnolia, acacia, and palm.

Something of the same stability may be found in the surface configuration of the American vision of the afterworld. This vision has been, and still is, of a land of rolling hills and highlands, replete with ridges, crests, and knolls and the occasional cliff or bluff, punctuated by valleys, dales, and glens (but nary a bottom or hollow, except for Sleepy Hollow), and by rivers, brooks, and lakes (but hardly

any ponds), with distant glimpses of mountain and sea. Evidently there is no room in the stately lexicon of the afterworld for such prosaic, slightly vulgar terms as *creek* or *branch*. Sloping land seems to prevail universally, for references to level terrain are almost nonexistent. It is a land of powerfully visual orientation, almost always with some striking feature to be viewed. Although the precise terminology may change, with the advent of *crest*, *highland*, and *vista*, the basic design is unaltered. The recent popularity of *edge* conveys an ambiguous message, for it may refer to the border between grass and grove or to the lip of an upland prominence.

Remarkably little attention is given to weather, season, or time of day in nineteenth-century cemetery names; the six occurrences of spring are the only pertinent examples. By 1967, however, there was much greater awareness of such phenomena. Spring has grown in popularity, and a few analogues have appeared: morning, sunrise, and resurrection. The sky is being noticed, and it is clear and sunny. The most arresting development, however, is the recent trend toward the adoption of sunset (as an anaesthetic euphemism for death?), a fact that makes the total absence of any reference to the analogous autumn seem illogical and puzzling.

Among the other items and attributes embedded in cemetery names, two are of special geographic interest: hue and compass direction. Green was the solitary color honored in nineteenth-century cemetery names, and the situation had changed but slightly by 1967, when 228 of 244 color references were to green, the others being to such exotic items as silver, golden, violet, and emerald. There is no mention of black and only three of white. The evolution of the directional references is fascinating.[29] The few from the earlier period appear to be almost randomly distributed, but the 1967 data display a strong predilection for west and east. The pervasive valedictory and resurrectional themes of sunset and sunrise, of death as a long winter sleep from which we shall eventually arise, manifest themselves once again.

The final section of table 4 is concerned with a miscellany of attributes that cannot be assigned to a single category. But excluding the term *fair*, the equally unspecific *hope*, and the expected allusions to Eden and Paradise, two general themes seem to emerge: refuge and tranquility. Thus the afterworld vision is that of a relaxed haven, home, or harbor, one that is pleasant and filled with grace, the seat of harmony, peace, and rest.

Many items are missing from the American view of the afterworld. The lack of several important plants, of autumn, of a great part of the color spectrum, and of numerous other items has already been noted, but there are other voids too. Thus it is a land totally bereft of fauna; a single reference to elk may or may not be locational. The avoidance of mammals may be explicable; yet, given the symbolic import of the dove or of bird song in general as the embodiment of dawn, spring, hope, and the cyclical continuity of life, several birds' names would surely be fitting. It is an utterly rural domain; the only urban reference I have come across is the poetic Silent City, and the only edifices are the occasional *abbey*, *chapel*,

monument, and *tower*, which are as much at home in the countryside as anywhere. It is highly—and so uncharacteristically for America—nonquantitative in character: Second Home seems to be the only name with any numerical content at all. Nor is size especially valued (another arrantly un-American feature!). The only adjective encountered denoting size is grand, a word having many connotations other than magnitude.

It is, moreover, a land where all the senses but the visual are numb. There is neither sound nor music, except that of chimes; the birds do not sing, and no wind blows. Neither is there mention of anything tactile or olfactory or of food or drink. It is a timeless place without a history. The term *modern* occurs but once, while such designations as *twentieth-century* or *progressive*, which are quite popular among other business enterprises, are totally unknown. Allusions to major events or celebrities are virtually nonexistent. There is a paucity of literary allusions (except for the biblical and for a few Sleepy Hollows). And, finally, it is a land of intense inactivity, where the only industry is remembering. There is absolutely no toponymic evidence for any form of work or play.

THE CHANGING MAP OF THE AFTERWORLD

This, then, is what the evidence of place-names reveals about the envisaged landscape of the American afterworld. It is an elliptical tract of rolling hills and indeterminate size, one that stretches far toward the west and east, but is quite narrow along its north-south axis, and is surrounded at some distance by water and high mountains. It is a monochromatic, evergreen, featuristic land of perpetual spring morning or evening lying under a cloudless, windless, sunny sky, but where brooks and fountains flow nonetheless, and trees, flowering shrubs, and grassy lawns thrive in a park-like ensemble, yet without any animal life. It is a rural place of intense tranquility and silence, where nothing goes on except the enjoyment of the view and reposeful recollection. Concerning the inhabitants of this territory our blurred map legend has nothing to say.

Although the afterworld is usually envisioned as eternal and fixed, our onomastic evidence has been changing over the past hundred years or so and, judging from a perusal of current telephone directories, may well be undergoing revision more rapidly now than ever before. The earlier copies of the map for what is veritably a *terra incognita* are disappointingly fragmentary, but a few scattered conclusions of a geosophical character can be drawn about the kinds of editing this subconscious collective doodle has been undergoing. Our newer versions show a grassier land and one no longer directionless but oriented from west to east, a land much more thickly planted with roses and one where a population of the dead that may have been previously unemployed is now busily engaged in gazing outward and remembering. But, old or new, the American view of the afterworld as expressed by cemetery names is that of an ideal realm far removed from the workaday world of the living. It would be difficult to imagine a greater

contrast than that between the gritty actuality of a hurried, disordered land and the calm visual harmony of our posthumous aspirations. Which is the more real?

COMMENT

The wishful thinking about the research potential of the cemeteries appearing on the U.S. Geological Survey's topographic series is no longer wishful. With the production of the agency's Geographic Names Information System, major analytical feats are within reach. For a rudimentary beginning, see my "Gathering Places for America's Dead," reprinted in this volume.

Martin J. Bowden and David Lowenthal, eds. (1975), *Geographies of the Mind: Essays in Historical Geosophy in Honor of John K. Wright* (New York: Oxford University Press), pp. 171–195

NOTES

1. Wright (1966: 83).

2. Mitford (1963). The fact that public discussion of death generates distinct feelings of discomfort in most Americans has been further brought home to me by audience reactions when this paper was twice presented in an abridged oral version. I was surprised at the amount of nervous laughter, often at quite inappropriate points.

3. Whyte (1968: 240). Interestingly enough, once cemeteries have become well established, they tend to serve as refuges for the wild or nearly wild fauna of the vicinity and important sites for individual and social recreation. The social and natural ecology of Boston's cemeteries is discussed sympathetically in Thomas and Dixon (1973).

4. For a splendid anthology of such early depictions of the American city, consult Reps (1965).

5. Three pioneering, but still isolated, efforts in these directions are Kephart (1950), Warner (1959: 280–320), and Florin (1971). The possible utility of cemetery data in analyzing social structure is briefly explored in Young (1960).

6. Notably Ludwig (1966) and Dethlefsen and Deetz (1966, 1967).

7. Reps (1965: 325–331).

8. Darden (1972), Deane (1969), Francaviglia (1971), Jackson (1967–68), Kniffen (1967), Knight (1973), and Price (1966).

9. The most substantial works in this genre are Pattison (1955) and Hardwick, Claus, and Rothwell (1971).

10. The single most important resource for such a study is the Geological Survey's ongoing series of large-scale topographic quadrangles. Some notion of the magnitude of an all-out effort may be gained from the fact that many 7½ minute sheets contain fifty or more cemeteries of one sort or another.

11. It is also feasible to treat the cemetery as an evolutionary phenomenon, to distinguish between the "living" and the "dead" cemetery, a theme perceptively developed by Warner (1959: 318–320). In the former case, the cemetery enjoys a lively duality, for it not only

serves as a repository for the dead but as long as it "is being filled with a fresh stream of the recently dead it stays symbolically a live and vital emblem telling the living of the meaning of life and death" (Warner 1959: 319). But when the community has ceased to bury its dead in a given graveyard, and it no longer provides visual and moral balm to the mourner, the place becomes truly dead and recedes into the realm of the historic. Personal memories are extinguished, and the cemetery ceases to serve as an instrument for reconciling the living to the unutterable mysteries of mortality. See also Knight (1973).

12. The most useful and penetrating accounts of this process are Stewart (1958, 1970).

13. Stewart (1970: xxviii–xxxii).

14. Admittedly, Stewart's (1970) commendatory names and the proposed new class of projective names do overlap to a substantial degree, but there is a basic difference between the two groups. The element of puffery, which is basic to the commendatory, may be missing from the projective, since the image contrived by the projective name may or may not be laudatory. Thus, for example, *Sunset Lane Cemetery* is not noticeably commendatory but is projective. Perhaps another, more inclusive, class is needed to embrace both types of names.

15. American Cemetery Association (1957, 1967). These directories include municipal, church-related, fraternal, and ethnic cemeteries as well as commercial enterprises. The main criterion is whether the cemetery is operated in a business-like fashion with an office and manager. The feasibility of using telephone directories as primary sources was investigated, but the listings are less exhaustive than those of the A.C.A. The telephone directory entries do, however, have one incidental virtue of more than passing interest: the paid advertisement and its content. (I am still totally baffled by the Celestial Memory Gardens of Columbia, S.C., which proclaims itself a "Freedom of Choice Cemetery.")

16. A good description of this exuberant source of local geographical information is available in Thrower (1961). There is strong regional bias in the areal distribution of these atlases, for they were particularly abundant in the Northeast (most of the counties of New York, Ohio, and Pennsylvania, for example, are covered quite handsomely), but rare for most of the Southern and Western states. There were few cemeteries to be mapped in the western half of the country before 1900; but in the South, where there must have been many, publication of what was basically a vanity press item was inhibited by shortages of funding.

17. Only rough conjecture can be ventured regarding the early nomenclature of American burial places pending the writing of the first comprehensive study of our funerary practices. My impression is that the cemetery was seldom given a name of its own before the early 1800s; it simply shared the name of the church, ethnic group, family, town, or city with which it was associated.

18. Two brief accounts are available. "When a question of a name for the proposed institution came up for consideration, various candidates for the honor were presented. . . . They fixed upon the pleasing and unpretending name which it bears, as appropriate to the wood crowned heights, and as indicating that it should always remain a scene of rural quiet, and beauty, and leafness, and verdure" (Cleaveland 1866: 14). "The natural topography of the grounds is admitted by all to be peculiarly beautiful—the gentle undulations, and the grove over the entire subdivision, having suggested the name of 'Graceland'" (*Charter of the Graceland Cemetery* 1861: 6).

19. Because of the great numerical disparity between the two sets of data, this compari-

son between pre-1914 and 1967 values must be taken with much caution. The same skeptical observation applies to all subsequent diachronic statements in this essay.

20. A parallel development has been noted in the history of American forenames (Zelinsky 1970b: 753).

21. Thus, for example, I have encountered in current South Carolina telephone directories two establishments using the generic designation "biblical gardens." They may have been created or named after the 1967 A.C.A. directory was compiled.

22. I should like to note in passing that the spatial distribution of each term is interestingly uneven, and that the two patterns are quite dissimilar.

23. For example, Wilson (1962: 96–98).

24. Warner (1959: 287–299).

25. For a sensitive discussion of this still poorly explored theme, see Jackson (1969). The shifting status of the two concepts is a recurrent theme in Jackson's more recent *American Space* (1972). Nehemiah Cleaveland, the effusive panegyrist of Brooklyn's Greenwood Cemetery, states the antiforest case with candor and feeling (1866: 137):

> Many of our villages, streets, and homes have become, or are becoming, so densely embowered as to leave small chance for the sun or the air to enter. Clearly this is wrong, unless it can be shown that a stagnant atmosphere—with whole armies of bugs and caterpillars—is promotive of cheerfulness and conducive to health. . . . This inconsiderate and reckless planting of trees and bushes in and around the spots where our dead repose is one of the absurdities of fashion. It is but too often the mere thoughtless copying of an example set by others. In Green-Wood the practice has already caused much inconvenience. . . . The Cemetery grounds which look best at all seasons, and give the highest satisfaction to the eye, are those which most nearly resemble a well-kept lawn. As a general thing, shrubbery and trees, in these little plots, are fatal to neatness. If there be any doubt on this point, let the open lots in Green-Wood be compared with those which are much shaded.

26. This idea is explored in Smith (1950), Sanford (1961), Marx (1964), Schmitt (1969), and Watson (1970–71).

27. Cornish (1946).

28. In many of the more elaborate cemeteries, the various paths and driveways are usually named after trees or flowers. For one especially thorough example, see *The Picturesque Pocket Companion and Visitor's Guide through Mount Auburn* (1839).

29. In cases where the reference was locational, e.g., North Hartford or South Bay, the item was not recorded; the table includes compass directions only when the terms appear to be intrinsic to the cemetery.

Transnationalism

The Roving Palate

INTRODUCTION

The examination of ethnic restaurant cuisines in North America serves more than one worthy purpose. It can enlarge our knowledge of, and thus heighten interest in, two sadly neglected topics: the geography of foodways; and the transnationalization of culture, i.e., that recent, large scale sharing among the peoples of many lands of social and cultural items previously restricted to individual countries. For the former the literature is meagre and rudimentary; concerning the latter, no geographer seems to have published anything of substance.

The notion that food and drink might serve as a central organizing theme for anyone studying the world of humankind seems to have eluded virtually all social scientists; but, after a bit of reflection, it does make abundant good sense.[1] Beyond the simple biological imperative for the frequent intake of nutrients and water, we encounter an immensely varied complex of diet, behavior, ideas, and attitudes subsumed under the term "foodways," one that lives strategically close to the heart of our dealings with the habitat and people near and far. We spend an inordinate amount of time, money, effort, and emotion in producing, procuring, and preparing food, in ingesting it and coping with the results, and in thinking and daydreaming about whatever charms our palate. For many of us, the rhythmic round of meals, snacks, and drinking provides the most memorable, or at least the most pleasurable and meaningful, happenings within the daily and weekly routine; and perhaps even more heavily laden with import are the ceremonial feasts that validate the sacred stations in our life-cycle and brighten the annual swing of the seasons.[2]

In light of the biological, socioeconomic, and emotional centrality of food to human endeavor, it is surprising to learn how little methodical attention the topic has received from the scholarly community, aside from the obligatory, narrowly focused efforts of nutrition scientists.[3] The nature of their vocation has compelled many students of folklore and folklife and a lesser number of anthropologists to begin looking carefully at foodways; but, with rare and honorable exceptions, historians, psychologists, economists, sociologists, and students of linguistics have shunned the entire subject.[4] Least excusable is the dearth of work by geographers.[5] The entire field of human ecology is unavoidably entangled with the phenomena of foodways, while the assiduous exploration of the latter reveals splendid routes into every corner of human geography. The geographer who begins with foodways and then charts all their ramifications cannot avoid shedding new light on all the traditional subfields of economic geography—agricultural, manufacturing, marketing, and so on—and gaining new perspectives on the nuances of climate, soil, and physiography. But, beyond such obvious rewards, there lies a richer understanding of medical geography and of many aspects of social and cultural geography, including ethnicity, language, religion, politics, demography, architecture, and, what is still largely *terra incognita*, our social relations and leisure activities.[6] Another virtue of the foodways strategy is that in an era of rapid social and cultural change, such as the present one, it furnishes a set of sensitive, easily readable clues as to the nature and direction of such change, as I hope to suggest in this paper.

Just why social scientists have been so reluctant or unexcited is not immediately clear, and it would take an extended essay to examine all the possible answers. It is true enough that we have no large, reliable, well-organized masses of data on the consumption of food or drink arranged by convenient spatial, social, and temporal categories, and that many phases of foodways are inherently hard to observe and record systematically. On the other hand, the mass of unorganized information readily at hand is simply enormous. Almost incalculably great is the space and time accorded to dietary items in articles and advertisements appearing in newspapers and magazines (be they general, trade, or special-interest in character) and on television, radio and hoardings.[7] The shelves of markets and the menus of restaurants are easily accessible to the explorer, and most of us would happily submit to questionnaires on food and drink.[8] We also have an embarrassing profusion of cookbooks and restaurant and travel guides.[9] In addition, of course, there is all that clandestine, in-depth intelligence locked away in the files of retail, marketing, and advertising firms and various franchising chains, a rich lode that may eventually come to light. Scholars determined to attack topics less accessible than foodways have usually found the means to generate sufficient data. Curiosity and will are the essential tools.

My suspicion is that the explanation for the rudimentary level of work con-

cerning foodways by geographers and most other social scientists lies in the realm of the sociology of knowledge. Members of the academic fraternity, consciously or otherwise, wish to appear businesslike and respectable to their colleagues and to the world at large. Consequently, they generally select Serious, Sober, Polite Topics and, observing the strictures of a late, lingering scholarly Victorianism that still seems to haunt the Western world, they ignore whatever smacks of frivolity, pleasure, or vulgarity. Thus, of the basic necessities of life—food, sex, and shelter—only the last, quite belatedly, has begun to receive the systematic geographic scrutiny it merits.[10] Geographers, like sociologists, have averted their gaze from clothing and fashion, significant though these matters may be for all of us; and their ignorance of the spatial patterns of music, dance, and art has only just begun to crumble.[11] We have barely begun to realize the glorious possibilities of the geography of sports, games, and other recreational activities, while most other aspects of popular culture still lie beyond the pale.

ETHNIC AND OTHER RESTAURANTS — AND ETHNIC FOOD

By selecting ethnic cuisines—a relatively visible and accessible topic—as the point of entry into what is virtually a vast *terra incognita*, I have commingled at least three large themes: changing food preferences; the shifting connotations of ethnicity; and the general transnationalization of culture in recent years.[12] And the stage upon which they meet is the restaurant, a vigorous latecomer to the North American scene.

It is only within recent times that the restaurant has become an important fact of life anywhere in the Western World.[13] For the most part it has remained what it was initially: a convenience for the traveler, businessman, worker, or other individual who, for whatever reason, cannot repair to his or her home for a meal and, occasionally, it is the setting for important social events. Increasingly, however, for those who can afford it, "eating out" has become a popular diversion and a way to escape the drudgery of the kitchen. The bare economic facts are impressive. In 1929, the earliest year for which we have solid information from the U.S. Census of Retail Trade, eating and drinking places accounted for only 4.4 percent of the total dollar volume of all retail establishments, and an amount equivalent to 19.6 percent of the money spent in all food stores. By 1977 these values had mounted to 8.8 and 40.1 percent respectively.

The usual restaurant bill of fare has closely duplicated or enhanced the standard local, regional, or national dietary regime. But, in recent decades, a considerable portion of the populations of the advanced countries of the world have inaugurated a new and, I believe, unprecedented pattern of existence, one in which the higher forms of consumption, the quest for pleasure and for varied knowledge and experience, have tended to displace our traditional preoccupation with producing or earning the necessities of life. Among the principal manifestations of this trend has been a reaching out to other times and places, the rise of

cosmopolitan or transnational transactions. Thus we have the spectacular growth of international tourism and the sharing across national boundaries of such things as popular and classical music, dance forms, clothing styles, coiffures, vocabulary, film, television, all levels of literature and art, architecture, religious and political innovations, knicknacks of all sorts, and, far from least, food and drink.

The transnationalization of diet is not limited to restaurants. Ethnic cookbooks have been proliferating in amazing fashion, and it is likely that, more often than not, their purchasers lack any ancestral tie with the ethnic groups in question. International food festivals have become annual events in some large American cities. Every self-respecting supermarket nowadays carries ample stocks of Italian, Chinese, Mexican and Kosher-style foods, and its "gourmet" section can be a sort of League of Nations.[14] Such previously exotic items as sauerkraut, macaroni, lasagna, shish kebab, crêpe, pastrami, chow mein, barbecued ribs, and enchiladas have become naturalized to the degree that these are now standard dishes on the tables of many "nonethnic" mainstream Americans. And pizza has become as American as apple pie. On the other hand, it can be argued that these foreign contributions have suffered in translation, losing authenticity and becoming Americanized, that "most ethnic cuisine has been adapted to prevailing taste—or some would say, tastelessness," in the United States.[15] But, of course, the same complaint applies to dishes originating in America and transplanted overseas.

How closely is the popularization of ethnic foods related to the "ethnic revival," the neoethnicity that has stirred up so much recent interest in Europe and North America?[16] Surely more than mere coincidence of timing is at work, and at some ultimate deep level a causative connection must exist. "Symbolic ethnicity—a nostalgic allegiance to the culture of the immigrant generation, or that of the old country; a love for and a pride in a tradition that can be felt without having to be incorporated in everyday behavior" involves food as one element in the array of cherished cultural heirlooms among third and later generations of foreign-stock Americans and Canadians.[17] But foods that were once the unique property of particular groups are now quite widely shared with outsiders, more so perhaps than language, gestures, certain holidays and religious observances, humor, costume, or peculiar conventions of behavior, and have lost much of their potency as cultural tonics. Perhaps it is only when the foodways remain principally the private property of the ethnic group, e.g., the soul food of blacks in and out of the South or the dietary practices of some Native Americans, that they can effectively rescue or reinforce social identity.[18]

The thesis of this paper is that, beyond its marginal utility in the cause of symbolic ethnicity, the ethnic restaurant (as defined below) is a major component in the transnationalization of culture in North America and elsewhere and that, like the other components of this rapidly growing phenomenon, it offers its participants the opportunity for vicarious joys, for exotic vacations without airports or baggage.[19] My contention is that the proprietor of an overtly ethnic restaurant provides, and its patrons expect to receive, not simply a nourishing meal but, to

a varying degree, an exotic experience, an effortless voyage into some distant enchantments. In those establishments where such a program is fully implemented, and the ideal extreme is not especially rare, something close to total immersion takes place. We enter a restaurant whose name, exterior design, and signs promise a reprieve from our workaday environment. The furniture, china, cutlery, and table-linen speak to us of alien delights, as do the wall decorations, paintings, maps, or photographs. The host or hostess, as well as the waiters, are natives of the foreign country, or reasonable facsimiles thereof, and are suitably costumed. Their English, if they speak it at all, is charmingly accented. The menu, which is frequently multilingual, displays what may pass for authentic artistic motifs. And, as we wait for the unfamiliar food and drink to arrive, we may be entertained by recordings or live performances by imported musicians and dancers, even while our nostrils are atremble with the astonishing aromas floating out from the mysterious kitchen. And, as we depart the premises after the meal, we may be tempted to purchase some mementos of this brief excursion at a gift counter or the satellite gift shop. Of course, the situation just described does not always fully materialize, but even when the ambience and various accoutrements of the ethnic restaurant are relatively modest, the implicit pledge of an experience out of the ordinary is still being transmitted. Thus I am dealing with entities that, to a decisive degree, are experiential rather than solely nutritional or social.

Continuing this line of reasoning, not all places in the United States and Canada serving dishes beyond those of the standard American and Canadian variety can qualify as ethnic restaurants. Eating places that make no effort to cater to nonlocal visitors or to members of other ethnic groups but are content to accommodate neighborhood residents or workers or the proprietor's compatriots fall into other categories, ones that certainly merit study. I am concerned with those establishments that make some sort of fuss about their differentness, not those that do not. Thus, for example, a Mexican café in an all-Mexican section of San Antonio, Texas, would not qualify unless it went to the trouble of advertising its menu to attract persons from afar; but a restaurant offering Mexican specialties in Edmonton, Alberta, would qualify almost automatically, as would a Chinese restaurant in a Jewish suburb of Chicago. Similarly, the various regional cuisines of North America, which one may regard as ethnic in the broader sense of that concept, are material for this study only when they aspire to some form of gastronomic tourism. A coffee shop in a Georgia county town may serve quite a different array of food than does one in Lancaster, Pennsylvania; yet both may be patronized only by the locals and are, consequently, more or less indigenous parts of the scene. But any place advertising "Southern" or "Soul" food in Lancaster or "Pennsylvania-German" fare in Macon (Georgia) would be just as 'ethnic' as a Korean restaurant in Peoria (Illinois) or a Basque establishment in Tulsa (Oklahoma).

Cinemas offering foreign movies to North American audiences provide a useful analogy. In many large cities we have had cinemas in the appropriate ethnic

neighborhoods showing films in Spanish, Chinese, and, formerly at least, German, Yiddish, and other European tongues (without subtitles, of course). Contemporaneous with the rise of the self-consciously ethnic restaurant we have also had the genesis of the "art" cinema house, more often than not located outside ethnic neighborhoods, one that offers the better foreign-language imports in any or all languages, but dubbed or subtitled in English: the audiovisual equivalent of the vicariously ethnic restaurant.

DATA SOURCES

In what follows it is essential to keep constantly in mind the distinction between two types of establishments: the self-consciously ethnic restaurants, whose cuisines form the subject of this essay; and what, for lack of a better term, can be called the indigenous restaurants, whether immigrant or mainstream American and Canadian in character. The term "ethnic" refers henceforth only to the former category. Awaiting exploration, and richly meriting it, are the varied indigenous, "neighborhood-type" eating places of North America, along with all those groceries, bakeries, public houses, theaters, funeral directors, and other businesses that cater to culture-bound communities. Clearly the maps accompanying this paper would display quite different patterns if they had included the latter type of restaurant.

I cannot sufficiently stress the point that the subject of this essay is the identification and discussion of the ethnic restaurant and its cuisines, not the characteristics of its patrons. The latter subject, an eminently worthy one to be sure, would call for a quite different *modus operandi.*

In lieu of any comprehensive collection of detailed information on North American restaurants and their menus, it requires some ingenuity to determine the location of ethnic restaurants and the nature of their offerings. The character of the business compels every eating place that can afford one to have a telephone and, obviously, all ethnic restaurants, as defined for this study, will usually go to some pains to identify their attractions in the directory listing. Consequently, the classified telephone directory cannot help but be an excellent source of data. Unfortunately, few libraries make any effort to retain older directories, so that most of my information refers to the present or very recent past. But support for the contention that ethnic restaurants are late arrivals on the American scene and that their numbers, variety, and importance have been increasing steadily and strongly does come from an analysis of listings in directories for the City of Philadelphia for the period 1920–1980 (table 1). There is no reason to expect that the pattern of change would be much different in other cities.

My data-gathering procedures are simple in principle, if tedious in practice. My assistants and I consulted the most recent classified telephone directory available for each Standard Metropolitan Statistical Area (SMSA) in the United States officially recognized as such in the mid-1970s and the Canadian cities of equiva-

TABLE 1. *City of Philadelphia: Ethnic and Regional Restaurant Cuisines, 1920–1980*

	1920	1930	1940	1950	1960	1970	1980
European	15	24	40	58	66	94	109
Italian	5	10	24	29	33	42	50
French	2	3	3	3	5	12	17
Others	8	11	13	26	28	40	42
Middle Eastern	—	1	—	2	2	4	3
East Asian	8	23	22	31	55	66	122
Chinese	8	23	22	31	55	64	112
Japanese	—	—	—	—	—	2	7
Others	—	—	—	—	—	—	3
South Asian	—	2	—	—	—	—	5
Latin American	—	—	—	—	—	1	3
North American	—	—	2	—	2	5	11
Miscellaneous	—	—	—	1	—	—	—
Total	23	50	64	92	125	170	253
Thousands of persons per cuisine	79.3	39.0	38.6	22.5	16.0	11.5	6.7

Source: Classified telephone directories.

lent size, a total of 271 places in all, including Burlington (Vermont), Cheyenne (Wyoming), and Charlottetown (Prince Edward Island), so that those areas should not go unrepresented. Directories were not found for six eligible places: Bay City, LaCrosse, Guelph, Kitchener-Waterloo, Peterborough, and Trois Rivières; but it is most unlikely that these omissions could substantially affect the findings. In those instances where one or more suburban directories have been published for a metropolitan area, we also exploited them, taking care to avoid duplications of listings. The overwhelming majority of the directories bore 1979 or 1980 dates, but we included a few 1981 and 1982 items and occasionally were obliged to use publications going as far back as 1974. In an effort to ascertain the metropolitan/non-metropolitan differentials in the attributes of ethnic cuisines, we scrutinized the directories covering the entire territory of one state, Pennsylvania, that presents more than adequate internal diversity.

Three different criteria, singly or in concert, serve to identify the ethnic restaurant. The name of the establishment may categorize it. Then, frequently, the name, address, and telephone number are accompanied by a one-line description or a display advertisement that specifically lists the cuisine(s). Finally, if all else fails, the advertisements often announce the specialties of the house, and there may be enough crucial items in that array to assign it to an ethnic pigeonhole or

two. In addition, many directories for larger cities may include a special section listing restaurants by type. Admittedly, a certain amount of subjectivity entered into the classificatory decisions, so that the data set is only an approximation of reality, but, I have reason to hope, a reasonable approximation. In any event, it is unlikely that any errors of judgement in scanning the raw materials have affected any of the larger generalizations in this study.

It is important to recall that there has been much lending and borrowing of particular dishes among national cuisines, so that the appearance of such "naturalized" items as onion soup, spaghetti, chop suey, wiener schnitzel, tempura, or tamales on an otherwise thoroughly nativistic menu does not necessarily confer ethnicity upon a restaurant. Following the same mode of reasoning, I have not included pizzerias that did not also feature an adequate roster of other Italian items in addition to pizza. It is interesting to note that, except for one chain of pseudo-Japanese eateries and the very recent burgeoning of national and regional Mexican enterprises, the franchising of ethnic restaurants has scarcely begun.

When a restaurant or, more strictly speaking, a cuisine offered by a restaurant had been identified as adhering to the culinary tradition of a foreign land or one of the regional varieties of North America, it was assigned to the appropriate national or regional category within one of seven larger categories, in order of importance: European; East Asian; Latin American; North American; South Asian; Middle Eastern; and Miscellaneous (table 2). In the case of several national cuisines, a respectable regional variety is also available, a development, I suspect, largely of the 1970s. Thus, in the case of Chinese restaurants, no fewer than eighteen provincial styles of cookery tempt the ravenous reader of telephone directories; and similar trends are under way for East Indian, Italian, and French cuisines. Strangely enough, the marvelous regional diversity of cuisine available in Mexico itself is in no way duplicated north of the border, if we accept the evidence offered by our documentary sources.

One of the more surprising developments on the ethnic restaurant scene is the large proportion of places advertising two or more different cuisines, often in addition to their American menu. French and Italian, Spanish and Mexican, or Greek and Middle Eastern are among the more popular combinations, but some are positively mind- or tongue boggling, as, for example, a Chicago café that characterizes itself as "Kosher & Soul." [20]

SPATIAL PATTERNS

As a geographer, I have attacked two problems in analyzing the significance of ethnic restaurant cuisines in North America. The first is simply locational: where do we find how many occurrences there are of each of the cuisines? The accompanying set of maps provides reasonably satisfactory answers. The second problem, or rather cluster of questions, is much more difficult, and I cannot pretend to have done more than start looking for answers. How do we explain the distri-

TABLE 2. *Ethnic and Regional Restaurant Cuisines in 271 Major Metropolitan Areas, United States and Canada, circa 1980*

	No. of Areas	Cuisines		No. of Areas	Cuisines
European: total	267	10461	Albanian	2	2
Italian	259	5530	Lithuanian	2	2
Northern Italian	46	106	Eastern European	1	1
Neapolitan	12	32	Slavonic	1	1
Sicilian	13	26	Southern European	1	1
Roman	2	3	North American: total	137	527
Florentine	1	1	Soul	93	227
French	156	1408	Southern	51	96
Basque	9	23	Creole	44	90
Continental and			Cajun	23	52
international	173	1139	Pennsylvanian-		
Greek	137	575	German	10	27
German	144	479	French-Canadian	5	17
Austrian	26	40	New England	9	15
Bavarian	25	33	Californian	1	1
Jewish	81	286	North American		
Spanish	58	266	Indian	1	1
Basque	2	5	Pueblo	1	1
Hungarian	38	123	South Asian: total	71	418
English	33	94	Indian	52	251
Scandinavian	36	90	Pakistani	8	15
Swedish	17	44	Bangladeshi	2	7
Danish	11	13	Nepalese	1	1
Finnish	5	7	North Indian	1	1
Norwegian	1	1	Punjabi	1	1
Irish	30	77	Thai	34	132
Swiss	35	64	Indonesian	11	25
Portuguese	18	58	Malaysian	3	4
Polish	21	56	Burmese	2	3
Yugoslav	14	39	Sri Lankan	2	2
Ukrainian	11	36	Cambodian	1	1
Russian	17	32	East Asian: total	270	9253
Czechoslovakian	10	30	Chinese	270	7796
Mediterranean	17	26	Cantonese	164	871
Belgian	10	12	Szechuan	152	658
Basque	3 (14)*	9 (39)*	Mandarin	164	655
Rumanian	5	9	Polynesian	128	412
Dutch	7	8	Hunan	83	223
Scottish	4	5	Peking	70	147
Macedonian	1	3			

(*Continued*)

TABLE 2. (*Continued*)

	No. of Areas	Cuisines		No. of Areas	Cuisines
Shanghai	40	75	Barbadian	1	1
Northern	28	41	Bolivian	1	1
Hong Kong	11	14	Central American	1	1
Mongolian	7	9	Ecuadorian	1	1
Singapore	3	3	South American	1	1
Taiwan	3	3	Latin American,		
Chuan-Yang	1	1	n.e.s.	25	399
Fu Chien	1	1	Middle Eastern: total	87	383
Manchurian	1	1	Lebanese	41	68
Nanking	1	1	Armenian	17	53
Southern	1	1	Arabian	19	36
Yunan	1	1	Moroccan	15	31
Japanese	160	1083	Turkish	10	16
Northern	1	1	Persian	8	15
Korean	67	165	Israeli	7	14
Vietnamese	51	146	Afghan	9	9
Filipino	25	63	Egyptian	3	6
Latin American: total	251	5437	Syrian	5	5
Mexican	250	4841	Tunisian	2	5
Cuban	21	61	Algerian	2	2
West Indian–			Yemeni	1	2
Caribbean	11	35	Muslim	1	1
Argentinian	13	31	Middle Eastern,		
Brazilian	5	14	n.e.s.	54	120
Peruvian	8	11	Miscellaneous: total	17	48
Colombian	6	8	Hawaiian	7	35
Jamaican	6	7	Tahitian	3	3
Salvadoran	3	7	Australian	2	3
Chilean	3	3	African	2	2
Haitian	2	3	Ethiopian	1	2
Nicaraguan	1	2	French Polynesian	1	1
Bahamian	1	1	Malagasy	1	1
			New Zealand	1	1
			Grand Total	270	26527

Source: Recent classified telephone directories.

*The larger value includes cuisines listed under French-Basque and Spanish-Basque.

bution of the various ethnic varieties? Or of the regional variations in the aggregate frequency of ethnic dining? What do these spatial and ethnic patterns tell us about larger issues in the cultural, social, and economic evolution of North American communities?

The first thing the data tell us is the sheer magnitude of the phenomenon. The 26,527 ethnic and regional restaurant cuisines identified in the major metropolitan areas of the two nations are equivalent to far more than 10 percent of the total number of restaurants in those places, even making generous allowances for those restaurants offering two or more cuisines. And if we can extrapolate the findings for Pennsylvania to other parts of the study area, then we can also expect to find a substantial complement of ethnic restaurants in the smaller cities, towns, and rural tracts of nonmetropolitan North America, although less frequently than in the metropolises. The 126 ethnic cuisines we identified in nonmetropolitan Pennsylvania, or one-ninth of the statewide total, were located in counties that account for one-sixth of the Commonwealth's population.

As might be expected, the number of occurrences per metropolitan area varies enormously. At one extreme, we have a maximum of 3,033 in the New York City metropolitan area; and, at the other, there is the Steubenville-Weirton (Ohio) SMSA, where not a single ethnic restaurant cuisine could be detected. But, in between, we find a half-dozen or more occurrences in even the smallest SMSAs and totals running up into the several hundreds for the larger places. Is the distribution pattern displayed in figure 1 simply a function of metropolitan size? It is tempting to assume as much, but a closer look suggests that a number of other factors are at work.

For each of the 271 metropolitan areas I have calculated the number of ethnic and regional cuisines per 100,000 inhabitants, as enumerated in the 1980 or 1981 Census.[21] Then, after rank-ordering the resulting values, I have mapped the places falling into the top two sextiles and the bottom two, as shown in figures 2 and 3. It is readily apparent that there is a definite regionalization in the proclivity of North Americans to operate or patronize ethnic restaurants. Or do these maps merely reflect regional differentials in the incidence of restaurants of all types? In order to test this hypothesis, I have calculated the ratio between ethnic restaurant cuisines and the total number of eating places reported in the 1977 Census of Retail Trade for each of the U.S. metropolitan areas. (Usable recent data are not yet available for Canada.) Surprisingly enough, the patterns on the resulting maps (not reproduced here) replicate almost perfectly those in the first set. Consequently, it seems reasonably safe to assume that, insofar as the acceptance of exotic cuisines serves as an index to the degree to which a society has become transnationalized, the process has advanced much more rapidly in certain parts of North America than in others.

Generally speaking, the incidence of ethnic restaurant cuisines is highest in the Northeastern and Western United States and throughout metropolitan Canada. The maximum values occur in northern Megalopolis and, most particularly, in

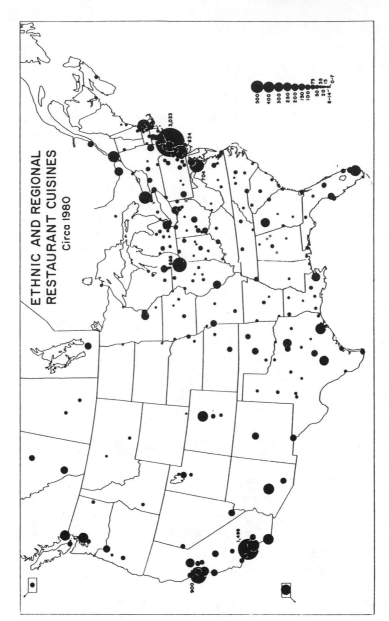

FIGURE 1 Ethnic and regional restaurant cuisines ca. 1980.

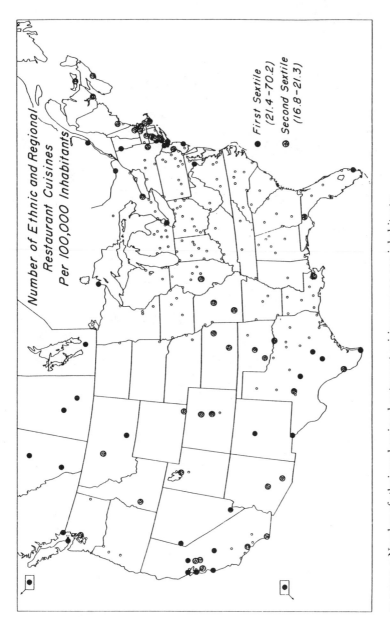

FIGURE 2 Number of ethnic and regional restaurant cuisines per 100,000 inhabitants: first sextile, second sextile.

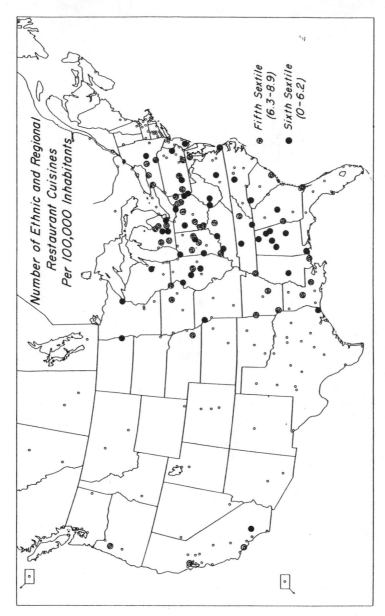

FIGURE 3 Number of ethnic and regional restaurant cuisines per 100,000 inhabitants: fifth sextile, sixth sextile.

the Connecticut metropolises, possibly reflecting an advanced cosmopolitan life-style in that area. No ready explanation comes to mind for the Canadian situation if we assume that the scores for those cities are not somehow artifacts of the research methodology, unless it is the rather heavy recent influx of New Canadians or that the popularity of exotic foods is a not-so-subtle commentary on the appeal of the domestic culinary traditions.

If the high-value metropolises are scattered widely along the periphery of the North American ecumene, the places with relatively few ethnic cuisines are bunched together rather tightly within the South, the Middle West, and the western reaches of the Mid-Atlantic Region. The poor showing of the South, excepting the states of Florida, Texas, and Oklahoma, might be attributed to more than one factor, including the insignificant size of the region's foreign stock, the relative poverty of the region, at least until quite recently, and the general tardiness of the South in accepting cultural innovations from whatever source.

The low scores registered by such places as Detroit, Cleveland, Gary, Johns-town, Buffalo, or Utica call into question the supposition that places with large ethnic populations would automatically acquire numerous ethnic restaurants. Quite to the contrary, we find that, as a rule, the industrial centers of the currently depressed Northeast, aside from those in New England and New Jersey, tend to have few such establishments despite rather large quotas of foreign stock.

The maps displayed thus far suggest a few other explanatory factors which I have not yet had the opportunity to explore systematically. A strong representation of ethnic cuisines seems to be correlated with a large volume of tourist, professional, and business visitors. The two national capitals, New York City, Miami, Reno, Las Vegas, Vancouver, Montreal, Honolulu, Atlantic City, Phoenix, New Orleans, and, perhaps, Fairbanks would seem to be cases in point. Also worth investigating is the possibility that state capitals and some of the larger college communities may have more than their share of exotic dining places. It is also conceivable that high rates of demographic and economic growth may encourage the opening of ethnic restaurants, especially in California and the Southwest with their large recent intakes of immigrant groups.

When we begin examining specific ethnic and regional cuisines, the problems of description and explanation multiply greatly. The only strong generalization is so obvious one hardly needs to record it: the diversity in ethnic cuisines is closely related to the total number in a given metropolitan area. Although the cuisines derived from European sources account for a solid plurality, by far the single most important individual item is the Chinese, accounting as it does for no less than 29.4 percent of all the ethnic and regional cuisines tallied.[22] Such culinary prowess is out of proportion with the relative size of the Chinese population in the U.S. or Canada. The 431,583 individuals identified as Chinese in the U.S. Census of 1970 amounted to slightly more than 0.2 percent of the total population and only about 1.24 percent of the entire foreign stock, while the 705,000 persons considering themselves as Chinese or Taiwanese in 1979 comprised only 0.4 percent of the

ethnically identified population (table 3). Furthermore, a glance at figure 4 suggests only the vaguest spatial correlation between Chinese restaurant cuisines and the Chinese-American or Chinese-Canadian populations.

To what degree, then, is the relative strength of a given ethnic restaurant tied to the size and distribution of the related ethnic population? Table 3 provides a rough sort of answer, namely, that the relationship is generally remarkably weak. The crudeness of the table may be blamed in large part on the deplorable shortcomings of ethnic statistics in the United States. The Census does not identify immigrant stock beyond the second generation; for the third and later generations the only ethnic or "racial" native-born groups tabulated are those considered to be non-Caucasian; and the process of self-identification used by the Current Population Survey in 1979 is susceptible to many kinds of error, deliberate or otherwise. In the case of the five leading cuisines in the United States—the Chinese, Italian, Mexican, French, and Japanese—the demographic ranking of the related populations is well below their performance on the restaurant scene.[23] The same statement applies as well to the Spanish, East Indian, and Korean, and probably also to the Greek, Vietnamese, Thai, and Indonesian cuisines. In the most general terms, it appears that the American or Canadian restaurant patron craving gastronomic thrills will seek out menus from Eastern Asia (except for the Filipino), Southern Asia, the Romance lands of Europe, and portions of Latin America. Perhaps cultural distance lends enchantment for, on the contrary, he shows much less disposition to salivate after the offerings of Great Britain, Ireland, Scandinavia, the Low Countries, or Germany, countries whose dietary traditions so closely resemble those of mainstream North American cookery.[24] Just why interest is so slack in the relatively exciting cuisines of Eastern or Southeastern Europe (I have yet to find a Bulgarian restaurant in metropolitan North America) remains a mystery to me.[25]

If I were to produce maps of the location of some of the minor ethnic cuisines, such as the Ukrainian, Polish, Basque, Rumanian, or Lithuanian, or some very recent arrivals of the 1970s, such as the Vietnamese, Thai, Arabian, Afghan, Ethiopian, or Filipino, it would be clear enough that they are mostly still confined to immigrant localities, presumably catering to mixed clienteles.[26] But when we examine the maps depicting the five leading cuisines, it is plain that the items in question have leaped over ethnic and spatial barriers and have plunged deep into the gentile palates and territory of North America. In a good many instances this means that for some or all of the restaurant personnel the only connection with the country or cuisine in question may be of a commercial character.

The three most important ethnic cuisines, the Chinese, Italian, and Mexican, are so popular, accounting as they do for 71.1 percent of the total in the U.S. and 58.6 percent in Canada, that they are well represented in nearly all metropolises, and nearly always rank either first, second, or third among the ethnic cuisines. Since maps of absolute quantities cannot readily indicate the relative strength of

TABLE 3. *United States and Canada: Ethnic Restaurant Cuisines and Related Populations*

A. United States

Ethnic Cuisine	% of Total *ca.* 1980	Related Population 1970 Census*	Related Population 1979 CPS†	Ethnic Cuisine	% of Total *ca.* 1980	Related Population 1970 Census*	Related Population 1979 CPS†
Chinese	29.0	1.24%	0.4%	English	0.3	7.09	22.3
Italian	21.7	12.20	6.6	Scandinavian	0.3	5.61	6.5
Mexican	20.4	6.73	3.7	Hungarian	0.3	1.74	0.9
French	5.0	0.99	7.8	Irish	0.3	4.17	24.4
Continental	4.5	n.a.	n.a.	Filipino	0.3	1.01	0.4
Japanese	4.3	1.69	0.4	Polish	0.2	6.83	4.7
Latin American, exc. Mexican	2.7	6.71	1.5	Swiss	0.2	0.63	0.7
Greek	2.0	1.25	0.6	Yugoslav	0.2	1.29	0.3
German & Austrian	1.9	13.22	28.8	Portuguese	0.2	0.69	0.5
Middle Eastern	1.3	1.30	0.2	Czechoslovakian	0.1	2.18	0.9
Jewish	1.1	n.a.	n.a.	Russian & Ukranian	0.1	5.59	2.2
Spanish	1.0	0.45	2.0	Indonesian	0.1	n.a.	n.a.
East Indian	0.7	0.24	0.1	Belgian	0.03	0.38	0.3
Korean	0.7	0.20	0.1	Rumanian	0.03	0.62	0.2
Vietnamese	0.5	n.a.	0.1	Dutch	0.03	1.10	4.5
Thai	0.5	n.a.	n.a.				

B. Canada

Ethnic Cuisine	% of Total *ca.* 1980	Related Population‡ 1971	Ethnic Cuisine	% of Total *ca.* 1980	Related Population‡ 1971
Chinese	39.2%	0.55	Indonesian	0.4	n.a.
Italian	17.3	3.39	Russian	0.3	0.30
French	9.3	28.65	Irish	0.2	0.18
Greek	4.2	5.77	Polish	0.2	1.47
East Indian	3.3	0.31	Belgian	0.2	0.24
Continental	3.3	n.a.	Mediterranean	0.2	n.a.
Japanese	3.3	0.17	German & Austrian	1.7	6.30
Middle Eastern	2.7	0.12	Vietnamese	1.5	n.a.
Mexican	2.1	n.a.	Jewish	1.4	1.38
Hungarian	1.9	0.61	Ukrainian	1.3	2.69
English	0.5	44.62	Latin American, exc. Mexican	1.0	n.a.
Korean	0.5	n.a.			
Czechoslovakian	0.4	0.38			

(*Continued*)

TABLE 3. (*Continued*)

Ethnic Cuisine	% of Total ca. 1980	Related Population‡ 1971	Ethnic Cuisine	% of Total ca. 1980	Related Population 1971
Spanish	1.0	0.13	Macedonian	0.1	n.a.
Portuguese	0.9	0.45	Thai	0.1	n.a.
Swiss	0.8	0.16	Romanian	0.04	0.13
Scandinavian	0.5	2.06	Dutch	0.04	1.97
Filipino	0.2	n.a.	Yugoslav	0.04	0.31
Malaysian	0.2	n.a.	Cambodian	0.04	n.a.

* Percentage of combined foreign stock, Puerto Ricans, and third or later generation Chinese, Japanese, Korean and Filipinos.

† Ethnic self-identification, as a percentage of persons reporting at least one specific ancestry, U.S. Bureau of the Census, Current Population Reports, Series P–23, No. 116 (1982) *Ancestry and Language in the United States: November 1979,* Table 1. G.P.O., Washington, D.C.

‡ Ethnic affiliation, as reported by Census, as a percentage of the total population.

the leading cuisines, I have prepared an additional set of drawings showing the rank of the item in question. In order to generalize the patterns and to minimize the amount of random noise, I have taken the mean of the ranks of the Chinese, Italian, or Mexican cuisines, as the case may be, in the ten nearest metropolises, a sort of moving spatial average.

An inspection of figures 4 and 5 reveals the two dominant facts about Chinese restaurant cuisines: they are virtually universal, appearing in 270 of our 271 locations; but they do not strongly dominate any region. The strongest showing is in Canada in general, the Pacific Northwest, northern California, and eastern New England.[27] The North American situation would seem to be an extension of what we find in other continents. During modern times, Chinese restaurants have penetrated into virtually every country of the world, or at least into the capital cities. The historical geography of this phenomenon remains to be done, and a fascinating project it should prove to be (especially considering the fieldwork involved). In any case, the great North American success story of the Chinese restaurant furnishes further testimony, if any be needed, to the remarkable entrepreneurial abilities of that small immigrant population.

It is quite likely that much of the good fortune of the earlier Chinese restaurateurs (as was also the case with the Chinese hand laundry and perhaps also the pioneering Italian eateries) was a matter of their remarkably low prices. As late as the 1950s, as I can attest from personal experience, a fully adequate Chinese meal could be had for half or less the amount charged at conventional eating places. Chinese, East Indian, and Italian restaurants may still offer bargains in Great Brit-

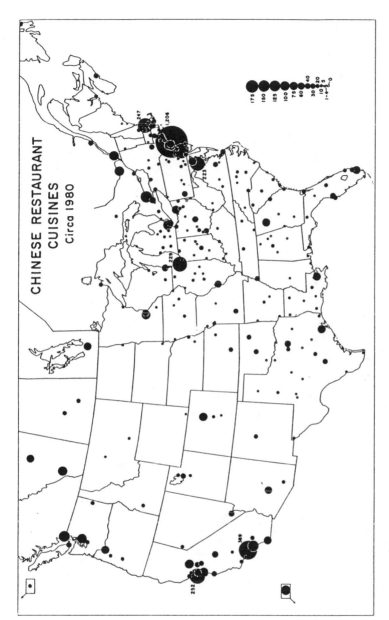

FIGURE 4 Chinese restaurant cuisines ca. 1980.

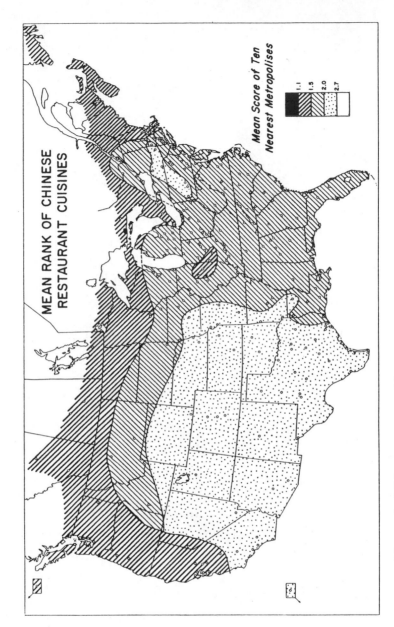

FIGURE 5 Mean rank of Chinese restaurant cuisines.

ain and other countries, but, alas, in North America the cost differential has vanished. The pricing policies in ethnic restaurants today closely parallel those found in other establishments.

Why the Italian cuisines should have assumed primacy among the European cuisines is not entirely clear. Nor is there any obvious explanation for the regional patterns revealed in figures 6 and 7. What may be surmised is that the Italian immigrants, arriving as they did in large numbers in the late nineteenth century from a land with noble culinary traditions, may have offered the dominant WASP (White Anglo-Saxon/Protestant) population its first good chance to sample an interestingly exotic, but non-Oriental, cuisine. Although Italian restaurants are now widely dispersed throughout the continent, with many being managed by non-Italians, the zone of their densest concentration, running from southern New England through New York into western Pennsylvania, may have more than a coincidental relationship with the distribution of first- and second-generation Italian-Americans.[28] Similarly, the secondary concentration in Peninsular Florida may have been generated by a southward migration from the Northeast augmented by an appreciative acceptance by non-Italians.

The Mexican restaurant phenomenon is, I strongly suspect, something that has developed in strength only within the past decade or two. If the Mexican-American population is growing rapidly in numbers and territorial range, its foodways are hurtling northward and eastward at an even faster pace. Thus figures 8 and 9 may have captured a major example of cultural diffusion in mid-flight.[29] If these drawings were to be updated in 1990, it would not be at all surprising to find an abundance of Mexican restaurants in those stretches of the Southeast and far Northeast where they are still rare today.

In a final effort to chart the dominant exotic features of North America's gastronomic terrain I have generated figure 10, which depicts which ethnic cuisine leads the others within each cluster of ten nearest metropolises. As might have been predicted, we find the Italian dominant in much of the Northeast, but with interesting extensions into the Upper South and beyond into Florida. The Mexican cuisine is well in the lead throughout the Southwest, much of the West, and the western fringes of the Midwest. An outlier occupying corners of Michigan, Indiana, and Ohio may well be linked to some recent migrations from the Southwest. All of the residual territory is claimed by the Chinese cuisine, though not by overwhelming majorities.

I cannot conclude without briefly noting the intriguing questions raised by the distribution of the French and Japanese cuisines (figures 11 and 12). Socially, both belong to a category quite different from that occupied by the Chinese, Italian, and Mexican. The latter group appeals to the entire socioeconomic gamut of restaurant customers. Although a number of such establishments are too expensive or specialized to appeal to any but the carriage trade, it is easy enough to find others barely above the greasy spoon level. For the time being, however, French

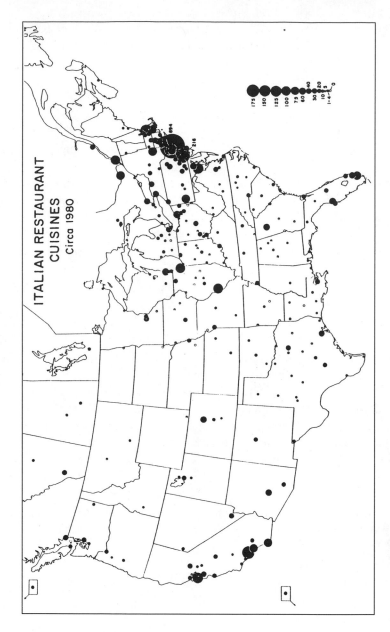

FIGURE 6 Italian restaurant cuisines ca. 1980.

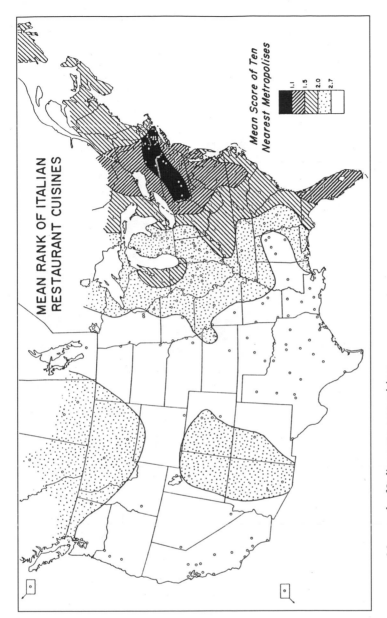

FIGURE 7 Mean rank of Italian restaurant cuisines.

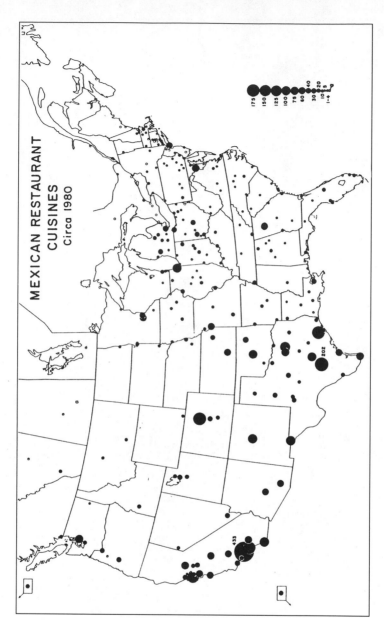

FIGURE 8 Mexican restaurant cuisines ca. 1980.

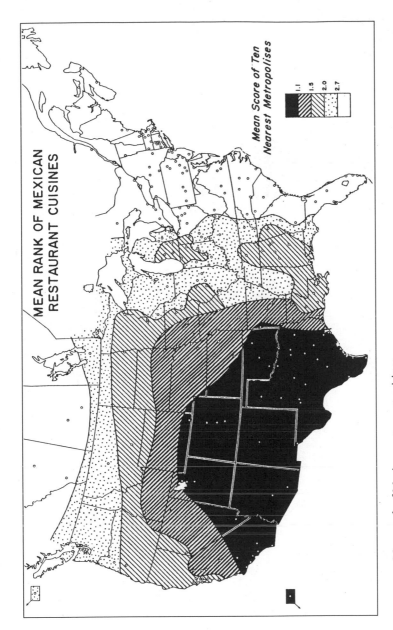

FIGURE 9 Mean rank of Mexican restaurant cuisines.

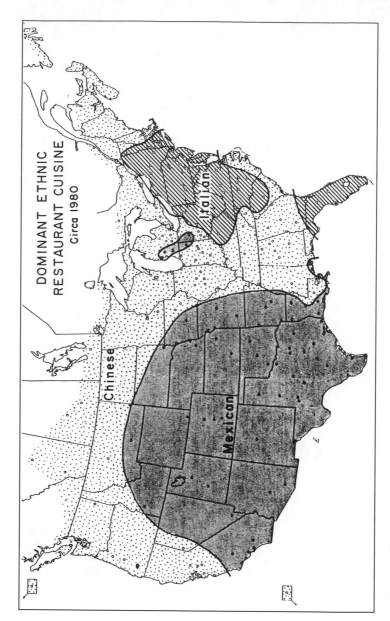

FIGURE 10 Dominant ethnic restaurant cuisines ca. 1980.

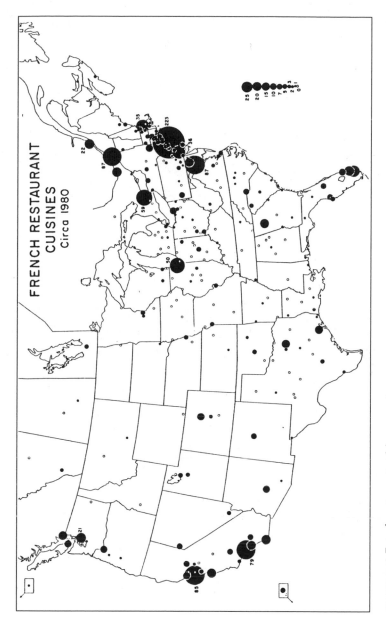

FIGURE 11 French restaurant cuisines ca. 1980.

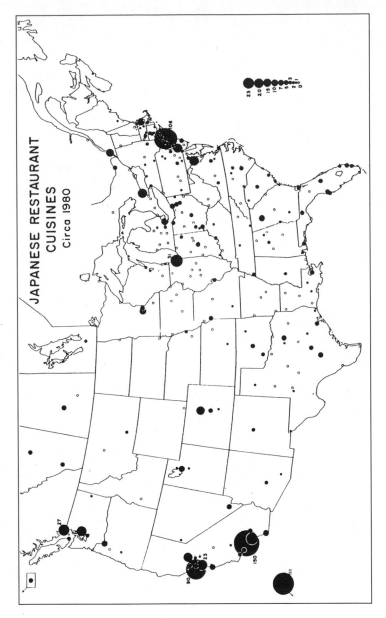

FIGURE 12 Japanese restaurant cuisines ca. 1980.

and Japanese restaurants attract only the well-to-do and the sophisticates, as the maps clearly suggest. Neither map has much meaningful relationship with the location of the relevant population beyond the predictable concentration of Japanese establishments in the five West Coast states and provinces and the profusion of French cuisines in or near the French-Canadian heartland. What the maps do reveal is strong representation among the cosmopolitan inhabitants of Megalopolis and those cities elsewhere having large flows of affluent transients or complements of upward-striving trendy folk.

CONCLUSIONS AND PROSPECTS

This reconnaissance of a previously unexplored topic has produced some significant findings and the promise of more to come from further explorations. It is clear enough that the incidence of ethnic restaurants, or, more precisely, ethnic restaurant cuisines, is considerable in the United States and Canada and that, to a varying degree, this innovation in North American eating habits has spread to all the larger urban places of the continent and, to a lesser extent, has penetrated nonmetropolitan areas. Moreover, it seems safe to infer that this is indeed a recent phenomenon and one still very much on the upswing. Casual personal observation and anecdotal evidence suggest similar developments in Western Europe and even, to a certain extent, in many cities of the Third World.

As the number of these cuisines has increased, so too has the range of ethnic varieties and the regional specializations within the major national types. With few exceptions, the popularity of a given cuisine seems to be inversely related to its unfamiliarity, to its cultural distance from the dietary complexes of Teutonic and Celtic Northwest Europe and early North America. Thus few restaurants feature the cuisines of the British Isles, Germany, Scandinavia, and the Low Countries, or the somewhat similar culinary regimes of Eastern Europe or the cuisines of other sections of North America. If, for this and other reasons, the immigrant influxes of the nineteenth and early twentieth centuries had little immediate impact upon the restaurant scene, the situation is quite different today. Now that such a large and growing proportion of newcomers to the United States and Canada are arriving from Latin American, Asian, and Mediterranean sources, many of these immigrants are promptly opening restaurants that appeal, with some success, to the dining public at large as well as their own countrymen. But immigration may be only one of a number of mechanisms whereby the foodways of North America and other regions of the world are becoming transnationalized; and, although we still lack the hard evidence to test the proposition, such ecumenicism of the palate may be intimately related to the transfer across international and ethnic boundaries of many other cultural attributes.

Within North America, there is much variation among metropolitan areas and regions in the popularity of ethnic restaurant cuisines in both their totality and in

terms of the specific cuisines analyzed in this study—the Chinese, Italian, Mexican, French, and Japanese—but presumably in others as well. Three of four factors seem to matter here, aside from the trivial effects of simple size of place. Firstly, the general socioeconomic status and thus cultural sophistication of the community: the higher the mean level of affluence, education, and associated characteristics, the more likely we are to find more eating places offering ethnic specialties. Secondly, places with an especially high turnover of tourists and other affluent transients tend to have more ethnic restaurants. Thirdly, the general cultural-cum-socioeconomic character of a region, most notably the South but perhaps the Middle West and Megalopolis as well, helps determine its receptivity to exotic dishes. If the incidence of ethnic restaurant cuisines is indeed higher in Canadian than American cities, as suggested by our data, then such a fact may reflect genuine differences in the cultural proclivities, as well as the recent demographic history, of the two countries. Lastly, the ethnic geography of North America may operate in isolated instances to shape the regionalization of ethnic restaurant cuisines, but is notably ineffective in other cases. Thus critical masses of Italians and Mexicans in the Northeast and Southwest, respectively—and, just possibly, the Japanese in the Far West—seem to have decisively modified the foodways of their regions, while the same process may have started in some of the very recent immigrant communities. On the other hand, the great waves of immigrant groups arriving before World War II, especially those in the Middle West and the western portions of the Middle Atlantic region (the Italians, of course, excepted), did little to change the general eating habits of their metropolitan neighbors outside the home.

Clearly we need much more information and analysis before we can fully appreciate the geographic and other implications of the advent of large numbers of ethnic restaurants. Several directions for further research come readily to mind. It would be instructive to expand the range of inquiry to many other lands, so that we could grasp the worldwide dimensions of the phenomenon. Within North America, the menus of small city and rural eating places await exploration, while the micro-scale distribution and characteristics of ethnic restaurants within our larger cities are certain to offer valuable insights into their social geography. It would be useful to know how closely recent changes in domestic culinary practices have paralleled those in the restaurant world and how important—and authentic—have been the borrowings from alien cuisines to be found in North American kitchens and pantries. As productive a strategy as any would be the study of the sociology and social geography of the patrons of restaurants featuring ethnic items. Who are they in terms of age, class, education, occupation, religion, ethnicity, places of origin and residence, and search and travel behavior with respect to dining out? In the light of the materials presented above, I am confident that the answers to such questions would validate the assumption that generated this paper: that the diligent study of foodways is one of the more productive approaches to the entire human scene.

Since the initial publication of this article, the American ethnic restaurant scene has continued to evolve pretty much as expected. The popularity, number, and variety of ethnic cuisines have increased steadily, and they have become even more specialized and exotic. Especially interesting is the nationwide success of Vietnamese and, more locally, Ethiopian establishments. (And would you believe the occasional Tibetan or Somali enterprise?) The franchising of ethnic and regional eateries has also proceeded apace, explosively in the case of the Mexican but rather less so for Cajun, Chinese, Italian, and (if it is still classifiable as regional) pit barbeque. In parallel fashion, there is no end in sight to the marketing of new nontraditional cookbooks and grocery items or to the blending of previously unrelated culinary traditions in both domestic and commercial kitchens.

In the realm of geographic scholarship, research on foodways still lags, but it is heartening to report a watershed event with the appearance of Richard Pillsbury's (1990) study of the history and geography of American restaurants. The outlook is promising in the field of social history. Growing numbers of its practitioners are becoming aware of the rewards of studying foodways, whether at the world scale, as, for example, in Sidney Mintz's (1985) enlightening volume on sugar, or in explorations of the American story. Especially notable and indicative of things to come are such works as Harvey Levenstein's (1993) and Warren Belasco's numerous articles on, and book-length treatment (1989) of, ongoing changes in our foodways.

Geoforum 16 (1985): 51–72

NOTES

1. This is not to suggest that the foodways strategy is the only good method, or even the best one, for reaching into the many interlocking facets of the human world, merely that its potential productivity is very large indeed. We have had a succession of central organizing themes in geographic scholarship that have been adopted with varying degrees of success, including land-use patterns, sequent occupance, the marketplace, the built landscape, and energy balance. Surely there is room for another.

2. Partaking of sustenance together (rather than singly, as beasts are wont to do) in certain prescribed ways is one of the essential practices that sets human beings apart from the rest of the animal kingdom. In addition to holiday feasts and those associated with rites of passage, food and drink play an indispensable role in virtually all of our other important social rituals, whether or not we happen to be hungry or thirsty. Thus the wine and wafer in the Roman Catholic mass or the wine sipped in some Orthodox Jewish services, as well as the comestibles polished off at the ever-popular church dinners and picnics. The theater is, of course, sacred in origin; and I suspect that more than physical appetite or the greed of the proprietors lies behind the popularity of dinner theater, the bar and refreshment

stands in many concert halls, theaters, and drive-ins, or the obligatory popcorn at the cinema. Some astute observers, e.g., Novak (1976) and Prebish (1982), have claimed that modern sports have replaced the traditional church as the genuine religion of the masses in the United States and elsewhere. In any event, is baseball thinkable without hot dogs and beer? Food and drink are prominent features of nearly all those orgies of communal celebration we call sporting events. Even when the audience is dispersed among millions of television sets, beer and snacks are de rigueur, though it is improbable that undernourishment would set in without them. Food and drink are also essential elements of the proper political rally or barbeque, and at the most solemn national and international occasions the toast is a central event. Note also the bottle of champagne used to christen naval vessels or the ceremonial beer and champagne following the ordeal of an academic oral examination. At less formal occasions, we have that pinnacle of civilized living, of stagecraft, and of kitchen craft: the dinner party. And what host or hostess would dream of conducting a late evening party without plying the guests, already presumably decently stuffed with dinner, with more food and drink? The examples are endless. Food does much more than sustain the flesh; it is one of the foundations of society and a talisman that admits us into the larger mysteries.

3. For a useful bibliographic entrée to the field, consult Camp (1982) or his earlier "Food in American Culture" (1979). Also useful are Anderson (1971), Wilson (1973), and the occasional items appearing in *The Digest*, a periodical published by the University of Pennsylvania's Department of Folklore and Folklife. After more than three decades, National Research Council (1945) has lost none of its value, remaining our best programmatic statement of what needs to be done by social scientists in the study of food.

4. Noteworthy for their searching analyses of the role of food in the life of a community are Richards (1948) and Vance (1935: 411–441).

5. For introductory, actually pioneering, statements on the geography of food, see Sorre (1962) and Kariel (1966). A small group of French geographers has begun to examine patterns of food consumption in France (Bernard, Salles, and Thouvenot 1980; Favier and Thouvenot 1980). Unfortunately, few geographers in North America or elsewhere have followed their lead. Wine may be the only important element in human diet that has begun to receive something like the attention it merits from geographers and others, e.g., Dickenson and Salt (1982) and Henderson (1982). One of the rare attempts to examine a significant foodways element at the national scale is Rooney and Butt (1978), a study of the consumption of alcoholic beverages. The only two geographic treatments of restaurants of which I am aware are Krueger (1970) and Gazillo (1981), but the latter does not deal with ethnic cuisines. There are also a few rather specialized publications, including Durand (1956), Simoons (1961), Hilliard (1972), and Vermeer and Frate (1975). Symptomatic of the general state of affairs is the fact that in what may be the most broadminded of the currently available introductory texts in human geography, diet receives no more than a few passing mentions, and then mainly in the context of religion (Jordan and Rowntree 1982: 184–186).

6. For discussions of the architecture of two specialized kinds of eating establishments and some hints of the geography thereof, see Gutman and Kaufman (1979) and Arreola (1982).

7. The Census of Retail Trade, conducted at irregular intervals since 1929, publishes statistics on eating and drinking places by state, metropolitan area, and country, but the tabulations offer no hints about the kinds of food being served in these establishments.

8. During the summer of 1976, the Society for the North American Cultural Survey maintained a booth at the Smithsonian Institution's splendid Festival of American Folklife on the Washington Mall at which many hundreds of visitors enthusiastically volunteered to fill out questionnaires on food preferences. Unfortunately, the organization has lacked the financial resources to make much headway in tabulating and analyzing the results.

9. For citations of regional and local guide literature, which often contain a good deal of restaurant information, consult Post and Post (1981) and Fondersmith (1980).

10. The only publication by a geographer I have ever encountered that treats eroticism in a serious, interesting way is Buchanan (1970).

11. But see Carney (1982).

12. Barer-Stein (1979) provides a compendious, semipopular guide to all the significant ethnic cuisines of North America.

13. There is a remarkable dearth of scholarly literature on restaurants, and indeed we are still awaiting comprehensive treatments of such larger, more obvious subjects as the general history of food. Such publications as Braudel (1973: 66–191) and Tannahill (1973) indicate the rich possibilities. For the United States, the best available discussions of the historical and other aspects of food are Cummings (1941), Cussler and De Give (1952), Stewart (1954: 70–101), *American Heritage Cookbook* (1964), Root and de Rochemont (1976), Hooker (1980), and the Time-Life regional series on American Cooking issued from 1968 through 1971. The only extended chronicle of the American restaurant phenomenon appears in Root and de Rochemont (1976: 313–355, 451–455). However, some of the fast-food chains have stimulated book-length accounts, e.g. Ingram (1964), Boas and Chain (1975), Fishwick (1978), and Belasco (1979). Although restaurants may have been an inevitable, spontaneous development in nineteenth-century America, there may also have been some formative influences received from continental Europe with its older, stronger restaurant traditions. Thus we find the non-English terms café, cafeteria, restaurant, and delicatessen used widely in North America for eating places and, less commonly, rathskeller, grotto, dinette, chalet, and bistro. Within the establishment, such exotic terms as menu, à la carte, buffet, chef, table d'hôte, maître d', rotisseries, china, and smorgasbord are in general use.

14. It may be useful to think of the contemporary supermarket as a living museum of food, one that has reached a level of artistry, excitement, and effectiveness only occasionally excelled by our conventional museums of art, natural history, or history. The amount of cultural and geographic information on the shelves and in the display cases inviting note-taking and analysis is staggering.

15. Sternberg (1981: 64). The discussion of "Ethnic Food: The Last Bastion" (pp. 63–65) is brief, useful, and provocative.

16. Perhaps the most useful introduction to this large, perplexing topic is Smith (1981).

17. Gans (1979). Only a single sentence in this valuable essay deals specifically with food: "Consumer goods, notably food, are another ready source for ethnic symbols, and in the last decades, the food industry has developed a large variety of easily cooked ethnic foods, as well as other edibles which need no cooking, for example, chocolate matzhos which are sold as gifts at Passover" (p. 10).

18. Welsch (1971).

19. The scholarly literature on ethnic restaurants is nonexistent. Even the trade press has been remarkably inattentive to the phenomenon, and the few items that do appear are not especially informative, e.g., Woicik (1981) and Sublette (1981).

20. Something close to the ultimate in catholicity appears in the advertisement for a place in suburban Cincinnati that describes itself as "the Italian restaurant with the Spanish name hosted by the Jewish couple with the Greek partner featuring American steaks, French onion soup, Ecuadorian ceviche, and Swiss fondue."

21. Since the match between the territories of SMSAs and metropolitan telephone directories is quite inexact, these values are necessarily approximate.

22. It may also have been the earliest ethnic restaurant cuisine in North America, appearing as it did as early as 1850 in California (Root and de Rochemont 1976: 177). One may conjecture that in most metropolitan areas the Chinese restaurant has served as the pioneer species, the earliest item in an ecological culinary succession.

23. Unless we accept the unlikely possibility that some 7.8 percent of the American population has one or more French ancestors. This may be wishful thinking on the part of some of those Current Population Survey respondents who consider it fashionable to claim a French connection.

24. The same line of reasoning would seem to apply to the relatively poor showing of regional North American cuisines outside their indigenous zones. They are simply too similar to one's own—or too humble in origin—to excite much interest among seekers after culinary novelty. The Creole and Cajun cuisines may be exceptions, but the necessary skills and ingredients are not easy to find outside Louisiana.

25. The one other national cuisine that seems to be missing in metropolitan North America is the Icelandic, but I have been told that several Icelandic eating places do exist in certain small cities.

26. It seems that a much larger fraction of recent immigrants are promptly entering the restaurant trade and featuring their own traditional fare than was the case with earlier generations of new Americans and Canadians. The current receptivity to alien dishes is well illustrated by the example of Greek Americans. For many years they tended to dominate the restaurant scene in much of small-town America and were also conspicuous as proprietors of cafés in larger cities. Only in the past few years have they discovered that it is profitable to introduce Greek items into the menu, and they have come out of the culinary closet.

27. There may be some regional patterns emerging among the various regional cuisines of China. One that is quite visible is the concentration of Chinese-Polynesian cuisines in New England. There is no obvious explanation.

28. Velikonja (1961, 1965).

29. Gottschalk (1982).

The Twinning of the World

No social structure has any concerted meaning unless there are people acting in the prescribed manner in the prescribed position. . . . New structures come into being because people—new people and old people—start doing new things, start dealing with each other in a new way. . . . If their action is on a large scale and aligned . . . then a revolution has taken place. —Galtung 1980: 147

Something new and remarkable, if not necessarily revolutionary, has been going on in the social geography of our late twentieth-century world: the sister-city phenomenon. Over the past forty years, more than 11,000 twinnings have been formalized among a wide range of communities in at least 159 countries—people-to-people relationships that, one is inclined to believe, are generally inspired by quite laudable ideals. But whatever the motivation, here, most certainly, is a development that cries out for methodical treatment by human geographers. Indeed the temptation to sort out and map this hoard of place-specific data is well-nigh irresistible.

But more than idle geographic curiosity prompts a study that has, I must admit, an ambitious ulterior agenda. As an incitement to research and critical reflection on the transnationalization of society and culture in our contemporary world, this paper could serve as foreword to a wide-ranging enterprise that might appeal to many scholars. In any event, it logs a voyage of discovery into uncharted waters. It began with no preconceived agenda—except, again, advocacy for the study of transnational sociocultural phenomena—no working hypotheses to be confirmed or negated beyond the self-evident growth of a planetary society. But, unavoidably, there was one guiding assumption: the essential validity of the core-periphery model of the present-day world-system. As it happens, the findings do support the model, despite a few interesting anomalies.

In recent years, given the unprecedented transnationalization of the manufacturing, banking, retailing, and other industries (Barnet and Müller 1974; Mattelart 1979), we have come to regard as axiomatic the interdependency of the world

economy and its actors. The literature on this interactive global system by geographers and many others in and out of the academy is too large and lively for even the most cursory of summaries here. Suffice it to note that such discourse is all to the good. Equally commendable, however belated, is the sudden realization by scientist and layperson alike of the environmental and ecological interdependency of all portions of this planet. Such issues as the thermal or chemical pollution of atmosphere and oceans, as perceived from a global perspective, have moved swiftly to the forefront of our collective attention.

But what I find both surprising and distressing is a near-total absence of systematic curiosity about another and, I believe, equally important aspect of an interdependent world: the sociocultural. Everyone now seems to take it for granted that our human world has been shrinking rapidly, that most places and their inhabitants are becoming more and more alike, and that placelessness is pandemic. Yet, strange to say, this presumably self-evident credo remains unexamined, supported only by impressionistic writings such as Iyer's (1988) sensitive *Video Night in Kathmandu*, or, at best, ruminations on selected aspects of the built environment (e.g., Relph 1976: 123–40). No one has subjected our new global togetherness to the sort of rigorous scrutiny it merits, to discover just what changes in hearts, minds, and behavior we have actually undergone of late hither and yon under the impact of those same novel modes of production, transportation, and communication that have done so much to transform the economy and ecosystem. Such relevant documents as we do possess deal with the diffusion of certain important innovations, but too rarely with their social consequences and, moreover, are usually confined to limited areas or to the earlier phases of the modern era.[1]

To cite a few examples, we still await an assessment of the worldwide impact on late twentieth-century thought and behavior wrought by mass tourism, telecasts and tape cassettes, church missions, international sport competition and its coverage, the scouting movement and other transnational fraternal groups, numerous social uplift and philanthropic organizations, the diffusion of dress and hairstyles or mass-produced foods, the universal popularity of rock music, or the work of literally thousands of NGOs (nongovernmental organizations) whose scope may be either continental or planetary.

My working hypothesis is that we are now well into the formation of an interactive planetary society, for the first time ever in human history, and that this novel interconnectivity has begun to enmesh all strata of humankind, not just a privileged elite. Corollary to this notion is the contention that the interdependencies within all three realms—the human, economic, and ecological—are themselves intimately related. What the hypothesis does not necessarily imply is that this evolving state of affairs is leading to the obliteration of place-to-place differences. Observations of the economic scene suggest that interdependency does not automatically produce homogeneity; in fact, it may generate novel forms of spatial complexity.[2] Perhaps neither history nor geography is ending; instead both may

be mutating in unexpected ways. The validity of any such claim could be the central issue of some challenging future research and discussion.

The use of the sister-city movement as an entering wedge into the much vaster subject of a globalizing society is perhaps opportunistic, given the availability of much geographically and historically specific data, but it is also a rewarding choice. Although city-twinning is certainly not the largest or most critical element within a grander complex of ongoing change, it is closely allied with other, possibly more important but yet-to-be-studied, developments. Analysis of these twinnings may not result in a comprehensive explanation of what is happening to the life of humankind today, but it should enable us to begin asking some of the proper questions.

Since this is evidently the second more or less scholarly, and the first explicitly geographic, effort to treat this cheerful subject in the English language, some definitions and background information are necessary before I can turn to the business of description and analysis or approach the larger implications of sister cities.[3] After defining twinnings and discussing their key attributes, I pose four questions: (1) How did this movement come about and evolve? (2) What is the present-day spatial array of this set of dyadic relationships at both the international and intranational levels? (3) How can we account for their geographic patterns? and (4) The most inviting question of all, what lessons bearing on the evolving social and cultural geography of contemporary humankind can we draw from the sister-city phenomenon?

DEFINING SISTER CITIES

Certain special characteristics set the twinning of sister cities apart from other forms of long-distance social interaction. The formal agreements, usually made by local officials but occasionally by ad hoc citizen groups, are intended to last indefinitely (although, of course, some may be canceled, suspended, or allowed to wither away for lack of lasting interest). Consequently, the relationship does not limit itself to carrying out a single project, but rather opens the way for a variety of shared activities, all presumably serving the overall objective of advancing mutual understanding and friendship. In addition to the inevitable back-and-forth junkets involving dignitaries, the more popular modes of sociability include: athletic and musical events; visits by theatrical groups, craft persons, hobbyists, dancers, and other purveyors of culture; joint church worship; language instruction; the staging of festivals and trade fairs; experiments in the other community's cuisine; exchanges of letters, publications, schoolchildren, college students, war veterans, and members of professional organizations (but rarely spokespersons for political parties); the sharing of technical expertise; the extension of material and other forms of aid when one of the partners is struck by disaster; and a basically one-way flow of advice, information, equipment, and other types of assistance when the pairing is between an advanced community and a less-developed

one. The formula for interaction is that there is no set formula. Each pair of sister cities must experiment constantly to realize whatever ensemble of activities ideally suits their peculiar resources and objectives.

It is not surprising to find that the great majority of persons involved in such nonlocal altruism are unpaid volunteers. Moreover, with or without the encouragement of national agencies, the decision as to whether to enter into a particular arrangement is initiated at the local level by the townspeople, not by any central bureaucracy. The foregoing statement hints at a unique quality of the sister-city movement: that it is open to and professes to include as active participants the entire noninfant population of the coupled communities regardless of age, gender, occupation, social status, religion, or ideology, not just officialdom or special-interest groups.

It is also understood that exchanges of visitors will take place on a regular basis, at least once a year, but preferably more frequently, and that, in contrast to usual tourist practice, most sojourners will be accommodated as guests in private homes. A final unspoken understanding, at least among relatively advanced communities or others within similar socioeconomic circumstances, is that there is to be genuine reciprocity of effort and benefit, with neither community profiting at the expense of the other. As a definitional aside, it is important to avoid confusion between sister cities and twin cities, the latter item a characteristic phenomenon found along the Mexican and Canadian borders of the U.S. The only instances in which such twin cities happened to be twinned formally are those of Port Huron, Michigan/Sarnia, Ontario and El Paso/Ciudad Juarez. But, clearly, there must be many other cases in Europe and Asia, as well as North America, in which pairs of cities facing each other across an international boundary have functioned effectively, if unofficially, as sister cities.

A broad range of social-territorial communities have entered into twinning relationships. The great majority are municipalities and run the gamut from villages or communes up to the world's largest metropolises. But states or provinces, regions, counties or their equivalents, and urban neighborhoods, e.g., within Paris, London, Berlin, and New York City, have also been active players. For the sake of convenience, I use the term "sister city" generically throughout, whatever the actual character of the places discussed. In this study, I have included all such subnational entities but have omitted a number of specialized sets of linkages, such as the network that has recently materialized of employees in some 190 postal, telephone, and telegraph offices and their families in six European countries (British Post Office European Twinning Council 1989); the twinning of various port authorities; and the prospective linking-up of international airports or of commercial radio and television stations and their personnel. Also excluded is the twinning of communities *within* a given country, largely because of a research agenda centered on transnational transactions. Although this practice may be unknown in the U.S., it is fairly popular in several other lands. Thus I have recorded 229 instances within France, 180 in the Philippines, and the following totals in

other nations: Austria, 68; Denmark, 56; Canada, 52; Spain, 39; Federal Republic of Germany, 31; Belgium, 24; and Italy, 16.

Definitely worthy of note are efforts at "trinning" an even greater number of places, e.g., the creation of three-member sets of sibling communities or even larger "rings." Unfortunately, it is difficult to identify or tabulate such relationships, which, in any case, tend to be ephemeral because of the formidable complexities of keeping multilateral dealings in equilibrium. But such collectivities may be effective in pursuing short-term objectives, such as a specific development project in a Third World village.

The majority of the participating communities have affiliated with only a single foreign locality, but a sizeable minority have entered into polygamous relationships with two or more partners. The propensity for multiple twinnings is roughly associated with population size. Thus, within the U.S., Kansas City has four liaisons and Houston eleven, while Los Angeles leads with sixteen. But such lavish sociability is easily surpassed by several European metropolises. Moscow is twinned with twenty-five places, and at the moment Madrid appears to be the world champion with no fewer than thirty-six linkages.

It is important to realize that sororal arrangements between places are not arrived at casually. Normally many months or even some years of exploration, courtship, and mutual foreplay must pass before the union is consummated. The unwritten rule is that the two places should be roughly comparable in size and, more to the point, that they have the wherewithal for becoming compatible partners. Compatibility, in turn, implies some sharing of economic, cultural, ideological, historical, recreational, or other type of concern or perhaps a beneficial complementarity of interests.

HISTORICAL BACKGROUND AND TRENDS

If sister cities did not appear in their present embodiment, i.e., as well-defined, self-conscious elements in an organized movement, before 1950, they nevertheless fail to violate the principle that social innovations do not suddenly erupt from a historical void. Indeed we can discern several antecedents that helped set the stage for the advent of twinning. The earliest may well have been Christian missionary efforts overseas, enterprises subsequently joined by freemasonry, the Rotarians (Nixon 1984), and other transnational fraternal, professional, philanthropic (Curti 1963), and political activities of a nongovernmental nature. The series of world's fairs initiated in the 1850s may have also whetted the appetite for people-to-people dealings across international boundaries, as has the proliferation of business and scientific conventions and those organizations promoting social causes that also began during the past century (Fighiera 1984). More directly relevant perhaps were the spontaneous international relief campaigns generated by such calamities as the Chicago Fire of 1871 or the Tokyo Earthquake of 1923 or the local Vereine organized in North America around the turn of the century and thereafter by

immigrants from specific Old World communities with some participation by their offspring. The most immediate progenitor of today's organized transnational companionship among communities was the International Union of Local Authorities (IULA) founded at Ghent in 1913 (Philippovich 1983: 1).

Concurrent with the development of sister cities from 1950 onward has been a spectacular growth in international tourism and sport; the pen pal movement; the formation of a planetary community of radio hams (Heyman n.d.); high-level scientific and cultural exchanges; numerous exchange agreements among widely separated universities and the resultant study-abroad programs; the Peace Corps and similar governmental and private programs based in affluent countries, such as the Experiment in International Living, Servas International, and the efforts of the World Federalists, the Universal Esperanto Association, and likeminded organizations agitating for international amity, and those concerned with global environmental and social issues. And, of course, we have the advent of the "Global Village" through the wizardry of telecommunications.

If the social and technological preconditions for widespread twinning were in place by the 1940s, the one event that finally catalyzed the movement was obviously World War II. It did so in two ways. During and just after the conflict, a number of war relief organizations, e.g., Bundles for Britain, Russian War Relief, and American Aid to France, Inc., channeled assistance from North America to the stricken populations of allied countries, occasionally from one specific place to another overseas. Thus, for example, the special relationship that developed between Vancouver and Odessa in 1944 persists to this day. In similar fashion, some combatants from across the Atlantic who had personally witnessed the physical havoc and human suffering in particular European towns took it upon themselves to organize hometown programs to facilitate rehabilitation.

Secondly, within Europe itself, a number of local community leaders from both recently warring camps had thoroughly absorbed the lesson of the futility of intra-European warfare and were determined to render another Thirty Years War impossible. Consequently, they set about the work of healing, reconciliation, and long-term fraternity, creating active twinning relationships between pairs of municipalities, initially in France and Germany but later involving other countries as well.

It is to the latter scene that we must turn for the effective origin of a movement that has grown so vigorously in recent decades. Although there had been a scattering of spontaneous pairings in earlier years, such as the continuing bond between Brugg, Switzerland, and Rottweil, Germany, initiated in 1918, or the twinning of Veulettes/Mer, France, with Greenock, U.K., and Bordeaux with Bristol, both in 1947 (Casagrande 1987: 2), the idea of a more general, formally organized grassroots form of rapprochement did not truly germinate before a special meeting of French and German mayors at Mont Pèlerin, Switzerland, in 1948 (Campbell 1974: 19). This conference led to the formation of the International Union of Mayors for Franco-German Understanding in 1950, and September of that year

witnessed the signing of a twinning agreement between Ludwigsburg, Germany, and Montbéliard, France, the first of many hundreds of Franco-German partnerships to follow (Campbell 1974: 22, 29–32). After a relatively sluggish beginning in the 1950s, the twinning idea achieved takeoff momentum in the next decade, and has continued to flourish ever since. Although France and West Germany retain leadership as the zone of most intense activity, the notion of sister cities has spread widely and successfully into the remainder of Western Europe. Within each country there and elsewhere, we find a national association that, with or without higher sanction, helps coordinate and instigate twinning operations, arranges conferences of key personnel, and usually publishes newsletters, such as the British *Twinning News* (1974–), and other materials. As a matter of incidental interest, many twinning communities within the European Community have erected a standardized welcoming sign at their corporate limits, one listing their sister cities (fig. 1). The practice is virtually unknown in the U.S.

There is no need here to recount the complex details of the institutional history of the Pan-European phase of the movement, since it has been ably set forth by Grunert (1981: 58–77, 98–119), while in another doctoral dissertation, Mayer (1986) has explored in depth the legalistic aspects of twinnings, especially as they have involved the Federal Republic of Germany. It suffices to say that various supranational organizations have taken a lively interest in, or actively fostered, European twinnings. They include: the Parliament of Europe, the Council of European Municipalities and Regions, the International Union of Local Authorities, and the United Towns Organizations (Féderation Mondiale des Cités Unies et Villes Jumelées). The basic motivation behind such patronage is that, quite apart from the other incidental virtues of twinning, it is seen as a potent instrumentality for creating an economically and politically unified Europe. In the words of Thomas Philippovich (1983: 3) reporting on the work of the 1983 Congress of European Twinnings,

> CEM [the Congress of European Municipalities] has . . . been committed clearly and directly to promoting the political unification of Europe, within the implementation of common European policies in various sectors, the strengthening of the European Institutions and notably of the European Parliament, and the development of Europe's role vis-à-vis the other parts of the world and the need for it to speak with a single voice on the world stage.

For an eloquent discourse on the philosophical basis for such activity, see Serafini (1978).

But if the practice of bonding sister cities across international borders is a social innovation that, like so many others, originated in Western Europe and has registered its greatest triumphs in that region, it has also spread to other portions of the world. Quite early on, North America and other neo-European lands emulated the European example; and, as we shall see later, more recently, mainly in the 1980s, twinning arrangements involving communities in the First World and

those in the Soviet Union and socialist countries of Eastern Europe have begun to multiply rapidly. Similarly, there has been a notable outreach to Third World communities, also considered in greater detail below.

The evolution of the sister-city movement in the U.S., the world's third largest in number of twinnings, has followed a rather different course from that experienced by the emergent European Community. Whether it has been an essentially autonomous phenomenon or an off-shoot of the European model is a moot point. What is incontestable is that the American program materialized several years later than the European and lacked the urgency of catalyzing Continental unification or reconciling historically hostile nations. Although such farflung conviviality may be in keeping with traditional American extroversion and idealism, the specific ways in which sister-city links were forged also appear to reflect, unwittingly or not, the general diplomatic and commercial posture of the national establishment.

If 1956 was the birth year of an organized American program, certain precursors did exist ("Sister City Antecedents . . ." 1981). The most widely publicized case was that of Dunkirk, New York, which, under the leadership of a local notable, adopted Dunkerque, France, as its overseas ward and crafted a formula for interaction that was later to be widely imitated (Reynolds 1947; International Advisory Council 1957: 6–15). The initial year (1946) was a resounding success in terms of the intensity of activity in the American town, the material and moral benefits for the French community, and public applause on both sides of the Atlantic. But the program foundered in 1948 because of sheer physical and financial exhaustion on the part of the New York partner. Other less celebrated but equally spontaneous twinnings developed from within the U.S. during the immediate postwar years, but also lost momentum and vanished in short order (International Advisory Council 1957: 17–20).

The American sister-city movement as it now exists is a direct outgrowth of the People-to-People Program inaugurated with maximum fanfare by Dwight Eisenhower in 1956 (Juergensmeyer n.d.). This was a complex enterprise, one that established no fewer than forty-two committees, each with its own agenda. Although heavily festooned with altruistic objectives, there can be little doubt that the project was, in effect, a product of the administration's overall Cold War strategy, albeit one of its less malevolent components. Despite the president's deep personal interest and involvement, the People-to-People Program quickly degenerated into a fiasco, a classic example of how not to launch an ambitious new project meant to combine elements of the governmental and private sectors. Inter-agency rivalries and suspicions, squabbles over jurisdictional turf, and the failure to pry open the purses of private foundations spelled doom. Out of all the many subgroups, only the Civic Committee survived. In 1967 it was reorganized as a legal entity, a nonprofit association entitled the Town Affiliation Association of the U.S., Inc., with an operating wing called Sister Cities International (Oakland 1989). Operating out of headquarters in Alexandria, Virginia, and Los Angeles and

with funding from A.I.D., various foundations, business firms, and private bene-
factors, SCI has functioned quite effectively as clearinghouse, catalyst, match-
maker, and advisor (Anderson n.d.). The organization assists in the quest for
compatible mates, offers technical advice and assistance, publishes newsletters and
other reports, and initiates or participates in regional, national, and international
conferences of interested parties.

In a related development, we must note Partners of the Americas, an organi-
zation whose mission of furthering socioeconomic development in Latin America
and the Caribbean operates in a mode intermediate between that of the Peace
Corps and Sister Cities International. It is the only surviving progeny of another
ill-fated government project, President Kennedy's Alliance for Progress, and, not
too surprisingly, relies for the bulk of its support on government grants. With the
blessing of elected officials and other influential individuals, its modus operandi
is a series of alliances between each of forty-five American states or a major por-
tion thereof (the Dakotas, Nevada, Alaska, and Hawaii being the only holdouts)
with some compatible state or province south of the border. The beneficiaries of
such attention include all or most portions of every country in the southern por-
tion of the hemisphere except Suriname, the Dutch and French territories, and,
of course, Cuba. The program facilitates a series of specific projects with volunteer
workers and professionals, principally from the U.S. (Luria 1989). Since the part-
nerships in question do not fully meet the criteria for sister cities, of place-
twinning, as specified above, I exclude them from further discussion.

Until the 1980s, the vast majority of twinnings occurred among communities
within the First World; as a consequence, dealings between partners generally
operated on the basis of reciprocity, of transactions between different but essen-
tially equal places. With the extension to less affluent regions of the world, a sig-
nificant segment of the sister-city movement has begun to reexamine its objec-
tives and working methods. More specifically, many communities have embarked
on a new course because of skepticism and disillusionment concerning official
development programs managed by national and international agencies and ma-
jor foundations. This disenchantment culminated in 1985 with the issuance of the
Cologne Appeal at a conference of the newly formed Towns and Development,
whose subtitle is the European Consortium for NGO [Non-Governmental Orga-
nization] and Local Authority Joint Action for North-South Cooperation, and
whose slogan is "From Charity to Justice" (Kussendrager 1988: 92–100). The
United Towns Organization has also actively promoted "cooperation-twinnings"
between European and Third World communities, beginning as early as 1971
when it persuaded the United Nations to adopt a relevant resolution; UTO has
recently intensified its efforts in this direction.

Thus, in place of the traditional top-down development approach, Towns and
Development adopted a program, one with obvious political overtones, to pro-
mote *joint* planning and action involving local authorities and populations, a
grassroots effort to deal in a concrete way with such fundamental issues as peace

TABLE 1. *United States Sister City Twinnings, 1962–1989*

Year	Cities with Twinning Agreements	States Represented	Number of Twinnings	Foreign Countries Involved
1962	186	36	202	46
1965	305	42	342	52
1971	366	41	444	59
1974	465	41	577	65
1975	540	46	684	73
1976	602	46	781	75
1977	613	47	818	76
1978	640	48	847	78
1979	676	47	905	76
1980	683	47	917	77
1981	702	47	951	77
1982	718	47	984	77
1983	708	47	986	79
1984	726	49	1,035	84
1985	738	49	1,059	84
1986	750	50	1,100	86
1987	786	50	1,153	86
1988	801	50	1,205	87
1989	834	50	1,420	90

Source: Data from Sister Cities International.

and security, hunger and poverty, and environmental protection. In a parallel development, a number of local groups in North America have initiated programs with a similar blending of ideological and developmental objectives, and directed mainly at troubled areas in Central America, South Africa, and the Middle East. Although the North American movement has not yet formed any central organization, it does find a publication outlet in the quarterly *Bulletin of Municipal Foreign Policy* (1987–). I will return to the implications of these movements.

TEMPORAL TRENDS

It may not be feasible to chronicle the expansion of sister cities over space and time in full, accurate detail, but there is no question that the general trajectory of new twinnings has been moving generally upward, accelerating, since the 1950s. This contention is borne out by table 1 and its listing by year of the number of American agreements in force, as recorded by Sister Cities International. Although no tallies are available for the pre-1962 period, one should remember that,

TABLE 2. *Sister City Twinnings by Date of Initiation for Austria, Canada, China, Japan, Taiwan, and Switzerland*[a]

Year	No.	Year	No.
Before 1950	5	1970	20
1950	4	1971	15
1951	0	1972	30
1952	0	1973	37
1953	2	1974	28
1954	1	1975	27
1955	4	1976	26
1956	0	1977	30
1957	10	1978	38
1958	8	1979	63
1959	21	1980	63
1960	15	1981	87
1961	11	1982	92
1962	15	1983	80
1963	20	1984	93
1964	12	1985	134
1965	29	1986	103
1966	20	1987	82
1967	14	1988	78
1968	18		
1969	24		
		Total	1349

Source: See text.

[a] The only countries besides the U.S. for which data are available.

as of 1956, the score would have been close to zero. It is plain enough from these numbers that not every twinning proved to be durable—indeed some thirty-five "divorces" took place in 1983 (Anderson n.d.: 23)—but gains certainly far out-number losses. Table 1 does not present a complete listing of twinnings by U.S. communities. I have identified some 414 partnerships that escaped SCI's scrutiny, and it is likely that most of them are of recent vintage.

Another glimpse of temporal trends in sister city twinnings is offered in table 2, which lists the number of agreements made per annum from 1950 onward for six other countries, the only ones for which such data are available. This is obviously a far from random sampling of countries, excluding as it does all members of the hyperactive European Community, but the numbers are still instructive. From a halting beginning in the 1950s, the pace of twinning has picked up decidedly, if irregularly, over the years, reaching an apparent peak in 1985. If documentation

were at hand for the entire world, there is a strong possibility that 1988 might have been the banner year to date. As two shreds of evidence, there is the fact that twenty-three Soviet and West German cities were paired off in that single year (Leary 1989), and the semi-annual British *Twinning News* recorded forty-four new twinnings in its March 1989 issue.

It is much too early to speculate as to when (not whether, of course) the quantitative growth of twinnings will taper off or at what level the movement might stabilize. In fact, it is difficult to estimate how near saturation the twinning marketplace may be at the present time in any given land or to score countries comparatively on a quantitative scale ("8.000 villes préparent l'Europe" 1988?). Different countries have different rules for defining and delimiting territorial-political entities, and may occasionally review them; any jurisdiction that is a proper candidate for twinship has the option of affiliating with more than one partner. Thus it is unclear how many unrealized opportunities for twinning are available for, say, Denmark, whose 275 communes and 14 counties already account for 654 linkages with places in other lands, or whether France with 3,753 twinnings recorded for its 36,500 communes, 100 départements, and 22 regions is closer to some ultimate maximum than the Federal Republic of Germany with 3,239 twinnings racked up by 8,500 communes and cities, 237 Kreise, and 11 Länder. On the other hand, an officer of Sister Cities International reports that he is worried about running out of candidate cities in the United States in the foreseeable future (Oakland 1989).

SPATIAL PATTERNS

I have presented in table 3 the number of twinnings as of late 1988 identified for communities within some 190 countries, i.e., sovereign states, colonies, and other territories with a certain degree of autonomy, and the number of countries with which they have so affiliated. The values are cumulative in the sense of including any pairing reported in any year and so retaining an undetermined number of twinnings now dormant or dead. Despite earnest efforts, I am sure the table is incomplete. No definitive central register of twinnings exists anywhere, although the United Towns Organization has striven to create such a resource. A special printout from their data bank, which was kindly provided in early 1989, is the principal source for table 3, but I have supplemented the UTO material with a large number of items gleaned from a listing by the Council of Europe (1986) of the pairing among the communities of its twenty-one member countries, by rosters solicited from various national organizations and embassies, and miscellaneous reports appearing in newspapers, magazines, and other publications. Sadly lacking is any centralized record of the specific twinning activities of sister cities; we have only the occasional anecdotal account. Also unavailable are any comprehensive data dealing with the frequency, intensity, or results of exchanges.

The handling in this paper of the available data on the when and where of

TABLE 3. *Twinning with Places in Foreign Lands by Nation or Territory, 1988*

	Number of Twinnings	Countries		Number of Twinnings	Countries
France[1]	3753	79	Bangladesh[4]	62	4
Federal Republic of Germany[1]	3239	61	Ireland[1]	61	8
			Colombia[4]	60	25
United States[2]	1859	96	Burkina Faso[4]	54	6
United Kingdom[1]	1563	58	Romania[3]	52	25
Italy[1]	900	52	Argentina[2]	48	27
Japan[2]	771	47	Peru[4]	46	24
Denmark[1]	654	28	Ecuador[4]	43	26
Norway[2]	645	22	Guatemala[4]	42	22
Finland[2]	609	22	Chile[4]	39	25
Belgium[1]	589	36	Costa Rica[4]	39	24
Sweden[2]	546	25	Faroes[4]	35	3
Netherlands[1]	478	36	India[4]	35	11
Austria[2]	432	32	El Salvador[4]	33	23
Spain[2]	413	60	Turkey[4]	32	16
U.S.S.R.[3]	401	62	Algeria[5]	31	15
China[5]	364	31	Dominican Republic[4]	30	23
Nicaragua[5]	323	37	Paraguay[4]	30	23
Canada[2]	297	45	Bolivia[4]	28	22
German Democratic Republic[3]	290	31	Honduras[4]	28	24
			Rwanda[4]	28	5
Australia[2]	259	23	Venezuela[4]	26	21
Israel[2]	242	28	Uruguay[2]	25	21
Mexico[4]	229	31	Egypt[4]	24	13
Yugoslavia[3]	218	26	Panama[4]	24	22
Bulgaria[3]	217	33	Greenland[4]	23	3
Switzerland[2]	204	21	Puerto Rico[4]	22	22
Philippines[4]	182	31	Cuba[5]	21	21
Portugal[1]	144	45	Mauritania[4]	21	4
Brazil[4]	139	28	Cameroon[4]	17	5
Czechoslovakia[3]	129	27	Cyprus[4]	17	10
Poland[3]	117	26	Kenya[4]	15	5
Taiwan[2]	112	9	Ghana[4]	12	4
Hungary[3]	100	17	Ivory Coast[4]	12	7
Iceland[2]	94	10	Madagascar[4]	12	3
New Zealand[2]	89	10	Vietnam[5]	12	7
Greece[1]	86	22	Zambia[4]	12	8
Tunisia[4]	84	22	Lebanon[4]	11	5
Luxembourg[1]	73	14	Jamaica[4]	10	4
Senegal[4]	72	16	Malaysia[4]	10	6
Republic of Korea[2]	69	12	Papua New Guinea[4]	10	3
Morocco[4]	68	21	Tanzania[5]	10	5
Mali[4]	66	7	Gambia[4]	9	3

(*Continued*)

TABLE 3. (*Continued*)

	Number of Twinnings	Countries		Number of Twinnings	Countries
Mauritius[4]	9	4	People's Republic of		
Nigeria[4]	9	3	Korea[5]	3	3
Pakistan[4]	9	6	Malawi[4]	3	2
Gabon[4]	8	2	Saudi Arabia[4]	3	3
Indonesia[4]	8	5	Sierra Leone[4]	3	2
Somalia[4]	8	2	Trinidad & Tobago[4]	3	3
Congo[4]	7	4	Zaire[4]	3	3
New Caledonia[4]	7	3	Afghanistan[5]	2	2
South Africa[2]	7	5	Bahamas[4]	2	2
Togo[4]	7	3	Burma[5]	2	2
Zimbabwe[4]	7	4	Central African		
Libya[5]	6	4	Republic[4]	2	1
Sri Lanka[4]	6	4	Guinea-Bissau[4]	2	2
Belize[4]	6	1	Monaco[2]	2	2
Cape Verde Islands[4]	5	4	Mozambique[5]	2	2
Haiti[4]	5	4	Nepal[4]	2	2
Iran[4]	5	3	Niger[4]	2	2
Liberia[4]	5	2	San Marino[2]	2	1
Benin[4]	5	2	São Tomé & Principe[4]	2	2
Ethiopia[5]	4	4	Solomon Islands[4]	2	2
Guam[4]	4	4	Sudan[4]	2	2
Mongolia[5]	4	3	Tahiti[4]	2	2
Andorra[2]	3	2	Thailand[4]	2	2
Botswana	3	2	Uganda[4]	2	1
Burundi[4]	3	1	Guyana[4]	2	2
Guadeloupe[4]	3	3	Liechtenstein[2]	2	2
Guinea[4]	3	3			
			Total[6]	11,283	
			[Σ/2]		

Source: See text.

[1]European Community member.

[2]Other advanced capitalist country.

[3]Advanced socialist country.

[4]Less developed capitalist country.

[5]Less developed socialist country.

[6]The total includes values for the following countries for which only a single twinning has been identified: Albania,[5] American Samoa,[4] Angola,[5] Barbados,[4] Brunei,[4] Cayman Islands,[4] Falkland Islands,[4] Fiji,[4] Gibraltar,[2] Grenada,[4] Jordan,[4] Kuwait,[2] Laos,[5] Lesotho,[4] Macao,[4] Marshall Islands,[4] Oman,[4] Palau,[4] Qatar,[4] Réunion,[4] St. Vincent & Grenadines,[4] Syria,[4] Tonga,[4] Yemen Arab Republic,[4] and Yemen Democratic Republic.[5] The following countries appear to have no twinnings at all: Antigua & Barbuda,[4] Bahrain,[4] Bermuda,[4] Comoros,[4] Djibouti,[4] Dominica,[4] Equatorial Guinea,[4] French Guiana,[4] Hong Kong,[2] Kampuchea,[5] Kiribati,[4] Maldives,[4] Malta,[4] Martinique,[4] Namibia,[4] Nauru,[5] Netherlands Antilles,[4] New Britain,[4] St. Christopher & Nevis,[4] St. Lucia,[4] Seychelles,[4] Singapore,[2] Suriname,[4] Swaziland,[4] Turks & Caicos Islands,[4] Tuvalu,[4] United Arab Emirates,[4] Vanuatu,[4] Virgin Islands,[4] Western Sahara,[4] and Western Samoa.[4]

twinnings is technically rudimentary: absolute numbers and percentile values plus rather generalized maps. The nature of the materials at hand does not justify the more sophisticated analysis that may become feasible in the future after we have collected more detailed information, including some quantifiable variables associated with specific twinnings.

Although the cartographic rendering of its contents would pose a ticklish design problem, table 3 is a kind of proto-map as well as tabulation. In any event, even a cursory glance confirms the fact that the sister city phenomenon is firmly anchored in Western Europe and a few other so-called advanced regions and there is a notable degree of correlation with conventional measures of socioeconomic attainment. Bolstering this observation is the fact that the thirty-one countries completely outside the twinning sisterhood are all miniature or seriously underdeveloped, or both. Insofar as one can infer geographic process from structure, table 3 seems to depict an intermediate stage in the hierarchical (and partly spatial) diffusion of a social innovation.

The diffusible character of twinning is apparent even within the European Community where we find the three outermost members—Greece, Portugal, and Ireland—still lagging well behind the core states. As would be expected, the other relatively advanced capitalist countries of Europe, including Austria, Switzerland, Spain, and the Scandinavian, have adopted the practice with decided enthusiasm, as have the overseas neo-European nations of North America, Australia, New Zealand, and Israel, along with upwardly striving Japan. Indeed East Asia in general, with the baffling exception of Hong Kong, has eagerly, if rather belatedly, taken the sister-city idea to its heart, as evidenced by the figures for China, the Philippines, South Korea, and Taiwan. The spurt in Chinese activity is all the more remarkable for its recency. Thus the twinning of Duisburg and Wuhan, the first between Chinese and West German communities, occurred in October 1982 (Leitermann 1988b: 617).

The Chinese experience parallels that of the Soviet Union and suggests that, in certain respects, the era of glasnost extends well beyond the latter's borders. The Soviets have been making up for lost time within the recent past in their fraternal outreach, not just to socialist lands, but to the capitalist countries as well (Ivanitski 1988). A report from the Third Annual U.S./Soviet Sister Cities Conference in 1988 has it that "the movement . . . has grown phenomenally during the past two years (with 27 new twinning agreements expected to be signed before the end of 1988). . . . Within the next five years, the group hopes to complete a further 100 official pairings" (U.T.O. News, Feb.–March 1989: 4). Even the hard-line regime of the German Democratic Republic finally relented and countenanced the first twinning between towns in the two Germanies in spring 1986 (Leitermann 1988a: 172). And, as table 3 indicates, twinning has become popular throughout Eastern Europe, with the predictable exception of the hermit republic of Albania. Given the stunning political upheavals in Eastern Europe during 1989 and the relaxation of barriers to travel and communication, it seems reasonable to forecast a healthy

expansion of twinnings involving the six republics in question. Indeed the process seems to be off to a running start as of early 1990 (Hubler 1990). In mid-1990, a twinning was established between Cleveland, Ohio, and Bratislava, Czechoslovakia.

When we turn to the Third World, we find that the sister-city idea has fared only moderately well in North Africa and is generally much weaker south of the Sahara. The course of developments in the Republic of the Congo may be representative of the level and timing of twinning agreements in the Third World in general as well as Tropical Africa (Banzouzi 1989). Although l'Association des Amis de Jumelages de la République du Congo received authorization to sign the necessary agreements in 1967, the initial pact was not concluded until 1975, the first of only seven to date (three with France and one each with China, East Germany, Italy, and the USSR).

Aside from Mexico (with its many ties to U.S. communities), Brazil, and Nicaragua (about which more later), twinning has developed poorly so far in Latin America, and many of the agreements that do exist link capital cities and are, I suspect, quite nominal in character. But the nadir of the phenomenon is unquestionably in southern Asia from Vietnam and Indonesia on the east to the Mediterranean on the West (Israel excepted). It is especially hard to understand why up-and-coming Thailand has been so reluctant to participate or why commercially gregarious Singapore has totally refrained. Similarly puzzling is the fact that India, with its hundreds of thousands of cities and villages and a population of roughly 850 million, has less than half the twinnings reported for minuscule Luxembourg with its one-third of a million inhabitants. The relatively high count for Bangladesh reflects the charitable impulses of some Western European communities that are appalled by its particularly horrendous succession of social and environmental crises rather than any mutuality of efforts.

In an effort to illuminate more clearly the relationships between level of twinning activity on the one hand and socioeconomic and political status on the other, I have compiled table 4. It presents the number of twinnings within each of five categories of countries and between each pair of categories. With the exception of the European Community, the cross-classification of countries within the two capitalist/socialist and advanced/less-developed dichotomies (see superscripts in table 3) is a matter of subjective judgment, and the assignments involve a good many decisions I am not eager to defend. I am confident that the configuration of the table would change only slightly if another, better qualified student were to categorize the countries. Because the table tallies the participation of each partner in a two-way relationship, the values represent double counting.

The tabulation reconfirms the preeminence of the European Community in the twinning world. The twelve countries in question account for slightly more than half (51 percent) of known relationships; and, furthermore, more than two-thirds of their linkages are internal, i.e., with members of the EC. The same sort of questing after one's own kind is evident in the values for the twenty-three non-

TABLE 4. *Sister City Twinnings by Category of Country, 1988*

			EC	I	II	IIIA	IIIB	Total
	European Community	No.	7,852	2,218	675	531	238	11,514
		(%)	(68.2)	(19.3)	(5.9)	(4.6)	(2.1)	(100.0)
I	Other advanced	No.	2,218	2,790	292	894	433	6,627
	capitalist countries	(%)	(33.5)	(42.1)	(4.4)	(13.5)	(6.5)	(100.0)
II	Advanced socialist	No.	675	292	524	87	42	1,620
	countries	(%)	(41.7)	(18.0)	(32.3)	(5.4)	(2.6)	(100.0)
IIIA	Less-developed	No.	531	894	87	442	62	2,016
	capitalist countries	(%)	(26.3)	(44.4)	(4.3)	(21.9)	(3.1)	(100.0)
IIIB	Less-developed	No.	238	433	42	62	10	785
	socialist countries	(%)	(30.3)	(55.1)	(5.3)	(7.9)	(1.4)	(100.0)

Source: See text.

EC countries labeled "advanced capitalist." Intra-categorical agreements account for a plurality of the total, but there is also a relatively high level of mingling with Third World communities as well as with those of the EC.

Such a mildly incestuous pattern is less well pronounced within the bloc of advanced socialist lands. Although transnational camaraderie has been growing at a healthy pace among the countries of the Warsaw Pact, such expressions of Second World sociability are outnumbered by twinnings with places in the capitalist camp, and especially the EC. Sister-city relationships within the Third World are not negligible, except for the socialist component thereof, where I have tracked down only five pairings. However, the greater part, at least three-quarters, of affiliations have been with First World communities. Most intra-Third World ties are with distant rather than nearby lands. The only notable regional clustering of sister cities within the Third World, a Northwest African network, may be the doing of the Union of African Towns, which happens to have headquarters in Rabat. Thus we have the following sets of twinnings among these Islamic countries: Morocco/Tunisia, 17; Mali/Senegal, 7; Senegal/Tunisia, 4; Mauritania/Morocco, 3; Morocco/Senegal, 3; and Mali/Tunisia, 1.

If we disaggregate the total tableau and look at the distribution of the sister-city outreach for specific countries, we gain substantially more insight into the geographic implications of the subject, and also edge closer to the next major question: the possible explanations for such spatial patterns. At this point in some ideal publishing world, the reader would be scanning a 159 × 159 table displaying how many sister-city relationships exist between Country X and Country Y in each of 12,561 cells. For obvious reasons, that is not possible here. Suffice it to say that, with only 1,042 linkages between pairs of countries, some 92 percent of the cells would be blank. It is feasible, however, to present, by means of table 5, the number of twinnings among the twenty-two leading countries, which account for

TABLE 5. *Number of Twinnings among Leading Countries, 1988*

	1	2	3	4	5	6	7	8	9	10	11	12	13	14	15	16	17	18	19	20	21	22	Other Countries	Total
1. France	X	1,361	87	664	257	37	7	3	5	249	9	36	32	134	54	19	15	69	138	4	40	3	530	3,753
2. West Germany	1,361	X	113	411	183	22	61	9	36	122	28	173	250	14	47	18	49	5	22	1	61	1	252	3,239
3. United States	87	113	X	102	50	231	7	18	15	10	23	17	14	37	31	88	91	58	0	72	44	162	589	1,859
4. United Kingdom	664	411	102	X	23	3	17	12	4	26	12	41	6	3	21	18	20	17	4	41	5	0	113	1,563
5. Italy	257	183	50	23	X	15	6	2	0	20	3	12	24	26	26	17	16	5	25	7	32	0	151	900
6. Japan	37	22	231	3	15	X	0	2	0	4	2	6	16	3	22	120	0	38	1	42	1	14	192	771
7. Denmark	7	61	7	17	6	0	X	162	132	0	162	10	4	1	4	1	2	1	3	0	5	0	69	654
8. Norway	3	9	18	12	2	2	162	X	169	0	166	2	1	1	11	0	1	1	0	0	3	0	82	645
9. Finland	5	36	15	4	0	0	132	169	X	0	93	1	2	0	58	0	7	4	14	0	1	0	68	609
10. Belgium	249	122	10	26	20	4	0	0	0	X	2	73	6	4	3	6	3	4	1	0	3	0	53	589
11. Sweden	9	28	23	12	3	2	162	162	93	2	X	2	1	0	6	1	16	1	1	1	1	0	17	546
12. Netherlands	36	173	17	41	12	6	10	2	1	73	2	X	11	1	1	2	16	10	1	0	8	0	55	478
13. Austria	32	250	14	6	24	16	4	1	2	6	1	11	X	0	5	3	8	1	2	0	1	0	45	432
14. Spain	134	14	37	3	26	3	1	0	0	4	0	1	0	X	5	1	44	1	2	1	4	19	112	413
15. U.S.S.R.	54	47	31	21	26	22	4	11	58	3	6	1	5	5	X	1	0	5	10	1	0	1	89	401
16. China	19	18	88	18	17	120	1	0	0	6	1	2	3	1	1	X	0	15	3	8	0	1	42	364
17. Nicaragua	15	49	91	20	5	0	2	1	7	3	16	16	8	44	0	0	X	0	0	2	0	1	32	323
18. Canada	69	5	58	17	38	1	1	4	4	4	1	10	1	1	5	15	15	X	0	9	10	0	43	297
19. East Germany	138	22	0	4	1	3	3	0	14	1	1	1	2	2	10	3	3	0	X	0	3	0	63	290
20. Australia	4	1	72	41	7	42	0	0	0	0	0	0	0	1	1	8	8	9	0	X	3	0	68	259
21. Israel	40	61	44	5	32	1	5	3	1	3	0	8	1	4	0	0	0	10	0	3	X	0	20	242
22. Mexico	3	1	162	0	0	14	0	0	0	0	0	0	0	19	1	1	1	0	0	0	0	X	27	229

Source: See text.

9,248, or 84 percent, of the totality recorded in table 3. Here the reader can discern a relatively small percentage of blank cells as well as certain regional and other types of groupings. But, for greater insight into the territorial patterning of these transnational linkages, one can turn to the listing for several selected countries that exemplify the more important varieties of spatial arrays.

In considering the roster of countries having places coupled with communities in the U.S. (table 6), one fact strikes us immediately: the truly global reach of such transnational chumminess. With ninety-six countries represented, the American sister-city network is more widely dispersed than those for even France and West Germany. (If all the tangled spokes of such far-flung affection were drawn on a map, we would discern something resembling an unusually excited millipede.) This impressive set of linkages quite plainly reflects the pervasiveness and complexity of American dealings—political, commercial, social, and cultural—with the rest of the inhabited world. One striking feature of the table is the fact that all of the six leading countries have been antagonists with whom the United States has waged declared or undeclared warfare at one time or another. This leads one to speculate on the salience of reconciliation as a motive in seeking out distant partnerships. Also prominent on the list are a number of past or present "client states," including Taiwan, the Philippines, Israel, and the Republic of Korea.

Anyone expecting to find propinquity playing a conspicuous role in explaining table 6 is certain to be disappointed. The only visible support for the gravity model is in the second-place position of Mexico and, much less persuasively, Canada in the eleventh slot. It is noteworthy that near-neighbor Cuba is completely missing from the list, and there is only a single twinning to report for the equally proximate Bahamas or for Puerto Rico and none at all for Bermuda.

The case for the efficacy of the neighborhood effect is much more powerful elsewhere in the world, but perhaps nowhere more convincingly than in Scandinavia. Although Denmark is a member of the European Community, no fewer than 511, or 78 percent, of its 654 twinnings are with other countries of the Nordic bloc, leaving only 101 with other (non-Scandinavian) members of the EC and 33 with the remainder of the world (table 7). Proximity in physical or, perhaps more meaningfully, cultural space exerts itself here with a vengeance. Although much smaller in magnitude, this decided regional clustering of twinnings within Scandinavia is a counterpart of the situation within the core zone of the EC.

Something of the same predilection for near-neighbors, physically, culturally, and ideologically speaking, manifests itself in Bulgaria's liaisons (table 8). Only 14 percent of its sister cities lie outside the socialist, mostly Eastern European, realm. But perhaps the disproportionate representation of the Soviet Union, accounting for half the total twinnings, is less a matter of post–World War II political posture or physical location than the heritage of the nineteenth-century pan-Slavic movement that made the two countries such enthusiastic bedfellows.

There is no resemblance whatsoever between the spatial array of Israel's sister-city affiliations and those for such countries as Denmark or Bulgaria (table 9).

TABLE 6. *United States: Twinnings with Places in Foreign Countries, 1988*

Country	No.	Country	No.
Japan	231	Switzerland	9
Mexico	162	Dominican Republic	8
Federal Republic of Germany	113	Ghana	8
United Kingdom	102	Denmark	7
Nicaragua	91	Kenya	7
China	88	Nigeria	7
France	87	Poland	7
Taiwan	87	Yugoslavia	6
Australia	72	Belize	5
Philippines	72	Egypt	5
Canada	58	Jamaica	5
Italy	50	Paraguay	5
Israel	44	Senegal	5
Brazil	42	Honduras	4
Spain	37	Liberia	4
Republic of Korea	31	Luxembourg	4
U.S.S.R.	31	Tanzania	4
Colombia	30	Uruguay	4
Sweden	23	Bolivia	3
New Zealand	22	Cameroon	3
Portugal	18	Mali	3
Guatemala	18	Panama	3
Norway	18	Turkey	3
Netherlands	17	Venezuela	3
Ecuador	16	Haiti	2
Finland	15	Cape Verde	2
Peru	15	Iran	2
Costa Rica	12	Ivory Coast	2
Ireland	12	Malawi	2
Argentina	11	Morocco	2
Austria	11	Pakistan	2
Chile	11	Tunisia	2
Greece	11	Zambia	2
Belgium	10		
El Salvador	10	Total[a]	1,859
India	9		

Source: See text.

[a] The total includes the following countries for which only a single twinning has been identified: Algeria, American Samoa, Bahamas, Benin, Botswana, Bulgaria, Burkina Faso, Burma, Cayman Islands, Cyprus, Fiji, Gambia, Iceland, Jordan, Lesotho, Mauritania, Nepal, Puerto Rico, Romania, St. Vincent & Grenadines, San Marino, Sierra Leone, Sri Lanka, Thailand, Togo, Trinidad & Tobago, and Vietnam.

TABLE 7. *Denmark: Twinnings with Places in Foreign Countries, 1988*

Country	No.	Country	No.
Norway	162	Italy	6
Sweden	162	Israel	5
Finland	132	Austria	4
Federal Republic of Germany	61	Poland	4
Iceland	29	U.S.S.R.	4
Greenland	20	German Democratic Republic	3
United Kingdom	17	Hungary	2
Netherlands	10	Nicaragua	2
France	7	Switzerland	2
United States	7	Yugoslavia	2
Faroes	6		
		Total[a]	654

Source: See text.

[a] The total includes the following countries for which only a single twinning has been identified: Bulgaria, Canada, China, Czechoslovakia, Romania, Sudan, and Switzerland.

TABLE 8. *Bulgaria: Twinnings with Places in Foreign Countries, 1988*

Country	No.	Country	No.
U.S.S.R.	107	Algeria	2
Czechoslovakia	18	Italy	2
German Democratic Republic	18	Japan	2
Hungary	10	Mongolia	2
Poland	10	Netherlands	2
Romania	9	Portugal	2
Yugoslavia	6	Spain	2
Greece	5	Turkey	2
France	3	Vietnam	2
United Kingdom	3	Total[a]	217

Source: See text.

[a] Total includes the following countries for which only a single twinning has been identified: Belgium, Cyprus, Denmark, Finland, Sweden, Tunisia, and the United States.

TABLE 9. *Israel: Twinnings with Places in Foreign Countries, 1988*

Country	No.	Country	No.
Federal Republic of Germany	61	United Kingdom	5
United States	44	South Africa	4
France	40	Spain	4
Italy	31	Australia	3
Canada	10	Belgium	3
Netherlands	8	Norway	3
Portugal	6	Philippines	2
Denmark	5	Total[a]	242

Source: See text.

 [a] Total includes the following countries for which only a single twinning has been identified: Austria, Argentina, Brazil, Chile, Cyprus, Finland, Greece, Japan, Luxembourg, Romania, Sweden, and Switzerland.

Indeed, given the location of the country amidst a constellation of hostile Islamic entities, the pattern of the Israeli connections is totally opposite to what the gravity model would lead one to predict. Thus we observe only a single Middle Eastern relationship, and that, we must assume, with a Greek Christian community in Cyprus. Obviously, considerations other than mere distance are uppermost, with historical, commercial, diplomatic, and cultural factors being conspicuous among them. It is especially revealing to discover that Israel, which has had such intimate dealings with South Africa, accounts for nearly all the twinnings of the latter's Caucasian communities.

In many ways, the most extraordinary array of twinnings among all our 159 participating countries is that involving Nicaraguan communities (table 10). The exceptional number of this small republic's twinnings—it even exceeds the total for populous Mexico or Brazil—has little to do with location, history, or economics, but is a reflection instead of wide-spread humanitarian and/or ideological concern for a beleaguered society among certain segments of First World populations from as far afield as Australia. We also have here a form of social activism that runs counter to the current foreign policy of at least one world power and may be raising hackles in some official quarters in European capitals. Nicaragua's regional network of partnerships is similar to those for nearly all other countries in Latin America: formal ties between Managua and the other capital cities, but with no other communities, not even in the case of Cuba.

SUBNATIONAL PATTERNS

In turning to the location and relative incidence of sister cities within particular countries, we both sharpen our research questions and increase the analytical pos-

TABLE 10. *Nicaragua: Twinnings with Places in Foreign Countries, 1988*

Country	No.
United States	91
Federal Republic of Germany	49
Spain	43
United Kingdom	20
Italy	16
Netherlands	16
Sweden	16
France	15
Austria	8
Switzerland	8
Belgium	7
Finland	7
Australia	2
Denmark	2
Total[a]	323

[a] Total includes the following countries for which only a single twinning has been identified: Argentina, Brazil, Bolivia, Chile, Colombia, Costa Rica, Cuba, Dominican Republic, Ecuador, El Salvador, Guatemala, Honduras, Liechtenstein, Luxembourg, Mexico, Norway, Panama, Paraguay, Peru, Portugal, Puerto Rico, Uruguay, and Venezuela.

sibilities. The first and most obvious conclusion striking us upon plotting numbers of sister cities by state or region within a nation is a replication of that same general correlation between level of socioeconomic development and popularity of twinning already discerned at the international level. Thus, in the Italian case, the great majority of participating communities are located in the Piedmont and other relatively advanced sections of the north (which also happen, by more than mere coincidence, to be closest to the most favored target areas), while sister cities are exceedingly rare in Sardinia, Calabria, and Sicily. There is a similar clustering of twinning communities in the relatively affluent southeast of Great Britain.

The American situation (as recorded by SCI) is rather more complicated, although a crude state-level association between twinning and general developmental status is clear enough (fig. 1). The outstanding feature of the map is a prodigious concentration of activity in California, whose total of 355 twinnings exceeds the sum of twinnings in the next five states. Even allowing for the fact that we are considering the most populous state, here is additional testimony for the contention that, for better or worse, California has become the leading region, the core center, for social innovation within the late twentieth-century U.S.

The rather high incidence of twinning in nine of the traditional Middle Western states, especially Michigan, in a region once notorious for its isolationism,

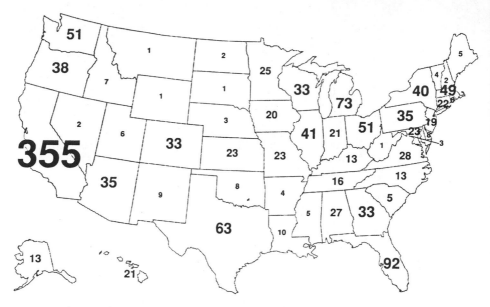

FIGURE 1 Number of twinned United States communities by state, 1989. Source: Sister Cities International 1989.

may be regarded as counter-intuitive; contrariwise, not every border or coastal state, e.g., New Hampshire, scores at all impressively. Although table 6 demonstrates the weakness of the distance factor in the selection of foreign partners, at least in the aggregate, compass orientation does matter a great deal in the selection of these faraway siblings. While not rendered cartographically here, simple inspection of the roster of American twinnings (Sister Cities International 1989) reveals that Latin American connections are especially prevalent in states along our southern perimeter, there is an even stronger Asian affinity on the part of the five Pacific states, European ties are particularly common in the Eastern states, and, predictably, twinnings with Canadian places are easiest to find in the northern states.

The mapping of how many French sister cities have affiliated, by region, with places in which of seven nearby fraternally important countries generates results resembling those observed for the U.S. (fig. 2). Once again there is a crude correlation between general socioeconomic attainment (and perhaps the inventory of amenities) in a country that is the leading player in the sister-city enterprise and the incidence of twinnings. Thus Corsica reports only a single sister city, and the numbers for such less prosperous regions as Auvergne and Franche Comté are 27 and 35, respectively. In contrast, the highly urbanized and industrialized Nord Region claims 143 twinnings, Provence/Côte d'Azur 131, and Rhone-Alpes 226, not to mention the 323 enumerated for the Paris Region.

The factors of distance and orientation combine to skew the patterns for extra-

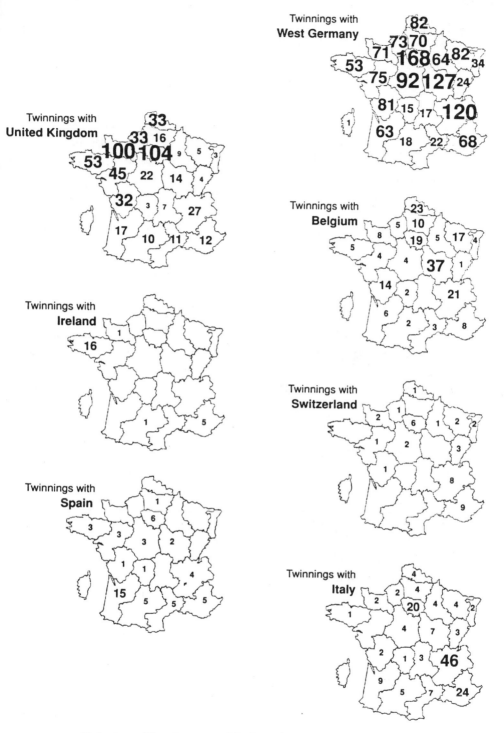

FIGURE 2 Twinnings of French communities by region, 1988. Source: Conseil des Communes et Régions d'Europe 1989.

mural communal affection. In each of the seven smaller maps comprising figure 2, proximity clearly plays a prominent role in shaping twinning decisions. This is especially obvious in the case of the British, Belgian, Italian, Spanish, and Swiss connections. The strong propensity for Irish communities to twin with places in Brittany (more than a quarter of all Ireland's sister cities) is patently a celebration of ancient Celtic commonalities as well as surrender to the friction of distance. And, of course, it is not a simple task to disentangle locational from cultural-historical considerations in the other cases, since the two sets of factors have interacted throughout the ages. Distance-decay is present, if not so immediately striking, in the most important set of French affiliations—those with the Federal Republic of Germany—its importance having been mapped convincingly elsewhere by Grunert (1981: 116). But however germane distance and direction may be in general, it is most interesting to note how many communities outside France have ignored mileage and opted for sisterhood with localities along or near the Riviera and in the attractive alpine districts of the country.

EXPLANATORY FACTORS

In evaluating candidates for a close, presumably long-lasting twinning relationship and in reaching eventual agreement, the prospective sister city faces decisions at two spatial levels: Which country? And which specific town, city, region, or other locality within that country? Although more still remains to be said on the topic, we have already discussed the relevance and complexity of distance and orientation at both geographic scales. Important though spatial constraints may be, another factor may outweigh them in fashioning the macro, i.e., international, structure of the sister city system: the political or, more precisely, the political factor set in historical perspective. In this connection, once again, the reconciliation of former foes is peculiarly important. Indeed rapprochement between recent belligerents was the crucial motive not only in the genesis of postwar Western European twinnings but has also mattered substantially in other parts of the world. Thus we find a proliferation of post-1950 liaisons between German, Austrian, and Italian towns on the one hand and places in their erstwhile enemy and conquered territories on the other, most notably France, Great Britain, Belgium, the Netherlands, the U.S., Yugoslavia, and the Soviet Union. The same scenario applies to Japan, for its cities have shown a special partiality for partners in the U.S., Canada, China, Korea, Australia, New Zealand, the Philippines, and France. The theme of reconciliation also looms large in the outreach of Israel's twinning communities, especially, of course, toward the Federal Republic of Germany.

On the other hand, the persistence of strained relations, or outright hostilities, between countries will negate any prospect of twinning. It comes as no surprise to find that the two Iranian twinnings with American cities have been placed on hold since 1979. Note again the absence of any U.S.–Cuban connection or the total lack of American pairing with towns in North Korea, Laos, Ethiopia, Angola,

Libya, South Yemen, or Syria. The unavailability of visas and other official restrictions make twinning with such lands a virtual impossibility. In a similar vein, no Chinese city sees fit to link with any in India; none in India has been bold enough to embrace a partner in Pakistan; and any sort of liaison between communities in the two Koreas is still unthinkable. And, as already suggested, South Africa seemed to be everyone's favorite pariah in the 1980s.

Quite apart from what we may hope are only temporary barriers to transnational socializing, there also remain those ancient grudges between nations that refuse to go away and which make town twinnings an awkward proposition at best. Thus only 6 of Ireland's scant 61 twinnings are with British communities; a measly 3 of Poland's 117 are with municipalities in the Soviet Union, the most deeply, persistently detested of its neighbors; no Greek city deigns to pair off with any in Turkey; and it is only quite recently that the first, and thus far only, twinning has materialized between a pair of Chinese and Soviet municipalities.

Closely related to the political is another potent factor that accounts for many of the broader geographic lineaments of the sister-city movement: the existence of a historic connection between a pair of countries. Thus in the majority of instances where a motherland has exported major streams of emigrants overseas, we find the anticipated abundance of sister-city pairings. Among the more striking examples are: the significant volume of twinnings between communities in Spain and those in Mexico, other Latin American lands, and the Philippines; the ten Portuguese-Brazilian affiliations; the fifty-two involving Japan and Brazil (a favored colonization target); the sixty-nine between France and Canada; and, as evidence of the durability of the long umbilical cord stretching between Great Britain and its Australian and New Zealand offspring, the existence of forty-one and eleven twinnings, respectively. The same situation generally prevails between the imperial powers of Europe and the U.S. and their former colonial possessions. In fact, it is the exceptions, such as the absence of twinning between Dutch and Indonesian communities, that pique our curiosity.

Long-lasting cultural sentiment also comes into play. Perhaps the most striking example I can muster comes from Hungary. Its nineteen twinnings with Finnish communities, second only to the twenty-three with West German places, seem to be premised on the truly ancient linguistic/ethnic linkages between peoples of two rather widely separated republics. On the other hand, I am taken aback by the absence of any twinning relationship involving English and Greek partners given the strong philhellenism that has prevailed in Great Britain for so long. Similarly, it is puzzling to document only a single British-Portuguese affiliation when the two countries have been so diplomatically cordial for centuries. A final self-evident factor operating at the macro-scale concerns relationships between relatively affluent, advanced countries and disadvantaged Third (or Fourth) World nations: the humanitarian or philanthropic impulse. A few examples will suffice, all between countries with no particularly meaningful historical association, even though one can never be certain that other calculations do not enter the picture.

Thus we find thirteen twinnings between the Netherlands and Bangladesh, fourteen between Japan and Mexico; West German towns have eight and three partners in Burkina Faso and Senegal, respectively; American communities are allied with seven in Kenya and three in Mali; Canada has two Ghanaian connections; and France has seven with Rwanda. The list could be greatly extended.

When we dip below the national scale to explore the choice of specific partners within a given pair of countries, we discover additional factors at work. Nonetheless historical ties retain their importance. Citing only examples within the American scene, Fall River, Massachusetts, is coupled with no fewer than five Portuguese towns; Santa Fe, New Mexico's three sister cities are in Spain and Mexico; and Tuskegee, Alabama, is twinned with three West African cities; New Glarus, Wisconsin, has recently linked with the canton of the same name in Switzerland, the source of its original settlers; at least four of Finland's American mates are localities with large complements of Finnish Americans; and Calais, Maine, cherishes sisterhood with Calais, France, on the basis not only of names but of early exploration and settlement as well. In a recent variant of this practice, a number of twinnings have developed between cities in Northwest Europe and the source areas in Southern Europe of their guest workers and their would-be permanent residents.

Sister cities bereft of any historical ties can often ground their relationship on some shared social or economic interest (Grunert 1981: 159; Sergent 1983: 26–27). Thus Negritude may be the basis for the selection of Litwe, Zimbabwe, by predominantly black Detroit, the twinning of both Philadelphia and Newark, New Jersey, with Douala, Cameroon, or the linking up of Washington, D.C., with Dakar, Senegal. Within the economic realm, the instances of major port cities that have twinned are too numerous to be cited, as is the case with communities identified with wine-making, but the linking of places along the same canal (Metz/Luxembourg) is less common. It is minimally surprising to find Pittsburgh affiliated with Sheffield, Saarbrucken, and Bilbao, or the coupling of the textile cities of Troyes, France, and Tournai, Belgium; and the Houston/Baku alliance seems made to order. Within the world of recreation what could be more appealing than the twinning of Vail, Colorado, with St. Moritz, Switzerland, or Aspen with Germany's Garmisch Partenkirchen? Similarly, all three of Lexington, Kentucky's sister cities—Deauville, France; Kildare, Ireland; and Shizunai, Japan—are notable centers for thoroughbred activity. Shared musical activities provide the rationale for the match between Charleston, South Carolina, and Spoleto, Italy, while the twinned cities of Chartres and Ravenna are both artistic meccas. New York City's Greenwich Village has found its inevitable soulmate in Paris's Montmartre, while Fort Lauderdale's twinning with Australia's Gold Coast is one of those marriages made in heaven. The possession of major universities is a logical reason for pairing Heidelberg with Montpellier or Ann Arbor with Tübingen. The cathedral towns of Speyer and Chartres have found it easy to form a partnership, as have Fulda and Arles, both seats of archbishoprics; and a similar explanation holds for

Aachen and Reims, the traditional sites for the crowning of monarchs in their respective kingdoms. Among the more esoteric excuses for twinning is identification with major paleolithic archaeological sites (Mauer, West Germany/Tantavel, France) or association with a renowned individual, as is the case for Pontcharra, France, and Rovasenda, Italy, which claim the birthplace and grave respectively of Bayard, 1473–1524, the heroic French soldier, "the knight without fear and without reproach." As previously noted, overseas missionary ties can segue into formal twinning as has occurred, for example, between Stavanger, Norway, and Antsirabe, Madagascar (Juncker 1988), and several towns in Flanders and Zaire (Hillegies 1987: 4).

Political ideologies can also manifest themselves in the quest for compatible partners, principally in European cities and some of their neighborhoods, but with increasing frequency in the U.S. as well. The twinning of Madison, Wisconsin, with Arcatao, El Salvador, and Managua is a case in point. One of the more striking European examples is that of Bologna, traditionally a radical stronghold. Among its seventeen sister cities, we find the following eight in socialist lands: Leipzig, East Germany; Brno, Czecho-Slovakia; Cracow, Poland; Kharkov, U.S.S.R.; Annaba, Algeria; San Carlos, Nicaragua; Tunduru, Tanzania; and Zagreb, Yugoslavia. Ten of Paris's arrondissements are twinned with foreign communities, and seven of them, presumably working-class in character, have affiliated with districts within East Berlin and no other places. On occasion, as with a few Soviet-American proposals and the effort to link Lambeth (Greater London) with a Nicaraguan town (Minghi 1989), there have been unpleasant public rows over the propriety of such uses of public or other funds.

Identity or similarity of names provides the cue for a surprising number of twinnings. It is a factor in no fewer than fifty-three American instances and thirty West German, thirty-three involving Spanish communities, thirty-five in Australia, and fifteen in Canada. But, curiously, despite ample opportunity, I have spotted only a single case involving an Israeli community: the linking of Nazareth with its namesake in Belgium. Frequently there is a historical as well as toponymic basis for the relationship, as with the matching of Gloucester, Taunton, Wareham, Wilbraham, Plymouth, and other municipalities in Massachusetts with corresponding places in England. Or the sister cities may be descended in some fashion from a common source, e.g., Albany, New York, and Australia, or the Hamiltons located in Australia, Canada, and New Zealand. In still other arrangements the source has hooked up, directly or otherwise, with its onomastic progeny, as happened when Stroud, Oklahoma, twinned itself with Stroud, England (with or without some historical excuse), along with Strouds in Australia and Canada. An especially piquant example of a three-generation relationship is that of Cartagena, Spain, which is twinned with Carthage, Tunisia (its parent), and Cartagena, Colombia (its offspring). In many instances, the toponymic twinnings seem whimsical, although one must assume other factors help sustain the collaboration. Only chance identity of names led to the pairing of Toledo, Ohio, with the Spanish city, San

Marino, California, with the minute republic of the same name, Jamestown, New York, with Jakobstad, Finland, Venice, Florida, with Venezia, or tiny Montevideo, Minnesota, with the outsize capital of Uruguay, but these relationships seem to be thriving or at least enduring. In a few cases, there may be no historical or etymological basis for a twinning, just a linguistic accident, as I suspect may have happened in the case of Salem, Oregon, and Salem, India.

An ample residuum of sister cities remains for which no real or imagined historical relationship or convergence of social, cultural, or economic preoccupations offers raw material for long-distance dalliance. Occasionally the explanation for a particular twinning is to be sought in the personal histories of the community's makers and shakers, be they war veterans, transplanted business executives, or other influential immigrants. In many other instances, the affiliation may be a matter of free choice among a number of random candidates, but only presumably after investigation produced some reasonable basis for long-term association. In this connection it is noteworthy that newsletters of twinning associations frequently carry notices by various communities in search of proper twins in which they set forth their major attributes and attractions, for example, the requests for partners from twenty-nine communities in thirteen Third World countries appearing in *Cités Unies Bulletin* No. 133 (1988?: 24–27). They bear an uncanny resemblance to the personal ads running in certain American alternative periodicals. The mating call of North Gem, Kenya, exemplifies the genre:

> 30,000 inhabitants, situated in the Nyanza Province. Primarily an agricultural land. Very dynamic women groups undertake kitchen gardening, livestock keeping of dairy cattle and small scale coffee production, while maintaining social and educational activities. Projects to alleviate the water problem and set up more modern methods of farming. Whould [sic] like to twin in Europe, Northern America or USSR. (*Cités Unies Bulletin* No. 133, 1988?: 25)

Before leaving the topic of local selectivity, a final word on the relevance of distance is necessary. According to one commentator,

> The distance must be *neither too great*—for that entails high financial cost and difficulties in keeping a sufficient number of exchanges going—*nor too short*, or it deprives the twinning of much of its interest from change of scene and discovery of different customs and way of life. (Sergent 1953: 27; emphasis in original)

One could quarrel with half of this formulation in the sense that after the traveler crosses a certain threshold of time, expense, and distance, the cost of continuing onward may recede in relative importance, especially if the person originates in an affluent community. And there are also those two exceptional cases of twin cities hugging the borders of the U.S. that seem to be faring well enough as sister cities. But obviously only rigorous investigation of a large sample of individuals

involved in sister-city exchanges can settle the question. On the other hand, the claim that a successful twinning calls for a gap in sociocultural, as well as geodetic, space does ring true. The entire sister-city exercise would become pointless if the two communities were near-duplicates. A dash of the exotic is a vital condiment.

IMPLICATIONS AND CONCLUSIONS

How effective has the sister-city movement been? What results has it produced? We can pursue answers to such questions at two levels: the immediate number of personal exchanges and volume of other transactions generated by sister cities; and the less tangible contribution to transnational and local social, cultural, and political change.

Some Measurable Effects
Unquestionably, the personal traffic engendered by twinning is substantial. A report on the Western European scene as of 1983 notes that the average annual number of participants per community was 188, and "this means that with a total of 5,600 twinned towns, over a million people are involved in contacts every year" (von Lennep 1983: 15). A more recent account indicates that 120,000 young persons participate in French/German exchanges each year (Casagrande 1987: 7). Certain individual flows are well above average as may be the case, for example, for that between Cherbourg and Poole, U.K., which generated some 30,000 "exchange days" in the period 1977–88 (*U.T.O. News*, Feb.–March 1989: 4). In the U.S., seventy-two sister cities, or roughly one-tenth of the total existing in 1983, reported 7,294 personal exchanges (Anderson n.d.: 36). If the value per American community ranges well below the European number, greater travel distance and expense may be a partial explanation. In any case, we can conservatively estimate the current annual total of individuals involved in sister city exchanges throughout the world as falling between one and two million.

Impressive though this number may be, and the monetary expenditure it implies, as is also the statement that 56 percent of the EC's population lives in twinned towns ("8.000 Villes Préparent l'Europe," 1988?), such values must be viewed in proper context. This two-way traffic is at least one order of magnitude smaller than the volume of international tourism, and the disproportion in terms of travel expenditures is undoubtedly even greater. But one must temper this observation by noting how the impact of sister-city travel is qualitatively distinct from that registered by ordinary tourists. The sister-city sojourners frequent many places that are seldom or never the object of touristic interest. Moreover, they may engage in intense interpersonal encounters leading often to lasting relationships (sometimes even marriage) of the kinds so uncommon in the standard tourist journey.

But before assessing the immediate or long-term results of twinning at the

global, national, or local scale, there is another factor to take into account: the population size of the communities in question. The scattered evidence at hand, e.g., Grunert (1981: 174–75), corroborates an intuitive speculation: the larger the place, the less likely the average inhabitant will participate in sister-city activities or even be aware that the relationship exists—especially if they are multiple in character, as they so often are in major cities. Conversely, the smaller the community, the greater the likelihood of both awareness and personal involvement.[4] Thus it is reported that in many twinned West European communes with fewer than a thousand residents, more than 75 percent of the population attend the twinning ceremony (Grunert 1981: 174). The excitement produced by foreign visitors may be a total novelty in the small town or village, and the impressions and attitudinal changes prompted by these shared enterprises could be deep and long-lasting. In the large metropolis, on the other hand, twinning activities must compete, often unsuccessfully, with all manner of multiple distractions. It is a reasonably safe bet that no Los Angeleno outside city hall personnel can name even half of that metropolis's sixteen foreign twins on the spur of the moment; and have even the officials in charge memorized all thirty-six of Madrid's sister cities?

This inverse relationship between population size and extent of involvement in twinning is of more than minor import. However consequential the opinions and policies of small town and rural residents may be locally or regionally, they matter less in the larger scheme of things than the thought patterns of metropolitan folk, for it is in the larger cities that decisive economic, social, and political power dwells and where the instruments of national opinion-making gather, process, and dispense their products.

Another way in which twinning activities can have measurable effect is through direct or incidental economic fallout, leaving aside the personal spending of exchange visitors. Despite high-minded protestations by instigators of twinning, the prospect of expanding local commerce, tourism, manufacturing, and other enterprises entailing foreign investment or technology transfers is not at all distasteful. Formal twinning agreements can confirm and enliven existing commercial and touristic links between partners, and perhaps help initiate new economic relationships. The Federation of Canadian Municipalities is quite blunt about the matter. "A 'people-to-people' approach should not lose sight of possible economic benefits" (Federation of Canadian Municipalities 1988: 11–12). And under the heading "Twinning Pays Off," we learn about the dividends issuing from such pragmatism in two prize exhibits—Vancouver's five twinnings and Granby's (Quebec) ten (with four European, four African, one U.S., and one Canadian city). Thus, for example:

> The senior municipal official responsible for all construction in Guangzhou [China] spent time in Vancouver on an exchange program. While there he was exposed to Canadian technologies and techniques and, as a result, bought sev-

eral hundreds of thousands of dollars worth of computer-aided design and mapping software from a Vancouver company.

Although it may be unfair to single out the Chinese for special notice, they have been unusually candid about the business opportunities springing out of "friendship city" relationships. Thus:

Some Chinese provinces and municipalities have held trade fairs and negotiations, exhibitions of agriculture and Chinese cultural relics in the United States. The volume of transactions at each of such fairs totalled more than 10 million of U.S. dollars. (Zhang 1989: 5)

Unfortunately, we have only anecdotal evidence of this sort concerning the economic consequences of twinning and no way to ascertain its actual magnitude for any given country or the world. The calculations would be complicated by the fact that many states and municipalities engage in economic diplomacy programs unrelated to the sister-city movement (Fry, Radebaugh, and Panayotis 1989). All one can safely say is that the economic benefits flowing from the latter are nontrivial and must surely outweigh the costs.

Some Political Lessons?

Rising above such mundane chores as counting heads and dollars, there is a much grander question: What effect, if any, is the sister-city movement having on the changing shape of world society as well as on the hearts and minds of men and women in participating communities? Since this is an initial exploration of a recent (intensely geographic) phenomenon still in a state of rapid quantitative and qualitative flux, no ready answers come to mind.

The most useful lessons we can draw from sister cities may lie in the political realm broadly defined. As already suggested, a given country's array of twinnings tends to reflect the larger national interest. Under the benevolent gaze of the central regime, the sister-city program usually serves to advance politically acceptable commercial and diplomatic ends or is at worst neutral. The close accordance between official objectives and those of the twinners is especially clear in such instances, inter alia, as Japan, China, Israel, the Congo, and the supranational European Community. But the interests of the state are not static and may be diverging from those of past generations in this increasingly interdependent world. New conditions call for new attitudes among the citizenry. What we need to know is how effective twinning has been in bringing about the desired attitudinal shifts not just among organizers and activists but among the rank and file. It is unfortunate that we have had no such research yet. The appropriate surveys might be costly but should offer no particular technical difficulties.

If the sister-city movement is eager to claim victories, the one apparent success story is that within the European Community. The fact that we can look forward

within our lifetimes to a meaningful political and economic union of the twelve countries, and perhaps others as well, might seem to be, in good measure, the product of a dense network of twinnings and one enjoying the active support of a number of national and supranational agencies. But such a claim is difficult to substantiate. The results of Thomas Grunert's (1981) mail questionnaire directed to a sampling of town officials involved in European twinnings are surprisingly ambiguous, yielding no straightforward conclusion. Once again, we can resort to that time-honored ploy: the call for further surveys and updated data from investigations dealing with ordinary folks in both twinned and untwinned communities. Engaging in counterfactual history, it is altogether conceivable that so many other larger forces have been operating in Western Europe forging the emergent superstate that the outcome would be inevitable with or without the twinnings.

Interesting though the officially sanctioned system of sister cities may be, there is an expanding underside to the phenomenon that could be pregnant with meaning for future political behavior at local and transnational levels. Indeed we may be witnessing the activation of a "sorcerer's apprentice." Imbedded within the standard Twinning Oath so often signed with appropriate pomp by the solid burghers of Western Europe is the following potentially subversive phrase: "Aware that western civilization found its origin in our ancient local communities, and that the spirit of liberty was first recorded in the freedom won by them . . ." (Council of European Municipalities n.d.: 18). Whether or not the sister-city movement resuscitates a dormant premodern Western European tradition of civic autonomy, the vitality of latter-day "citizen diplomacy" may be one of a number of developments undermining the integrity of the nation-state system. Even at the local level, the twinning organization and other mission-oriented groups may be loosening the constraints of traditional legalisms, for "there is a slight tendency . . . as each twinning develops, for its organization to become less dependent on the local authority" (von Lennep 1983: 14), as well as the national authority.

One way of implementing the philosophy of "thinking globally and acting locally" is the practice, already noted as being codified in the Cologne Appeal, of a local First World community, acting solo or in concert with likeminded partners, engaging directly and intimately in development projects in less developed countries. It is, of course, too early to judge the success of this new North/South strategy as compared with the conventional top-down bureaucratic approach. In any case, no national or international agency could quarrel with the objectives, even though there may be some distress over tactics, such as the subterfuges whereby municipalities lacking the legal power to do so somehow manage to allocate public funds to needy communities in other lands (Soto Ferreiro 1983: 60). Similarly, in this period of more or less official detente between the capitalist West and the Soviet Union, it is difficult to grumble about local initiatives to build people-to-people programs with the Soviet population through sister cities and other devices (Warner and Shuman 1987: 360−63).[5]

But the degree to which national governments monopolize the shaping and

conduct of foreign policy becomes more contentious when "many local officials and citizens have embraced the logic of the Nuremberg trials and believe that they have a duty to fulfill international norms and laws" (Shuman 1986–87: 159) and when, in doing so, they defy official doctrine. In the U.S., the relevant legal issues are complex and have yet to be subjected to definitive judicial review or legislative or administrative action (Kincaid 1989; Shuman 1986–87; Spiro 1988). Much, but far from all, local American activism having foreign policy implications can be characterized as leftward-leaning, most notably in the struggle against South African apartheid and in support of Nicaragua's Sandinista regime. In any case, such dissident freedom of thought and action has aroused not a little fear and loathing in the American foreign policy establishment (Pasley 1987; Spiro 1988) and certain British and continental European offices as well. More than any other single development, it is the Nicaraguan situation that illustrates the potentialities of an autonomous sister-city movement and related transnational forms of citizen activism (Chilsen and Rampton 1988). Writing in 1986, Michael Shuman (1986–87: 193–94) notes that "more than 70 sister-city agreements between Nicaraguan and United States towns . . . have channeled more than $20 million in humanitarian aid to the Nicaraguan participants—all this despite decidedly unfamilial relations between the two countries at the national level," not to mention at least 100,000 U.S. visitors motivated by twinning relationships. In 1988 delegates from 115 cities in fourteen West European countries, Australia, the U.S., and Nicaragua discussed a city-linking movement providing material and moral aid for the Central American country through cooperation among the overseas communities ("European Conference on City-Linking with Nicaragua" 1988). Indeed it is plausible that without the sustenance provided by sister cities and other varieties of assistance by foreign localities (amounting to a great deal more than $20,000,000) the Nicaraguan revolution might well have succumbed to its adversaries.

SUMMARY AND UNFINISHED BUSINESS

What have we learned? Useful or intriguing though they be, the substantive findings in what, for the time being, can be little more than a descriptive treatment can only suggest much larger questions for future exploration. But these few rudimentary generalizations are certainly worth listing. First and most obvious is the fact of the recency of the sister-city phenomenon and an extraordinarily rapid growth in the late twentieth century in the number of participating communities and their territorial range. From all indications, this expansion is continuing at a brisk pace. Next I have discerned an emphatic positive correlation between number (and probably intensity) of twinnings and level of socioeconomic development at both the intra- and international scale, as well as an apparent inverse relationship between size of place and level of local interest.

But other factors also intervene. The level and pattern of these transnational twinnings are shaped, to a noticeable degree, by propinquity and/or compass di-

rection, historical and cultural legacies, and the diplomatic and commercial policies of the national regimes in question. Indeed the sister-city movement has certainly helped extend, solidify, and humanize the entrenched political and economic programs of participating states that are, in turn, increasingly interdependent members of a world system. On the other hand, it can be a double-edged instrument since a growing number of twinnings seek to promote social ideals that transcend national borders and/or constitute controversial enterprises that challenge statist interests and are a rebuke to the idea of the unbridled sovereignty and omnipotence of nation-states. In either case, a minority of the world's citizens too large to ignore are sipping the heady wine of local autonomy and perhaps rediscovering the meaning of community by joining hands with distant people, with ultimate consequences no one can foresee.

The larger implications of sister cityhood offer the scholar exciting but difficult challenges. I envision two general strategies, each of which feeds upon the other. It would be most rewarding to mount a series of case studies in a diversity of carefully chosen paired communities (the greater the number, obviously, the richer the results) to learn in detail the history of their linkage and the precise nature of current activities. Insofar as possible, such studies should delve into the effects of twinnings. What sorts of people were involved, in what ways, to what extent, and who was not? What has been the impact of twinning upon the community, upon individuals? How has consciousness been raised? How have attitudes and perceptions evolved? Any measurable economic or political results? In an optimal research project, the inquiry would continue over a significant span of time in order to detect both immediate and long-term effects.

The second approach would involve examining, probably at a less localized scale, the interrelationships between the sister-city movement and other forms of long-distance social interaction. One would seek to elucidate to what extent twinning has been cause or effect of such phenomena as international tourism, church missions and religious pilgrimages, trade fairs, labor migration, kith and kin contacts among international migrants, telecommunications, the peregrinations of college students, commercial dealings, the activities of NGOs, and a variety of other networks.

At the moment, the only certainty about the intrinsically fascinating spatial web of sister cities is that we are witnessing one of many facets of a new, swiftly evolving phase of social geography, one of many related forms of transnational activity that are profoundly restructuring the ways whereby the peoples of the world deal with each other. It will bear close watching.

Annals of the Association of American Geographers 81 (1991): 1–32

NOTES

I owe a special debt of gratitude to Dick Oakland of Sister Cities International, Alexandria, Virginia, for the sharing of personal knowledge as well as free access to office files.

1. No comprehensive study of the social and cultural dimension of transnationalism has appeared as yet, but useful discussions are available in Field (1971), Skjelsbaek (1971), Galtung (1980), Inkeles (1980), and Falk (1987), while a remarkably prescient volume by Stead (1901) appeared many decades ago. Despite limitations in topical, temporal, or spatial coverage, we do have some worthwhile contributions on specific portions of the large phenomenon in treatments, for example, of the spread of clock-time in the modern world (Landes 1983), the implications of printing for early modern Europe (Eisenstein 1983), the way in which the English language has conquered the world (Fishman, Cooper, and Conrad 1977), and the transfer or diffusion of major crop plants (Crosby 1972; Mintz 1985). As central an issue as any has been the impact of modern communications, but, amidst an enormous mass of literature, only a handful of scholars, e.g., Cherry (1971, 1978), Meyrowitz (1985), and Postman (1985), have considered the geographic or social consequences in any depth.

2. A recent work (Weiss 1989) that exploits census and market research data at the zip code area level for the U.S. in 1970 and 1980 strongly, but not yet convincingly, indicates a trend toward greater spatial segregation of pre-existing social groups and the appearance of new ones.

3. To date, aside from a single master's thesis (Campbell 1974), the North American literature on sister cities consists only of newspaper and magazine journalism, the essentially promotional output of the two national organizations and associated local offices, and some manuals for would-be participants, e.g., Warner and Shuman (1987) and Chilsen and Rampton (1988). The European situation is rather better. In addition to the same sort of material noted above, we have Grunert's (1981) detailed account of the evolution of European twinnings and the implications thereof along with a praiseworthy though somewhat dated sketch (pp. 81–98) of the world geography of twinning. It is, however, a presentation centered on the European scene with only cursory attention to the remainder of the world.

4. A personal comment by R. R. Grauhan, Président du Comité de Jumelage, Montier-en-Der, a town of modest size, as quoted by Grunert (1981: 175), drives home the point: "Personally, I have had the experience of asking residents of large cities (Nancy, Troyes, etc. . . .) the name of their sister city. The responses are disappointing—half of these individuals are unaware even of the existence of any twinning! In contrast, all the inhabitants of Montier-en-Der know Buchschlag, and vice versa. When a German auto with an OF license plate arrives in Montier-en-Der, the locals realize that it probably means Buchschlagers, and indeed they recognize that the green Taunus belongs to Herr Muller, the gray Opel to Herr Hans, etc. . . . and the opposite is true. I believe that such mundane details are the true expression of success."

5. Citizen diplomacy can take two forms. According to Lofland's (1989) persuasive study, the American sister-city outreach to the Soviet Union (and, one suspects, to China as well) is largely a nonideological, consensual, "feel-good" sort of affair in distinct contrast to the politically driven program involving Central American, Palestinian, and South African Black communities.

Conventionland USA

oes anyone need reminding that the shape of our economic, social, and cultural worlds today is strikingly different from what it was only a few decades ago (Inglehart 1990)? Or that we can associate much of the change with transformations in our social geography, with shifts in the spatial patterning of the ways in which we interact with other human beings near and far?

Peculiarly symptomatic of the emerging general order of things is a remarkable increase in the volume of objects being circulated hither and yon, the unprecedented pace at which commodities, information, ideas—and people!—are being transferred among places. It is an acceleration so rapid and so massive as to generate a qualitative as well as quantitative reshaping of the life of the species. If much attention has been lavished on movements of capital, business enterprises, and their products, much about them still awaits exploration, as do the implications of the newer modes of communication. Perhaps even richer in theoretical potential is the pendular traffic involving people themselves. Although many scholars have been looking at the huge expansion in domestic and international tourism (Urry 1990: 47) and long-distance flows of migrant labor (Jones 1990: 244–247), we are still far from grasping the full meaning and consequences thereof. Smaller in magnitude, but possibly more consequential than the numbers might suggest, and also less than adequately researched, is the increasing mobility of college students, businessmen, professionals and skilled technicians of all sorts, and participants in various transnational activities (Zelinsky 1991).

There remains one further form of circulation of surprisingly recent vintage that may have exceptional value in illuminating societal change but one that has thus far eluded serious scrutiny: national and international conventions. Whereas pilgrims, seasonal labor migrants, vagrants, itinerant scholars, mercenaries, affluent tourists, merchant adventurers, and other wanderers may have been among us for ages, the conventioneer is truly something new under the sun.

Why should conventions and conventioneers have appeared at such a late date

in social history? The answer seems to be that these events were neither needed nor practical until modernizing communities had crossed a certain threshold in terms of (1) an unprecedented diversification of social, economic, and cultural activity,[1] (2) the attainment of a critical level of interdependence among widely separated entities—a "network of networks" to use Hannerz's (1992) terminology—and (3) certain breakthroughs in transport and communication that facilitate these interconnections. Given the interdependencies among fragmented, widely scattered interest groups, the convention fills a communication niche otherwise left void; and individuals by the millions and localities by the hundreds have responded to the opportunities created by this innovation. The basic contention is that initiation and growth of convention traffic was not just one more perennial component of the general rise in territorial mobility that is so vital a part of the modernization process (Zelinsky 1971). Instead it is evidence of a qualitatively distinct latterday stage in that immense socioeconomic transformation.

Conventions and other types of conferencing are a manifestation of a revolution in the ways information is now being created and distributed. In a functional sense, these events offer a means for coping with an unprecedented explosion of knowledge, and they satisfy the need for interpersonal relationships among members of our atomized societies. The significance of these upheavals in the information scene has not been lost on specialized scholars (Castells 1989; Hepworth 1990). But scholarship dealing with the deeper meanings of the ongoing changes has lagged behind the reality, despite the pioneering efforts of Colin Cherry (1978, 1985). Clearly we are still far from initiating any theories that could clarify the entire dynamic world of communication, including its geographic component. Within geography, the study of communication is still in its infancy or early adolescence. The only book-length attempt to summarize existing knowledge, a multi-author publication, frankly admits its lacunae and stopgap status (Brunn and Leinbach 1990: xviii–xx). Not surprisingly, only two of its paragraphs touch on conventions, and those of a quite particular character (Brunn and Leinbach 1990: 65–66).

This paper, accordingly, amounts to an introduction to the geography and history of that latterday mode of communication to which we apply the term "convention" or some synonym thereof. Although it emphasizes the empirical, this introduction is pregnant with theoretical implications since the convention, more than any other kind of circulatory phenomenon, resides near the core of our new social order. A truly definitive treatment of conventions might well contribute not simply to a fuller understanding of contemporary patterns of human circulation but would also help meet the most awesome of challenges confounding the social scientist: building a general theory of social change. Given the shortcomings of data, however, the immediate goal is much more modest: testing the proposition that conventions, as entities sensitive to the altered circumstances of the postindustrial world, can tell us much about the structure and behavior of an evolving urban system. Do these events gravitate toward a particular class of places

emblematic of the new ways of handling the world's business and pleasures? Do they bear a message about the novel character of these places? But, before seeking answers to these questions, some preliminary matters intervene.

WHAT IS A CONVENTION?

Arriving at a good working definition of conventions is harder than one might expect. We can regard them as one category, the most elaborate as it happens, within that larger universe of events termed "temporary assemblages of human beings." The two most complex types of such ephemeral clusterings are Meetings and Conventions (I capitalize these terms here and henceforth when using them in the ways specified below). Although the two types of events overlap, they do differ in some important respects.

Meetings embrace a wide range of events but share one common essential attribute: some degree of obligation to participate by virtue of membership in a kinship group, friendship circle, corporation, work unit, school, political entity, church, or other (usually localized) organization. Meetings are normally place-bound and confined to a specific, well-defined group. Most are routine or repetitive, or at least cyclical, and the obligations are usually governed by tradition or necessity, as, for example, school classes, church services, factory and office shifts, committee meetings, family reunions, periodic markets, and many athletic gatherings. Still others are one-time affairs, but still rule-bound, as happens with weddings, funerals, political rallies, building dedications, or dinner parties. Some festivals, trade fairs, expositions, or sport tournaments may be hard to distinguish from genuine Conventions.

At least six attributes of Conventions distinguish them from Meetings and other transient clusters of human beings:

1. Conventions are carefully structured events with unique agenda that promise the dispensation of new information, and thus are unlike the annual repetition of Geography 101, the 3000th performance of *Carmen*, a Roman Catholic mass, or a Punch and Judy show.

2. As such, they are preplanned, announced beforehand, and require the services of organizers before, during, and often after the event.

3. They occupy a predetermined time slot and are relatively brief in duration, ranging from a half-day upwards to one or two weeks at the most, thus differing from such open-ended Meetings as certain treaty negotiations, judicial proceedings, or prisoner-of-war camps.

4. Conventions contain the potential for give-and-take, for active involvement rather than passive attendance, listening, and watching, as happens at so many Meetings. Conventions facilitate interaction among strangers as well as friends, enemies, and acquaintances.

5. Participants converge from a rather broad territory ranging from a single metropolitan area to the entire world, being drawn together because of some

specialized interest. In any case, for most registrants, the Convention takes place at a site well removed from their normal action-space.

6. And, perhaps most crucially, attendance is basically voluntary, although there are often not-so-subtle pressures to be present and counted.

Other features commonly characterize the Convention but are less central to its definition:

7. The authentic Convention usually generates an elaborate documentary trail.

8. Most Conventions observe a periodic schedule, generally meeting annually during a given season of the year, but many others follow a semiannual, biennial, quadrennial, or some other regular pattern usually, but not necessarily, in a different locale each time. Some events, however, are unique, ad hoc affairs.

9. Most Conventions mount exhibits and have sales booths at which relevant wares may be bought or ordered, a fact that sometimes makes it hard to draw the line between an exposition and a true Convention.

Identifying the meeting place may not enable us to classify events, for Conventions share space with all manner of other gatherings. This is especially true in the case of larger hotels, the most popular settings for Conventions, whether situated in downtown districts, suburbs, airport complexes, or recreational areas. Two or more Conventions may run simultaneously within the same building on days when weddings, local banquets, press conferences, closed business conclaves, and other non-Convention events are also scheduled. Municipal convention centers, which are growing in number, splendor, and complexity, can host trade shows, athletic meets, show-biz extravaganzas, and other happenings as well as Conventions. And the same observation applies to dedicated conference facilities operated on a nonprofit basis by colleges on or off campus or as commercial ventures, and for country clubs, churches, cruise ships, and federal, state, and other governmental buildings. The least useful criterion is number of participants. Values range from a small roomful upwards to 20,000 or even more for the largest of professional and fraternal organizations.

A FALLOW FIELD

Two formidable obstacles confront the study of Conventions: the paucity of relevant scholarly material (Shaw and Mazukina 1984; Abbey 1987: 267) and an inadequate supply of quantified place-and time-specific data. To be sure, there is a vast amount of material from American trade associations and publishers of such periodicals as *Association Meetings*, *Association and Society Manager*, and *Successful Meetings*, but their contents are singlemindedly profit-oriented and "how-to" in character, offering only crumbs for the social scientist. Such titles as "More Bodies, More Bucks" (Chipkin 1990) are not atypical.

At the international level, some serious scholarship has appeared in the work of such authors as Alkjaer and Erikson (1967), de Coninck (1990), and Fighiera

(1990), material published in the journal *Transnational Associations*, and via activities of the Union of International Associations. The slim volume by Mead and Byers on *The Small Conference* (1968), an admirable manual dealing with both transnational and more localized events, exists in near-solitary splendor, along with a related earlier symposial effort (Capes 1960), but is of only marginal relevance by limiting itself to occasions with "a single self-contained group around a table" (Mead and Byers 1968: vi). More recent analyses are scarce, as can be seen by scanning the extensive bibliographies in Rutherford (1990) and Getz (1991). Rare exceptions are Bradley Braun's (1992) analysis of the substantial contribution to Orlando, Florida's economy created by its Conventions, Christopher Law's survey (1987) of the growth and economic impact of conference and exhibition centers in Great Britain, and a single page on international Convention cities (Gappert 1989: 322–323).

Research on tourism has resulted in a thriving literature, but it tells us little about Conventions. The recent growth of academic interest in religious pilgrimages (Nolan and Nolan 1989; Rinschede and Bhardwaj 1990) suggests the possibility that work in that sector may eventually throw light upon one quite special category of transient gatherings. The intriguing phenomenon of reunions, many of which qualify as Conventions, has thus far received only cursory scholarly notice (Funderburk 1989; Swenson 1989). In short, taking an optimistic view, one may surmise that, for students of communications and circulation, the Convention constitutes a rich, but fallow, field for research.

THE DATA PROBLEM

Procuring usable statistics on Conventions is a truly daunting task. Their scarcity is a matter of organizational shortcomings, a lack of interest and/or capability on the part of governmental and other groups. No federal or state agency in the United States collects information on Conventions and related events in detailed, comprehensive fashion, and there is no prospect of any serious future effort. Some trade associations periodically survey the industry, but the published figures provide only national totals, and they fail to distinguish Conventions from trade shows, expositions, incentive travel, and other non-Convention business events. At the local level, 340 American organizations belonging to the International Association of Convention and Visitors Bureaus (1991) must maintain some sort of roster of events. Unfortunately, some localities lack such coverage, the offices in question apparently listing only those activities they help plan or coordinate or having other restrictive qualifications,[2] and most are unwilling or unable to furnish outsiders with the required data. Efforts to solicit information from bureaus serving the twenty busiest Convention metropolises yielded just five calendars containing relevant data.

Technical problems can frustrate even the best-intentioned organization trying to tally attendance at Conventions. Not every person who preregisters actually

TABLE 1. *National and International Convention Sites in the United States, by Metropolitan Status, 1964–1965 and 1990–1991*[a]

	Metropolitan	Non-metropolitan	Total
Number of localities			
1964–1965	167	72	239
1990–1991	205	117	322
Number of conventions			
1964–1965	4,909	236	5,145
1990–1991	8,750	326	9,076
Estimated participants			
1964–1965	5,814,476	98,600	5,913,076
1990–1991	12,828,160	177,394	13,005,554
Mean number of participants			
1964–1965	1,184	418	1,149
1990–1991	1,466	544	1,433

Source: *Successful Meetings* DataBank 1964, 1990.
[a] 1990 definition of Metropolitan Statistical Areas.

materializes; then there is the question of counting exhibitors, support staff, spouses, children, and hangers-on; and, as any seasoned convention-goer is well aware, every gathering of any size attracts a large, but indeterminate, number of gate-crashers who manage to evade detection and payment of fees.

The quest for information produced only a single compendium of Convention data meriting serious consideration: the annual *Directory of Conventions* published by *Successful Meetings* magazine and issued in two installments yearly. The initial book, the more massive of the two, lists events scheduled from January through December of the approaching year and, in lesser number, those planned for the following year. The *Supplement*, issued a few months later, carries the chronicle forward from July of the given year through the next calendar year. The volume of entries is impressive: some 14,907 in the initial 1990 volume for years 1990 and 1991 for the United States and Canada and approximately 2,600 in the *Supplement*, including an uncounted number of duplications. But the number of American events meeting the criteria for Conventions listed above is considerably smaller, as indicated in tables 1, 2, and 3.

The *Directory* groups Conventions chronologically within a given locality. A complete entry includes: name of organization; territorial range of event, that is, district or metropolis, state, regional, national, or international; *anticipated* attendance; name, address, and telephone number of organizer; dates; and meeting

TABLE 2. *Rank Order of Sites for National and International Conventions in the United States by Estimated Number of Participants, 1964–1965*

Rank by Estimated Number of Participants		Metropolitan Statistical Area[a]	Scheduled Conventions	
1964– 1965	1990– 1991		Number	Estimated Participants
1	3	Chicago, Ill.	620	969,920[b]
2	11	New York, N.Y.	690	831,796[b]
3	1	Washington, D.C.-Md.-Va.	307	462,065
4	27	Miami, Fla.	264	356,515[b]
5	42	Atlantic City, N.J.	113	297,535[b]
6	15	Los Angeles-Long Beach, Calif.	151	278,995
7	26	Philadelphia, Penn.-N.J.	267	274,965[b]
8	25	Detroit, Mich.	102	236,240[b]
9	6	San Francisco, Calif.	174	225,475
10	41	Cleveland, Ohio	133	160,150[b]
11	9	Dallas, Tex.	83	136,820
12	22	Denver, Colo.	148	117,345
13	19	St. Louis, Mo.-Ill.	107	111,285
14	31	Portland, Ore.	75	89,560
15	28	Minneapolis-St. Paul, Minn.-Wis.	76	87,985
16	2	New Orleans, La.	109	80,330
17	20	Kansas City, Mo.-Kans.	82	76,110
18	37	Pittsburgh, Penn.	67	69,720
19	10	Boston, Mass.	76	65,240
20	4	Las Vegas, Nev.	66	60,365
21	17	Houston, Tex.	68	52,270
22	40	Memphis, Tenn.	35	37,105
23	21	Cincinnati, Ohio-Ky.	44	33,980
24	30	Louisville, Ky.	28	29,855
25	13	San Antonio, Tex.	33	28,475
26	24	Indianapolis, Ind.	45	22,855
27	16	Seattle, Wash.	21	22,180
28	58	Buffalo, N.Y.	20	22,170[b]
29	33	Milwaukee, Wis.	33	19,905
30	81	Oklahoma City, Okla.	18	19,680
		Other MSAs (n = 137)	942	537,585
Total			4,909	5,814,476

Sources: *Successful Meetings* DataBank, 1964; Union of International Associations 1964.
[a] 1990 definition of Metropolitan Statistical Area.
[b] 1964–1965 value exceeds 1990–1991 value.

TABLE 3. *Rank Order of Sites for National and International Conventions in the United States, by Estimated Number of Participants, 1990–1991*

Rank Estimated Number of Participants	Rank Popu- lation	Metropolitan Statistical Area	Scheduled Conventions Number	Scheduled Conventions Estimated Participants
1	6	Washington, D.C.-Md.-Va.	625	927,162
2	41	New Orleans, La.	440	868,475
3	3	Chicago, Ill.	473	842,500[a]
4	65	Las Vegas, Nev.	313	760,600
5	9	Atlanta, Ga.	285	679,378
6	28	San Francisco, Calif.	399	663,961
7	16	Anaheim-Santa Ana, Calif.	178	582,950
8	45	Orlando, Fla.	382	561,374
9	12	Dallas, Tex.	177	476,345
10	7	Boston, Mass.	261	462,385
11	2	New York, N.Y.	247	435,795[a]
12	13	San Diego, Calif.	381	373,245
13	36	San Antonio, Tex.	284	332,245
14	49	Nashville, Tenn.	210	330,075
15	1	Los Angeles-Long Beach, Calif.	173	310,640
16	22	Seattle, Wash.	189	273,045
17	8	Houston, Tex.	93	240,848
18	18	Phoenix, Ariz.	251	240,676
19	15	St. Louis, Mo.-Ill.	149	231,345
20	29	Kansas City, Mo.-Kans.	83	184,985
21	31	Cincinnati, Ohio-Ky.	100	179,225
22	27	Denver, Colo.	128	170,195
23	17	Baltimore, Md.	139	169,540
24	39	Indianapolis, Ind.	82	163,370
25	5	Detroit, Mich.	91	147,130[a]
26	4	Philadelphia, Penn.-N.J.	154	144,015[a]
27	23	Miami-Hialeah, Fla.	113	136,545[a]
28	14	Minneapolis-St. Paul, Minn.-Wis.	126	131,185
29	44	Salt Lake City-Ogden, Utah	66	112,284
30	53	Louisville, Ky.	78	107,376
		Other MSAs (n = 175)	2,080	589,266
Total			8,750	12,828,160

Sources: *Successful Meetings* Data Bank, 1990; Union of International Associations 1990.

[a] 1964–65 value greater than that for 1990–91.

sites. On its face, this source may look splendid, but the *Directory* suffers from some grave defects. The number of registrants is estimated, and there is no way to determine how accurate the forecast may have been. Furthermore, a small proportion of the entries lack numerical estimates altogether.

But the most disturbing aspect of the *Directory of Conventions* is the incompleteness of coverage. A comparison of calendars provided by the Anaheim, Detroit, Los Angeles, San Antonio, and San Diego convention and visitors bureaus with listings in the *Directory* for the 1990–1991 period indicates that the latter failed to note between 27.3 and 32.1 percent of the events recorded by the bureaus. Compounding the problem is the fact that these organizations have neglected to chronicle events on college and university campuses and possibly other less conspicuous venues as well.[3]

MODUS OPERANDI

If I have persevered despite a data supply of limited utility, it is because of three considerations. First, the flourishing convention industry is much too important to be ignored by students of the contemporary scene, displaying as it does every sign of becoming even grander in magnitude; second, the likelihood that superior materials will ever supersede current data sources is poor; and third, and the truly decisive factor for a geographer, *after careful scrutiny, I find no evidence of spatial bias in the information presented by the* Directory of Conventions *except for deflated values in smaller, college-dominated communities.* From this point onward, then, the reader must keep in mind a major caveat it would be tiresome to repeat: although interareal patterns are credible and reasonably resemble actuality, especially for metropolitan areas, the absolute numbers most assuredly fall short of the true values.

I rely, then, for virtually all statistical data on the *Directory of Conventions* with only minor addenda from the Union of International Associations' annual *International Congress Calendar*, a series in which fewer than 20 percent of entries include predicted registration. Two time periods receive attention: 1964 and 1965 and 1990 and 1991; the latter because it was the latest compilation accessible at the outset of the project, the former because those were the oldest available volumes in the series. A biennial time-frame seems prudent as a device to dampen the impact of uniquely large events in certain localities.

I examined only those events that seem to satisfy the stated criteria for Conventions. Absent, then, are trade shows, expositions, sporting events, and the like. Present, however, are the auxiliary events clustering around some of the more formidable gatherings, such as the American Bar Association, Modern Language Association, or American Medical Association. In these cases, persons will register for two or more simultaneous or consecutive happenings and thus be doubled-counted.

Worthy of note is the endless variety of organizations holding Conventions

along with the sheer number thereof. Thus, consulting the "Industry Section" of the index for the principal 1990 *Directory* number, one that classifies all 14,907 entries, including trade fairs, pageants, expositions, etc., as well as Conventions, we find the following distribution by broad category: livelihood-related, 7,254; social, cultural, and physical betterment, 2,752; professional, 2,258; social, 1,034; science and technology, 1,024; leisure-related, 544; political, 8; other, 33. And, within each category, marvelous diversity.

Although I include Conventions of national Canadian groups held in American localities, the analysis omits the many events scheduled by American groups in Canada and other foreign venues. The propensity to arrange meetings of various kinds, including a great deal of incentive travel, in inviting places abroad has grown remarkably in recent years (Juergens 1990; Nestler 1990). Although the *Directory* grossly underreports these largely business-related excursions, the leading destinations noted for 1990–1991 are probably representative, namely (excluding Canada): Mexico, Bermuda, England, the Bahamas, Puerto Rico, Virgin Islands, France, and Jamaica.

A sharp narrowing of focus occurs by eliminating Conventions designated as District, State, or Regional in their geographical range, so that we have an analysis devoted solely to national and international items. The former categories richly merit study, but gatherings of continental or global scope offer the most immediate rewards for observers of the social scene. Moreover, the number of participants may be larger and the economic and social impact more substantial. For obvious reasons, planners who schedule state and regional events usually limit their choices to appropriate locales within the given state or region.

LOCATIONAL AND TRAVEL DECISIONS

What factors shape the decision to book an event in a specific place? And then, what factors determine just how many individuals will actually attend? Both questions presuppose a receptive community able to host Conventions of a certain size. As it happens, of course, only a minority of communities have the infrastructure and the desire for staging Conventions.

Site Selection

Deciding where to convene is usually the prerogative of the executives of an organization, sometimes in consultation with the membership. A primary consideration is membership size and thus anticipated volume of attendance. The largest American Conventions, those with 10,000 or more registrants, are constrained in locational choice to no more than a score of metropolises. Conversely, of course, if only 100 or fewer persons are expected, the locational possibilities are almost unlimited.

Organization officers often are besieged by the solicitations of potential host cities and barraged by generalized advertisements in trade magazines and other

media. But the hard-headed decision-maker will attend to the particular needs of her clientele (Dalton 1978). She must assure herself that the general setting is compatible with the nature and purpose of the meeting and the predilections of the members.[4] The optimum solution may range from the most sequestered of bucolic retreats to a crowded seaside resort, a motel under the flight path of a major airport, or the CBD of a large metropolis, among many options. But, in all cases, the sine qua non is the adequacy of physical facilities.

Accessibility is a close second. Attendance may be disappointing if the site cannot be reached quickly, comfortably, and at reasonable cost by most of the target group. As a matter of administrative convenience, there can be a bias toward assembling wherever the organization's headquarters are located. In some instances, associations have set up a geographical rotational system whereby each major region of the country receives its due in turn. In yet other cases the organization is rooted to a single site, as happens with the Daughters of the American Revolution and their annual Continental Congress in Washington's Constitution Hall.

Political factors can sway meeting planners. Just as it is most unlikely that any transnational group centered largely in the United States will select Havana, Tripoli, or Pyongyang, other organizations with headquarters abroad may balk at an American site if some members are barred from entry by reason of political belief or sexual preference. Not too long ago, American planners worried about whether Black, Jewish, Hispanic, and other minorities, as well as physically handicapped persons, would feel welcome or even find accommodations in the potential host community. And today entire states or particular cities face actual or threatened boycotts because of what are regarded as obnoxious laws, ordinances, referenda, or incidents involving sensitive social or political issues.

Sometimes historic factors can be decisive. Thus the Pearl Harbor Survivors are inclined to gather in Honolulu. Most college and military reunions (none of the former are listed in the *Directory*) take place at or near the alma mater or military base in question. Major anniversaries may bring associations back to memorable sites.

But overarching all of these factors and influences is another great, pervasive variable: the reputation or image of a potential Convention site. How attractive, interesting, and congenial is it perceived to be? How rich the array of amenities and other notable features? Although these judgments may be wholly or partly subconscious for individual conventioneers as well as organizers, they are nonetheless crucial. Such evaluations sometimes apply to an entire state. Most observers would admit, for example, that Mississippi (aside perhaps from Biloxi), West Virginia (aside from White Sulphur Springs), New Jersey (aside from Princeton and Atlantic City), and perhaps Utah have had their image problems. Whether these are deserved is beside the point. Perception is what matters, and it matters mightily.[5] Thus, to take a specific case, although Pittsburgh is now a much more attractive setting than during its manufacturing heyday, reality has not caught up

with the stereotyped image, and its Convention traffic may still be sliding downward. Conversely, such destinations as San Francisco, Honolulu, and New Orleans have prospered in good part because of seductive, exotic images projected on film and television.

A final factor, or, more accurately, alternative, is doing without conventional Conventions. There is much talk in the trade about adopting teleconferencing in terms of both cost savings and effectiveness of communication. The technology, however, is not yet fully elaborated, so that the verdict is pending (Abbey 1987: 271–272; Lieberman 1991).

Personal Decisions

At the personal level, other factors come into play in the decision to attend a specific Convention. Personal considerations, e.g., conflicts with religious holidays, family obligations, work or academic schedules, and the like, can enter the equation but are probably irrelevant in shaping the patterns shown in figures 1 and 2.

More to the point is affordability: costs in dollars and time of going and returning, registration fees, and subsistence away from home. For example, the dearness of almost everything in New York City serves as a disincentive (Bloom 1981: 50). Clearly too, peaks and dips in the business cycle affect travel decisions. Unpredictable contingencies play their part as well and act to depress attendance: transportation and hotel strikes, riots and epidemics or rumors thereof, and major fires, storms, and floods.

The accessibility factor must be mentioned again, this time as a major determinant of number of persons materializing at a given Convention or the totality of activity in a given locality. Larger metropolitan areas enjoy a built-in advantage simply by virtue of population size inasmuch as a disproportionate share of the locals will come and register while forgoing most expenses incurred by long-distance travelers. The advantage is all the greater if the metropolis is surrounded by a populous suburban and exurban commuter shed and lies within convenient reach of other major centers. That is one, but only one, of the reasons for the remarkable success of Metropolitan Washington. In addition to its 3.9 million residents as of 1990, Baltimore, Richmond, Wilmington, Philadelphia, and other substantial cities are only an hour or two distant by auto or rail.[6]

At the other extreme, one can only marvel at the improbable ascendancy of Las Vegas or the more modest, but still impressive, growth of Convention business in Salt Lake City. The former has a hinterland with a decided dearth of inhabitants, and both cities are hundreds of miles from other significant population concentrations. But, despite such glaring exceptions, anyone who analyzes registration records for most Convention towns will agree that the Gravity Model is alive and well.

When all is said and done, the appetite for novel experiences may be *the* crucial factor in reaching a go/no-go verdict, most obviously for those who have never

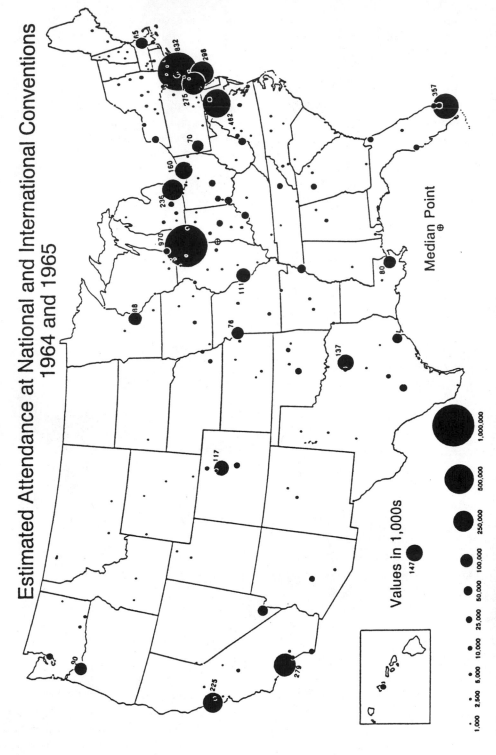

FIGURE 1 Estimated attendance at national and international conventions, 1964 and 1965.

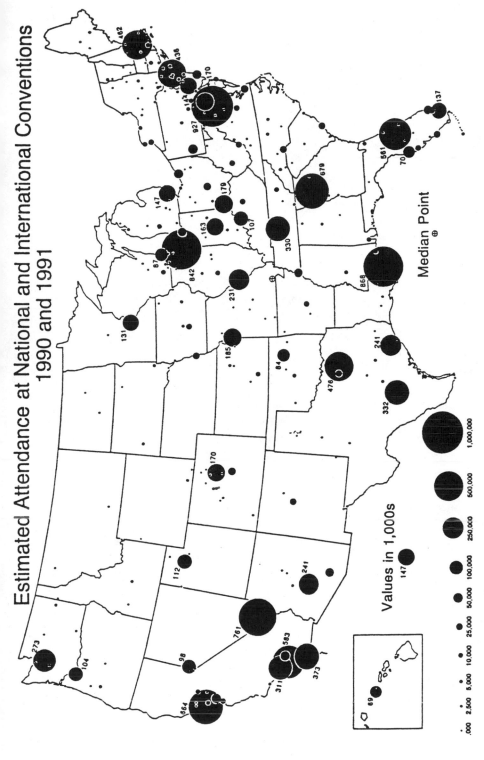

Estimated Attendance at National and International Conventions 1990 and 1991

Median Point
⊕

Values in 1,000s

1,000,000
500,000
250,000
100,000
50,000
25,000
10,000
5,000
2,500
.000

FIGURE 2 Estimated attendance at national and international conventions, 1990 and 1991.

previously sampled the Convention locality. And here, it is worth repeating, the role of image, of place perceptions, can be decisive. The long-term economic and demographic consequences of such initial exposure can also be substantial. One's first impressions may lead to later vacation or tourist trips, to a shift in residence before or after retirement, to accepting or rejecting job offers in the Convention area, or even to transferring a business there.

Some or all the factors discussed above may be influential in the fortunes of specific places, but, as we turn to the broader canvas and view the national scene, it becomes clear that more profound forces have shaped the macrogeographic patterns of conventioneering over time.

FINDINGS AND IMPLICATIONS

Quantitative Change

Tabulating and mapping the data extracted from the two sources discussed previously has produced tables 1, 2, and 3 and figures 1, 2, and 3. What is immediately apparent in inspecting table 1 is an impressive rise in Convention activity. Over a quarter-century interval, the number of localities hosting national and international Conventions increased by 34.7 percent, the estimated number of participants by 119.9 percent, and the mean number of participants per Convention by 24.7 percent.

Obviously we can attribute some expansion to simple national population growth, approximately 30 percent for the period in question. More meaningful perhaps has been the proliferation of formal organizations, i.e., those entities most likely to stage Conventions, and this we can document with confidence. The 1964 edition of the truly encyclopedic *Encyclopedia of Associations* lists 12,500 American groups, while no fewer than 22,389 appear in the 1992 edition, a gain of 79 percent.

Corroboration for the trends displayed in table 1 is available from other sources, but only for the recent past. It would be useful to consult the still nonexistent account of their origins and learn just when, where, and how Conventions came into being. In lieu of such, it is likely they materialized sporadically, but with increasing frequency, in the larger cities of the Western World during the late nineteenth century as modernization took hold decisively, although there may have been scattered earlier instances. What is certain is the recent trajectory of Conventions and related enterprises. Moreover, convention and visitors bureaus ("Turning Back the Clock" 1989), convention centers of all sorts (Migdal 1991), associations and publications catering to the meetings trade, and professional personnel have multiplied vigorously. Especially well chronicled is the boom in international congresses held in North America. These have increased from 70 in 1950 and 155 in 1960 to 1,072 in 1988 (Fighiera 1990: 95). Within the academic realm, Johnston (1991: 75–76) has noted the proliferation of conferences and symposia since the 1970s, often using major anniversaries as excuses for staging the events.

By the late 1980s, the American meetings industry, which includes Conventions

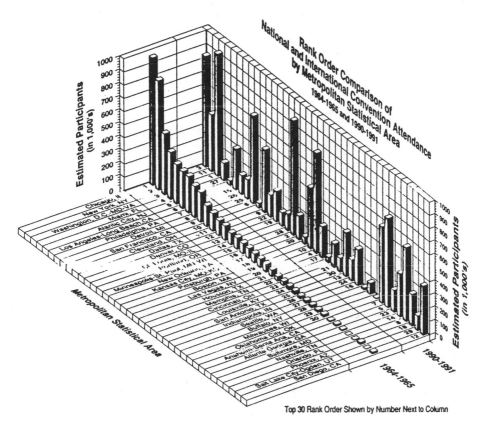

FIGURE 3 Rank order comparison of national and international convention attendance by metropolitan statistical area, 1964–65 and 1990–91.

inter alia, generated $44.5 billion (Halbrooks 1990: 16), and industry observers remain confident that growth will continue. Escalation of activity has been especially impressive during the past decade. According to an industry survey, attendance at association meetings rose from around 14 million in 1979 to 21 million in 1989, while related expenditures grew from $5.5 to $30 billion ("Meetings Are No Longer 'Filler' Business" 1990).

These findings are all the more impressive given the sluggish performance of the national economy since about 1973 and the apparent decline of per capita income during the past two decades. Indeed Conventions seem to be *relatively* recession-proof (Abbey 1987: 265). Thus, contrary to expectations, attendance at association meetings, expositions, and educational seminars remained steady during the 1981–1982 recession, however poorly the lodging industry may have fared in general (American Society of Association Executives 1983: 1). And history seems to have repeated itself during the troubling recession that materialized by mid-1990, although growth may have slackened temporarily ("Business or Pleasure?"

1991). Recessions have some effects, however. It seems that "association meetings exhibit more variability than the corporate segment of the market" because free-lance participants may be more sensitive to the condition of their wallets than persons on expense accounts ("Meetings Are No Longer 'Filler' Business" 1990).

Questions of Location

Turning to figures 1 and 2 and tables 1, 2, and 3, we enter forthrightly into the domain of social geography. As striking a feature of that geography as any is a marked unevenness in the distribution of events. Conventions are much more concentrated within metropolitan areas than is true for the American population as a whole. Nonmetropolitan localities (places with fewer than 50,000 inhabitants) account for only 4.5 and 3.5 percent of events for the earlier and later study periods, respectively, and an even lesser share of estimated participants (table 1). (Adequate inclusion of college-related events would redress the imbalance only slightly.)

Although figures 1, 2, and 3 do suggest a rough correspondence between the population map on the one hand and the spatial array of Conventions on the other, it is a most tenuous relationship. Thus only seven of the ten leading Convention metropolises as of 1964–1965 ranked among the nation's ten most populous, and by 1990–1991, the number had dropped to a mere four. In the 1960s, such major centers as Baltimore, Boston, Cincinnati, Pittsburgh, and Seattle performed poorly in attracting Conventions despite their large populations. By the early 1990s, any association between population numbers and Convention business had weakened considerably. Such MSAs as Los Angeles, New Orleans, Detroit, Orlando, Nashville, Atlantic City, and Reno are only some of the more striking cases of sharp disconformity between population and Convention rankings. Indeed for many currently or formerly popular nonmetropolitan gathering places, the number of local residents seems irrelevant. Furthermore, many medium-sized metropolitan areas failed to book any national or international Conventions in either study period.

If population size is at best a mediocre explanatory factor, the two maps do suggest the workings of grander forces at the macroscale. With two notable exceptions, metropolises that fared well in 1964–1965 served as principal nodes of transportation, commercial, and manufacturing activity in the epoch of urban evolution designated by Borchert (1967) as "Steel-Rail." Indeed, roughly three-quarters of all Convention business occurred within the Manufacturing Belt, that rectangular tract whose corners were staked out by Boston, Richmond, St. Louis, and Minneapolis-St. Paul. But it would also seem that the Convention was an ancillary rather than vital component within the economy of the leading centers, an automatic byproduct of their role as regular crossroad junctions for businessmen, professionals, and other members of a growing mobile elite. I am confident that, if one could construct a map of Conventions for the 1920s or earlier, the domi-

nance of those larger cities based principally on transport and industry would have been even more emphatic.

The outstanding exceptions to the "steel-rail" model of the 1960s are Atlantic City and Miami (though a nascent Las Vegas and a busy Washington also fall outside the expected pattern). The success of these resorts and tourist centers is a portent of things to come. Indeed, with its success in soliciting major gatherings from the 1890s onward (Funnel 1975: 17), Atlantic City may well have been the first place anywhere in the world to capitalize on the city-building potentialities of Conventions in a nonbusiness setting.

Locational Change

The spatial array of Convention activity in 1990–1991 (figure 2) only weakly resembles the situation a quarter-century earlier. In addition to considerable increases in number of events, participants, and sites already noted, Convention locations shift decidedly southward and westward. The leading metropolitan centers are re-ordered, as the laggards in the 1960s—New Orleans, Las Vegas, Atlanta, San Francisco, Anaheim, Orlando, Boston, Dallas, Nashville, and others—surge sharply upward and the Washington MSA achieves primacy. Equally striking are absolute losses in patronage suffered by Chicago, New York, Miami, Atlantic City, Philadelphia, Detroit, and Cleveland among the prominent Convention magnets of the past. Spatial dispersion is accompanied by a more equitable allocation of business among the more successful. Whereas in 1964–1965 the five leading places—Chicago, New York, Washington, Miami, and Atlantic City—accounted for 50.2 percent of the national total of conventioneers, in the more recent period, it required nine dominant localities to soak up half (49.6 percent) of the aggregate traffic.

The changing fortunes of particular localities is attributable in part to simple physical considerations or other place-specific factors. Such places as Philadelphia and Charleston, South Carolina, failed to create adequate convention halls and ancillary facilities or they lacked enough large, attractive hotels (Snyder 1992). Completion of the Interstate Highway System and improvements in the air passenger system facilitated travel to Meetings and Conventions generally, but some places, among them Atlanta and Dallas, may have benefited more than others. And, then, of course, some convention and visitors bureaus have been more effective in their promotions than their rivals.

Popular fashion also plays a part, just as in the tourist industry. Some cities that once exuded glamour and the lure of the exotic have lost much of their appeal, at least for conventioneers. Atlantic City and Miami are prime examples, however well they may have fared in other respects. Quite a few venerable spas and retreats that once drew elite gatherings are now regarded as somewhat dowdy and may be falling by the wayside. But venerability can be a powerful asset, when properly packaged, of course. A refurbished past accounts for the uptick in Con-

vention (as well as tourist) activity in Williamsburg, Virginia, it contributes strongly to New Orleans's success, and no doubt figures meaningfully in Boston's recent boom.

Even more fundamental processes are reshaping the map of Conventionland USA. Figures 1 and 2 mirror familiar interregional shifts to the so-called Sunbelt of a number of important items—working-age adults, retirees, manufacturing, and various forms of advanced economic activity—all of which have stimulated rapid growth in many cities toward the southern and western rims of the nation (Sale 1975; Fitzsimmons, Borchert, and Adams 1980; Sawers and Tabb 1984; Fairbanks and Underwood 1990; Findlay 1992). If anything, the mobility of Conventions exceeds that of other enterprises or the population as a whole. Thus the 1964–1965 median point for participation in Conventions, near Danville, Illinois, was well to the north and east of the nation's population center, but in 1990–1991 lay some 275 miles to the southwest in the eastern Ozarks, well to the south of the current population center. In any event, shifts in the spatial patterns of Conventions can come about automatically and imperceptibly because so many change location from year to year, unlike the often traumatic transfers or shutdowns of manufacturing and wholesaling facilities and corporation offices, or the stressful migration of families or individuals. It is a case of footlooseness translating into structural reorganization.

A New Metropolitan Regime?

What we are witnessing in the world of Conventions is more than the mere reshuffling of a widely scattered array of enterprises. Instead the tabular and map evidence reflects the emergence of a new generation of American cities. If the geographic pattern of Conventions in earlier times rather faithfully conformed to the structure of the coeval metropolitan system, it seems logical to assume the same kind of parallelism today. A cohort of newly minted cities, along with recycled versions of many older metropolises, is no longer heavily reliant on producing and distributing material goods. In fact, to take an extreme example, Washington's only important physical product is printed matter. Nor is mode of transport the prime determinant of urban success as it was during the heydays of water and, then, rail commerce, however potent the auto, truck, and airplane have been in refashioning the morphology and physiology of the present-day metropolis (Garreau 1991).

No one would ever confuse such hotbeds of Convention activity as Las Vegas, Orlando, Anaheim, or Phoenix—or, for that matter, such other latterday creations as Huntsville, Alabama, Oak Ridge, Tennessee, Sun City, Arizona, or State College, Pennsylvania—with the likes of Gary, Indiana, Butte, Montana, Altoona, Pennsylvania, New Bedford, Massachusetts, or Buffalo, New York. In essence, then, in the much-altered American world of the 1990s, primary and secondary industries account for a smaller, shrinking share of the work force and of total economic output; service and leisure-oriented industries are growing lustily;

managerial and communication functions have come to the fore; and daily life centers upon consumption and entertainment. A revised urban hierarchy mirrors the new order of things.

Hosting Conventions is only one of several functions setting the Postmodern City apart from its antecedents, and, important and profitable a pursuit as it may be, it is never the single leading source of wealth and growth. These latterday activities include, in addition to Conventions: tourism, entertainment, and recreation (all symbiotically allied with Conventions); research and development; higher education; retirement services; mounting festivals (including, for the lucky very few, Olympic Games and World's Fairs); a much expanded governmental apparatus; corporate and association offices and the latest systems for manipulating and dispensing information; and a concentration of legal, financial, medical, and other highly sophisticated professional services ratcheted to new, loftier levels.[7] Also symptomatic of today's evolving urban system are elaborate theme parks within easy reach of major metropolises and of suburban shopping malls masquerading as theme parks.

Looking at the current scene, the situation is one of rapid but uneven development among a constellation of interactive centers. Although no single metropolis excels in all of these functions of the Postmodern City, the successful strivers cultivate two or more of them. A handful of Postmodern Cities are recent artifacts—Orlando and Las Vegas being the most inescapable examples—but a larger group of older places are weathering the passage into postmodernity. Their ranks include Boston, San Francisco, Atlanta, Seattle, and New Orleans (and perhaps Nashville, thanks to high-tech commodification of country music and the lure of Opryland).

But the finest example of self-transformation is our champion among Convention towns: the Washington Metropolitan Area. As documented so effectively by Paul Knox (1991), in the past few decades the nation's capital has catapulted forward, beyond its narrowly political function, becoming something both qualitatively and quantitatively far removed from its earlier incarnation. The enormous, unceasing growth of political and administrative activity scarcely needs recounting, nor for that matter the multiplication of association offices, lobbyists, journalists, publishers, and other vendors of information. With its unparalleled assemblage of nationalistic shrines and abundance of museums, galleries, theaters, concert halls, libraries, and other attractions, Washington ranks toward the top of all American tourist meccas (Zelinsky 1988: 104). It is an unrivaled site for festivals and every kind of public spectacle. Less visible perhaps is its drawing power for the elderly retired, a cluster of colleges and research institutes, and high-tech research and development enterprises. Their synergy combined with Washington's strategic location within densely populated Megalopolis have helped generate an extraordinary volume of conventioneering.

But most metropolises operate today at some intermediate stage of transition. Thus New York City and Chicago have acquired or nurtured some diagnostic

functions of the new metropolitan genre while still retaining some vigor in the traditional realms of manufacturing, transportation, and trade. Like Pittsburgh, Kansas City, St. Louis, and Minneapolis–St. Paul, they host respectable numbers of Conventions, albeit at rates well below those enjoyed by the new leaders.

UNFINISHED BUSINESS

In this initial foray into the geography of American Conventions, the limitations of imperfect data constrain the analytical possibilities. Nonetheless the available information has proved sufficiently robust to dispose of a central empirical question. With some confidence, we may say that the spatial patterning of recent Conventions offers a useful index to the differential fortunes of cities in the late twentieth-century American urban system and, specifically, reflects the degree of their advance into a postmodern condition. Moreover, the nature of the Convention phenomenon per se is such that it reveals much about the essence of this latest stage of social life. Perhaps no other entity so ideally embodies three of its key attributes: extreme diversification of interests and activities; the interdependency of a multitude of far-flung, special-interest communities; and the fugacity of such "communities without propinquity" (Webber 1963) and that of their members.

Given enough time and resources, several strategies for advancing knowledge of Conventions suggest themselves. It would be useful to examine the totality of the Convention experience of a given metropolis over a limited period and to learn the provenience and demographics of participants in detail. Equally rewarding would be a study of a representative postmodern metropolis and the interconnections among: the political establishment; institutions of higher learning; promotional agencies; the hospitality, travel, information, and research and development industries; and the physical infrastructure as they affect Convention activities. Quite as revealing might be a historical geography of the Convention strategies of a mixed batch of organizations, carefully chosen in terms of size and diversity, or a comparative analysis of Conventions in the more active foreign countries, such as France, the United Kingdom, Germany, or Japan.

But, like the present effort, such empirical projects, however worthy, are preliminaries in the approach toward a general geographical theory of communication. Perhaps one way to stimulate such a quest would be to deal with a seemingly simple question. Why has the United States (and the remainder of the First World) enjoyed such a boom in conventioneering? If we regard the Convention primarily as a mode of communication in our increasingly information-driven society, we face a paradox. The bulk of information formally dispensed at Conventions involves oral presentation to audiences, a decidedly old-fashioned procedure, or the even more primitive practice of face-to-face communication. Given the superior efficiency of modern communications, one might ask whether Con-

ventions are any longer a functional necessity for many, possibly even most organizations. Thus even a generation ago, Wolstenholme fretted about the "obese degeneration of scientific congresses" (1964), while, more recently, Reid (1992) expressed concern about the shortcomings of the annual meetings of the Society for American Archaeology.

Much of the business transacted and information disseminated can be handled more expeditiously and cheaply via either traditional means, i.e., small committee Meetings and the distribution of announcements, papers, and other materials by mail or electronically via telephone, fax, e-mail, tapes, radio or television narrowcasts, or newer technologies. One of the virtues of Conventions, however, especially those of a scholarly or technical nature, is the opportunity for serendipitous revelations. "This is partly because the volume of scholarly publications has swollen out of control. Because even the most industrious scholars can no longer survey works pertinent to their field, everyone must rely on contacts established at formal and informal meetings" (Johnston 1991: 75)—not to mention job opportunities.

Still other factors may operate. Although the hypothesis is difficult to prove or to falsify, the history of modern communications indicates that adoption of advanced technologies does not lessen desire for face-to-face contact; indeed it may even quicken our appetites (Abler 1992). Part of the explanation may be that not every important bit of information can be reduced to documentary form. Certain messages call for nuances of gesture, facial expression, and vocal tone, projecting things one could not hope, or dare, express in writing. In addition, many Conventions involve the display of new merchandise or expertly guided field trips, experiences for which there is no alternative to personal presence. Just as the telephone has not doomed the business lunch, television and other technological marvels have failed to eliminate the need to huddle together periodically and press the flesh. Without dismissing the Convention's value as a device for exchanging fresh information in timely and pleasant fashion, I suspect that it is the social factor that prevails—a simple craving for conviviality among the likeminded that cannot be satisfied by other means (along with a yen for encounters with novel places and things). Herewith a powerful stimulus for having Conventions, one that the ongoing evolution of postmodern societies renders increasingly urgent.[8]

Consequently it is quite conceivable that the greatest rewards to be won through intensive study of Conventions may not relate directly to the geography of cities or even the general field of social geography, welcome though such findings might be, but would rather be insights into the sociology of communication. When we at last find the reasons for the proliferation of Conventions during an era when there are so many other splendid means for sharing information, we shall have solved one of the knottiest of all human riddles.

Annals of the Association of American Geographers 84 (1994): 68–86

1. The exponential growth in organizations that hold Conventions is clearly one aspect of an ongoing "Division of Labor in Society," to use the phrase coined by Emile Durkheim (1933). In his many-sided exploration of the phenomenon, Durkheim treats it as a function of increasing population size and density. In any case, recent scholars have been curiously reluctant to probe in any depth the causes, consequences, and implications of a momentous sociological development. Among the few responding to the challenge is Judah Matras, who regards the appearance of formal organizations as society's response to the growth of knowledge as well as population, "sometimes supplementing or replacing primordial groups in the creation of certain rewards, sometimes assuming part of the tasks and functions of previous organizations, sometimes doing new tasks altogether" (1979: 43). Furthermore, he claims that "the growth of knowledge operates to differentiate population, quite independently of population trends themselves; and it generates new kinds of groupings and social subsystems" (1979: 47). Treating the same general problem, Scott Greer notes rather ominously, "It is possible that we are faced with the Durkheim dilemma. Increasing interdependence requires more cultural integration than we can manage; growth itself has undermined the cultural support system" (1979: 315).

2. As is evident in the information collected by the San Diego Convention & Visitors Bureau (1992) and disseminated with the following proviso: "QUALIFYING CONVENTIONS: A meeting or convention must bring in at least 50 percent of the delegates from outside the county, use a headquarter hotel with a proportionate number of rooms blocked, and hold meetings for more than one day." The president of the Anaheim Area Visitor and Convention Bureau has written me in the same vein (Snyder 1992). So much for any events at the local universities or a major church facility.

3. Readers desiring further information on this point and other matters omitted from this paper because of the constraints of space can obtain it by writing the author.

4. "The choice of conference site is extremely important, especially for the conference that is to meet only once and remain a unique event, and for the first conference in a unique series. For such conferences the site itself should have distinction and style and should provide the kind of setting that can be used to shape as rapidly as possible the developing conference ethos" (Mead and Byers 1968: 32–33).

5. What better illustration of this fact than the case of Los Angeles? During the study period, it fell from sixth to fifteenth place in terms of Convention participants, while the absolute total thereof grew by only 11 percent, a rate well below that of the county's population. Over the same span of time, the numbers of convention-goers in nearby Anaheim-Santa Ana, San Diego, and Riverside-San Bernardino grew by 6,625, 2,500, and 1,480 percent, respectively. The explanation? Without discounting the promotional efforts of the other neighboring metropolises, the essential problem, in the words of an officer of the Los Angeles Convention & Visitors Bureau, would seem to be that "national press coverage produced perceptions that run counter to the essential fact that the Los Angeles visitor 'product' is vastly better than its perceptions. Like most dynamic urban centers worldwide, Los Angeles owns a variety of troublesome social and financial distinctions. Unlike most other cities, Los Angeles receives geometrically more media news attention" (Beadle 1992). Events in April 1992 cannot have helped a great deal.

6. Localities that might otherwise be strong bidders for Convention business may suffer from a "shadow effect" if they lie too close to one of the leading centers or are wedged

between a pair of them. Such a fate seems to have befallen Toledo, Baltimore, Fort Worth, Texas, Wilmington, Delaware, and the entire set of Connecticut cities.

7. It may be some time before the definitive work on the Postmodern City appears, but in the interim there are some worthy initial efforts to consult, among them Venturi, Brown, and Izenour (1972), Noyelle and Stanback (1984), Garreau (1991), Knox (1991, 1993), and Findlay (1992). Los Angeles clearly wins the competition for archetype, the same role filled by Manchester or Chicago as *the* emergent Modern City in the past century. Many authors have treated it with mingled dread and fascination, e.g., Banham (1971) and Brino (1978), who stress the latter approach, while Soja (1986) and Davis (1990) tend to view the California metropolis as an unmitigated dystopia.

8. Ray Oldenburg's (1989) argument concerning the importance of "Third Places" and the tragedy of their imminent extinction in the contemporary North American and European metropolis is relevant here. Third Places are those "where people of all walks of life and all social levels congregate to converse, usually over a glass of wine or beer, a cup of coffee, or a plate of food. . . . Places that become their 'home away from home'. . . . The third place is one of conviviality, where we can meet and converse with others who are not exactly like ourselves. It is a place to broaden our horizons in a warm and human way, not just intellectually" (Goldstein 1991: 45). I suspect that Conventions may be serving as ephemeral Third Places. The best way to find out is to observe a few of the events in question. For a witty, but decidedly acerbic, report of what actually went on at an annual meeting of Meeting Planners International in St. Louis, see Owen (1988). Even more revealing is a satiric novel by David Lodge (1984), a rollicking send-up of academic conferences that is painfully close to reality.

References

Abbey, James R. (1987). "The Convention and Meetings Sector—Its Operation and Research Needs," pp. 265–274 in: J. R. Brent Ritchie and Charles R. Goeldner, eds., *Travel, Tourism and Hospitality Research: A Handbook for Managers and Researchers.* New York: Wiley & Sons.

Abernethy, T. P. (1932). *From Frontier to Plantation in Tennessee.* Chapel Hill: University of North Carolina Press.

Abler, Ronald F. (1973). "Monoculture or Miniculture: The Impact of Communication Media on Culture in Space," pp. 186–195 in: D. A. Lanegran and R. Palm, eds., *An Invitation to Geography.* New York: McGraw-Hill.

——— (1983). Personal communication, Nov. 2.

——— (1992). Personal communication, Jan. 2.

Abler, Ronald F., Donald Janelle, Allan Philbrick, and John Sommer, eds. (1975). *Human Geography in a Shrinking World.* North Scituate, Mass.: Duxbury Press.

Advertising Research Foundation (1956). *A Bibliography of Theory and Research Techniques in the Field of Human Motivation.* New York.

——— (1960). *Sources of Published Advertising Research.* New York.

Agard, Walter A. (1957). "Classics on the Midwest Frontier," pp. 165–183 in: Walker D. Wyman and Clifton B. Kroeber, eds., *The Frontier in Perspective.* Madison: University of Wisconsin Press.

Albinski, Henry S. (1967). "Politics and Biculturalism in Canada: The Flag Dispute," *Australian Journal of Politics and History* 13: 169–188.

Alkjaer, Eiler, and Jørn L. Erickson (1967). *Location and Economic Consequences of International Congresses.* Copenhagen: Harck.

Allen, D. Elliston (1969). *British Tastes: An Enquiry into the Likes and Dislikes of the Regional Consumer.* London: Hutchinson.

Allen, L., V. Brown, L. Dickinson, and K. C. Pratt (1941). "The Relation of First Name Preferences to Their Frequency in the Culture," *Journal of Social Psychology* 14: 279–293.

Allen, Sister Christine Hope (1983). "Public Celebrations and Private Grieving: The Public Healing Process after Death," Paper presented at Biennial Meeting of American Studies Association, Philadelphia.

Allwood, John (1977). *The Great Exhibitions.* London: Studio Vista.

Almagià, Roberto (1945–46). *Fondamenti di Geografia Generale,* 2 vols. Roma: Perrella.

American Cemetery Association (1957). *International Cemetery Directory.* Columbus, Ohio.

——— (1967). *International Cemetery Directory.* Columbus, Ohio.

American Heritage Cookbook and Illustrated History of American Eating and Drinking (1964). New York: Simon & Schuster.

American Heritage Pictorial Atlas of United States History (1966). New York: American Heritage.

American Society of Association Executives (1983). *Association Meeting Trends: Perspective on the Future.* Washington, D.C.: ASAE and Hotel Sales Management Association.

American Telephone and Telegraph Co. (annual). *Telephone Directory Price List.* New York: Long Lines Department.

Anderson, Burnett (n.d.). *Sister Cities International: A Study Conducted for U.S. Information Agency, November 17, 1984 – January 15, 1985.*

Anderson, J. Allan (1971). "The Study of Contemporary Foodways in American Folklife Research," *Keystone Folklore Quarterly* 16(4): 155 – 163.

Arensberg, Conrad (1955). "American Communities," *American Anthropologist* 57: 1131 – 1141.

Arfwedson, C. F. (1834). *The United States and Canada in 1832, 1833, and 1834.* London: R. Bentley.

Ariès, Philippe (1962). *Centuries of Childhood.* London: Cape.

Armstrong, George Henry (1930). *The Origin and Meaning of Place Names in Canada.* Toronto: Macmillan.

Arreola, Daniel D. (1982). "Mexican Restaurants and the Changing Landscape of Diet," Paper presented at Annual Meeting of Association of American Geographers, San Antonio.

Audit Bureau of Circulations (19———). *A.B.C. Blue Book for Period Ending June 30, 19———. Publishers' Statements. Magazines.* Chicago.

Austin, Mary (1933). "Geographical Terms from the Spanish," *American Speech* 8(1): 7 – 10.

Bailey, Alfred Goldsworthy (1972). *Culture and Nationality: Essays by Alfred Goldsworth Bailey.* Toronto: McClelland & Stewart.

Bailyn, Bernard (1986). *Voyagers to the West.* New York: Random House.

Balch, George (1890). *Methods of Teaching Patriotism in the Public Schools.* New York: Van Nostrand.

Banham, Reyner (1971). *Los Angeles: The Architecture of the Four Ecologies.* New York: Harper & Row.

Banzouzi, Jean Pierre (1989). Personal communication, May 24.

Bardsley, C. W. E. (1880). *Curiosities of Puritan Nomenclature.* London: Chatto & Windus.

Barer-Stein, T. (1979). *You Eat What You Are: A Study of Ethnic Food Traditions.* Toronto: McClelland & Stewart.

Barnet, Richard J., and Ronald E. Müller (1974). *Global Reach: The Power of the Multinationals.* New York: Simon & Schuster.

Bartram, John (1942). "Diary of a Journey through the Carolinas, Georgia, and Florida from July 1, 1765 to April 10, 1766," *Transactions of the American Philosophical Society,* N.S. 33: 121 – 242.

Baughman, Robert W. (1961). *Kansas Post Offices, May 29, 1828 to August 3, 1961.* Topeka: Kansas Postal History Society.

Beadle, Roger S. (1992). Personal communication, Feb. 19.

Bean, L. L. (1980). "The Genealogical Society of Utah as a Data Resource for Historical Demography," *Population Index* 46: 6 – 19.

Belasco, Warren J. (1979). "Toward a Culinary Common Denominator: The Rise of Howard Johnson's, 1925 – 1940," *Journal of American Culture* 2: 503 – 517.

——— (1989). *Appetite for Change: How the Counterculture Took On the Food Industry, 1966 – 1988.* New York: Pantheon.

Bell, Daniel (1968). *Toward the Year 2000: Work in Progress.* Boston: Houghton Mifflin.

———— (1973). *The Coming of Post-Industrial Society: A Venture in Social Forecasting.* New York: Basic Books.

Berger, Carl (1966). "The True North Strong and Free," pp. 3–26 in: Peter Russell, ed., *Nationalism in Canada.* Toronto: McGraw-Hill.

Bernard, A. J. M., P. Salles, and C. Thouvenot (1980). "Consommation Alimentaire: Une Orientation Interdisciplinaire," *Annales de Géographie* 89: 258–272.

Berton, Pierre (1975). *Hollywood's Canada: The Americanization of Our National Image.* Toronto: McClelland & Stewart.

———— (1982). *Why We Act Like Canadians: A Personal Exploration of Our National Character.* Toronto: McClelland & Stewart.

Beveridge, Sir W. (1936). "Marriage and Birth Seasons," *Economica,* N.S. 3: 133–161.

Bjorklund, Elaine M. (1964). "Ideology and Culture Exemplified in Southwestern Michigan," *Annals of the Association of American Geographers* 54: 227–241.

Blau, P. M., and W. R. Scott (1962). *Formal Organizations: A Comparative Approach.* San Francisco: Chandler.

Bloom, Heidi (1981). "Marketing to Meeting Planners: What Works?" *Cornell Hotel and Restaurant Administration Quarterly* 22: 45–50.

Blumer, H. (1968). "Fashion," pp. 341–345 in: D. L. Sills, ed., *International Encyclopedia of the Social Sciences,* Vol. 5. New York: Macmillan & Free Press.

———— (1969). "Fashion: From Class Differentiation to Collective Selection," *Sociological Quarterly* 9: 275–291.

Boas, M., and S. Chain (1975). *Big Mac: The Unauthorized Story of McDonald's.* New York: Dutton.

Bogue, Donald J. (1959). "Religious Affiliation," pp. 678–709 in: *The Population of the United States.* Glencoe, Ill.: Free Press.

Bonner, James C. (1945). "Plantation Architecture of the Lower South on the Eve of the Civil War," *Journal of Southern History* 11: 370–388.

Borchert, John R. (1967). "American Metropolitan Evolution," *Geographical Review* 57: 301–332.

Bourgeois, J. (1946). "Le Mariage, Coutume Saisonnière: Contribution à une Étude Sociologique de la Nuptialité en France," *Population* 1: 623–642.

Bradley, L. (1970). "An Enquiry into Seasonality in Baptism, Marriages and Burials," *Local Population Studies* 4: 21–40.

Brady, Alexander (1964). "The Meaning of Canadian Nationalism," *International Journal* 19: 348–363.

Brasil (1960). *Divisão Territorial do Brasil.* Rio de Janeiro: Conselho Nacional de Estatística.

Braudel, Fernand (1973). *Capitalism and Material Life 1400–1800.* London: Weidenfeld & Nicholson.

Braun, Bradley M. (1992). "The Economic Contribution of Conventions: The Case of Orlando, Florida," *Journal of Travel Research* 30(3): 32–37.

Brazeu, Jacques, and Edouard Cloutier (1977). "Interethnic Relations and the Language Issue in Contemporary Canada: A General Appraisal," pp. 204–227 in: Milton J. Esmon, ed., *Ethnic Conflict in the Western World.* Ithaca: Cornell University Press.

Brender, M. (1963). "Some Hypotheses about the Psychodynamic Significance of Infant Name Selection," *Names* 11: 1–9.

Brino, Giovanni (1978). *La Città Capitalista: Los Angeles*. Florence: Edizioni Medicea.

British Post Office European Twinning Council (1989). *Twinning News* 30.

Britt, S. H. (1967). *Consumer Behavior and the Behavioral Sciences: Theories and Applications*. New York: Wiley.

Broek, Jan O. M. (1959). "Progress in Human Geography," pp. 34–53 in: P. E. James, ed., *New Viewpoints in Geography: Twenty-Ninth Yearbook, National Council for the Social Studies*. Washington, D.C.

Brookfield, Harold C. (1969). "On the Environment as Perceived," *Progress in Geography* 1: 53–80.

Brown, Craig (1966). "The Nationalism of the National Policy," pp. 155–163 in: Peter Russell, ed., *Nationalism in Canada*. Toronto: McGraw-Hill.

Brown, Ralph H. (1948). *Historical Geography of the United States*. New York: Harcourt, Brace.

Brown, Richard D. (1976). *Modernization: The Transformation of American Life, 1600–1865*. New York: Hill & Wang.

Brownell, Joseph W. (1960). "The Cultural Midwest," *Journal of Geography* 59: 43–61.

Brunn, Stanley D., and Thomas R. Leinbach, eds. (1990). *Collapsing Space & Time: Geographic Aspects of Communication*. London: HarperCollins Academic.

Brush, John E. (1949). "The Distribution of Religious Communities in India," *Annals of the Association of American Geographers* 39: 81–98.

———— (1957). Personal communication.

Buchanan, D. W. (1931). "The Mormons in Canada," *Canadian Geographical Journal* 2: 255–270.

Buchanan, Keith (1970). *The Map of Love*. Sydney: Pergamon.

Bunge, William (1971). *Fitzgerald: Geography of a Revolution*. Cambridge, Mass.: Schenkman.

Burrill, Meredith F. (1956). "Toponymic Generics," *Names* 4: 129–137, 226–240.

Bush-Brown, Harold (1937). *Outline of the Development of Early American Architecture* [Historic American Buildings Survey]. Atlanta.

———— (1940). "Southern Romanticism." *House and Garden* 77: 16–29.

"Business or Pleasure?" (1991). *The Economist* 319(7703): 25.

Caldwell, J. C. (1981). "The Mechanisms of Demographic Change in Historical Perspective," *Population Studies* 35: 5–27.

Camp, C. (1979). "Food in American Culture: A Bibliographic Essay," *Journal of American Culture* 2: 559–570.

———— (1982). "Foodways in Everyday Life," *American Quarterly* 34: 278–289.

Campbell, Edwina (1974). "Sister Cities: Community Action for Europe," Paper in files of Sister Cities International, Alexandria, Va.

Campbell, Jon C. (1991). "Stream Generic Terms as Indicators of Historical Settlement Patterns," *Names* 39: 333–365.

Campbell, R. D. (1968). "Personality as an Element in Regional Geography," *Annals of the Association of American Geographers* 58: 748–759.

Canada, Department of Mines and Surveys, Geography Branch (1957). *Atlas of Canada*. Ottawa.

Canada, Department of the Secretary of State (1966). *The National Flag of Canada.* Ottawa.

Capes, Mary, ed. (1960). *Communication or Conflict: Conferences, Their Nature, Dynamics and Planning.* London: Tavistock.

Carlsson, G. (1966). "The Decline of Fertility: Innovation or Adjustment Process," *Population Studies* 20: 149–174.

Carney, George O. (1982). "Music and Dance," pp. 234–253, 303–304 in: J. F. Rooney, Jr., W. Zelinsky, and D. R. Louder, eds., *This Remarkable Continent: An Atlas of United States and Canadian Society and Cultures.* College Station: Texas A&M University Press.

Carter, H., and G. F. Sutton (1959). "Factors Associated with Seasonal Variation in Marriage in the United States," pp. 1–12 in: *International Population Conference, 1959.* Vienna.

Casagrande, Claude (1987). "The Organization of Twinnings and Problems of Finance" [Report for Working Group 1], *5th Congress of European Twinnings, Bordeaux, 20–21 March 1987.*

Cassidy, Frederic G. (1947). *The Place-Names of Dane County, Wisconsin* [Publications of the American Dialect Society, No. 7]. Greensboro, N.C.

Castells, Manuel (1989). *The Informational City.* Oxford: Blackwell.

Catell, R. B. (1950). *Personality: A Systematic, Theoretical, and Factual Study.* New York: McGraw-Hill.

——— (1965). *The Scientific Analysis of Personality.* Baltimore: Penguin.

Chamberlain, Samuel (1944). *Ever New England.* New York: Hastings House.

——— (1948). *Six New England Villages.* New York: Hastings House.

——— (1955). *A Tour of Old Sturbridge Village.* New York: Hastings House.

Charter of the Graceland Cemetery (1861). Chicago: James Barnet.

Cherry, Colin (1971, rev. 1978). *World Communication: Threat or Promise? A Socio-Technical Approach.* London: Wiley-Interscience.

——— (1978). *On Human Communication: A Review, a Survey, and a Criticism,* 3rd ed. Cambridge: MIT Press.

——— (1985). *The Age of Access: Information, Technology and Social Revolution. Posthumous Papers of Colin Cherry.* London: Croom Helm.

Chilsen, Liz, and Sheldon Rampton (1988). *Friends in Deed: The Story of U.S.-Nicaraguan Sister Cities.* Madison: Wisconsin Coordinating Council on Nicaragua.

Chipkin, Harvey (1990). "More Bodies, More Bucks," *Meetings and Conferences* 25(7): 19–21.

Cités Unies Bulletin (1988?). No. 133.

Clark, Andrew H. (1957). Personal communication.

——— (1960). "Old World Origins and Religious Adherence in Nova Scotia," *Geographical Review* 50: 317–344.

Clark, S. Delbert (1938). "Canadian National Sentiment and Imperial Sentiment," pp. 225–248 in: H. F. Angus, ed., *Canada and Her Great Neighbor.* Toronto: Ryerson.

Cleaveland, Nehemiah (1866). *Green-Wood Cemetery: A History of the Institution from 1838 to 1864.* New York: Anderson & Archer.

Cole, J. P., and C. A. M. King (1968). *Quantitative Geography: Techniques and Studies in Geography.* London: Wiley.

Collins, Herbert R. (1979). *Threads of History: American History Recorded on Cloth, 1775 to the Present*. Washington, D.C.: Smithsonian Institution Press.

Common, R. (1964). *Northern Ireland from the Air*. Belfast: Queen's University Press.

Congdon, H. W. (1946). *Old Vermont Houses*. New York: Knopf.

Connors, Daniel (1982). Personal communication.

Conseil des Communes et Régions d'Europe (1989). *French Twinnings in Europe*. Paris.

Conway, Jill (1974). "Culture and National Identity," pp. 71–81 in: Geoffrey Milburn and John Herbert, eds., *National Consciousness and the Curriculum: The Canadian Case*. Toronto: Ontario Institute for Studies in Education.

Conzen, Michael P. (1971). "Urban Street Systems of Pennsylvania," *Annals of the Association of American Geographers* 61: 204–209.

Conzen, M. R. G. (1960). *Alnwick, Northumberland: A Study in Town-Plan Analysis*. London: George Philip & Son.

Cook, Ramsay (1971). *The Maple Leaf Forever: Essays on Nationalism and Politics in Canada*. Toronto: Macmillan.

———— (1974). "Landscape Painting and National Sentiment in Canada," *Historical Reflections* 1: 262–283.

Coon, Carleton S. (1965). *The Living Races of Man*. New York: Knopf.

Cornish, Vaughan (1946). *The Churchyard Yew & Immortality*. London: F. Muller.

Corry, J. P. (1930). "The Houses of Colonial Georgia," *Georgia Historical Quarterly* 14: 181–201.

Coulter, E. M. (1947). *The South during Reconstruction*. Baton Rouge: Louisiana State University Press.

Council of Europe (1986). *Twinnings of European Towns and Regions*. Strasbourg.

Council of Europe Municipalities (n.d.). *The Art of Twinning: A Practical Handbook*. Paris.

Cox, E. G. (1938). *A Reference Guide to the Literature of Travel, Vol. 2, The New World* [University of Washington Publications in Language and Literature, Vol. 10]. Seattle.

Cox, Kevin R., and Georgia Zannaras (1973). "Designative Perceptions of Macro-Spaces: Concepts, a Methodology, and Applications," pp. 162–178 in: Roger M. Downs and David Stea, eds., *Image and Environment*. London: Edward Arnold.

Craigie, Sir William A., and James R. Hulbert (1938–44). *A Dictionary of American English on Historical Principles*. Chicago: University of Chicago Press.

Credner, Wilhelm (1947). "Kultbauten in dem Hinterindischen Landschaft," *Erdkunde* 1: 48–61.

Cresswell, Donald H. (1975). *The American Revolution in Drawings and Prints*. Washington, D.C.: Library of Congress.

Cribier, Françoise (1969). *La Grande Migration d'Été des Citadins en France*. Paris: Centre de Recherches et Documentation Cartographiques et Géographiques.

Crisler, Robert M. (1948). "Missouri's 'Little Dixie,'" *Missouri Historical Review* 42: 130–139.

———— (1949). "An Experiment in Regional Delimitation: The Little Dixie Region of Missouri," pp. 352–356 in: *Summaries of Doctoral Dissertations 17 (1949)*. Evanston: Northwestern University.

Crosby, Alfred W., Jr. (1972). *The Columbian Exchange*. Westport, Conn.: Greenwood Press.

Cross, Whitney R. (1950). *The Burned-Over District: The Social and Intellectual History of Enthusiastic Religion in Western New York.* Ithaca: Cornell University Press.

Cummings, R. O. (1941). *The American and His Food: A History of Food Habits in the United States,* rev. ed. Chicago: University of Chicago Press.

Curti, Merle (1963). *American Philanthropy Abroad.* New Brunswick: Rutgers University Press.

Curtis, J. (1971). "Voluntary Association Joining: A Cross-National Comparative Note," *American Sociological Review* 36: 872–880.

Cussler, Margaret, and M. L. De Give (1952). *'Twixt the Cup and the Lip': Psychological and Socio-Cultural Factors Affecting Food Habits.* New York: Twayne.

Cybriwsky, Roman A. (1972). *Social Relations and the Spatial Order in the Urban Environment: A Study of Life in a Neighborhood in Central Philadelphia* [Ph.D. dissertation]. University Park: Pennsylvania State University.

Dalton, Michael J. (1978). *The Image of the Salt Lake Valley, Vol. 2: Convention Analysis.* Logan: Utah State University, Institute of Outdoor Recreation and Tourism.

Darden, Joe T. (1972). "Factors in the Location of Pittsburgh's Cemeteries," *Virginia Geographer* 7(2): 3–8.

Davies, William E. (1955). *Patriotism on Parade: The Story of Veterans and Hereditary Organizations in America, 1783–1900.* Cambridge: Harvard University Press.

Davis, John (1803). *Travels of Four Years and a Half in the United States of America.* London: T. Ostell.

Davis, Mike (1990). *City of Quartz: Excavating the Future in Los Angeles.* London: Verso.

Davis, William C. (1951). *The Columns of Athens: Georgia's Classic City.* Athens.

Deane, Donald G. (1969). "The Traditional Upland South Cemetery," *Landscape* 18(2): 39–41.

Dearing, Mary R. (1952). *Veterans in Politics: The Story of the G.A.R.* Baton Rouge: Louisiana State University Press.

de Coninck, Ghislaine (1990). "Les Réunions Internationale en 1989," *Transnational Associations* 42(3): 172–176.

Deffontaines, Pierre (1948). *Géographie et Religions.* Paris: Gallimard.

De Laubenfels, David J., John H. Thompson, and John E. Brush (1966). "The Urban Landscape," pp. 333–357 in: John H. Thompson, ed., *Geography of New York State.* Syracuse: Syracuse University Press.

Delgado de Carvalho, Carlos (1966). Personal communication, March 9.

Dennis, James S., Harlan P. Beach, and Charles H. Fahs, eds. (1911). *World Atlas of Christian Missions.* New York: Student Volunteer Movement for Foreign Missions.

Dethlefsen, Edwin, and James Deetz (1966). "Death's Heads, Cherubs, and Willow Trees: Experimental Archaeology in Colonial Cemeteries," *American Antiquity* 31: 502–510.

——— (1967). "Death's Head, Cherub, Urn, and Willow," *Natural History* 76(3): 28–37.

De Vise, Pierre (1973). *Misused and Misplaced Hospitals and Doctors: A Locational Analysis of the Urban Health Care Crisis* [Commission on College Geography, Resource Paper No. 22]. Washington, D.C.: Association of American Geographers.

Dickenson, J. O., and J. Salt (1982). "In Vino Veritas: An Introduction to the Geography of Wine," *Progress in Human Geography* 6: 159–189.

Dingemans, Dennis J. (1975). "The Urbanization of Suburbia: The Renaissance of the Row House," *Landscape* 20(1): 20–31.

Dodge, Stanley D. (1942). "The Frontier of New England in the Seventeenth and Eighteenth Centuries and Its Significance in American History," *Papers of the Michigan Academy of Science, Arts and Letters* 28: 435–439.

Dorson, Richard M. (1959). *American Folklore.* Chicago: University of Chicago Press.

Dow, G. F. (1935). *Every Day Life in the Massachusetts Bay Colony.* Boston: Society for the Preservation of New England Antiquities.

Downs, Roger M. (1981). "Maps and Mappings as Metaphors for Spatial Representations," pp. 143–166 in: L. Liben, A. Patterson, and N. Newcombe, eds., *Spatial Representation and Behavior across the Life Span.* New York: Academic Press.

Downs, Roger M., and David Stea (1973). *Image and Environment: Cognitive Mapping and Spatial Behavior.* Chicago: Aldine.

Duchesne, L. (1975). "Weekly Patterns in Demographic Events (with Examples from Canada and England)," *Local Population Studies* 14: 53–60.

Dunbar, Gary S. (1961). "The Popular Regions of Virginia," *University of Virginia Newsletter* 38(3): 10–12.

Duncan, James S., Jr. (1973). "Landscape Taste as a Symbol of Group Identity: A Westchester County Village," *Geographical Review* 63: 334–355.

Duncan, Otis Dudley (1957). "Report of the Committee on the 1960 Census, Population Association of America," *Population Index* 23: 293–305.

Dupaquier, M. (1977). "Le Mouvement Saissonier des Mariages en France (1865–1968)," *Annales de Démographique Historique* 1977: 131–147.

Durand, Loyal, Jr. (1943). "Dairy Barns of Southeastern Wisconsin," *Economic Geography* 19: 37–44.

——— (1956). "Mountain Moonshining in East Tennessee," *Geographical Review* 46: 168–181.

Durbin, P. T. (1972). "Technology and Values: A Philosopher's Perspective," *Technology and Culture* 13: 556–576.

Durkheim, Emile (1933) [1893]. *The Division of Labor in Society.* Glencoe, Ill.: Free Press.

Eaton, Lilley (1874). *Genealogical History of the Town of Reading, Massachusetts.* Boston: A. Mudge & Son.

Edwards, W. J. (1977). "Marriage Seasonality 1761–1810: An Assessment of Patterns in Seventeen Shropshire Parishes," *Local Population Studies* 19: 23–27.

Eisenstein, Elizabeth L. (1983). *The Printing Revolution in Early Modern Europe.* Cambridge: Cambridge University Press.

Eldridge, Hope T., and Dorothy S. Thomas (1964). *Population Redistribution and Economic Growth, United States, 1870–1950, III. Demographic Analyses and Interrelations.* Philadelphia: American Philosophical Society.

Elkin, Frederick (1975). "Communications Media and Identity Formation in Canada," pp. 229–243 in: B. D. Singer, ed., *Communications in Canadian Society.* Toronto: Copp Clark.

Ellegård, A. (1958). "Notes on the Use of Statistical Methods in the Study of Name Vocabularies," *Studia Neophilologica* [Uppsala] 30: 214–231.

Elson, Ruth Miller (1963). *Guardians of Tradition: American Textbooks in the Nineteenth Century.* Lincoln: University of Nebraska Press.

Encyclopedia of Associations (1964, 1992). Detroit: Gale.

Eng, Peter (1981). "American Flags Are Flying High Again across the U.S.," *Washington Post* (July 31): B1, B7.

English Place-Name Society (1924). *Introduction to the Survey of English Place-Names: Part 2, The Chief Elements Used in English Place-Names.* Cambridge.

Ensminger, Robert F. (1992). *The Pennsylvania Barn: Its Origin, Evolution, and Distribution in North America.* Baltimore: Johns Hopkins University Press.

Ericksen, J. E., E. P. Ericksen, J. A. Hostetler, and G. E. Huntington (1979). "Fertility Patterns among the Older Order Amish," *Population Studies* 33: 255–276.

"European Conference on City-Linking with Nicaragua" (1988). *Towns and Development.*

Eysenck, H. J. (1960). *The Structure of Human Personality.* London: Methuen.

Fairbanks, Robert B., and Kathleen Underwood, eds. (1990). *Essays on Sunbelt Cities and Recent Urban America.* College Station: Texas A&M University Press.

Falk, Richard (1987). "The World Order Approach: Issues of Perspective, Academic Discipline and Political Commitment," pp. 1–33 in: *The Promise of World Order: Essays in Normative International Relations.* Philadelphia: Temple University Press.

Farrell, James J. (1980). *Inventing the American Way of Death.* Philadelphia: Temple University Press.

Favier, A., and C. Thouvenot (1980). "Eléments de Cartographie Alimentaire," *Annales de Géographie* 89: 273–289.

Federal Writers' Project (1937a). *Vermont: A Guide to the Green Mountain State.* Boston: Houghton Mifflin.

——— (1937b). *Massachusetts: A Guide to Its Places and People.* Boston: Houghton Mifflin.

——— (1938). *New Hampshire: A Guide to the Granite State.* Boston: Houghton Mifflin.

Federation of Canadian Municipalities (1988). *A Practical Guide to Municipal Twinning.* Ottawa.

Feldman, H. (1959). "The Problem of Personal Names as a Universal Element in Culture," *American Imago* 16: 237–250.

Ferm, Vergilius, ed. (1953). *The American Church of the Protestant Heritage.* New York: Philosophical Library.

Feutl, Rita (1984). "The Do's and Don'ts of Flying the Flag," *Toronto Globe and Mail* (Aug. 30): 11.

Fickeler, Paul (1947). "Grundfragen der Religionsgeographie," *Erdkunde* 1: 121–144.

Field, James A., Jr. (1971). "Transnationalism and the New Tribe," *International Organization* 25: 353–372.

Fighiera, Gian Carlo (1984). "The Geographical Distribution of Meetings throughout the World," *Transnational Associations* 36: 142–159.

——— (1990). *I Congressi: Prodotto e Mercato.* Milan: Franco Angeli.

Finch, M., H. Kilgren, and K. C. Pratt (1944). "The Relation of First Name Preferences to Age of Judges or to Different although Overlapping Generations," *Journal of Social Psychology* 20: 249–264.

Finch, V. C., G. T. Trewartha, A. H. Robinson, and E. H. Hammond (1957). *Elements of Geography, Physical and Cultural,* 4th ed. New York: McGraw-Hill.

Findlay, John M. (1992). *Magic Lands: Western Cityscapes and American Culture after 1940.* Berkeley: University of California Press.

Finley, Robert, and E. M. Scott (1940). "A Great Lakes-to-Gulf Profile of Dispersed Dwelling Types," *Geographical Review* 30: 412–419.

Firth, Raymond W. (1973). *Symbols: Public and Private*. Ithaca: Cornell University Press.

Fischer, Eric (1956). "Some Comments on a Geography of Religion," *Annals of the Association of American Geographers* 46: 246–247.

———— (1957). "Religions: Their Distribution and Role in Political Geography," pp. 405–439 in: Hans W. Weigert et al., *Principles of Political Geography*. New York: Appleton-Century-Crofts.

Fischer, J. L. (1965). "Psychology and Anthropology," in: B. J. Siegel, ed., *Biennial Review of Anthropology*. Stanford: Stanford University Press.

Fishman, Joshua A., Robert L. Cooper, and Andrew A. Conrad (1977). *The Spread of English: The Sociology of English as an Additional Language*. Rowley, Mass.: Newbury House.

Fishwick, Marshall, ed. (1978). *The World of Ronald McDonald*. Bowling Green, Ohio: Popular Culture Press.

Fisk, M., ed. (1973). *Encyclopedia of Associations*, 3 vols. Detroit: Gale.

Fitch, James Marston, Jr. (1966). *American Building: Vol. 1, The Historical Forces That Shaped It*, 2nd rev. ed. Boston: Houghton Mifflin.

FitzGerald, Frances (1979). *America Revised: History Schoolbooks in the Twentieth Century*. Boston: Little, Brown.

Fitzsimmons, James D., David J. Borchert, and John S. Adams (1980). "Recent U.S. Population Redistribution: A Geographical Framework for the 1980s," *Social Science Quarterly* 61: 485–507.

Flanders, Ralph (1933). *Plantation Slavery in Georgia*. Chapel Hill: University of North Carolina Press.

Fleure, H. J. (1951). "The Geographical Distribution of Major Religions," *Bulletin, Société Royale de Géographie d'Egypte* 24: 1–18.

Flick, Alexander C. (1937). "New York Place Names," pp. 181–186 in: *History of the State of New York*, Vol. 10. New York: Columbia University Press.

Florin, John (1966). *The Advance of Frontier Settlement in Pennsylvania, 1638–1850* [M.S. thesis]. University Park: Pennsylvania State University.

———— (1971). *Death in New England: Regional Variations in Mortality*. [Studies in Geography No. 3] Chapel Hill: University of North Carolina, Department of Geography.

Fondersmith, John (1980–). *American Urban Guidenotes: The Newsletter of Guidebooks*. Washington, D.C.

Foster, Annie H., and Anne Grierson (1967). *High Days and Holidays in Canada: A Collection of Holiday Facts for Canadian Schools*. Toronto: Ryerson Press.

Foster, George M. (1960). *Culture and Conquest: America's Spanish Heritage*. New York: Wenner-Gren Foundation for Anthropological Research.

Fowke, Edith F., and Richard Johnson (1954). *Folk Songs of Canada*. Waterloo: Waterloo Music Co.

Francaviglia, Richard V. (1971). "The Cemetery as an Evolving Cultural Landscape," *Annals of the Association of American Geographers* 61: 501–509.

Frazier, E. E. (1951). *The Negro Family in the United States*. Chicago: University of Chicago Press.

Freeman, H. E., E. Novak, and L. G. Reeder (1957). "Correlates of Membership in Voluntary Associations," *American Sociological Review* 22: 528–533.

Friedrich, E. (1917). "Religionsgeographie Chiles," *Petermanns Mitteilungen* 63: 183–186.

Friis, Herman R. (1940). *A Series of Population Maps of the Colonies and the United States, 1625–1790* [Mimeographed Publication No. 3]. New York: American Geographical Society.

Fry, Earl H., Lee H. Radebaugh, and Soldatos Panayotis, eds. (1989). *The New International Cities Era*. Provo: Brigham Young University.

Frye, Northrop (1971). *The Bush Garden: Essays on the Canadian Imagination*. Toronto: Anansi.

Funderburk, M. Laney, Jr. (1989). "Reunions," pp. 133–139 in: Charles H. Webb, ed., *Handbook for Alumni Administrators*. New York: Macmillan and American Council on Education.

Funnell, Charles E. (1975). *By the Beautiful Sea: The Rise and High Times of That Great American Resort, Atlantic City*. New York: Knopf.

Galtung, Johan (1980). *The True Worlds: A Transnational Perspective*. New York: Free Press.

Gannett, Henry (1947). *American Names: A Guide to the Origin of Place Names in the United States* [reprint of U.S.G.S. Bulletin 258, 1905]. Washington, D.C.

Gans, Herbert J. (1979). "Symbolic Ethnicity: The Future of Ethnic Groups and Cultures in America," *Ethnic and Racial Studies* 2: 1–20.

Gappert, Gary (1989). "A Management Perspective on Cities in a Changing Global Environment," pp. 312–325 in: Richard V. Knight and Gary Gappert, eds., *Cities in a Global Society*. Newbury Park, Calif.: Sage.

Garreau, Joel (1991). *Edge City: Life on the New Frontier*. New York: Doubleday.

Garry, L., ed. (1970). *The Standard Periodical Directory*, 3rd ed. New York: Oxbridge.

Gastil, Raymond D. (1973). "The Pacific Northwest as a Cultural Region," *Pacific Northwest Quarterly* 64: 147–162.

———— (1975). *Cultural Regions of the United States*. Seattle: University of Washington Press.

Gaustad, Edwin S. (1962). *Historical Atlas of Religion in America*. New York: Harper & Row.

Gazetteer of Canada: Ontario (1962). Ottawa.

Gazillo, Stephen (1981). "The Evolution of Restaurants and Bars in Vieux-Québec since 1900," *Cahiers de Géographie du Québec* 25: 101–118.

Georgia Writers' Project (1940). *Georgia: A Guide to Its Towns and Countryside*. Atlanta: Tupper & Love.

Gerbers, Ronald W. (1979). *The Country Cemetery as Cultural Epitaph: The Case of Penns and Nittany Valleys, Pennsylvania* [M.A. thesis]. University Park: Pennsylvania State University.

Getz, Donald (1991). *Festivals, Special Events and Tourism*. New York: Van Nostrand Reinhold.

Gibson, Martha Jane (1935). "'Swamp' in Early American Usage," *American Speech* 10(4): 303–305.

Glass, Joseph W. (1971). *The Pennsylvania Culture Region: A Geographical Interpretation of Barns and Farmhouses* [Ph.D. dissertation]. University Park: Pennsylvania State University.

Glassie, Henry (1969). *Pattern in the Material Folk Culture of the Eastern United States.* Philadelphia: University of Pennsylvania Press.

——— (1993). Personal communication, Nov. 19.

Glenn, Norval D. (1967). *Massification versus Differentiation: Some Trends from National Surveys,"* Social Forces 46: 172–180.

——— (1969). Personal communication.

Glenn, Norval D., and J. L. Simmons (1967). "Are Regional Cultural Differences Diminishing?" *Public Opinion Quarterly* 31: 176–193.

Glenn, Norval D., and J. P. Alston (1967). "Rural-Urban Differences in Reported Attitudes and Behavior," *Southwestern Social Science Quarterly* 48: 381–400.

Goldberg, Michael, and John Mercer (1985). *Continentalism Challenged: The Myth of the North American City.* Vancouver: University of British Columbia Press.

Goldstein, Joyce (1991). "The Third Place," *San Francisco Focus* (July): 45–47.

Good, Dorothy (1959). "Questions on Religion in the United States Census," *Population Index* 25: 3–16.

Good, James K. (1976). "A Perceptual Delimitation of Southern Indiana" [Professional Paper No. 8]. Bloomington: Indiana University, Department of Geography and Geology.

Gordon, C. W., and N. Babchuk (1959). "A Typology of Voluntary Associations," *American Sociological Review* 24: 22–29.

Gottmann, Jean (1964). *Megalopolis: The Urbanized Northeastern Seaboard of the United States.* New York: Twentieth Century Fund.

Gottschalk, E. C., Jr. (1982). "Hot New Markets for Mexican Restaurants Spring Up Fast in the East and Midwest," *Wall Street Journal* 106 (March 3): 25.

Gould, Peter, and Rodney White (1974). *Mental Maps.* Baltimore: Penguin.

Gowans, Alan (1958). *Looking at Architecture in Canada.* Toronto: Oxford University Press.

——— (1964). Review of Marion MacRae and Anthony Adamson, *The Ancestral Roof—Domestic Architecture of Upper Canada, 1783–1867,* in *Journal of the Society of Architectural Historians* 23: 49–50.

——— (1966). *Building Canada: An Architectural History of Canadian Life.* Toronto: Oxford University Press.

——— (1968). "The Canadian National Style," pp. 208–219 in: W. L. Norton, ed., *The Shield of Achilles: Aspects of Canada in the Victorian Age.* Toronto: McClelland & Stewart.

——— (1982). Personal communication, May 2.

Graham, Gerald S. (1969). "Canada and Canadian History as Viewed from the United Kingdom," pp. 273–287 in: Mason Wade, ed., *Regionalism in the Canadian Community.* Toronto: University of Toronto Press.

Grant, George (1965). *Lament for a Nation: The Defeat of Canadian Nationalism.* Princeton: Van Nostrand.

Greer, Scott (1979). "Discontinuities and Fragmentation in Social Growth," pp. 308–316 in: Amos H. Hawley, ed., *Societal Growth: Processes and Implications.* New York: Free Press.

Grunert, Thomas (1981). *Langzeitwirkungen von Städte-Partnerschaften.* Kehl am Rhein: N. P. Engel.

Gutman, R. J. S., and E. Kaufman (1979). *American Diner.* New York: Harper & Row.

Hägerstrand, Torsten (1952). *The Propagation of Innovation Waves* [Lund Studies in Geography, Ser. B. Human Geography, No. 4]. Lund.

———— (1965). "Quantitative Techniques for Analysis of the Spread of Information and Technology," pp. 244–280 in: C. Arnold Anderson and Mary Jean Bowman, eds., *Education and Economic Development*. Chicago: Aldine.

Hahn, Helmut (1958). "Konfession und Sozialstruktur: Vergleichende Analysen auf Geographischer Grundlage," *Erdkunde* 12: 241–253.

Halbrooks, John (1990). "Meeting Grads," *Association Meetings* (April): 16–21.

Hale, Edward Everett (1865). *The Man without a Country*. Boston: Ticknor & Fields.

Hale, Edward Everett, Jr. (1929). "Dialectical Evidence in the Place-Names of Eastern New York," *American Speech* 5(2): 154–167.

———— (1932). "Geographical Terms in the Far West," *Dialect Notes* 6 (Pt. 4): 217–234.

Hale, Ruth F. (1971). *A Map of Vernacular Regions in America* [Ph.D. dissertation]. Minneapolis: University of Minnesota.

Hall, Capt. Basil (1829). *Travels in North America in the Years 1827 and 1828*, 3 vols. Edinburgh: Carey, Lea & Carey.

Hamlin, Talbot (1944). *Greek Revival Architecture in America*. New York: Oxford University Press.

Handlin, Oscar, et al. (1954). *Harvard Guide to American History*. Cambridge: Harvard University Press.

Hanley, Charles (1966). "A Psychoanalysis of Nationalist Sentiment," pp. 303–319 in: Peter Russell, ed., *Nationalism in Canada*. Toronto: McGraw-Hill.

Hannerz, Ulf (1992). "The Global Ecumene as a Network of Networks," pp. 34–56 in: Adam Kuper, ed., *Conceptualizing Society*. London & New York: Routledge.

Hardwick, W. G., R. J. Claus, and D. C. Rothwell (1971). "Cemeteries and Urban Land Values," *Professional Geographer* 23: 19–21.

Harris, Cole (1966). "The Myth of the Land in Canadian Nationalism," pp. 27–43 in: Peter Russell, ed., *Nationalism in Canada*. Toronto: McGraw-Hill.

———— (1981). "The Emotional Structure of Canadian Regionalism," pp. 9–30 in: *The Challenges of Canada's Regional Diversity*. Toronto: Omnigraphics.

———— (1987). *Historical Atlas of Canada. Vol. 1. From the Beginning to 1800*. Toronto: University of Toronto Press.

Harris, Louise (1971). *The Flag over the Schoolhouse*. Providence: Brown University.

Hart, John Fraser (1967). *The Southeastern United States*. Princeton: Van Nostrand.

———— (1975). *The Look of the Land*. Englewood Cliffs, N.J.: Prentice Hall.

Hart, John Fraser, and E. C. Mather (1961). "The Character of Tobacco Barns and Their Role in the Tobacco Economy of the United States," *Annals of the Association of American Geographers* 51: 274–293.

Hartje, Robert G. (1973). *Bicentennial USA: Pathways to Celebration*. Nashville: American Association for State and Local History.

Hartman, A. A. (1958). "Name Styles in Relation to Personality, *Journal of General Psychology* 58: 289–294.

Harvey, Thomas (n.d.). Personal communication.

Hathaway, Helen (1928). *Manners: American Etiquette*. New York: Dutton.

Hauk, Sister Mary Ursula (1958). *Changing Patterns of Catholic Population in Eastern United States (1790–1950)* [Ph.D. dissertation]. Worcester: Clark University.

Hausknecht, M. (1962). *The Joiners: A Sociological Description of Voluntary Association Membership in the United States.* Totowa, N.J.: Bedminster.

Hayes, Carlton J. H. (1926). *Essays on Nationalism.* New York: Russell & Russell.

Hébert, Bruno (1980). *Monuments et Patrie: Une Réflexion Philosophique sur un Fait Historique. La Célébration Commémorative au Québec de 1881 á 1929.* Québec: Les Editions Pleins Bords.

Hébert, John R. (1972). "Panoramic Maps of American Cities," *Special Libraries* 63: 554–562.

Hélias, P. J. (1978). *The Horse of Pride: Life in a Breton Village.* New Haven: Yale University Press.

Henderson, Floyd M. (1982). "Foodways," pp. 225–232, 308–309 in: J. F. Rooney, Jr., W. Zelinsky, and D. R. Louder, eds., *This Remarkable Continent: An Atlas of United States and Canadian Society and Cultures.* College Station: Texas A&M University Press.

Hepworth, Mark E. (1990). *Geography of the Information Economy.* New York: Guilford Press.

Herrick, Francis H. (1934). *The American Eagle.* New York: Appleton-Century.

Hervey, G. W. (1852). *The Principles of Courtesy.* New York: Harper.

Hettner, Alfred (1947). *Allgemeine Geographie des Menschen, I. Band.* Stuttgart: Kohlhammer.

Heyman, Sidney (n.d.). *Amateur Radio and Sister Cities.* Washington, D.C.: Sister Cities International.

Hillegies, Günther (1987). "An Overview of Developments in Belgium, Germany, and the Netherlands," *Towns and Development* (Nov.): 4–5.

Hilliard, Sam B. (1972). *Hog Meat and Hoecake: Food Supply in the Old South, 1840–1860.* Carbondale: Southern Illinois University Press.

Hills, T. L. (1955). "The St. Francis to the Chaudiere, 1830—A Study in the Historical Geography of Southeastern Quebec," *Canadian Geographer* 6: 25–36.

————— (1957). Personal communication.

Hitchcock, Henry (1927). *Marching with Sherman.* New Haven: Yale University Press.

Hodgson, Adam (1823). *Remarks during a Journey through North America in the Years 1819, 1820, and 1821.* New York: J. Seymour.

Holdsworth, Deryck (1984a). "Architectural Symbols of Canadian National Identity," Paper presented at Annual Meeting of Association of American Geographers, Washington, D.C.

————— (1984b). Personal communication, July 16.

Honigman, J. J. (1967). *Personality in Culture.* New York: Harper & Row.

Hooker, R. J. (1980). *Food and Drink in America.* Indianapolis: Bobbs-Merrill.

Hope, Ashley G. (1973). *Symbols of the Nations.* Washington, D.C.: Public Affairs Press.

Hornberger, Mark A. (1974). *The Spatial Distribution of Ethnic Groups in Selected Counties in Pennsylvania 1800–1880* [Ph.D. dissertation]. University Park: Pennsylvania State University.

Horwitz, Elinor L. (1976). *The Bird, the Banner, and Uncle Sam: Images of America in Folk and Popular Art.* Philadelphia: J. B. Lippincott.

Hotchkiss, Wesley Akin (1950). *Areal Patterns of Religious Institutions in Cincinnati* [University of Chicago, Department of Geography, Research Paper No. 13]. Chicago.

Houdaille, J. (1976). "Evolution Démographique de Quelques Villages du Nord-Ouest de l'Espagne, du XVIᵉ au XIXᵉ Siècle," *Population* 31: 704.

———— (1978). "Un Indicateur de Pratique Religieuse: La Célébration Saisonnière des Mariages avant, pendant et après la Révolution Française (1740–1829)," *Population* 33: 367–380.

Houston, Cecil J., and William J. Smyth (1980). *The Sash Canada Wore: A Historical Geography of the Orange Order in Canada.* Toronto: University of Toronto Press.

Houston, T. J., and F. C. Summer (1948). "Measurement of Neurotic Latency in Women with Uncommon Names," *Journal of General Psychology* 39: 289–292.

Howard, J. A., and J. N. Sheth (1965). *The Theory of Buyer Behavior.* New York: Wiley.

Hubka, Thomas C. (1984). *Big House, Little House, Back House, Barn: The Connecting Farm Buildings of New England.* Hanover: University Press of New England.

Hubler, Shawn (1990). "Jostling to Find a Sister City," *Los Angeles Times* (Feb. 22): A1, A18.

"8.000 Villes Préparent l'Europe" (1988?), *Cités Unies* 133: 13.

Hunt, E. E., Jr. (1972). "Epidemiologic Considerations," *Advances in Psychosomatic Medicine* 7: 148–172.

Huntington, Ellsworth (1938). *Season of Birth.* New York: Wiley.

Hurst, Rev. John F. (1892). "The Salzburger Exiles in Georgia," *Harper's New Monthly Magazine* 85: 392–399.

Huxley, Aldous (1932). *Texts & Pretexts: An Anthology with Commentaries.* Toronto: University of Toronto Press.

Inglehart, Ronald (1990). *Culture Shift in Advanced Industrial Society.* Princeton: Princeton University Press.

Ingram, E. W., Sr. (1964). *All This from a 5-Cent Hamburger—The Story of the White Castle System.* New York: Newcomen Society.

Inkeles, Alex (1980). "The Emerging Social Structure of the World," pp. 452–515 in: Harold D. Lasswell, Daniel Lerner, and Hans Speir, eds., *Propaganda and Communication in World History, Vol. 3. A Pluralizing World in Formation.* Honolulu: University Press of Hawaii.

International Advisory Council, Inc. (1957). *Study of Community Participation in the People-to-People Program.* New York.

International Association of Convention and Visitors Bureaus (1991). *General Information and Membership Directory.* Champaign, Ill.

Isaac, Erich (1959–60). "Religion, Landscape and Space," *Landscape* 9: 14–18.

Isaacs, Harold R. (1975). *Idols of the Tribe: Group Identity and Political Change.* New York: Harper & Row.

Isaacson, Philip M. (1975). *The American Eagle.* Boston: New York Graphic Society.

Ivanitski, Oleg (1988?). "Les Soviets au Pouvoir Local," *Cités Unies* 133: 34–38.

Iyer, Pico (1988). *Video Night in Kathmandu.* New York: Knopf.

Jackson, J. B. (1952). "A Catalog of New Mexico Farm-Building Terms," *Landscape* 1(3): 31–32.

———— (1967–68). "From Monument to Place," *Landscape* 17(2): 22–26.

———— (1969). "A New Kind of Space," *Landscape* 18(1): 33–35.

———— (1972). *American Space: The Centennial Years.* New York: W. W. Norton.

———— (1982). Personal communication, Nov. 20.

Jacobson, P. H. (1959). *American Marriage and Divorce.* New York: Rinehart.

Jacobus, D. L. (1923). "Early New England Nomenclature," *New England Historical and Genealogical Register* 77: 10–16.

James, Preston, and Clarence F. Jones, eds., (1954). *American Geography: Inventory and Prospect.* Syracuse: Syracuse University Press.

Jennings, E. (1970). "Mobiocentric Man," *Psychology Today* 4(2): 34–36.

Johnson, Harry G. (1961). "Problems of Canadian Nationalism," *International Journal* 16: 238–249.

Johnson, Lucille B., and Amanda Watkins (1935). *LaGrange, City of Elms and Roses: A Sketch Book.* N.p.

Johnston, F. B., and T. T. Waterman (1941). *The Early Architecture of North Carolina.* Chapel Hill: University of North Carolina Press.

Johnston, William M. (1991). *Celebrations: The Cult of Anniversaries in Europe and the United States Today.* New Brunswick, N.J.: Transaction Publishers.

Jones, Howard Mumford (1964). *O Strange New World. American Culture: The Formative Years.* New York: Viking.

Jones, Huw (1990). *Population Geography,* 2nd ed. London: Paul Chapman.

Jordan, Terry G. (1967). "The Imprint of the Upper and Lower South on Mid-Nineteenth-Century Texas," *Annals of the Association of American Geographers* 57: 667–690.

———— (1974). "Antecedents of the Long-Lot in Texas," *Annals of the Association of American Geographers* 64: 70–86.

———— (1977). Personal communication, May 10.

———— (1978). "Perceptual Regions in Texas," *Geographical Review* 68: 293–307.

———— (1982). *Texas Graveyards: A Cultural Legacy.* Austin: University of Texas Press.

———— (1992). Personal communication.

Jordan, Terry G., and Lester Rowntree (1982, rev. 1990). *The Human Mosaic: A Thematic Introduction to Human Geography.* New York: Harper & Row.

Jordan, Terry G., and Matti Kaups (1989). *The American Backwoods Frontier: An Ethnic and Ecological Interpretation.* Baltimore: Johns Hopkins University Press.

Juergens, Jennifer (1990). "International Intrigue," *Meetings and Conventions* 25(7): 32–36.

Juergensmeyer, John E. (n.d.). *The President, the Foundations, and the People-to-People Program* [Inter-University Case Program, No. 84]. New York: Bobbs-Merrill.

Juncker, Fredrikke (1988). "City-Linking in Norway," *Towns and Development* (Spring): 5.

Kalm, Peter (1937). *America of 1750: Peter Kalm's Travels in North America; The English Version of 1770.* New York: Wilson-Erickson.

Kalman, Harold, and Joan Roaf (1983). *Exploring Ottawa: An Architectural Guide to the Nation's Capital.* Toronto: University of Toronto Press.

Kane, Joseph Nathan (1960). *The American Counties.* New York: Scarecrow Press.

Kariel, Herbert G. (1966). "A Proposed Classification of Diet," *Annals of the Association of American Geographers* 56: 68–79.

Kariel, Herbert G., and P. E. Kariel (1972). *Explorations in Social Geography.* Reading, Mass.: Addison-Wesley.

Kelly, Cathy (1977). *Marriage Migration in Massachusetts, 1765–1790* [Discussion Papers Series, No. 30]. Syracuse: Syracuse University, Department of Geography.

Kennedy, J. Robin, Jr. (1907). "Examples of Georgian and Greek Revival Work in the Far South," *Architectural Record* 21: 215–221.

Kenny, Hamill (1945). *West Virginia Place Names.* Piedmont, W.Va.: Place Name Press.

Kephart, W. (1950). "Status after Death," *American Sociological Review* 15: 635–643.

Kidd, Bruce (1982). "Sport, Dependency and the Canadian State," pp. 281–303 in: Hart Cantelon and Richard Gruneau, eds., *Sport, Culture and the Modern State.* Toronto: University of Toronto Press.

Kincaid, John (1989). "Rain Clouds over Municipal Diplomacy," pp. 223–247 in: Earl H. Fry, Lee H. Radebaugh, and Soldatos Panayotis, eds., *The New International Cities Era.* Provo: Brigham Young University.

King, L. J. (1969). *Statistical Analysis in Geography.* Englewood Cliffs, N.J.: Prentice Hall.

Kingsland, B. (1901). *Etiquette for All Occasions.* New York: Doubleday, Page.

Kirk, Dudley (1960). "The Influence of Business Cycles on Marriage and Birth Rates," pp. 241–260 in: *National Bureau of Economic Research, Demographic and Economic Change in Developed Countries.* Princeton: Princeton University Press.

Klimm, Lester E. (1954). "The Empty Areas of the Northeastern United States," *Geographical Review* 44: 325–345.

Kniffen, Fred B. (1936). "Louisiana House Types," *Annals of the Association of American Geographers* 26: 179–193.

——— (1951a). "The American Agricultural Fair: Time and Place," *Annals of the Association of American Geographers* 41: 42–57.

——— (1951b). "The American Covered Bridge," *Geographical Review* 41: 114–123.

——— (1951c). Personal communication, Aug. 1.

——— (1952). Personal communication, Jan. 9.

——— (1965). "Folk Housing: Key to Diffusion," *Annals of the Association of American Geographers* 55: 549–577.

——— (1967). "Necrogeography in the United States," *Geographical Review* 57: 426–427.

Knight, David B. (1973). *Cemeteries as Living Landscapes* [Ottawa Branch, Ontario Genealogical Society, Publication 73-8]. Ottawa.

——— (1977). *Choosing Canada's Capital: Jealousy and Friction in the 19th Century.* Toronto: McClelland & Stewart.

——— (1978). "Regionalisms, Nationalisms, and the Canadian State," *Journal of Geography* 83: 212–220.

——— (1982). "Identity and Territory: Geographical Perspectives on Nationalism and Regionalism," *Annals of the Association of American Geographers* 72: 514–531.

Knox, Paul L. (1991). "The Restless Urban Landscape: Economic and Socio-Cultural Change and the Transformation of Metropolitan Washington, D.C.," *Annals of the Association of American Geographers* 81: 181–209.

———, ed. (1993). *The Restless Urban Landscape.* Englewood Cliffs, N.J.: Prentice Hall.

Kollmorgen, Walter M. (1942). *Culture of a Contemporary Rural Community: The Old Order Amish of Lancaster County, Pennsylvania* [U.S. Department of Agriculture, Bureau of Agricultural Economics, Rural Life Studies No. 4]. Washington, D.C.

——— (1943). "The Agricultural Stability of the Old Order Amish and Old Order Mennonites of Lancaster County, Pennsylvania," *American Journal of Sociology* 49: 233–241.

Konrad, Victor (1983). "Symbolic Landscapes of Nationalism and Regionalism in Canada: A Proposal to the Canadian Studies Faculty and Institutional Grant Programme" [ms.]. Orono: University of Maine at Orono.

―――― (1984). "Emerging Symbols of Canadian Nationalism," Paper presented at Annual Meeting of the Association of American Geographers, Washington, D.C.

Krapp, G. L. (1925). *The English Language in America*, 2 vols. New York: Century.

Kroeber, Alfred L., and Clyde Kluckhohn (1952). *Culture, a Critical Review of Concepts and Definitions* [Papers of the Peabody Museum of American Archaeology and Ethnology 47 (1)]. Cambridge, Mass.

Krueger, G. E. (1970). "The Ethnography and Spatial Distribution of Restaurants: Pennsylvania" [M.S. paper]. University Park: Pennsylvania State University.

Krug, S. E., and R. W. Kulhavy (1973). "Personality Differences across Regions of the United States," *Journal of Social Psychology* 91(1): 73–80.

Krythe, Maymie R. (1968). *What So Proudly*. New York: Harper & Row.

Kuethe, J. Louis (1935). "Runs, Creeks, and Branches in Maryland," *American Speech* 10(4): 256–259.

Kurath, Hans (1939). *Handbook of the Linguistic Geography of New England*. Providence: Brown University.

―――― (1939–43). *Linguistic Atlas of New England*. Providence: Brown University.

―――― (1949). *A Word Geography of the Eastern United States*. Ann Arbor: University of Michigan Press.

Kussendrager, Nico, ed. (1988). *Towns and Development*, 2nd ed. The Hague: Towns and Development Campaign.

Labovitz, S. (1965). "Territorial Differentiation and Societal Change," *Pacific Sociological Review* 8: 70–75.

Lambert, R. D. (1975). *Nationalism and National Ideologies in Canada and Quebec: A Bibliography*, rev. Waterloo: University of Waterloo, Department of Sociology.

Landes, David S. (1983). *Revolution in Time: Clocks and the Making of the Modern World*. Cambridge: Harvard University Press.

Landgraf, J. L. (1954). *Land Use in the Ramah Area of New Mexico: An Anthropological Approach to Areal Study* [Papers of the Peabody Museum of American Archaeology and Ethnology 32(1)]. Cambridge, Mass.

Landis, Benson Y. (1959a). "A Guide to the Literature on Statistics of Religious Affiliation with References to Related Social Studies," *Journal of the American Statistical Association* 54: 335–357.

―――― (1959b). *Yearbook of American Churches . . . 28th Issue, Annual Edition for 1960*. New York: National Council of Churches.

Latourette, Kenneth Scott (1941). *A History of the Expansion of Christianity. Vol. 4. The Great Century, A.D. 1800–A.D. 1914, Europe and the United States of America*. New York: Harper & Bros.

Lautensach, Herman (1942). "Religion und Landschaft in Korea," *Nippon, Zeitschrift für Japanologie* 8: 204–219.

Law, Christopher M. (1987). "Conference and Exhibition Tourism," *Built Environment* 13(2): 85–95.

Leary, Mike (1989). "East, West Both Pull W. Germans," *Philadelphia Inquirer* (May 11): 13A.

Leitermann, Walter (1988a). "Deutsch-Deutsch Städtpartnerschaften," *Der Städtetag* 3: 172–176.

———— (1988b). "Deutsch-chinesische Beziehungen auf Kommunaler Ebene," *Der Städtetag* 9: 617–619.

Lemon, James T. (1966). "The Agricultural Practices of National Groups in Eighteenth-Century Southeastern Pennsylvania," *Geographical Review* 56: 467–496.

———— (1967). "Urbanization and the Development of Eighteenth-Century Southeastern Pennsylvania and Adjacent Delaware," *William and Mary Quarterly*, 3rd Ser. 24: 501–542.

———— (1972). *The Best Poor Man's Country: A Geographical Study of Early Southeastern Pennsylvania.* Baltimore: Johns Hopkins University Press.

Lentner, Howard H. (1970). "Canada and the U.S.—There's a Profound Difference," *Canadian Journal of History and Social Science* 6(2): 9–19.

"Letter from Mr. Thomas Hawkins, dated Frederica 28 Nov 1737. Recd 12 April 1738. To Benj Martin Esq. Secty to the Honorable Trustees" (1913), pp. 15–18 in: *Colonial Records of the State of Georgia* 22. Atlanta: Franklin Printing & Publishing.

"Letters from John Stewart to William Dunlop" (1931), *South Carolina Historical and Genealogical Magazine* 32: 1–114.

Levenstein, Harvey (1993). *Paradox of Plenty: A Social History of Eating in America.* New York: Oxford University Press.

LeVine, R. A. (1963). "Culture and Personality," in: B. J. Siegel, ed., *Biennial Review of Anthropology.* Stanford: Stanford University Press.

Lévi-Strauss, Claude (1966). *The Savage Mind.* Chicago: University of Chicago Press.

Lewis, Peirce F. (1972). "Small Town in Pennsylvania," *Annals of the Association of American Geographers* 62: 323–351.

———— (1976). *New Orleans—The Making of an Urban Landscape.* Cambridge, Mass.: Ballinger.

Lieberman, Gregg (1991). "A User's Guide to Teleconferencing," *Meetings and Conventions* 26(10): 80–89.

Lieble, Charles L. (1974). *Regional Consciousness in West Virginia* [Ph.D. dissertation]. Knoxville: University of Tennessee.

Lipset, Seymour Martin (1963). *The First New Nation: The United States in Historical and Comparative Perspective.* New York: Basic Books.

———— (1965). "Revolution and Counter-Revolution—the United States and Canada," pp. 21–64 in: Thomas R. Ford, ed., *The Revolutionary Theme in Contemporary America.* Lexington: University of Kentucky Press.

Lodge, David (1984). *Small World: An Academic Romance.* New York: Macmillan.

Lofland, John (1989). "Consensus Movements: City Twinning and Derailed Dissent in the American Eighties," pp. 163–196 in: *Research in Social Movements, Conflicts and Change.* Greenwich, Conn.: JAI Press.

Lowenthal, David (1961). "Geography, Experience, and Imagination: Towards a Geographical Epistemology," *Annals of the Association of American Geographers* 51: 241–260.

———— (1968). "The American Scene," *Geographical Review* 58: 61–88.

———— (1977). "Bicentennial Landscape: A Mirror Held Up to the Past," *Geographical Review* 67: 253–267.

Ludwig, Allen I. (1966). *Graven Images: New England Stonecarving and Its Symbols, 1650–1815*. Middletown, Conn.: Wesleyan University Press.

Luria, David (1989). Personal communication, June 8.

MacCann, Richard Dyer (1973). *The People's Films: A Political History of U.S. Government Motion Pictures*. New York: Hastings House.

Macdonald, R. R. (1992). "Bad Blood at the Burial Ground," *New York Times* (Sept. 12): 12, I21.

MacFadden-Bartell Corp. (1971a). *The Total Average-Issue Male Audience of "Sport" and Other Selected Magazines, 1971*. New York.

——— (1971b). *The Total Average-Issue Adult Women Audience of "True Story," "Photoplay," and Other Selected Magazines*. New York.

MacRae, Marion, and Anthony Adamson (1983). *Cornerstone of Order: Courthouses and Town Halls of Ontario, 1784–1914*. Toronto: Clarke Irwin.

Magazine Advertising Bureau of Magazine Publishers Association (1969). *Sources of Consumer Magazine Information*. New York.

Major, Howard (1926). *The Domestic Architecture of the Early American Republic*. Philadelphia: J. B. Lippincott.

Market Research Corporation of America (1960). *"The Profitable Difference." A Study of the Magazine Market . . . Its Size, Quality and Buying*. New York.

Marling, Karal Ann (1984). *The Colossus of Roads: Myth and Symbol along the American Highway*. Minneapolis: University of Minnesota Press.

Marr, Charles (1926). "Origin of the Classical Place-Names of Central New York," *Quarterly Journal of the New York State Historical Association* 7: 155–168.

Marschner, Francis J. (1959). *Land Use and Its Patterns in the United States* [U.S. Department of Agriculture, Agriculture Handbook No. 153]. Washington, D.C.

Martin, Howard H. (1958). "The Fourth of July Oration," *Quarterly Journal of Speech* 44: 393–401.

Marvick, D., and J. H. Bayes (1969). "Domains and Universes: Problems in Concerted Use of Multiple Data Files for Social Science Inquiries," pp. 533–553 in: M. Dogan and S. Rokkan, eds., *Quantitative Ecological Analysis in the Social Sciences*. Cambridge: MIT Press.

Marx, Leo (1964). *The Machine in the Garden: Technology and the Pastoral Ideal in America*. New York: Oxford University Press.

Mastai, Boleslaw, and Marie-Louise D'O. Mastai (1973). *The Stars and Stripes: The American Flag as Art and as History from the Birth of the Republic to the Present*. New York: Knopf.

Matheson, John Ross (1980). *Canada's Flag: A Search for a Country*. Boston: G. K. Hall.

Mathews, L. K. (1909). *The Expansion of New England: The Spread of New England Settlement and Institutions to the Mississippi River, 1620–1865*. Boston & New York: Houghton Mifflin.

Mathews, Mitford M., ed. (1951). *A Dictionary of Americanisms on Historical Principles*. Chicago: University of Chicago Press.

Matras, Judah (1979). "Mechanisms and Processes of Societal Growth," pp. 30–60 in: Amos H. Hawley, ed., *Societal Growth: Processes and Implications*. New York: Free Press.

Mattelart, Armand (1979). *Multinational Corporations and the Control of Culture: The Ideological Apparatus of Imperialism*. Atlantic Highlands, N.J.: Humanities Press.

Mayer, Ernst Georg (1986). *Auslandbeziehungen deutscher Gemeinden: Bestansaufnahme und rechtiche Probleme* [Ph.D. dissertation]. Bonn: Rheinisch Friedrich-Wilhelms-Universität.

Mayer, F. E. (1956). *The Religious Bodies of America*, 2nd ed. St. Louis: Concordia Publishing House.

Mayer, Harold M., and Richard Wade (1969). *Chicago: Growth of a Metropolis.* Chicago: University of Chicago Press.

McCarty, Harold H., John C. Hook, and Duane S. Knos (1956). *The Measurement of Association in Industrial Geography.* Iowa City: State University of Iowa.

McClelland, D. C. (1961). *The Achieving Society.* Princeton: Van Nostrand.

McDavid, J. W., and H. Harari (1966). "Stereotyping of Names and Popularity in Grade-School Children," *Child Development* 37: 453–459.

McDavid, Raven I., Jr. (1958). "The Dialects of American English," pp. 480–543 in: W. N. Francis, ed., *The Structure of American English.* New York: Ronald Press.

McJimsey, George Davis (1940). *Topographic Terms in Virginia* [Reprints and Monographs, No. 3]. New York: Columbia University Press.

McKinsey, Lauren S. (1976). "Dimensions of National Political Integration and Disintegration: The Case of Quebec Separatism, 1960–1975," *Comparative Political Studies* 9: 335–360.

McMillan, Ernest (1949). *A Canadian Song Book*, 2nd ed. Toronto & Vancouver: J. M. Dent & Sons.

McMillan, James B. (1949). "Observations on American Place-Name Grammar," *American Speech* 24(4): 241–248.

McMullen, E. Wallace, Jr. (1953). *English Topographic Terms in Florida, 1563–1874.* Gainesville: University of Florida Press.

Mead, Frank S. (1956). *Handbook of Denominations in the United States*, rev. ed. New York: Abingdon-Cokesbury.

Mead, Margaret, and Paul Byers (1968). *The Small Conference: An Innovation in Communication.* Paris: Mouton.

Mecking, Ludwig (1929). "Kult und Landschaft in Japan," *Geographischer Anzeiger* 29: 1–10.

"Meetings Are No Longer 'Filler Business' for the Lodging Industry" (1990). *Meetings and Conventions* 25 (7): Advertising insert.

Meigs, Peveril (1941). "An Ethno-Telephonic Survey of French Louisiana," *Annals of the Association of American Geographers* 31: 243–256.

Meinig, Donald W. (1957). "Three American 'Northwests': Some Perspectives in Historical Geography," Paper presented at Annual Meeting of Association of American Geographers, Cincinnati.

——— (1957–58). "The American Colonial Era: A Geographical Commentary," *Proceedings of the Royal Geographical Society, South Australian Branch (1957–58)*: 1–22.

——— (1965). "The Mormon Culture Region: Strategies and Patterns in the Geography of the American West," *Annals of the Association of American Geographers* 55: 191–220.

——— (1968). *The Great Columbia Plain: A Historical Geography.* Seattle: University of Washington Press.

——— (1969). *Imperial Texas: An Interpretive Essay in Cultural Geography.* Austin: University of Texas Press.

——— (1972). "American Wests: Preface to a Geographical Interpretation," *Annals of the Association of American Geographers* 62: 159–184.

——— (1984). "Interpreting Canada: An American View," Paper presented at Symposium on Canadian Studies, University of British Columbia, Vancouver.

——— (1986). *The Shaping of America: A Geographical Perspective on 500 Years of History, Vol. 1. Atlantic America, 1492–1800.* New Haven: Yale University Press.

Mencken, Henry L. (1947). *The American Language*, 4th ed. New York: Knopf.

——— (1948). *The American Language, Supplement 2.* New York: Knopf.

Merrens, H. Roy (1964). *Colonial North Carolina in the Eighteenth Century: A Study in Historical Geography.* Chapel Hill: University of North Carolina Press.

Merrill, Gordon (1968). "Regionalism and Nationalism," pp. 556–568 in: John Warkentin, ed., *Canada: A Geographical Interpretation.* Toronto: Methuen.

Merritt, Richard L. (1966). *Symbols of American Community.* New Haven: Yale University Press.

Metropolitan Life Insurance Co. (1950). "June Brides," *Statistical Bulletin* 31(9): 1–3.

Meyer, Alfred H. (1945). "Toponymy in Sequent Occupance Geography, Calumet Region, Indiana-Illinois," *Proceedings of the Indiana Academy of Science* 54: 142–159.

Meyer, Richard E., ed. (1989). *Cemeteries and Gravemarkers: Voices of American Culture.* Ann Arbor: UMI Research Press.

Meynen, Emil (1939). "Das Pennsylvaniendeutsche Bauernland," *Deutsche Archiv für Landes und Volksforschung* 3: 253–292.

Meyrowitz, Joshua (1985). *No Sense of Place: The Impact of Electronic Media on Social Behavior.* New York: Oxford University Press.

Migdal, Dave (1991). "The Boom Goes On," *Meetings and Conventions* 26(9): 78–90.

Milburn, Geoffrey, and John Herbert, eds. (1974). *National Consciousness and the Curriculum: The Canadian Case.* Toronto: Ontario Institute for Studies in Education.

Miller, E. Joan Wilson (1968). "The Ozark Culture Region as Revealed by Traditional Materials," *Annals of the Association of American Geographers* 58: 51–77.

Miller, James M. (1938). *Genesis of Western Culture: The Upper Ohio Valley, 1800–1825.* Columbus: Ohio State Archaeological and Historical Society.

Miller, N. (1927). "Some Aspects of the Name in Culture History," *American Journal of Sociology* 32: 585–600.

Minghi, Julian V. (1989). Personal communication, April 6.

Minott, Rodney G. (1962). *Peerless Patriots: Organized Veterans and the Spirit of Americanism.* Washington, D.C.: Public Affairs Press.

Minton, Arthur (1958). "Some Aspects of the Form of Personal Names in American Speech," *American Speech* 33 (Pt. 2): 84–91.

——— (1959, 1961). "Names of Real-Estate Developments," *Names* 7: 129–153, 9: 8–36.

Mintz, Sidney W. (1985). *Sweetness and Power: The Place of Sugar in Modern History.* New York: Viking.

Mitford, Jessica (1963). *The American Way of Death.* New York: Simon & Schuster.

Moore, Frank (1846). *Songs and Ballads of the American Revolution.* New York: Appleton.

Morrill, Richard L. (1963). "The Development and Spatial Distribution of Towns in Sweden: An Historical-Predictive Approach," *Annals of the Association of American Geographers* 53: 1–14.

Morton, W. L. (1962). *The Canadian Identity.* Toronto: University of Toronto Press.

Mumford, Lewis (1924). "The Classic Myth," pp. 53–71 in: *Sticks and Stones: A Study of American Architecture and Civilization.* New York: Boni & Liveright.

——— (1967). *The Myth of the Machine.* New York: Harcourt, Brace & World.

Murphy, W. F. (1957). "A Note on the Significance of Names," *Psychoanalytic Quarterly* 26: 91–106.

Murray, James A. H., ed. (1888–1928). *A New English Dictionary on Historical Principles,* 10 vols. Oxford: Clarendon Press.

Murtagh, William J. (1957). "The Philadelphia Row House," *Journal of the Society of Architectural Historians* 16(4): 8–13.

Myers, Robert J. (1972). *The Complete Book of American Holidays.* New York: Doubleday.

Myrdal, Gunnar (1944). *An American Dilemma.* New York: Harper.

Nakagawa, Tadashi (1987). *The Cemetery as a Cultural Manifestation: Louisiana Necrogeography* [Ph.D. dissertation]. Baton Rouge: Louisiana State University.

Nasgaard, Roald (1984). *The Mystic North: Symbolist Landscape Painting in Northern Europe and North America 1890–1950.* Toronto: University of Toronto Press.

National Center for Health Statistics (annual). *Vital Statistics of the United States.* Hyattsville, Md.

National Council of Churches (1953). *1953 Yearbook of American Churches.* New York.

——— (1956–58). *Churches and Church Membership in the United States: An Enumeration and Analysis by Counties, States, and Regions.* New York.

National Family Opinion (1959). *We Asked 10,000 Families about the American Flag.* Toledo.

National Industrial Conference Board (1967). *Market Profiles of Consumer Products.* New York.

National Research Council, Committee on Food Habits (1945). *Manual for the Study of Food Habits* [Bulletin of the NRC, 111]. Washington, D.C.

Nelson, Howard J. (1974). "Town Founding and the American Frontier," *Yearbook of the Association of Pacific Coast Geographers* 36: 7–23.

Nestler, Herbert (1990). "Meeting Internationally," *Meeting News* (May): 47.

Nevitte, Neil (1979). "Nationalism, States and Nations," pp. 343–359 in: Elliot J. Feldman and Neil Nevitte, eds., *The Future of North America: Canada, the United States, and Quebec Nationalism.* Cambridge: Harvard Center for International Affairs.

Niddrie, David L. (1965). Personal communication, Feb. 27.

Nietz, John A. (1961). *Old Textbooks.* Pittsburgh: University of Pittsburgh Press.

Nixon, Daniel W. (1984). "Sister Cities," *Rotarian* (Dec.): 25–29.

Nolan, Mary Lee, and Sidney Nolan (1989). *Christian Pilgrimage in Modern Western Europe.* Chapel Hill: University of North Carolina Press.

Novak, Michael (1976). *The Joy of Sports.* New York: Basic Books.

Noyelle, Thierry J., and Thomas M. Stanback, Jr. (1984). *The Economic Transformation of American Cities.* Totowa, N.J.: Rowman & Allenheld.

Oakland, Richard (1989). Personal communication, Feb. 8.

O'Dea, Thomas F. (1957). *The Mormons.* Chicago: University of Chicago Press.

Odum, Howard W. (1936). *Southern Regions of the United States.* Chapel Hill: University of North Carolina Press.

Odum, Howard W., and H. E. Moore (1938). *American Regionalism: A Cultural-Historical Approach to National Integration.* New York: Holt.

Ogden, Philip (1973). "Patterns of Marriage Seasonality in Rural France," *Local Population Studies* 10(1973): 53–64.

Oldenburg, Ray (1989). *The Great Good Place: Coffee Shops, Community Centers, Beauty Parlors, General Stores, Bars, Hangouts, and How They Get You through the Day*. New York: Paragon House.

Olmsted, Frederick Law (1856). *A Journey in the Seaboard Slave States in the Years 1853–54*, 2 vols. New York: G. P. Putnam's Sons.

Orkin, Mark M. (1970). *Speaking Canadian English: An Informal Account of the English Language in Canada*. Toronto: General Publishing.

"Our Classical Belt" (1907). *Nation* 84 (Sept. 5): 203–204.

Owen, David (1988). "Meet Me in St. Louis," pp. 22–39 in: *The Man Who Invented Saturday Morning*. New York: Villard Books.

Paget, H. P. (1969). Personal communication.

Palm, Risa (1973). "Factorial Ecology and the Community of Outlook," *Annals of the Association of American Geographers* 63: 341–346.

Paltsits, Victor Hugo (1911). "The Classical Nomenclature of Western New York," *Magazine of History* 13: 246–249.

Parkins, A. E. (1938). *The South: Its Economic-Geographic Development*. New York: Wiley.

Parsons, C. G. (1855). *Inside View of Slavery; Or a Tour among the Planters*. Boston: J. P. Jewett & Co..

Parsons, James J. (1949). *Antioqueño Colonization in Western Colombia* [Ibero-Americana No. 32]. Berkeley & Los Angeles: University of California.

——— (1966). Personal communication, Sept. 11.

Pasley, Jeffrey L. (1987). "Twisted Sister," *New Republic* 196(14): 14–18.

Pattison, William D. (1955). "The Cemeteries of Chicago: A Phase of Land Utilization," *Annals of the Association of American Geographers* 45: 245–257.

——— (1957). *American Rectangular Land Survey* [Department of Geography, Research Paper No. 50]. Chicago: University of Chicago.

Paullin, Charles O., and John K. Wright (1932). *Atlas of the Historical Geography of the United States*. New York & Washington, D.C.: American Geographical Society and Carnegie Institution of Washington, D.C.

Payne, Roger L. (1984). *Geographic Names Information System Users Guide* [U.S.G.S., National Mapping Division, Open-File Report 84-551]. Washington, D.C.

——— (1992). Personal communication, June 18.

Peers, Mark M. (1966). "Broadcasting and National Unity," pp. 215–228 in: Benjamin D. Singer, ed., *Communications in Canadian Society*, rev. ed. Toronto: Copp Clark.

Pelto, P. J. (1967). "Psychological Anthropology" in: B. J. Siegel and A. R. Beals, eds., *Biennial Review of Anthropology*. Stanford: Stanford University Press.

Perkerson, Medor Field (1952). *White Columns in Georgia*. New York: Rinehart.

Philippovich, Thomas (1983). "European Twinnings—Achievements, Problems, Prospects" in: *General Report*. Brighton: Congress of European Twinnings.

The Picturesque Pocket Companion and Visitor's Guide through Mount Auburn (1839). Boston: Otis, Broadus & Co.

Pierce, Bessie L. (1930). *Civic Attitudes in American School Textbooks*. Chicago: University of Chicago Press.

Pillsbury, Richard (1967). "The Market or Public Square in Pennsylvania 1682–1820," *Proceedings Pennsylvania Academy of Science* 41: 116–118.

—— (1968). *The Urban Street Patterns of Pennsylvania before 1815: A Study in Cultural Geography* [Ph.D. dissertation]. University Park: Pennsylvania State University.

—— (1969). "The Street Name Systems of Pennsylvania before 1820," *Names* 17: 214–222.

—— (1970). "The Urban Street Pattern as a Culture Indicator: Pennsylvania, 1682–1815," *Annals of the Association of American Geographers* 60: 428–446.

—— (1971). "Comment in Reply," *Annals of the Association of American Geographers* 61: 210–213.

—— (1990). *From Boarding House to Bistro: The American Restaurant Then and Now.* Boston: Unwin Hyman.

Planhol, Xavier de (1959). *The World of Islam (Le Monde Islamique; Essai de Géographie Religieuse).* Ithaca: Cornell University Press.

Plateris, A. A. (1973). *100 Years of Marriage and Divorce Statistics, United States, 1867–1967* [Vital and Health Statistics—Series 21, No. 24]. Rockville, Md.: National Center for Health Statistics.

Post, J. A., and J. B. Post (1981). *Travel in the United States: A Guide to Information Sources.* Detroit: Gale.

Postman, Neil (1985). *Amusing Ourselves to Death: Public Discourse in the Age of Show Business.* New York: Viking.

Powell, A. G. (1943). *I Can Go Home Again.* Chapel Hill: University of North Carolina Press.

Powell, Sumner Chilton (1963). *Puritan Village: The Formation of a New England Town.* Middletown, Conn.: Wesleyan University Press.

Power, Tyrone (1836). *Impressions of America, during the Years 1833, 1834, and 1835,* 2 vols. Philadelphia: Carey, Lea & Blanchard.

Prebish, C. S. (1982). "Sport Religion: The New Nirvana," *Women's Sport* 4: 58–60.

Price, Edward T. (1968). "The Central Courthouse Square in the American County Seat," *Geographical Review* 58: 29–60.

Price, Larry W. (1966). "Some Results and Implications of a Cemetery Study," *Professional Geographer* 18: 201–207.

Prinzinger, A. D. J. (1882). "Die Ansiedlung der Salzburger in Staate Georgien in Nordamerika," *Mitteilungen der Gesellschaft für Salzburger Landeskunde* 22.

Proctor, George A. (1980). *Canadian Music in the Twentieth Century.* Toronto: Copp Clark.

Proshansky, H. M., W. H. Ittelson, and L. G. Rivlin (1970). *Environmental Psychology: Man and His Physical Setting.* New York: Holt, Rinehart & Winston.

Pulgram, E. (1954). *Theory of Names.* Berkeley: American Name Society.

Pullen, John J. (1971). *Patriotism in America: A Study of Changing Devotion.* New York: American Heritage Press.

Pyles, Thomas (1947). "Onomastic Individualism in Oklahoma," *American Speech* 22: 257–264.

Quaife, Milo M. (1942). *The Flag of the United States.* New York: Grosset & Dunlap.

Quaife, Milo M., M. J. Weig, and R. E. Applebaum (1961). *The History of the United States Flag.* New York: Harper.

Rand McNally Commercial Atlas and Marketing Guide, 96th Edition (1965). Chicago: Rand McNally.

Raper, Arthur F. (1936). *Preface to Peasantry: A Tale of Two Black Belt Counties.* Chapel Hill: University of North Carolina Press.

Raup, H. F. (1957). "Names of Ohio's Streams," *Names* 5: 162–168.

Raup, H. F., and William B. Pounds, Jr. (1953). "Northernmost Spanish Frontier in California as Shown by the Distribution of Place Names," *California Historical Society Quarterly* 32(1): 43–48.

Reed, John Shelton (1976). "The Heart of Dixie: An Essay in Folk Geography," *Social Forces* 54: 925–939.

Rees, Ronald (1978). "Landscape in Art," pp. 48–68 in: Karl Butzer, ed., *Dimensions of Human Geography* [Research Paper 186]. Chicago: University of Chicago, Department of Geography.

Regenstreif, Peter (1974). "Some Social and Political Obstacles to Canadian National Consciousness," pp. 53–66 in: Geoffrey Milburn and John Herbert, eds., *National Consciousness and the Curriculum: The Canadian Case.* Toronto: Ontario Institute for Studies in Education.

Reid, Dennis (1973). *A Concise History of Canadian Painting.* Toronto: Oxford University Press.

Reid, J. Jefferson (1992). "The Annual Meeting as Text or Exhibition," *American Antiquity* 57: 391–392.

Relph, Edward C. (1976). *Place and Placelessness.* London: Pion.

Reps, John W. (1965). *The Making of Urban America.* Princeton: Princeton University Press.

Reynolds, Quentin (1947). "Dunkirk—One World Town," *Collier's* 119 (June 7): 12–13.

Rezvan, D. A., comp. (1951). *A Comprehensive Marketing Bibliography*, 2 vols. Berkeley & Los Angeles: University of California Press [1950–1962 supplement published 1963].

Richards, Audrey R. (1948). *Hunger and Work in a Savage Tribe: A Functional Study of Nutrition among the Southern Bantu.* Glencoe, Ill.: Free Press.

Richardson, J., and A. L. Kroeber (1947). "Three Centuries of Women's Dress Fashions: A Quantitative Analysis," *Anthropological Records* 5: 111–153.

Rickert, John E. (1967). "House Facades of the Northeastern United States: A Tool of Geographic Analysis," *Annals of the Association of American Geographers* 57: 211–238.

Rinschede, Gisbert, and Surinder M. Bhardwaj, eds. (1990). *Pilgrimage in the United States.* Berlin: Dietrich Reimer Verlag.

Roberts, H. L. (1913). *The Cyclopedia of Social Usage.* New York: G. P. Putnam's Sons.

Roberts, Warren E. (1984). *Log Buildings of Southern Indiana.* Bloomington: Trickster Press.

La Rochefoucauld-Liancourt, Duc de (1799). *Travels through the United States of North America . . . in the Years 1795, 1796, and 1797*, 2 vols. London: R. Phillips.

Romstorfer, K. A. (1915). *Der Land und Forstwirtschaftliche Bau in Anlage und Ausführung.* Vienna & Leipzig: F. Deutike.

Rooney, John F. (1974). *From Cabin Creek to Anaheim: A Geographic Interpretation of American Sport.* Reading, Mass.: Addison-Wesley.

Rooney, John F., and P. L. Butt (1978). "Beer, Bourbon, and Boone's Farm: A Geographical Examination of Alcoholic Drink in the United States," *Journal of Popular Culture* 12: 832–856.

Root, Waverly, and R. de Rochement (1976). *Eating in America: A History.* New York: Morrow.

Roy, Pierre-George (1923). *Les Monuments Commémoratifs de la Province de Québec.* Québec: Proulx.

Rubin, Morton (1951). *Plantation County.* Chapel Hill: University of North Carolina Press.

Ruffner, F. G., Jr., et al. (1968). *Directory of Associations,* 3 vols. Detroit: Gale.

Rummel, R. J. (1967). "Understanding Factor Analysis," *Journal of Conflict Resolution* 2: 444–480.

——— (1970). *Applied Factor Analysis.* Evanston: Northwestern University Press.

Russ, William A. (1948). "The Export of Pennsylvania Place Names," *Pennsylvania History* 15: 192–214.

Russell, Peter, ed. (1966). *Nationalism in Canada.* Toronto: McGraw-Hill.

Rutherford, Denney G. (1990). *Introduction to the Conventions, Expositions, and Meetings Industry.* New York: Van Nostrand Reinhold.

Rutman, D. S., C. Wetherell, and A. H. Rutman (1980). "Rhythms of Life: Black and White Seasonality in the Early Chesapeake," *Journal of Interdisciplinary History* 11: 29–53.

Saarinen, Thomas F. (1969). *Perception of Environment* [Commission on College Geography, Resource Paper No. 5]. Washington, D.C.: Association of American Geographers.

Sage, Evan T. (1929). "Classical Place-Names in America," *American Speech* 5: 261–271.

Saggus, C. D. (1951). *A Social and Economic History of the Danburg Community in Wilkes County, Georgia* [M.A. thesis]. Athens: University of Georgia.

Said, Edward (1993). *Culture and Imperialism.* New York: Knopf.

Sale, Kirkpatrick (1975). *Power Shift: The Rise of the Southern Rim and Its Challenge to the Eastern Establishment.* New York: Random House.

San Diego Convention & Visitors Bureau (1992). *1991 San Diego Meeting & Convention Statistics.* San Diego.

Sanford, Charles L. (1961). *The Quest for Paradise: Europe and the American Moral Imagination.* Urbana: University of Illinois Press.

Sardon, J. P. (1979). "Mariage et Révolution dans une Petite Ville de Vignerons: Argenteuil (1780–1819)," *Population* 34: 1162–1167.

Savage, B. M., and F. L. Wells (1948). "A Note on Singularity in Given Names," *Journal of Social Psychology* 27: 271–272.

Sawers, Larry, and William Tabb, eds. (1984). *Sunbelt/Snowbelt: Urban Development and Regional Restructuring.* New York: Oxford University Press.

Schele de Vere, Maximilian (1872). *Americanisms: The English of the New World.* New York: Scribner.

Schiller, Beatriz (1982). Personal communication, Nov. 13.

Schlesinger, A. M., Sr. (1944). "Biography of a Nation of Joiners," *American Historical Review* 50: 1–25.

Schmitt, Peter J. (1969). *Back to Nature: The Arcadian Myth in Urban America.* New York: Oxford University Press.

Schwartz, Mildred A. (1967). *Public Opinion and Canadian Identity.* Berkeley & Los Angeles: University of California Press.

Schwartzberg, Joseph E. (1967). "Prolegomena to the Study of South Asian Regions and Regionalism," pp. 89–91 in: Robert I. Crane, ed., *Regions and Regionalism in South Asian Studies: An Exploratory Study* [Comparative Studies on South Asia, Monograph No. 5]. Durham: Duke University Press.

Scofield, Edna (1936). "The Evolution and Development of Tennessee Houses," *Journal of the Tennessee Academy of Sciences* 2: 229–240.

———— (1938). "The Origin of Settlement Patterns in Rural New England," *Geographical Review* 28: 652–663.

Scrivener, Leslie (1981). *Terry Fox: His Story.* Toronto: McClelland & Stewart.

Sealock, R. B., and P. A. Seely (1948). *Bibliography of Place Name Literature, United States, Canada, Alaska, and Newfoundland.* Chicago: American Library Association.

Searle, J. R. (1958). "Proper Names," *Mind* 67: 166–174.

Séguin, R. L. (1963). *Les Granges du Québec du XVIIe au XIXe Siècle* [Musée National du Canada, Bulletin 192]. Ottawa.

Serafini, Umberto (1978). *The Europeans Come of Age: European Elections and the Political Responsibilities of Local and Regional Authorities* [General Political Report for the Meeting of the 1,000 European Twinned Municipalities]. Mainz: Council of European Municipalities.

Sergent, Monique (1983). "The Practice of Twinning—Finding Solutions to Problems of Organisation, Finance, Travel, Public Relations, etc.," pp. 26–39 in: *General Report.* Brighton: Congress of European Twinnings.

Shankle, George E. (1955). *American Nicknames: Their Origins and Significance,* 2nd ed. New York: Wilson.

Shaw, Margaret, and Ellen Mazukina (1984). "The Meetings Market: Where the Research Is," *Hotel Sales Marketing Association International* (Fall): 27–30.

Sherwood, J. (1884). *Manners and Social Usages.* New York: Harper & Bros.

Shirk, George H. (1965). *Oklahoma Place Names.* Norman: University of Oklahoma Press.

Shoemaker, A. L., ed. (1955). *The Pennsylvania Barn.* Lancaster: Pennsylvania Dutch Folklore Center.

Shortridge, James R. (1976). "Patterns of Religion in the United States," *Geographical Review* 66: 420–434.

———— (1977). "A New Regionalization of American Religion," *Journal for the Scientific Study of Religion* 16(2): 143–153.

Shryock, Richard H. (1964). "The Middle Atlantic Area in American History," *Proceedings of the American Philosophical Society* 108: 147–155.

Shuman, Michael H. (1986–87). "Dateline Main Street: Local Foreign Policies," *Foreign Policy* 65: 154–174.

Shurtleff, H. R. (1939). *The Log Cabin Myth.* Cambridge: Harvard University Press.

Sievers, Angelica (1958). "Christentum und Landschaft in Sudwest-Ceylon," *Erdkunde* 12: 107–120.

Sills, David L. (1968). "Voluntary Associations: Sociological Aspects," in: *International Encyclopedia of the Social Sciences.* New York: Macmillan and Free Press.

Simmel, G. (1957). "Fashion," *American Journal of Sociology* 62: 541–558.

W. R. Simmons & Associates Research, Inc. (1971). *Selective Markets and the Media Reaching Them.* 1971 Marketing Report. New York.

Simoons, F. J. (1961). *Eat Not This Flesh.* Madison: University of Wisconsin Press.

Sister Cities International (1989). *Directory of Sister Cities, Counties, and States by State and Country.* Alexandria, Va.

"Sister City Antecedents, Precedents and Where They Led" (1991). Pp. 10–11 in: *Sister Cities International 25th Anniversary.* Washington, D.C.: Sister Cities International.

Skjelsbaek, Kjell (1971). "The Growth of Nongovernmental Organizations in the Twentieth Century," *International Organization* 25: 420–443.

Sloane, David C. (1991). *The Last Great Necessity: Cemeteries in American History.* Baltimore: Johns Hopkins University Press.

Sloane, Eric (1954). *American Barns and Covered Bridges.* New York: Funk & Wagnalls.

——— (1955). *Our Vanishing Landscape.* New York: Ballantine.

——— (1957). Personal communication.

——— (1966). *An Age of Barns.* New York: Funk & Wagnalls.

Smith, Allan (1970). "Metaphor and Nationality in North America," *Canadian Historical Review* 51: 247–275.

——— (1971). "American Culture and the English Mind at the End of the Nineteenth Century," *Journal of Popular Culture* 4: 1045–1051.

Smith, Anthony D. (1981). *The Ethnic Revival.* Cambridge: Cambridge University Press.

Smith, David M. (1973). *The Geography of Social Well-Being in the United States: An Introduction to Territorial Social Indicators.* New York: McGraw-Hill.

Smith, Elsdon C. (1952). *Personal Names: A Bibliography.* New York: New York Public Library.

Smith, H. A. M. (1909). "Purrysburgh," *South Carolina Historical and Genealogical Magazine* 10: 187–219.

Smith, Henry Nash (1950). *Virgin Land: The American West as Symbol and Myth.* Cambridge: Harvard University Press.

Smith, J. Frazer (1941). *White Pillars: Early Life and Architecture of the Lower Mississippi Valley Country.* New York: W. Helburn.

Smith, T. Lynn (1948). "Religious Composition," pp. 175–189 in: *Population Analysis.* New York: McGraw-Hill.

Smith, Whitney (1975). *The Flag Book of the United States,* rev. ed. New York: William Morrow.

Snyder, William F. (1992). Personal communication, Feb. 25.

Soja, Edward W. (1986). "Taking Los Angeles Apart: Some Fragments of a Critical Human Geography," *Environment and Planning D: Society and Space* 4: 255–272.

Sokal, R. R., and P. H. A. Sneath (1963). *Principles of Numerical Taxonomy.* San Francisco: W. H. Freeman.

Solomon, R. J. (1966). "Procedures in Townscape Analysis," *Annals of the Association of American Geographers* 56: 254–268.

Sopher, David E. (1967). *Geography of Religions.* Englewood Cliffs, N.J.: Prentice Hall.

——— (1972). "Place and Location: Notes on the Spatial Patterning of Culture," *Social Science Quarterly* (Sept.): 321–337.

Sorre, Maximilien (1947–52). *Les Fondements de la Géographie Humaine,* 3 vols. Paris: Armand Colin.

——— (1962). "The Geography of Diet," pp. 446–456 in: P. L. Wagner and M. W. Mikesell, eds., *Readings in Cultural Geography.* Chicago: University of Chicago Press.

Soto Ferreiro, Manuel (1983). "Solidarity in Action—The Contribution of Twinning to the Development of Poor Communities in Europe and the Third World," pp. 55–65 in: *European Twinnings—Achievements, Problems, Prospects: General Report.* Brighton: Congress of European Twinnings.

Spencer, Joseph E., and William L. Thomas (1969). *Cultural Geography: An Evolutionary Introduction to Our Humanized Earth*. New York: Wiley.

Sperry, Willard L. (1946). *Religion in America*. Cambridge: Cambridge University Press.

Spiro, Peter (1988). "Taking Foreign Policy Away from the Feds," *Washington Quarterly* 11(1): 191–203.

Stahl, William A. (1981). *Symbols of Canada: Civil Religion, Nationality, and the Search for Meaning* [Ph.D. dissertation]. Berkeley: Graduate Theological Union.

Stamp, Robert M. (1973). "Empire Day in the Schools of Ontario: The Training of Young Imperialists," *Journal of Canadian Studies* 8(3): 32–42.

Standard Rate and Data Service, Inc. (annual). *Consumer Magazine and Farm Publication Rates and Data*. Skokie, Ill.

Stanislawski, Dan (1950). *The Anatomy of Eleven Towns in Michoacán* [University of Texas Latin-American Studies, 10]. Austin.

Stanley, George F. F. (1965). *The Story of Canada's Flag*. Toronto: Ryerson.

Stannard, D. E. (1977). *The Puritan Way of Death: A Study in Religion, Culture and Social Change*. New York: Oxford University Press.

Daniel Starch & Staff, Inc. (annual). *Annual Media Study of Primary Audiences, Consumption of Media*. Mamaroneck, N.Y.

——— (annual). *Profile of U.S. Consumer Market Segments, 19———*. Mamaroneck, N.Y.

Stead, W. T. (1901). *The Americanization of the World: Or the Trend of the Twentieth Century*. New York: Horace Markley.

Steinberg, Stephen (1981). *The Ethnic Myth: Race, Ethnicity, and Class in America*. New York: Atheneum.

Stewart, George R. (1939). "Nomenclature of Stream-forks on the West Slope of the Sierra Nevada," *American Speech* 14(3): 191–197.

——— (1943). "What Is Named?—Towns, Islands, Mountains, Rivers, Capes," *University of California Publications in English* 14: 223–232.

——— (1945). *Names on the Land*. New York: Random House.

——— (1948). "Men's Names in Plymouth and Massachusetts in the Seventeenth Century," *University of California Publications in English* 7(2): 109–138.

——— (1953). *US 40*. Boston: Houghton Mifflin.

——— (1954). "Food," pp. 70–101 in: *American Ways of Life*. Garden City, N.Y.: Doubleday.

——— (1958). *Names on the Land: A Historical Account of Place-Naming in the United States*, rev. ed. Boston: Houghton Mifflin.

——— (1970, rev. 1980). *American Place-Names: A Concise and Selective Dictionary for the Continental United States of America*. New York: Oxford University Press.

Stilgoe, John R. (1982). *Common Landscape of America, 1580 to 1845*. New Haven: Yale University Press.

——— (1983). "Small Town and Urban Edges," *UD Review* 6 (Spring/Summer): 5–7.

Stokes, Anson Phelp (1950). *Church and State in the United States*, 3 vols. New York: Harper.

Stonestreet, Minnie (1952). Personal communication.

Stoney, S. G. (1938). *Plantations of the Carolina Low Country*. Charleston: Carolina Art Association.

Strack, Conrad (1969). Personal communication.

Strauss, A. L. (1959). *Mirrors and Masks*. Glencoe: Ill.: Free Press.

Struik, D. J. (1948). *The Origins of American Science*. New York: Cameron Associates.

Stump, Roger W. (1984). "Regional Divergence in Religious Affiliation in the United States," *Sociological Analysis* 45: 283–299.

——— (1986). "Regional Variations in the Determinants of Religious Participation," *Review of Religious Research* 27: 208–225.

Sublette, W. (1981). "The Joy of Mex," *Restaurant Hospitality* 65(5): 79–82.

Successful Meetings Data Bank (1964, 1990). *Directory of Conventions*. New York.

Suttles, Gerald D. (1968). *The Social Order of the Slum: Ethnicity and Territory in the Inner City*. Chicago: University of Chicago Press.

Sviatlovsky, E. E., and W. C. Eels (1937). "The Centrographical Method and Regional Analysis," *Geographical Review* 27: 240–254.

Swan, Conrad (1977). *Canada, Symbols of Sovereignty*. Toronto: University of Toronto Press.

Swedish Statistical Office (1861). *Bidrag till Sverige Officiella Statistike, Ser. A. Befolkningsstatistik, 1856–1860*. Stockholm.

Sweet, William Warren (1950). *The Story of Religion in America*. New York: Harper.

Swenson, Greta E. (1989). *Festivals of Sharing: Family Reunions in America*. New York: AMS Press.

Tannahill, R. (1973). *Food in History*. New York: Stein & Day.

Taylor, Griffith, ed. (1957). *Geography in the Twentieth Century*, 3rd ed. New York: Philosophical Library.

Taylor, Isaac (1888). *Words and Places: Studies in Geographical and Topographical Nomenclature*. London: Macmillan.

Thomas, Dorothy S. (1924). "Changes in Marriage Season," *Economica* 4: 97–100.

Thomas, Jack Ward, and Ronald A. Dixon (1973). "Cemetery Ecology," *Natural History* 82(3): 61–67.

Thompson, E. M. (1915). *Reconstruction in Georgia* [Columbia University Studies in History, Economics, and Public Law, No. 154]. New York: Columbia University.

Thompson, John H., and Edward C. Higbee (1952). *New England Excursion Guidebook* [17th International Geographical Congress, 1952, Publication No. 1]. Washington, D.C.

Thompson, M. (1959). "Abstract Terms," *Philosophical Review* 68: 281–302.

Thompson, W. R. A. (1965). *A Preface to Urban Economics*. Baltimore: Johns Hopkins University Press.

Thornborough, L. (1923). *Etiquette for Everybody*. New York: Dutton.

Thorndike, E. L. (1939). *Your City*. New York: Harcourt, Brace.

Thrower, Norman J. W. (1957). "Cadastral Survey and Roads in Ohio," *Annals of the Association of American Geographers* 47: 181–182.

——— (1961). "The County Atlases of the United States," *Surveying and Mapping* 21: 365–373.

——— (1972). "Cadastral Survey and County Atlases of the United States," *Cartographic Journal* 9(1): 43–51.

Tippett, Maria (1984). *Art at the Service of War: Canada, Art, and the Great War*. Toronto: University of Toronto Press.

Toffler, Alvin (1970). *Future Shock*. New York: Random House.

Tomkins, George (1974). "National Consciousness, the Curriculum, and Canadian

Studies," pp. 15–129 in: Geoffrey Milburn and John Herbert, eds., *National Consciousness and the Curriculum: The Canadian Case.* Toronto: Ontario Institute for Studies in Education.

Tracy, Stanley J., ed. (1956). *A Report on World Population Migrations as Related to the United States of America.* Washington, D.C.: George Washington University.

Trewartha, Glenn T. (1943). "The Unincorporated Hamlet: One Element of the American Settlement Fabric," *Annals of the Association of American Geographers* 33: 32–81.

——— (1946). "Types of Rural Settlement in Colonial America," *Geographical Review* 36: 568–596.

——— (1948). "Some Regional Characteristics of American Farmsteads," *Annals of the Association of American Geographers* 38: 169–225.

Tuan, Yi-Fu (1974). *Topophilia: A Study of Environmental Perception.* Englewood Cliffs, N.J.: Prentice Hall.

Tunnard, Christopher, and Henry Hope Reed (1953). *American Skyline: The Growth and Form of Our Cities and Towns.* Boston: Houghton Mifflin.

Turner, Frederick Jackson (1950). *The Significance of Section in American History.* New York: Peter Smith.

"Turning Back the Clock: The History of C&VBs" (1989). *Meeting News* 13(11): supplement.

Twinning News: Review of the Joint Twinning Committee of the Local Authority Associations of Great Britain and Northern Ireland (1974–). London.

Tyler, Clarice E. (1929). "Topographical Terms in the Seventeenth Century Records of Connecticut and Rhode Island," *New England Quarterly* 2(3): 382–401.

Ullman, Edward L. (1954). "Amenities as a Factor in Regional Growth," *Geographical Review* 44: 119–132.

Union of International Associations (1964). *International Congress Calendar.* Brussels.

United Nations, Department of Economic and Social Affairs (1956). *Demographic Yearbook 1956.* New York.

——— (1969). *Demographic Yearbook 1969.* New York.

U.S. Board on Geographic Names (1963). *Brazil: Official Standard Names Approved by the United States Board on Geographic Names* [Gazetteer No. 71]. Washington, D.C.

U.S. Bureau of Labor Statistics (1963–66). *Consumer Expenditures and Income.* Washington, D.C.

U.S. Bureau of the Census (1914). *Statistical Atlas of the United States.* Washington, D.C.

——— (1958). "Religion Reported by the Civilian Population of the United States: March, 1957" [Current Population Reports, Series P-20, Population Characteristics, No. 79]. Washington, D.C.

——— (1964–67). *Area Measurement Reports* [Series GE-20]. Washington, D.C.

U.S. Census Office (1872). *Ninth Census, Vol. 1, The Statistics of the Population of the United States.* Washington, D.C.

——— (1874). *Statistical Atlas of the United States, Based on the Results of the Ninth Census of 1870.* Washington, D.C.

——— (1898). *Statistical Atlas of the United States, Based upon the Results of the Eleventh Census.* Washington, D.C.

——— (1907–08). *Heads of Families at the First Census of the United States Taken in the Year 1790.* Washington, D.C.: Government Printing Office.

U.S. Department of Agriculture (1939). *The Farm-Housing Survey* [Misc. Publ. No. 323]. Washington, D.C.

U.S. Department of Labor, Bureau of Labor Statistics (1963–66). *Survey of Consumer Expenditures, 1960–61* [BLS237 Series]. Washington, D.C.

Urlsperger, Samuel (1744). *Ausführliche Nachricht von den Saltzburgischen Emigranten . . .* Halle: In Verlegunen des Waysenhauses.

Urry, John (1990). *The Tourist Gaze: Leisure and Travel in Contemporary Societies.* London: Sage.

U.T.O. New (1989). Paris: United Towns Organization.

Vail, R. W. G. (1949). *The Voice of the Old Frontier.* Philadelphia: University of Pennsylvania Press.

Vance, James E., Jr. (1972). "California and the Search for the Ideal," *Annals of the Association of American Geographers* 62: 185–210.

Vance, Rupert B. (1935). *The Human Geography of the South.* Chapel Hill: University of North Carolina Press.

Vaumas, Etienne de (1955). "La Répartition Confessionnelle au Liban et l'Equilibre de l'État Libanais," *Revue de Géographie Alpine* 30: 511–604.

Velikonja, Joseph (1961). "Distribuzione Geografica degli Italiani negli Stati Uniti," pp. 1–2 in: *Atti del XVIII Congresso Geografico Italiano, Trieste, 4–9 Aprile 1961.*

——— (1965). "Gli Italiani nelle Città Canadesi appunti Geografici," pp. 271–288 in: *Atti del XIX Congresso Geografico Italiano, Como, 18–23 Maggio 1964.* Como: Editrice Noseda.

Venturi, Robert, Denise Scott Brown, and Steven Izenour (1972). *Learning from Las Vegas.* Cambridge: MIT Press.

Vermeer, Donald E., and D. A. Frate (1975). "Geophagy in a Mississippi County," *Annals of the Association of American Geographers* 65: 414–424.

Vidal de la Blache, Paul (1941). *Principes de Géographie Humaine.* Paris: Colin.

Vipond, Mary Jean (1974). *National Consciousness in English-Speaking Canada in the 1920's: Seven Studies* [Ph.D. dissertation]. Toronto: University of Toronto.

Vocelle, J. T. (1914). *History of Camden County, Georgia.* St. Marys, Ga., & Jacksonville, Fla.: Kennedy, Brown-Hall & Co.

von Lennep, Hans-Gerd (1983). "The Practice of Twinning—Participation and Activities," in: *European Twinnings—Achievements, Problems, Prospects: General Report.* Brighton: Congress of European Twinnings.

Wacker, Peter O. (1975). *Land and People: A Cultural Geography of Pre-industrial New Jersey: Origins and Settlement Patterns.* New Brunswick: Rutgers University Press.

Waddell, Eric (1979). "French Louisiana: An Outpost of l'Amerique Française, or Another Country and Another Culture?" [Working Paper No. 4]. Québec: Université Laval, Departement de Géographie.

Wagner, Philip L. (1972). *Environments and Peoples.* Englewood Cliffs, N.J.: Prentice Hall.

Walcott, R. R. (1936). "Husbandry in Colonial New England," *New England Quarterly* 9: 218–252.

Wales, H. G., and R. Ferber (1963). *A Basic Bibliography of Marketing Research.* Chicago: American Marketing Association.

Wallace, A. F. C., and R. D. Fogelson (1962). "Culture and Personality," in: B. J. Siegel, ed., *Biennial Review of Anthropology 1961.* Stanford: Stanford University Press.

Wallace, W. Stewart (1920). "The Growth of Canadian National Feeling," *Canadian Historical Review* 1: 136–165.

Wallach, Bret (1982). "The Facsimile Fallacy," *American Review of Canadian Studies* 12: 82–86.

Walton, W. W. (1946). "Affective Value of First Names," *Journal of Applied Psychology* 23: 187–195.

Warkentin, John (1959). "Mennonite Agricultural Settlements of Southern Manitoba," *Geographical Review* 49: 342–368.

Warner, Gale, and Michael Shuman (1987). *Citizen Diplomats: Pathfinders in Soviet-American Relations and How You Can Join Them.* New York: Continuum.

Warner, Sam Bass, Jr. (1972). *The Urban Wilderness: A History of the American City.* New York: Harper & Row.

Warner, W. Lloyd (1959). *The Living and the Dead: A Study of the Symbolic Life of Americans.* New Haven: Yale University Press.

Watkins, Melville (1966). "Technology and Nationalism," pp. 284–302 in: Peter Russell, ed., *Nationalism in Canada.* Toronto: McGraw-Hill.

Watson, J. Wreford (1970–71). "Image Geography: The Myth of America in the American Scene," *Advancement of Science* 27: 1–9.

———— (1976). "Image Regions," pp. 15–28 in: J. Wreford Watson and Timothy O'Riordan, eds., *The American Environment: Perceptions and Policies.* London & New York: John Wiley.

Watt, Frank (1966). "Nationalism in Canadian Literature," pp. 235–251 in: Peter Russell, ed., *Nationalism in Canada.* Toronto: McGraw-Hill.

Webb, E. J., D. T. Campbell, R. D. Schwartz, and L. Sechrest (1966). *Unobtrusive Measures: Nonreactive Research in the Social Sciences.* Chicago: Rand McNally.

Webb, Walter Prescott (1931). *The Great Plains.* New York: Ginn.

Webber, M. M. (1963). "Order in Diversity: Community without Propinquity," in: L. Wingo, Jr., ed., *Cities and Space: The Future Use of Urban Land.* Baltimore: Johns Hopkins University Press.

———— (1964). "Culture, Territoriality, and the Elastic Mile," *Regional Science Association, Papers* 13: 59–70.

———— (1968). "The Post-City Age," *Daedalus* (Fall): 1091–1110.

Webster's New International Dictionary of the English Language, 2nd ed. (1925). Springfield, Mass.: C. & G. Merriam.

Wecter, Dixon (1941). *The Hero in America: A Chronicle of Hero-Worship.* New York: Charles Scribner's Sons.

Weekly, E. (1940). *Jack and Jill: A Study in Our Christian Names.* New York: Dutton.

Weiss, Michael J. (1989). *The Clustering of America.* New York: Harper & Row.

Welsch, Roger (1971). "We Are What We Eat: Omaha Food as Symbol," *Keystone Folklore Quarterly* 16: 165–170.

Wertenbaker, T. J. (1938). *The Founding of American Civilization: The Middle Colonies.* New York & London: Charles Scribner's Sons.

———— (1942). *The Old South: The Founding of American Civilization.* New York: Charles Scribner's Sons.

———— (1947). *The Puritan Oligarchy: The Founding of American Civilization.* New York: Charles Scribner's Sons.

West, Robert C. (1954). "The Term 'Bayou' in the United States: A Study in the Geography of Place Names," *Annals of the Association of American Geographers* 44: 63–74.

Whitbeck, R. H. (1911). "Regional Peculiarities in Place Names," *Bulletin of the American Geographical Society* 43: 273–281.

White, A. R. (1901). *Twentieth Century Etiquette*. New York: A. R. White.

Whitehill, Walter M. (1968). *Boston: A Topographical History*, 2nd ed. Cambridge: Harvard University Press.

"Who Owns the Stars and Stripes?" (1970). *Time* 96 (July 6): 1.

Whyte, William H. (1968). *The Last Landscape*. Garden City, N.Y.: Doubleday.

Wilkins, Ernest Hatch (1957). "Arcadia in America," *Proceedings of the American Philosophical Society* 101: 4–30.

Williams, Colin H. (1980). "The Desire of Nations: Québecois Ethnic Separatism in Comparative Perspective," *Cahiers de Géographie de Québec* 24: 47–68.

——— (1981). "Identity through Autonomy: Ethnic Separatism in Québec," pp. 389–418 in: A. D. Burnett and P. J. Taylor, eds., *Political Studies from Spatial Perspectives*. London: John Wiley & Sons.

Williams, J. E., J. K. Morland, and W. L. Underwood (1970). "Connotations of Color Names in the United States, Europe, and Asia," *Journal of Social Psychology* 82: 3–14.

Wilson, C. S. (1973). "Food Habits: A Selected Annotated Bibliography," *Journal of Nutrition Education* 5: 39–72.

Wilson, Edmund (1962). *Patriotic Gore: Studies in the Literature of the Civil War*. New York: Oxford University Press.

Wilson, Herbert M. (1900). "A Dictionary of Topographic Forms," *Journal of the American Geographical Society* 32: 32–41.

Wilson, L. R. (1938). *The Geography of Reading: A Study of the Distribution and Status of Libraries in the United States*. Chicago: American Library Association and University of Chicago Press.

Winks, Robin W. (1979). *The Relevance of Canadian History: U.S. and Imperial Perspectives*. Toronto: Macmillan.

Woelfly, S. J. (1914). *Under the Flag: History of the Stars and Stripes*. Harrisburg: United Evangelical Press.

Woicik, C. (1981). "Raga: The Ethnic Restaurant Is Big Business," *Restaurant Hospitality* 65(3): 77–78.

Wolfe, James W. (1975). *The Kennedy Myth: American Civil Religion in the Sixties* [Ph.d. dissertation]. Berkeley: Graduate Theological Union.

Wolstenholme, G. E. W. (1964). "Obese Degeneration of Scientific Congresses," *Science* 145(3638): 1137–1139.

Wright, John K. (1929). "The Study of Place Names: Recent Work and Some Possibilities," *Geographical Review* 19: 171.

———, ed. (1933). *New England's Prospect*. New York: American Geographical Society.

——— (1966). *Human Nature in Geography*. Cambridge: Harvard University Press.

Wright, Joseph, ed. (1898–1905). *The English Dialect Dictionary*. New York: G. P. Putnam's Sons.

Wright, Martin (1950). *The Log Cabin in the South* [M.S. thesis]. Baton Rouge: Louisiana State University.

Wurster, William (1957). "Row House Vernacular and High Style Monument," *Architectural Record* 124: 141–150.

Young, Frank W. (1960). "Graveyards and Social Structure," *Rural Sociology* 25: 446–450.

Zelinsky, Wilbur (1951a). "Where the South Begins: The Northern Limit of the Cis-Appalachian South in Terms of Settlement Landscape," *Social Forces* 30: 172–178.

——— (1951b). "An Isochronic Map of Georgia Settlement," *Georgia Historical Quarterly* 35: 191–195.

——— (1953). *The Settlement Patterns of Georgia* [Ph.D. dissertation]. Berkeley: University of California.

——— (1954). "The Greek Revival House in Georgia," *Journal of the Society of Architectural Historians* 13: 9–12.

——— (1955). "Some Problems in the Distribution of Generic Terms in the Place-Names of the Northeastern United States," *Annals of the Association of American Geographers* 45: 319–349.

——— (1960). "The Religious Composition of the American Population," *Geographical Review* 50: 272–273.

——— (1961). "An Approach to the Religious Geography of the United States: Patterns of Church Membership in 1952," *Annals of the Association of American Geographers* 51: 139–193.

——— (1967). "Classical Town Names in the United States: The Historical Geography of an American Idea," *Geographical Review* 57: 463–495.

——— (1970a). "Beyond the Exponentials: The Role of Geography in the Great Transition," *Economic Geography* 46: 498–535.

——— (1970b). "Cultural Variation in Personal Name Patterns in the Eastern United States," *Annals of the Association of American Geographers* 60: 743–769.

——— (1971). "The Hypothesis of the Mobility Transition," *Geographical Review* 61: 219–249.

——— (1973). *The Cultural Geography of the United States.* Rev. ed., 1992. Englewood Cliffs, N.J.: Prentice Hall.

——— (1975). "Personality, Free Choice, and Self-Discovery: Some Hints Concerning the Future Social Geography of the United States," pp. 109–121 in: R. F. Abler, D. Janelle, A. Philbrick, and J. Sommers, eds., *Human Geography in a Shrinking World.* North Scituate, Mass.: Duxbury Press.

——— (1977). "The Pennsylvania Town: An Overdue Geographical Account," *Geographical Review* 67: 127–147.

——— (1978). "Marriage Dates and the Social Geography of Innermost Pennsylvania," *Earth and Mineral Sciences* [Pennsylvania State University] 47(4): 5, 29–30.

——— (1983). "Nationalism in the American Place-Name Cover," *Names* 30(1): 1–28.

——— (1988). *Nation into State: The Shifting Symbolic Foundations of American Nationalism.* Chapel Hill: University of North Carolina Press.

——— (1990). "A Toponymic Approach to the Geography of American Cemeteries," *Names* 38: 209–229.

——— (1991). "The Twinning of the World: Sister Cities in Geographic and Historical Perspective," *Annals of the Association of American Geographers* 81: 1–32.

——— (1992). Review of Michael J. Weiss, *The Clustering of America,* in *Annals of the Association of American Geographers* 82: 182–185.

Zhang, Xueling (1989). "Progress in Sino-U.S. Friendship City Relationship over the Past Ten Years," *Voice of Friendship* [Beijing] 33: 5–7.

Zimmerman, C. C., and R. E. Du Wors (1952). *Graphic Regional Sociology: A Study in American Social Organization.* Cambridge, Mass.: Phillips.

Zink, S. (1963). "The Meaning of Proper Names," *Mind* 72: 481–499.

Other Relevant Publications by Wilbur Zelinsky

BOOKS AND ARTICLES

"The Population Geography of the Free Negro in Ante-Bellum America," *Population Studies* [London] 3 (1950): 386–401.

"An Isochronic Map of Georgia Settlement, 1750–1850," *Georgia Historical Quarterly* 35 (1951): 191–195.

"Walls and Fences," *Landscape* 8, No. 3 (1959): 14–20; reprinted in: Erwin H. Zube, ed., *Changing Rural Landscapes* (Amherst: University of Massachusetts Press, 1977).

"Changes in the Geographic Patterns of Rural Population in the United States, 1790–1960," *Geographical Review* 52 (1962): 492–524.

"Of Time and the Geographer," *Landscape* 15, No. 2 (1965–66): 21–22.

"On Some Patterns in International Tourist Flows" [with Anthony V. Williams], *Economic Geography* 46 (1970): 549–567.

The Cultural Geography of the United States (Englewood Cliffs, N.J.: Prentice Hall, 1973; rev. ed., 1992).

"The United States: Patterns of Settlement and Cultural Development," *Encyclopedia Britannica* 18: 918–926 (Chicago, 1974).

"The Demigod's Dilemma" (1975). *Annals of the Association of American Geographers* 65: 123–143.

"Personality, Free Choice, and Self-Discovery: Some Hints Concerning the Future Social Geography of the United States," pp. 109–121 in: R. F. Abler, D. Janelle, A. Philbrick, and J. Sommers, eds., *Human Geography in a Shrinking World* (North Scituate, Mass: Duxbury Press, 1975).

"Marriage Dates and the Social Geography of Innermost Pennsylvania," *Earth and Mineral Sciences* [Pennsylvania State University] 47, No. 4 (1978): 25, 29–30.

"Lasting Impact of the Prestigious Gentry," *Geographical Magazine* 52 (1980): 817–824.

This Remarkable Continent: An Atlas of North American Society and Cultures [with John F. Rooney, Dean Louder, and John D. Vitek] (College Station: Texas A&M University Press, 1980).

"By Their Names You Shall Know Them: A Toponymic Approach to the American Land and Ethos," *New York Folklore* 8, Nos. 1–2 (1982): 85–96.

"Nationalism in the American Place-Name Cover," *Names* 30 (1983): 1–28.

"You Are Where You Eat," *American Demographics* 9, No. 7 (1987): 30–33, 56–61; reprinted in *Journal of Gastronomy* (1989).

"The Making of a Landscape Critic," pp. 137–151 in: Margaret McAvin, ed., *Landscape and Architecture: Sharing Common Ground, Defining Turf, Charting New Paths* (Proceedings of Annual Conference, Council of Educators in Landscape Architecture, August 13–15, 1987) (Providence, Rhode Island, School of Design, 1988).

"The Mapping of Language in North America and the British Isles" [with Colin H. Williams], *Progress in Human Geography* 12 (1988): 337–368.

The Atlas of Pennsylvania [with David J. Cuff, Edward K. Muller, William J. Young, and Ronald F. Abler] (Philadelphia: Temple University Press, 1989).

"The Game of the Name," *American Demographics* 11, No. 4 (1989); reprinted in: Boyd Davis, ed., *A Language Reach* (New York: Macmillan, 1993).

"The Imprint of Central Authority," pp. 311–334, 392–393 in: Michael P. Conzen, ed., *The Making of the American Landscape* (Boston & London: Unwin Hyman, 1990).

"Nationalistic Pilgrimages in the United States," pp. 253–267 in: Gisbert Rinschede and Surinder M. Bhardwaj, eds., *Pilgrimage in the United States* (Berlin: Dietrich Reimer Verlag, 1990).

"Seeing Beyond the Dominant Culture," *Places* 7 (1990): 32–35.

"A Toponymic Approach to the Geography of American Cemeteries," *Names* 38 (1990): 209–229.

"The Changing Character of North American Culture Areas," pp. 113–135 in: Glen E. Lich, ed., *Regional Studies: The Interplay of Land and People* (College Station: Texas A&M University Press, 1992).

"American Social and Cultural Geography," pp. 307–317 and "Landscapes," pp. 1289–1297 in: M. K. Cayton, E. J. Gorn, and P. W. Williams, eds., *Encyclopedia of American Social History* (New York: Charles Scribner's Sons, 1993).

"North America: People and Economy" [with J. Wreford Watson], *The New Encyclopedia Britannica* 24: 1019–1031 (Chicago, 1993).

"Cultural Patterns, "Ethnic Geography," and "Recreation and Tourism" in: E. Willard Miller, ed., *The Geography of Pennsylvania* (University Park: Pennsylvania State University Press, 1994).

REVIEWS AND NOTES

The Urban South, Rupert B. Vance and Nicholas J. Demerath, eds., *Geographical Review* 46 (1956): 299–300.

American Barns and Covered Bridges, by Eric Sloane, *Our Vanishing Landscape*, ibid., *American Yesterday*, ibid., and *The Pennsylvania Barn*, Alfred L. Shoemaker, ed., *Geographical Review* 48 (1958): 296–298.

"The Religious Composition of the American Population," *Geographical Review* 50 (1960): 272–273.

The American Counties, by Joseph Nathan Kane, *Professional Geographer* 13, No. 4 (1961): 59–60.

The Squeeze: Cities without Space, by Edward Higbee, *Geographical Review* 52 (1962): 314–317.

Historical Atlas of Religion in America, by Edwin Scott Gaustad, *Professional Geographer* 15, No. 3 (1963): 31.

From Prairie to Corn Belt, by Allan G. Bogue, *Geographical Review* 55 (1965): 122–124.

Pattern in the Material Folk Culture of the Eastern United States, by Henry Glassie, *Geographical Review* 60 (1970): 275–276.

St. Croix Border Country, by Harry Swain and Cotton Mather, *Annals of the Association of American Geographers* 60 (1970): 802–803.

Atlas of Early American History, The Revolutionary Era, 1760–1790, Lester J. Cappon, ed., *Annals of the Association of American Geographers* 67 (1977): 437–440.

Cultural Regions of the United States, by Raymond D. Gastil, *Geographical Review* 67 (1977): 120–122.

Land and People, A Cultural Geography of Pre-industrial New Jersey, by Peter Wacker, *New Jersey History* 45 (1977): 112–114.

La Cittá Capitalista—Los Angeles, by Giovanni Brino, *Professional Geographer* 32 (1980) 261–262.

One South: An Ethnic Approach to Regional Cultures, by John Shelton Reed, *Annals of the Association of American Geographers* 73 (1983): 452–454.

Texas Graveyards, by Terry Jordan, *Professional Geographer* 36 (1984): 118–120.

Discovering the Vernacular Landscape, by John Brinckerhoff Jackson, *Landscape* 28, No. 3 (1985): 32–33.

The Tourist: Travel in Twentieth-Century North America, by John A. Jakle, *Canadian Geographer* 29 (1985): 372–374.

Metropolitan Corridor: Railroads and the American Scene, by John R. Stilgoe, *Annals of the Association of American Geographers* 76 (1986): 301–302.

Dictionary of American Regional English. Volume 1. *A–C*, Frederic G. Cassidy, ed., *Annals of the Association of American Geographers* 77 (1987): 144–148.

The Shaping of America: A Geographical Perspective on 500 Years of History. Volume 1. *Atlantic America, 1492–1800*, by D. W. Meinig, *Journal of Geography* 86 (1987): 80–82.

We the People: An Atlas of America's Ethnic Diversity, by James P. Allen and Eugene J. Turner, *Geographical Review* 78 (1988): 439–441.

The Middle West: Its Meaning in American Culture, by James R. Shortridge, *Geographical Review* 80 (1990): 323–325.

Regions and Regionalism in the United States, by Michael Steiner and Clarence Mondale, *Professional Geographer* 42 (1990): 272–273.

Albion's Seed: Four British Folkways in America, by David Hackett Fisher, *Annals of the Association of American Geographers* 81 (1991): 526–531.

News in the Mail: The Press, Post Office, and Public Information, 1700–1860s, by Richard B. Kielbowicz, *Journal of Historical Geography* 17 (1991): 478–479.

The Shape of Culture: A Study of Contemporary Cultural Patterns in the United States, by J. R. Blau, *Progress in Human Geography* 15 (1991): 341–343.

The Clustering of America, by Michael J. Weiss, *Annals of the Association of American Geographers* 82 (1992): 182–185.

Geography in America, G. L. Gaile and C. J. Willmott, eds., *Progress in Human Geography* 16 (1992): 119–122.

The Pennsylvania Barn: Its Origin, Evolution, and Distribution in North America, by Robert F. Ensminger, *Pennsylvania History* 60 (1993): 235–236.

Rock Fences of the Bluegrass, by Carolyn Murray-Wooly and Karl Raitz, *Geographical Review* 83 (1993): 226–228.

Index

Mennonites, 76, 88, 92, 121 (map), 178

Methodists, 79, 81, 87, 94, 95, 97, 105 (map), 124 (map)

Mexican restaurant cuisines, 466, 479, 482 (map), 483 (map)

Mexicans, 83, 85

Mexican War, 225

Mexico, 274, 511, 519

Miami, Fla., 93, 266, 473, 547

"Middle America," 22, 26

Middle Atlantic, as vernacular region, 424, 425 (map)

Middle West, 31, 34, 94, 412, 419, 420 (map)

"Middle West Extended," 33

Midland, 30–31, 34, 94, 424

Midland and Midwest vs. Southwest Factor, 30–31

Migrant Factor, 27–28, 34

Migration, 4, 73–74, 81, 89

Military Tract, N.Y., 327

Miller, E. Joan Wilson, 412

Mill pond, as generic term, 408

Milwaukee, Wis., 11, 283

Minneapolis–St. Paul, Minn., 11, 84, 550

Mintz, Sidney, 489

Missions, overseas, 74, 497, 521

Miss Liberty, 46, 224

Mitford, Jessica, 437

Modernization, 142, 146–150, 287–288

Montreal, Que., 473

Monuments, national, 49, 61, 168, 231, 268

Moravians, 68, 78, 88, 123 (map)

Mormon Region, 34–35, 85, 92, 95, 98

Mormons, 28, 66, 67, 76, 78, 79, 90–91, 111 (map)

Moscow, Russia, 497

Mound, as generic term, 384

Mount, as generic term, 384

Mountain, as generic term, 381

Mount Auburn Cemetery, 446

Mounties (Royal Canadian Mounted Police), 47, 57

Mules, 189–191, 190 (map)

Murals, 274

Music, 51

Names, personal, 5, 42, 46, 295–296, 329–365

Nashville, Tenn., 546, 547

National character, 277

National Council of Churches, 66

National Geographic, 11, 22

Nationalism, 221–237, 272

Nation-state, 232–233; vitality of, 526, 528

Native Americans, 130, 209, 290, 462

Nazarenes, 76, 90, 91, 94, 117 (map)

Necrogeography, 279, 437–456

Negritude, as factor in twinning, 520

Negroes. *See* African Americans

Nelson, Howard J., 175

Netherlands, 71, 141, 277, 520

Nevada, 34

New Brunswick, 239, 245, 247

New England, 34, 92, 93, 94, 98, 238–251, 255, 419, 421 (map)

"New England Extended," 296, 316

New England village, 166

New Jersey, 172

New Orleans, La., 473, 541, 546, 547

Newport County, R.I., 337, 344

Newspapers, 50

New York, upstate, 298, 305, 307

New York City, 11, 34, 82, 93, 177, 254, 266, 283, 337, 469, 541, 547, 549–550

New Zealand, 57, 59, 277, 296

Nicaragua, twinnings with, 514, 515 (table), 527

Norfolk, Va., 82

North, as vernacular region, 425 (map)

North Carolina, 86

Northeast, 27; as vernacular region, 427 (map)

Northwest, as vernacular region, 424, 426 (map)

Notch, as generic term, 384, 388 (map)

Numerical taxonomy, 340

Nutritionists, 460

Oak Ridge, Tenn., 548

Odessa, Russia, 498

Oldenburg, Ray, 553

Vly, as generic term, 391
Voluntary associations, 8–11
Von Eckhardt, Wolf, 179

Wacker, Peter O., 172
Walker, Francis A., 326
War of 1812, 56
Warsaw Pact countries, twinnings with, 509
Washington, D.C., 33, 49, 82, 84, 165, 168, 177, 283, 541, 547, 548, 549
Washington, George, 47, 224
Weather in cemetery names, 452
Webber, Melvin, 39
Weekly patterns in marriages, 134, 136, 152–153

Weiss, Michael, 38–39
Welcome centers, 356
Welcoming signs, 252–267, 273
Wells, 199
West, 27, 32, 35, 95; as vernacular region, 419, 422 (map), 431
Whyte, William H., 437
Williamsburg, Va., 177, 548
World's fairs, 52–53, 497
World War I, 49, 62, 133
World War II, 133, 498
Wright, John K., 260, 437

Yellow ribbons, 272

The American Land and Life Series